Prehistoric
and
Primitive Art

Luis Pericot-Garcia
John Galloway
Andreas Lommel

PREHISTORIC AND PRIMITIVE ART

with 51 colour plates
and 438 plates in black and white

THAMES AND HUDSON · LONDON

Prehistoric Art, translated from Spanish, and
The Art of Oceania, translated from German,
by Henry Mins

First published in Great Britain in 1969 by
Thames and Hudson Ltd, London
' La preistoria e i primitivi attuali' © 1967 by
Sansoni Editore Florence
Printed in Italy
500 44003 4

Contents

PREHISTORIC ART | *Luis Pericot-Garcia*

AFRICAN ART | *John Galloway*

THE ART OF THE NORTH AMERICAN INDIAN | *John Galloway*

THE ART OF OCEANIA | *Andreas Lommel*

Prehistoric Art | LUIS PERICOT-GARCIA

Introduction

Scientific research has given modern man some startling surprises. In history, few can be compared with the discovery of the unsuspected antiquity of man's roots. But although our attention is attracted to the flint axes and arrowheads used by paleolithic man and we are excited by the discovery of his remains, and although we are fascinated by the sight of the first utilitarian creations of man, still greater interest is aroused in us by the first evidence of his spiritual life. And nothing is so revealing of the mentality of our pleistocene forefathers as their contribution to humanity's first art. We are gratified to discover that they were able to create and enjoy works in which, for the first time, man went beyond the wearisome daily task of obtaining his subsistence and produced marvelous idealized images of the animals that accompanied him in his comings and goings, and even images of himself.

Through art we can escape the limitations of prehistory, which relies almost exclusively on the study of such elements of material culture as worked stones and potsherds. Art places us in contact with the mind and spirit of prehistoric peoples, enables us to penetrate into their souls, and helps us to compare their life with that of existing primitive peoples whose art we can study directly.

Over the century or so that archaeology has been concerned with this subject, a striking number of works of prehistoric art have been discovered. On every continent representations of the most diverse kinds are constantly being revealed, works that merit being included in this fascinating chapter of the history of art.

Although prehistoric art is to be regarded as one aspect of primitive art in general, the study of prehistory has its specific methods and values, distinct from those of ethnology. Therefore, the two branches of art connected with these studies must not be confused, even though they have some elements in common. Prehistoric art is distant in time, and is a résumé of the first stages of universal art. There are two aspects to the study of it: as a chapter or link in the history of art, it can be considered from the aesthetic point of view and be analyzed as an exhibition of modern painting would be analyzed; as the evidence of material and spiritual elements of the most diverse cultural significance, it is to be regarded as a document of inestimable value in the writing of prehistory.

We propose to give an over-all description of it, discussing its most outstanding manifestations, stressing those of the highest merit, which are also the most ancient. A study of the decorative arts, such as ceramics, would be equivalent to a review of neolithic prehistory, since ceramics have constituted the most important type of remains for the archaeologist ever since the Neolithic. We shall devote major attention to sculpture, engraving, and painting, and consider only those groups whose age is beyond question, although the description of the rock art of non-European continents will include recent times in order that we may trace in them the evolution of archaic forms.

One of the preliminary problems in this study is that of the origin of prehistoric art. The process in which man began to feel himself an artist is not easy to trace. It is not difficult for us to imagine various manners in which the artistic sense could have been awakened in primitive man: the irregularities and fissures in the walls of his caves might have reminded him of the form or outline of an animal; or such a form might have been suggested by a line absently traced by his finger in the clay. Likewise, we might imagine the slow development

of artistic consciousness that culminated in the spark of genius that definitively mastered the language of art. But it is difficult, if not impossible, for us to be certain that our imagination corresponds to reality.

Understandably, there are enormous differences of opinion among authors concerning this point. It might be argued that all that is necessary for an understanding of prehistoric art is the observation of what today's primitive peoples have done or are still doing. But can we be sure that the feelings and attitudes are equivalent in the two cases? Contacts, borrowings, and exchanges were certainly possible in the course of the periods of thousands of years involved, and we must conduct our study with the utmost caution.

The idea of plastic representation in volume of natural beings was undoubtedly the first that occurred to the mind of man, and it was only later that he arrived at the first schematic, linear representation in engraving or painting. We also believe that this process by which man first developed a technique of representation must have preceded his use of magic for utilitarian purposes, and, indeed, it may well have generated the idea in his mind.

We can also imagine the situation of man without writing, that is, with no way of expressing and transmitting his thoughts, desires, and beliefs to his fellows. Drawing on stone or bone by means of engraving or painting might have been a means of making that transmission possible.

From the outset the artist found himself torn between the instinctive tendency to represent what he perceived with his senses, and the imaginative tendency, which led him toward symbolism and abstraction. Art has never ceased to oscillate between the two poles. Recently, A. C. Blanc asserted the chronological priority of abstraction. This and other problems can be solved only on the basis of much more complete knowledge than we now possess. We shall return later to the chronological aspect of this art and its meaning.

A History
of the Discoveries

It is now a little over a century since it became accepted that man was contemporaneous with species of animals that are now extinct and with remote geological epochs. France was the first major center of studies; there, in the caves of Chaffaud, a bone with engraved representations of two deer was found in 1840. E. Lartet brought to light the first works of prehistoric art to be recognized as such, for example the bear's head drawn on a piece of antler, from the cave of Massat (1860). As the exploration of sites in the Dordogne and other equally rich French regions was pursued, an extraordinary number of small works of art came to fill private collections and museums. The fact that these works were found in untouched strata of the excavations put their authenticity beyond dispute.

The beauty of many of the small works of art is undeniable, but a satisfactory knowledge of paleolithic art was not attained until, by dint of great effort, it was demonstrated that the art that appears on the walls of caves and rock shelters is authentic. Incidentally, the history of the discovery of this rock art is fascinating and occurred recently enough for us to have spoken to some of its principal protagonists. It also presents perfect examples of the possibility of error and of the uncertainties that are inevitable in any study of so deep a past.

The existence of rock art was documented as early as the fifteenth century, and citations of the sixteenth, seventeenth, and eighteenth centuries refer to cave paintings and drawings, for shepherds and inquisitive people had discovered their existence in shelters (as with the paintings of Las Batuecas in Spain, referred to by Lope de Vega) and in caves (as at Rouffignac in France). The country people who knew of them always considered them magical, and up to recent times the populations of some localities at the sites of cave art have built up local legends and superstitions around them.

The true discovery of cave art did not occur until 1879, in the cave of Altamira, at Santillana del Mar, Santander Province, Spain. Although in 1878 L. Chiron had seen engraved figures in the cave of Chabot, in the Ardèche, he had not considered them important. In 1879 a Santander engineer, Marcelino de Sautuola, was continuing excavations begun in the preceding year in the cave of Altamira. The cave had been unknown until a hunter found its entrance in 1868. Sautuola was working in a large hall with a low roof. One day he was accompanied by his daughter, Maria; because she was small, she had a better view of the roof and noticed there painted figures that she called bulls (fig. 1). Her father at once realized the importance of the find and was confident of the authenticity of the paintings.

Sautuola made his discovery known and soon found a supporter in a Spanish scholar, one of the most important initiators of the study of prehistory in Spain, J. Vilanova y Piera. Vilanova strove to have the art of Altamira accepted as genuine and defended his position at the International Congress of Prehistoric Anthropology and Archaeology held in Lisbon in 1880. His efforts were in vain; he could not overcome the resistance and eliminate the doubts and suspicions of the foreign, together with many Spanish, prehistorians. Among the French scientists, who at that time were in the forefront of investigation, some went so far as to insinuate that Spanish clericals might have painted the figures as a hoax in order to discredit the young science. Others suggested that they might have been the work of idle Roman soldiers during the Cantabrian wars.

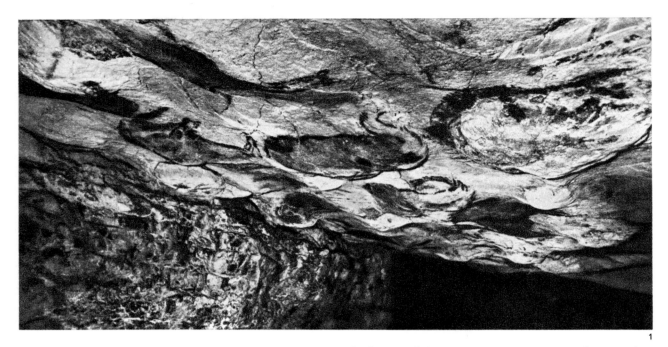

1

Today it seems incomprehensible that anyone could deny the authenticity of these magnificent frescoes at a time when other small art works of the same epoch were already known and not only provided clear evidence of the high artistic sense of our paleolithic ancestors but also showed the same, or a similar, style as that of the paintings in question. The doubts may be explained by the fact that the first paintings discovered were those with the richest polychromy and had no connection with the strata of the excavation. Both Sautuola and Vilanova y Piera died before the discovery was accepted.

At last, the constant explorations of French caves bore fruit. In 1895 E. Rivière discovered some engravings on the walls of the cave at La Mouthe, near Les Eyzies. The next year, F. Daleau uncovered the paintings of the cave of Pair-non-Pair; similar finds were reported from the caves of Marsoulas and Chabot. These discoveries recalled those of Altamira, but resistance to the latter was not overcome until, in 1901, the magnificent engravings of Les Combarelles and the beautiful paintings of Font-de-Gaume at Les Eyzies were discovered. It was no longer possible to doubt that this marvelous art went back to the Quaternary period. E. Cartailhac, who had opposed the authentication of the Altamira paintings and had silenced by the weight of his authority those in Spain who had favored it, went to Altamira, along with the Abbé H. Breuil, a young priest who was to devote his life to the work; there Cartailhac acknowledged the amazing truth and copied the paintings. He later published his noble and famous " Mea culpa d'un sceptique " (L'Anthropologie, 1902).

Thenceforth discoveries were made at a rapid pace both in France and Spain, and important findings of the same nature were made on other continents. From 1903 on, the finding of a variety of this Franco-Cantabrian art in the Spanish Levant offered a new subject for polemics and produced an extraordinary flood of ethnographic data. Later, on the Iberian Peninsula proper, it was discovered that Cantabrian art had extended as far as Andalusia, and that a schematic art had continued down to recent times. A sensational discovery of paintings was made at Lascaux (Montignac, Dordogne; fig. 2) in 1940, and the much discussed paintings at Rouffignac, not far distant, were found in 1956 (fig. 4). In 1949 the finding of wall engravings in a cave on the island of Levanzo (off the west coast of Sicily; fig. 6) and the subsequent discovery of others of the same kind demonstrated the existence of an artistic province of great antiquity in southern Italy.

Investigation continued to reveal the existence of other prehistoric artistic provinces less ancient, but no less interesting, than those previously discovered; these include engravings in the Atlantic region of Europe and in Scandinavia, engravings in the Alpine region, engravings in Russia and Siberia (fig. 5), prehistoric paintings in India (fig. 3) and other regions of Asia extending as far as Australia, and others. Two major regions are especially worthy of mention. The first is Africa, where many engravings and paintings had been discovered by the end of the last century, and where the sites known today number thousands; outstanding among the investigators in this field are such scientists as G. Flamand, H. Obermaier, L. Frobenius, H. Breuil, and H. Lhote. The second area that is revealing an interesting prehistoric art is the Western Hemisphere. Some cave paintings and many engravings have long been known there, and recently O. Menghin has

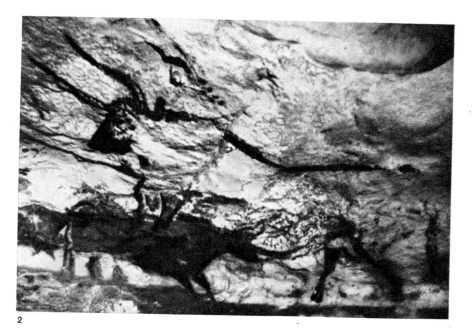

2

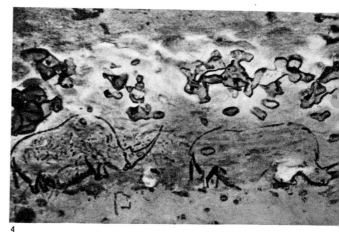

4

3

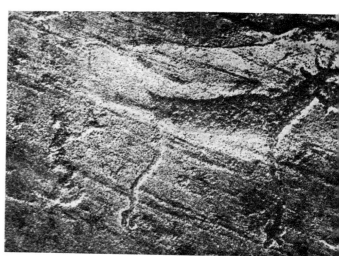

5

been able to prove the antiquity of at least the finds in Patagonia and other Argentine regions.

Because of the efforts of devoted investigators, it has been possible in the past century to write a rich, and entirely new, chapter in the history of world art. We can hope that there still remains much to be discovered, and that a solution can be found to many of the enigmas concerning the origin and evolution of this early form of art.

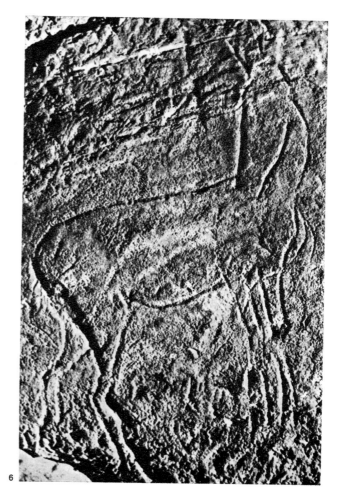

1. Ceiling with painted bison. Altamira cave (Santander), Spain. Magdalenian period.

2. Great Hall of the Bulls (detail of painted frieze). Lascaux cave (Dordogne), France. Late Perigordian or Magdalenian period.

3. Rock painting of archers (reproduction). Madhya Pradesh, India.

4. Rock painting of rhinoceros (detail of frieze). Henri Breuil Gallery, Rouffignac cave (Dordogne), France.

5. Rock engravings of a man on snowshoes and a reindeer. Zalavruga, White Sea, U.S.S.R.

6. Rock engraving of a deer. Cave of Cala Genovese, Levanzo, Egadi Islands, Italy.

6

The Art
of the Hunting Peoples
of Paleolithic Europe:
Portable Objects

The only prehistoric art that can be dated with certainty to the Pleistocene age is that of western Europe. Furthermore, the art of this area forms a homogeneous whole, despite its great variety. It is an art of hunters who lived at a propitious moment in a region that has been described as a hunters' paradise. For this reason it merits our first attention. We shall divide it into the two clearly differentiated major categories of portable objects and cave art.

The art of objects that can be easily transported is often a purely decorative art, used to beautify tools and small objects in common use. Here, two groups can be distinguished: sculptures and reliefs of human beings or animals, and engravings and paintings on stone

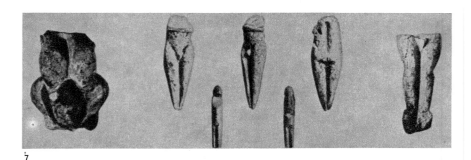

7

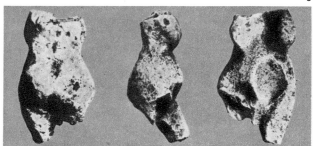

8 9

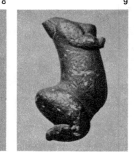

10 11

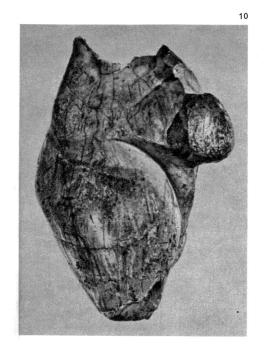

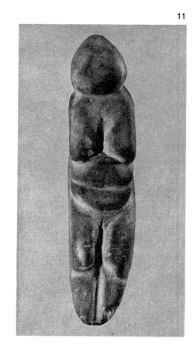

7. *Fragmentary anthropomorphic figurines, from Brassempouy (Landes), France. Aurignacian-Perigordian period. Ivory. Musée des Antiquités Nationales, Saint-Germain-en-Laye.*

8. *Human figurine (three views), from Brassempouy (Landes), France. Ivory. Musée des Antiquités Nationales, Saint-Germain-en-Laye.*

9. *Female figurine, from Sireuil (Dordogne), France. Calcite, height 3 5/8". Musée des Antiquités Nationales, Saint-Germain-en-Laye.*

10. *Female torso, from the Grotte du Pape, Brassempouy (Landes), France. Aurignacian-Perigordian period. Ivory, height 3 1/8". Musée des Antiquités Nationales, Saint-Germain-en-Laye.*

11. *"Venus of Chiozza," found near Scandiano (Emilia), Italy. Sandstone, height c. 8". Musei Civici, Reggio Emilia, Italy.*

or bone. The study of portable objects has the immense advantage over that of cave art, since these objects appear in known archaeological strata, and have a definite chronology.

Anthropomorphic Sculpture

From the beginning of the Aurignacian on, from the Pyrenees to Siberia, a number of female figurines in ivory, bone, and stone have survived; these are striking evidence of the sculptural ability of the first artists in the history of man. As a group, they have been classified under the name of " Venus, " not without a certain amount of humor. The exaggeration of the female form and sex characteristics indicates that they are undoubtedly images of a fertility cult.

The oldest examples are those in ivory from Brassempouy (Landes; figs. 7, 8, 10). They are incomplete and may include one male figure. The female figures include three bulky torsos and a head with cropped hair (fig. 12). Of a somewhat later date, in the Middle Aurignacian, the female figurine from Sireuil (Dordogne; fig. 9) is in stone. The flexed position of the extremities gives this figure a rare aspect of realism; apparently it was used as a pendant. There are peculiar details also in the Venus found in the Abri du Facteur at Tursac in 1959.

The masterpiece of the entire group, in this author's opinion, was found in a cave in the

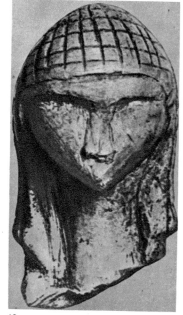
12

13

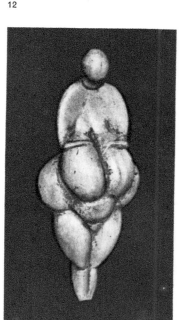
14

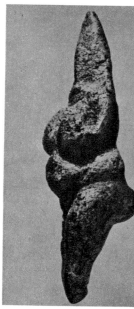
15

12. *Female head, from the Grotte du Pape, Brassempouy (Landes), France. Ivory, height 1 3/8".
Musée des Antiquités Nationales, Saint-Germain-en-Laye.*

13. *Head, from Dolni Vestonice, Moravia. Aurignacian-Perigordian period. Ivory, height c. 1 3/4".*

14. *"Venus of Lespugue," from Lespugue (Haute Garonne), France. Aurignacian-Perigordian period. Ivory, height 5 3/4". Musée de l'Homme, Paris.*

15. *"Venus," from Savignano sul Panaro, near Modena, Italy. Serpentine, height 8 5/8". Museo Pigorini, Rome.*

16. *"Venus of Vestonice" (two views), from Dolni Vestonice, Moravia. Clay with bone ash, height 4 1/2". Moravian Museum, Brno, Czechoslovakia.*

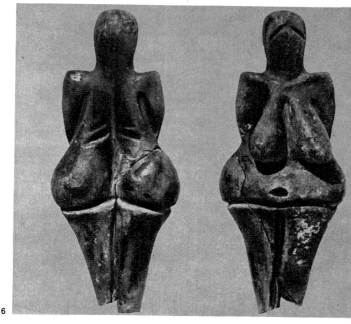
16

13

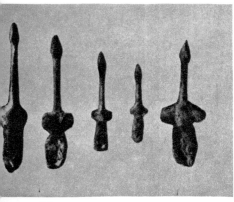
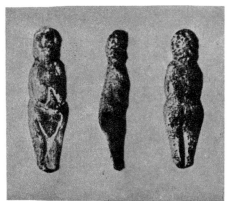
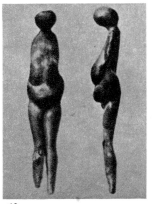
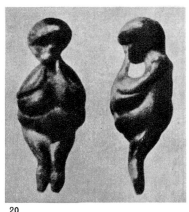

17

18

19

20

Pyrenees, which are at one end of the Venus territory, since nothing has been discovered in Spain that can be related to this type. It comes from the cave of Lespugue (Haute-Garonne) and was found by Count René de Saint-Périer. It is carved out of ivory and is slender, despite the exaggerated steatopygia (fig. 14). The legs, without feet, terminate in a point, the head is small, and the face is oval, without details; the arms rest on the excessively pendulous breasts. It is the mature work of an artist who went beyond elementary realism to create, in the conventional female form of the epoch, a precious object of paleolithic art. There is another detail of unusual interest in this figure. The skillful play of the masses of flesh is animated by a little skirt of intertwined fibers over the lower rear portion of the body. This is a valuable proof that the beginnings of weaving were known as early as the beginning of the Upper Paleolithic period.

Farther to the east the finds continued, belonging to the Grimaldian and Gravettian eras, or survivors thereof. Seven pieces come from the Grimaldi caves (Menton): one is in bone and

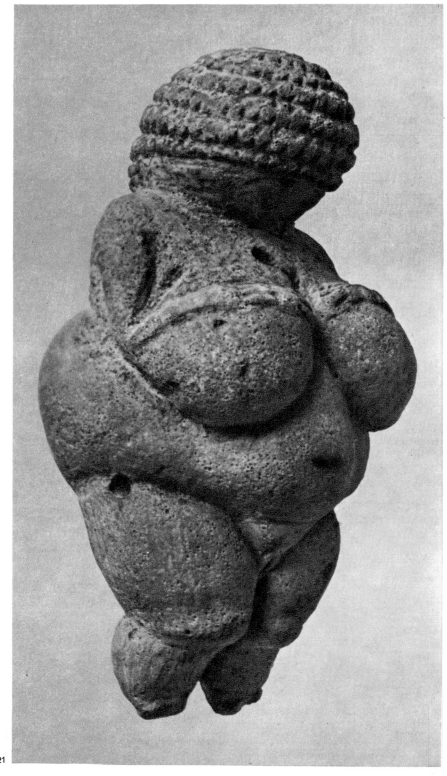

17. Figurines of birds (?), from Malta, near Lake Baikal, Siberia. Height 7 to 12".

18. Female figurine (three views), from Malta, near Lake Baikal, Siberia. Aurignacian-Perigordian period. Ivory.

19. Female figurine (two views), from Gagarino, near Tambov, U.S.S.R. Aurignacian-Perigordian period. Ivory.

20. Female figurine (two views), from Gagarino, near Tambov, U.S.S.R. Aurignacian-Perigordian period. Ivory.

21. "Willendorf Venus," from Willendorf, Austria. Upper Paleolithic period. Limestone, height 4 3/8". Naturhistorisches Museum, Vienna.

21

14

the others in steatite; six are female and steatopygous; one head has Negroid traits. The male figure has no head; it wears a belt and the skin of an animal. In a grossly steatopygous figure from Savignano (Modena; fig. 15), the legs taper to a point, as does the head, giving the effect of a hood. Two other Italian figurines, less perfect, come from Chiozza (fig. 11) and Lake Trasimeno.

Perhaps the most famous of all these Venuses comes from Willendorf, Lower Austria (fig. 21), and is carved out of a limestone pebble. It is a work as skillful as that from Lespugue in the firm stylization of the female form, but the figure is less slender and represents a squat, fat woman with her hair in ringlets. There is a large group from Moravia. In addition to the male figurine from Brno and the four figures of seated men carved from mammoth metacarpals, from Predmosti, there are the extremely interesting figures found at Dolni Vestonice, modeled in a mixture of clay and bone powder and baked. One of them, more complete and with features less exaggerated than those mentioned above, deserves the appellation of "Venus" (fig. 16). The small head of a woman with a long nose and high forehead, apparently with her head covered, it has attractive features (fig. 13). Predmosti has also yielded figurines of the Venus type and others representing women giving birth; a stone Venus comes from Petrkovice.

Still farther east, various sites of mammoth hunters in the loess have yielded examples of this art, although these do not have the obesity that is a feature of the occidental figures. In the region of the lower Don were found the figures from Kostienki, including an ivory Venus; the seven figures from Gagarino, also of ivory (figs. 19, 20); and still others from Avdeevo. Curiously, eleven ivory figurines found in Malta, in Siberia (figs. 17, 18), and others from the nearby locality of Buret should be attributed to this great family of occidental sculpture. The statuettes from Mezin (Ukraine) belong to the same cycle, but undoubtedly to a later phase; although the female sex characteristics can be distinguished in almost all of these, there is a curious schematization. Few features are indicated, and the decoration with geometric motifs seems to reflect a new artistic tendency.

22. Stylized female figurine, from Dolni Vestonice, Moravia. Aurignacian-Perigordian period. Ivory, height 3 1/2". Moravian Museum, Brno, Czechoslovakia.

22

This oriental art persisted in the northern regions of Eurasia and, after a few millenniums, reached the Arctic region of North America, its heir being the art of the Eskimos.

In the West, too, the Perigordian (or Gravettian) sculpture persisted, although in a somewhat degenerate form. Thus, from the Middle Magdalenian of Laugerie Basse comes the so-called Shameless Venus of Vibraye, a crude ivory figure with some parts of another material. Of the same epoch are some cruder, or schematized, figures of horn and bone from sites in the Dordogne and the Pyrenees. A German site has yielded highly schematized female figures made of jet.

Available data are not yet sufficient to determine whether the Natufian art of Palestine, and all the oriental schools in which the representation of fertility images was related to the

spread of agriculture, might have been derived from this occidental sculptural tradition.

Zoomorphic Sculpture

Under this heading there exist a great number of masterpieces, evidence of the hunters' mastery of their craft and their gifts of observation. The oldest examples, from the Middle Aurignacian, are those from Vogelherd in Württemberg, in ivory (mammoth, horse, etc.) and are succeeded by those from Predmosti, in ivory (a fine mammoth), and those from Dolni Vestonice, in clay and bone dust.

The great bulk of findings—sculptures, high reliefs, and cutout outlines—attributable

23. Chamois carved on a throwing stick, from Le Mas d'Azil (Ariège), France. Antler, length 11 5/8". Collection Péquart, Saint-Brieuc, France.

24. Bison, from La Madeleine (Dordogne), France. Magdalenian period. Antler, length c. 4". Musée des Antiquités Nationales, Saint-Germain-en-Laye.

25. Cervid carved on a throwing stick, from the cave of Arudy (Basses-Pyrénées), France. Upper Magdalenian period. Antler, length 4 1/4". Musée des Antiquités Nationales, Saint-Germain-en-Laye.

26. Throwing stick, carved with a goat, from Le Mas d'Azil (Ariège), France. Length 10 5/8". Musée des Antiquités Nationales, Saint-Germain-en-Laye.

23

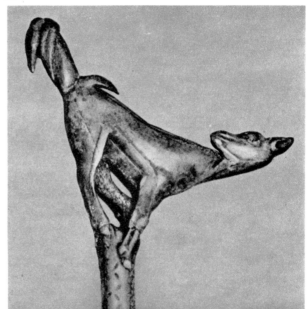

26

24

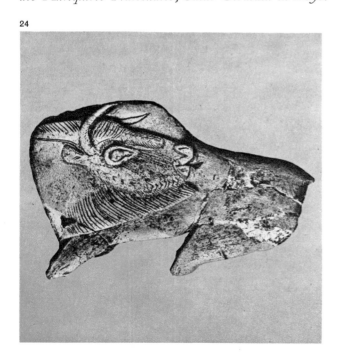

25

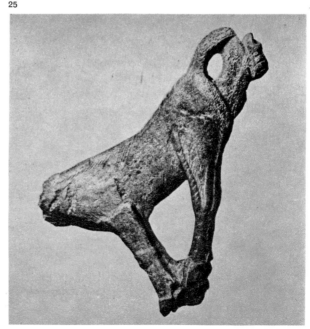

16

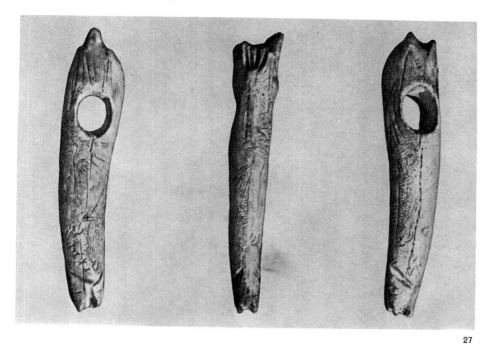

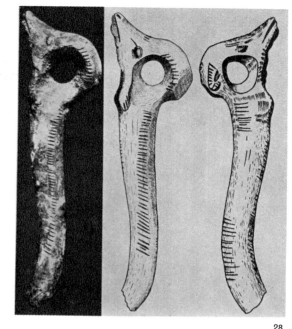

27

28

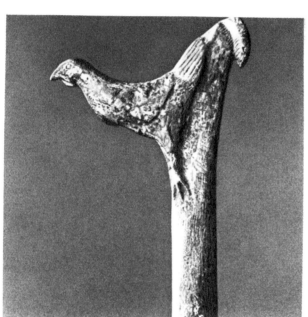

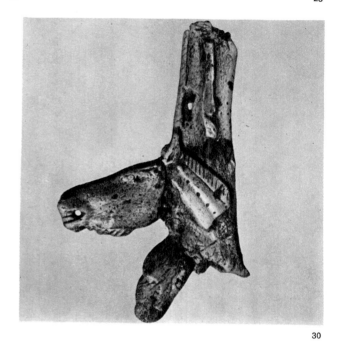

29

30

27. *Pierced baton in the shape of a horse's head (three views), with engraving, from El Pendo (Santander), Spain. Magdalenian period. Antler, length 6 1/2". Museo Provincial de Prehistoria, Santander.*

28. *Pierced baton with animal head (with schematic drawings), from Le Placard (Charente), France. Late Magdalenian period. Bone, length c. 13". Musée des Antiquités Nationales, Saint-Germain-en-Laye.*

29. *Spear thrower with bird (reconstructed), from Le Mas d'Azil (Ariège), France. Late Magdalenian period. Antler. Musée des Antiquités Nationales, Saint-Germain-en-Laye.*

30. *Carving with two horses' heads, from Le Mas d'Azil (Ariège), France. Magdalenian period. Antler, height c. 6 1/2". Musée des Antiquités Nationales, Saint-Germain-en-Laye.*

to the Upper Solutrean and the Middle and Upper Magdalenian, comes from sites in France and from a few Swiss sites, such as Kesslerloch, near Lake Constance. The materials employed are stone, bone, ivory, and horn from various deer; exceptionally, jet and amber also are used. There are curious representations of insects (Coleoptera).

In some cases we can speak of regular workshops. One of these is the famous cave of Isturitz, from which more than fifty figurines, many of them broken and reused, have come down to us; the bears and a feline with engraved arrows and holes in its body (fig. 96) are outstanding. Other such centers include Bédeilhac, Bruniquel, and Le Mas d'Azil. Among the many beautiful works of this kind, we might mention the two reindeer, male and female,

from Bruniquel; the horse from the cave of Les Espélugues (Lourdes); and the horse's head and pendant amulet, with two mountain goats in high relief, from Le Mas d'Azil.

An object that frequently was decorated with carvings or reliefs is the throwing stick. These are being found in increasing numbers, generally made of reindeer horn and showing the rich inventiveness of their makers (fig. 25). Such animals as bison, goats, horses, reindeer, mammoths, and birds are represented on them. The shape of the animal's body is skillfully adapted to the piece; thus, in one marvelous example from Le Mas d'Azil, a goat is represented by its forelegs, breast, and head, with its horns curving back at one end, while in another example from the same site, a fish pursued by an eel forms the body of the piece. We might mention, also, the bison turning its head, from La Madeleine (fig. 24); the chamois from Le Mas d'Azil (fig. 23); the two headless intertwined chamois from Les Trois Frères; and an infinite number of other pieces, admirable for attention to detail within the framework of a uniform style that reflects the unity of the school.

Even more numerous are the controversial perforated sticks, or batons (figs. 27, 28); they have been called *bâtons de commandement*, although their real function is not known. In addition to those that are only engraved, described below, many have ends carved with zoomorphic figures similar to those described in the preceding paragraphs. There are curious bones carved into fish-shaped spatulas and hyoid bones of cattle in the form of horses' heads; even a seal is represented in this way at Isturitz.

Engraving on Bone and Stone

This constitutes the most substantial group of portable objects; it has a greater variety than the sculptured works, doubtless because it could be done by beginning artists, and because the nature of the material permitted great variations. However, the engravings are often so superposed and intertwined that it is difficult to decipher them. There are a remarkable number of animal figures. Although these pieces often are crude, they can shed much light on the evolution of Quaternary art, since most of them have a known chronology. Nevertheless, the data are not adequate; in fact, many of these works have not been suitably published.

When the engraving is deep, it comes close to the intaglio technique, which, in turn, approaches low relief (fig. 31). There are many such engravings from the Upper Magdalenian in the Dordogne; at the end of the Magdalenian they degenerate, the execution being rough and abrupt. Laugerie Basse furnishes some precious examples: a pregnant woman next to a reindeer; a hunter throwing a dart at a bison; an otter eating a fish. To this group we could add the Venus found in 1958 by H. L. Movius in the Abri Pataud (Les Eyzies), although its chronology and style would link it to the other Venuses.

As with those on stone, the engravings on bone first occur in the Aurignacian but had their main development from the Gravettian on and were best expressed during the Magdalenian. The bones used for engraving were shoulder blades, frontal and other large bones, and the flat portion of reindeer antlers (fig. 67). Sometimes, as in Le Mas d'Azil, a group of engraved shoulder blades found in the same place suggests a sort of art collection. There is a notable collection of very finely worked deer heads, dating from the Middle Magdalenian, in the caves of El Castillo and Altamira; the same type is repeated in the well-known batons from the caves of El Valle and El Pendo, also in the Cantabrian region. On the batons from the caves of the Dordogne we find magnificent carvings of deer heads; together with those of the Pyrenees, they constitute a group of precious pieces, whose fine and highly detailed draftsmanship cannot be described in detail within the limits of this chapter. There are representations of deer with salmon between their legs at Lorthet (fig. 34); chamois heads at Gourdan; seals at Montgaudier; and swans at La Mairie. The extent of the artistic interest and curiosity of those draftsmen is indicated by the engraving on bone of a grasshopper in the cave of Les Trois Frères; the insect is drawn in such detail that we can determine its species. The animals most frequently represented in engravings on bone are horses and bison, reindeer, other species of deer, and goats. Curiously, there is an abundance of fish representations and a scarcity of human figures, which are sometimes so imperfect that it is difficult to identify them as such. There are some carnivores (wolves, foxes). There is a delightful engraving on bone representing a hunt, with bison shot with arrows, from the cave of Pekarna (Czechoslovakia), where some highly schematized female figurines also have been discovered. Some groups, or sketches of scenes, have been found; the most moving piece of this type is the bone plate found in Isturitz, which shows a man looking at, or following, a nude woman who has highly accentuated forms.

On such bone tools as tubes, vessels, darts (especially the bevels on darts of Magdalenian I), and disks, we find some animal figures, along with purely decorative drawings, which we shall discuss below.

The ready availability of flat surfaces of limestone, slate, sandstone, and other stones led to a great abundance of engravings on stone; there are thousands of examples. In general, engravings on stone are less fine than those on bone, because of the inherent difficulty presented by the material. The fact that many finds of such engravings have been made at particular sites, while nothing has been discovered at other sites nearby, confirms the theory that there were workshops, or, better, sanctuaries

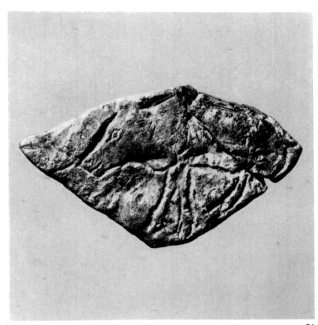

31

31. Stone fragment with reindeer in low relief, from Isturitz (Basses-Pyrénées), France. Length c. 6". Musée des Antiquités Nationales, Saint-Germain-en-Laye.

32. Stone fragments with engraved or painted motifs, from the Romanelli cave, near Otranto (Apulia), Italy. Collection Blanc, Rome.

33. Schematic drawings of stone fragments with engravings of female figures, from the cave of La Marche, Lussac-les-Châteaux (Vienne), France. Magdalenian period.

34. Deer with salmon, impression of engraving around an antler, from Lorthet (Hautes-Pyrénées), France. Magdalenian period. Length of design 5 1/2". Musée des Antiquités Nationales, Saint-Germain-en-Laye.

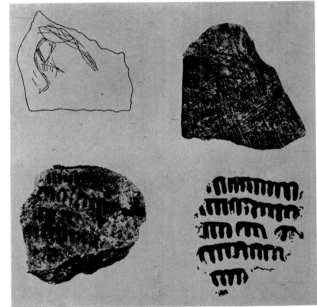

32

33

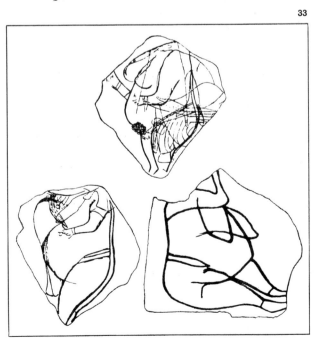

34

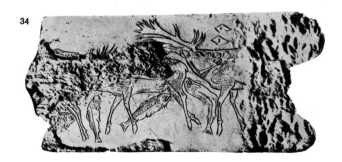

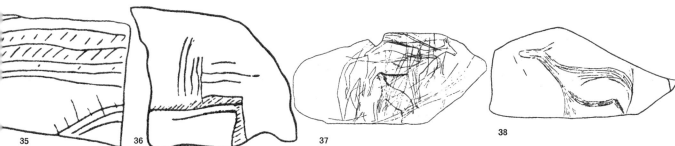

35 36 37 38

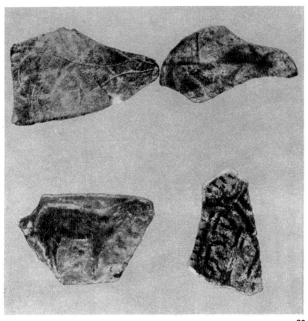

39

where stone fragments with animal figures were used in certain rites. In many cases the stone fragments bear superposed and intricate engravings, which may be considered as leaves of an album in which sketches are reworked, or as amulets that have proved efficacious and on which images are accumulated in repeated magic rites.

One last general observation, derived from our personal experience, is that undoubtedly there have been many excavations in which engraved stones have gone unnoticed. Any more or less flat stones that appear at a digging must be washed with infinite patience and then examined carefully in order to make sure that nothing is overlooked. These precautions have not been observed in many excavations where the finding of engraved fragments was not anticipated, and this is especially true of early diggings. There probably are many works of art in the rubbish heaps of the early excavations.

The oldest known example is the limestone fragment from La Quina, with fine, undecipherable engravings of the Early Aurignacian. Later, from the Gravettian and the Solutrean, the number of examples increases. In the Perigordian stratum of the cave of Péchialet, in the Dordogne, a slate fragment shows a man being attacked by a bear and another man coming to his aid. In the cave of Le Trilobite (Yonne), very fine representations of hairy rhinoceroses decorate the two faces of a slate fragment. A set of pebbles from La Colombière (Ain) shows a complicated network of lines among which a series of animals (bear, rhinoceros, musk ox, deer, horses), together with a man and a woman, can be discerned. The style is most unusual and cannot be mistaken for that of the other French regions. On a piece of schist from Keblice (Czechoslovakia), a lamprey and a salmon are represented.

The period richest in engravings on stone is the Magdalenian. The interesting examples are many, but we shall name three sites of special significance.

One is the cave La Marche (Lussac-les-Châteaux, Vienne) where many engraved stone

35, 36. Schematic drawings of stone fragments incised with geometric motifs, from the cave of El Parpalló (Valencia), Spain. Museo de Prehistoria, Valencia.

37. Schematic drawing of a stone fragment engraved with a deer suckling a fawn, from the cave of El Parpalló (Valencia), Spain. Length 15 3/8". Museo de Prehistoria, Valencia.

38. Schematic drawing of a stone fragment with engraving of a deer, from the cave of El Parpalló (Valencia), Spain. Length c. 5". Museo de Prehistoria, Valencia.

39. Stone fragments with engraved or painted motifs, from the cave of El Parpalló (Valencia), Spain. Museo de Prehistoria, Valencia.

40. Finger painting on rock of a rhinoceros. Cave of La Baume Latrone (Gard), France.

41, 42. Rock painting of rayed motifs and a horse. Cave of La Pileta (Málaga), Spain.

20

fragments were found in a stratum of the Middle Magdalenian; the images on these include a large number of figures of bears and lions, along with some remarkable, obese female figures (fig. 33) and male heads with faces that are so strange and even grotesque in expression that we are reluctant to accept without further evidence all those copies which have been published.

At Limeuil, about 150 good-sized stone fragments, apparently from the Upper Magdalenian, bear engravings, many depicting cattle; they are in the best style of the region and form the most homogeneous group in this class.

In the cave of El Parpalló (Gandía, Valencia) our own excavations unearthed a great number of engraved limestone fragments. Since all of those at the site were collected and their positions in the strata are known, much information has been obtained from them. Unfortunately, their artistic level, with a few rare exceptions, is not equal to the perfection of the works found in the Dordogne or the French Pyrenees; thus, these engraved fragments represent something marginal, and not everything learned from them can be applied to Quaternary art as a whole. Nonetheless, the five thousand incised fragments of El Parpalló, together with the painted fragments, constitute a wealth of data that no other site has yielded (figs. 35–39). For this reason it is worthwhile to indicate the main outlines of its development.

The art of engraving in the cave of El Parpalló began with very crude representations of animals (predominantly deer, horses, cattle, and goats), corresponding to a Gravettian age. In the course of the various Solutrean stages the style improved, and there are many large plaques covered with superposed figures, frequently in double silhouette. At an advanced period of the Solutrean the animal motifs are accompanied by geometric patterns which are undoubtedly symbolic in origin and which, in some cases, may represent hunters' traps. Some small stone fragments from the end of this period show animals in more lively movement. The Magdalenian fragments are of medium size and the drawing is finer, with the features in sharper relief; in a few cases the engraving is deep and approaches intaglio. The highest perfection is attained in some examples from the Middle Magdalenian, in which there is a great deal of a geometric art, with such motifs as tectiforms (tent-shaped patterns), stripes, and sinuous bands with an inner line (figs. 35, 36). This geometric style clearly is different from that of the Solutrean.

40

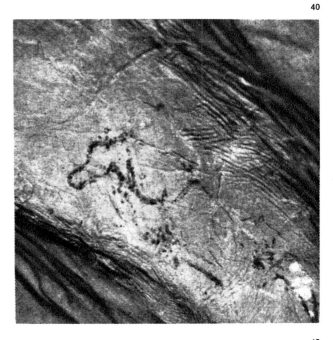

41

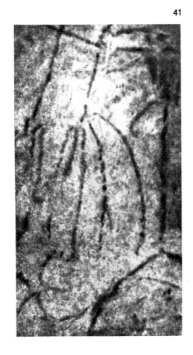

42

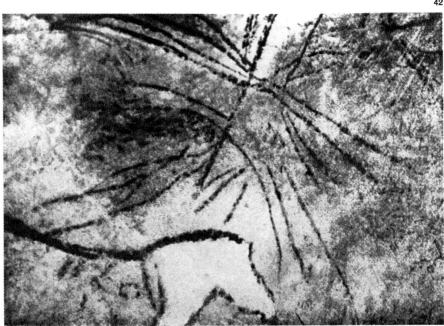

Decorative
and Schematic Motifs

We have seen, as in the cave at El Parpalló, that on various occasions, at the same site and by the same people, there has occurred, simultaneously, the development of a naturalistic art and the use of more or less geometric motifs, symbolic in nature, whose significance is unknown to us in most cases. We must also consider that engravings made on tools assume a decorative function, and that there were drawings that had a purely ornamental purpose.

From France to the Ukraine we find schematic engravings as early as the Upper Perigordian (or Gravettian); this was the range of the Venus figurines. At Predmosti, a most curious female motif on ivory, composed of several striped oval patterns, attests the high degree of intellectualism or abstraction that had been arrived at even then.

Most of these motifs appear during the Magdalenian period. In the initial phase a series of motifs is used on throwing sticks and other implements (as at Le Placard). In the Middle and Upper Magdalenian the number of such drawings increases remarkably. Breuil proved that most of the decorative elements on bone from the advanced and the end of the Magdalenian are stylized natural forms, mainly heads of cattle, deer, and fish. Other motifs are the result of the techniques employed in working the pieces; many decorations are probably utilitarian—marks indicating ownership, bands that permit a better grip of the object—or are pure imitations of cords, bindings, rings, basketry, or stitching.

In Moravia and the Ukraine we find the highest development of geometric decoration with bands and frets imitating basketwork in a style that persisted in the region until a very late period.

Another source of inspiration for the schematic motifs that appear on small objects —and also on the rock walls—are arrows and darts, which are represented in the bodies of animals; bows; and traps or huts.

A southern extension of this schematic art is found in Italy, where the caves of Romanelli, near Otranto, and Polesini, near Tivoli, have many features in common with El Parpalló cave. Several stone fragments from Romanelli bear geometric motifs (fig. 32). The path taken by this art southward from central France is marked by a number of caves near the Pont-du-Gard, in which engraved or painted stones were found to bear motifs of the same kind.

Later, during the Mesolithic period, this schematic art was produced exclusively in the Occident; numerous examples survive on stone fragments. To mention only engravings, there are the pieces from Laugerie (Dordogne) and those from the cave of La Cocina (Dos Aguas, Valencia).

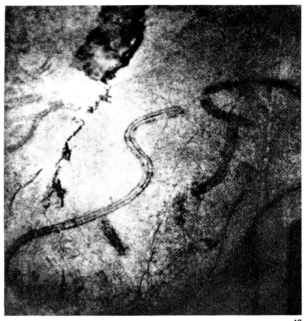

43

Painting
on Portable Objects

As compared with the mass of examples of engraving on portable objects, which we have outlined only generally, painting in this art seems to be but a minor adjunct. This situation is the opposite of that of cave wall art, in which the paintings are undoubtedly much more interesting than the engravings. And yet we are convinced that activity in painting was more extensive on portable objects than extant examples would indicate. Stones with colored patches and fragments of pigment are found at many sites, but painted figures are not easily preserved among the debris of habitation, and, moreover, vestiges of this type were not looked for in many early diggings.

If we possessed a series of stone fragments with decipherable painted figures from well-dated sites of the Upper Paleolithic, many of the problems posed by cave art, which we shall consider below, would easily be solved.

43. Serpentine finger tracings in red and yellow clay on rock. Cave of La Pileta (Málaga), Spain.

22

Unfortunately, we have no such treasures and must be content with a few dozen pieces, the best of which are from the above-mentioned El Parpalló cave; there, too, they constitute only a small percentage, as compared to the engraved fragments.

In the caves of the Pont-du-Gard and Romanelli, there are small stone fragments with schematic paintings; this is further evidence of our observation regarding the engravings, that is, that the schematic predominates in the regions east of the Dordogne.

In the cave of El Parpalló, over a thousand stone fragments with traces of painting were collected; many of the figures have engraved contours as well. There is one obvious fact, to which we are trying to give a certain chronological value in considering the evolution of Quaternary art: the absolute preponderance of painting in the Solutrean and Gravettian stages, that is, during the pre-Magdalenian era. In the Magdalenian period at El Parpalló, there is less painting and there no longer are representations of large animals with bodies covered with color; we find only one tent-shaped representation, another plantlike one, and the silhouette of a goat's head, treated as a simple outline.

From the pre-Magdalenian stages, apart from various indeterminate animal parts, there are a monochrome deer in black, with engraved outline; a deer colored in ocher, also engraved; a deer caught in a trap; and two horses. One horse, on a stone fragment about fifteen inches long, is represented in the act of jumping and seems to have been modeled on a painted horse from Font-de-Gaume; the same fragment bears a series of dots, a motif found frequently in the cave paintings of the epoch.

Several stone fragments of the Upper Solutrean from El Parpalló are painted with rectangles, a motif that is repeated in engravings in the same strata, sometimes with elongated sides. The same motif is repeated in the cave of La Pileta and appears sporadically in such Franco-Cantabrian sites as the caves of La Pasiega and Lascaux. We shall, therefore, use it as a valuable chronological datum, despite the fact that it has not been considered significant. Other painted blocks with known chronologies, such as those from Sergeac, are really detached fragments of wall paintings and will, therefore, be included in the section on cave wall art.

It is difficult to determine whether these small painted stone fragments may have been derived from the painted pebbles of the Azilian, with their purely schematic motifs. They are concentrated around Le Mas d'Azil, but also extend through the Pyrenees, central France, and beyond as far as Birseck, near Basel; the Victoria cave, at Settle in northern England; and the Netherlands and Hungary. Even if the Azilian should be deprived of the special characteristics that have been attributed to it thus far, it would always remain a final and decadent phase of the Magdalenian and its painted portable objects would be the last evidence of an interesting artistic sequence that we should like to know better.

The Art
of the Hunting Peoples
of Paleolithic Europe:
Cave Art

Cave art is the most famous, the most fascinating, the outstanding manifestation of prehistoric man. We have already referred to its relatively recent acceptance. The major portion of this chapter will be devoted to it, even though, because of the short time that some of its sites have been known and the incompleteness of much data, many of the questions we raise will be left unanswered. Our main attention will be given to painting; but we shall also make reference to the engraving that usually accompanies it, although some sites have only engraved figures.

The artistic ensemble, undoubtedly of the Upper Paleolithic, is located in central and southern France and in the Cantabrian region of Spain, with extensions to the southern plateau and Estremadura, down to the province of Málaga. For this reason its usual designation as Franco-Cantabrian art would seem to be mistaken; it has been so named because the Dordogne and the region of the French Pyrenees are the districts best known from this point of view and because it has been catalogued by the French school of researchers. It could be called a Cantabro-Aquitanian province, or a Franco-Hispanic one, but the use of its customary designation persists, and this appears throughout the bibliography.

With some exceptions, the pictures are of isolated animals and do not form scenes; they are usually large, in some cases larger than life-size. In addition to the animal figures, there are some figures of human beings, paintings of hands and geometric signs that are interpreted as representing maces, traps, or unidentifiable objects and themes.

The figures are naturalistic in style; the technique employed varies with the stage of development of the art. There are engravings with simple or multiple lines, figures with the outline engraved and the body painted, animals in silhouettes of solid or broken lines, figures in solid areas of color or in shadings that approach polychromy. The ensemble is vivid and indicates a marvelous power of observation and an ability to bring the figures to life in the most varied postures.

General Characteristics

Clearly, this is cave art, found on the walls or roofs of the interiors of caves, generally deep in galleries or halls that are almost inaccessible; its discovery is one of the most interesting chapters in archaeology.

44. Checkerboard motifs painted and incised on rock. Lascaux cave (Dordogne), France.

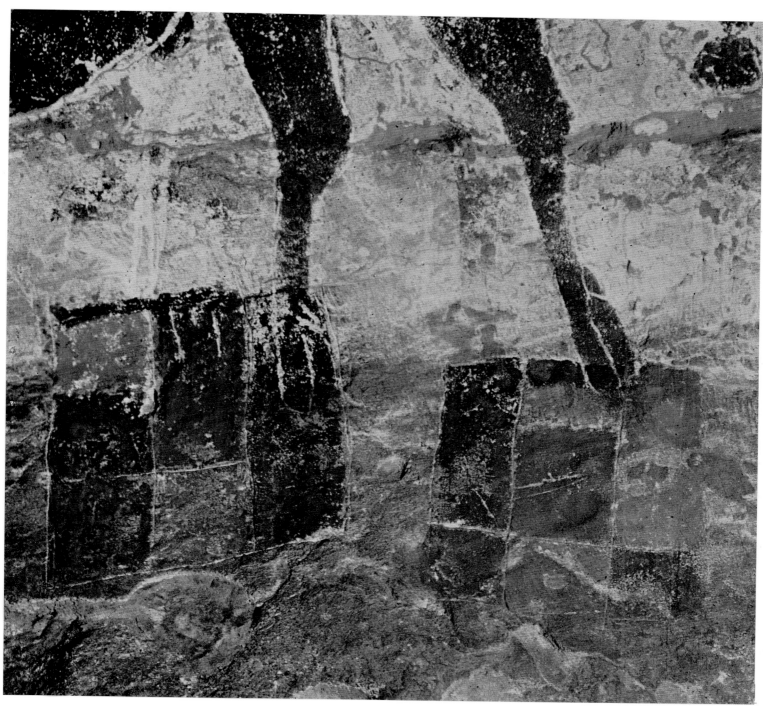

44

The procedures are primitive. The engravings were made with flint points. Paintings were executed with sticks of ocher (which makes much of this art drawing rather than true painting) or brushes of horsehair, feathers, or vegetable fibers; the pigment also was applied with the fingers, and in some cases the pulverized pigment was blown directly onto the surface through a tube. The colors used are the black and blue-black obtained from charcoal or manganese ores; the yellow, red, violet, and brown, from ochers and hematites; and the white, rarely used, from calcined marl. Green and blue were unknown. These materials perhaps were mixed with animal fat, white of egg, blood, or vegetable juices. Artificial light for painting in the caves was provided by torches and lamps of stone, shell, or skulls, which were filled with fat and had hair or moss wicks.

The following animals are depicted most frequently: the horse, mountain goat, deer, bison, mammoth, and reindeer (the last two were not represented in Spanish cave art). Rarer are representations of the rhinoceros, wild bull, wolf, bear, lion, chamois, ibex, wild boar, birds, fish, saiga antelope, and an animal that may be the hairless elephant. There are some curious aspects of the chronological and topographical distribution of the animals represented in the paintings. For example, fish representations are rare in cave art but abound in portable objects; does predominate over bucks in Cantabrian caves while bucks predominate on the walls of some French caves.

Some of the animals represented are extinct and few are still found in the region; still fewer exist in a wild state. This is one of the arguments that can be presented in favor of the antiquity of the paintings. Other equally convincing arguments are the exact resemblance of cave art to engravings and paintings on stone or bone found in paleolithic sites, the fact that the entrances of some of the painted caves have been sealed since the Quaternary age, and the existence in some sites of paintings or engravings covered by intact archaeological strata.

The number of sites that should be included in this group is a difficult one to fix accurately, because of some doubtful examples. Apart from the five caves found in Italy, there are about seventy sites in France and thirty-nine in Spain.

45. *Superimposed drawings on rock of a fish and indecipherable motifs. Cave of La Pileta (Málaga), Spain.*

45

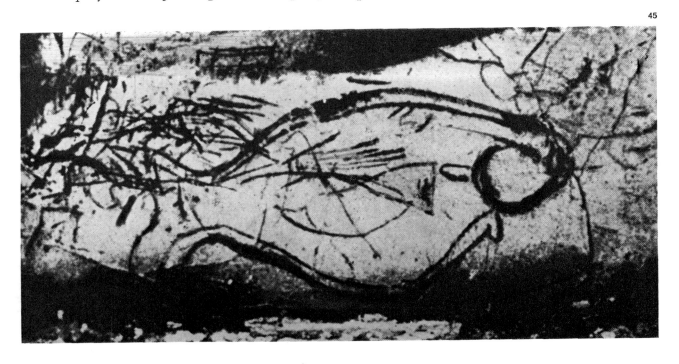

26

The Problems of Chronology

We have mentioned our reasons for placing these artistic productions in the Upper Paleolithic, beyond any possible doubt. However, this period continued for more than 25,000 years, by moderate estimates, and, obviously, art during that period underwent a continuous evolution. We must, therefore, try to distinguish the phases of this artistic development and relate them to the various archaeological and climatic eras of the Upper Paleolithic. It is not an easy task, and must be accomplished by means of stylistic analysis, which enables us to distinguish various styles and phases from the outset by a study of the superpositions of figures and by a comparison with portable objects, which fortunately have an incontestable chronology.

This task was one of the principal concerns of the great specialist, Abbé Henri Breuil, who devoted himself with noble enthusiasm to the study of cave art in every country. The following is a summary of his ideas on the evolution of Franco-Cantabrian cave art.

The origin of cave art in early stages of the Upper Paleolithic is envisaged by Breuil as a consequence of the hunting life: the hunter is gifted with keen visual memory and knows the most minor details of animal forms and movements; toying with clay, passing his finger over it, he traces curving lines and, in a moment of genius, discovers the first animal silhouette; he later imitates the result in clay, wood, bone, or stone. As regards painting, it is known that natural colors were used for painting the body as early as the Mousterian period. A mark left on a wall by a painted hand could present man with the idea of painting the wall in negative; other silhouettes would follow.

Breuil's basic idea is that Quaternary cave art developed in two distinct and successive cycles, the first during the Aurignacian and Upper Perigordian (or Gravettian), the second from the end of the Solutrean down to the end of the Magdalenian. The first of these cycles begins in the Lower Aurignacian with finger tracings in clay and crude sexual representations, footprints, and simple animal silhouettes that sometimes were based on the natural forms of the rocks. Later, fine engraving with a flint was introduced. The body of the animal is represented as striped; only two stationary legs are shown, and the antlers and hooves are shown frontally, while the figure is in profile. However, toward the end of the cycle the profile is more perfectly conceived, and all four legs are shown.

The first cycle of paintings begins with loops of triple lines, executed with the fingers in yellow or red, at La Pileta (fig. 43) and La Baume Latrone. Later there are crude silhouettes in black, red, or bister, with very rigid legs; the body of the animal gradually is filled in with color and a less tortured perspective is achieved. Color is blown onto the surface by means of a tube. Thus, we arrive at the high point of the cycle, which, according to Breuil, is the cave at Lascaux. According to him, by virtue of certain details this cave represents a link with the art of the Spanish Levant. The same illustrious authority holds that the pieces of fallen rock found by Didon in the Abri Blanchard and the Abri Labatut at Sergeac (the first dates from the Middle Aurignacian; the second represents a male deer, showing his antlers in twisted perspective) confirm both the relationship of this cycle to the art of the Spanish Levant and its chronology as proposed by him.

The second cycle, which follows an interruption that lasts through the first two-thirds of the Solutrean, includes the Upper Solutrean and the entire Magdalenian. From the beginning this cycle reveals a skillful style in the execution of low relief in friezes or on blocks, a style that produced such impressive works as those at Angles-sur-Anglin, prior to the Middle Magdalenian. At the same time there are many deep engravings or intaglios, and silhouettes in shallowly engraved lines with a parallel line filling out the figures, as in the engravings on bone of Altamira and El Castillo, of the same epoch. In what Breuil called Magdalenian IV, the technique of modeling in clay developed in the Pyrenees zone and produced marvelous works. At the same time engraving reached its high point, recording the most minute details of figures. A "cameo" technique made use of the various layers of the rock formation with their differing tonalities. In the Upper Magdalenian, the engraving became finer and was usually employed to outline the contour of the figures.

In this second cycle the development of painting is parallel to that of engraving. It began modestly, ignoring the progress that had been made during the Gravettian, and produced simple silhouettes in black. Gradually the figure is filled in with lines suggesting modeling; there is a good deal of solid color, and various experiments culminated in the achievement of polychromy in Magdalenian VI. The engraved outline, which is shallow in the Pyrenees region and deep in the Dordogne, is emphasized by a black line that follows the contours of the figure, which is modeled in ocher tones, reds, violets, and oranges. There are excellent examples of polychromy at Altamira, Font-de-Gaume, and Marsoulas. This polychromy persisted for a

short while and disappeared suddenly as the Magdalenian ended, unless we admit that somehow or other the vital impulse of this great art was transmitted to the Spanish Levant, or to the Africa of the Bushmen, or to other hunting cultures on various continents. In the Occident, mesolithic man lost all artistic ability and, at most, was capable of painting simple patterns in red on pebbles.

To complete this exposition of Breuil's ideas on the evolution of cave painting, we point out that schematic art is found in all regions but becomes more strongly accentuated toward the south. In the Dordogne there are paintings of tectiforms; at Lascaux there are rectangles and checkerboards (fig. 44, colorplate). In the Pyrenees region the tectiforms appear again, along with band shapes, branched signs, series of dots, combs, etc. All these motifs appear even more frequently in the Cantabrian region. To the south, at the cave of La Pileta, the patterns are more numerous, especially in the paintings in black, which are believed to be later than those in red. They include human figures and rectangles with striped corners, similar to those at Altamira, which Breuil assigns to Magdalenian III.

This chronological reconstruction by Breuil is a marvel of observation and patient analysis. It was universally accepted for years since no one had enough knowledge or data to the contrary to challenge the master. Today, however, we believe that the time has come to revise it in the light of new data and new theories that can not be ignored. There are differences of opinion regarding the dating of Lascaux, which was discovered after Breuil's system had been devised; many authors feel that this famous cave in Montignac should be assigned to an advanced phase of the Magdalenian. It is difficult to maintain the clear distinction between two cycles of art that, however mutually independent, were subject to complicated cultural interweavings in the initial phases of the Magdalenian. And Breuil did not take into account the results of our excavations in the cave of El Parpalló, perhaps because he thought it was of marginal importance as compared to the great creative centers of Quaternary art. In our opinion, the painted plaques of El Parpalló lead to the following conclusions: that there existed a continuity of artistic evolution, without breaks, in the Lower Solutrean; that probably at least a major portion of paleolithic painting is from the Solutrean; that the simple rectangular patterns and those with striped corners date from the Solutrean; that, in view of the affinities with La Pileta, there existed a Mediterranean province of paleolithic art. The abundance of schematic art in the cave at Gandía forces us to accept the possibility that the same people could create expressions of naturalistic art and, at the same time, also use abstract motifs. It is to be hoped, therefore, that someone who has broad knowledge of Quaternary art and is endowed with a fine aesthetic sense will be able to revise Breuil's chronological scheme, adapting it to the data presently available and thus paying tribute to his memory.

Recently some authors have begun that revision. A. Leroi-Gourhan has attempted to draw conclusions from the location of the paintings in the caves, and Mme. A. Laming-Emperaire has made an outstanding effort to restructure Breuil's chronology. In 1960 J. Combier ascribed the group of paintings in the caves of the Ardèche to the Solutrean. J. Cabré had already suggested the possibility that the paintings of Altamira were Solutrean.

Another problem is the end of this extraordinary pictorial art. The suddenness with which it appears to have terminated may be the result of a false perspective on our part. But there is solid truth in Breuil's phrase that many thousands of years were to pass before humanity was able to rediscover a vigorous perspective and a sympathetic view of living things.

Some progress has been made regarding absolute chronology. If the Magdalenian came to an end in the European countries between 10,000 and 8000 b.c., that would be the terminal date for the Altamira polychromy, according to Breuil's system; but the paintings of Altamira generally are assigned an older age: 12,000 to 15,000 years. Carbon-14 analysis indicates an age of about 14,000 years for the paintings at Lascaux. However, we can not be sure that the piece of charcoal analyzed is contemporaneous with the paintings, nor do we know to what stage of cultural evolution the paintings belong.

46. The "Sorcerer" (watercolor copy). Cave of Les Trois Frères (Ariège), France. Paleolithic period. Graffito and painting, width 29 1/2".

A date recently obtained for the Solutrean of Seriñá (Gerona, Spain), which resembles the paintings of Lascaux, leads us to accept it for much of the Solutrean painting that Breuil regarded as late Perigordian. In that case, we could accept a date for Altamira later than that indicated by analysis of a specimen from the cave of El Juyo (Santander), of the Magdalenian III; the specimen is to be dated about 13,500 B.C., and this would allow sufficient time for the development and evolution of Magdalenian art.

Granting that the beginning of this evolution occurred in an early phase of the Aurignacian, and basing our calculation on Movius' perfected chronology, that beginning could have occurred some 30,000 years ago; in that case it would fall somewhere in the middle of the four hundred centuries of Quaternary art accepted by Breuil. Perhaps our calculation is more probable in the light of the constant laws of artistic evolution, as noted by Camón Aznar.

The Significance of Cave Art

There now arises another problem, no less fascinating or profound than the preceding ones, but one in which personal viewpoints will always have some importance and scientific rigor cannot be so strict. We have to explain how so marvelous an art could have arisen and survived for so many thousands of years at a stage of obvious cultural primitivism, when social organization was in its infancy and it is hardly conceivable that there might have existed artists with free time and organized schools of art.

Not surprisingly, after an initial phase of admiration for the genius and ability of these first artists, the scientists—ethnologists and archaeologists—began accumulating data in favor of purely utilitarian explanations of this

46

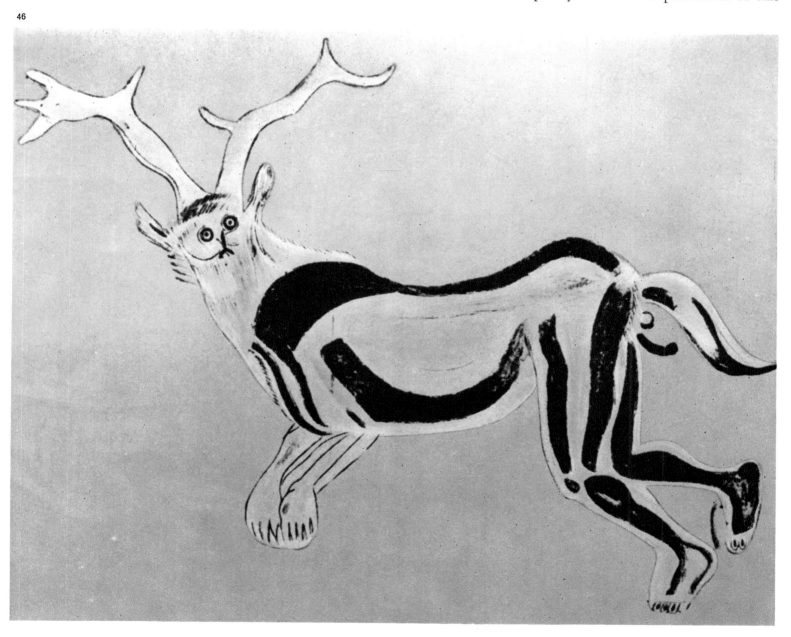

art. Primitive peoples of today give us an idea of what the early artists may have been. For today's primitives the representation of figures by means of painting or engraving is a means of practicing magic, particularly the magic of the hunt. Certain rites are more efficacious if performed before the image of the animal to be hunted. These rites are performed by priests or sorcerers, secretly or in holy places, sometimes in mysterious recesses in the depths of caves. All this bespeaks a society based on totemism, with its totem animals whose death must be propitiated, and with its taboos and ceremonies. However, the problem of totemism is a very complex one, and there are authors who doubt the totemism of paleolithic man.

Clearly, the picture fits what we know of the environment of the Upper Paleolithic in western Europe. Cave art is found in only a few sites, with no apparent reason for its absence from neighboring sites (only about two hundred sites out of five hundred known ones have yielded works of art). Favored locations for cave art are corners into which daylight does not penetrate, sometimes hundreds of feet from cave entrances, accessible only through narrow passages. The images frequently show the animal with arrows or darts fixed in its body, or otherwise wounded, trapped, or killed. To avoid the action of enemy magic, the human figure is not reproduced, or is represented only as a mask. The magician takes on an animal form and often is represented in this manner; sometimes, as in the large hall of the Pyrenees cave of Les Trois Frères (fig. 46), he is shown presiding over walls covered with thousands of superposed engravings that had served thousands of the faithful for their personal magical rites. Many other factors favor the thesis of the utilitarian purpose of Quaternary art. The very fact that the figures were painted in locations where they could not be seen without artifical light, and were superposed without any organization, proves that their aesthetic value was unimportant. The same was true of portable objects; beautiful objects have been found broken, discarded, or thrown onto hearths and debris heaps.

Nonetheless, few today believe that the birth of this marvelous art is to be attributed solely to a utilitarian purpose. It would be ridiculous to assert that every line has a magic purpose and that the artist never was transported by the fantasy or by the inner satisfaction of artistic creation. Without aesthetic ability, the experience gained by apprenticeship in a school, and the background of a tradition, no artist would spontaneously paint a bison such as those of Altamira. However, unless these artistic conditions, which we might call eternal or

47. Rock painting of a bovine head. Altamira cave (Santander), Spain.

47

perennial in modern man (and even those prehistoric painters belonged to modern races), had been united to a social need, the artist would not have been able to enjoy the leisure necessary for the development of his innate talents and to have the protection of the society that needed him.

Thus, we accept for the Upper Paleolithic a situation similar to that of art and artists at all times and in every country. The Greek artist created his masterpieces for the decoration of temples; the Romanesque and Gothic artists did the same for their churches; and the modern creative artist is supported and inspired by a society that believes that it must foster art for its own spiritual welfare.

Altamira

Curiously, the greatest achievement of Quaternary cave art is still universally recognized to be the first example of it to be found, the cave that J. Dechelette has called the "Sistine Chapel" of Quaternary art. Hence, our description of the finest examples of that art begins with this famous cave.

The cave of Altamira is on the outskirts of Santillana del Mar, Santander Province in Spain; its entrance is almost invisible even at a short distance. Its galleries are about 900 feet long; the best paintings are on the roof of the large hall that opens out about 85 feet from the entrance. This hall is approximately 60 feet long by 30 feet wide, and was originally about 6 feet high, sloping down to 43 inches; recently the level of the soil has been lowered for the convenience of visitors. In the entrance corridor flint and bone tools belonging to the periods of the Upper Aurignacian, Upper Solutrean, and Lower Magdalenian have been found; sometime after the last of these periods, a part of the roof of the vestibule caved in, rendering the cavern uninhabitable and closing it until, in 1868, a hunter discovered the entrance and cleared away the debris. There are other figures of lesser importance as far as the end of the gallery beyond the hall.

The number of figures counted on the walls of the cave comes to about 150, dating from various epochs. In addition to the paintings, which most interest us, there are some representations that are entirely engraved and others with the outline and some details engraved. Although there are some simple painted outlines (figs. 47, 48), striking polychromes predominate; modeling was achieved in them by washing or rubbing the color to create shading (figs. 49–53). It is curious that here, as at other sites, the projections on the roof of the large hall, which form a series of undulations, were utilized to give relief to animal figures, such as those of bison, that could be adapted to incorporate the natural forms of the rock. No apparent order can be seen in the arrangement of the figures, and frequently they are superposed.

The great frieze on the roof of the hall contains a number of impressive bison figures. Their bodies are usually shown in a resting position, with head lowered and legs drawn close to the body; their forms are adapted to the rounded projections of rock. In other images these projections are used to bring out in relief only a part of the body, such as the head, back, or haunches. In this type of image, the animals are shown at rest, lying down or standing still; some, as mentioned above, are shown wounded or writhing on the ground. Other animals are depicted moving slowly or galloping. There is a figure of a wild boar painted in black. One painting of a doe measures more than six feet in length. Another boar is shown with eight legs, possibly to indicate that it is running. The bison present the greatest variety of postures and in some cases seem to have an almost human expression, perhaps the result of unconscious humor or the reflection of some magical idea. There are impressive instances of observation and realism, as in the female bison lowing, the one turning its head, the one shown at molting time, and another, headless, one.

Other motifs in this group are those of hands, in positive impression or in colored outline; tectiform, or tent-shaped, signs, which may represent huts or traps; and others in the form of combs, ladders, and other objects. The large hall also has representations of eight human figures. These are crudely executed engravings, in which, while the outline of the body, the arms, and the legs are definitely human, the head seems to be that of an animal, indeterminate in nature; these may be images of hunters or sorcerers masked for the performance of secret rites.

On the walls of the galleries, there are engravings in the form of meanders, made with the fingers or with a three-pointed tool, along with engravings and paintings of deer, goats, and other animals in simple silhouette, executed in a primitive technique that could be classified as the style characteristic of the Aurignacian or the Gravettian. There are also, in the galleries and in the great hall, a number of engraved deer heads that have great vigor and beauty.

The number of polychrome figures in the great hall totals twenty-five. The animals represented at Altamira include bison, horses, bucks and does, wild bulls, boars, elks, and wolves.

48. *Rock painting in black of a bison. Altamira cave (Santander), Spain.*

49. *Polychrome rock painting of a bison. Altamira cave (Santander), Spain. Magdalenian period.*

50. *Polychrome rock painting of a bison. Altamira cave (Santander), Spain.*

51. *Polychrome rock painting of a bison. Altamira cave (Santander), Spain.*

48

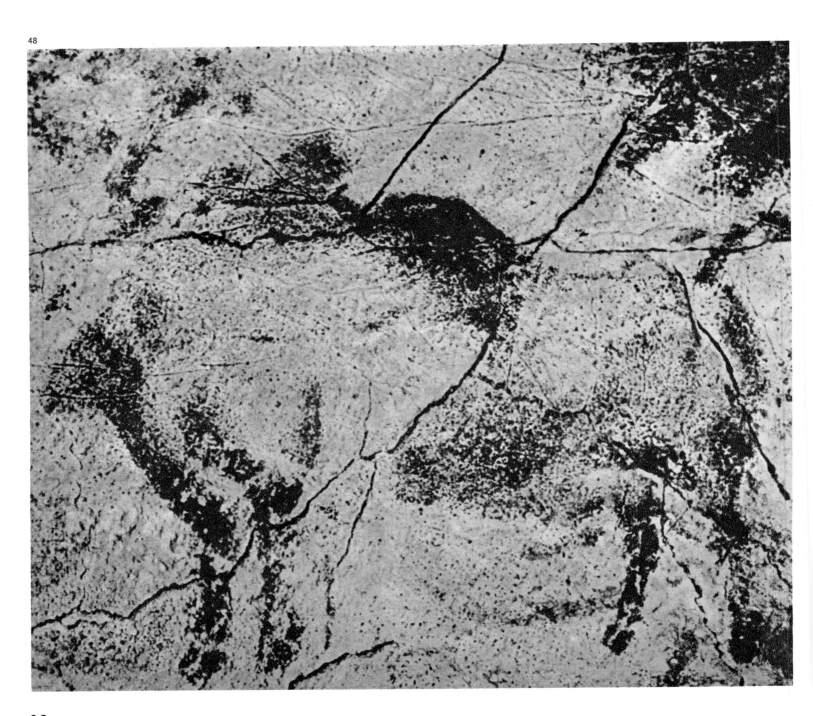

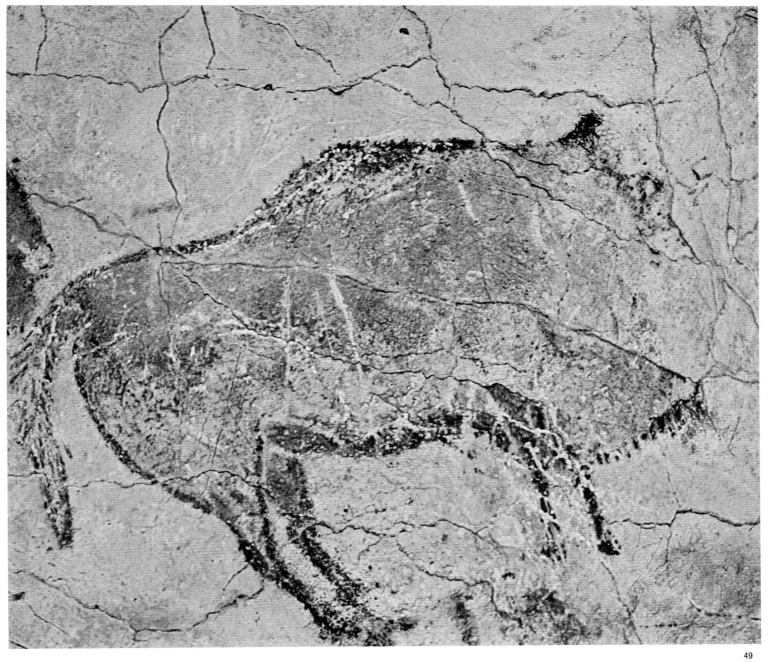

49

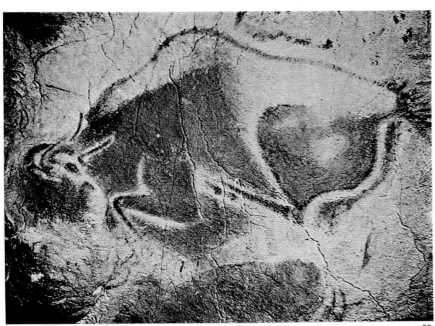

50

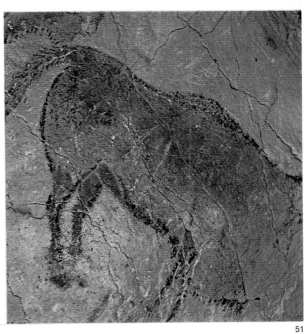

51

52. Polychrome rock painting of a bison. Altamira cave (Santander), Spain. Magdalenian period.

The most recently discovered of the important caves is Lascaux, near Montignac, in the Dordogne, found by some boys September 12, 1940. It became famous at once and today rivals Altamira as a prime example of this school of art. The styles of the two caves are different, probably because they are of different epochs and, also, because they belong to different schools and peoples. However, both of them contain an extraordinary number of masterpieces.

The cave of Lascaux has an entrance nave from which a lateral passage leads to a high nave off which branch short galleries; there are also a few shafts with painted figures. There are no engravings in this cave. The great hall and the lateral passage contain the finest part of the pictorial decoration. The colors are exceptionally well preserved on the layer of calcite that covers the hall for all its approximately one hundred feet and provides an effective ground for the brown, red, ocher, and black tones of the paintings.

The huge figures of bulls are outstanding here. There are four well-preserved examples in the great hall; fragments and traces of a number of others include a frieze of four bulls' heads in yellow ocher. The typical examples are painted in black, with the outline emphasized by broad bands of the same color. The figures are executed in a somewhat distorted perspective. One example is about eighteen feet long, an unprecedented and unique size. There are many other images of bulls or cows in various color tones in the rest of the cave. One of them, seemingly about to fall, reminded Breuil of a mortally wounded bull in the ring. In the lateral passage are four figures of cows in red; there is another represented in the act of jumping. The largest bull is shown with an arrow piercing his muzzle.

A very curious figure, at the entrance to the great hall, is that known as the "unicorn," so called because it can not be classified as any

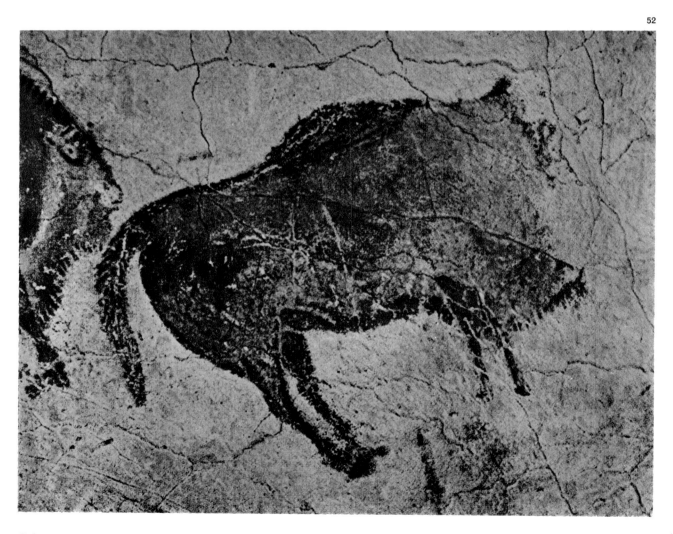

52

known animal. While the body, which is covered with a number of oval spots, recalls that of a bovine or a rhinoceros, the neck and head are tiny; the head is that of a feline but has two horns protruding from the forehead. It has been suggested that this represents a masked man.

Also noteworthy are the series of horses that appear in various parts of the cave. They are variously painted, some in monochrome, others in a bichromy that approaches polychromy (fig. 61, colorplate). Some are large in size, almost ten feet long. Others are very small and resemble modern ponies, as in the frieze with five small horses in the passage leading off the great hall, which follows another frieze of six horses in dark bister. Some of the horses are represented with several arrows in their bodies (fig. 54).

Some of the deer have highly developed antlers (fig. 62, colorplate). The most interesting series is a frieze, about sixteen feet long, on a

wall of the side nave, in which five magnificent deer heads in black form a composition of high decorative value (fig. 55). Because of the raised position of the heads, it has been conjectured that they represent deer swimming across a river. A black rectangle appears under the front portion of a large sepia figure of a deer with a small head and highly developed antlers.

In the same nave, two bison are depicted in a vigorous attitude, leaping in opposite directions. Pregnant mares, bison (fig. 75, colorplate), a bear, a wolf, and an ibex are included in the repertory of animals painted at Lascaux; mammoth and reindeer are absent. The cave also contains a scene so strange that it raises many questions. At the bottom of one of the shafts, twenty-three feet deep, one of the walls bears a famous scene, painted in black, showing a rhinoceros apparently moving away, a schematized figure of a man with the head of a bird falling after him, and a bison, seemingly in an attacking position, its abdomen pierced by a lance and its intestines dangling (fig. 56). Beneath the man are a throwing stick, a series of dots, and a bird on a stick, similar to a totem pole. The representation of a human figure, very rare in Franco-Cantabrian art, along with other technical details, suggested to Breuil that

53

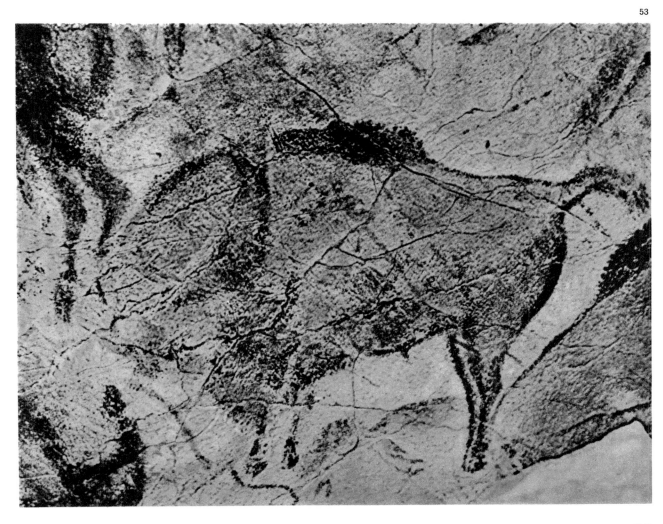

this might be one of the sources of Spanish Levantine art, which developed similar scenes to a high degree of perfection. Evidently the scene with the man and the bison is a meaningful one, but we are not yet able to interpret its significance.

There are, among the paintings, signs that are difficult to interpret, such as rectangles, lattices, dots, and checkerboards, in addition to many arrows and darts. Three checkerboards appear in the cave, each with nine squares painted in ocher, red, and black (fig. 44, colorplate). Nothing in Quaternary art shows so clearly the persistence of artistic trends, since in these we seem to see some of the abstract paintings that hang in museums today.

A number of engravings cover the walls of the galleries. In some cases they are combined with painting, and in others present the usual confusion of lines in which it is difficult to distinguish individual figures. When this is possible, however, we find delightful pictures, for example, those of horses and deer; there are also some engraved lions of simple workmanship. Among the few engraved signs, one has been interpreted to be a sorcerer wearing a mask of braided fibers.

Lascaux—with its bright colors, which seem not to have suffered as have those of other caves

54. Painted and engraved figure of a horse struck by an arrow. Lascaux cave (Dordogne), France. Upper Paleolithic period. Height 43 1/4".

55. Rock painting of a row of stag heads, known as the frieze of swimming deer. Lascaux cave (Dordogne), France. Upper Paleolithic period. Width c. 16'.

56. Rock painting of a wounded bison attacking a man. Lascaux cave (Dordogne), France. Late Perigordian or Magdalenian period. Length of bison 43".

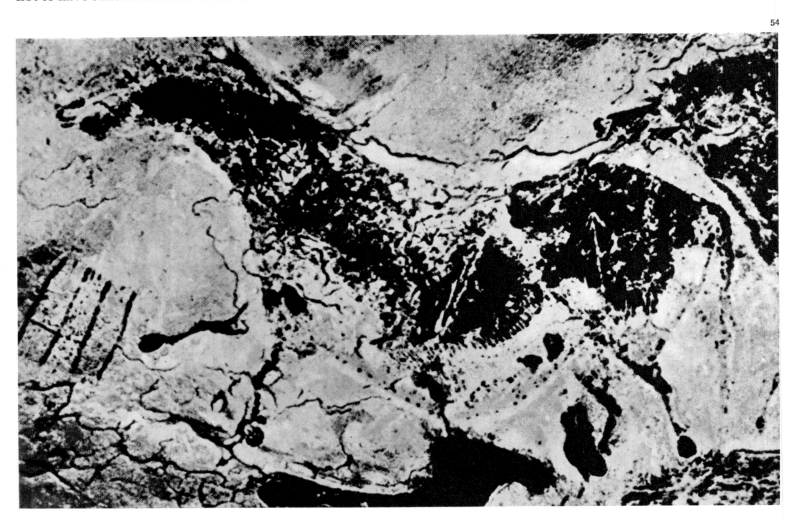

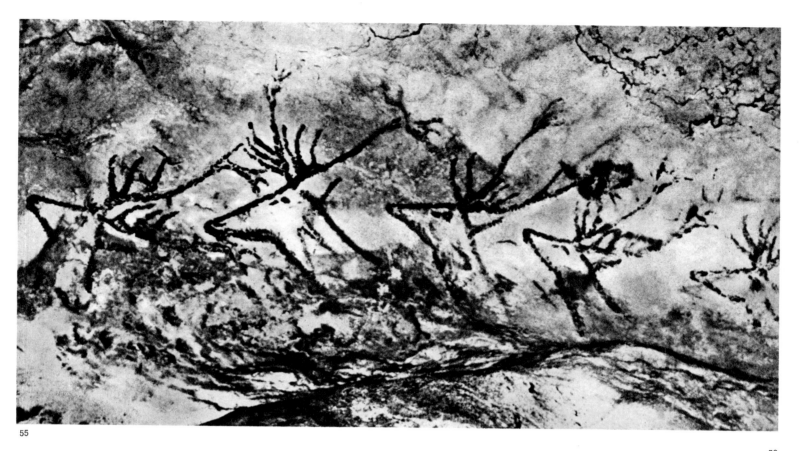

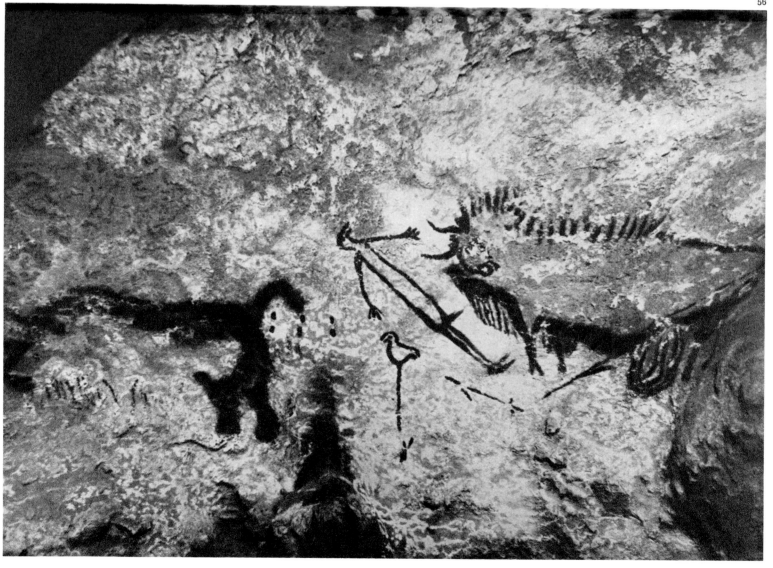

where conditions are less favorable to the preservation of frescoes; with its huge figures, executed with rare ability; with its variety of techniques that include frequent use of color blown from a tube; with its intriguing abstract signs; with its one human scene; with its chronological problems, the solution of which may alter our hypotheses concerning other aspects of prehistoric art—is one of the basic documents of our study and an indication of how much we still can hope for. It is, beyond doubt, a worthy rival of Altamira.

The Caves of the Dordogne

Our study of the remaining sites of cave art begins with the key region of this entire epoch—the Dordogne, particularly the area around the Vezère River.

The cave of Font-de-Gaume, near Les Eyzies, was discovered by D. Peyrony in September, 1901. It merits first mention because its paintings were the first to confirm the authenticity of this art. It is formed of a gallery approximately 400 feet long, never more than 10 feet wide and with a maximum height of about 26 feet. A very narrow passage about 215 feet from the entrance gives access to the principal gallery; the paintings are on the walls of this gallery, which ends in a small, low hall. The number and type of figures, as counted by Breuil, is as follows: 80 bison, 40 horses, 23 mammoths, 17 reindeer and other deer, 8 bulls, 4 animals of the goat family, 2 rhinoceroses, 1 or 2 felines, 1 wolf, 1 bear, 1 human figure, and 4 hands, 19 tectiforms, and 5 or 6 miscellaneous signs. The chronology established by Breuil extends from the simple silhouettes of the Perigordian through modeled blacks and deep engravings to polychromes and very fine engravings. While figures of rhinoceroses and goats appear only in the early stages, the bison dominates in the final ones.

The painted figures are now badly deteriorated, but a part of the principal frieze still can be appreciated. A magnificent series of polychrome bison, reminiscent of those in Altamira, have superposed engraved figures of mammoths and reindeer; one of the mammoths, both engraved and painted, is among the best figures in the cave. A large number of bison figures in various styles are brought together in the last hall. Two magnificent polychrome reindeer, male and female, face each other in a group nine feet long (figs. 57, 59). The red-painted image of a hairy rhinoceros is the finest representation that we have of this animal. A horse in black, in the lateral gallery, is depicted in the act of jumping and is reminiscent of the red-painted Solutrean horse in El Parpalló cave. The many tectiforms are an important feature of the art of Font-de-Gaume, which for the number of its figures and the

57

57. *Rock painting of a male and a female reindeer face to face. Cave of Font-de-Gaume (Dordogne), France (cf. fig. 59).*

58. *Rock engraving of an animalized anthropomorphic figure (detail). Cave of Les Combarelles (Dordogne), France. Full size 19 5/8".*

59. *Rock painting of a male and a female reindeer face to face (reconstruction by Breuil). Cave of Font-de-Gaume (Dordogne), France (cf. fig. 57).*

beauty of its polychromes is one of the most important sites of Quaternary art.

Les Combarelles cave, nearby, was discovered one week earlier than Font-de-Gaume. The main gallery is about 780 feet long, and the engraved frieze begins at a point about 526 feet along its length. There are only a few poor specimens of painting here (deer, he-goat, mammoth, horse, elk). The superposed engravings are less easily deciphered than paintings, but Breuil concluded that most of the works at Les Combarelles were executed between the Lower and Middle Magdalenian. Among the 291 figures that Breuil was able to distinguish (cf. fig. 58) there are 116 horses, 37 bison, 19 bears, 14 reindeer, 13 mammoths, 9 mountain goats, 7 cattle, 5 bucks, 3 does, 1 ibex, 5 lions, 4 wolves, 1 fox, 1 rhinoceros, 1 hand in negative, 4 tectiforms, 39 more or less anthropomorphic images, and other signs difficult to interpret. The engraving techniques vary and include intaglio; the dimensions of the engravings range from about 4 to about 40 inches. As always with superposed engravings, the intricacy of the lines makes careful study necessary before we can appreciate the single works. When they occur separately, we can admire their beauty and minute detail, as in the mammoth with trunk folded back and the feline.

Beyond the front gallery, another has been explored. There are some wall engravings that probably date from the Lower Magdalenian. The most interesting of these is a saiga ante-

58

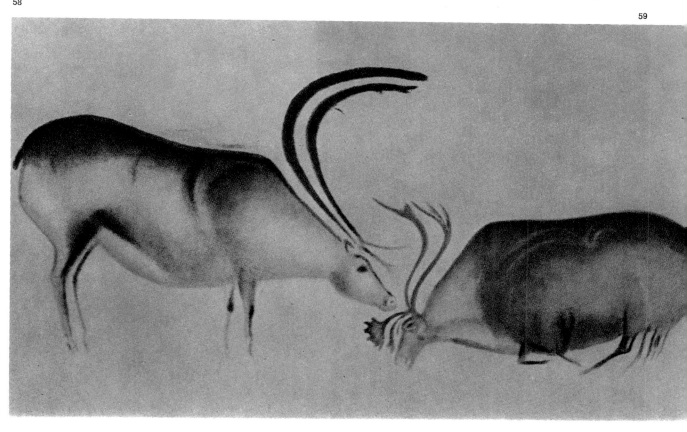

59

39

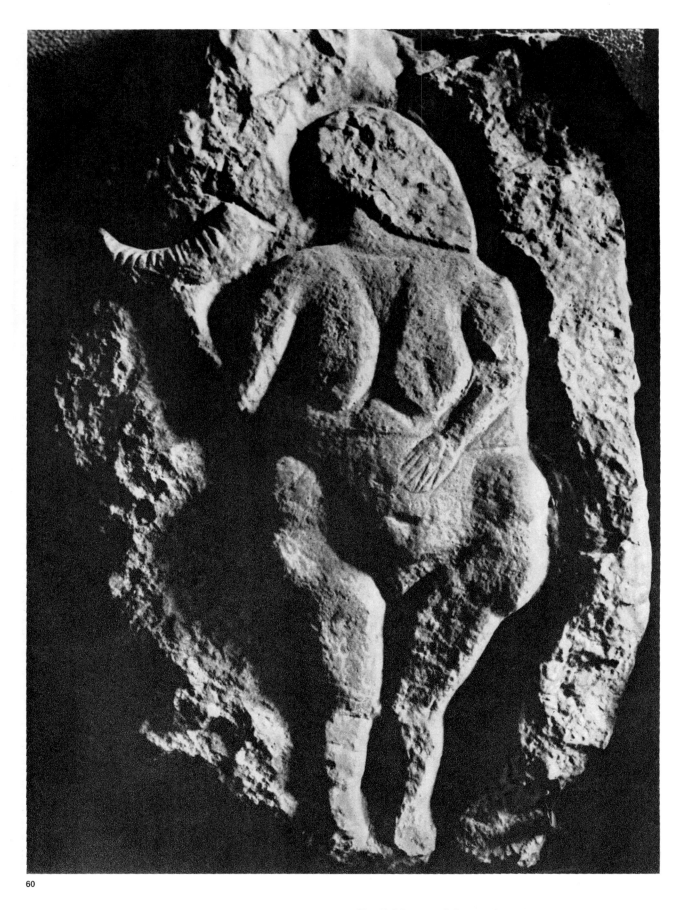

60

60. "Venus of Laussel," from the Abri Laussel (Dordogne), France. Stone slab, height of figure 17 3/4". Musée National de Préhistoire, Les Eyzies.
61. Superimposed rock paintings of a great bull and running horses. Lascaux cave (Dordogne), France.
62. Rock painting of deer. Lascaux cave (Dordogne), France.

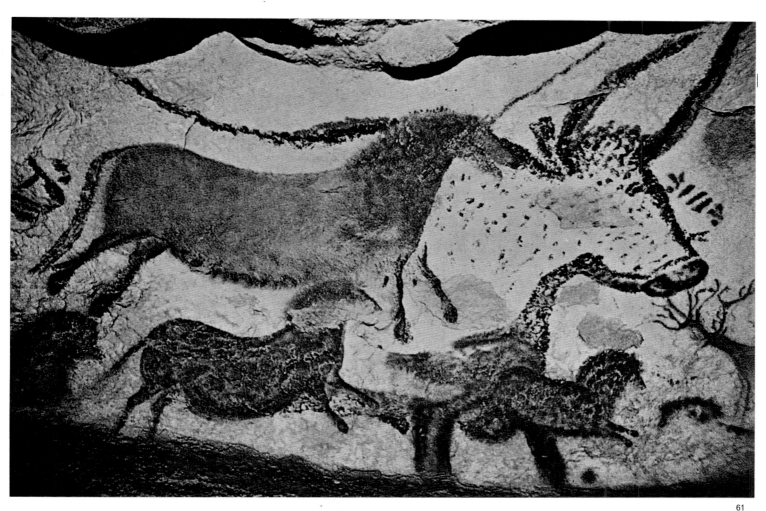

61

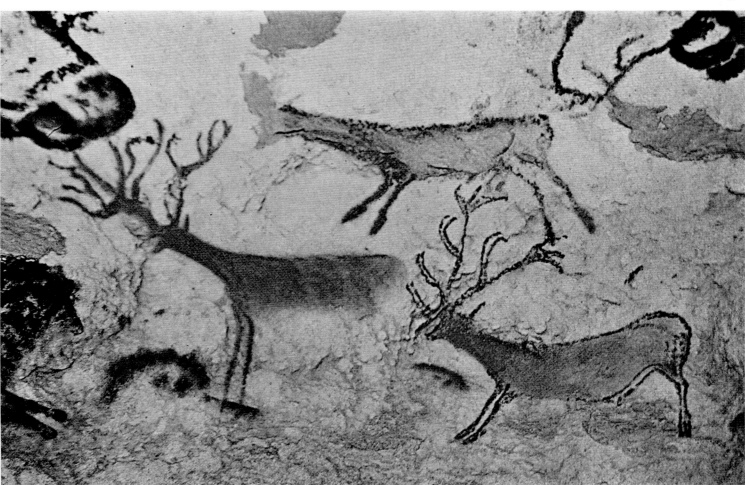

62

42

lope, an animal that appears in wall art only in this cave.

There are many other interesting sites in the region. Laussel is famous; it is a huge rock shelter, rich in archaeological materials. A number of curious reliefs have been taken in blocks from its walls. There occurred here an artistic manifestation akin to the Aurignacian or Perigordian (Gravettian) Venuses. The best piece, known as the " Venus of Laussel " (fig. 60), shows a nude woman, with bulky form and a shapeless head, holding one hand on her abdomen and grasping a bison horn in the other; it is 17³/₄ inches high. There are three other, less complete, female images, one of which holds a curved object, possibly a lamp, in her hand. A slim male figure is represented wearing a belt; its head has been lost (fig. 63).

Very near Laussel is the shelter of Le Cap Blanc, which contains a famous frieze carved in high relief. In it there appear, in succession, a poorly preserved animal figure, possibly a reindeer or bovine; a pregnant mare, in relief that attains a depth of 11³/₄ inches; a horse; another horse, more than 6¹/₂ feet long, splendidly executed and bearing traces of red ocher. Other horses follow, making a total of seven; the fourth, 7¹/₂ feet long, has some noteworthy details. There are also images of small bison and cattle. Because of the date of artifacts discovered in the shelter, this frieze is assigned to the Magdalenian.

Bernifal was discovered by Peyrony in 1902. In addition to some paintings, the most notable of which are a red mammoth with a red outline and a series of black dots, there are four noteworthy engraved mammoths in the corridor and other engravings in the main hall that comprise fifteen figures: four mammoths, a bison, a reindeer, a horse, five tectiforms, and other motifs; some of the tectiforms are above the mammoth figures.

The cave of La Mouthe also is near Les Eyzies. In 1895 a boy was able to slip into the gallery of the cave, where he saw a bison engraved on its walls. He notified E. Rivière, who cleared more than 42 feet of the gallery and then studied the paintings and engravings on its walls.

He reported on them to the Académie des Sciences in 1896. In 1900 Breuil copied some of the figures; and on August 14, 1902, the cave was visited by the members of the Association Française pour l'Avancement des Sciences, who were in congress at Montauban. This date marked official recognition of the authenticity of Quaternary wall art.

The paintings and engravings of La Mouthe belong to various epochs. The first group, nearest the entrance, shows four large bulls and a horse, all painted in archaic style. Next comes a hall with twenty-one finely engraved figures, including a number of excellent bison, deer, and goats. Other galleries contain excellent paintings or engravings of large female reindeer, horses, bison, rhinoceroses (including one magnificent hairy rhinoceros), a musk ox, and other animals. The so-called Hall of the Hut contains a number of friezes. There are beautiful engravings with rhinoceroses, reindeer, mammoths, bulls, horses, etc., over which, in one place, is superposed a figure painted in red and black and incised, formed by several rectangles with lateral appendages; the whole gives the impression of a hut, and everyone who has studied this important cave agrees with this interpretation.

The most recently discovered site is the cave of Miremont at Rouffignac, near Les Eyzies, discovered in June, 1956, by the well-known archaeologists L. R. Nougier and R. Robert. It became the subject of one of the most violent polemics in the history of the study of Quaternary art. Curiously, the cave had already been well known for centuries and was much visited, as is demonstrated by the numerous modern inscriptions on its walls and the fact that it appears on old maps of the region. Its miles of galleries are one of the reasons for its popularity; today, visitors can view the paintings from a little train.

The animal image that predominates on the walls of this cave is that of the mammoth, of which there are splendid examples. Two groups of mammoths appear facing one another. The number of mammoths represented, according to the first studies, totals 47 in engraving and 31 in painting. There are also 17 bison, 11 goats, 10 rhinoceroses, 9 horses, and other figures (meanders, serpentines, and lines drawn with the fingers). Breuil dates the representations of three hairy rhinoceroses to the initial Magdalenian; he regards them as among the masterpieces of that epoch (fig. 76, colorplate). Their outlines are painted in black, which is the color used in Rouffignac, and elements of the painting are emphasized by incised lines.

The cave of La Mairie at Teyjat contains a large number of engravings on a stalagmitic

63. *Male figure in relief, from the Abri Laussel (Dordogne), France. Aurignacian-Perigordian period. Height of figure 15". Musée National de Préhistoire, Les Eyzies.*

cascade, from which came blocks that were found in a stratum of the Upper Magdalenian. Some of these blocks suggested to Breuil a sort of stele that might have been set up as a portable shrine. He has distinguished 19 reindeer, 11 horses, 10 deer, 3 bulls, 3 bison, and 2 bears. Some of the figures are engraved with great skill.

The locality of Sergeac is the site of a number of shelters (*abris*) that contain important specimens of cave art. Among these are the Abri Blanchard, with cattle painted on a block fallen on a stratum of the late Aurignacian; the Abri Castanet; the Abri Reverdit, with a carved frieze of the early Magdalenian that includes two horses and three bison; the Abri Labatut, with a number of blocks fallen on strata of the Upper Perigordian, showing a

horse in relief, mammoths painted in bichromy, and an unfinished deer painted in black outline with the antlers in distorted perspective. This last is one of the elements on which the Abbé Breuil based his system of dating Lascaux and dealing with the chronological problems of Spanish Levantine art.

The list of minor sites of cave art in the Dordogne is endless: The cave of Bara-Bahau (Le Bugue) chiefly contains figures of horses incised on a friable rock wall covered with meanders; the animals are large in size and appear together with cattle and what may be rhinoceroses. Abri Belcayre (Thonac), Les Bernous (Bourdeilles), and La Calévie (Meyrals) contain some interesting engravings. At Beyssac (Sireuil) there is only the silhouette of a hand in red. Commarque (Sireuil) has reliefs, some very

high, particularly of horses. La Tour, Delluc (Les Eyzies), and Fongal (Feyzac) also contain engravings. La Croze, at Gontran, has interesting archaic engravings drawn with the fingers. La Ferrassie is interesting for the reliefs and engravings of animals and one small human bust (Perigordian V) that have been found at various Aurignacian and Perigordian levels. Blocks with reliefs representing animals also have come from Le Fourneau du Diable at Bourdeilles (figs. 64–66). Two deeply incised male figures of the Aurignacian were found in Terme-Pialat, near Combe Capelle. Other sites of engravings in the same department are Le Gabillou at Sourzac, near Mussidan, where very fine engravings depict the usual repertory of animals, with the exceptional addition of two hares and a human face in profile; La Grèze, at Marquay, has a single clear figure of a magnificent bison in the Aurignacian style; Laugerie Haute and Laugerie Basse; Nancy, at Vieil-Mouly (with a horse in low relief); Le Roc de la Pépue, at Manaurie; La Sudrie, near Villac en Terrasson. Near Les Eyzies, the cave of Gorge d'Enfer is known for the beauty of its low relief of a salmon, more than three feet long. The shelter of Les Jean-Blancs, near Couze, has yielded a number of blocks on which bison are engraved, sometimes in low relief. Oreille d'Enfer contains small carvings covered by Perigordian strata.

The Caves of the Lot

Many sites of Quaternary art exist in the department of Lot. For the most part, they have been discovered and studied by Abbé André Lémozi. Near Cabrerets are the caves of Cantal, with animal representations in red and with tectiforms; Marcenac, with engravings; and Sainte-Eulalie. Near Rocamadour are the caves of Les Merveilles, with paintings in black and silhouettes of hands, and Abri Murat, with wall figures and a large number of engraved stone fragments. There is an important cave at Cougnac, which contains many human figures, including what may be a witch shot with arrows. The reliefs of the cave of La Magdelaine, at Penne du Tarn, are especially interesting: representations of two reclining nude women (figs. 68–71) and a horse (fig. 78).

The most famous site in this region is the cave of Pech Merle, a short distance from Cabrerets; its paintings were discovered in 1922. The cave is large and complex, and undoubtedly there still remains much to be unearthed.

65

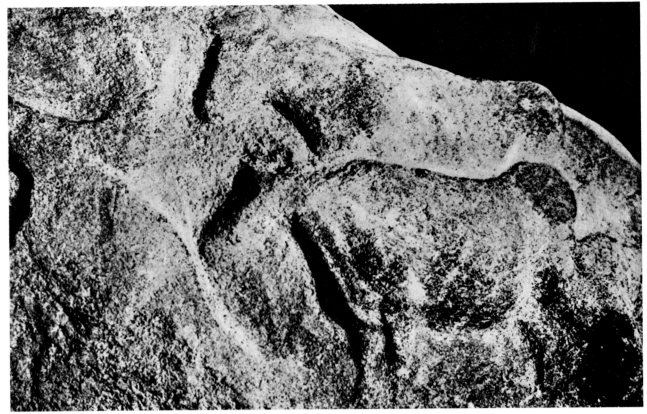

66

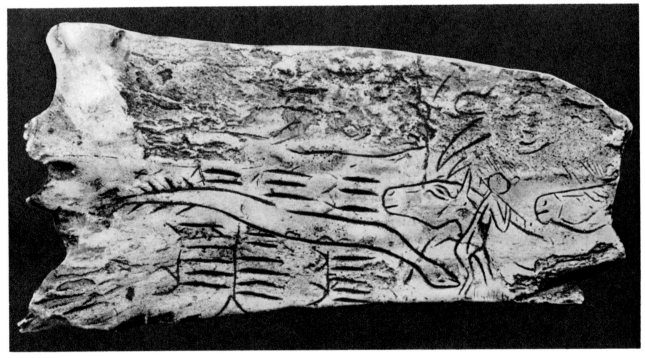

67

66. *Relief with horses, from Le Fourneau du Diable (Dordogne), France. Length of figures c. 14". Musée National de Préhistoire, Les Eyzies.*

67. *Engraving of a human figure, a snake, and horses' heads, from La Madeleine (Dordogne), France. Antler, length c. 6". Musée des Antiquités Nationales, Saint-Germain-en-Laye.*

46

68

69

70

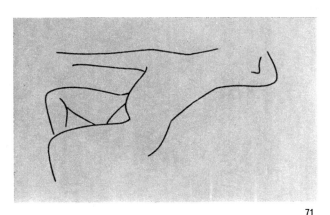

71

68, 69, 70, 71. Low reliefs of reclining women (with schematic drawings of the figures, after Bétirac). Cave of La Magdelaine (Tarn), France.

In the entrance chambers and corridors there are hands in negative and finger tracings of meanders in the clay. The greatest wealth of representations is found in a vast gallery about 460 feet long and 65 feet wide, with graffiti and impressions of human feet on the ground. On the walls and roof are a finely engraved bear head, many finger tracings of meanders, and, among them, as many as five mammoths and three women of strongly emphasized forms; a large animal, which may be a bison; mammoths; and other animals; there is also the figure of a headless man who seems to be carrying a bow under his arm. Other galleries contain bison and mammoths in black outlines. In the so-called Chapel of the Mammoths there are ten images of this animal (fig. 72), in addition to those of four cattle of the *Bos longifrons* species, a pair of bison, and a horse (fig. 73). The violent postures of some of these animals, and the simple yet precise expression of the mammoths, would indicate that these figures are the work of a great master of archaic art.

In a neighboring hall, six left or right hands in negative on black seem to frame a group of paintings, outstanding among which are two pregnant mares, superposed at the haunches, outlined in black; their heads are small and their bodies are painted with black spots (fig. 77). These important figures are accompanied by a fish more than three feet long (fig. 74), a number of dots, and some additional animals. In another part of the cave, a masked man, pierced by many darts, is painted in violet.

The Caves of Western France

West and northwest of the Dordogne there are fewer sites, but some of these are of great interest. Along the river that gives its name to the neighboring department is the cave of Les Fées, or Pair-non-Pair, at Marcamps, which F. Daleau excavated as early as 1874, and where, in 1883, he discovered some engraved figures that he interpreted correctly and published. The interest of these figures at the time of their discovery lay in the fact that they were covered by archaeological strata identifiable as Upper Perigordian (Gravettian). The figures must, therefore, belong to the end of the typical Aurignacian or to the Gravettian.

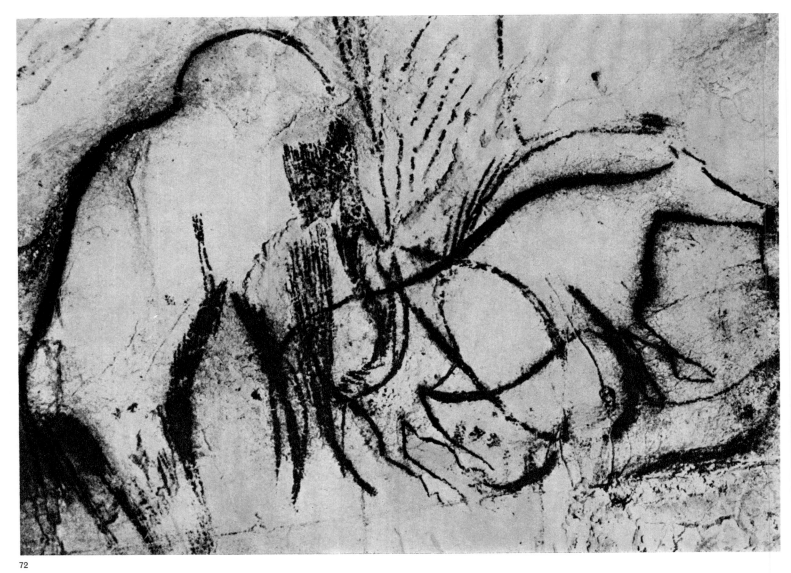

72

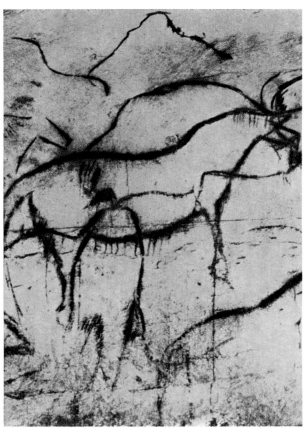

74

73

72. *Rock painting of mammoth and horse (detail of frieze). Chapel of the Mammoths, cave of Pech Merle (Lot), France.*

73. *Superposed rock painting of bison and horse (detail of frieze). Chapel of the Mammoths, cave of Pech Merle (Lot), France.*

74. *Figure of a fish outlined in red (diagram, after Lémozi). Cave of Pech Merle (Lot), France.*

75. *Polychrome rock painting of a bison. Lascaux cave (Dordogne), France.*

76. *Rock painting of a rhinoceros (detail of frieze). Henri Breuil Gallery, Rouffignac cave (Dordogne), France.*

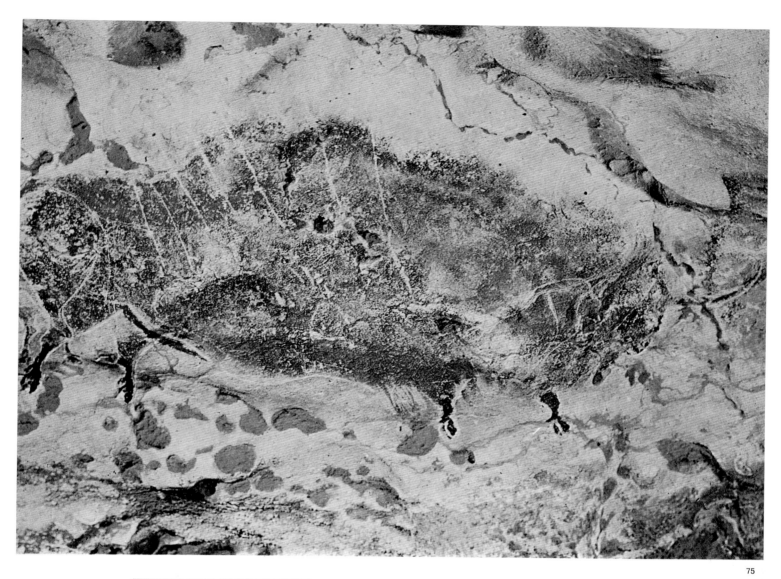

75

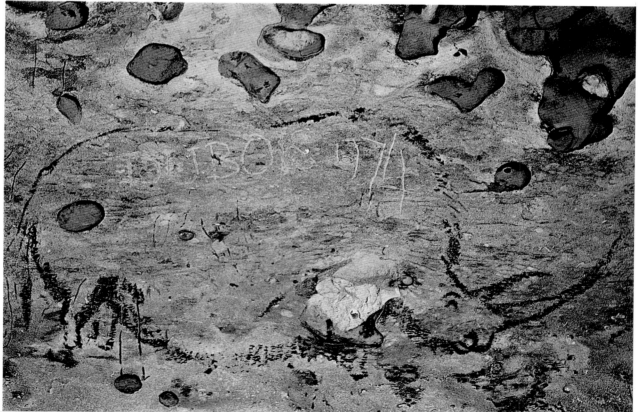

76

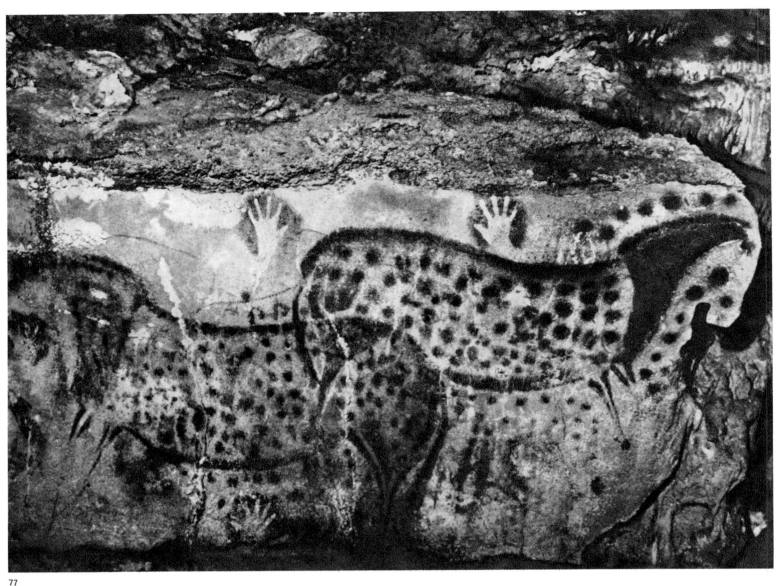

77

78

77. *Rock painting of horses, and stenciled hands. Cave of Pech Merle (Lot), France. Width of panel 11' 2".*

78. *Rock engraving of a horse. Cave of La Magdelaine (Tarn), France.*

79. *Le Roc de Sers (Charente), France, showing the position of the animal reliefs (reconstruction by H. Martin). Solutrean level (cf. figs. 80, 91).*

50

In modern times they have been studied by Breuil. They are all strongly executed engravings in various friezes running the length of the cave's galleries (less than one hundred feet). The repertory of Pair-non-Pair comprises mammoths, felines, bears, horses, bulls and cows, bison, goats, reindeer, and what may be a rhinoceros's head and a figure combining the forms of a bear and a bull.

La Chaire à Calvin, or La Papeterie, at Mouthiers in the department of the Charente, contains a frieze of carved horses that is similar to the frieze in Le Roc de Sers (Causadaux). The latter is open to the sky and was found by H. Martin under levels of the Upper Solutrean, which guarantees a date in the Solutrean for this very interesting group. The frieze is formed by a series of blocks that have come loose from a semicircular rocky border, as was brought out by the new discoveries made in 1950 (fig. 79). The first findings consisted of six equines (pregnant mares), three or four bison, another bison with the head of a boar (figs. 80, 91, colorplate), two he-goats in combat, several deer, a musk ox pursuing a man with a stick on his shoulder, and a bird. The recent finds include goats and bison. These are the work of consummate artists and make this one of the major sites of Quaternary art.

In 1949, in one of a number of shelters near the locality of Angles-sur-Anglin, in the department of Vienne, Mlle S. de Saint-Mathurin and Miss D. Garrod, after observing that there were reliefs on some blocks in the debris left by an amateur, succeeded in reconstructing the site; they discovered precious portions of a frieze that can be included among the culminating achievements of Quaternary art. Intact reliefs representing a number of bison, horses, and goats, and three lower torsos with accentuated female sex characteristics were found. Among the unearthed blocks are an extraordinary one representing a bearded human head in profile, incised, carved, and bearing traces of painting (fig. 83), and another with a delightful head of a young kid. Breuil regards this ensemble as belonging to Magdalenian III. This is the date given also to the nearby Grotte de La Marche, where, from 1937 on, L. Péricard and S. Lwoff found a large quantity of stones engraved with figures of lions, bears, horses, deer, bison, and an exceptional number of human faces (figs. 81, 82) and steatopygous women. Breuil offers the hypothesis that these stone fragments constituted a movable frieze that was set up on the wall of the cave, which did not lend itself to decoration.

The Caves of the Pyrenees

The region of the French Pyrenees formed a well-marked province during the Upper Paleolithic. In addition to its great archaeological riches, it has numerous sites that have yielded

79

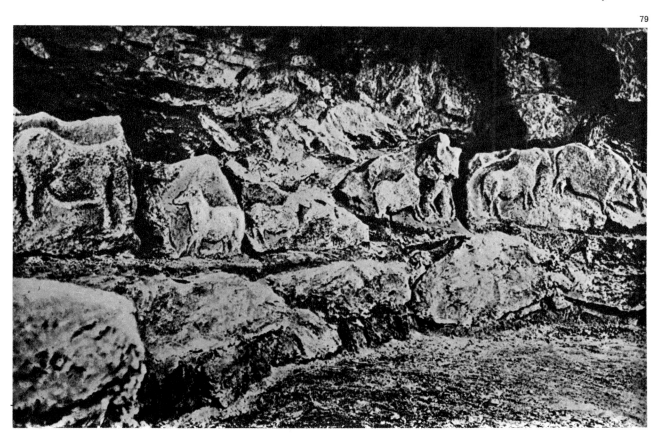

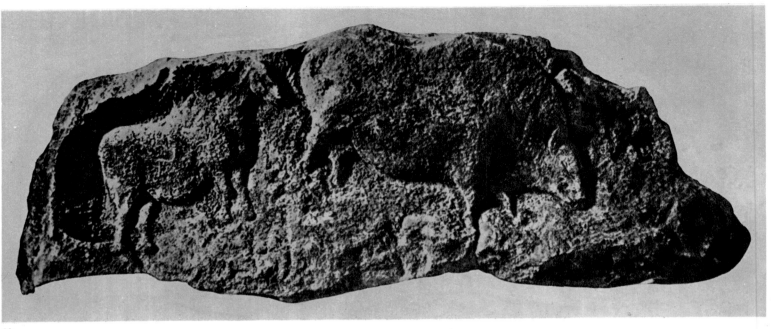

80

81

82

83

52

80. *Relief with a pregnant mare and a bison with a boar's head, from Le Roc de Sers (Charente), France. Solutrean period. Stone, length of slab 64 1/2". Musée des Antiquités Nationales, Saint-Germain-en-Laye.*

81, 82. *Stone fragment with engraving of a human head (with schematic drawing), from Grotte de La Marche, Lussac-les-Châteaux (Vienne), France. Height 4 3/4".*

83. *Stone fragment with a carved and painted human head, from Angles-sur-Anglin (Vienne), France. Height 17 3/4".*

84. *Wall covered with painted bison.* Salon Noir, Niaux cave (Ariège), France.

works of art that make the region a worthy rival of the Dordogne and the Cantabrian zone. For many years Count H. Bégouën, a splendid researcher, worked in this region.

The easternmost group of sites is in the department of the Ariège, where there are several caves with paintings of minor importance: Bédeilhac (Tarascon), an immense cavern with a polychrome horse, bison painted in black, and incised horses and bison, one of which has two holes in its side; Lombrive (Tarascon), with a bison in black; Pradière (Tarascon), with series of red dots; and the Grotte des Eglises at Ussat, with bison, horses, animals of the goat family, and tectiforms, mainly painted (one of the tectiforms seems to be sheltering a schematized human figure). In the Grotte du Peyort, between Prat and Cazavet, A. Glory

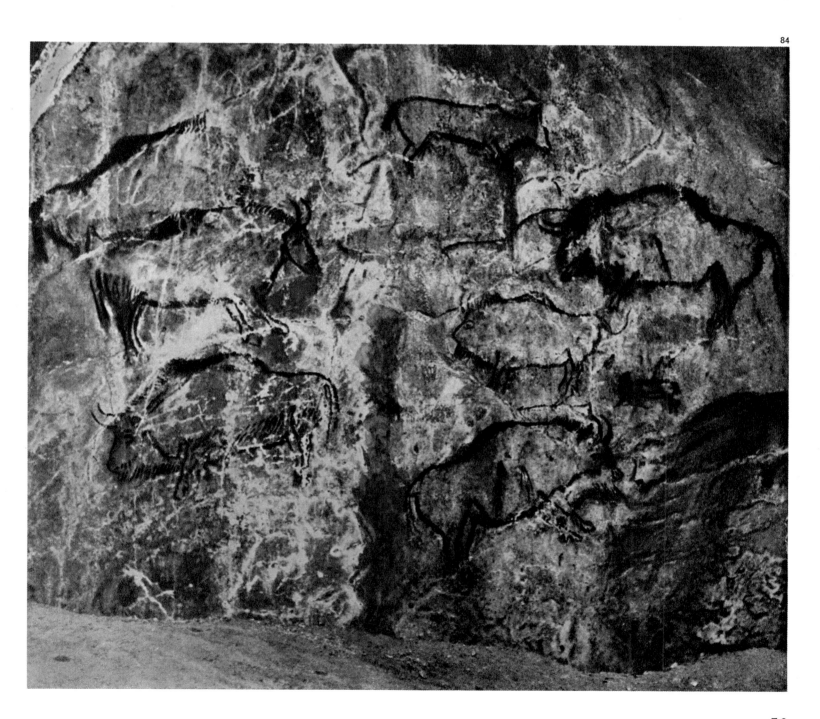

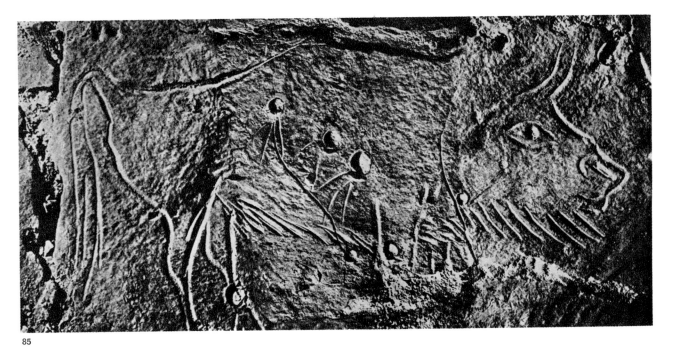

85

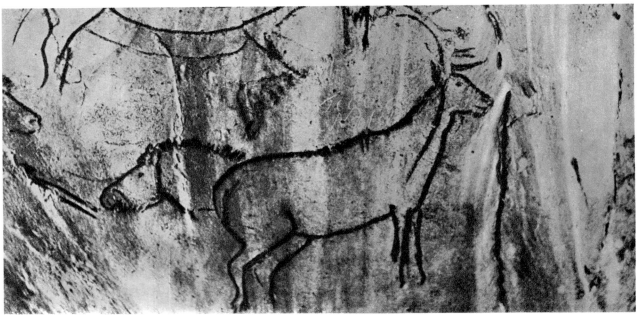

86

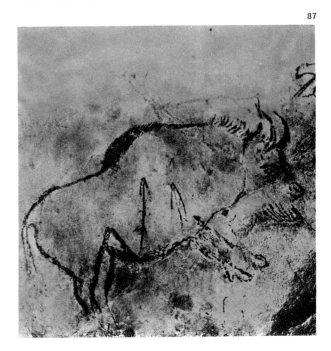

85. Bison engraved in clay displaying the use of indentations formed by dripping water to represent the eye and wounds. Niaux cave (Ariège), France. Length of bison 23".

86. Rock painting of horses and a drinking deer. Salon Noir, Niaux cave (Ariège), France.

87. Rock painting of a bison pierced by arrows. Salon Noir, Niaux cave (Ariège), France.

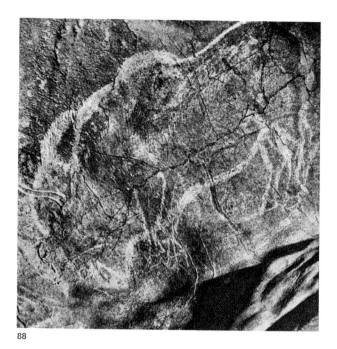

88

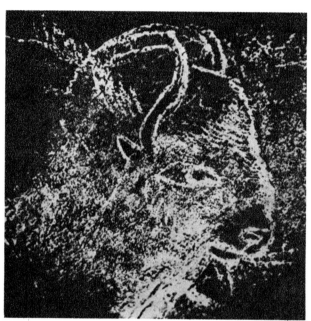

89

88. *Rock engraving of a bison. Cave of Les Trois Frères (Ariège), France.*

89. *Head of a bison executed in the "cameo" technique. Cave of Les Trois Frères (Ariège), France. Rock engraving.*

unearthed the engraved and modeled head of a bear.

The cave of Niaux, at Tarascon, was discovered in 1906 and is regarded as one of the most important French sites of cave art. As early as 1866 Dr. Garrigou had noted the existence there of paintings in black. The cave is very deep and difficult of access; the so-called *Salon Noir* is more than half a mile from the entrance. A number of lakes impede exploration, which has been carried out as far as a lake about 4,500 feet from the entrance. The most interesting series of figures consists of those painted in black, including 25 bison, 16 horses, 6 mountain goats, and 1 deer (figs. 84, 86); many of the bison are shown with darts fixed in their bodies (fig. 87). In this group the silhouette was painted and lines were added to bring out details. Breuil supposes the group to belong to the Upper Magdalenian. The engravings in the compact glacial sand are extremely fine and show cattle wounded with arrows and two trout facing each other. Among the black or red signs are arrows; dots, which Breuil believes may have served as guide marks for the labyrinthine cavern; and bandlike signs.

The cave of Le Portel, at Loubens, discovered in 1908, is not so important as Niaux. It, too, is deep, and contains paintings and some engravings in various halls and corridors several hundred feet from the entrance. The early phase includes red signs, a hand with four fingers, two or three anthropomorphic figures, silhouettes of goats, cattle, and especially horses; in these last, some bichromy is achieved. In the Magdalenian, bison predominate, with one small example in polychrome. Some of the best figures of horses are of this phase; a fine incised bison appears together with a horse, also incised and pierced with arrows. The image of an owl is in the entrance corridor.

The cave of Les Trois Frères was discovered by the three sons of Count Bégouën in 1916 and is located at Montesquieu-Avantès. It was found a few years after the discovery of the cave of Le Tuc d'Audoubert; both must be divisions of the subterranean course of the Volp River, and hence are intercommunicating. Each is about 2,500 feet long. The maze of galleries and narrow crevices makes this cave one that has demanded the greatest effort on the part of its explorers and at the same time makes it one of the clearest examples of what the sanctuaries of paleolithic man must have been—places full of mystery for the uninitiated, fitting realms of the fantasies fostered by the sorcerers that had their lairs in them. The complex system of corridors leads into a great hall, which has been called the "Sanc-

55

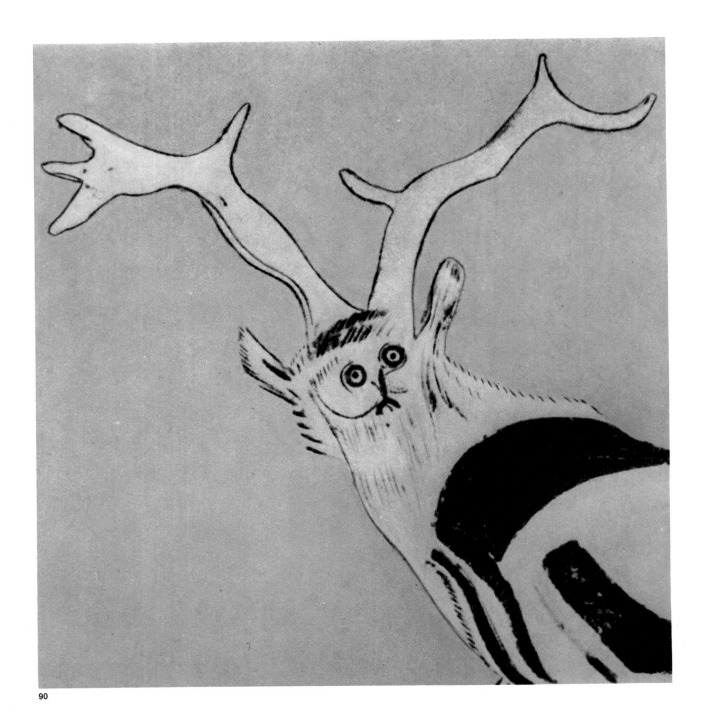

90

tuary" because its walls are covered with engravings that are dominated by the image of a masked sorcerer, evoking the strong magic impulse that held this infant society in thrall. In no other prehistoric cave do we feel the emotional charge of the environment so strongly; here we are transported into an unreal atmosphere of man's primitive superstitions.

The complexity of the engravings, which intertwine in a veritable labyrinth of lines (fig. 93), and the difficulty of access to and of staying at the site explain why its study, both by its discoverers and by Breuil, who here, too, undertook the immense task of copying, cannot yet be considered complete. Moreover, the copies made have not yet been published in full. But what has been published thus far is sufficient to indicate the importance

90. The "Sorcerer" (watercolor copy). Cave of Les Trois Frères (Ariège), France. Paleolithic period. Graffito and painting (cf. fig. 46).

91. Sculptured bison with a boar's head, from Le Roc de Sers (Charente), France. Musée des Antiquités Nationales, Saint-Germain-en-Laye (cf. fig. 80).

56

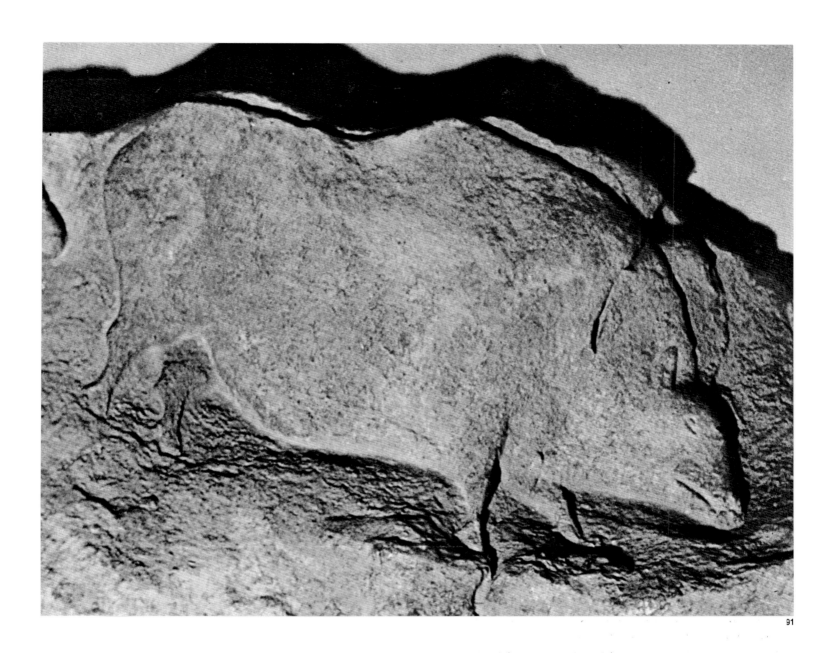

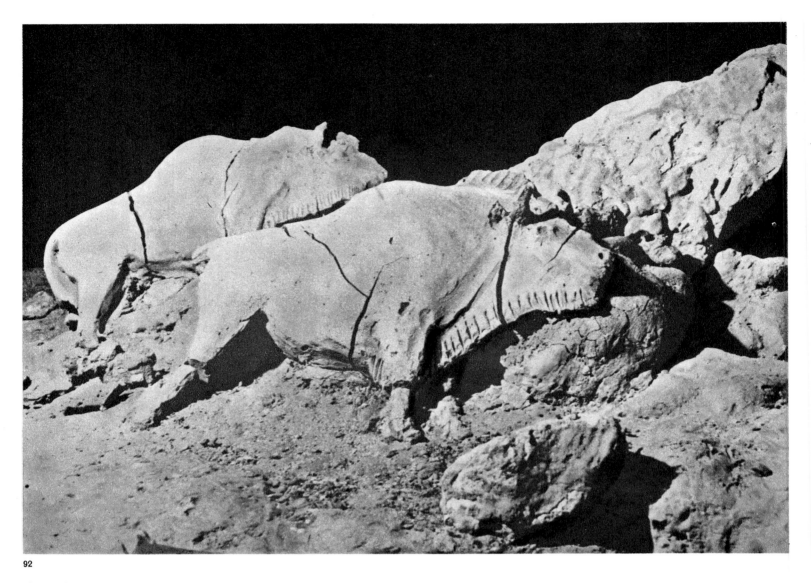

92

that the " Sanctuary " must have had as a sacred place.

In the galleries are a number of engravings and some paintings. Several oustanding representations of lions seem to be guarding one of the passages; an engraved lioness is painted black; her litter is engraved. There are two splendid engraved owls, with their brood shown between them. A long series of red dots may indicate the path through one of the galleries.

93

92. Two bison modeled in clay. Cave of Le Tuc d'Audoubert (Ariège), France. Length of bison at right 24".

93. Schematic drawing of a tangle of finely engraved figures. Cave of Les Trois Frères (Ariège), France.

94. Negative imprints of mutilated hands. Gargas cave (Hautes-Pyrénées), France.

But all these are insignificant compared with the riches on the walls of the " Sanctuary." We can not begin to describe or enumerate all the figures visible there. Hundreds can be identified, predominant among them reindeer, bison (figs. 88, 89), horses, bears, and goats; but there are also a mammoth or two, a wild ass, and other animals. Some figures are quite strange, such as a palmiped reindeer, a man disguised as a bison with a spindle-shaped object in his mouth that may be a musical bow, a delightful depiction of a bison turning its head (the lower part of its body is human), a bear with the head of a wolf, and a bear riddled with arrows and vomiting blood (bosses on the fur probably signify wounds). There are many anthropomorphic representations, often indeterminate.

The figure of the sorcerer that dominates the " Sanctuary " is about thirty inches high and is entirely engraved, although there are some traces of painting on the face and some black bands outlining the body, tail, and extremities (figs. 46, 90). The eyes are round, the ears and horns those of a deer, the tail that of a wolf or horse. It is usually thought to be the image

of a masked sorcerer who was in charge of the ceremonies in the "Sanctuary," but Breuil believes that it is something more—that it represents the spirit who governed the multiplication of game, in other words, that it was an image of the divinity. We cannot, of course, exclude this possibility, but we believe that any conjecture regarding the graphic form that paleolithic hunters might have given to their religious ideas is far-fetched indeed.

The cave of Le Tuc d'Audoubert was discovered in 1912 by Count Bégouën and his sons when they traversed the lake formed by the Volp as it rises to the surface after running underground for more than a mile. A series of galleries in this cave contain engravings (a key-shaped sign, horses, and fantastic animals) and some paintings. At about 2,350 feet from the entrance are two bison modeled in clay on a rock; they represent a male following a female and are about 24 inches long (fig. 92). A smaller bison, $5^1/_8$ inches long, was nearby, and there remain traces of similar sculptures that have disappeared because of the perishable nature of the material in which they were executed. The existence of footprints of a

young human being leads us to believe that this may have been an initiation site.

The cave of Le Mas d'Azil is an immense tunnel through which the Arize River runs, and it has yielded archaeological remains of great importance. In 1901 Breuil discovered engravings and paintings in some galleries that open off the cave. By 1912 he had distinguished a number of bison and horses painted in red or black. In 1939 J. Mandement found an additional twenty-five paintings, including a magnificent bison.

In the department of Haute Garonne, adjoining the Ariège, there are the very important caves of Marsoulas and Montespan. The first is at Salies-du-Salat and is only about 230 feet long. F. Regnault, who excavated it, saw the paintings on its walls and reported them in 1897, with no great success. Later they were

95. *Negative imprints of mutilated hands. Gargas cave (Hautes-Pyrénées), France.*

96. *Feline figure, with perforations and engraved motifs, from Isturitz (Basses-Pyrénées), France. Antler, length c. 4". Musée des Antiquités Nationales, Saint-Germain-en-Laye.*

accepted as authentic and were studied by Cartailhac and Breuil, who were able to decipher the superposition of figures and thus calculated the relative chronology of the styles, which seem to range all the way from the middle to the end of the Magdalenian. In addition to some excellent engravings (horses, one of them grazing; bison; reindeer; etc.), there are interesting paintings: a large polychrome horse, a large polychrome bison that is painted above other black ones and has various red signs above it, a bison with a spotted body, series of red dots, and fretted bands in red.

The art of the cave of Montespan was not discovered until 1923 by N. Casteret. The most important section can be reached only through a short water trap that separates the two parts of the cavern. In the first part there are some handsome engraved figures of horses, bison, a wild ass, and a bird; there also is a horse with its body full of holes. In the part beyond the water trap, there are more engravings, most of them poorly preserved; in addition to the usual animals, there is a hyena. In the clay of the cave floor are representations of a number of stallions and mares, incised or in relief, and the remains of several modeled figures. The anterior of a lion is shown pierced by many javelins. About ninety feet farther on is the headless statue of a bear; the remains of a bear skull found near the statue and a cavity in the statue indicate that the animal skull was mounted on the statue, the body of which had been pierced by some thirty javelin blows. Although the artistic workmanship of the Mon-

tespan bear is far inferior to that of the bison at Le Tuc d'Audoubert, it is the best evidence in paleolithic sculpture of the magical purpose of that art.

In the Hautes-Pyrénées department are the caves of Labastide and Gargas. The first was discovered by Casteret in 1932 and contains engravings that include a magnificent lion's head, a goose, a human face, another human figure, and a large polychrome horse more than $6\frac{1}{2}$ feet long.

The unusual features of the Gargas cave, at Aventignan, have made it famous. The cave had been known for centuries, but the paintings and engravings it contains were first noted in 1905. The most striking feature of this cave is the number of depictions of hands in negative, surrounded by black or red (figs. 94, 95).There are more than 150 of them, and there are also negative paintings of fingers; those in black seem to be later than those in red. A curious detail is that many of the hands seem to be mutilated, as has been ascertained by counting the phalanges of some of the fingers. This occurs in none of the other dozen caves in Europe where painted hands are found, but it appears on other continents (Australia) and may have ritual significance. Left hands predominate over right, as is logical if the artist was outlining his own hand. Except for the hands, all the figures on the walls are engraved. The oldest of these are the meanders and arabesques traced by fingers on the clay walls of the cave. The engravings of animals are of good style and consist of the usual repertory, including mammoths; the execution

96

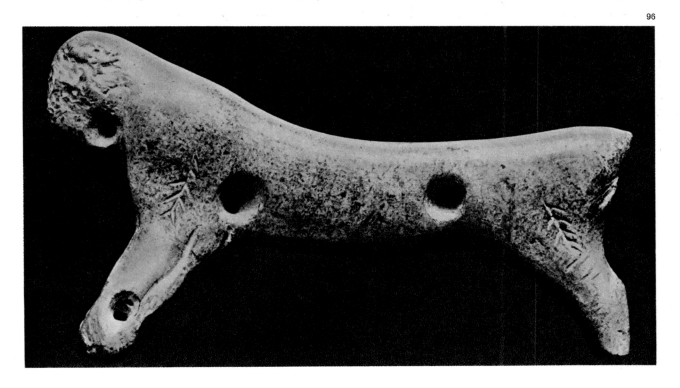

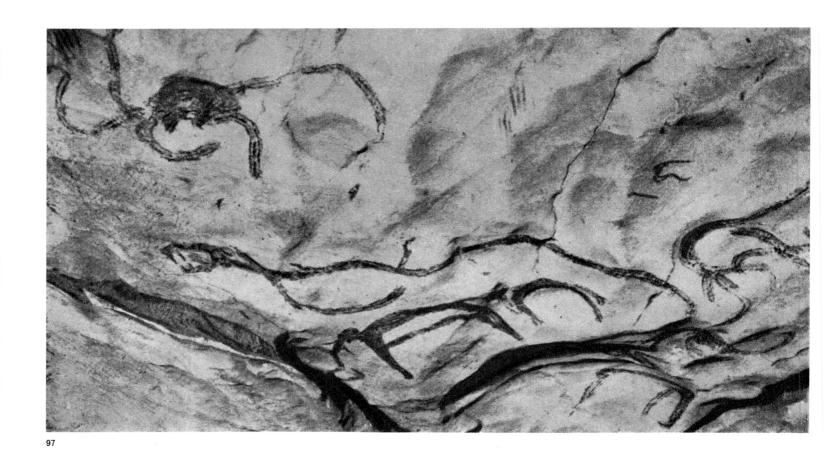

is similar to that which we have described in the other sites of the region. An upper gallery bears traces of polychrome figures, and a nearby recess shows engravings with the addition of black paint.

Three caves in the Basses-Pyrénées department contain some wall art. Two of them, at a short distance from each other, were discovered a few years ago. That at Etcheberri has various figures painted in black silhouette; they are attributed to the Lower Magdalenian. The one at Sasiziloaga shows two bison. Much more important archaeologically is the cave of Isturitz, near Biarritz, where the excavations of L. Passemard, and, later, of Count R. de Saint-Périer, have unearthed some excellent examples of implements and portable objects of the Paleolithic. Low reliefs found by Passemard on a stalagmitic wall recall those of sites in the Dordogne that we have described. In them can be seen a reindeer with two superposed deer, a bear, a reindeer, and two horses.

creation in the Occident. However, much of the interest of the sites of cave art in southwestern France and its extensions lies in the fact that these areas underwent an evolution of their own during the prehistoric era, and their art brings together various styles whose meaning and chronology still present many problems.

Since 1947 the cave of Sallèles-Cabardès, or the Gazel Cave, in the department of the Aude, has yielded a number of rather imperfect engravings of doubtful epoch, representing mountain goats, horses, and a duck. In the adjoining department of the Hérault, the cave of Aldène, or Fauzan, at Olonzac, is very long and has not yet been thoroughly explored. On its walls

The Caves of Southwestern France and the Rhone Valley

Outside of the regions we have described above, there is an evident decrease in the value and quality of the cave art; clearly, we are leaving behind the great centers of artistic

97. Outlines of zoomorphic figures drawn in red clay on rock. Cave of La Baume Latrone (Gard), France.

98. Rock painting of horse and bison. Santimamiñe cave (Vizcaya), Spain. Magdalenian period. Length of horse, c. 18".

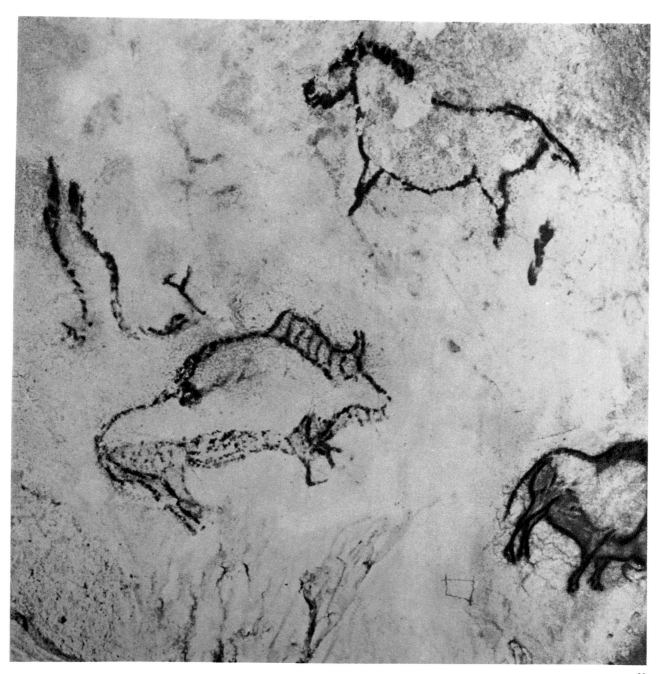

are many scratches made by bear claws and some fine depictions of that animal, incised or painted in red ocher, along with other less important figures.

The department of the Gard is quite rich in cave art. The cave of Chabot, at Aiguèze, on the right bank of the Ardèche River, is the first cave in which a modern archaeologist studied its works of art. L. Chiron, a teacher, noted in 1878 that there were lines incised on its walls, but made nothing of them. Later, Breuil and others studied the cave and discovered a number of engravings, mostly of mammoths. The nearby Oulen Cave also contains engravings of mammoths. The cave of Les Colonnes, or Bayol, at Collias, discovered by the Abbé Bayol, has yielded a horse's head in black; a mountain goat outlined in red, of archaic style; and hands directly imprinted in

red. Of greater importance is La Baume Latrone, a cave at Sainte Anastasie, near Russan. Its galleries with figures were discovered in 1940. These figures include hands, mainly left hands, directly imprinted in clay, and intertwined bands traced by the fingers on the clay; in the latter, if we stretch a point, as Breuil says, we may distinguish sketches of elephants, cattle, equines, and deer. In the same cave are the more interesting paintings in clay on a light-colored rock base (fig. 97), recalling some figures of the La Pileta cave. This curious style is used in depictions of six or seven elephants, a rhinoceros, and a snake; on a somewhat higher level of development are some figures in contour outline (a bear, a rhinoceros without horns, and an elk). The ensemble undoubtedly belongs to an archaic phase of wall art.

Farther north is the department of the Ardèche. In 1946, in the valley of the Ardèche River that gives the department its name, the Abbé A. Glory discovered the cave of Ebbou (Vallon), which contains a large number of engravings. As many as seventy have been identified, including twenty-four horses, twelve cattle, a mammoth, and other, less distinct, figures. The style diverges from that which predominates in the other French districts. Usually, only a single horn or antler is shown, except in representations of goats, and the legs are crudely drawn. Because of its stylistic resemblance to portable objects of La Colombière and to the wall art of Sicily and the archaic El Parpalló engravings, this cave of the Ardèche is particularly important in the geography of the western Upper Paleolithic. Interesting engravings also are to be seen in the caves of Le Figuier, Huchard, Sombre, Rimouren, and Bouchon.

Well to the north, in the department of the Yonne, is Arcy-sur-Cure, where there are several famous sites, such as the cave of Le Trilobite. Nearby is the entrance to the cave of Les Mammouths (or Le Cheval), discovered in 1946, whose walls show a number of mammoths and other animals and signs, traced on the clay or incised in the rock.

Reference should also be made to the paintings discovered by J. L. Baudet in the forest of Fontainebleau, some of which he regards as paleolithic, and he seems to be supported in this view by Breuil. A representation of a deer in the Spanish Levantine style appears in the valley of the Loing, and there are black tectiforms in the valley of the Ecole; this variant seems to extend as far as the Vosges and Luxembourg.

The Caves of the Spanish Cantabrian Region

Strangely, there is no parallel on the Spanish slope of the Pyrenees to the fine French caves described above. Only in the Basque region and that of the Cantabrian mountains do we find a continuation of the art of the French centers. We still regard Altamira as the supreme product of Quaternary cave art; its existence proves that there were magnificent schools of art on the Spanish side of the Pyrenees, and that they could create original solutions. At the same time there is present a fundamental unity with the two most important French districts.

Our description of the sites that we shall include here begins with the easternmost region in Navarre, and ends with the final manifestations of the art in the region of Nalón, in Asturias.

Up to the present, the province of Navarre is known to contain only a single site of cave art, Alquerdi or Berroberria, at Zugarramurdi, discovered by the French speleologist N. Cas-

99. Rock painting of a deer. Covalanas cave (Santander), Spain. Length 31 1/2".

100. Rock painting of a horse and a deer. Cave of La Pasiega (Santander), Spain. Length of horse c. 19".

99

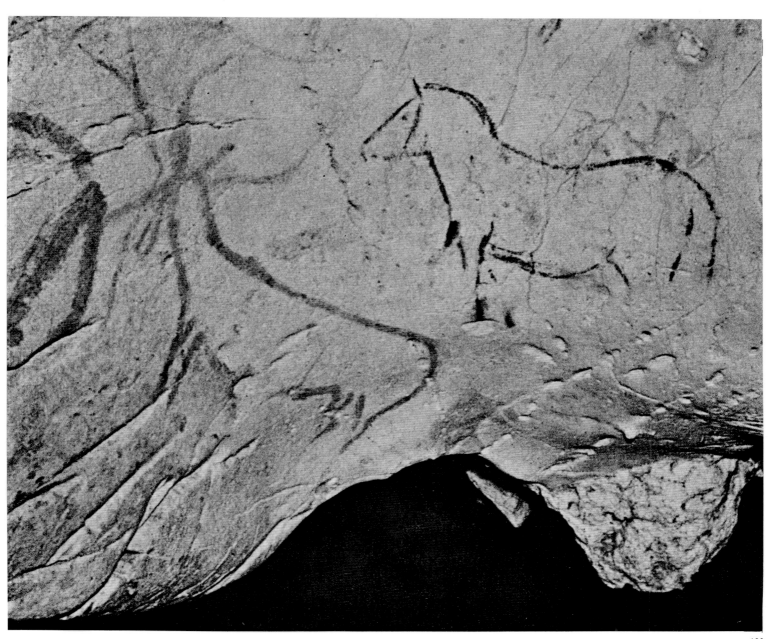

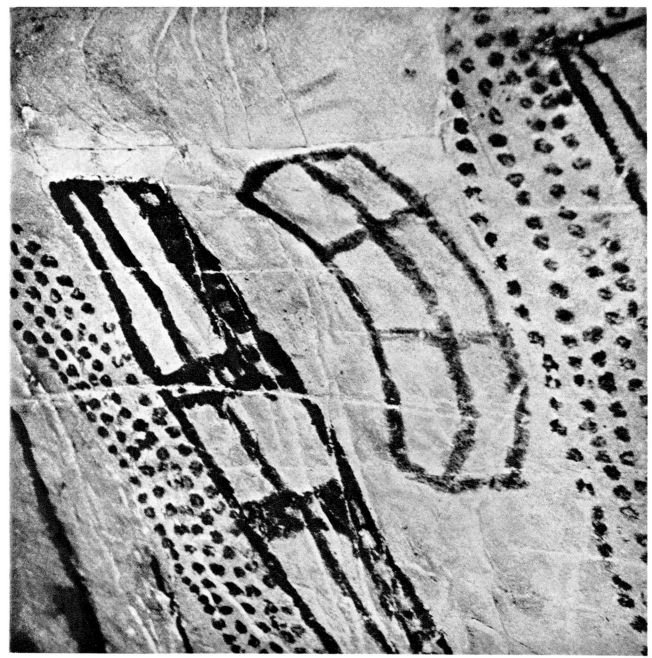

101

teret, in 1930. The findings are poor and consist of the finely engraved rumps of two bison and a deer head of Magdalenian aspect, also engraved.

In Vizcaya Province the cave of Santima-miñe, or Basondo, at Cortézubi near Guernica, was discovered in 1916. It is about 150 feet long; the vestibule leads to a hall on whose wall are friezes of figures painted in black, some of which are engraved. In all, there are 26 bison, 4 horses, 2 mountain goats, 1 deer, and 1 bear. In general they are represented in simple outlines, painted with great vigor; several bison are well modeled over the entire figure (fig. 98). The general aspect and the horns in profile indicate the Middle Magdalenian, according to Breuil.

At the western end of the same province, near its border with Santander, is the valley of

101. Painted shield-shaped and tectiform motifs. Cave of El Castillo (Santander), Spain. Upper Paleolithic period.

102. Rock painting in red of an elephant or mammoth. Cave of El Castillo (Santander), Spain.

66

the Carranza, where two sites of cave art are known: La Venta de la Perra and Sotarriza. The first was discovered by P. Sierra in 1904 and has a number of engraved animals that are believed to be Aurignacian: two bison, one bovine, and one bear; in addition, crossed rectilinear engravings appear on the outside of the cave. At a short distance in the same pass is the entrance to the cave of Sotarriza (Molinar de Carranza), which contains the figure of a small legless horse pierced by a number of arrows, painted in black. A neighboring cave, Cueva Negra (Gibaja), probably contained figures in black that are now lost.

Santander Province is the most important location of cave art in Spain. Close to the caves just mentioned are several others that open off the valley of the Asón River. One, La Haza, contains three horses drawn in a blurred red; all are dotted along the outline of the body, and in one case the entire figure is covered with round spots. Less clear are a doe's head, a figure that may be a hyena, and another carnivore. Nearby is the cave of La Cullalvera, in which recent explorations have uncovered some figures.

Part of the same group is the cave of Covalanas, near Ramales, which has some important pictures. It was discovered in 1903 by H. Alcalde del Rio and P. Sierra. The paintings begin in a gallery about 250 feet from the entrance. They are usually executed with a dotted silhouette in red, in a technique that seems to have employed a wad (fig. 99). According to Breuil, this is a variant of the figures in blurred linear contour of the Cantabrian Perigordian (Gravettian). Does predominate in the pictures; there are as many as

seven, with a figure that may be a reindeer, in the first group. A second group shows a horse with highly developed mane surrounded by four does. In a small gallery there are a lightly formed bovine and two does; in a corner is a delightful group of three does with elegant silhouettes, in which the dotting that traces the outline of the body is accentuated at some points by broad lines. Nearby are two elongated rectangular signs.

In the valley of the Miera River, near the village of Ajanedo (Miera), is El Salitré cave, also discovered by P. Sierra in 1903. It contains fragments of paintings: a dubious deer's antler; a bison head, also dubious; a doe's head in red; and another doe outlined in black.

In the district near the capital of the province are the caves of El Pendo (Escobedo-Camargo) and Santián (Puenta Arce), both discovered by

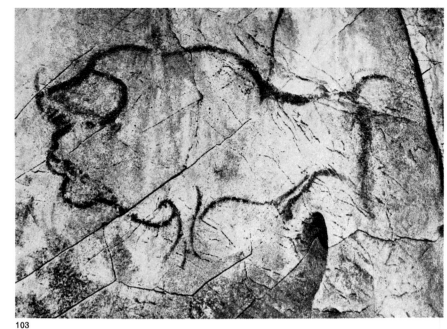

103

104

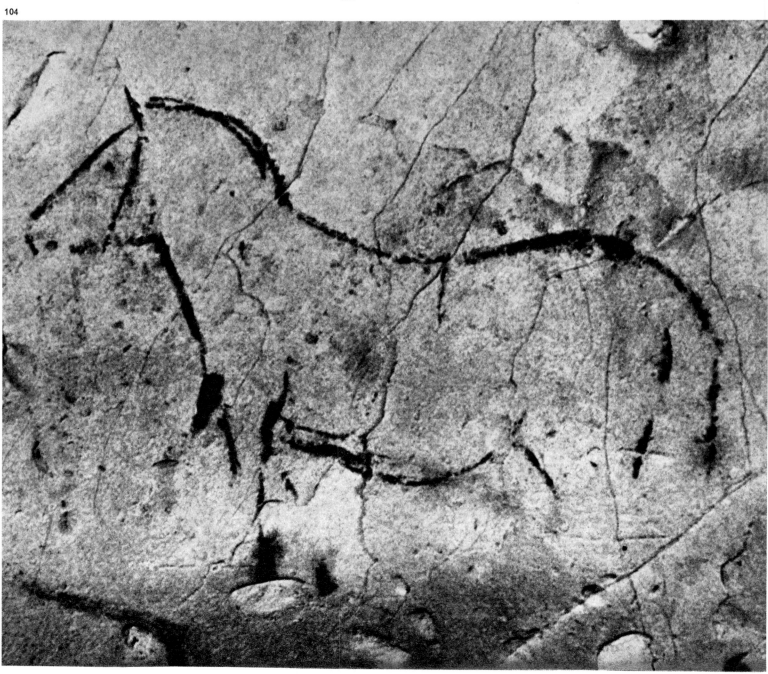

68

103. Rock painting of a bison. Cave of La Pasiega (Santander), Spain. Length 26".

104. Rock painting of a horse. Cave of La Pasiega (Santander), Spain. Length c. 19".

105. Rock painting showing a man leading an animal; stylized figures; and a tree. Cave of Doña Clotilde, near Albarracín (Teruel), Spain.

P. Sierra. The first contains nothing more than two incised birds, the figures crossing; one may be a penguin and the other a vulture. In the Santián cave there are some curious signs that do not appear elsewhere. There are fifteen, in two rows, ten below and five above. They are macelike, and one of them clearly is a representation of a foot and two are in the form of hands; others end in a trident or various points, while some are simply maces. Breuil supposes them to be of the Early Aurignacian.

An extraordinary ensemble has been found on Monte Castillo at Puente Viesgo in the Pas Valley. The mouths of four caves containing wall art open within a short distance of one another, at road level. The most famous is undoubtedly the cave of El Castillo, since its vestibule is the site of one of the most

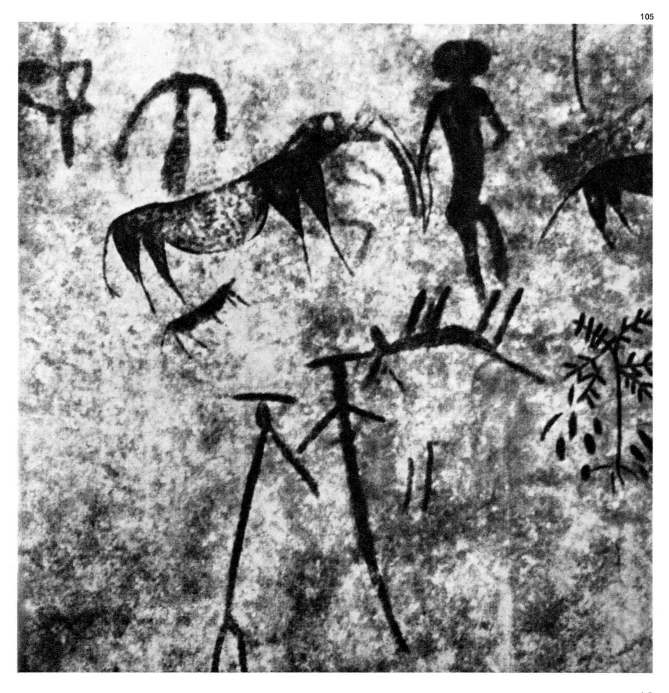

complete stratigraphies in the European Paleolithic. It was discovered by H. Alcalde del Rio in 1903. From 1909 to 1914 H. Obermaier and P. Wernert conducted excavations there that made it the focal point of the world's experts on the Paleolithic. A series of halls and corridors, not excessively complex, penetrates many hundreds of feet from the entrance in almost every direction, leading to some areas that are difficult to study and revealing a large number of animal representations and a substantial repertory of various kinds of signs (fig. 108, colorplate).

Grouped on some ceilings are hands in negative, with red pigment blown around them. None is mutilated; there are thirty-five negatives of the left and nine of the right hand, in addition to some blurred examples. Series of dots appear with the hands. A large series of dots is on the wall of the farthest gallery. In one of the less accessible areas are dense groups of dots and curious tectiform designs that are varied in form and, in one case, crossed (fig. 101). Some designs cannot be classified.

There are many outlines in red or yellow (horses, cattle, does, bison) of fairly good quality. Notable in this style is a hairless elephant (or ancient elephant); some contend that it is a mammoth (fig. 102). There are bison, horses, and deer of coarser blurred outline. Black is used in many figures, generally as a solid color or for modeling the figure. A few bison are executed in a polychromy that is rather poor compared to that of Altamira.

Engravings abound, and each new visit by E. Ripoll, the latest explorer of the art of El Castillo, has added to the number of engravings known. Many heads of does, of fine line and great expressiveness, recall those mentioned in the description of portable objects, that is, those incised on shoulder blades of the Magdalenian and found in this same cave. Some paintings reproducing human patterns in red or black may be compared with the Azilian patterns or, still better, with the stylizations of neolithic art.

While working in the cave of El Castillo in 1911, Obermaier and Wernert discovered the nearby cave of La Pasiega, which has a more complex system of galleries and is more difficult of access. Engravings are few here, while red-painted figures are numerous (figs. 100, colorplate; 103; 104). Breuil divides them into the following types: simple outlines in red, sometimes in yellow, rarely in black, the oldest in Cantabrian art (8 horses, 6 does, 5 bison, 1 chamois); light silhouettes with darks and lights (10 does, 7 bucks, 5 cattle, 3 horses, 1 chamois, 1 mountain goat); dotted outlines, more or less blurred (4 does, 4 horses, 1 buck); wide blurred outlines (5 horses, 1 bovine);

figures partly in solid color (2 does, 2 cattle, 1 horse); figures completely in solid color (3 does, 2 cattle, 1 horse); and figures in two colors (1 horse, 1 bison). Figures in black, in addition to a positive hand with traces of the arm, include 4 horses, 5 bison, 5 she-goats, 3 cattle, 1 elephant, and another animal, possibly a carnivore, all in outline or with rudimentary modeling.

Of the strange signs that abound at La Pasiega, some are key-shaped or shield-shaped and many are tectiform. A perfect rectangle appears below a richly modeled horse.

A few years ago, while a better road to these two caves was being built, two other caves were discovered and were given the names of Las Chimeneas and Las Monedas. The first contains some skillfully drawn animals in black outline, and digital engravings. The second is very interesting; it was explored as early as the sixteenth century, to judge from coins found there, and it contains many paintings in linear outline and engravings. Among the animals represented at Las Monedas are reindeer, a bear, horses, goats, cattle, bison, and deer; there are also other indeterminate animals and signs.

To the west, in the valley of the Besaya River, is the cave of Hornos de la Peña, whose rich engravings merit it a place of honor in Cantabrian art as a whole. In what is left of the entrance are figures of a bison and a horse; the walls of the interior halls and corridors, which were unsuited to painting, bear many figures incised at various periods. From a first Aurignacian stage there remain meanders and digital tracings and some crude animal figures; a second group, finer in line, is still archaic. Of a later era is a series of deep engravings, the most numerous in the cave, representing eight horses, two she-goats, two cattle, one bison, one deer, and a human figure; this series shows an enthusiastic attention to detail: the eyes, ears, manes, the four legs, etc. A horse and four bison belong to a series that dates from the Magdalenian, and they are more perfect. The best of these bison can be compared to those of the Upper Magdalenian at Altamira. The only examples of painting here are a small horse in black and some traces of other figures.

A group in western Santander Province, in the basin of the Saja, comprises several caves, in addition to Altamira: The cave of La Clotilde de Santa Isabel, discovered in 1906 by Alcalde del Rio and Breuil, is especially interesting because it contains only finger tracings in the clay that lines its walls. Eight of these engravings are preserved on the roof of a gallery about 560 feet from the entrance; they

106. *Rock painting in red of an elephant or a mammoth. Cave of El Pindal (Oviedo), Spain.*

represent an enormous lion's head and seven cattle with crescent-shaped horns and striped bodies; there is also one tectiform and another sign or two, all crudely drawn. At the end of a long corridor in the cave of Las Aguas de Novales, discovered by Alcalde del Rio in 1909, there is a finely incised bison, painted in red, which recalls those of Altamira, as well as another bison and such designs as a striped rectangle. In 1907 in the cave of La Meaza, the same scholar discovered an anchor-shaped sign in red, formed by three lines of dots; Breuil is not sure that this is paleolithic.

In Asturias, in the valley of the Deva River in the Panes district, is the cave of La Loja, near the village of Mazo. It was discovered by Breuil and Alcalde del Rio in 1908 and contains only a small group of engraved figures of cattle—four cows, one head, and what is

perhaps a heifer; they would be *Bos brachyceros* or *Bos longifrons*. The perspective of the figures is fairly good; these engravings may belong to the Perigordian (Gravettian) or the Lower Magdalenian.

In a striking natural setting, the cave of El Pindal (Pimiango), in easternmost Asturias, opens onto a cliff rising from the sea. The cave forms a long gallery, 1,075 feet long and more than 60 feet wide at its center. It was discovered in 1908 by Alcalde del Rio. The left wall bears few pictures: a horse, a bison, and a deer, modeled in black; the outline of a horse in red; and black signs that perhaps are later in date. There are many figures on the right wall. The most simply executed are the outlines in red: two shield-shaped signs, one horse, and an interesting elephant figure (fig. 106). The latter is 16½ inches high; the animal, at rest,

107. Rock painting in black and brown of horses and the incomplete figure of a bull. La Peña de Candamo (Oviedo), Spain.

108. Rock painting of a tectiform figure. Cave of El Castillo (Santander), Spain.

107

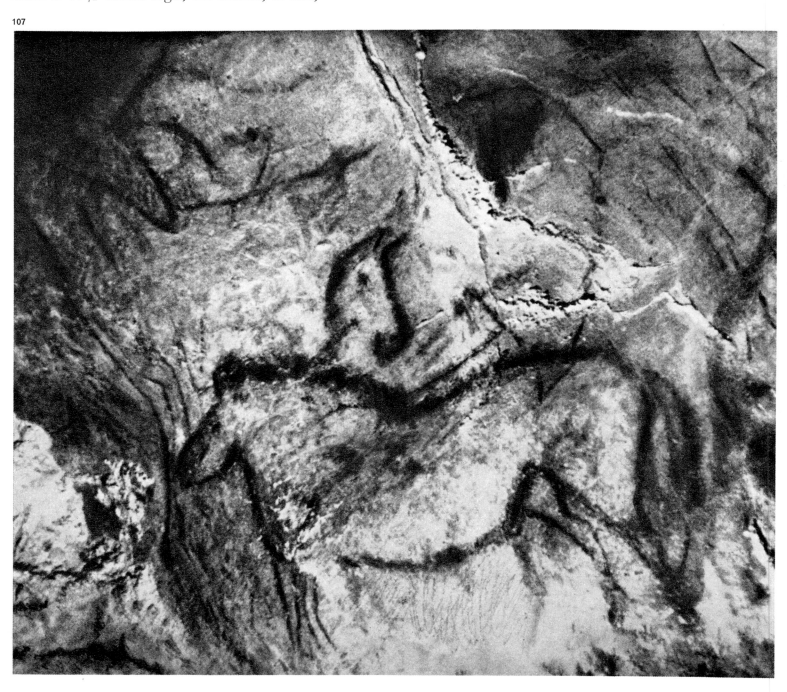

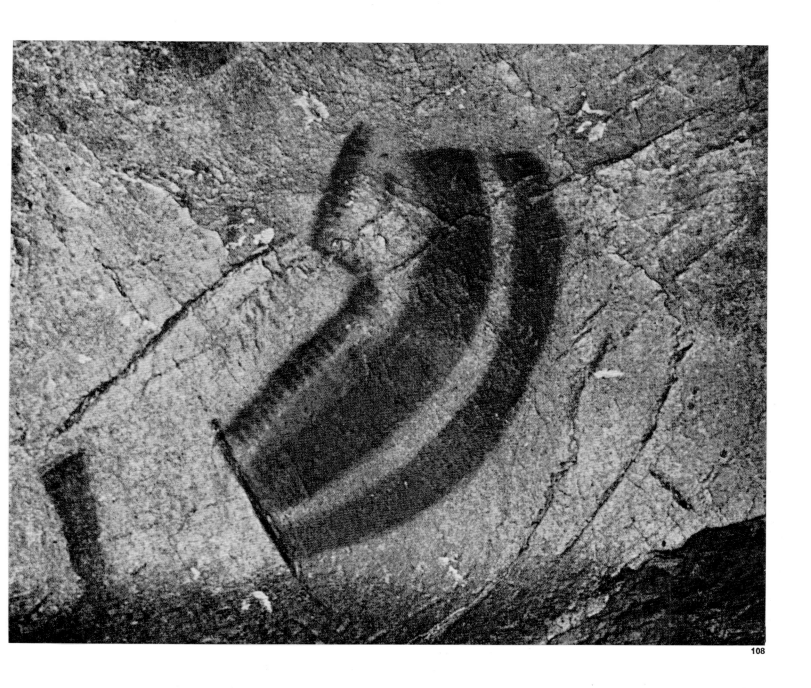

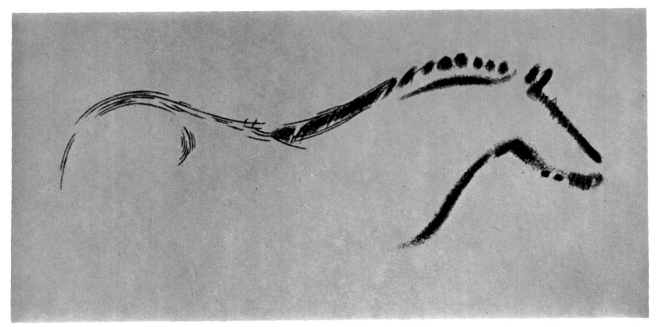

is denoted by a fine red contour line with almost no details; the tusk is very short, the forehead is high and bulging, and the trunk falls straight and curves at the end. The most curious detail of this elephant is the red spot on its chest; this has frequently been reproduced and was believed to be the representation of a heart, although today that hypothesis is questioned and the spot should be considered to be without significance. The animal may be a hairless elephant, such as that in El Castillo, and in that case we should have to suppose that the ancient elephant survived in the Cantabrian region until the Aurignacian, along with the *Rhinoceros mercki*. Many authors currently are inclined to regard these animals as mammoths. Dots in red and figures that may be hand patterns appear around the elephant figure. The entire group must date from the Aurignacian.

Many other series of dots accompany other figures of later style. The many bison are in blurred or dotted outlines, with part of the contour painted in red and the rest finely engraved, and with a red dart piercing the body; one example shows an incipient polychromy that recalls Altamira; another engraved bison has bars and points on its body. Below the splendid painted and engraved bison are six key-shaped signs in red, which clearly represent hafted maces or axes; two other key-shaped signs in black appear next to a doe in blurred red contour. An incomplete engraving of a horse on its back and another, very detailed one are evidence of a fine engraving technique, as are also a large bison and a fish, probably a tuna, 16⅞ inches long.

In the cave of Mazaculos, or La Franca, a short distance away, Alcalde del Rio found only a zigzag pattern and dots in red. In the cave of Quintanal, or Quintana, at Balmori, he discovered a finger tracing that is possibly a representation of a wild boar.

The area around Llanes, Posada, and Ribadesella contains several caves with unimportant remains: San Antonio (Ribadesella), with a small outline of a horse in black; Las Herrerias or Bolado (Llanes), with a frieze of red tectiforms and short, striped rectangles; Coberizas (Posada, Llanes), where Obermaier found the outline of a deer. The cave of El Cuetu at Lledias, near Posada, studied by Uria in 1944, contains many paintings of bison and goats, in addition to deer and horses, but serious doubts exist as to their authenticity, and it would be prudent to reserve judgment until more complete studies have been made.

In the region of Cangas de Onís, Count R. Vega del Sella discovered near Cardes the cave of El Buxu, which is made up of narrow passages. On its walls are seven engraved horses, sometimes with traces of black line painting; five bucks and two does, also engraved, and with vestiges of painting; an engraved animal of the deer family, perhaps an ibex; several goats, one in black; and an engraved bison painted in black. There are noteworthy tectiform signs, which resemble some of those in black at

109. Schematic drawing of an engraved and painted horse. La Peña de Candamo (Oviedo), Spain.

110. Rock engraving of anthropomorphic figures. Los Casares (Guadalajara), Spain (cf. fig. 132).

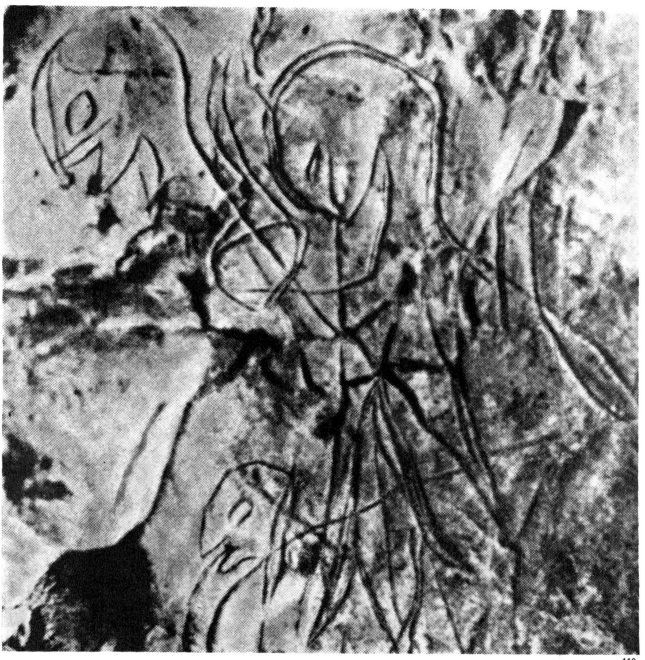

Altamira; here, however, they are engraved. Breuil interprets them not as symbols of traps, which is the usual hypothesis, but as symbols of a habitation in which the spirits of ancestors reside.

The cave of Las Mestas at Las Regueras, near Trubia, was discovered by Obermaier and Count Vega del Sella in 1916; it seems to contain nothing more than a few primitive engravings, including one or two animal silhouettes.

The last of the known sites of cave art in the Cantabrian district is the cave of San Román de Candamo, which is called La Peña de Candamo. It is in the valley of the Nalón and was discovered in 1914 and published by E. Hernandez-Pacheco. With the exception of some red signs (human feet?), all the engravings and paintings are in a large hall with a niche at its end. There are a number of stallions and mares with more or less blurred outlines (fig. 107); some of them are also partly engraved (fig. 109). The best image is that of the mare in the niche, next to a horse's head that is striped in black and is very vigorous. Under the three images of horses in the niche is that of a bull, in yellow silhouette. A pregnant mare in black seems to be of a later date, as does a fine Magdalenian engraved horse. There are some splendidly engraved bison that are masterpieces; the cattle, bucks, does, and goats also are masterfully executed, but these are Magdalenian and are sometimes accompanied by black painting. According to Breuil, the technique of distored perspective was preserved down to the Lower Magdalenian in this cave, in contrast to what occurred in the other sites of Cantabrian and Pyrenean wall art.

The Extension
of Cantabrian Art
in the Spanish Plateau

The vitality of the Cantabrian centers of cave art is reflected by the extension of their influence southward on the peninsula, along a route marked by a number of sites on the upper and lower plateaus. In the province of Burgos, the Penches cave at Barcina de los Montes, near Oña, was discovered in 1915. It contains five engraved mountain goats in good style; one of them is also painted. Breuil attributes these figures to the Middle Magdalenian. Near Ibeas, in the same province, is the cave of Atapuerca, discovered in 1912 by Alcalde del Rio; the only figure of interest that it contains is the head of a bear (?), whose outline is painted in the dotted technique known at Covalanas and La Haza.

In the lower plateau, in the province of Madrid, M. Maura has studied the cave of El Reguerillo at Torrelaguna, which contains archaic engravings representing a small deer and some fish.

Two very important caves are found in the neighboring province of Guadalajara: the cave of Los Casares, discovered in 1933 by Layna Serrano at Riba de Saelices, and the nearby cave of La Hoz, discovered in 1934 at Santa Maria de Espino by J. Cabré, who also studied Los Casares. At La Hoz appear a horse and other engraved figures, including tectiforms, in addition to schematic paintings. The cave of Los Casares opens into a long gallery about half a mile long; the engravings begin at about 210 feet from the entrance. This cave undoubtedly merits more detailed study and publication than it has yet been given, since, according to indications, there must be many more pictures in addition to those seen by Cabré, who noted the images of 15 horses, some of them magnificent; 10 bulls; many deer; 4 mountain goats; 2 lions; 1 wolf; 1 wolverine; 1 bird; and many fish, in a scene with human beings. There is a fine engraving of a hairy rhinoceros. The small figures seem to belong to an earlier phase because they are cruder. The larger figures measure almost five feet long. Breuil prefers to call the human figures "semihuman" (fig. 110); their faces are grotesque and they are shown with fish or frogs; in one scene, a man is about to dive into the water. Some traces of black paintings are present. Breuil finds parallels between the art of Los Casares and Hornos de la Peña, Les Combarelles, Ebbou, and the North African engravings, and presumes that they are

from the end of the Perigordian (Gravettian), as it was passing into the Magdalenian. We are inclined to seek parallels to these engravings in those in Sicily. Undoubtedly, the location and characteristics of the art at Los Casares make it one of the key examples of the mural art of the Upper Paleolithic. It also indicates that we may expect further surprising discoveries from the Spanish plateau, as has been demonstrated by the recent discovery in Estremadura of the cave of Maltravieso, near Cáceres, which contains paintings of hands in negative, along with other signs.

The Andalusian Nucleus

From the plateau of Castile we must go as far as Málaga Province to find the last link in the chain of sites that begins in the central regions of France. The situation of this southern center is highly important, since it indicates the possibility of contacts both with the nearby African continent and with the Mediterranean world.

Works of Quaternary wall art have been found in four sites in Málaga Province and in one site in the province of Cadiz, but only one of these—La Pileta—is of outstanding importance. At the cave of La Cala, near Málaga, there are fragmentary remains of red figures. Those in the cave of Merfa, west of Málaga, have not yet been properly studied and published. We know that the cave of Doña Trinidad at Ardales contains much more than has been published. Both of the last two were discovered and studied by Breuil. In the cave at Ardales, fallen blocks bear engraved horses of Aurignacian style and festooned bands engraved on clay; on another block are three engraved does and a buck, a painted sign, and an engraved shield-shaped sign. Breuil has compared these engraved animals with those at El Parpalló. A frieze on the wall is in very archaic ocher and reddish tracings and consists of ten doe heads and one bovine head; another frieze has a number of painted does, one in a broad, somewhat blurred, black band, with striped haunches.

In the vicinity of Laguna de la Janda, Cadiz Province, there are innumerable sites with neolithic wall art. A horse's head in the cave of Las Palomas, painted in broad lines in brown and a series of dots, has been regarded by Breuil as being in the naturalistic style characteristic of Quaternary caves. This would extend the manifestations of this art as far as the Straits of Gibraltar.

The famous cave of La Pileta, at Benaoján,

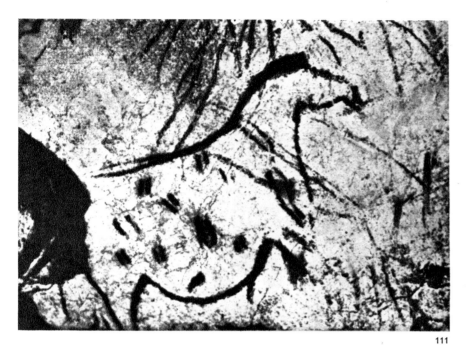

111

not far from Ronda, is in one of the wildest parts of Spain's rugged landscape. It was discovered by Colonel W. Verner in 1911, and subsequently was studied by Obermaier, Wernert, and Breuil. The cave is one of the most intricate and formidable ones in Spain, but almost 5,000 feet of its galleries are now known. The oldest pictures are those in yellow, representing snake motifs, dots, faces, etc. Goats, does, and bulls are painted in silhouette in the same color. Painted in red are 3 bulls, 3 horses, 1 headless bison, 3 mountain goats, and 4 does, sometimes with shaded lines and some modeling, and sometimes in solid color; in this they are close to Spanish Levantine art. There are innumerable signs in red, of a type not found elsewhere, with the exception of El Parpalló: these include darts, which may represent daggers; spirals; ovals; and circles; in addition to footprints and tectiforms of great diversity, usually appearing singly. The entire rich series of neolithic motifs that we shall mention below are painted in black here, along with a great variety of figures of the Paleolithic. In the group Breuil counts about 80 figures, including 17 mountain goats, 14 horses, 9 deer, 6 cattle, and 6 fish, one of which gives its name to the hall because of its great size—almost five feet in length. Snake motifs (fig. 43) appear on other parts of the cave's ceilings, where the same series of animals is repeated in more blurred form. In one of these locations are a number of

111. Rock painting of a horse. Cave of La Pileta (Málaga), Spain.

rectangles with striped vertexes, compared by Breuil to similar motifs painted at Altamira and engraved at El Buxu; we believe them to be identical to those appearing on small stone fragments at El Parpalló from the Upper Solutrean. Another parallel between Altamira and La Pileta is evident in some spiral signs that seem to have been executed by the same hand; this also confirms the similarity of some pictures of does and cattle.

The cave of La Pileta is one of the best arguments in favor of the thesis of a western Mediterranean artistic province which included southern France and the Mediterranean coasts of Spain and southern Italy and Sicily, and which perhaps was related to the African art.

The Extensions in Italy

Up until a few years ago, there were no noteworthy indications of the possibility of the existence of Quaternary mural art in Italian caves. However, recent sensational discoveries have shed new light on problems that had seemed to defy solution because they had always been regarded from the same point of view.

Since 1914 the Romanelli cave, at Castro near Otranto, excavated by G. A. Blanc, has yielded great archaeological treasures. It has also produced engraved stones similar to those at El Parpalló, representing a feline, a wild boar, and geometric motifs with crossed lines. On a wall of the cave is a bovine, engraved in profile, also reminiscent of El Parpalló and La Pileta. Many spindle-shaped designs may be interpreted as highly schematized representations of women. There are also parallel and ladderlike bands and a few painted geometric motifs. A few years ago, A. M. Radmilli found a large number of small limestone fragments, or plaquettes, engraved with animal figures, in the Polesini cave near Tivoli.

The remarkable petroglyphs of the cave of Cala Genovese were discovered by P. Graziosi while he was studying the neolithic paintings of the cave, which is on Levanzo, one of the Egadi Islands, off the west coast of Sicily. The lower strata of the site yielded material from the Gravettian. During the Würmian glaciation, the island of Levanzo had been joined to Sicily. The figures in Cala Genovese are engraved representations of deer, aurochs, and a small equine that must be *Equus hydruntinus* (figs. 113, 116); alongside are a series of strange anthropomorphic figures that surely are disguised men, such as appear in so many Franco-

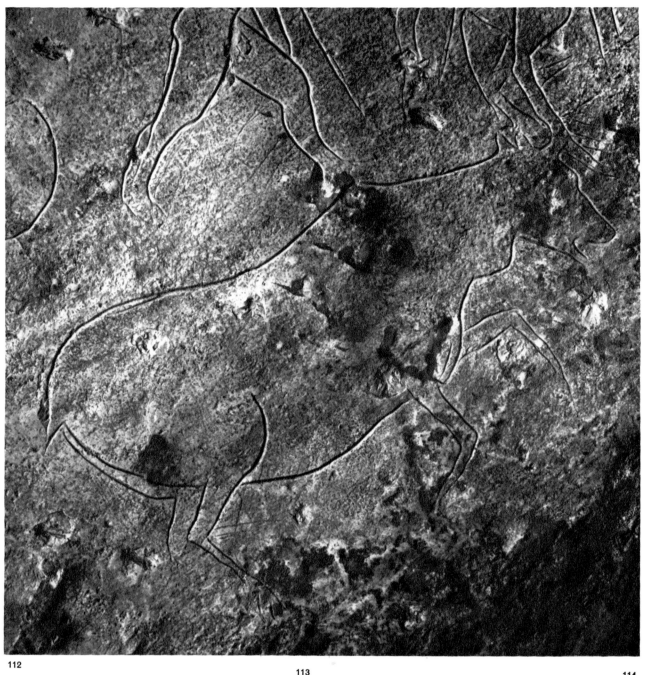

112

113

114

112. *Rock engraving of a reindeer Addaura cave, Monte Pellegrino, near Palermo, Italy.*

113. *Rock engraving of a horse, probably* Equus hydruntinus. *Cave of Cala Genovese, Levanzo, Egadi Islands, Italy.*

114. *Rock paintings of human and animal figures. Cave of Cala Genovese, Levanzo, Egadi Islands, Italy. Height of human figure c. 12".*

115. *Small rock engraving of a bison. Cave of Cala Genovese, Levanzo, Egadi Islands, Italy.*

116. *Small rock engraving of a horse, probably* Equus hydruntinus. *Cave of Cala Genovese, Levanzo, Egadi Islands, Italy.*

117. *Rock engraving of an equine figure. Addaura cave, Monte Pellegrino, near Palermo, Italy.*

115

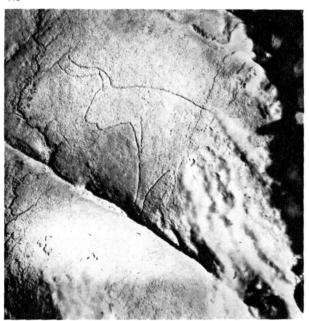

116

Cantabrian groups. The animals are naturalistic in style, and although they are lacking in the details found on many figures of the great artistic centers of the epoch, the realistic expression of life is unmistakable (fig. 115). The sense of movement and simplicity of line, together with other features, relate them to the art of the Spanish Levant.

In 1952, Mrs. J. Bovio-Marconi discovered at Monte Pellegrino, near Palermo, the petroglyphs on the walls of the small Cave of Addaura, where the explosion of a store of munitions had dislodged the accretions that hid the original engraved wall. The engravings of animals resemble those at Levanzo and are even more simple and expressive (figs. 112, 117); the equine animal turning its head is one of the finest works of Mediterranean mural art. There are other equines, and two deer, but the anthropomorphic pictures are of special interest (figs. 118, 119). Nude or masked men form a number of scenes of uncertain interpretation. Two of them seem to be fighting. Others are tied and are lying on the ground. It may be that this represents a suicide by strangulation or a scene of torture, as some details of the violent positions would seem to indicate. These strange images recall somewhat the human figures in the cave of Los Casares, but no satisfactory chronology can be established for this ensemble.

The nearby cave of Niscemi, also on Monte Pellegrino, contains some representations of equines and bovines of the same style as those at Addaura. The fact that the horns of the animals are in accurate perspective has seemed to some authors sufficient evidence for dating them from the Magdalenian. However, we can not yet consider this a definitive dating.

117

118. Rock engravings of human figures and an equine figure. Addaura cave, Monte Pellegrino, near Palermo, Italy.

118. Rock engravings of human figures and an equine figure. Addaura cave, Monte Pellegrino, near Palermo, Italy.

119. Engraved human figures. Addaura cave, Monte Pellegrino, near Palermo, Italy.

Other possible extensions of the western artistic centers during the Upper Paleolithic lead to parts of northern Europe, to Oriental lands on the route to Asia, and possibly to others on the route to distant America. One of the great enigmas of prehistory is the question of whether this expansion halted on the European shores of the Mediterranean, or whether it reached Africa. We shall return to this question when we consider the vast wealth of African cave art.

118

119

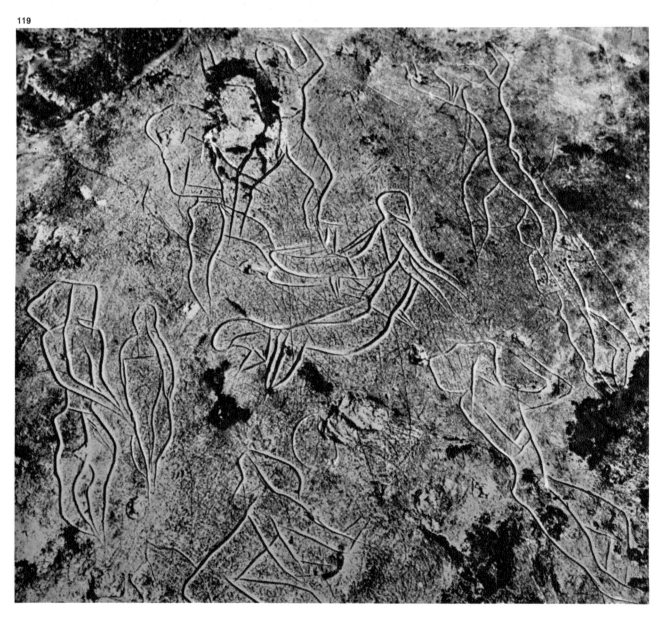

80

Mesolithic Art
of the Spanish Levant

Thus far we have described the artistic activities of the men who lived during the last glacial period and saw the beginning of a new era. Hunting was their main occupation and supplied their basic food, while artistic expression met their social need. This first art must have given rise to currents that carried it to lands far from its place of origin, producing trends that developed in post-Paleolithic times. However, one of these artistic phenomena is confined to a rather limited area, whose evolution presents two features of the greatest interest. First, the inclusion of the human figure in this art is a source of extremely valuable data concerning life during the prehistoric period. Second, it raises an essential question for all of European prehistory, that of chronology—a problem intensified by passionately held views and one of vital importance to us. The fact that the question is still in dispute and is, in a way, bound up with paleolithic times explains why we take it up at this point.

General Characteristics

Very soon after the authenticity of Quaternary cave art had been acknowledged, it was learned that shelters containing paintings reminiscent of that art existed in the Spanish Levant. As early as 1903 Juan Cabré, who later became one of the most successful explorers and experts in Spanish prehistory, discovered some figures of animals painted in the overhang at the base of Calapatá, near the village of Cretas, near Teruel in the region known as Bajo Aragón.

In 1907, R. Huguet, the parish priest of Cogul, a village in southern Lérida Province, discovered a shelter in which there were paintings of animals and women. Breuil became interested in this ensemble; his visit marked the beginning of a long period of exploration and study in which he played the principal role, dedicating himself with the same intensity that he had devoted to Franco-Cantabrian art. Spanish authors such as Cabré, E. Hernandez-Pacheco, and J. Porcar, and many others, also took an active part in the discovery and publication of this surprising aspect of Spanish prehistory. Discoveries came rapidly. The first findings at Albarracín occurred in 1909; in 1910 the great group at Alpera was found; in 1917 the paintings of the undercut shelter of La Valltorta were discovered; and other discoveries have occurred practically uninterruptedly down to the most recent ones by E. Ripoll in 1960. Today approximately sixty sites are known, many of them containing several shelters or independent ensembles.

The territorial limits of this art can be drawn from southern Catalonia through the entire Valencia district and the eastern regions of Teruel Province into Bajo Aragón and the Albarracín district. It extends into the eastern portion of Cuenca Province and then through Albacete and Murcia provinces, dying out in northern Almería Province. Some of its manifestations may extend westward through Andalusian regions of the Sierra Morena.

Unlike Franco-Cantabrian art, the paintings of Spanish Levantine art are found in shelters in the open air. The limestone mountains of the Levantine region have many shelters throughout the length of their undercuts, and it is there that these frescoes are to be found. In them, human figures appear along with animals, and all are usually grouped into scenes of vari-

ous kinds, including many hunting scenes. In general, the figures are small, sometimes tiny, in size. Engravings are rare. The predominant, almost sole color is red; black is uncommon and white is very rare. Porcar, who has studied this art from a painter's point of view, distinguishes light red, dark red, black, brownish black, and manganese tints, and among the reds he lists warm, cold, earth, and carmine tones; he points out the effect of the applied color in relation to the color of the rock and the fact that the rock sometimes seems to have been rubbed before being painted; on rare occasions incised lines trace the outline of the figure. Any isolated instances of polychromy that there may be do not approach the perfection found in the north. Porcar notes the use of the calligraphic line in the small figures and asserts, on the basis of his own experiments, that the best results in imitating this line have been obtained by using a quill and a medium of red ocher with water and white of egg.

One curious stylistic detail recurs. The animals are represented naturalistically, while the human figures, hunters or warriors, are more or less stylized. The most realistic ones are those in the frieze at Alpera, and the name of this site has been given to the style in general. A short and heavy type of human figure is called pachypod; another, linear, type is designated nematomorphous; finally, the type with a disklike head, triangular trunk, and legs of exaggerated length and thickness is known as cestosomatic. The horns of the cattle are shown frontally, with the body in profile, and the antlers of the deer have the same twisted perspective; Breuil attaches great importance to this fact in his chronology; it seems to relate this art to the oldest phases of the Franco-Cantabrian and to some aspects of El Parpalló.

A Description of the Sites

The only known site in Lérida Province is Roca de los Moros, at Cogul, south of Lérida. The discovery of this small shelter with faded paintings was instrumental in drawing attention to this type of art. The shelter contains a scene that may be termed "classical" and is probably the best known in the Spanish Levant. It shows a satyr with ornaments on his knees surrounded by a group of women with pendulous breasts and knee-length bell-shaped skirts (fig. 120). He is painted in a black tint that must have been red in a first version; the women, of whom nine are clearly evident and two others are suggested, also have been

120. Ensemble of naturalistic and schematic rock paintings and engravings (copy, after Almagro). Covacha de los Moros, Cogul (Lérida), Spain.

120

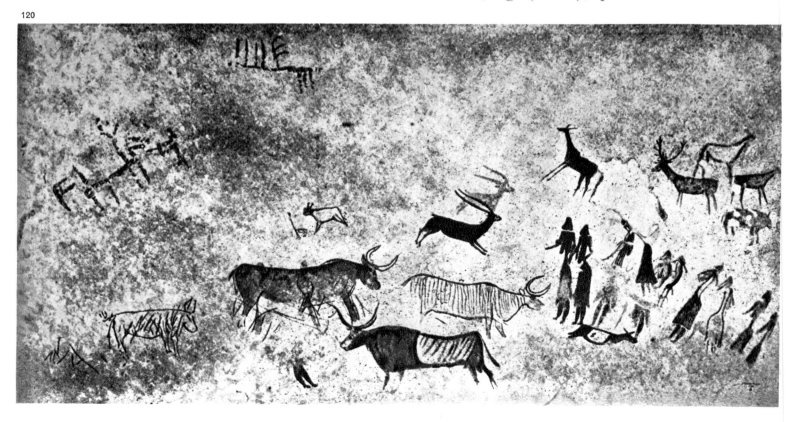

repainted, first in red and then with black bands. This, and the fact that the women are in pairs, suggests that this is a depiction of some ritual act performed by two women before the satyr, the symbol of fertility, an act that was repeated over a long period and thus required successive retouchings of the painting. Deer, goats, and bulls in various styles and colors complete the ensemble. Some of the bulls, with outlines that were incised before being painted, must be very archaic; their legs and horns are represented in false perspective. They are earlier than the female figures, which, in turn, are earlier than the other animal figures. At one end of the frieze a hunter is shown attacking an indeterminate animal, which Breuil supposes to be a young bison and which, as we shall see, has been the subject of intense controversy. As evidence that the site retained its character as a holy place for thousands of years, there are a number of schematic figures, such as an archer shooting at a deer, and, finally, remains of votive inscriptions in archaic Latin and Iberian.

A number of stations are known in Tarragona Province, but they are of little importance generally. The northernmost is Mas d'en Llort at Rojals, where there are several shelters; another fairly compact group is in the mountains on the left bank of the Ebro: Cova del Remat and Cova del Cingle in the recess of the Font Vilella (Tivisa), Cova de Cabra Feixet at Perelló, and Cova de Culla at Benifallet, the last being dubious. In the ravine of the Cenia River, near La Cenia on the border of Castellón de la Plana Province, a shelter has been discovered and named Els Rossegardors, or El Polvorín; its pictures include that of a hunter capturing an animal with a lasso, some small human figures, a few men with accentuated facial profiles, a woman wearing a skirt, and—very rare in this art—a number of birds.

In Bajo Aragón, closely linked geographically with the above-mentioned districts, are some of the most typical and earliest-recognized paintings. In the ravine of the Calapatá, at Cretas, are the shelters of the Roca de los Moros, which contains a number of beautiful deer at rest, and the Barranco de los Gascones, in which two archers, executed with great skill, face two large deer, one in black and the other in red. In the El Secans shelter, at Mazaleón, is a figure of a hunter wearing breeches of a type that is still in use in the region, the *zaragüelles*. A very interesting decoration appears in the cave of the Val del Charco del Agua Amarga, near Alcañiz; in addition to a spirited boar hunt and representations of two women and several large animals, a veritable

battle between two tribes is depicted, in which some bowmen with feather headdresses flee from other warriors, slightly larger in size, some of whom wear high bonnets.

The nearby El Maestrazgo district is in the province of Castellón de la Plana, which is presently the richest of all the coastal provinces in this art. At Morella la Vella, near the capital of El Maestrazgo, are the Galeria Alta de la Masia, the Cova del Roure, the Covacha de la Viña Baja de la Masia, and the shelter of Sant Antoni. In the first-mentioned is a curious scene of hunters following the trail of a deer. In the Cova del Roure there appears an extremely animated scene of struggle, or of a war dance, with eight very schematized figures of bowmen represented in a veritable frenzy; here, too, is a scene of a hunter following the track of a wounded goat and a flock of sparrows, a subject that is not frequently found in prehistoric art.

The group of painted shelters in the ravines of the Ares del Maestre district, some of which were made known in 1935 by Breuil, Obermaier, and Porcar, who has continued to study and publish them, is, in our opinion, the richest of all those known in the Spanish Levant. It is so important that we hope to have a complete publication of it some day. The shelters are in the ravine of La Gasulla; they include the Remigia cave, nine niches in the Cingle de la Mola Remigia, the Cova dels Cirerals, the Recó Molero, and the nearby shelters of Les Dogues. In all likelihood, still others exist.

Among the hundreds of figures that have been published is a rich variety of hunting scenes: archers running or shooting in various attitudes, others following wounded animals or pursuing game, which usually comprises wild boars, deer, and mountain goats. In one curious scene a wounded wild bull is charging the hunter, who runs away, looking behind him. The exciting depictions of boar hunts, in some of which a boar has already been brought down and is shown with feet in the air, are masterpieces of expressionist skill (figs. 131, 137). The hunters seem to be flying. In two instances archers seem to have executed a man; the victims are shown some distance away, wounded by arrows and fallen to the ground. In another group in the shelter of the Cingle de la Mola Remigia, four archers with weapons upraised are marching behind their chief, who wears the high fur cap that also appears in other paintings. Another shelter in the same ravine, at Les Dogues, contains a vivid scene of a combat, with a number of tiny figures in the style that Porcar has described as calligraphic (fig. 121). In the Remigia cave are several pictures of spiders and flies, but undoubt-

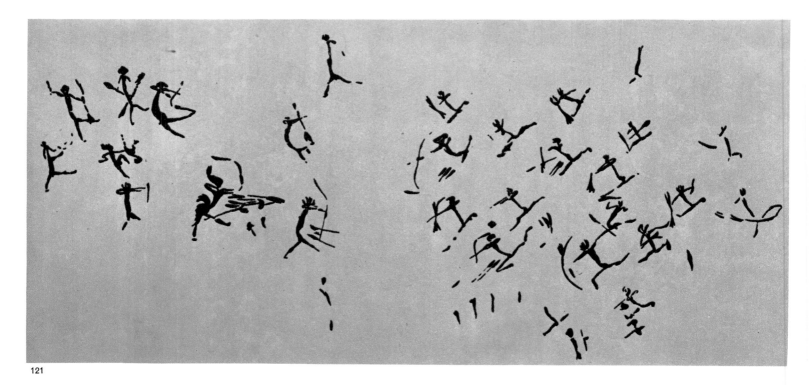

121

edly the best representations of this type are in one of the shelters of the Cingle de la Mola Remigia, which also contains a fine anthropomorphic figure, a man disguised as a bull. Baskets or purses, arrows, and other small objects are depicted, in addition to the ornaments and trappings on the human figures. There is also a man climbing a rope. Along with the usual fauna, there are animals that the above-mentioned authors identify as members of the deer family, as a carnivore, and as a nocturnal bird; the absence of any representation of a horse is noteworthy.

Nearby is another magnificent group, in the ravine of the Valltorta (districts of Tirig and Albocácer), which was studied independently by Obermaier, Cabré, and Durán y Sanpere, among others; its discovery in 1917 by A. Roda caused a furor among the archaeologists of the time. Many of the scenes discovered in the eleven shelters that have been found in this ravine have become classics. In the cave of Civil, a group of some twenty-five bowmen are shown as if in a ritual dance, or in the act of preparing their weapons; around them are various wounded animals. In the Cova dels Caballs, the best scene represents deer being driven by hunters; some of them are wounded, and four hunters are lying in wait and shooting at them. In Mas d'en Josep a scene of a hunt, with a wild boar and one of two bucks being chased by an archer running at full speed, is notable for the foreshortening of the figures and the skill with which the little figure of the archer is painted, complete to the ornaments on his head, waist, and legs. Finally, there are six groups in the cave of Saltadora; four are

hunting scenes, one of which shows five bucks surrounded by hunters. In addition to a number of figures of goats and deer, this cave contains three strange figures, apparently three men dancing. There is a noteworthy figure of a warrior falling wounded, with a sort of diadem falling off his head as he sinks to the ground, perhaps to symbolize the authority he is about to lose.

Not far away are the paintings of Benasal, which are yet to be studied and which we include here with some reservations. To the south, near the coast, is the shelter of La Joquera (Borriol), where there are remains of a human figure and two unidentifiable figures.

The shelters recently discovered in central Teruel Province remind us that we can not yet claim to have a thorough knowledge of the extensive territory of Spanish Levantine art. The shelters are in the localities of Ladruñán and Alacón and were discovered by Ortego; they show a wealth of new scenes. El Pudial shelter (Ladruñán) contains a magnificent figure of a bull, about twenty inches in size. At Alacón, the seven shelters of El Mortero and El Cerro Felio contain scenes repeating curious motifs of Levantine art already mentioned in sites nearer the coast: hunting

121. Rock painting of a battle scene (copy, after Obermaier). Les Dogues, Barranco de la Gasulla, Ares del Maestre (Castellón de la Plana), Spain.

84

and battle scenes (fig. 128, colorplate), many female figures, some quite pretty and one in a reflective pose, a group of warriors aligned for a dance, a number of donkeys, some men taming donkeys and a man already mounted on one, two men climbing tree trunks or rope ladders, etc. In 1960 E. Ripoll discovered and published painted scenes at nearby Santolea.

The group of paintings in the Albarracín district were found very early, and subsequent explorations have contributed new findings. Here, too, are figures of unusual style, notably some realistic representations of bulls, which we believe to be the oldest manifestations of this art. In the Cocinilla del Obispo, or Callejón del Plou, the bulls are painted in red, with fine incised silhouettes. The bulls are of various sizes in the Prado del Navazo, where there also are a number of archers, one of whom is squatting on his heels, that seem to be of a later date than the original composition; some that are painted in black seem to be the most recent. In the frieze of the Prado del Navazo, almost ten feet long, white was used to make the figures stand out against the reddish color of the rock. The largest of the bulls is over thirty inches long and shows some polychromy, very rare in the Spanish Levant; the figures are painted in white, with red at the center, shading off toward the edges.

The cave of Doña Clotilde, discovered by M. Almagro in 1944, contains a painting of a tree, perhaps a pine, in addition to animal and human figures. In the Barranco del Cabrerizo, which Breuil and Cabré discovered in 1909, there are various engravings, including a horse or ass; El Arquero contains the figure of an archer. Las Tajadas de Bezas (Bezas) includes three shelters, two at La Paridera and one at El Huerto, discovered by Ortego; one of the former has finely executed figures of stylized does in white, and the latter contains a series of spots and a figure that may be an ibex. The Tormón group of shelters, discovered in 1926 by L. Sierra and P. Garcia, is of particular interest. Los Toros shelter, in the ravine of Las Olivanas, contains as many as ten human figures, including one woman with a belled skirt of the type common in Spanish Levantine art, nine bulls, five deer, a horse, and an ibex; the ibex is shown dead, while before it stands a hunter carrying his bow and wearing the high bonnet that we have referred to above.

Farther to the south, in Cuenca Province, are two shelters near Villar del Humo and Boniches, known as Peña del Escrito and Rambla del Enear, respectively; in them are pictures of deer, bulls, boars, goats, and human beings. One man is shown leading a horse by a rope,

and this scene suggests that the group must be relatively modern.

In Valencia Province the sites are less numerous than in the above-mentioned provinces, but some are of great importance. Near Dos Aguas are the shelters of Cinto de las Letras and Cinto de la Ventana, both discovered in 1940. In the first are hunting scenes of deer and goats and a scene that may possibly represent women dancing; a small figure of a running woman with skirt and basket is truly outstanding. Some pictures of goats appear in the second shelter, which is near a cave with a rich mesolithic deposit, the cave of La Cocina; this may be a chronological indication. The shelter of La Tortosilla at Ayora, discovered in 1911 by P. Serrano, contains three small figures of animals, including a chamois, and several human figures. The shelter of El Sordo, discovered in 1946, shows a running archer between a figure of a goat and traces of other, poorly preserved figures.

Of great interest are the shelters of the so-called cave of La Araña, at Bicorp, discovered in 1919 by J. Poch and studied by E. Hernandez-Pacheco. They contain many scenes, some of which display great realism despite the simplicity of the means employed (fig. 122). One of them represents a hunt for mountain goats, in which a group of the animals has been surrounded by archers who are shooting them down; one has fallen with its legs in the air alongside the blood it has shed; others are brought down as they try to escape. The best-known scene in this ensemble is that of the honey-gathering (fig. 129, colorplate): a man or woman has climbed up some ropes secured at the top of the ravine with some sticks; he pauses, basket in hand, before a hive, with bees buzzing around him, while, below, another man begins the ascent.

In the province of Albacete, the shelter of El Mugión, on the mountain of the same name near Almansa, was discovered by Breuil in 1913 and contains some figures of little importance. Nearby, at Alpera, P. Serrano in 1910 discovered the caves of El Queso and La Vieja or El Venado. The first contains a picture that may represent an elk. The well-known frieze of La Vieja is one of the most important of the entire Spanish Levant. It is approximately 34 feet long and includes a series of scenes that do not seem to be related to one another. It has 17 goats, 15 does, 5 bulls, 2 horses, 7 carnivores, 1 ibex, and other animals, in addition to some 70 human figures, 13 of which are archers shooting at other men or animals; 3 are larger than the others, as if to indicate their pre-eminence, and they wear clearly distinguishable ornaments of feathers on

their heads and bands at their knees. There are also 3 women, 1 nude and 2 wearing skirts similar to those of the female figures at Cogul and other sites. Some of the human figures are represented in a war or religious dance. In some cases the hunter is accompanied by a canine animal, which has been supposed to be a jackal or, more likely, a dog. One man seems to be climbing up a tree or a rope. There also are scenes of combat between archers of different tribes. Some hunters are disguised with animal heads; the details of ornaments and weapons are very interesting. A group of mountain goats is led or guided by a he-goat. As in almost all groups of Spanish Levantine art, schematized figures of a later epoch are present alongside the naturalistic ones.

In the southern part of the same province of Albacete, Breuil discovered several shelters with paintings at Minateda (Agramón, near Hellín). The most important one is in the Barranco de la Mortaja and contains the longest frieze known; it measures more than sixty feet in length, and has a vast number of figures—several hundred of them—in addition to later schematic signs. Breuil identified as many as thirteen periods or stylistic phases in this large group of figures, with frequent superpositions; this would make the frieze representative of the entire evolution of Spanish Levantine art.

Most of the animals depicted at Minateda are deer and goats or bulls, but the chamois, wild boar, and the jackal or wolf also are represented, along with fish, birds, and antelopes (figs. 123, 138). Breuil also saw figures of lions, a rhinoceros, bear, saiga antelope, elk, ibex, and reindeer; in the face of much criticism, he finally revised his earlier judgment but upheld his identification of the elk, rhinoceros, and ibex. Other authors, however, flatly deny that any such animals can be identified, in view of the state of deterioration of the Minateda paintings, just as they deny similar identifications of figures in other Spanish Levantine shelters. The human figures at Minateda sometimes show marked realism and are executed in various techniques. Among the many

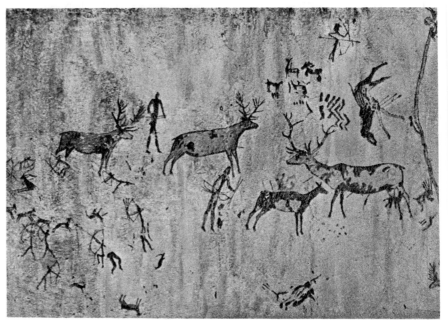
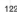

122

123

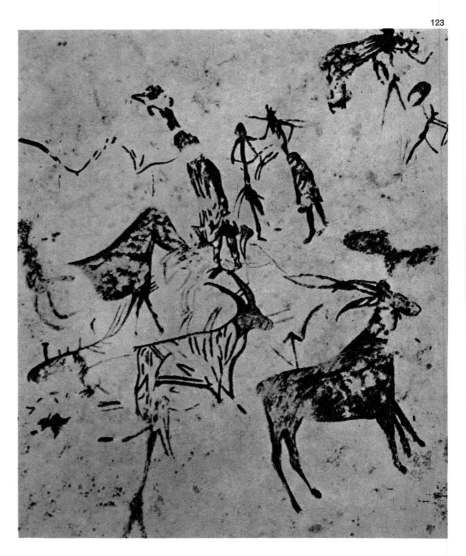

122. Rock painting of deer and human figures (copy, after Hernandez-Pacheco). Cave of La Araña, Bicorp (Valencia), Spain.

123. Rock painting of animal and human figures (copy, after Almagro). Minateda (Albacete), Spain.

86

scenes scattered in disorder throughout the intricate frieze are a deer hunt and a combat scene. A scene in which eight warriors with striped bodies surround and attack five others, who are painted in solid color (one of the five has been wounded by several arrows), reveals interesting details of the weapons. Some of the female figures in the frieze wear skirts, and one woman holds a child by the hand, in one of the most domestic scenes in all of Spanish Levantine art.

In the same district, in the province of Murcia, a number of shelters with paintings were found in the localities of Yecla and Jumilla. In 1912, in Yecla, on the slopes of Monte Arabí, Zuazo discovered the two caves of Cantos de la Visera. The larger of the two, El Mediodia, contains paintings of horses, bulls, deer, chamois, and human figures, along with many examples of schematic art. The smaller shelter has a total of 43 deer, horses, bulls, and goats in black and red, and other figures that are less clear. There are 73 figures in El Mediodia, 11 of them bulls; some of them, facing one another, are masterfully drawn in a dark red. There are also paintings of 3 men, 2 birds (storks), and the figure of what may be a carnivorous animal, in addition to many signs and schematized figures, which are neolithic; the affirmation that one of the figures represents a chamois seems doubtful to us. A more recent discovery, the cave of El Peliciego, at Jumilla, contains some figures.

There are four shelters in the province of Almería: Las Grajas, or El Coto de la Zarza (Topares); Los Lavaderos de Tello, or El Desfiladero de Leiria; El Estrecho de Santonge at Vélez Blanco; and Chiquita de los Treinta, at Chirivel. The four were discovered by Breuil and Cabré in 1913. The first shelter contains the head of a goat, and the first three have a few figures of deer and goats. The last-named shelter, with three deer, a mountain goat, and three male figures, is interesting because an arrowhead found in its archaeological strata could be of the Levantine Solutrean type, as occurred also in the shelter of Cantos de la Visera.

There is some question as to whether some shelters in the Sierra Morena and Cádiz Province should be included here; Breuil believes that they contain figures in the same style. These shelters are the Tabla del Pochico and Prado del Azogue, at Aldeaquemada; El Santo, at Santa Elena; Rabanero, at Ciudad Real; and the caves of Las Palomas, near Facinas-Tarifa, and Pretina, at Medina Sidonia, in the Cádiz district. And we might include here some of the paintings of two shelters in Portugal, Las Batuecas and Arroches.

If we add to this long list the isolated figures and scenes in the many sites we have not described in detail, and consider that new groups are constantly being discovered, we have an idea of the density of these traces of a population that, although sparse, moved for many thousands of years through the mountains where today we are discovering the remains, fossilized, as it were, of the spirit of those people.

The Problems of Chronology

Franco-Cantabrian art forms a rather unified ensemble, and thus it has been relatively easy for us to place it within a well-defined chronological and cultural framework. The only problem was one of establishing the various periods of its development. Spanish Levantine art, however, lacks the characteristic of unity and all aspects of it present difficult problems. In particular, we have not been able to arrive at a solution to the problem of chronology that satisfies all scholars.

It is not surprising, therefore, that few problems of prehistory have given rise to such polemics and heated controversies as this chronology. We shall briefly state the elements of the problem and the proposed solutions, including our own personal point of view.

In this ensemble we do not have the portable objects that are such an excellent basis for chronology as parallels to the art works on the walls. The only such portable objects we know

124

124. Detached rock painting with stylized human figures, from Aldeaquemada (Jaén), Spain. Museo Nacional de Ciencias Naturales, Madrid.

125. *Rock painting of hunters and animals with superposed schematic figures of later epochs (watercolor copy). Tajo de las Figuras, near the Laguna de la Janda (Cadiz), Spain.*

126. *Stone fragments covered with engraved lines, from the cave of La Cocina, near Los Aguas (Valencia), Spain.*

127. *Stone fragments with painted or engraved animals, from the cave of El Parpalló (Valencia), Spain. Solutrean (two at left) and indeterminate strata.*

128. *Rock painting of a hunting scene (watercolor copy). El Cerro Felio, near Alacón (Teruel), Spain.*

129. *Rock painting of honey gatherers on ropes (watercolor copy). Cave of La Araña, Bicorp (Valencia), Spain.*

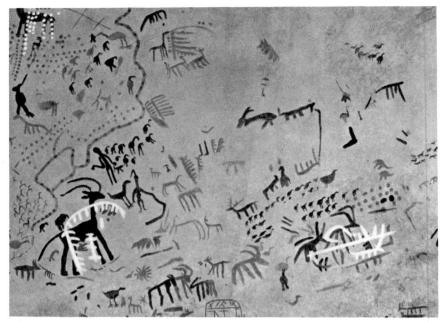

125

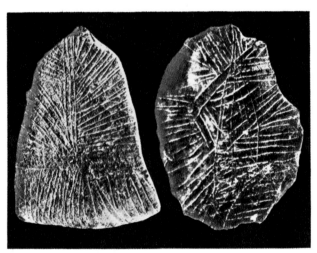

126

127

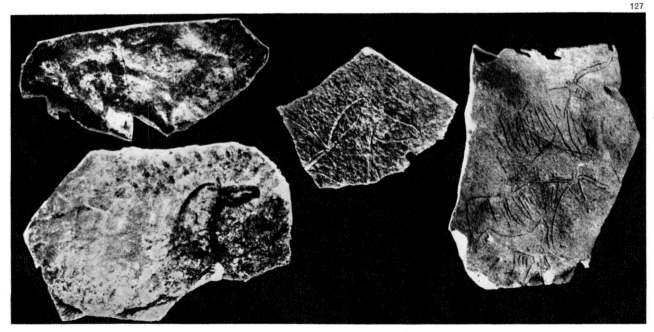

128

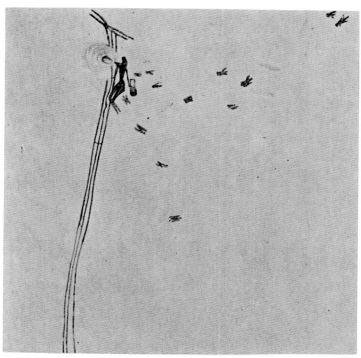

129

in the Spanish Levant comprise the few examples at Seriñá, of no use for our purpose; an engraved doe of the Epigravettian from the shelter of Sant Gregori at Falset; and the engraved or painted stone fragments from the caves of El Parpalló (Gandía; figs. 127, 130), Mallaetas (Barig), and La Cocina (Dos Aguas). The material at Mallaetas is very sparse. El Parpalló is rich in stone fragments, as we have seen, but these belong to periods of the Upper Paleolithic and represent only animals; they can be related to portable objects of the French Upper Paleolithic. La Cocina has yielded examples of a type of decoration engraved on small stone fragments that is new in Spanish prehistory. This consists of purely geometric motifs (fig. 126), which have no connection with the images of animal and human beings in the shelters nearby, although we are convinced that some of the painters of those shelters lived in the cave of La Cocina at some time or other.

No archaeological stratum has been found covering the figures of any of the friezes, but the paintings in some shelters have an archaeological stratum at the base. It would be rash to date the paintings according to the material of this stratum; to do so would be comparable to dating a church from the furniture or fittings found in its vestry. The stratum can only testify that, at the time it was laid down, the place was inhabited and the pictures probably had some vital significance, that is, the cultural cycle that they represented was still in existence. Thus, none of the criteria we might use are of help to us, and we can only resort to stylistic and ethnographic comparisons with the Franco-Cantabrian Quaternary; and, undeniably, this kind of parallel cannot aspire to chronological accuracy and is highly subject to errors of perspective.

It is not surprising, therefore, that when, from 1907 to 1913, the basic discoveries that made known the new Spanish Levantine style were made, along with the sensational discoveries in the Franco-Cantabrian zone, the first tendency among scholars was to assert complete parallelism and synchronism between the two. Breuil, Obermaier, Wernert, Bosch Gimpera, and, after them, all the foreign scholars accepted this hypothesis, which became the standard one. As he had done for the art of the Dordogne and Cantabria, and primarily on the basis of superpositions of style, especially in the great frieze at Minateda, Breuil, with his indisputable authority as the greatest of experts on cave art, set up six fundamental periods for Spanish Levantine art. The first contains crude little figures, with primitive schematization; the second has larger and more naturalistic figures, which are still linear; both these phases would

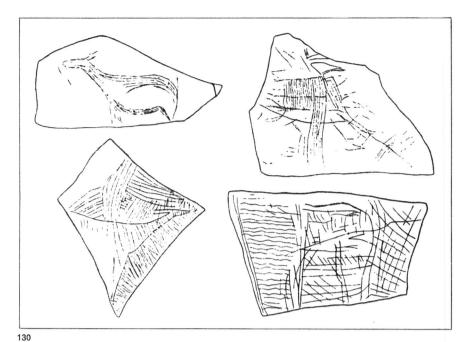

130

fall within the Aurignacian. The three following periods span the Solutrean-Magdalenian eras. In the first the figures are uniform in color, of good style and technique, and sometimes are striated, as in the deer at Alpera; the second stage shows monochrome figures, with slight modeling; and the third stage, which would correspond to the Upper Magdalenian, shows a semipolychromy which is parallel to that in the north and is evident in various figures of Cogul, Albarracín, and Los Lavaderos de Tello. Breuil's sixth and last stage, decadent and schematic, would correspond to the Mesolithic.

This is not the place for an extensive presentation of the arguments put forth by the advocates of this classical doctrine of parallelism. It will suffice to summarize the arguments that have been made in the course of the sharp dispute, so that the reader may judge for himself the impressive strength of the reasoning of these notable archaeologists.

Technique and style are similar in the north and the Spanish Levant. The evolution, too, is similar, if we accept Breuil's sequence. In the fauna, virtually all the representations are limited to species now in existence or indifferent to climate, but some figures were interpreted as belonging to typically Quaternary species. This was true, for example, of a rhinoceros at Minateda, the elk at the same site and at Alpera and La Gasulla, the ibex at Minateda, the chamois at La Tortosilla and La Gasulla, and, perhaps, the bison at Tormón, Minateda, Cogul, and La Gasulla. Moreover, the mere abundance of wild animals, even though of species that are still extant, indicates the Paleolithic. The environment suggested by the painted scenes is characteristic of the Paleolithic, since the paintings reflect the activities of hunting peoples

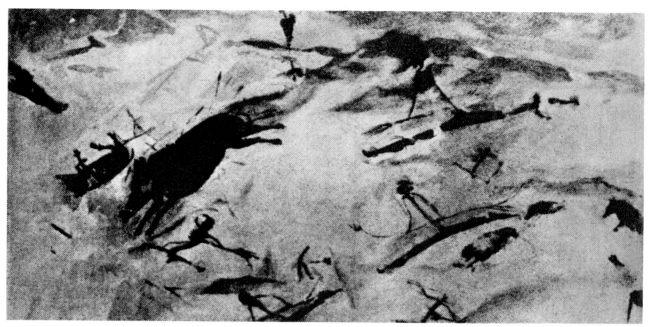

with physical traits suited to the chase, who were food collectors as well as hunters. The weapons and ornaments are paleolithic; the short skirt on a woman at Minateda and that seen on some figures at Alacón have been compared with the one on the female statuette of Lespugue, which is of the Aurignacian period.

The magical or totemistic environment is evident in the paintings of the Spanish Levant: scenes of wounded animals and the hunt that evoke sympathetic magic; personages singled out as chiefs and others who have fallen or who are about to lose their symbols of authority; anthropomorphic figures or disguised sorcerers; scenes of ritual dances; etc. Some discoveries in France of indisputably Aurignacian painted stone fragments (Péchialet and Labatut in the Dordogne), as well as the remarkable paintings of the cave at Lascaux, have features that may be regarded as Levantine. Breuil

130. Schematic drawings of painted or engraved stone fragments, from the cave of El Parpalló (Valencia), Spain. Solutrean strata.

131. Rock painting of a hunting scene (copy, after Porcar). Cave of Remigia, Barranco de la Gasulla, near Ares del Maestre (Castellón de la Plana), Spain (cf. fig. 137).

strongly emphasizes the presence in both groups of twisted perspective, especially in the horns of cattle and deer. There are geometric and abstract motifs in both regions. The cave at El Parpalló has proved that painting was known in the Spanish Levant as early as the Aurignacian and the Solutrean, and that the fauna represented was the existing fauna, just as the animal remains found in the same cave do not belong to typically Quaternary animals, although their abundance and their status as wild animals are Quaternary. All available data seem to demonstrate that during the epoch corresponding to the Magdalenian, the climate of the Spanish Levant already was temperate and supported a modern fauna.

It is evident that the Spanish Levantine paintings have been retouched any number of times; further, they clearly show superpositions that may indicate different stages of artistic development. In the ensemble at Minateda, Breuil finds as many as thirteen stages; possibly, as is maintained by E. Ripoll, who has studied this ensemble directly, this number might be reduced to four or five. Very important, in connection with Minateda, is Breuil's assertion that the lowest layer evaluated by him contains highly schematized human figures in light red, which would mean that from the very outset of this pictorial style the human figure was represented schematically. We may agree that the cave art of the Spanish Levant, like that of El Parpalló, presents parallels with the art of southwestern France and with that found in Italy and Sicily, and with African art.

For the authorities of the school that we have designated as "classical," the separation between Spanish Levantine and Franco-Cantabrian art must have taken place during the

Aurignacian, after which, as the climate became colder, the two zones remained isolated and Levantine art developed along independent lines. The human figure is represented in Franco-Cantabrian art, and the cave at Lascaux contains a scene in which a schematized human figure appears. It must be remembered that Los Casares cave, located slightly more than sixty miles from the Albarracín group and indisputably paleolithic, has many engravings representing human figures, although they are not of the same style as those in the shelters of the Levant. The parallels with the engravings in Sicily, which are regarded as paleolithic, and even the possible connections with African mural art, which Breuil and other authors consider paleolithic, at least in part, are further arguments in favor of the classical hypothesis. Another favorable element is the fact that Solutrean arrowheads have been found in some strata in the shelters of Chiquita de los Treinta and Cantos de la Visera. To complete the argument, we need only recall the post-paleolithic Azilian stones painted with schematic motifs and the small engraved stone fragments with purely geometric decoration from La Cocina, which indicate that the evolution of naturalistic art must have occurred prior to the Mesolithic.

Although this accumulation of arguments may seem impressive, it has been vigorously attacked by many authors. Prominent among the dissenters are the Spaniards, some of whom were so bold as to dissent when no one else dared. Cabré, Durán y Sanpere, and Hernandez-Pacheco early expressed their doubts regarding the paleolithic origins of Levantine art, and in 1925 Hernandez-Pacheco published his opinion, well reasoned and thoroughly structured.

132. Schematic drawing of rock engravings of anthropomorphic figures fishing (after Cabré Aguilár). Cave of Los Casares, Ribas de Saelices (Guadalajara), Spain.

His arguments were based on the evident differences between the two styles. He rejects the interpretations of Quaternary animals; such interpretations can be made because the pictures are so poorly preserved. He believes that the climate and the environment too are post-Quaternary. No human figures of Spanish Levantine style have appeared at El Parpalló. In the strata at the bottom of the figures there are abundant remains of microlithic tools, clearly of the Mesolithic age. The " half-moon " flints that appear in some deposits are types that were used down to the beginning of the Age of Metals; this point reinforces the hypothesis of a late date. Also, for many reasons, the argument regarding the stylization of the motifs of the Azilian stones is no longer valid.

Another important factor in reducing the antiquity of Levantine art is the decline of the hypothesis of the presence of the Capsian culture in Spain. Supposing that the two styles were contemporary, the undeniable differences in mentality were explained by presuming that

132

the Cantabrian region of Spain was occupied by a population ethnically and culturally linked to that of France and of Europe in general, while the rest of the peninsula, including the Levant, was occupied by the Capsian people and culture, an extension of the Capsian culture of North Africa. Today we know that no such Capsian culture existed on the Iberian Peninsula. The Capsian has been seen to have been limited to an interior region of the Maghrib, at a period that most authors believe to be Mesolithic, and there are carbon-14 datings that support this view. It we accept the impossibility of Capsian influence while upholding the Paleolithic dating of Levantine art, we would have to assert that similar and neighboring populations had two essentially different arts at the same time. Undeniably, it is more convenient to attribute the difference to a diversity of epoch.

Thus, by as early as 1925, Hernandez-Pacheco had formed the hypothesis that Levantine cave art was mesolithic in date. Later, young archaeologists reinforced and even exaggerated the revisionist position, seeking to date this art to the Neolithic and even to the Bronze Age (F. Jordá). Outstanding champions of this argument were two distinguished Spanish prehistorians, J. Martinez Santa-Olalla and M. Almagro.

For my part, although I began by defending the position of my teachers, I was forced to modify my opinion by my own discoveries in El Parpalló cave, whose art definitely disproves the presence of the African Capsian culture on the Iberian Peninsula. My view, which lies between the two extreme theories, follows to a certain extent the theory that Hernandez-Pacheco proposed so many years ago, a theory that has been taken up by such disciples as E. Ripoll, an archaeologist of the younger generation who has personally copied and studied the known groups and discovered new ones in the mountains of eastern Spain.

Our hypothesis may be stated in the following manner. The final stage of the Würmian in the Spanish Levant came to an end earlier than in the more northern regions. After a period simultaneous to, or even earlier than, the Middle Magdalenian, the Spanish Levant had a moderate climate and fauna of modern aspect, among which may have been some specimens of glacial fauna that had survived. In this environment lived some human groups descended from the Gravettian populations in which the Solutrean phenomenon had taken root, with great specific peculiarities, and for causes and in ways that we can not determine. We have called this culture Epigravettian; in it is accentuated the microlithic tendency that was to lead to the

predominance of geometric forms in the Mesolithic age. The presence of a Lower and Middle Magdalenian in the cave of El Parpalló is a northern intrusion that, by contrast, sheds light on the Gravettian. In view of the aversion to painting attributable to the Magdalenians of El Parpalló, we must conclude that it was the epigravettian peoples, moving along these Levantine mountains, who carried on the pictorial tradition of the Gravettian (Perigordian) and the Hispano-French Solutrean cultures. At this point in the evolution of the Spanish Levantine style, evidence is lacking and there are no strata that enable us to trace cultural development down to the Neolithic. We have only the above-mentioned site of La Cocina, which has not yet been completely studied. Along with other evidence, it indicates that a phase occurred in Mediterranean Spain which corresponds to the final phase of the Magdalenian of the Franco-Cantabrian region and which was followed by another phase corresponding to the Azilian of the same region; we may even envisage another, final stage, Epipaleolithic or belated Mesolithic, that occurred prior to the advent of the first neolithic phenomena to reach the peninsula.

Thus, the painters of the Spanish Levant would be descendants of the Gravetto-Solutreans, a people of Mediterranean stock reinforced by new population strains in which the Mediterranean character was already well established. This would give us at least three cultural strata for the paintings, which, in the proto-Neolithic, reflected careless execution and some schematization, and then fell into a state of decadence that characterized this art until late in the Bronze Age.

In order to form groups within this ensemble of Levantine art and assign to each its chronological place within the system we have suggested, it would be necessary first to prove that the stylistic differences in the shelters are always chronological rather than topographical in nature, that is, that they are caused by the general development of technique and not by the varying tastes of schools contained in a particular district; then it would be necessary to consult a complete study of the superpositions in the friezes, a study that we do not believe has yet been made satisfactorily.

For this reason, we offer the following merely as a working hypothesis. In the first stage, which would be within the limits of the western Paleolithic, would come the animals oldest in species and in pictorial technique, those which are large in size, depicted realistically, sometimes in repose; there would be no human figures, unless we accept Breuil's identification of beginnings of them in the first layers at

Minateda. The second stage would show the development of the human figure in mixed scenes, and the third would be characterized by an extreme mobility, with the preciosity that culminates in such styles as that which has been called calligraphic. This would gradually evolve into a kind of stylization, with the creation of scenes that foreshadow the proto-Neolithic. This last phase would come down to the fourth millennium B.C. In the third millennium a completely schematic art would be at its height; during this period the series of Vélez Blanco, Sierra Morena, and Laguna de la Janda, etc., would run their rapid course, throughout the peninsula, down to the second millennium. The art of engraving in the Bronze Age, to which we shall refer below, with its extraordinary intaglios in the northwestern regions, would produce the last examples of this art before the Roman era.

It remains to explain the relationship of this art to that of southwestern France, Italy, and Africa; we must also consider the possibility of African influences in Spain, and vice versa, if we wish to account for the appearance of the human figure in cave art. Although we shall refer to this in discussing African art, we shall not be able to solve the riddle, since much more data will be required for a clear view of this fascinating problem.

The Significance of the Art of the Spanish Levant

The difficulties persist when we attempt to determine the significance of this art. At first sight it seems so different from Cantabrian art—in environment, execution, and motifs—that we are tempted to believe that its purpose, too, is different, and that it was not magic that led the hunters of the Levantine mountains to initiate this curious pictorial activity, as it had been for the peoples to the north. Indeed, several authors have conjectured that the Levantine frescoes might have a commemorative or historical purpose, being a form of memoirs, as it were, if not simply a pastime. However, even if we accept a more intellectual inspiration for these paintings, there are still many reasons for supposing that their purpose was primarily magical.

It would not seem that most of the scenes, mainly hunting scenes, to which we have referred were important enough to merit being commemorated or recorded graphically. Combats must have been too frequent to have genuine historical importance. Other pictures seem to be domestic, and often the figures do not form true scenes. The warlike groups lack the detail that would make individuals of the figures, and this is an indication of a magical purpose, in this instance, negative, protective magic to avoid harm to the persons represented; the detail in the ornaments seems to have a similar significance. The depiction of the stoutness of the hunters' legs and their agility and velocity cannot have had any aim other than the magical one of promoting these qualities in reality. The figure in the Saltadora cave that represents a fallen warrior transfixed with arrows and with his diadem falling off has been interpreted as the manifestation of a desire to hex a chief to make him lose the power and authority symbolized by the diadem. The combat scenes would have had a similar purpose; some are probably war dances, as, for example, the scenes in the Ares del Maestre shelters that have been thought to be executions.

Some figures may represent heroes and constitute utilitarian magic. Faced with failures in the hunt or dangers from attack by hostile peoples, the artist has sought to evoke the memory of famous hunters or warriors, whose deeds would have come down in oral tradition. As he painted them, he would have exaggerated their figures and their actions.

In depictions of animals, the parallel with the aims of northern art is more evident. There are many hundreds of representations of wounded animals, such as the beautiful ibex of Tormón. In other pictures, the hunter is seen tracking the animal. Often, a representation of one animal has been converted into another or has been painted over, sure evidence that the magic rites were repeated in the same sacred spot. The depictions of animals would aim at favoring not only their capture, but also their reproduction.

All these deductions are supported by ethnographic comparisons, since the practices of existing primitive peoples present clear analogies with those supposed ones of the early painters. In the following section we shall consider a vast number of rock paintings in Africa, executed in a style similar to that of the Spanish Levant. In shelters in Tanganyika, Rhodesia, and South Africa there are friezes that bear a curious resemblance to the Spanish ones, although the animal species represented are not always the same; the common elements are human figures interpreted in the same manner, women wearing skirts, the same type of artistic vision, and even the same aspect of rigidification of the paintings. However, the art endured in Africa, and until a few centuries ago the Bushmen continued to paint in their

133. Rock paintings of dancing figures, seated woman, and animals (watercolor copies of various slabs). Cave on Upper Longreach farm, Cathcart district (Cape Province), Republic of South Africa.

134. Shaded polychrome rock painting of eland and human figures. Underberg district (Natal), Republic of South Africa.

135. Shaded polychrome rock painting of an eland, foreshortened view. Matatiele (Cape Province), Republic of South Africa.

shelters. This has made it possible to study directly the purpose for which the natives created this art; it was found that all these groups of paintings are to be related to the magic rites of the hunting peoples, mainly to assure a good chase, celebrate its success, or appease the spirits of the hunted animals.

The discovery of undoubted anthropomorphic figures in Levantine art, especially the two examples in the shelter of La Gasulla (fig. 136), is further evidence in favor of the same thesis. These figures may represent masked hunters or members of some secret society. It is well known that secret societies are common among primitive groups, and their ceremonies and magic dances play an important role in the life of the tribe. The fact that they occur in the world today proves that the Levantine painters had an animal mythology and beliefs similar to those of contemporary totemistic peoples and that their magico-mythological conceptions must have

133

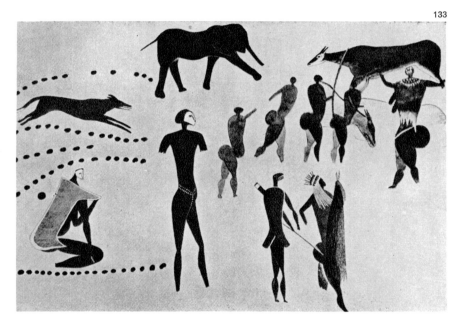

134

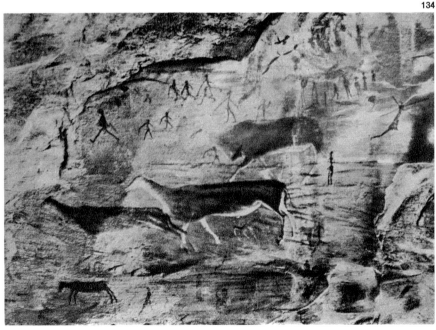

135

been close to those of the Franco-Cantabrian people. The images of spiders have an analogous explanation; the insects must have been part of the mythology of those people, perhaps because of their skill in capturing their prey in traps.

The superposition of the compositions indicates that aesthetic considerations were not the dominant factor in Levantine art. On the contrary, there was an evident desire to paint always at the same tradition-consecrated sites. Magnificent shelters, where we would expect to find remains of pictures, are without them, while other shelters that seem to us to be less suitable were preferred, for reasons that we cannot divine. Despite the fact that a wall surface was covered with images, the artists kept returning to it, superposing scenes on one another and, when necessary, repainting the figures to revivify the magical rite, sometimes even transforming one animal species into another, different one, generally by depicting another type of horns. All these facts indicate beyond doubt that magic must have been at the root of Levantine rock art.

Nonetheless, we personally are inclined to concede that in the latest manifestations of that art the artist suited himself by portraying domestic scenes that had no major significance. Examples are the woman leading a child by the hand, at Minateda, and the man leading a horse by a rope, at Boniches. We cannot exclude, in less modern phases, the existence of a certain commemorative or memorial intent, which appears also in the art of existing primitive peoples. And we always recognize, as we did in Franco-Cantabrian art, that it is impossible to ignore the factors of artistic feeling, aesthetic pleasure, and great technical ability that were transmitted by veritable schools of painter-magicians; without these, not even the most passionate spiritual commitment to the magical idea could explain this magnificent display of frescoes in the rocky shelters in the mountains of the Spanish Levant.

Ethnological Conclusions

There is still another dimension to the study of Spanish Levantine art. Because it presents the human figure in rather realistic scenes, it provides data concerning the lives of the hunters, data that are scarce in Franco-Cantabrian art. Although we cannot be sure that the data obtained from Spanish Levantine art can be applied to the creators of Franco-Cantabrian art, we believe that the environment of the two hunting peoples was the same, with some climatic differences, and that what we learn from the pictures in eastern Spain can be applied to both peoples. After all, the division between Paleolithic and Mesolithic is an arbitrary one, and the actual historical transition took place slowly and with no sharp breaks; it would be difficult to prove that the Levantines of the end of the Paleolithic, such as those of El Parpalló, for example, lived very differently from those that are shown hunting at Alpera or La Gasulla. Thus we gain an important source of information regarding minute details of clothing and ornaments, which appear repeatedly in this art. Sometimes, the men wear a kind of short pants; often, both men and women wear short skirts, which are braided, like that on the Aurignacian image of the Venus of Lespugue, or are made of separate fibers: skirts of this kind appear to have been worn in front or in back of the figure, or both. Very often women are shown with bell-shaped skirts that hang to their knees; these may, perhaps, have been of fur. It should be remembered that braided fibers or proto-textiles were already known in this epoch. The headdresses shown are very varied: feathers and ribbons adorn the hair, which is sometimes gathered into a kind of topknot; curious caps or bonnets apparently are sometimes made of fur; a cylindrical cap appears at some places (at Val del Charco del Agua Amarga; on the hunter at Tormón; etc.). The arms, waist, knees, and legs are almost always decorated with ribbons or sashes, and diadems or crowns abound.

136

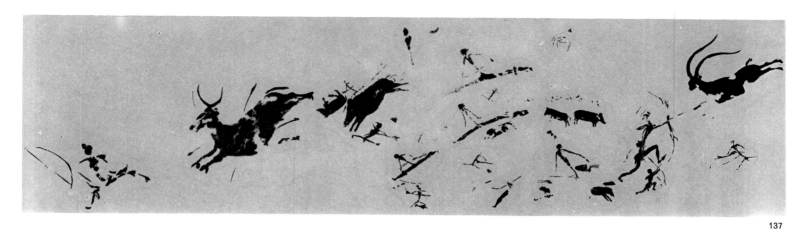

The principal weapon is the bow, which is pictured constantly. This may indicate the greater modernity of this art as compared with Franco-Cantabrian paintings and portable objects, in which the bow never appears and the throwing stick is the means by which extra momentum is imparted to the weapon. The time of the invention of the bow is a problem, since many of us believe that the delicate arrowheads of the Solutrean must have been used with the bow. In the Spanish paintings the bow is usually simple, but there are also, as at Minateda, more complex bows that Breuil has interpreted as the double-curved or Asiatic type; this, too, would indicate a late date. Arrows and darts are shown scattered, fixed in the body, or in quivers. Hunters depicted on the march brandish their bows above their heads. Sticks and nooses are also shown, but no throwing sticks are evident.

Many paintings represent vessels, such as baskets of various forms. Basketry must have been well developed. There are also many scenes of food-gathering, as would befit a society of hunters. The most outstanding of these scenes is that of the gathering of wild honey, in La Araña, which is identical to similar scenes photographed among some existing primitive tribes, such as the Vedda tribe of Ceylon. The scene of a man or woman climbing a rope or rope ladder appears repeatedly.

Other scenes give us an idea of various aspects of communal life. In some cases the chase is an individual activity of a single hunter, but more often it occurs as a group hunt, in which the archers deploy to surround the game and then drive it over a cliff or shoot it down (fig. 137). All the men of the tribe would take part in these hunts by stampeding. Some kind of political organization is indicated by the depiction of a group of warriors led by their chief, in Remigia, and by the scenes of execution, tribal battles, etc., that we have mentioned. As for the existence of ceremonies of religious or magical nature, we might recall the "dance" represented in Cogul, the masks, and our conclusions on the aims of this art. We have even tried to calculate the number of individuals who made up the tribe; we arrive at a figure of about a hundred, and, by extrapolation, to estimate a maximum of about a hundred thousand inhabitants for the entire Iberian Peninsula at that time.

The preceding is a brief summary of an art that evolved probably from 10,000 to 3000 B.C. in a region limited to the eastern mountains of the peninsula, an art carried on by a group of hunting peoples descended from those who had been settled there since the time of the Upper Paleolithic. Although its origins are not clear, its termination was marked by the advent of a new schematic art.

136. Rock paintings of masked anthropomorphic figures (copy, after Porcar). Recó Molero (left) and the cave of Remigia (right), both Barranco de la Gasulla, near Ares del Maestre (Castellón de la Plana), Spain.

137. Rock painting showing a great hunt (copy, after Porcar). Cave of Remigia, Barranco de la Gasulla, near Ares del Maestre (Castellón de la Plana), Spain.

Post-paleolithic Art of Spain

Only in Spain is it so easy to follow the evolution from a naturalistic Quaternary art, accompanied by patterns and abstractions that demonstrate the mental capacity of the primitive artist, through a transitional naturalistic art, which we have discussed above, to a terminal artistic style that emerged as the neolithic revolution went on, in which the old traditions were maintained despite the evident formal degeneration and the presence of influences from various sources. This evolution did not come to an end as long as primitive Spain existed, that is, until the Roman conquest.

Schematic Paintings

Many shelters with naturalistic paintings also contain schematic ones; there are also many with schematic paintings and no naturalistic ones. Moreover, the schematic style was not confined to the Levant, as was the naturalistic; it appeared in extensive regions of the southern mountains, especially the length of the Sierra Morena, and, finally, extended over very diverse regions of the peninsula. Gradually, the technique of engraving came to be preferred over painting and it was in this technique that the final stages of the evolution were made manifest.

We do not know whether the new style was the result of the arrival in Spain of new populations, who brought with them these neolithic advances, or whether it was the creation of hunters or shepherds, mountain people who had been influenced by foreign currents. Breuil himself, in magnificent studies of the schematic paintings of the peninsula, the fruit of many years of patient search in the mountains of Spain, has

defended the thesis of some foreign element—oriental and, specifically, Egyptian. Certainly, the vases of the predynastic epoch in Egypt and African paintings contain figures that could be the prototypes of Spanish schematic pictures. Personally, we tend to accept the most simple solution, that of the continuity of the art of the mountains of Spain; this would not exclude possible contacts with North African art, schematic in a parallel course, or possible changes of taste caused by a foreign influence.

We may suppose that the first schematic paintings are those of the most recent Mesolithic times, coming down to the Neolithic and even overlapping it. The final stage can be pinpointed much more precisely, for vases dated in the Aëneolithic bear engravings that are clearly parallel to the paintings of the rock shelters. This brings them down to a very recent period, beginning somewhat later than at least 2000 B.C. and probably continuing until much later, for the dagger shown at Peña Tú is of the Bronze Age, in the first half of the second millennium.

Breuil has attempted to trace the probable evolution of this art, also. In his view, the oldest phase (which Breuil places in the Mesolithic, an opinion we do not share) would correspond to the last series of paintings at Minateda. The human figures have not yet been reduced to mere lines, and body ornaments are shown; the animals are perfectly recognizable, and among them the deer are most frequently represented. This group would correspond to our suggested fifth phase of Levantine naturalistic art, and would indicate that it had expanded toward the southwest. In Breuil's first phase there are even figures whose style could be included among those that the French

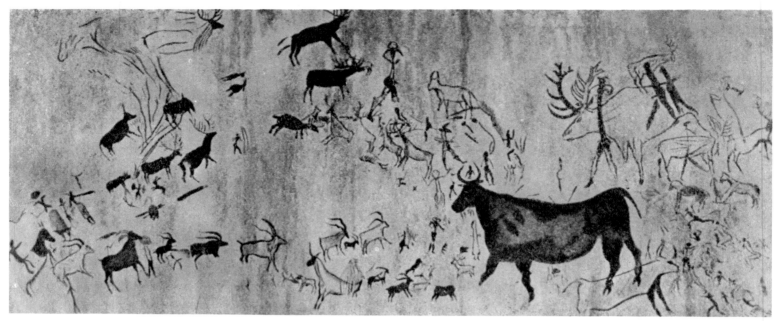

138

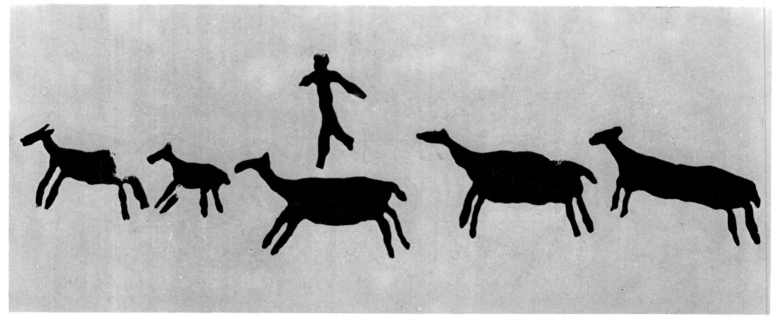

139

scholar believes to be paleolithic. One such figure is that of a doe painted in red which appears in La Pretina cave at Cádiz and in other sites of the Cádiz region, where the predominant motif is the same animal, only slightly schematized, e.g., the Cimera cave and the El Arco cave of the Peñon del Tajo de las Figuras (Casas Viejas). The Cueva Negra at Alpera also contains paintings of this group, which, moreover, face a floor with Tardenoisian flint, which we now know can be very late.

Another group, perhaps less naturalistic but still to be distinguished from the bulk of strongly schematic paintings, includes some paintings at Las Batuecas, with goats of fairly good style, and the scenes in Valdejunco (Arronches, Portugal), in La Graja (Miranda del Rey, Jaén), Los Canjorros (San Lorenzo, Jaén), the Puerto de Malas Cabras (Alanje,

138. Rock painting with an ensemble of human and animal figures (copy, after Almagro). Minateda (Albacete), Spain.

139. Rock painting of guanacos and an anthropomorphic figure (copy, Vignali expedition), Rio di Las Pinturas, Argentina.

Badajoz), and elsewhere. However, also in this group, which is not the most modern, are scenes that are already completely neolithic: couples of men and women, men with domestic animals, and, at Peñon de la Graja, representations of neolithic idols.

There is a much larger number of paintings in which the old naturalistic figures are no longer recognizable without effort, or in which such degenerate motifs as horseshoes appear. In this group could be placed the majority of the schematized figures of the paleolithic and mesolithic frescoes, such as those of some Cantabrian caves, Cogul, Morella, Calapatá, Alcañiz, Dos Aguas, Bicorp, Alpera, Minateda, Doña Clotilde, Cantos de la Visera, Tabla del Pochico, and La Pileta, among others. Many shelters in the Levant proper, however, contain nothing but schematic art. Rojals (Tarragona) was the northern limit of this art; the recent discovery of some paintings at Olerdola (Barcelona) indicate that it can be placed a little farther north. Schematic art also appears in the Cova del Pi at Tivisa, the Cova de los Calobres at Perelló, Culla at Benifallet, Benasal at Castellón, Beniatjar in Valencia, Tárbena in Alicante, some shelters of Villar del Humo and Boniches in Cuenca, and others of Monte Mugión in Almansa. To the south there are the caves of Lubrín and Vélez Blanco, where the Los Letreros has long been famous. There are other shelters in the provinces of Granada and Málaga: Benaoján, Montejaque, Antequera, and others. In Cádiz Province some fifty sites are known in the district of Laguna de la Janda. The densest group is that in the Sierra Morena and the basin of the Guadiana River. Of great importance are the cave of La Graja at Jimena (Jaén) and the groups of Santa Elena, Santisteban, Aldeaquemada, Fuencaliente, and Almadén in Jaén and Ciudad Real. Badajoz Province has the groups of Peñalsordo, Cabeza del Buey, Helechal, Hornachos, Alanje, and San Servando (Calamonte), Helechosa, Hoz del Guadiana, and Alburquerque; the art extends into Portugal via Valdejunco (Arronches). Farther to the north, Portugal has two famous painted shelters, Pala Pinta at Alijó, and that of Cachao da Rapa, both in Tras os Montes. In the first, solar motifs are related to those of Valdejunco and all the schematic art of the south; the art of Cachao da Rapa corresponds to the more advanced phase and is related to the paintings on dolmen steles and with the intaglios of Galicia. To the north of the Meseta, we find the paintings of Las Batuecas, which are partly in naturalistic styles; those of Pereña and Garcibuey (Salamanca), Camasobres (Palencia), and Atapuerca (Burgos); and those of the Sepúlveda region (Segovia)

and of the Candelada district in the Sierra de Gredos (Ávila). Paintings appear on dolmen steles at the Granja del Toniñuelo (Lerez de los Caballeros, Badajoz), at Cota and Baltar in Portugal, at La Capilla de Santa Cruz (Asturias), and at Pedra Coberta (Erbellido, La Coruña).

The northernmost limit of this style of art is at Peña Tú, at Llanes (Asturias), an ensemble of paintings in which well-marked chronological indications have been found, notably representations of an idol and a metal dagger that suggest a date within the Bronze Age. Thus, almost the entire peninsula is covered by this schematic art, the distribution of which can be better appreciated on a map.

When we come to analyze the nature of the images found in this large number of sites, we note at once that the original meaning of the figure is often lost, leaving a conceptual, interpretive art, halfway to an ideographic calligraphy. When we can discern the meaning of the scenes, we find representations of some sort of hunt, poor imitations of the lovely naturalistic works of the Spanish Levant, and domestic motifs. The human figures are very simply stylized and are ultimately reduced to a few simple sticks, a cross, a cross over a circle, or a circle with a line through it; sometimes the schematized figures are more complicated, as in the so-called man-pines, with their many arms, which may represent masked human beings. The last is true of some figures of Los Letreros, which are to be interpreted as masked human beings performing agricultural rites because of their evident parallels with modern African masks of the same nature. Female figures are reduced to a simple triangle; sometimes two triangles joined at their vertexes symbolize the human figure and are related to neolithic idols of more or less the same form. Another tendency in human stylization is the exaggeration that reduces the figure to two huge eyes. This is found in aëneolithic idols on bone or stone and in Mediterranean types of the owl-eyed goddess that was later to be identified with Athena.

Similar patterns of stylization apply to animals. The horns are exaggerated and rendered complex, as is seen frequently in the friezes of the Almadén region; the legs, reduced to mere lines, increase in number and ultimately make identification impossible. El Tajo de las Figuras, at Casas Viejas, contains some noteworthy bird figures, mainly cranes and storks, and also palmipeds, nests with eggs, and figures that may be turtles. In the Sierra de Almadén and at Peñalsordo there are many images of carts, which must be of a very late date. Serpentine motifs, series of dots, and sun motifs mark the last stages of the development.

The significance of this art is less clear than it was in that of earlier periods, for the environment and mentality of the neolithic populations that produced it were different from those of the mountaineer hunters of earlier times. Nonetheless, the painters of a large proportion of these shelters must have been hunters and were only continuing the practices of their ancestors. We shall, therefore, with some reservations, persist in attributing a magico-symbolic significance to them.

We have said that this art is related to Mediterranean and North African art and that definite contacts with Egypt have been hypothesized. The most interesting extrapolation, however, is in the direction of various regions in France, and from there, perhaps, still farther into other regions, as indicated below.

Schematic Engravings

To complete the study of the last, decadent phase of the great art that had had its beginnings many thousands of years earlier, we refer briefly to the engravings. These almost always accompany the paintings, becoming independent only in the final stage, in which there are many rocks covered with engravings of motifs identical to the painted ones, but with the greater stylization entailed by the technique employed.

As the most important centers we may cite that in the mountains of central Tarragona Province and the very dense group in Segovia and Guadalajara provinces that Cabré began to study. The last examples of this technique are on dolmen slabs (Espollá; Soto de Trigueros; Menga, in Antequera; and several others in Portugal) or on true steles. On cliffs such as those at Campmany (Gerona), Rogerals, and others in Tarragona, and at many other sites that have not always been given due attention because of the ungainliness of the crude designs, the artistic ability of these remote peoples in the use of natural rocks and rock refuges for figural images is lacking. There is no doubt that alongside truly prehistoric engravings, engravings of the modern epoch seem crude and insignificant.

There is, however, one region of the peninsula in which the art of engraving continued in full strength down to the Iron Age; this is the northwest, comprising Galicia and northern Portugal, and the engravings have been called "intaglios." Thousands of engraved signs are preserved on the granite cliffs of those Atlantic regions, in addition to the many that must have been destroyed over the centuries. Study of them has led to the tentative formulation of the existence of several types of stylization. At the very least, they may be classified in two stages, the oldest of which is presumed to date from the Aëneolithic, judging from the parallels that can be drawn between its figures and the engravings of the dolmen slabs that are known to be of that epoch.

In this phase, which we take to be the older one, there predominate human figures stylized in the form of crosses and figures of animals, which may be deer, in a similar degree of stylization. The circular figures have not yet reached their full development. To this phase should be attributed such intaglios as those known as the Polvorín and the Altar, near the Torre de Hércules (La Coruña), the frieze of the Eira dos Montes at San Jorge de Sacos, and the Pedra Bullosa (Las Fraguas, Campo Lameiro), all of which are in Pontevedra Province, which is richest in these works. Curiously, no rock paintings are found in Galicia, whereas they do exist, as we have pointed out, in northern Portugal, where engraved megaliths frequently appear.

Most of the Galician intaglios belong to a second phase that must have lasted throughout the Bronze Age. They are most often found on horizontal slabs near the sea or a spring. The figures usually form groups, and the motifs are derived from the stylized human figures that had prevailed in the earlier period. The dominant motifs in the second phase are circular: concentric circles with a deeply incised point in the center, or with a cross in the center, or filled with points, or with a line starting at the center, or in strange and various combinations (figs. 143, 144). There is an enigmatic labyrinthine motif on the intaglio of Mogor, near Marín, Pontevedra Province (fig. 140). Less frequently, there are stylized depictions of animals, sometimes constituting the only motif of the composition; these are so schematic, however, that only occasionally can figures of goats and deer be identified.

The purpose of these compositions has been much discussed, and some amateurs have even tried to interpret them as maps and plans indicating huts and walls, rivers and roads. It is wisest to regard them simply as ritual signs. Some of the most famous are at La Caeyra, near Pontevedra; Laxa das Lebres and Piedra de los Ballotes at Carril; Portela da Cruz at San Jorge de Sacos; and Penedo das Tenxinas at Pazo de Borben. In Pontevedra Province alone, the number of intaglios is estimated at more than five hundred.

This type of rock carving extends to other districts. In northern Portugal there are about fifty sites. With them can be grouped the Peña

140

de los Siete Infantes de Lara at Yecla de Yeltes (Salamanca Province), with its pictures of horses. The engravings of Villadesusos, near the Miño, with pictures of carts, are of a distinct type. In northern Portugal there is an abundance of the horseshoe motifs that are found in paintings in the Spanish Levant. The most unexpected extension leads to Brittany and Ireland, and thence to even more distant regions.

Throughout the second millennium B.C., sites of these engravings must have continued to be favored by the inhabitants of the Atlantic northwest of the peninsula. This was an era of commerce and cultural achievement among the Atlantic regions of Europe; the abundance of gold in these regions resulted in an atmosphere of greater wealth than in the Mediterranean territories of Spain. But we may conjecture that even in the first millennium, in the Iron Age, engraved cliffs still were regarded as sacred places. In a fortified site near Pias (Pontevedra), Castro de Troña, a snake is engraved on a vertical rock that stands like an altar in the center of the camp. It must have been worshiped down to the Roman epoch, for the native fortified sites were inhabited up to that time. It is known how difficult it was to stamp out pagan practices in those districts during the Middle Ages, and even today the folklore of the mountains where the site that we excavated is located retains a legend of a serpent that dwelt there and caused great damage.

Thus ends the history of Spanish rock art, which over a period of hundreds of generations, perhaps as many as six hundred, was created, flourished, and declined, leaving some very long and vague traces; it was the product of a combination of a mentality oriented toward magic and an indisputable skill. At its outset these qualities produced great art, realistic in Altamira, intellectual in the Spanish Levant, but already imbued with the great qualities that Spanish art has always had: realism, vivid expression, and spontaneity, frequently allied to a certain imprecision, as has been noted by such a connoisseur as the Marqués de Lozoya.

140. *Labyrinth intaglio, Mogor, near Marin (Pontevedra), Spain.*

Post-paleolithic Art in the Rest of Europe

We have devoted so much space to Spanish post-paleolithic art because, obviously, it is the only artistic development that we can follow through all its prehistoric stages. We shall now consider other artistic provinces, with characteristics peculiar to themselves, that in some ways were dependent on the traditions of the hunting peoples of the Quaternary and in other ways reflect later influences from Mediterranean centers.

Rock Art in Southwestern France

The regional art of southwestern France seems to be derived from Spanish schematic art, and this would parallel other phenomena of expansion outward from the Iberian Peninsula. In recent years various sites with paintings resembling the Spanish ones have been studied. One is the Lhermite cave at Ussat-les-Bains (Ariège), where there is an abstract figure of a woman; nearby is the Grand-Père cave, with stylized paintings in red. Paintings of human figures, which sometimes have parallels in Spanish paintings, have been found in other caves in the Ariège, the most important being those of La Vache (Alliat) and La Garosse (Labastide de Seron), in addition to those of Baulou, Baichon (Miglos), Montferriet (Lavelanet), and Peyort (Prat). Sainte-Eulalie (Ussat-les-Bains), Grand-Père, and Peyort also contain engravings in the same style.

Another major center of this late schematic art is the department of the Var. At Evenos and Ollioules are several caves with paintings of stylized men and animals. Among them are the Abri Hilaire, the caves of Neukirch, Alain, Chelo, Chuky, Dalger, Charbonier, Saint-Estève, Monier, Cabro, Dumas, Georgeot, and La Toulousanne. In the last, a series of schematized human figures recalls similar types in Spanish paintings; schematized animals and human figures interpreted in abstract form have been identified in the caves of Saint-Estève and Monier. A painted figure in the Dumas cave recalls the idol of Peña Tú. These pictures are extremely crude, and more data will be necessary in order to date properly these rudimentary artistic expressions, which also extend into Italy.

Although the site is geographically distant from the southwestern region, we may include here the paintings and engravings with human faces and symbolic signs that Baudet has noted in the environs of Paris. The most important sites are at Noisy-sur-Ecole, Chalouette, and Coincy, the last being in the department of the Aisne; moreover, the number of known sites is much larger and is constantly being increased.

Italian Rock Art of the Bronze Age

Rock art has an interesting extension, clear and homogeneous, in northern Italy. It takes the form of engravings, which are present in large numbers and have been known for centuries. There are several regions; the richest is at Monte Bego and includes nearby valleys (Fontanalba, Valmasca, Valauretta, Valle d'Inferno,

and Arpeto) close to the Italian-French frontier, not far from Ventimiglia. The engravings are found at altitudes of between 6,500 and 9,000 feet. C. Bicknell devoted his life to studying them, and he had a successor in C. Conti. The rubbings total about 40,000.

Bicknell has analyzed the motifs appearing in this ensemble of engravings, which were made with hammers that left furrows up to $1^1/_8$ inches deep, and he grouped them into a number of classes: figures with horns, plows, weapons and tools, people, cabins and enclosures, skins, geometric forms, and indeterminate figures. The style is highly schematic but the objects depicted can be recognized. The plows, represented with the farmer and the draft oxen, are interesting. The weapons were probably of metal; some have long handles, and these would have been axes, darts, and daggers. The halberds, too, are interesting. There are some netted rectangular figures with appendages at the corners that have been interpreted as houses and skins. Among the small human figures are some outstanding ones that have been uncertainly identified as dancers, magicians, or tribal chiefs.

The chronology of this immense ensemble is disputed; some authors place it in the Neolithic, linking it with the cave art of paleolithic tradition. Today we do not doubt that this art flourished during the Bronze Age and part of the Iron Age. The value and significance of this art, which must have undergone an evolution, although we are not in a position to formulate the stages, has also come under discussion. Some, like Issel, have maintained that it constitutes a primitive ideographic or symbolic writing, and C. Bicknell accepts this interpretation in one sense. Barocelli prefers to interpret it as having magical value; in this sense it would be a continuation of Quaternary art. Conti, to whom we owe recent noteworthy studies, confirms the religious character of this art as the work of a cultural complex that had been evolving over a long period. According to him, there would have been an ancient cycle, which he calls pre-Merveilles, dating from the Mesolithic and connected with the Iberian Peninsula, and another, so-called Merveilles cycle, which would go from the end of the Neolithic to the Roman epoch, showing both North African and Spanish influences and the influences of more advanced Oriental and Mediterranean cultures, which introduced new religious conceptions and flourished in the commerce of the Bronze Age.

Another group, not far from the preceding one, is at Orco Feglino, near Finale, in the district of Albenga, and is characterized by large schematized human figures and incised symbols and cruciform signs. Similar finds have been made at Acquasanta (Voltri, near Genoa).

Another important center was discovered in 1916 near Lake Garda, at Val Camonica (Capodiponte, Ceto, Cimbergo, Nadro). Its figures are reminiscent of those at Monte Bego and are worked with the hammer in the same manner. Deer and cattle, the former with highly developed antlers, are repeated in friezes arranged in very orderly fashion; other animals, not easily classified, are carefully aligned. The same is true of the daggers. There are also human figures, sometimes armed with daggers or in the act of praying. In some friezes, as at Paspardo, or Borno, there are circular motifs and others that recall certain types of ornaments characteristic of the late Bronze Age, comparable to those found on Iron Age steles (as at Caven, in Valtellina) and on anthropomorphic statues of the Alto Adige region.

These very rich ensembles, which seem to have a fairly definite chronology, and which have stylistic links to other areas that have been mentioned above, still present important unsolved problems. They must have been the work of mountain peoples who continued their periodic sojourns in the high regions until the Roman epoch.

Rock Art in Brittany

This Atlantic region forms part of the great artistic and cultural province of the Atlantic West, and really should be studied in connection with the northwest Iberian Peninsula and with Ireland and Great Britain, since these territories are bound by obvious ties that may perhaps extend as far as the coast of northwest Africa.

In Brittany, engravings appear on the many dolmens that are the principal feature of the prehistory, one might almost say, of the landscape of these outermost territories. The decorated monuments are concentrated in the departments of Finistère and Morbihan; Z. Le Rouzic and Saint Just Pequart have given us the most complete studies. The art dates back as far as the second millennium B.C., and persisted until more recent times.

The spiral motif dominates in the decoration of the slabs of the dolmen of Gavr'inis Island, on which almost all available space is filled with concentric semicircles, wavy lines, spiral curves, and consecutive groups of concentric arcs (fig. 142). If we grant that this Atlantic art also is a

product of a magico-symbolic environment, we may suppose that the motif of the spiral, like the theme of the serpent, is related to fertility symbols. Serpents also are engraved on the dolmens of Kermaillard, Petit Mont, and Mane Lud, and on the menhir of Manio. Spoked wheels, symbolizing the sun or moon, and other symbols of these heavenly bodies are found in the burial grounds at Ile Longue, Mane Lud, Petit Mont, Tachen Paul, Mane Kerioned, and Table des Marchands.

Highly schematized representations of boats seem to appear among the signs engraved at Kerveresse, Lufang, Mane Lud, and Petit Mont. At Petit Mont there is what may be a picture of a ship with a large cabin, which would have been unique in the Europe of those days. Figures of bulls with exaggerated horns are found at Mane-er-Hroek, and representations of human feet appear at Petit Mont and Roch Priol. There are a great number of representations of axes, either hand axes or hafted axes, on most of the engraved dolmens. Figures that may be idols have been noted on a slab of the *allées couvertes* (gallery graves) at Coudée (Pierres Plates, at Locmariaquer), Lizo, Penhape, and Lufang. The figure at Lufang could also be interpreted as a picture of an octopus.

A complete list of the Breton engravings would be as long as that of the Galician intaglios, since about seven hundred dolmens are known in the two departments mentioned, and a large proportion of them have engraved slabs. In addition to the motifs and monuments already cited, the following important examples should be listed: in the department of Finistère, commune of Penmarch, those at Kermorvan, with cavities and axes; at Mougan, those with axes and spearheads; and at Poulguen, those with axes, images of huts, peaks, etc. In the department of Morbihan, at Mane-er-Hroek, there are stylized pictures of human beings holding axes or halberds.

Rock Art in Ireland

Ireland has an interesting prehistory. By the time of the Bronze Age, there was on the island a wealth of gold and an abundance of jewels that has since been found in its tombs and now fills its museums. The development of megalithic culture there was accompanied by the appearance of the schematic engravings that had characterized it ever since its development on the Iberian Peninsula.

In Ireland there seems to be a parallel to the Galician intaglios that perhaps was transmitted

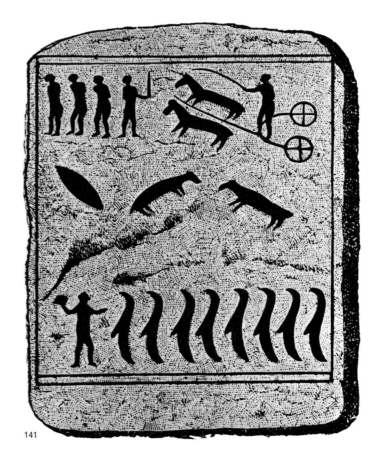

141

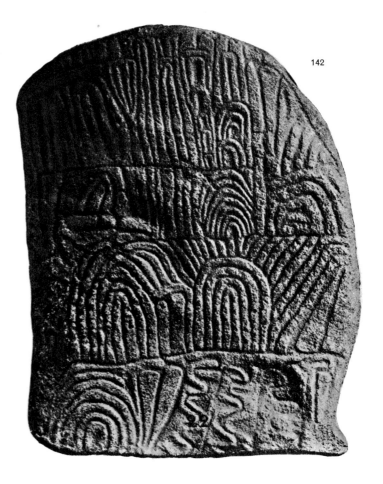

142

106

through the Breton engravings; perhaps we can establish a more direct relationship between the two terminals of the stylistic trend. In Galicia we noted an early period of intaglios with abundant cruciform signs and stylized human figures; the corresponding feature in Ireland would be a slab of the dolmen of Clonfinloch (Athlone), which shows figures of this kind, possibly human, as well as dots. Doubts are expressed today as to the probative value of this interesting relic; the last word on it has not yet been spoken.

Some other monuments are of great interest. At Lochcrew (Oldcastle, Meath) is a monument with a cruciform plan; some of its slabs bear zigzags, wavy lines, circles, spirals, concentric circles and semicircles, and stars, all engraved, although there is also a zigzag line painted in red. In County Tyrone the dolmens of Knockmany (Clogher) and Sess-Killgren (Ballygawley) bear concentric circles and semicircles, spirals, and stars; the first also has a representation of an idol.

The most famous of the engraved Irish dolmens is at Newgrange (Drogheda, Meath) and has impressive engravings that include spirals, lozenges, hollows, zigzags, treelike patterns, a ship, etc. Near Newgrange is the dolmen of Dowth, with similar engravings, which are, however, simpler and cruder.

There is a parallel to the Galician intaglios in the engraving of a labyrinth on a slab from Holywood, now in the National Museum of Ireland in Dublin. Its formal and technical similarity to the Mogor labyrinth is evident.

143

144

Rock Art in Great Britain

The same culture reached Great Britain, where it produced a considerable number of engravings on rock, or, rather, on dolmen slabs, from Wales to the highlands of Scotland. One of the best-known works, Borlase, is impressive for the great number of traces it bears; modern studies say little about them, perhaps because they are less spectacular than the examples mentioned up to now. In our opinion, curious coincidences in the way certain animal figures are schematized suffice to prove the origin of this series of decorations.

Circles, semicircles, spirals, intersecting lines, and what may be plans of huts have been found on dolmens in Northumberland (Dod Law, Old

141. Tomb slab with engraved figures, from Kivik (Skåne), Sweden (copy, after Montelius). Historiska Museet, Stockholm.

142. Engraved dolmen slab. Gavr'inis Island (Brittany), France.

143. Labyrinth intaglio, Pontevedra, Spain.

144. Rock engravings. "Pedra dos Mouros," San Jorge de Mogor, near Marin (Pontevedra), Spain.

Bewick Hill, Routing Linn, etc.). A dolmen slab with circular and intersecting line engravings has been found at Auchnabreach in Scotland. In addition, V. Gordon Childe found engraved rhombs and zigzags on the slabs he excavated in the town of Skara Brae in the Orkney Islands; this represents the last phase of the evolution, the persistence of the last manifestations of this art down to the Roman era.

This entire ensemble of dolmens and rock engravings in the Atlantic region, particularly the British Isles, is of interest in that it serves as an intermediary between the Mediterranean roots of this art and the Scandinavian world. In Scandinavia, during the Bronze Age, which was so important in that region, the art of engraving developed from beginnings that may have come from the hunting peoples of the Mesolithic; this art has its own characteristic features and presents so many and such interesting examples that it merits the attention usually given it in books on prehistoric rock art in general.

Rock Art in Scandinavia

It would seem that as the hunting peoples of western Europe emigrated to northern territories at the end of the Pleistocene, they took with them, along with industrial traditions, the concept of a naturalistic art. We find this art in the form of engravings on the rocks of the coast of Norway and up to the northern regions of the country, penetrating inland into Sweden. Its geographical location explains why it has sometimes been called "Arctic art," a name that could strictly be applied only to its northernmost occurrences in Norway.

It was an art that evolved slowly and endured for a long period. We can judge it by the superpositions that have been observed. For example, engravings in naturalistic style are found under those that represent ships and are characteristic of the Bronze Age. The same is true of the images of birds at Sletjord (Nordland). The entire span of this art extends from the end of the glacial age in Scandinavia, between about 8000 and 6000 B.C., to the Bronze Age, about 1600 B.C., and in some places it survived as late as about 1000 B.C.

Various stages may be distinguished during this long period. The first, coinciding with the Mesolithic, is characterized by large naturalistic animals; it would extend from the beginning to about 3000 B.C. After a transitional stage, with angular and very schematic animal figures,

comes the final stage, which has stylized human figures, providing a link with Bronze Age engravings. On the whole, it is a linear art and lacks movement and plasticity of representation; it is sometimes reminiscent of North African and Spanish Levantine art.

The technique employed in the first stage consists of engraving a line $3/8$ inch deep and $3/4$ inch wide, which is polished, probably by rubbing with a stick, sand, and water. An engraved and painted deer at Leiknes (Tys Fjord, Nordland) suggests that the engraving was done after the rock was painted. The northern group (seventeen known stations in Norway and Sweden), with its naturalistic tendency and the large scale of the figures, is apparently very ancient. The animals depicted are reindeer, bears, and, rarely, whales. There are very vigorous examples more than thirteen feet long, with details of execution that, despite the geographical distance, recall the art of the French Upper Paleolithic, which we suppose was its source. The stations at Fykanvatu (Glaom fjord), Klubba, Böla, and Valla are well known.

A second stage, later than 3000 B.C. and, therefore, already at the beginning of the Neolithic, shows some angular silhouettes executed in a hammered technique, without polishing. A site characteristic of this stage is at Vingen. The third stage shows a finer technique, with shallow engravings and stylized human figures, such as those at Tennes (Nordland); this stage constituted a transition to the schematic or imaginative art of the Bronze Age.

Curiously, several paintings that really do no more than heighten the contour have been fairly well preserved; they were executed in iron oxide mixed with whale oil. They appear, it seems, throughout the three stages of engraving, at such sites as Forberg, Honhammer, More, Ovnen, Kvithammer, and Ulveneset.

There seems to be no question that this art was magical in purpose. Most of the engravings are on cliffs where hunting was carried on. At Ekeberg (Sporanes) there is a representation of an animal caught in a trap; the internal organs are drawn, with what is called the life-line. At other sites there are scenes related to the fertility cult. In the only cave of its kind, at Solsem (Nord-Tröndelag), there is a painting of men performing a phallic dance; a great quantity of offerings, including human bones, were found in the cave, which dates back to the Neolithic. There are also animal figurines in amber and other materials, worked with some naturalism. Later echoes occur in Lapp and Eskimo art down to the present, and, in antiquity, in Scythian art.

Moreover, Scandinavia has a much richer

145. *Scandinavian rock engravings of a late period (copy, after Almagren).*

source of engravings on rock, which are a development of the art of paleolithic tradition, with some influences derived from Atlantic engraving. In the center and south of the peninsula, but particularly in Bohuslän, eastern Gotland, Uppland, and Skåne (fig. 141), there are hundreds upon hundreds of engraved rocks, more than in all the rest of Europe. They have been under study for a long time and are called *Hällristningar*.

The figures are engraved on horizontal or slightly sloping rocks, and are sometimes more than six feet long. They are highly schematic. Predominant among the motifs are ships and gods, whom we can recognize by their symbols. There are many human figures, represented in the act of plowing, leaping, dancing, or wrestling; there also are animals: horses, deer, cattle, birds, seals, and serpents; there are tools and weapons: axes, swords, shields; and four-wheeled carts drawn by horses or oxen (fig. 145). Feet, circles, and solar wheels are frequently used symbols. The figures sometimes form scenes, similar to processions, which we cannot always identify. There is no trace of painting. In the older works, the engravings are deeper.

This is a province of the great art of European engraving of the Bronze Age, but it has some

145

curious specific characteristics, since, despite its schematism, it preserves the human figure and the representation of scenes. This has lent weight to the oft-repeated hypotheses that this art was nothing more than a diversion, or that it was intended as a kind of writing or historical account. Almagren, a noted specialist, has however, proved that this, too, was a religious art, conceived either as an expression of a cult of the dead or a fertility cult.

The chronology of this art is not difficult to establish, since such objects as the razors of the late Bronze Age show drawings of forms of ships, and other objects represented are found in the excavated strata. It follows from this evidence that engravings of this type began around 1600 B.C. and reached their high point between 1400 and 750 B.C., continuing virtually down to our era. The development can be divided into six periods, of which the most important is the fourth, in the tenth century B.C. This chronology, of course, is contingent on the date ascribed to the final stage of the Bronze Age in Germany and Italy, a date which has been much discussed and which, in recent years, has tended to be set at a somewhat earlier time.

The human figures are schematized and elongated and usually are represented with tails. There are representations of priests officiating at rites, and gods are shown with animal heads or holding their attributes (hammer, wheel, bow, or lance) in their hands.

A series of traditions, together with the hollows in the engraved rocks, are evidence that the rites were sacrificial. The feet and the ax are symbols of fertility, while the wheel, represented above ships, on poles, or on carts, symbolizes the sun (fig. 145). Processions, trees, and even the numerous ships also may be related to the fertility cult. Remains indicate that ritual bonfires were lighted alongside the engravings.

The god represented with a hammer is Thor, or Donar, sometimes shown in a cart drawn by many goats; Odin, or Wotan, with his lance, horse, and ring, also is shown. In their final phase, the Scandinavian rock engravings are of great value as documents of the beginnings of Germanic mythology. They are also clear evidence of the origins of the Viking ships; the engravings show these ships, probably of limewood or oak boards, with benches for the rowers, who use sticks rather than oars, and with bow and stern of equal height.

A curious fact, clearly evident today, is that the rock engravings of the maritime territories of western and northern Europe were contemporaneous. Those in Scandinavia reached their high point about 1000 B.C. The intaglios of

Galicia and northern Portugal must be of about the same date. And the best works of Ireland, Great Britain, and Brittany cannot be of a very different period, although it is possible that in the western Atlantic regions this art was earlier than in Scandinavia.

Rock Engravings in Russia

Russian post-paleolithic rock art is an extension of the Scandinavian. Various zones, very far apart, are now known as sites of this art. Those in the Lake Onega region were found more than a century ago. Other groups are on the west coast of the White Sea, at Melitopol on the Sea of Azov, and in Asiatic Russia—at the Irtysh River; the Altai region; the Yenisei, Kazakhstan, and other regions which are links with those of Mongolia and Afghanistan.

W. J. Raudonikas has studied the groups at Lake Onega and those on the shores of the White Sea (figs. 146–48). The resemblance of the former to the Scandinavian and Siberian engravings is obvious. All invoke the magic of the chase and belong to the Bronze Age. In the northern groups (Onega, White Sea) there appear ships, gods, and symbols that resemble those in Scandinavia; semischematic human figures also are shown. These engravings correspond to those of the advanced stages of the Scandinavian, since the technique employed is always that of smoothly engraving the entire surface of the figure.

At Zalavruga (White Sea) the animal figures are superposed on representations of ships; this seems to confirm that the tradition of the hunting peoples and their naturalistic art persisted in the Russian territories after it vanished in the Occident, and that this was preserved as the characteristic art of these territories and as the basis of the later Scythian art.

The finding of ceramics with comb decorations near several stations of this Russian rock art confirms the chronology that can be deduced from other evidence; the high point of this art would have been reached between 1000 and 500 B.C. On the basis of these ceramics, the epoch may be classified as belated Neolithic.

The magic, religious purpose of rock art in Russia is undisputable. There are masked sorcerers, symbols of the sun and moon, hunting scenes with the magic bow, ships, gods of thunder, series of animals, footprints, and aquatic birds, which are fertility symbols. Some of the human figures wear skis or snowshoes. According to popular tradition the painted rocks are believed to be bewitched.

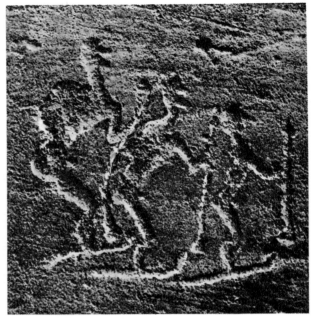

146

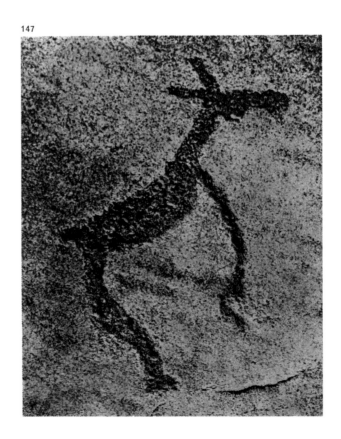

147

148

All this seems to reflect a society that knew agriculture but preserved the memory of a life devoted to the chase. Much farther to the south, engravings similar to those in the north have been found at Plevna (Bulgaria).

146. Rock engraving of men on snowshoes. Zalavruga, White Sea, U.S.S.R.

147. Rock engraving of an animal. Bessovy Slédki, near Vyg-Ostrov, U.S.S.R.

148. Rock engraving of a man on snowshoes. Bessovy Slédki, near Vyg-Ostrov, U.S.S.R.

German Engravings of the Bronze Age

Although the German territories are not far from regions that were rich with rock art during the Bronze Age, thus far they have not revealed any traces of such art. There are, however, five dolmen slabs with engravings of great interest.

One, at Anderlingen (Hanover), dates from the second Bronze Age (about 1500–1200 B.C.) and is evidently linked to the Scandinavian engravings since it shows the three gods, Donar, Tyr, and Ull. A schematic representation of a man appears on the Schulldort slab (Rendsburg, Schleswig-Holstein), in which there are eleven cavities; a covering slab of the *allée couverte* at Dingelstedt (Oschersleben, Saxony) shows atypical engravings (ax, ring). Another *allée couverte* at Züschen (Hesse-Nassau) bears an engraving that is related to the Italian rock carvings, since it represents, very schematically, a cart drawn by two oxen; it must date from the beginning of the Bronze Age (1800–1400 B.C.). The best work of the German art of this period, the Gohlitzsch slab, is of about the same epoch. It presents a number of vertical zigzag bands, a horizontal band, and other motifs, all finely engraved. The Gohlitzsch slab is of particular interest not only because of the parallels that may be drawn between its decorations and those of some dolmens in northwestern Spain but also because of its much-discussed symbolism and significance. If the hypothesis put forward by Matthes is accepted, that is, that the engravings represent a piece of cloth in a loom, it would be of great significance in the history of European culture. The German engravings can be extended to include the art of the engraved steles of Belgium.

Rock Art
of Africa

The prehistory of the African continent presents one of the most intriguing mysteries of our study. For a long time Africa was regarded as backward, conserving old forms of culture but unable to create new ones; however, the continent has offered striking surprises to the archaeologists of Europe, who soon realized that important cultures had indeed existed there. Sensational discoveries finally gave weight to the idea that the first human races might have begun there, together with the first industries. Today we know that African prehistory went through basically the same stages as in Europe and Asia. Although the nomenclature used is not the same as that for Europe, the prehistory of Africa presents a stage that we may describe as Upper Paleolithic; it occurred at the end of the glacial age (the pluvial age in Africa), and it is characterized by techniques that recall the Solutrean. Eventually, microlithic techniques prevailed throughout the continent. On the basis of these microlithic industries (those of the Capsian, Ibero-Mauritanian, Sebilian, Magosian, etc.) the neolithic innovations were made, whereby archaic cultural phases were prolonged, despite the knowledge of metals. In this same framework belong the examples of rock art, engraved or painted, that are preserved in Africa in amazing numbers. A complete catalogue of these artistic productions does not exist, nor can one be drawn up, but they are infinitely more numerous than those at the European stations. While we have a criterion for grouping European rock art chronologically and (with some reservations) for explaining its origin and development, opinions regarding that of Africa are at variance, and it cannot yet be determined whether Africa's works of art are as ancient as those of Europe, or whether there was an interplay of contacts or derivations between the two continents.

Our presentation of prehistoric African art must be brief and does not permit any sure chronological division into periods. For this reason we shall study it according to its successive manifestations in large regions. A map of its distribution shows that this is particularly intense in certain areas; however, there are many rich zones that have not yet been properly explored.

Rock Art
of North Africa

The entire prehistory of this region is especially interesting because of its possible links with that of Europe, and the same is true of its rock art. Its extension is vast, from its center, in what is now the desert region of the Sahara, down to the Sudan, and from the Atlantic to the Libyan desert; it extends beyond the Nile Valley, as far as Morocco, and even to the Canary Islands. Within the scope of what has been explored in the Sahara region, there are some areas of particular intensity: the Spanish Sahara, Mauritania, the region south of Oran, the Saura, Ugarta, Adrar des Iforas, Air, Hoggar, Adrar Ahnet, Djebel Auenat, Ennedi,

149. Rock painting of male and female figures. Wadi Sefar, Tassili des Adjjer, North Africa.

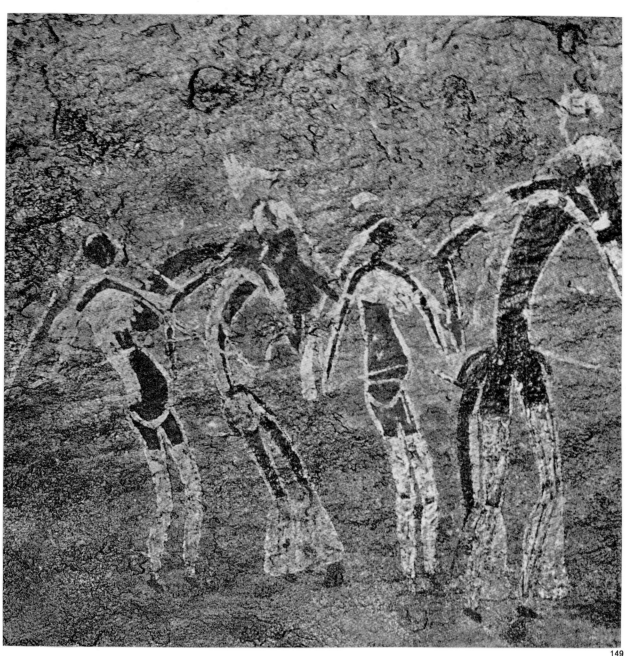

149

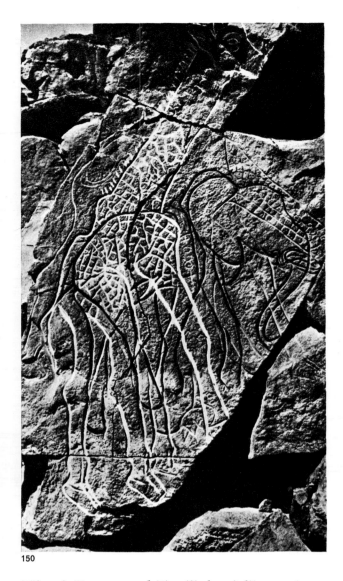

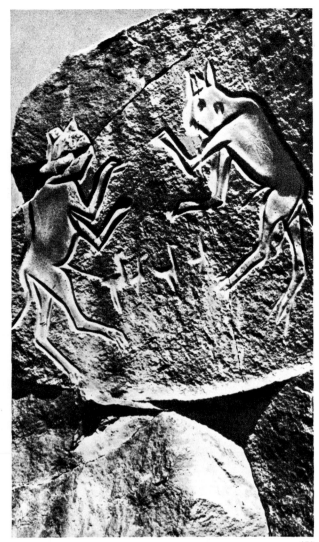

150 151

Tibesti, Fezzan, and Tassili des Adjjer regions. The work of G. Flamand, H. Obermaier, and L. Frobenius has been crowned in recent years by the efforts of various French and Italian missions. P. Graziosi and Mori have made outstanding studies, and the findings of H. Lhote in the Tassili area have had great impact.

The majority of the images are engraved, but there are paintings as well; occasional examples have engraved outlines and painted forms. Ochers of various shades and black are the colors most frequently used; white, gray, and blue are rare. Engraving techniques seem to undergo an evolution; the oldest technique is a U- or V-shaped engraving; later the line becomes less firm and the hammered technique is used. In North African rock art it is seldom that the surface of the figure is polished and the outer portion carved in a hint at relief.

As in Europe, rock-art stations in North Africa have retained their character as shrines down to modern times, with the works of successive epochs accumulating in them. The superpositions in these stations favor our efforts to set up a relative chronology. It is helpful, to this end, to study the fauna and the climatic

changes that led to the predominance of new species of animals. Some species could exist in what is now the desert only when favorable moisture conditions prevailed; the oldest of these animals are the elephant, rhinoceros, hippopotamus, giraffe, and crocodile. A later stage is indicated by an abundance of bovines, and still later stages are suggested by the prevalence of the horse and then the camel. Here,

150. *Superposed rock engravings of an elephant and giraffes. In Habeter IId, Wadi Bergiug (Fezzan), Libya.*

151. *Polished rock engravings of strange beings. Matendusc, near Murzuch (Fezzan), Libya.*

152. *Coarse pecked and polished rock engravings of giraffes. Matendusc, Wadi Bergiug, near Murzuch (Fezzan), Libya.*

153. *Rock painting of bovine animals. Sollum Ba'at, Acchelé Guzai, Eritrea, Ethiopia.*

114

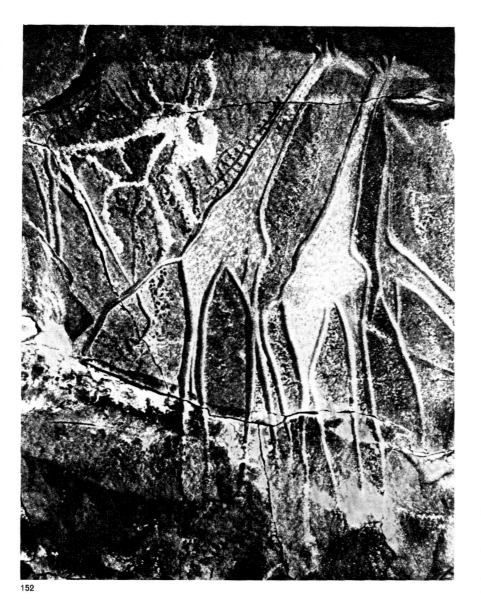

152

153

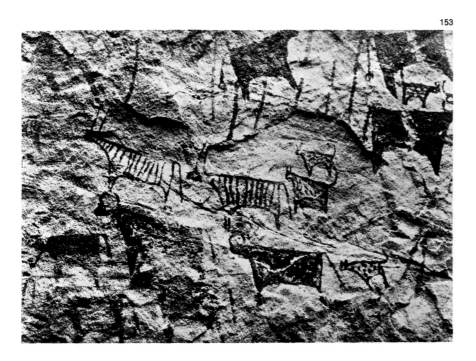

too, the contrast between the naturalistic style and the trend toward stylization and schematization is evident; these different trends are of value in tracing the evolution and chronological phases of the figures. Unquestionably, the simultaneous occurrence of representations of ancient fauna in a naturalistic style, in continuous and deep-line engravings, denotes the oldest stage of North African art, the stage in which arises the question of parallels and contacts with European paleolithic or, at least, mesolithic art. When these engravings become lighter and less well defined, the fauna depicted is more recent and the representations are more stylized. Representations of the horse and especially the camel are executed in this manner; they appear with tifinagh and even Arab inscriptions, and this is explained by the historical fact that the camel was probably introduced into North Africa during the Roman Imperial period. We may certainly make a basic distinction between pre-camel and post-camel art; the latter has persisted in the Sudan down to the present.

Flamand has classified Saharan art in three stages: Neolithic, Libyan-Berber, and Arab. The first is marked by ancient fauna and naturalistic style; the second is indicated by an emphasis on cattle, horses, and carts. For the first stage, Graziosi proposes a "hunter" group characteristic of hunting peoples, and another group with domesticated animals. R. Mauny offers a more precise classification. The naturalistic group, with Ethiopian fauna, Neolithic, and dated between 5000 and 2000 B.C., would be followed by a group that was the work of cattle-herders, much more widespread than the previous group and persisting until 1000 B.C. At that point would come the third group, characterized by representations of the horse, introduced from Egypt; at this time there appear images of carts, and the Libyan alphabet begins. The period from 200 B.C. to A.D. 700 is the era of the Libyan-Berber group, corresponding to the epoch of Roman and Byzantine influences in this part of Africa and to the spread of the camel, an animal of great utility in desert life. With the rise of Islam, the Arab-Berber group emerged.

Lhote's sensational discoveries at Tassili des Adjjer, consisting mainly of paintings, enabled him to establish a pattern that is valid for that zone of the Sahara. The ancient phase, that of the hunters, begins with human figures with rather schematic bodies and round heads (figs. 149, colorplate; 154; 155), goes on to a certain polychromy, and shows Egyptian influences of the time of the Eighteenth Dynasty, finally ending in a decadent style. This first phase is Neolithic. The second phase is also

115

Neolithic, but is typical of pastoral peoples and emphasizes representations of cattle. The third phase is protohistoric, with images of horses and carts, and, finally, there is the phase of the camel. The cattle phase in Tassili is very interesting for its stylistic characteristics; the figures are smaller and show long-horned oxen coexisting with animals from moist climates (elephants, rhinoceroses, lions).

What interests us most, of course, is the question of the date at which this art began; this could help explain its origin. In order to date it we would have to be able to connect the paintings and engravings with industries that can be correlated with the European. At the outset of the investigation of this art, it was assumed, as it had been for the art of the Spanish Levant, that the first stage corresponded to the Upper Paleolithic, to which the Capsian was attributed at that time. The antiquity of this group then had to be reduced because of the radical changes brought about by the relegation of the Capsian to Mesolithic times and also as a result of the work of R. Vaufrey, who links the art of the southern Oran region with neolithic art of Capsian tradition. However, the probability that an animalistic art came into being in an environment of hunting peoples, and the possibility that the roots of the Capsian are to be sought in an epoch equivalent to the terminal Paleolithic of western Europe, compel us to prudence in order that we may avoid dating the beginning of this art in too modern a period. It cannot be ignored that some types of portable objects of the Capsian culture have certain parallels to the art of the Spanish Upper Paleolithic, and that there are many stone slabs in the Sahara with engravings of animals in naturalistic style.

The most plausible chronology for North African rock art would place it at the beginning of the Mesolithic or, perhaps, in an era corresponding to the European Magdalenian. However, if we accept dates as early as this, we have the difficult problem of a possible relation to the rock art of the western Mediterranean, where the findings in Sicily constitute new evidence in favor of the theory of contact with Africa. There is no doubt that the basin of the western Mediterranean from La Pileta to Levanzo, including El Parpalló, the Spanish Levant, southwestern France (Ebbou), and Romanelli, has an evident character of its own in both industry (epigravettian, with early predominance of the microlithic) and art, and it is tempting to think that this great arc can be closed in a circle with the addition of the North African territories.

As was also to be the case later, some elements in the marginal region of northwestern Africa reflect European art. At Beni Issef (northwest Morocco), paintings have been discovered that seem to relate to the later phases of prehistoric Spanish painting. In the Grand Atlas mountains, in the Marrakesh region (Ukaimedem), at an altitude of more than 6,500 feet, hundreds of engraved ensembles have been discovered in a setting reminiscent of the great stations with engravings in Liguria. J. Malhomme is outstanding among the investigators of this region. Strangely, the motifs of the Atlas engravings are not very different from those that appear in European sites; some of them suggest that the influence of the circular engravings of the Atlantic regions may have reached this far (and there are indications that it may have extended even farther south); among the other themes that appear here are daggers and halberds, which the Alpine artists repeatedly represented in their compositions.

Finally, mention should be made of the group of rock engravings in the Canary Islands. Except for the most modern of them, which are dated by their tifinagh characters, many, of various islands, can be related to the Spanish Neolithic. We consider the most interesting to be those on the island of La Palma (Balmaco and La Fuente de la Sarsa, at Garafía), since they have circular and spiral motifs that clearly are part of the great family of Atlantic Bronze Age engravings. This bespeaks a people who did not fear the dangers of the ocean, and who engaged in the tin and gold trade, a people that may have played an important part in some aspects of the development of man's culture in general.

Paintings are far fewer than engravings in North African rock art. Very few were known until the painted cave of In Ezzan was discovered to the southwest of Tassili des Adjjer; this cave contains images of naked men with tails, individuals with bell-shaped or bitriangular clothing, and archers. Then the paintings of Ued Djerat at Djanet (Hoggar) were discovered, with fine figures of men and women, frequently clothed, and figures of animals, usually domesticated ones. Other centers of paintings are Ued Mertutek, at an altitude of about 6,500 feet, with depictions of dancing girls; Dohone, in the Tibesti Mountains; Ennedi; etc. The fact that the paintings are concentrated on an axis that crosses the Sahara, where moist conditions lasted longer, suggests that they are more recent in date than most of the engravings.

Because of the significance of its discovery and publication, we present a rather detailed discussion of the paintings of the shelters of Tassili des Adjjer, investigated by H. Lhote. The findings were made mainly during the

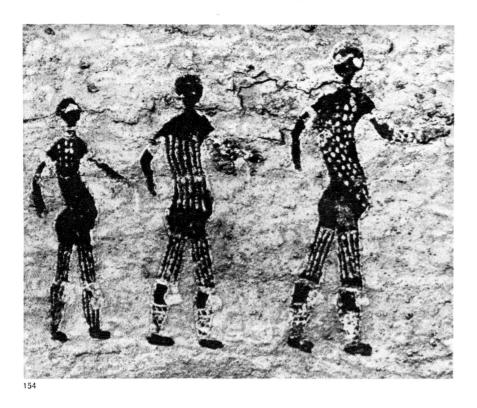

154

campaigns of 1956 and 1957, and, according to Lhote, number over ten thousand. Study revealed sixteen superpositions, with about thirty identifiable styles. It is possible that Tassili indicates a period of paintings contemporaneous with the stage of the Bubalus engravings, but the majority of the paintings must belong to an intermediate period between Bubalus and the pastoral stage; their symbolism and animism, together with other details (such as masks), suggest that this may be a Negro art. The pastoral stage in question has been dated by means of carbon-14, and it can be placed between 4000 and 1200 B.C. In Tassili there are magnificent scenes of herds, hunts, and dances of men and women with masks, that even show musical instruments. The clothing and ornaments can be distinguished on some figures (fig. 154), who may well represent princesses or goddesses. This is true of the figure that has been called the "White Lady" of Aouanrhat, or the Horned Goddess of Aouanrhat (fig. 155), which is of the period known as that of the round heads, earlier than that of the superposed figures of the pastoral period. This is an agricultural goddess that can be identified with Isis, and thus the figure represents one aspect of the Egyptian influence, which must have been very strong at various times. Another instance of that influence on Saharan culture is the painting of a woman in gray and white tones; the kneeling figure, who wears the pschent, or royal symbol, on her forehead, has been given the name of Antinea. There exists evidence of many other contacts between Saharan and Egyptian art, and these lead us to suppose that the former, in its initial, or Bubalus, stage, might derive from predynastic Egyptian art.

Over a broad area of the Sahara there are stone statuettes representing human figures that are reduced to mere design, to the extent that they have been compared with the Phoenician *baetuli* (sacred stones). One curious find occurred at Tin Hinan in the Hoggar Mountains, where a female statuette was unearthed that recalls those of the Upper Paleolithic in Europe, although it appeared in a much later setting. There are also statuettes representing animals: sheep, cattle, antelopes, and gazelles.

155

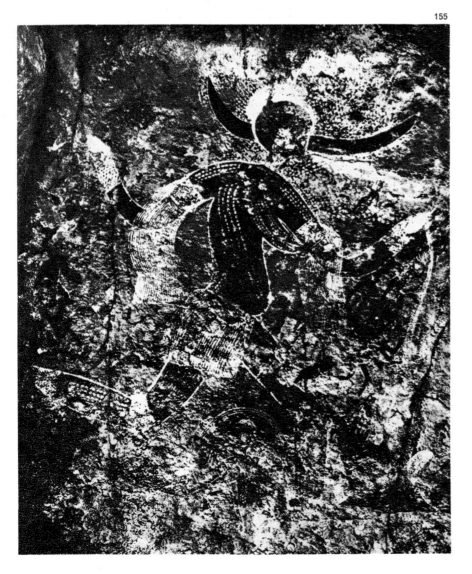

154. Rock painting of women with decorated bodies. Wadi Sefar, Tassili des Adjjer, North Africa.

155. Rock painting of a horned female figure. In Aouanrhat, Tassili des Adjjer, North Africa.

117

Rock Art
of Libya and Egypt

This is the natural extension of North African rock art from the Nubian desert to the Djebel Auenat in the Libyan desert. In the latter region, mainly paintings are found. The styles and the animals represented are similar to those of the Sahara. In the Nile region, there are pictures of ships with people on board and with men towing them; this permits us to set up a chronological parallel with similar representations on predynastic Egyptian ceramics.

The work of Italian archaeologists has acquainted us with a large number of sites in the Djebel Auenat, north and south of Murzuch, Djebel-es-Soda, Ued Zemzen, and Ued Marsit-Soffegin, the last-named stations being near the coastal region. The most recent ones known are those found by Mori in the Acacus.

In the Djebel Auenat, the ancient group includes handsome naturalistic figures (giraffes, ostriches) executed in the hammered technique (figs. 150–52, 160), perhaps related to the South African figures of similar style. Domesticated cattle and goats are painted in beautiful frescoes together with men carrying bows, and women. The men with bitriangular tunics in later representations have been interpreted as being Libyan, with Cretan affinities.

There are important engravings in the upper Nile at Uadi Hammamat, near Aswân, which have been studied by H. A. Winkler; in general, they are crude (figs. 156, 157). By studying the superpositions, Winkler has been able to distinguish four consecutive stages: (1) that attributable to the first hunters, highly schematic, with representations of elephants; (2) that of the autochthonous mountaineers, hammer-pecked, showing the first domestic animals, men (Hamites) with the Libyan sling, and many ships; (3) that of the invaders who came from the Red Sea, with representations of boats, seagoing ships, and hunting scenes, in the hammered technique, in abstract style; (4) that of the ancient inhabitants of the Nile Valley, in abstract style, with representations of many human figures, naked men with Libyan features, and river boats.

In connection with this art, a study would have to be made of the decorative art of the predynastic Egyptian periods, with its many examples of sculptured human and animal figurines, reliefs and engravings on slate, painted ceramics, etc.

Rock Art
of the West-central Regions

In the western Sudan and Nigeria there are caves and shelters with engravings and paintings that derive from those of the Saharan centers but in a markedly inferior style. In the Bamako and Kita region, explored by Zeltner, are a number of caves with hands painted in negative, ladder-shaped designs, and other schematic figures alongside clearly realistic paintings. Rock engravings have been found on the Ivory Coast and in the north of Cameroon, at Yagua; the latter are exclusively geometric. (The first of the two stages of red paintings at Dajo Hills in the Sudan shows no domestic animals.) The same marked schematism characterizes the pictures found in the caves and on the rocks of Katanga. Best known are the caves of Kiantapo, on the Biano plateau, and Kiamakonde, as well as the stations of Luena. They include an ancient group, which may be neolithic, with pictures of human beings and animals in the dotted style of engraving, in painting, or even in low relief, and a recent group with engraved representations of feet and hands. A find of portable objects in a style similar to those of

156

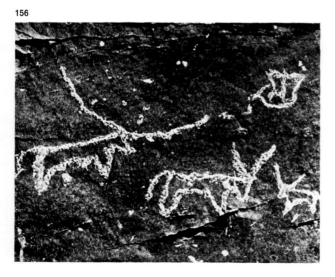

157

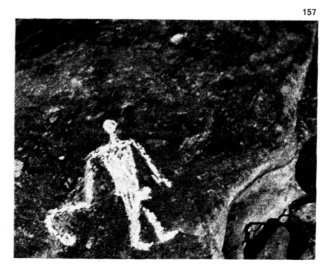

Katanga has been made in Angola, confirming the late date that we have given.

Rock Art of East Africa

The prehistory of East Africa is so rich in data and the area has yielded such sensational finds that it may become the most interesting zone of the entire continent in this respect.

In Ethiopia is the well-known Cave of the Porcupine at Diredawa; this cave also contains paintings, in which Breuil has distinguished eight phases; there is a clearly ancient naturalistic period, but in general, the other phases belong to a pastoral stage in which the schematized human figure dominates, with elephants, lions, and other animals represented in red, yellow, and brown. On the rock of Sourré, Breuil has also distinguished eight phases, with a naturalistic ancient period, that again, as a whole, reflect a pastoral ambience (cf. fig. 153). In Eritrea, the cave of Carora contains paintings, and the shelter of Lago-Oda, not far from the above-mentioned Sourré, contains about one thousand figures, including elephants, rhinoceroses, giraffes, buffaloes, lions, etc.

The findings in Tanganyika, which were first made in 1908, are of great interest; they number in the hundreds. Especially rich is the northern region of Tanganyika; Kenya has not supplied important instances of this art. In addition to a number of explorers, such as Kohl-Larsen, special mention should be made of Mr. and Mrs. Leakey, who have made a systematic exploration of the shelters of this region in search of paintings, displaying the same tenacity and good fortune that they have previously had in exploring the archaeological and anthropological sites of this part of Africa.

Out of this mass of findings we shall select those we consider outstanding. In one of a series of shelters at Kondoa Irangi is a representation of an elephant pursued by a stylized human figure, and a rhinoceros who appears to have been attacked by a slinger. A large rock at Ilongero is covered with superposed figures; the paintings in silhouette are older than those in solid color. Kisama, Iramba, Singida, Bwanjai, and Bukoba have similar examples. The greatest density is found in the neighborhood of Kondoa. Besides the shelters of Tumbelo, Kolo, Tlawi, Fenga Hill (with pictures of elephants fallen into a trap), Pahi, Kinyasi, etc., there is a series of shelters between Kisese and Cheke that also is outstanding for several reasons. In this limited region, which we were able to visit in 1947, Mr. and Mrs. Leakey have found more than two hundred painted shelters.

At Kisese and Cheke, as everywhere in Africa, there are a large number of relatively modern works of art, existing together with a considerable number of figures of undoubted antiquity. The animals are usually shown in naturalistic style, while the human figures are in various stages of stylization. Basing his judgment on the superpositions, Leakey distinguishes as many as nineteen successive styles, the bottom five of which must be very old, since the figures are covered with a coating of silica that makes them difficult to study. The oldest figures here are those painted in red with the head in outline. Then come human and animal figures in purple, together with dots in circles; the next stages have animal figures in purplish-red silhouette, which later becomes black; in the fifth phase comes the artistic high point, with animals in light red that are naturalistic in style and show details inside the body. Thereafter the figures become cruder; they are at first executed in yellow and then in light red, and, subsequently, in broad red outline (notably elephants). There are also stylized animal silhouettes and, finally, crude orange-colored human and animal figures.

The human figures here provide useful data; they are shown with bows, traps, maces, and other weapons, and they wear belts, dresses, complicated headdresses, and ornaments at their wrists, knees, and ankles. There are scenes of elephant hunts, dances, a kidnaping, a man attacked by bees, etc.

Especially striking in the figures in these shelters—and we give our personal impression, since we visited the one at Cheke with Breuil in 1947—is the fact that the patina and general aspect are remarkably reminiscent of the shelters of the Spanish Levant, and the works seem truly to be old, at least mesolithic. On another occasion we have compared the treatment of the theme of a doe suckling its fawn in a Tanganyika painting published by Kohl-Larsen with the depiction of the same subject on a stone fragment at El Parpalló. This is a very complex problem, and today this art is usually regarded as modern; however, we do not consider the question settled.

156, 157. Rock engravings of bovids and a man. Sabagura, Nubia, Egypt.

Rock Art
of Southern Africa

The mural art of this part of the continent is extraordinarily rich and has elements that give it a well-defined personality. The sites with paintings number 1,500; those containing engravings are fewer. The latter are concentrated in the center of the territory, where the volcanic diabase is suitable for engraving. In the regions that surround this central one, the granitic caves in the north and those in the sandstone of southwest Africa provide surfaces suitable for paintings. The stations of southwest Africa form a well-defined ensemble. The naturalistic paintings in Rhodesia are related to those of Tanganyika, but in the northern region a group of geometric paintings appears among those of naturalistic style.

This art has often been called Bushman. There is no doubt that, down to the last century, the Bushmen painted and engraved on the rocks, following the traditions of their ancestors; however, other peoples, such as the Hottentots, Hill Damaras, and Bantus, were the authors of part of the works that have survived. Many instances of superposition can be seen, and on the basis of these it can be inferred that some of the ensembles are very old. Problems arise, however, when we try to specify just how ancient they are and attempt to compare their age with that of European paintings. Breuil took a brilliant part in the polemics attendant upon this problem, after having devoted a good part of the last years of his life to studying the sites of South African rock art.

In southern Africa there are no examples of portable objects that could help resolve this problem. There are a few specimens of the Smithfield stage and some painted stones in caves along the coast. In the Chifubwa Stream

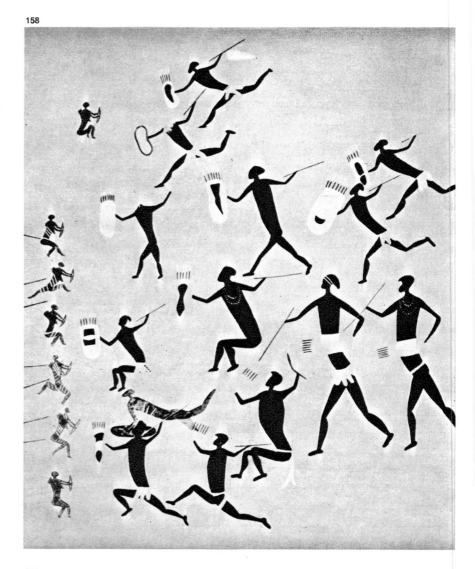

158. Rock painting of a Bushman cattle raid, detail showing Bantu giving chase (watercolor copy). Cave on Ventershoek farm, near Wepener (Orange Free State), Republic of South Africa.

159. South African rock painting of eland and gazelles.

160. Rock engraving of hunter and ostriches. Matendusc, near Murzuch (Fezzan), Libya.

161. The "White Lady" of Brandberg, South-West Africa. Rock painting.

120

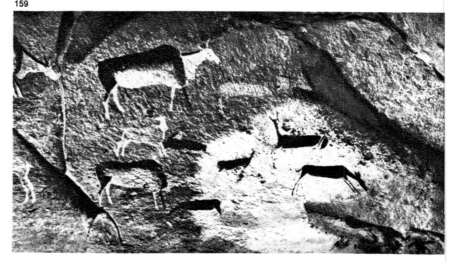

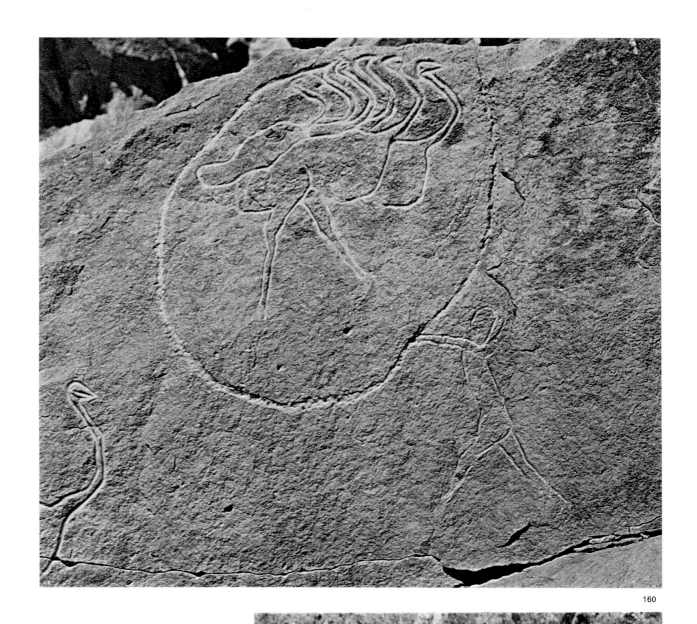

160

161

shelter in Zambia, there are wall engravings that are covered by a layer of sand that in turn is covered by an archaeological stratum. In other instances we do not know the level to which the paintings correspond. There are sticks of color for body painting, which date at least to the Magosian. Neither the patina nor the state of fossilization of the paintings is an adequate criterion, since these conditions depend on the nature of the rock and other circumstances. In a shelter in Zambia, at Kesama, deposits of flaked-off fragments of painting that have fallen from the wall have been found in levels prior to those of the time of the introduction of ceramics. All this indicates a date going back at least to the Mesolithic. Some carbon-14 datings obtained from samples from painted shelters confirm the above dates.

A study of the fauna depicted is not very helpful in dating, since, in general, it reflects a fauna that has existed since the end of the Pleistocene. The presence of domestic animals is evidence that the pictures are very modern, and they are even more so when they show Hottentots, Europeans, and rifles, as do the last works of art of the nineteenth century. Much has been said concerning Sumerian and Mediterranean (Cretan, Greek) influences in southern African art, supposedly introduced in the course of the foreigners' search for gold, ivory, and other materials that early sources tell us were sought in these regions. Breuil, who studied the famous "White Lady" of Brandberg (fig. 161, colorplate), took it to be a Cretan girl with a lotus flower or a cup in her hand. Other hypotheses have been proposed, based on supposed relationships with the rock art of Kenya or of North Africa and even with prehistoric Egypt.

Today, most authors do not accept the optimistic theories regarding the great age of South African rock art, such as that maintained by Breuil; they doubt the existence of ethnic or ideological contacts and immigrations and would rather assume that this art was produced by groups that evolved independently, in a manner at times more or less parallel to that of the rest of the continent, with some connection possible because of the common descent of the peoples involved. According to these authors, no details of the pictures recall Nordic or Mediterranean peoples. For example, the supposedly Egyptian or Greek bows would be Bantu or Hamite, and the paintings in white, such as the "White Lady," would be nothing more than pictures of Bantus, their bodies painted white as part of an initiation ceremony.

In the opinion of these authors, among them such authorities as C. Van Riet Lowe and J. Desmond Clark, the oldest instances of this art would be some linear engravings of the Smithfield A and B period, which are now almost invisible. Also lost are the first paintings, in caves in southern Matabeleland, where, as in the Tanganyika shelters that Leakey describes, the painting has disappeared, leaving a region of lighter-colored area on the rock that hints at the former presence of a painting there. Since the Smithfield A phase in the Matjes River shelter (on the southern coast of the Cape of Good Hope) has been dated by means of carbon 14 at about 9000–8500 B.C., we have a solid basis for the chronology of the oldest phases of African rock art and a curb on tendencies toward the acceptance of extreme dates.

Thus, this art may be divided into an early stage, characterized by naturalism and figures in simple postures, and a later stage, which we may designate as Bushman, denoted by complicated scenes and figures that lead us to believe that different peoples were present in the area. In a first phase of this later stage, the groups are depicted in peaceful poses; in a more recent phase, scenes of combat predominate. Such scenes are prevalent in the southwest, where they date from the eighteenth century.

A serpentine wall engraving in the Molopo shelter in Basutoland is covered over by a Magosian stratum. If we grant that the perfection of this art required a previous phase of creation and progress, and that the Magosian paintings were lost by exfoliation of the painted rocks, we have a confirmation of the previous date, and it may well be that the paintings date back to 8000 or 10,000 B.C., that is, to a period contemporary with the Mesolithic in southern Europe.

The painting techniques employed in this region have been carefully studied and do not differ fundamentally from those used in European rock art. The only noteworthy special feature is the predominant use of red, orange, and yellow; black and white also are much employed (the white is made from kaolin, euphorbia sap, and bird droppings). In engraving, the oldest technique employed was simple carving made with a burin, quartz crystal, or a diamond. Later, the technique of hammer-pecking with a sharp stone was used; such a tool has been found among objects of the Smithfield stage.

In no other region of the world can the magical and totemistic character of prehistoric rock paintings be studied better than here, for the Bushman hunters still perform the magic hunting rites that were the occasion for this

marvelous art. We know from tradition that the painters were individuals of high social rank. However, even here most of the complex and modern scenes may have a purely narrative purpose.

There are a number of important sites. Themes such as those which appear in Katanga and Angola (simple engravings of geometric motifs, hammer-pecked engravings of these same motifs and of human and animal figures, and curved engravings) appear in Zambia, near Johnston Falls on the Munwa River, where, until quite recently, it seems, the meetings of a secret society were held. The Chifubwa shelter, near Solwezi, has important engravings, and perhaps paintings existed there, too. There are a large number of engravings in the Lusaka district and the middle valley of the Zambezi. All of these can be related to the Bantu peoples and their ceremonies.

In the northern zones are geometric and naturalistic paintings. The latter seem to be more ancient than the engravings, and constitute a link to the Tanganyika paintings. In Zambia, the first examples of these paintings are in solid colors and chiefly depict antelopes and zebras; the next paintings are outlines that are partly filled in, and the final paintings are of seminaturalistic animals, which are difficult to identify. The distribution of the geometric paintings extends from southern Tanganyika and eastern Katanga to Mozambique and Malawi. Many of the motifs seem strange, and there are engravings that some believe to be imitations of Kufic writing. Although some of this geometric painting can be connected with the end of the Nachikufu period, most of it is modern Bantu and is related to intiation rites.

In southern Rhodesia there are very few engravings; in the eastern zone, some patterns represent plans of Bantu villages. Paintings, however, are amazingly abundant. The Matabeleland group contains the very rich Matopo series, the oldest of which shows animals at rest and stylized human figures. Red is the color used in the oldest works; there are some unusual techniques, such as those which entail polishing the rock surface before applying the paint, or painting it first with a kind of mastic, onto which the liquid paint is applied. The next phase shows silhouettes of animals, and it is followed by one in which human and animal figures in motion, sometimes stylized, appear. There are paintings in bichromy and even in polychromy; the faces and ornaments of the human figures are sometimes in white. In the region of Mashonaland there are more complex scenes, with superpositions of as many as fifteen styles. At the beginning there are

silhouettes and animals in solid yellows or reds. Next there appear complex scenes of men and animals, sometimes mythological in character; men of various races can be distinguished, and bichromy and polychromy appear once again. Finally, as in the other districts, the last stage has much cruder representations, with human and animal figures and geometric motifs.

On the central plateau is an extensive zone of engravings. The geometric engravings appear to be the oldest and are closely followed by those representing animals. There are famous sites at Vosburg (north of the Cape), Afvallingskop (Koffyfontein, Orange Free State), Gestptefontein (Transvaal), and Die Groot Moot (Krugersdorp). The last-named has silhouettes of single animals, in the ancient style. The animals most frequently represented are the rhinoceros, buffalo, and antelope, but there are also elephants, hippopotamuses, kudus, gnus, ostriches, and even, it seems, the giant buffalo *(Homoioceras)*, which became extinct some time ago. At Dornkloof there is a scene of a dance of sable antelopes. Some figures with grooved engraving recall the use of this technique in Saharan engravings. Of a later period are engravings in the hammered technique; these are found in the central part of the territory and date from two different epochs. Excellent animal figures are executed in the earlier of the two styles, while the human figures are rare and crudely done. In the second style there is an abundance of geometric and schematic motifs; the most important sites of this art are Driekops Eiland and others in southwest Orange Free State and western Griqualand. The engravings of animals and their footprints in the southern Kalahari Desert and southwestern Africa must also be very modern, since they are to be attributed to the Bushmen; a group of hammered engravings in Natal is to be attributed to the Zulus.

The wall paintings within the actual boundaries of the Republic of South Africa are the most artistic and uniform, and the best known, of all the prehistoric art of this part of the continent (figs. 133–35). Five groups may be distinguished: the group in the northwest is related to the paintings of Rhodesia; it shows animals and human figures, singly or in groups, in monochrome. The central group comprises a few sites in Karoo and the Kalahari, where there is a lifeless, decadent art with many stylized and geometric motifs. The western group is found in the Brandberg and Erongo mountains in southwest Africa, and its art follows the usual sequence of development: monochrome, bichrome, and polychrome, terminating in a degenerate style, with stylized

and schematic motifs. The human figures in this group appear using long horses, and their bodies are in red or, totally or in part, in white or black; various ornaments and sandals, etc., are represented. Breuil took the "White Lady" of Brandberg (fig. 161) to be the symbol of this mysterious art, with its echoes of the past; however, in the opinion of many this figure is neither white nor female. There are large human figures with bows, some of which are triple-curved, that have been painted over and altered and are comparable to those that are found in Rhodesia. The southern group, especially those found along the coast, presents a poorer art, with monochrome paintings, few superpositions, and painted burial slabs. The engraved figures that were painted at a later date seem to belong to very recent periods.

The group in the southwest area of the Republic of South Africa is the richest and has been said to have the largest number of sites in the entire world. It includes the territories on either side of the Drakensberg Mountains, including Basutoland; the east part of Orange Free State; the west portion of Natal; and the eastern zone of the Cape. The pre-Bantu group antedates 1620 and comprises monochrome human and animal figures, in silhouette or solid color (red, yellow, or brown); the figures are sometimes tiny, but full of life and movement. In some cases paintings of this group are found in the depths of caves, and some parts must be as old as the Wiltonian or the Smithfield, as we have said. At the beginning of the post-Bantu phase, bichromy and polychromy and perspective and composition are introduced; the life and ceremonies of the people are depicted with a certain sense of humor and caricature. Fishing scenes occur, and, in general, the representations indicate a relatively happy period. In 1800, this peace came to an end with the invasions of the Bantus, especially the Zulus, and warriors and combat scenes were represented (fig. 158); the evolution of this belated pictorial art ended with representations of Europeans with their rifles and horses.

Among these paintings are some that show a noteworthy similarity to those of other African regions and those of the Spanish Levant. This similarity has often been noted in books on prehistoric art. But even those of us who believe in a remote contact are unable to formulate a satisfactory hypothesis regarding the paths this contact may have taken and its cultural and ethnic aspects. The age that has been accepted for the oldest forms of South African art would coincide with the age we have proposed for the art of the Spanish Levant.

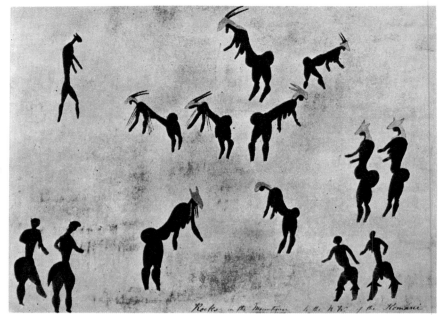

162

However, we shall not venture any further into this difficult question.

Another interesting aspect of this art in southern Africa is the fact that anthropologists have been able to study the traditions, legends, myths, and rituals of present-day Bushmen and other peoples of this part of the African continent. Their cultures reveal a rich world that finds its expression in painted scenes and confirms what had been presumed by European scholars regarding the religious significance of these paintings. It bears repeating that if Bushman society had not included individuals gifted in art and disciplined by instruction transmitted by true masters it would not have produced these magnificent compositions, which rival those in Europe; the vivid expression, the mysterious charm, the beautiful workmanship of this art endear it to us and, despite its great age, render it modern.

162. Rock painting of a dance of masked women (watercolor copy). Tiffin Kloof, Madeira Hill, Queenstown district (Cape Province), Republic of South Africa.

163, 164. Rock paintings of dancers. Çatal Hüyük (Anatolia), Turkey.

124

Rock Art
of Asia

The immense continent of Asia has thus far revealed only a small part of its prehistoric treasures. We have referred above to the female figurines found at Malta and Buret, near Lake Baikal; the Buret figurine presents Mongoloid traits. The Natufian figurines of Palestine, which correspond to a mesolithic stage, also are in the tradition of the female representations of the Upper Paleolithic.

Rock art exists in many areas of Asia; it has not been thoroughly studied, however, and many of the works in which it has been published are not readily available. There are rock paintings in Turkey (figs. 163, 164), and we know of rock engravings in Asia Minor and Afghanistan; these have been compared to those of North Africa, with figures of goats and sheep predominating in the Asiatic engravings. Those of Mgvimevi, in the Caucasus, are believed to be very old; they may be related to those at Melitopol, near the Sea of Azov. Many engraved rocks have been found around Lake Baikal; at Shiskino the oldest engravings show silhouettes of cattle and horses filled in with red. There is an important group of rock engravings at Quruq-tagh in Sinkiang. A.

163

164

M. Tallgren has studied the pictures of Central Asia and Siberia. Some rocks at Chapa, in North Vietnam, bear engravings depicting men with tails, resembling those of New Guinea.

Paintings have been reported at the mouth of the Lena. But the best-known rock paintings in Asia are those of the shelters of central India: Adam Gahr, Raigarh, Chakradharpur, Hoshangabad, Mirzapur, etc. (figs. 165–67). The most important are those at Singanpur, which recall somewhat those of Australia, while others with schematized figures of animals resemble those of the Spanish Neolithic, with which they were once believed to be contemporary; Gordon has since demonstrated that they should not be regarded as prior to the fifth century B.C.

165. *Rock painting. Hoshangabad (Madhya Pradesh), India.*

166. *Rock paintings associated with microlithic stage (red line drawings) and Chalcolithic Age (solid figures). Modi Rock No. 3, Malwa, India.*

167. *Rock painting of archers. Hoshangabad (Madhya Pradesh), India.*

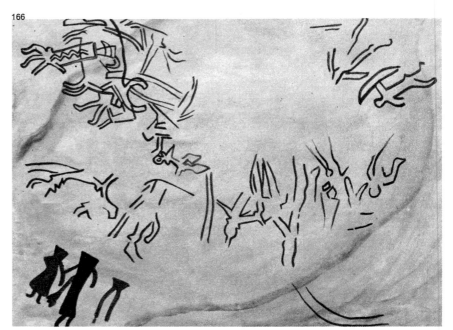

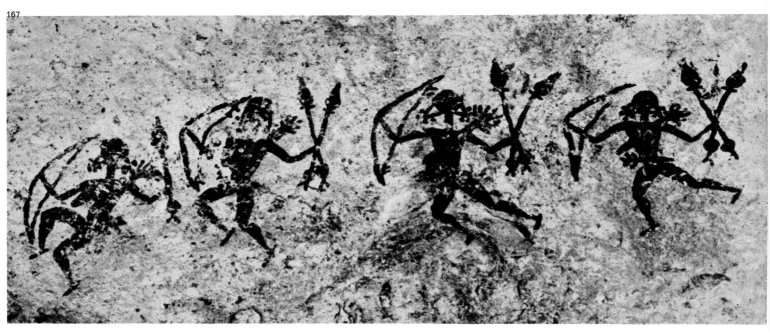

Rock Art
of Oceania

Prehistoric rock art extended throughout southeast Asia and nearby Indonesia. A large number of shelters have been reported in New Guinea, with paintings that seem to come from a proto-neolithic level. As many as four superposed styles appear in the shelters of the islands of Ogar and Argoeni (MacCluer Gulf). Hands and feet in negative are the oldest themes, and a red color is older than white. Symbolic designs also appear. On the neighboring island of Ceram, negative hands in red have been reported. The paintings in the Fiji Islands must be modern.

Much better known and much more important is the rock art of Australia, whose ethnic and cultural contacts with southeast Asia were effected through its northwestern area. Its rock art is varied and consists, for the most part, of paintings, which occur over virtually its entire area. In general, the paintings of naturalistic style predominate in the northwest belt, in Queensland, on the coast of New South Wales, and in the interior of Victoria, while those of geometric style are concentrated in a belt extending from New South Wales to West Australia. The two styles meet at the ends of their respective zones.

Anthropomorphic figures (called *wondjina*) abound in the northwest. The oldest style seems to be the one known as the "elegant" style with graceful little figures that suggest refined Western art (fig. 168). There are clothed figures, complete with baskets and complicated headdresses, and also grotesque or demoniacal female figures with striped bodies, usually represented in a squatting position.

Rock art in southern and south-central Australia is unique and is characterized by schematism and abstraction. There are engravings of circles, spirals, comb forms, and labyrinths (Devon Downs) and schematized human figures. Painted human figures seem to reflect the northern influence. The geometric style recalls the decorations of the churinga amulets, on which the predominant motifs are lozenges and herringbones.

The Kimberleys in the northwest and Oenpelli in the north (Arnhemland) are the most important centers in northern Australia. The "elegant" style preceded that of the *wondjinas*. At Oenpelli and in the surrounding region there are many representations of animals, such as fish, tortoises, and snakes, in what is called the X-ray style. They appear together with many human figures in very diverse postures of motion. The influence of this center seems to have radiated to distant regions, both west and south. Art in the south never attains the same level as that in the north. In New South Wales engravings in primitive technique predominate; they represent men (sometimes dancing), kangaroos, ostriches, fish, shields, and boomerangs. In Victoria there are no engravings and few paintings, although these are of some interest, at Glenisla, Langi Ghiran (Serpent Cave) and, especially, the shelter of Conic Range, with human figures in dark red that recall the "elegant" style of the northwest. The few rock paintings of the central region are in geometric or abstract style. In all these zones, images of human beings have been executed in an increasingly schematic manner down to recent times, especially after the transition to painting on bark was made.

Many problems are posed by Australian rock art. Anthropological study has introduced us

to the mythology to which it corresponds. That mythology is very rich, as are the initiation and hunting rites that demonstrate that the society is more complex than its material achievements would indicate. In Australia, too, there are paintings of hands in negative, which provide yet another link with other territories. It seems evident that the northern zone is the point of contact with Indonesia and Asia. The fine style of painting has been said to be the product, perhaps, of an ethnic element, pre-Australoid or Negrito-Tasmanoid, that has since disappeared.

Reconstruction of the chronology and development of Australian rock art is made more difficult by the disappearance of many paintings from shelters that are exposed to the weather.

168. Rock painting of running women, in the "elegant" style (copy). Oenpelli, Arnhemland, Australia.

Nonetheless, a carbon-14 dating confirms the relative antiquity of Australian rock paintings; this date applies to the art of Devon Downs in the central portion of the continent, which comprises poorly preserved geometric paintings in an advanced style. The paintings date from the third millennium B.C. Thus, at least a part of the Australian paintings and engravings must be as old as the majority of the rock art of the other non-European continents.

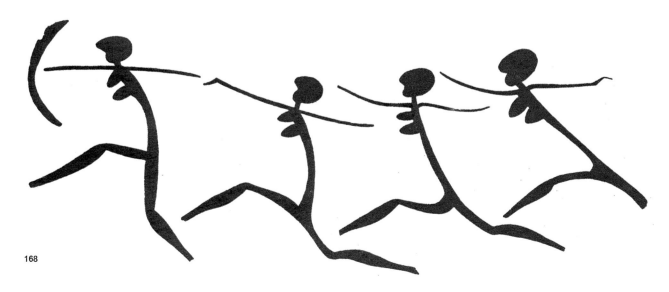

168

Rock Art
of America

This constitutes a recently opened chapter in research. Although the presence of prehistoric rock art in American lands was first reported some time ago, it was only a few years ago that a small part of it was convincingly presented as having an antiquity comparable to the prehistoric art of the Old World.

Here, too, we must distinguish engravings and paintings. Vast regions have proved to have a great wealth of engravings and an immense variety of motifs: the Venezuelan mountains; the southeastern and southwestern United States, with a center in Arizona; other North American regions; and the mountain ranges of northern Argentina. These regions have been incompletely explored and the findings published only in part, and many more groups must exist.

The immense ensemble of American rock engravings still remains to be catalogued, and its significance and chronology are yet to be established, notwithstanding the efforts of such specialists as Schuster and R. Heizer. All types of motifs are present in it, from animal and human figures in varying degrees of naturalism and schematization to geometric patterns, rectilinear, circular, or spiral in tendency. The same variety is evident in the techniques employed. Comparison with other continents is not yet possible, although such motifs as the labyrinth occur on both sides of the Atlantic.

Fortunately, rock paintings, also, are not lacking in America. They have been best studied in Argentina, particularly Patagonia. As early as 1877, the geographer Francisco P. Moreno discovered the first rock paintings near Lake Argentino. Other discoveries followed, and, in 1951, O. Menghin, already the author

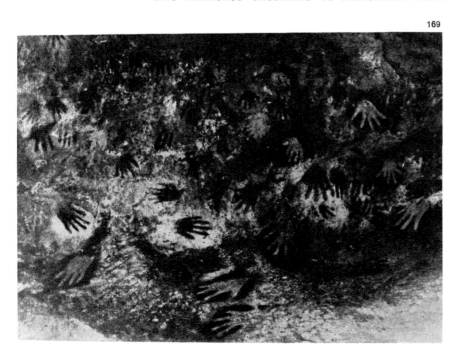

169

169. Negative and positive imprints of hands. Cave No. 2, Estancia Los Toldos (Santa Cruz), Patagonia, Argentina.

of notable works on the Stone Age throughout the world and on prehistoric art in Europe, began his study of this subject. He has established a chronological system for the entire area of South America.

The center of rock paintings in Patagonia extends between the Deseado and Santa Cruz rivers, but they also exist in the valley of the Gallegos River; to the north, there are large numbers of them in the Córdoba region, and paintings of hands are reported in San Luis and La Rioja provinces. Menghin classifies the motifs that appear in Patagonian paintings in three main groups. The largest group consists of paintings of hands in negative. The painting is usually of the left hand, and youthful hands are shown along with those of adults; there are also some positive paintings of hands and some paintings of hands with mutilated fingers. Pictures of feet are rare, while those of hands sometimes number in the hundreds at a single site (fig. 169). There are sixteen paintings of feet at the Piedra pintada del Arroyo de Vaca Mala in the Neuquén. One of the stations with many painted hands is the Cañadón de las Cuevas, in the territory of Santa Cruz. A second group of motifs comprises human and animal pictures, with hunting scenes, especially scenes of the hunt of the guanaco; figures of ostriches and pumas are less frequent. Scenes of the dance, possibly with masks, abound in the region of the Pinturas River. The third group of motifs is that of symbolic designs; these are schematic and geometric and include frets, circular, ladder-shaped, shield-shaped, and stepped motifs, etc.

This Patagonian rock art is of extreme interest to us because the system of Argentine prehistory established by Menghin makes it possible to defend the hypothesis that it began at a time contemporaneous with the Upper Paleolithic in Europe (Menghin's Miolithic), or at least with its final phase, about 9000 B.C. The same author goes so far as to distinguish a first pictorial period, which would include the hands; red would have been the first color used, followed by black, and then by yellow and white in later epochs, for hands in positive or negative have been painted down to modern times. From the eighth to the second millennium B.C., a second period would be marked by compositions with hunting and other scenes and with various signs, in a seminaturalistic style that recalls Spanish Levantine art; this period would include at least part of the paintings discovered in northern Chile. Next would come a third period, characterized by the so-called footprint style and by engravings, which are abundant in Patagonia and the rest of Argentina. From the middle of the first millennium

of our era the style of parallels develops, with linear motifs—broken, wavy, and fretted—for the most part engraved. Many of these motifs are derived from textile and ceramic decoration and are contemporary with the Spanish conquest. Evidence of this modernity are the paintings of the Córdoba region, with images of mounted Europeans superposed on figures of men with feathers and arrows.

Northwestern Argentina, comprising the ancient Calchaquí territory, is very rich in paintings and engravings. Caves with paintings of hands are found in San Luis and La Rioja. Large ensembles are known in the provinces of Mendoza, Córdoba, Santiago del Estero, Jujuy, and Salta. In the mountains of Córdoba alone, Pedersen discovered some two hundred caves and shelters and copied more than thirty thousand drawings. Paintings of this kind extend as far as Uruguay, where there are also many pictographs with frets and other motifs (departments of Flores and Durazno), and into Chile. In northern Chile a substantial number of rock paintings have been discovered in the last few years. Most of them are seminaturalistic and include does painted in red and orange and schematized human figures. It is curious to note how much some of these paintings resemble those of the Spanish Levant; their antiquity is regarded as certain. Farther to the north, there is another abundance of sites. In the Brazilian state of Paraná paintings are reported at Piraí do Sul, and representations of animals and lattice work have been found at Las Cavernas; engravings and paintings are known in the region of Lagoa Santa; in the Goiaz region appear engraved human figures and horseshoe signs. Schematic engravings abound in the Amazon basin region. In Guyana there are positive paintings of hands and engravings and paintings representing animals, schematized men, and geometric motifs. For some time much attention has been given to the petroglyphs of Venezuela, which display a very rich repertory of motifs.

We have already made reference to North America's wealth of engravings. Paintings also are present, although no groups have been reported thus far that can be assigned an age comparable to that of the Patagonian paintings. They have been found especially in Texas, New Mexico, Arizona, and California, where those of Valverde and Santa Barbara counties may be considered representative of the best style. Some of them, such as those published from Lower California (e.g., Cave of San Borjita), could very well be assigned parallels in Oceania. Obviously, if Menghin's theories are confirmed, paintings should exist in North America that are at least as archaic in aspect

as those of the first period distinguished by him. Paintings of hands in negative have been found in Arizona, but they are in white, which is very late also in South America, and their chronology does not extend beyond that of the preceramic Basket Makers of the Southwest.

An enormous amount of work is still required for the study of American rock art; the major difficulty is the enormous mass of material that must be studied and the fact that the findings have not always been entirely satisfactorily documented.

Conclusion

We have tried to present a brief panorama of the varied aspects of the great art of prehistory. The subject is vast and is not yet fully known. It is one of the most impressive ensembles of the art of all ages, as well as one of the most complex, since it arises out of highly diverse mentalities and races and is dispersed over all the continents and over a time span comprising many millenniums.

Brilliantly outstanding within this panorama is the art of the hunter peoples of western Europe, which indicates that that part of the world was first in time to produce so remarkable a manifestation of human genius, unless more complete data that may be forthcoming from other continents in the future compels us to modify our present hypotheses.

Among the innumerable problems that remain to be solved, perhaps the most important one is that concerning the possible Asiatic roots of this art. Equally absorbing are the problem of the chronology of African art and the question of the connections between geographical or chronological groups. Related to this is the problem of whether the prehistoric art of the Americas is indigenous.

Another subject of further study is the question of how man discovered art and acquired mastery in it. Related to this is the problem of the significance of this art, and many other problems which as yet defy solution, and perhaps always will.

It is our opinion that all the prehistoric art of humanity forms a single ensemble and that, by one path or another, the series of later manifestations in secondary centers derived from the original source, which, until new facts contradict the hypothesis, must be located in western Europe. However, this remains but a hypothesis, one which we are not in a position to prove, since so many links in the chain of evidence are still missing. Proof will become possible only after all the findings that have been made, together with those that are yet to be discovered, have been adequately published.

With the death of Abbé Breuil, it has become necessary to formulate a new structure for the Quaternary art of the Occident. This task has already been begun, as in such essays as that of Mme Laming-Emperaire. The problem is very complex, however, and a new "orthodoxy" can be arrived at only by a major effort of systematization and synthesis, including a study of all data, even that which does not directly relate to the focus of this art.

We repeat what we said at the outset, that nothing attracts us so much in prehistory as this first and great manifestation of the spirit of man, produced in an archaic phase of the development of humanity.

African Art | JOHN GALLOWAY

Introduction

The great tribal art of Negro Africa has become popular and deeply respected among both the art public and the professional student since the first years of the twentieth century. It is now recognized as a major contribution to the history of world art. This recognition became possible only after African works were accepted as "art" by French, German, and Spanish painters shortly after 1900.[1] Sculptures in wood and metal from West and Central Africa first provided both emotional and formal stimulus to the Fauves in France and to the German Expressionists of the Brücke group in Dresden.[2] Then the Spaniard Pablo Picasso, who had collected a large and diverse quantity of African carvings after settling in Paris, began in 1906 to adapt Negro rhythms with more systematic analysis than was being applied by his colleagues. Directly and indirectly, African primitive imagery thereafter began forcefully to penetrate Western aesthetic. The masks and fetish figures which in 1903 or 1904 appeared strange and exotic even to the sensitive eyes of Maurice de Vlaminck, André Derain, Henri Matisse, Ernst Ludwig Kirchner, Emil Nolde, and others, and which had served during 1906 to clarify Picasso's then unconfirmed hypotheses of a new figural expression, have a generally familiar appearance to us in the middle of the twentieth century.

As diffuse as particular aspects of the initial European assimilations of primitive art and the complexities of its extension into Western artistic consciousness may be, it is possible to outline the principal developments which have contributed to the widespread and advanced stage of popularity mentioned above.

First, Picasso was the only European to interpret cogently before 1910 the structural mode as well as the immediate visual presence of African art. No others, then or later, directly and incisively analyzed the core of this aesthetic as it exists in the original African works themselves. But from 1920 onward the influence of Picasso's Cubist style upon a whole generation of European and American artists became incalculably great, if not actually inescapable. This phenomenon has been so widely recognized that we have come to take it more or less for granted. Since African sculpture had been deeply significant to the formation of Picasso's style at an early and crucial phase, its mark, though sometimes only obscurely disclosed, has been omnipresent in that artist's subsequent expressiveness. Few sensitive modern painters or sculptors have failed, then, to receive at least indirect impetus from the potent tribal aesthetic which became inexorably woven into Picasso's style. Moreover, the impact of African works was hardly less great upon the German Expressionists, even if theirs was a more emotional and less systematic assimilation than Picasso's. The formal message of primitive structure and character of image was by no means lost on them. Since Expressionist art has also become influential upon a majority of recent European styles, African modes have reached us through still another wave of response to that movement. It is thus happily inevitable that an art public which has followed the growth and character of modern painting, sculpture, and graphics has been concomitantly aware of the presence of African imagery. That public has been well prepared to receive the now frequently exhibited tribal art which was largely unfamiliar to it at the turn of the century, even though such art had been scientifically displayed much earlier in the West in ethnographical museums. But, it was the creative artist of our time, not the ethnologist or art historian

or critic, who first and most tellingly contributed to our present admiration for these once shocking images.[3]

Our awareness and acceptance of African Negro art as art, rather than as scientific evidence of primitive technological skill or embodiment of tribal behavior, owes much also to the writings of the 1910s and 1920s of several poets and critics who, some of them through their acquaintance with Picasso and the others, had early sensed the aesthetic potency of Negro style. It has been charged that the enthusiasm of such individuals lacked a disciplined and scholarly understanding and that it was based upon a confusion of true aesthetic evaluation with *négrerie*[4] or upon a certain susceptibility on the part of Western intellectuals to "exotic" or minority manifestations of cultural expression. Without arguing the aptness of the allegation—and it is by all means a conjectural one—it is difficult to understand why African art should be singled out for exemption from the rule of fashionability which has applied to every great art now represented in the museums; nor has our past acceptance of Classical and Renaissance and Medieval arts been without the equivalent of well-meant sociological empathy with the peoples who produced it. We must remember that, even as late as the last half of the nineteenth century, few trained scholars, let alone popular admirers of the arts, recognized as valid many of the expressions which we now take more or less for granted.[5] A "fashion" and a certain degree of ethnic involvement accompanied the approval of Greek Archaic style, early phases of Christian art, the Romanesque, Romantic painting, Impressionism—all modes which in kind, if not in particulars, underwent complex stages of popular and academic acceptance. The non-scientific articles and reviews of articulate admirers of Negro art such as Christian Zervos, Guillaume Apollinaire, Clive Bell, Roger Fry,[6] Paul Guillaume, Thomas Munro[7] (to mention only a few) do not represent a faddish response to an art which was indeed fraught with societal and political import: the enthusiasm of these and other men was based upon sound intuition, as we may now clearly perceive, and the drive to bring before others a little-known and eminently deserving aesthetic. That they helped immeasurably through the medium of scholarly or popular journals and monographs[8] is undeniable. Theirs was an indispensably important, if in a sense indirect, role in the presentation by museums and galleries of African and other primitive art as art, not as batches of ethnographically classified "objects of material culture." Our debt to them is indelible.

Older contrasts drawn between primitive and nonprimitive arts by social scientists and art historians have become less pertinent as our understanding of both African and contemporary Western arts has grown. Moreover, most recent specialists in both anthropology and art history have broadened their vision. A man like the distinguished French ethnologist Marcel Griaule, a leading authority on West African arts,[9] referred in the late 1930s and 1940s to the inability of the Westerner to grasp the ritual import of tribal masks seen in the glow of ceremonial fires; but neither did Griaule, as a deeply civilized scholar, lack an appreciation of the sculptural form of African art.

A number of other scholars oriented to the social sciences have recognized in the object of art an aesthetic entity. Albert Maesen, A. A. Gerbrands, Paul Radin, William Bascom, Denise Paulme, Olga Boone, Julius F. Glück, Margaret Trowell, Elsy Leuzinger, Frans Olbrechts, Joseph Maes, Hans Himmelheber, and, in his last writings, Ralph Linton, are among those who have contributed valuable work reflecting this sensitivity.[10] These writers were joined by others such as Eckart von Sydow, who undertook a psychoanalytic investigation of origins and changes in African art,[11] and Carl Kjersmeier, whose interests closely resemble those of the art historian.[12] All of these scholars have been instrumental in popularizing indigenous Negro sculpture among an art public already made partially sympathetic by Western artists' creative adaptations of primitive styles.

Just as the majority of anthropologists now objectively respect the integrity of the work of art itself, so have most historians of art come to recognize the results of recent social-scientific field work. The relevance of ethnology to art history has been demonstrated in a number of especially valuable American contributions to the study of primitive arts. Among the relatively small number of scholars trained in art history in the United States who have written on African art, Paul Wingert and Robert Goldwater[13] stand out as pioneers. Wingert's *The Sculpture of Negro Africa* of 1950 perhaps remains, for its compressed format, the most instructive single volume on the subject yet written in English.[14] James Johnson Sweeney, best known for his writings on modern European and American sculpture and painting, has also had an impact on the popular response to African art.[15] All of these men have shown awareness of the value of ethnographical study.

The statements of these and other nonanthropologically trained scholars have reached an immense popular as well as academic audience. A growing faction of younger art historians specializing in the art of primitive peoples[16]

will encourage still greater understanding between the scientific and humanistic disciplines.

Moreover, African sculpture and crafts have recently shared with Oceanic and American Pre-Columbian Indian material increasing public attention resulting from special museum and university expositions. In the United States many college galleries have actively sponsored important showings. This bringing of African art before Western university students has unquestionably stimulated educational hopes for a more sensitive understanding of non-Western cultures. Its presence is already yielding cultural, humanitarian dividends which exceed the specialized aims of art-historical and anthropological disciplines.

In its effort to outline the chief reasons for our acceptance and support of African art, the preceding discussion seeks also to indicate the relevance to artistic study of ethnological and related kinds of information on the matrix of African life from which such a viable art has sprung. The problem facing the Westerner is not simply to recognize the distinctively African qualities of that life and art, but also to recognize how those entities relate to his own. He not only must bring to his study the openness and curiosity requisite of the scholar approaching any unfamiliar area of world art but he is obliged to apply to this strange material all of his capacity to envision it clearly in the context of total world art. Fortunately, those who advance the quaint hypothesis that the non-African can see African Negro art only through simulated African Negro eyes are, indeed, few in number. We are led to wonder if proponents of the see-and-think-African aesthetic approach do not hold as invalid, for example, the writings of the German-born Erwin Panofsky on Italian Renaissance art or those of the American William Dinsmoor on classical Greek architecture because those brilliant men did not live among, nor did they think principally like, Quattrocento Neoplatonists or Periclean designers. The tragedy of this point of view lies not so much in its being patently more romantic than scientific but in its failure to take into account this stratagem: the aesthetic of the traditional Negro African artist now having become, in however conjectural a degree, an integrated component of Western visual expression, we need no longer place the one art in disparate confrontation with the other. To evaluate fully the content and form and motivation of the art of the African, we must understand increasingly more of the content and form and motivation of very recent, as well as older, European art. This tandem responsibility imposes a stringent burden; but the ultimate relief will be reached neither through social-scientific nor humanist penetrations of specific problems of style and content but as an organic, natural result of the future growth of Negro Africa itself, following the recent return of much of its art-producing territory to indigenous rule. Once this growth has placed a noncolonial Africa alongside other free nations as a parallel world power, the self-consciousness of our manner of approaching African art will, hopefully, diminish. As we have already proceeded, with what capacities we as modern Western people possess, to examine the once strange arts of the ancient Mediterranean, the exotic Near and Far East, and of the Medieval and Renaissance epochs to which we are no longer especially close, so may we soon rid ourselves of useless self-imposed restrictions upon the full interpretation of African Negro art—a great art which has become already a facet of our aesthetic consciousness.

We may now turn to a brief account of the milieu in which the distinguished traditional art of the African Negro was created. The region is topographically immense. It begins just below the Sahara Desert near the uppermost bend of the Niger River, reaches southward to Rhodesia and thence extends eastward most of the distance to the Indian Ocean coast. The vastness of this territory, which embraces a third of the world's second largest continent, is paralleled by the astonishing diversity of tribal groups, regional dialects, and topography within it. The population is fairly dense but unevenly distributed.

Most of the art-producing peoples followed an agricultural existence often supplemented by hunting, fishing, or food-gathering. Cattle raising was practiced in some regions. The slave trade was once an extraordinary source of wealth in certain areas. Mining of surface gold deposits and of tin was profitably developed, though of course removed from indigenous control when European colonization took place.

The terrain varies from open grasslands to richly vegetated coastal forests to arid cliffs and plateaus. Africa is much less heavily forested than is commonly realized. Rainfall varies from less than ten inches to eighty inches a year, the heaviest occurring in the Guinea Coast and in sections of western or coastal Nigeria, Gabon, and the Congo, the most heavily populated areas. The most arid stretches lie in Mali and Angola, at the extreme northern and southern parts respectively of the region of our particular interest.

Linguistically, the West and Central African tribes of interest to us belong to a complex sometimes referred to as the Niger-Congo linguistic group; but a distinction is usually made between Sudanic and Bantu tongues. Most

tribes from Mali southward to Gabon speak Sudanic; those of the Congo use Bantu dialects. Throughout, local and regional variants of language abound.

Many of these peoples had to devote their main energies to the production of food adequate for survival; others enjoyed the results of advanced forms of agriculture. But art, especially sculpture, was practiced richly throughout Negro Africa. Most of it was created to meet specific religious or secular demands of a tribal group; a men's or women's secret society within that group; a monarchical court (that of the Bini, the Bushongo, or Ashanti, for example); or, less often, a connoisseur whose requirements derived from aesthetic yearning and the attendant prestige of collecting (as among the Guro and Baoule). The worship or commemoration of ancestors; fertility rites which invoked the benevolence of nature deities or other supernatural spirits; boys' and girls' tribal initiations and ceremonial dances sponsored by special societies; divination (the oracular seeking of knowledge of future events); the expunging of evil spirits which represented threatening forces; supplication to fetishes to assure well-being or to avert a specific misfortune; and aristocratic seeking of prestige—all of these institutions required the production of a multitude of figures, masks, or decorative carvings. It hardly needs to be stated that certain of the motivations just mentioned are by no means without parallel in one or another phase, including the present one, of Western civilization.

The traditional Negro sculptor and his product belonged to a political milieu which was marked by a general homogeneity, as was artistic style; but, as sculpture might vary remarkably from one specific subregional expression to the next, indigenous African government ranged in structure from near anarchy among certain tribes to thoroughgoing, organized kingdoms elsewhere. In most instances, however, the family unit headed by the father was basic; it answered to a village chief or "headman" who in turn was committed to an immediately higher authority, the chieftain of several villages or of a small district of tribes. That individual was responsible to the principal ruler, sometimes an absolute monarch, of an entire people. More or less systematic taxation, organized military bodies, and elaborate courts were not uncommon. It has been the approach of most social scientists until fairly recent years to emphasize the contrasts, rather than the similarities, between Western institutions and primitive ones; but comparisons are not lacking.

There are ancient and remarkably forceful traditions of sculpture in various mediums.

Wood was by all means the most characteristic of these; but terra cotta, stone, brass, iron, bronze, gold, copper, silver, and ivory were also prolifically used in certain regions. All of these materials were known by the Negro artist long before significant European settlement took place in Africa. Metal-casting techniques, including the lost-wax method and surface chasing, were practiced with consummate finish.

Recent evidence indicates that the first sculptures to be created in West Africa were the terra-cotta figures and heads of the Nok people of central and northern Nigeria, some of which may predate by five or more centuries the time of Christ.[17] Wood carving was probably undertaken at an earlier stage.

Material intended for sculptural use was carefully selected according to the purpose of the object to be created; hence masks, which were usually supported on the head or shoulders for long intervals during complex rites, were typically fashioned of lightweight, soft woods.[18] Ancestral figures, on the other hand, were more often carved from tougher, more durable wood so that they might last almost indefinitely if protected from the ravages of insects and humidity.

We are accustomed to seeing African sculptures of quite dark tone, sometimes warmly blackish; but a majority of these carvings were fashioned of wood which was originally light-colored or slightly reddish in hue. Then the surface, depending upon the choice of the sculptor or the convention observed by his tribe, was usually treated by one of several methods that deepened and enriched the tone. Prolonged rubbings with *tukula* or camwood powder, the deliberate smoking plus staining with grease or vegetal extracts, or, in quite recent times, the application of commercial polishes and varnishes, brought about the desired coloration and gloss. Some classes of sculpture were also painted fairly elaborately.

The principal woodworking tool of the Negro sculptor was the short hand adze, a narrow, straight-edged iron blade affixed at counterangles to a shaped wooden handle. It was worked with a short, chopping stroke directed toward the body of the artist. In parts of the Congo a straight knife blade was set in the leading end of an arm-length wooden shaft, the butt of which was tucked crutchlike beneath the armpit, giving remarkably close manual control over the cutting edge.[19]

The sculptor himself was often a professional artist, though he frequently doubled as village priest or farmer. He knew as a trained scientist the woods of his region. He was also necessarily a specialist in the rites and legends of his tribe. The social status of the artist was by no means uniform throughout Negro Africa. Among

certain peoples who sponsored a courtly style he enjoyed immense prestige; in other places his creative occupation was only part-time and altogether secondary to commoner pursuits of livelihood—a dichotomy of energies not unknown among Western artists.

West Africa
and Cameroon

It has been mentioned that African Negro art abounded in an immense region which included the systems of the Niger and Congo rivers plus certain adjacent territories. These areas may be defined geographically, and, in a sense which demands more specific qualification than is often accorded, stylistically, as West Africa and Central Africa. The sculpture of the Cameroon is treated here along with that of West Africa.

There is a greater homogeneity of expression in Negro African sculpture than there is in any other ambiance of world primitive art. This applies by all means to West Africa from northern Mali with the Dogon people, through the Guinea Coast, and past the Niger River Delta into the Cameroon. We must, of course, allow for variants, some of them occurring even within the same geographical or stylistic subdivision. But perceptible characteristics of whole tribal styles, when seen in quantities of examples, reveal distinctive units within the general homogeneity of regional statement. It is sometimes difficult to distinguish between, let us say, one particular seated figure from the Bambara and another from the Dogon;[20] but a large group of the masks, figures, and decorative objects from each tribe is individual in flavor and is subject to detailed analysis within itself. We encounter certain unifying principles of both style and choice of themes which have resulted from innumerable past migrations and interchanges of cultural traits between peoples of much of West Africa. But marked distinctions are present everywhere.[21]

Confinement of interpretation to the art of well-known tribes and the presentation of generally familiar classifications of works has been decided upon as one reasonable procedure in developing a brief study such as the present

one. It has thus been necessary to omit, but with great reluctance, reproductions of the works of certain less widely familiar peoples —the Malinke, Kurumba, Agni, Bron, Kwahu, Ekoi, Montol, and Afo among them—in order to examine more systematically characteristics of style among the best known of West and Central African groups. Some figures and masks will be familiar to students and connoisseurs as "classics" which have often been shown in publications. Many items have been taken from little-publicized collections and will be totally unfamiliar; and it has not been the purpose merely to illustrate a selection of African masterpieces.

Mali
and the Guinea Coast

The Bambara, Bobo, Mossi, Dogon, and Baga (the latter assignable to the Guinea Coast geographically, but to the Mali complex of styles artistically) form a sculptural tradition which is best associated with the Republic of Mali, or the former French Sudan. The West Guinea Coast stylistic area and the political entities of Guinea, Sierra Leone, and Liberia include the Mendi tribes and the peoples active to one or another degree in the strong Poro society—the Dan, Ngere, and Gio, for example. The state called the Ivory Coast, home of the Senufo, the Guro, and the Baoule, is sometimes combined with Ghana (formerly the Gold Coast)[22] as a region called the Central Guinea Coast; but the art of the Ashanti of Ghana may well be treated on the whole as stylistically unique.

The East Guinea Coast embraces Nigeria with the Ife and Bini groups and their spectacular cast-metal traditions and the Yoruba, a people notably prolific in their art.[23] Less well-known tribes, the Idoma, Jaba, Montol, and certain of the Igala, have been little influenced in style by the traditions of the other Nigerian peoples.[24] The Niger River Delta, the south easternmost section of Nigeria, is the center of still other expressions which are largely independent of Ife-Bini-Yoruba aesthetic. Of these, the Ibo and Ibibio styles are among the most representative.

The Cameroon is often studied separately from West Africa proper, as its topographical position might suggest. For our purposes, however, it is linked with the Guinea Coast. There are some echoes of Guinea Coast figural conception in the sculpture of the Bamum, Bangwa, Bafum, and other Cameroon tribes, although such characteristics are obscured by the vigorous, sometimes contorted poses found in Cameroon Grasslands art.

The Bambara

The Bambara, a people who subsist on agriculture supplemented by some hunting, are among the larger tribes of Mali in Sudanese West Africa, numbering about one million. Their traditional sculpture, striking for both its semi-adstract syntheses of animal and human forms and its technical virtuosity, was motivated largely by supplication to fertility gods whose favors were sought on behalf of crop and herd growth. Ancestral worship and animism—the latter a belief that all beings and objects in nature contain spirits or life forces—were also responsible for rituals and ceremonies which engendered the making of masks (fig. 171), dance headpieces, and figures.

One of the most unmistakable forms of all African Negro art is the *seguni-kun* mask super-structure (figs. 170; 179, colorplate). This exciting, formalized conception of the antelope is notable for its elegance of technique as well as for its delicate counterpoise of solids against voids. The *seguni-kun* was used in elaborate dances at cultivation times by members of the Chi-wara society. That group invoked the benefaction of the spirit of the legendary antelope, Chi-wara, who taught the Bambara the science of agriculture. Pairs of dancers wearing these sensitive, space-piercing forms made rhythmic leaps with the aid of vaulting poles, imitating the fluid gait of the animal they impersonated.[25] While the truism obtains that there is homogeneity of style in the great com-

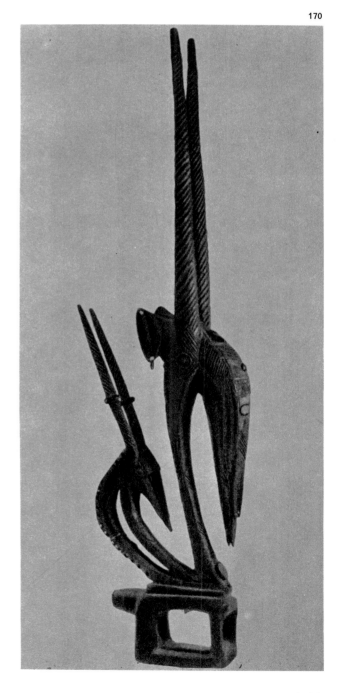

170. Chi-wara society antelope mask headpiece (seguni-kun), from Mali. Bambara. Wood, height 25 5/8". Collection Pierre Vérité, Paris.

141

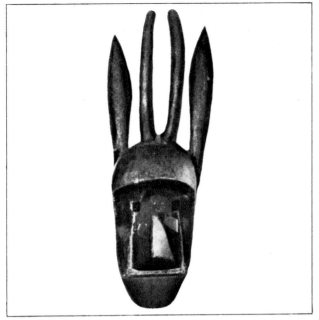

plex of *seguni-kun* masks, we invert the conventional order of that observation and emphasize that, within the general type, impressive variety exists. No two of these carvings are precisely alike. In any case, fifty Chi-wara headpieces taken at random are little more and little less alike than are, for example, a like number of courtly portraits by assorted seventeenth century Flemish or Dutch masters.

"Puppet" figures or half-figures (fig. 172), with outthrust bosoms positioned beneath a stalk-like neck, were also used at sowing or harvest time. The flattish, slightly concave facial area, pointedly oval, is flanked by banana-shaped, tiered flaps of hair. A distant affinity with the Dogon mask forms and high-relief house-posts [26] is seen. These marionette-like objects, most of them less than two feet in height, were manipulated during fertility dramas. They may also have been carried at funeral rites.

The Ntomo society of the Bambara sponsored the making of facial masks of a type remarkably different from the *seguni-kun* dance headpiece, although specific elements of the latter appear in rearrangement. The Ntomo spirit assured protection of young boys who were to be circumcised and initiated into adult tribal status. The heads of such masks are often superposed by a horned or comblike openwork before the center of which may be carved an animal, human, or composite miniature figure, usually seated. The faces are planar or slightly concave or convex and given a thin-bridged, finlike nose. Color is sometimes applied conservatively to such masks, and raffia strands or tassels of cloth were occasionally tied on through perforations at the ear.

One of the most beautifully sculptural works of Bambara provenience is the standing ancestor figure (figs. 173, 174). This remarkable commem-

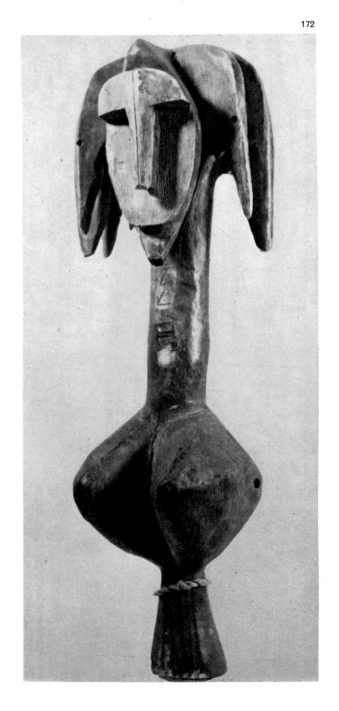

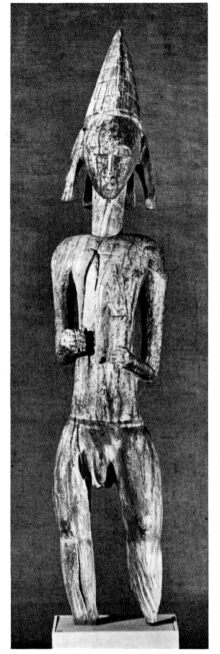

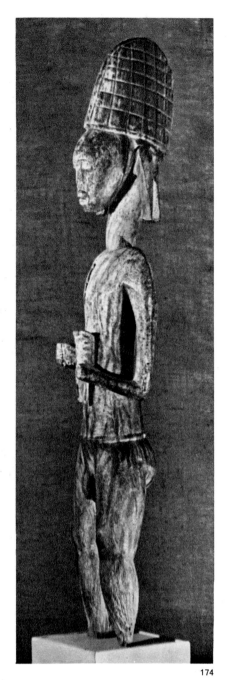

orative image of a deceased familial or tribal hero possesses a complexity of pose which stands in sharp contrast to the typical rigidity of much African figural art. A gentle, swaying movement deviates from the vertical axis and softly places the greater weight upon the right leg. There is a certain torsion present in the shoulder and neck area as well. The entire image contains a swelling, quietly restless force which intrudes graciously upon the observer's consciousness. Although this is a carved wooden figure, the subtlety of its shaping reflects a modeled, not cut away, quality. Its dignity matches that of the standing figure in the art of any society. Works of this quality forcefully persuade us that, independently of tribal dictates that ancestors be revered (an attitude by no means confined to primitive groups), the sheer magnetism of imagery might compel a response of adoration.

Islamic as well as Christian culture was long resisted by the Bambara, who had developed a strong, essentially monarchical government during the eighteenth century. The Moslems eventually penetrated Bambara life style, but despite the proscription of image making, this Negro tribe still practices to some extent the art of figure carving. Theirs is a memorable West African style for its boldness of rhythmic contrasts combined with refinement of surface.

The Bobo

The Bobo, a tribe much smaller than their Bambara neighbors, inhabit the Upper Volta region. Their art appears to be one of the older Sudanic styles and is typified by elaborate vertical masks, one variety of which is painted with geometrical passages (fig. 175). These carvings were worn or carried at harvesting ceremonies not unlike those of the Bambara and Baga, and, indeed, there are stylistic affinities between other types of Bobo masks and certain ones of the Baga. Delicate yet striking counterbalances are established by the use of semicircular, circular, diagonal, and rectangular, flatly carved shapes or painted motifs. A strongly formalized face, almost perfectly circular, is joined by means of a triangular or diamond-shaped stem to a panel-like rectangle above it. A sharply pointed, upturned crescent sometimes completes the vertical sequence of clearly defined elements, suggesting a totemic meaning. Not the least purpose of the tall mask form is to lend to the wearer a sense of great height [27] and a consequent transformation of personality.

171. Kore society antelope mask, from Mali. Bambara. Wood, height 30 3/4". Rietberg Museum, Zurich. Von der Heydt Collection.

172. "Puppet" figure (merekun), from Mali. Bambara. Wood, height 17 7/8". Collection Allen C. Davis, Washington, D.C.

173, 174. Ancestor figure (front and side view), from Mali. Bambara. Wood, height 43 1/2". The Museum of Primitive Art, New York.

143

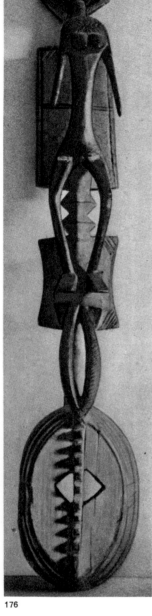

The Mossi

Mossi art is also characterized by masks of a perpendicular kind, which are used by the Wango society (fig. 176) in protective rites. The face and horns often represent an antelope spirit; the superposed figure is probably that of an earth goddess.

The Mossi are a very large tribe of the central Upper Volta area who number about a million and a half. They have undergone Islamic influence and their carving tradition has become vitiated. Wango society masks are related in design to those of the Bobo, although they derive somewhat more evidently from natural shapes and are less geometrically patterned than the latter. There are also similarities to Dogon and Bambara styles. It is not possible to postulate confidently which of these groups first established its sculptural tradition.

The Dogon

The Dogon are among the oldest practitioners of sculpture in the Sudanese region, and theirs is one of the most style-conscious expressions of West Africa. Lacking the refinement of detail known to much Bambara work, Dogon pieces offer sharp breaks of contour and appealing repetitions of shapes. Most of the finest traditional carvings, especially figures and

175

176

177

175. Mask personifying the village guardian spirit, from Upper Volta. Bobo. Wood and fibers, height 68 1/8". Musée de l'Homme, Paris.

176. Wango society mask, from Upper Volta. Mossi. Wood, height 42 1/2". Formerly collection Princess Gourielli, Paris.

177. "Tellem" figure, from Mali. Dogon. Wood, height 43 1/4". Collection Christophe Tzara, Paris.

178. Antelope dance mask (walu), from Mali. Dogon. Wood and fibers, height 22". Collection Allen C. Davis, Washington, D.C.

179. Chi-wara society antelope mask headpiece (seguni-kun), from Mali. Bambara. Wood, height c. 36". Collection Harry Bober, New York.

180. Antelope dance mask (walu), from Mali. Dogon. Wood, height 21 1/2". Collection Allen C. Davis, Washington, D.C.

144

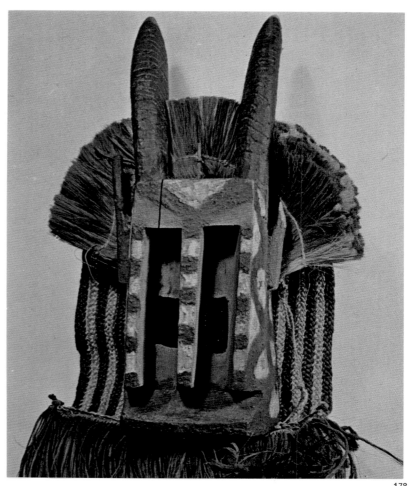

178

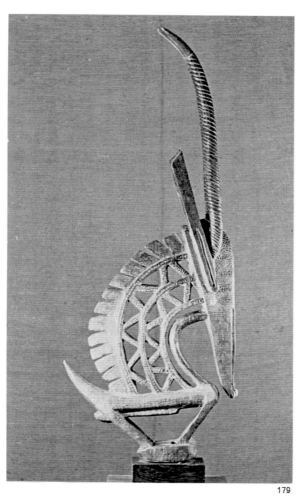

179

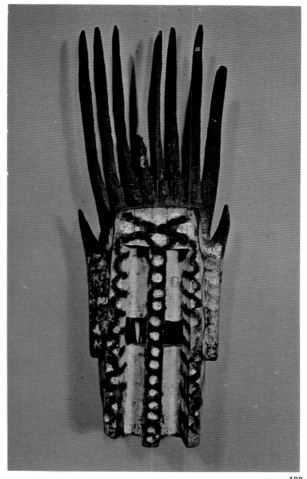

180

masks, were created by persons who may be called professional artists, members of a prestigious caste of smiths. There is also a comparatively crude style which was carried out by untrained carvers. Intransigently proud of their tribal religion and customs, the Dogon long averted Moslem acculturation by retreating to an all but inaccessible cliff-sided plateau in northern Mali, near the great bend of the Niger River. Their subsistence, like that of the neighboring Bambara, comes largely from agriculture, though the rocky Dogon soil is less productive. Hunting is an important secondary source of food and in some areas it is still carried out with the ancient weapons, the spear and the knife. Animals are prolifically represented in mask forms and on the elaborately carved reliefs of granary or sanctuary doors. The cultivation of crops and attendant fertility beliefs occasion the making of supplicatory figures with arms upraised in one or another attitude of prayer for rain. Some fertility carvings were placed in or near grain fields and were used in rites intended to produce increased crops. The oldest works, such as commemorative figures carved in honor of Sigi, the legendary first ancestor, were placed in caves or other places of sanctuary and were honored by sacrificial gifts. Verticality is apparent or implicit in all Dogon figures, standing or seated (fig. 182). An austere, semiabstract conceptualism is asserted. Reduction (not simplification) of body components to their essences is common to the older ancestral figures (fig. 177), which, according to Dogon oral records, may have been created by an ancient people, the "Tellem," who preceded them in their present habitat. More recent figural works have greater elaboration of surface and more obvious geometrization of such elements as the eye. The older figures are the more dramatic in pose; the newer ones are closer in their refinement to Bambara carvings, with which, as we have mentioned, they are not infrequently confused. All Dogon figures receive the numen (or *nyama*), the spirit or vital force of ancient or recently dead ancestors; and lurid rites are held to preserve that sacred energy and to invoke the beneficence of the departed for the welfare of living descendants.

While Dogon figures are among the strongest of Sudanese works in that form, the masks of these people are even more striking (figs. 178, 180, colorplates; 181). Without sacrificing the austerity so impressive in the "Tellem" and other full-length images, Dogon masks are provocative, their abrupt forms enhanced in effect by extensive use of painted geometrical motifs.[28] The illustrated *walu* or antelope masks characterize the main type. Their over-all

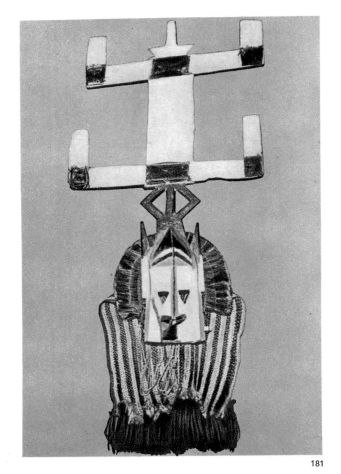

181

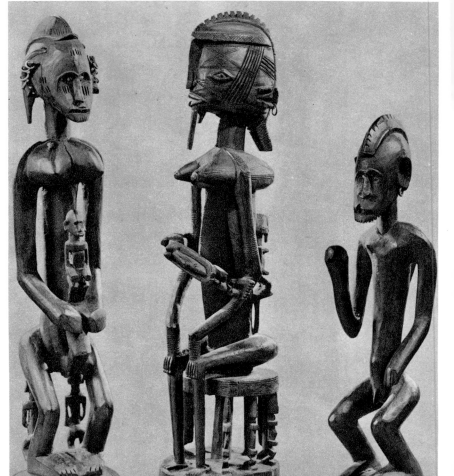

182

146

146

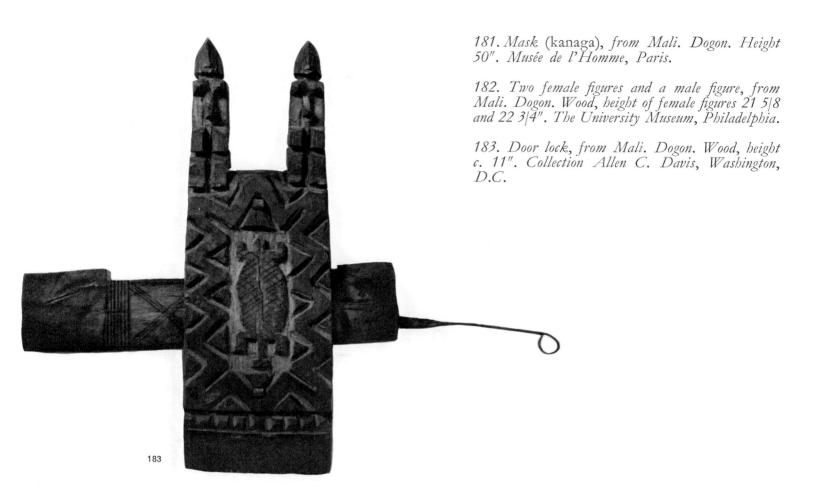

183

rectangular format and horned-and-eared upper elements, as well as the repetitive zigzag and rectilinear painted designs, are well represented in these examples. Fringes of brilliantly colored raffia or woven cloth usually appear atop or completely surrounding the face. The vertical, recessed orbital areas are unmistakably Dogonese in conception. These often range panel-like from mouth to upper forehead, enclosing the eyes proper, which are squarish, pierced openings. The *walu* type, closely approximated by other masks representing birds and monkeys, is architectonic in gestalt. This becomes apparent if we compare the contour of a *walu* mask (fig. 178, colorplate) with the structural form of the door lock of a granary or shrine (fig. 183). Such masks of rectangular or sometimes oval shape, usually treated with the paneled and pierced eye structure, were used in rites intended to expel the evil of dreaded, recently deceased spirits, or otherwise to protect the tribe from danger. They were frequently worn at funerals, and, in the case of the *walu* type, at harvest dances as well. The function of the antelope in literally fertilizing the earth was a ritually observed connection. Doors and door locks comprise another classification of Dogon art. The locks are often topped by miniature human figures (as in fig. 183) or contained figural reliefs, ancestors being represented in either case. The lizard in our illustrated example is totemic.

Dogon art, lacking the sophisticated surface modulation of Bambara carving, is no less interesting stylistically. It is distinctive for the effectiveness of its abrupt planar contrasts and its angularities, and, in the case of masks, the lively enhancement of surfaces with color and fabric. Affinities with Bambara and other Sudanic expressions are often apparent, but Dogon style is frequently dramatic, and, especially in the case of the *walu*-type masks and the older figures, unmistakable in formal characteristics.

The Baga

The Baga belong geographically to the Guinea Coast but are related in their art style to the Mali area, to the Bambara, the Dogon, and the Bobo. Theirs is the most outgoingly sexual sculpture of West Africa, and, though curves additional to the exponential ones emphasized by William Fagg [29] are encountered in this fertility-loaded art, there can be no question here of the relation of parabola to procreation. A blatant, dark poetry is projected by the swelling bulk of head and breast which is both counteracted yet echoed by startlingly trim, Elie Nadelman-like legs (as in the full-length cult figures) or equally thin, four-part supports as in the Nimba goddess (fig. 185). Nimba, wife of the omnipotent deity Simo Guinea,

epitomizes for the Baga the idea of propitiation. This fearsome image is of a unique type of combined shoulder-and-helmet mask, the whole lower bulk usually made the more ponderous by the presence of a great raffia fringe which wholly concealed the dancer. The wearer, whose head fitted into the void behind the astonishing breasts, looked out from a hole located between them. At harvest time these apparitions were brought into the village, where they became symbols of the fecundity of crop and animal and human beings. The breasts, flattened as if beaten, and bent downward with compositional purpose to conform to the slope of the great chest, are deflated containers with nipples like snipped pegs; yet they know a fruition only momentarily gone which will again burst forth abundantly.

There are no more awesome images in all African art than Nimba and related standing figures which appear also to signify fructification. Some are unmistakable for their gesture of arms and hands, which sweep upward on each side to meet beneath a long, sharp-chinned jaw. Beneath is a stalklike neck and the lumpish cylinder of the torso, its frontal verticality broken by a pluglike navel. Supporting this explosive mass and the jutting head above are tiny, often shapely legs. But it is the head, like that of Nimba herself, which moves us to astonishment. Banded passages of chevroned and beaded relief or incised crosshatchings traverse the face and serve as delicate foils to the immense glandlike nose and tabbed ears. Inordinately long from back to eye and crowned by a low, notched crescent of hair, the head is fronted by a nose which is more penile in aspect than are most actual phalluses appearing on African sculptures.

184

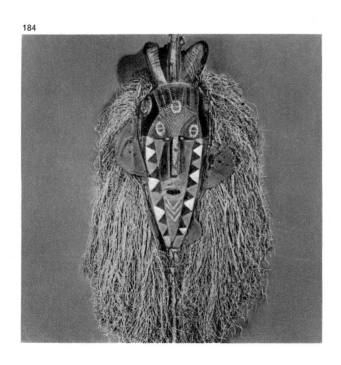

185

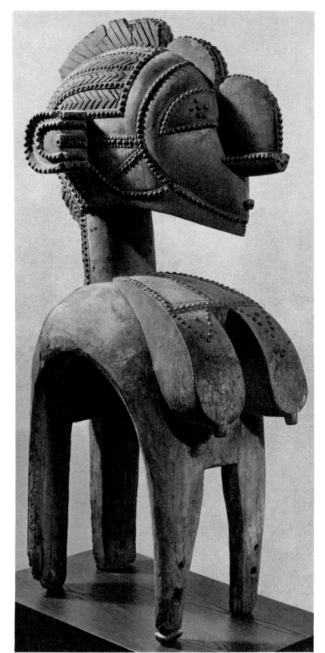

184. Simo society mask (banda), *from the Guinea Coast. Baga. Wood and fiber.*

185. Simo society dance headdress with carrying yoke (nimba), *from the Guinea Coast. Baga. Wood, height 52". Collection John J. Klejman, New York.*

186. Simo society composite image (anok), *from Guinea. Baga. Wood, length 35". Collection John J. Klejman, New York.*

The *banda* mask of the Simo society (fig. 184), a type not commonly collected, was as secret as the Nimba mask was public. Those who were not initiates of the Simo society might be put to death for looking at it. This mask combined crocodile and land-animal features, which may have signified spiritual linkage between water and earth. It was worn horizontally or slightly declined.

Another comparatively scarce form in Baga carving, not unrelated in mode to the *banda* mask, is the pedestal-mounted bird or composite (*anok* or *elek*) mask (fig. 186). Margaret Plass has pointed out that, while such objects give the first impression of being birds, further study reveals human and crocodile features as well.[30] Such objects were reported to have been carried as handle masks, although their use in Simo rites as static fertility or "guardian" figures also appears to have been possible.

It is unfortunate that the Baga people, whose art has afforded us one of the most distinctive, unforgettable expressions in West African sculpture, have not been more extensively studied. Carl Kjersmeier reported in the 1930s that Islamic intrusion had already obliterated much of Baga indigenous custom and belief.[31] Their practice of traditional art has dwindled.

The Kran, Ngere, Dan, Gio, Kissi, and Mendi

The region of tribal styles sometimes referred to as the West Guinea Coast [32] reveals, if not a homogeneity of form in sculpture, at least the effect of a unifying principle of motivation:

the domination of the powerful and widespread Poro society of men, and, in Sierra Leone among the Mendi, its feminine parallel, the Bundu, or Sande, cult. The Poro is uniquely active in political and ritual functions as well as in private life throughout Liberia and parts of adjoining Sierra Leone and the Ivory Coast. It is in the mask forms of this center that we encounter a stylistic continuum; but, as is the case almost everywhere in Negro Africa, variants by the individual sculptor, as well as in a whole tribal output, are notably independent of norms. Agriculture and fishing are the chief material foundations of tribal society in this area, but European trade has become increasingly important except in the hinterlands.

The Kran of Liberia, a tribe whose art is comparatively little represented in collections, have only recently lessened the production of traditional carvings. Their Poro society masks (fig. 198, colorplate) are boisterously extroverted, brilliantly colored, and more closely related to the so-called expressionistic carvings of the Ngere than to the less strident forms of the Dan proper. We witness in the illustrated example, dating from the 1930s, an anticipation of the New York Pop Art school constructions, which developed twenty years later. The surprisingly fresh-looking discharged shotgun cartridges not only reinforce the rhythms of the biggish oval of the face and echo the swollen circular lumps of the eyes, but they serve to introduce into this droll creation the extrapictorial sensations of sound and scent. The result is a clownlike, gaudy climax of polychromed wooden surfaces accentuated by extrusions of red paper and gleaming brass. Pieces of this kind were worn, as were Poro masks through-

186

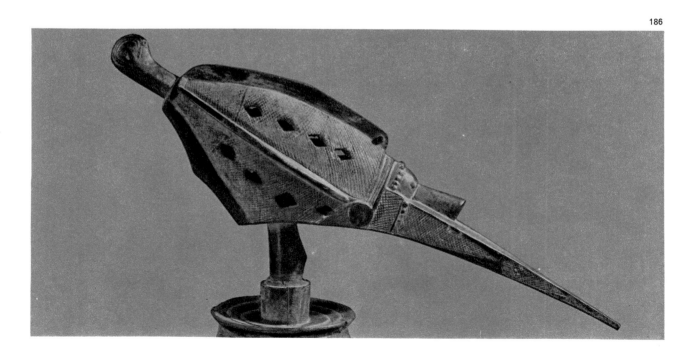

out the West Guinea Coast, at frightening initiation rites which involved the circumcision of boys as well as the incising of tribal markings into the skin of both youths and adults.[33]

A more restrained Kran sculpture is the elongated animal—at first sight doglike, but horned—which was used by villagers in the tribal game of "country checkers" (fig. 187). The sharp opposition of angular to curved forms and the extensive activation of surface with striated and crosshatched designs relate it, despite its contained silhouette, to the busy style of the polychromed and brass-bedecked Poro mask.

Another work of Liberian provenience is the Ngere "warthog" mask (fig. 188). This carving lacks the buffoonishness of the Kran shotgun-cartridge assemblage, but it nonetheless reveals, behind its awesome tusked and wart-covered features, a trace of humor which belies the gravity of its purpose in dark ritual functions. Two claws, so paired on the forehead as to form an upturned crescent, lend textural contrast to the limp fringe beneath the mouth.

The neighboring Dan tribes typically produced a more reserved, yet by no means unimaginative, variety of Poro mask. Closer to a base in naturalism than Kran and Ngere carvings, the Dan pieces are distinctly facelike in conception. Some of them even suggest an origin in portraiture (fig. 191). Others realistically depict a pathological condition such as a deformed or diseased mouth.[34] The more serene example of Poro mask (fig. 194) is a masterpiece of its type. It is of Gio rather than Dan provenience. The fully rounded, yet not bulbous forehead; the slitted, upturned crescent eyes, enclosed by keenly pointed ellipses; and the full mouth with its extruded, curved metallic

187. *Game-board animal, from Liberia. Kran. Wood, length 36 5/8". Collection Allen C. Davis, Washington, D.C. (on loan to Oakland University, Rochester, Michigan).*

188. *"Warthog" mask, from Liberia. Ngere. Wood, brass nails, and claws, height 10 1/8". Collection Allen C. Davis, Washington, D.C.*

189. *Poro society mask, from Liberia or Ivory Coast. Mano. Wood, height 15 3/4". Musée de l'Homme, Paris.*

190. *Mask, from Liberia. Ngere. Collection Charles Ratton, Paris.*

teeth are characteristic of the basically naturalistic images of this important style. The tablike ears alone interpose a strongly schematic accent. The perforations encircling the jaw and hairline held at one time the knots of a raffia fringe or full garment.[35] One variation of this classification of mask is bisected from its uppermost edge to the bridge of the nose by a ridge in low relief (fig. 193). Other elements which differ from one piece to another are the eyes, which may be formed by circular or crescent-shaped perforations or by tubular projections; the nose, which may be moderate in scale or, less often, given a distinct flare at the base; and the mouth, usually full in form but contained in expressiveness, although occasionally pronounced in emotion. It should be noted that miniature forms of Poro masks, three inches or less in height, are worn by youths who are being groomed for advancement in

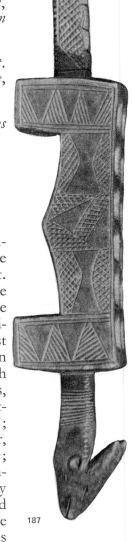

187

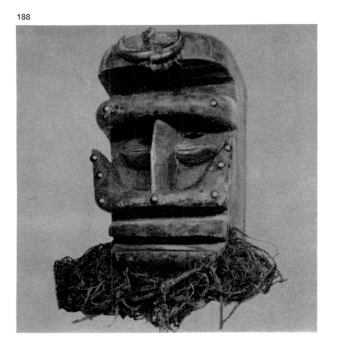

188

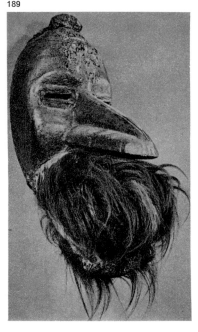

189

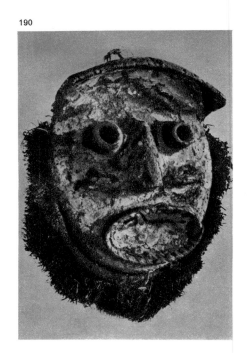

190

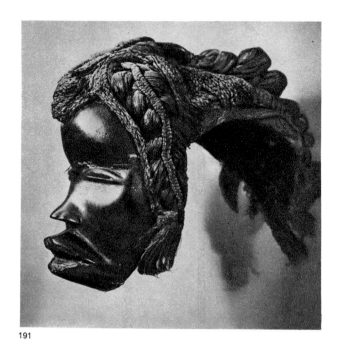

191

191. Face mask, from the Guinea Coast. Dan. Wood, height 10 5/8". Collection J. Morris Pinto, Paris.

192. Statuette (pomdo), from the Kissi district, West Guinea Coast. Stone, height 5 7/8". Musée de l'Homme, Paris.

193. Poro society initiation mask, from Liberia. Dan or Ngere. Wood, fur background, and metal teeth, height of face 8 1/8". Oakland University, Rochester, Michigan. Gift of The Hon. G. Mennen Williams.

194. Poro society mask, from Liberia. Gio. Wood with metal teeth, height c. 9 1/2". Collection Dr. and Mrs. Hilbert H. De Lawter, Bloomfield Hills, Michigan.

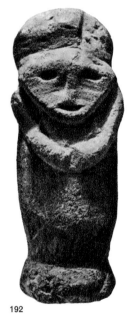

192

the society. The purpose of these tiny images is roughly parallel to the wearing of necklace charms by members of certain Christian sects, namely, protection against threatening forces, or symbols to which to make supplication for similar causes.

Another classification of Dan-Ngere mask combines animal with human features and has a grotesquely long, paddle-like lower jaw, a more or less organic extension of the kind of projection seen in the specimen in figure 194. These more fanciful, less naturalistic pieces stand midway between the luridly formed Kran and Ngere "warthog" masks and the restrained Dan style proper.

The Kissi districts in Sierra Leone and Guinea have produced a complex of smallish steatite figures of human subject, most of them

four to nine inches in height (figs. 192, 195–97). Mendi legend is not explicit about these forms. They are sometimes said to be "ancient," though their archaeology remains largely to be clarified.[36] The modern Mendi refer to them as *nomori* (and the Kissi, as *pomdo*) and have not hesitated to utilize them upon discovery as crop increase deities and divination objects. Mendi wood carvings have been to some extent influenced by these curious, bluntly formed pieces. But the crude upswept-arms-and-hands-to-chin posture of many of the stone *nomori*, only in slight degree demanded by the friable nature of the material, is more nearly reminiscent of the gesture of standing Simo cult figures of the Baga; and the elongated head and assertive nasal structure no less suggest a Baga affinity.[37] The small *nomori*

193

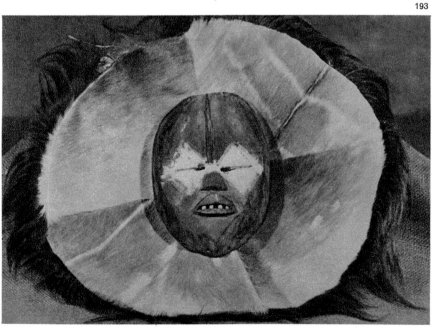

194

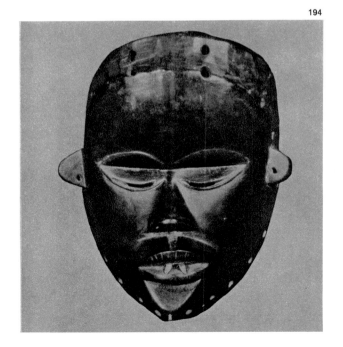

151

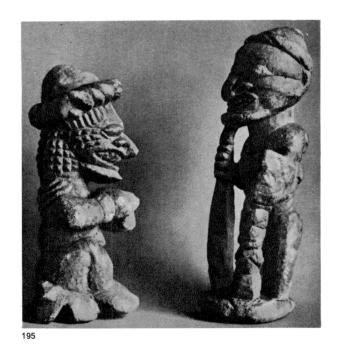

195

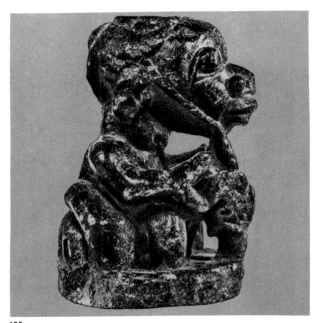

196

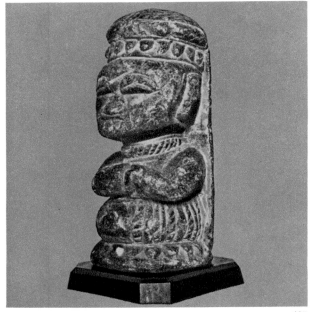

197

195. *Statuettes* (nomori *or* pomdo), *from the Kissi district, Sierra Leone and Republic of Guinea. Stone. British Museum, London.*

196. *Statuette* (nomori *or* pomdo), *from the Kissi district, Sierra Leone or Republic of Guinea. Steatite, height 6". British Museum, London.*

197. *Divinatory statuette* (pomdo) *connected with ancestor worship, from the Kissi district, Sierra Leone or Republic of Guinea. Steatite, height 9". Collection Pierre Guerre, Marseilles.*

198. *Poro society mask, from Liberia. Kran. Wood and discharged shotgun cartridges, height c. 15". Lowie Museum of Anthropology, University of California, Berkeley.*

199. *Maternity figure, from Ivory Coast. Baoule. Wood. Private collection, Milan.*

carving in figure 196 represents a figure astride an elephant.

The Mendi are a large tribe who subsist, depending upon the proximity of the particular village to the coast or interior, upon fishing or farming. Their principal women's secret society, the Bundu, or Sande, rivals in prestige the men's Poro fraternity. Like the latter, it has sponsored quantities of ritual carvings connected with the initiation of adolescents into adulthood and tribal grade. The Mendi have produced a distinctive, full-length type of figure notable for its elongated, ringed neck and essentially normative proportion of legs to torso. Their Yassi society, whose priestesses served as intermediaries in foretelling the future, sponsored the carving of shallow bowls with female half-figures. But the best-known form in Mendi art is the Bundu (Sande) helmet

mask (fig. 200), the purposes of which included representation of the guardian spirit of young girls. Like its male counterpart, the Poro mask, it is a distinctive type, yet it has found expression in countless individual interpretations. So worn by cult leaders as completely to engulf the head, its black-stained, gleaming patina was complemented by an attached gown of black-dyed cloth or fiber. The effect was unforgettably ominous. The helmet mask itself is of stilted-conical or beehive shape, often crowned by one or more figures which are rooted to a lobed, striated, or scalloped coiffure. The upper features begin with a bulbous forehead beneath which are set narrow-cut eyes. A depressed horizontal line reaching from temple to temple bisects the orbital zone and serves as the base for an inverted equilateral triangle. The latter contains a tiny nose and mouth.

152

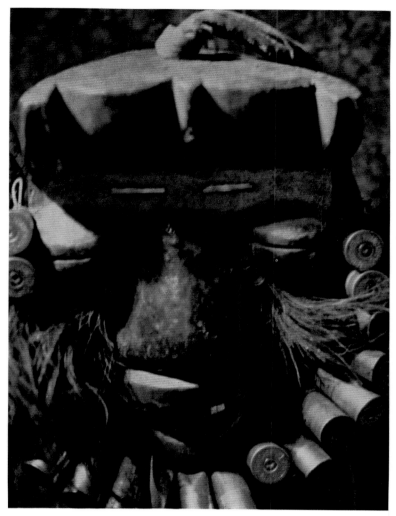

198

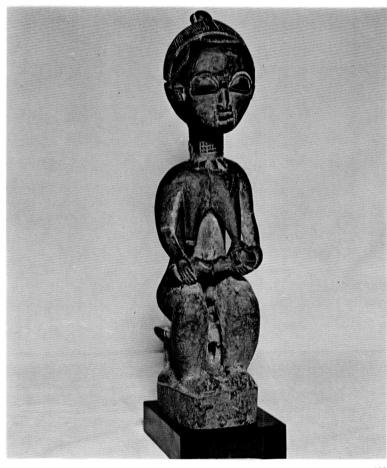

199

Echoing the mid-facial horizontal crease are swelling, ringlike circles of a massive neck, the diameter of which at the base equals the widest section of the face above (usually the zone containing the small but pursed mouth). Paired, tripled, or quadrupled rows of short, incised or grooved accents interrupt the otherwise bland surface. This interpretation of the face is common also to the emergent half-figures of Mendi divination bowls mentioned above and to most full-length statues. It is also found in heads or busts which crowned ceremonial staffs, the latter being another characteristic Mendi sculptural form.

The Bundu, or Sande, helmet mask and the heads or faces related to it throughout Mendi art comprise a suave but imaginative expression as distinctively West African as the Chi-wara antelope dance headpiece, the ancient Dogon ancestral figures, the Baga Nimba creations, and the Dan-Ngere mask types.

The Senufo

The peoples called the Senufo, Guro, and Baoule inhabit, respectively, the north-central, west-central, and east-central to southeastern districts of the Ivory Coast. The Senufo also range into eastern Upper Volta and southern Mali. It is more often than not the practice to group the art of these tribes in a general context either regionally (Central Guinea Coast) or stylistically; but, if we study the regional complexes in broader format, the three styles seem as closely linked by one or another characteristic to Mali or Guinea Coast modes as to one another. It is as easy to mistake certain Bambara figures for those of the Baoule as it is difficult to distinguish between Guro and Baoule loom pulley busts, for example; and there are Senufo carvings which, unless quite closely studied, may be mistaken for those of any of the peoples mentioned. Bambara works, in fact, have been reported to be present among "collections" in Senufo villages.

The Senufo [38] include more than a score of sub-tribes and number one million in population. Their society, like that of neighboring groups, is fundamentally agrarian. Senufo carvings vary significantly in quality of finish; but, at its best, this style stands as one of the boldest and most imaginative seen in West Africa. Standing and seated figures (single or paired), facial masks, helmet masks, horizontal "firespitter" masks, and elaborately decorated granary doors were created abundantly until the mid-twentieth century. It is not unusual to find quite recent Senufo pieces of excellent

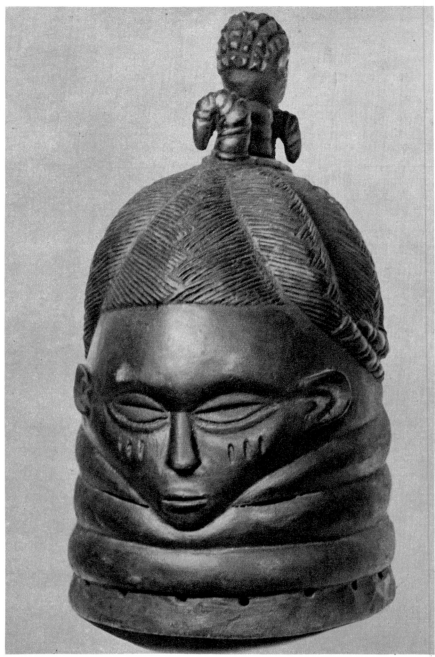

200

200. *Bundu society helmet mask, from Sierra Leone. Mendi. Wood, height 14 1/4". Collection Allen C. Davis, Washington, D.C.*

201. *Korubla society "firespitter" mask, from Ivory Coast. Senufo. Wood, height 37 1/2". Smithsonian Institution, Washington, D.C.*

202. *Mask, from Northeast Congo, Great Lakes Region. Possibly Makonde. Wood, height, 13". Brooklyn Museum, New York.*

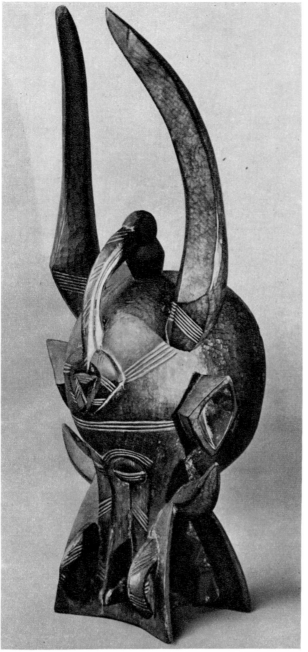

201

One among several prominent Lo statuary types was the seated female figure, sometimes depicted nursing an infant (fig. 203). The protective bird atop the illustrated statue is removable and serves with its base as cover for the container beneath it. A reptilian motif, probably totemic, encircles the vessel. The angularly bent, hornlike element leading downward from the coiffure is a distinctive Senufo form, as are the strongly articulated jawline and rapid transition of its convex shape into the plane of the cheek. The unity of the entire figure with the stool upon which it rests—or from which it seems to grow—is likewise typical of Lo society seated images. This carving is of recent origin and is remarkably large for its type, being almost four feet in height. Female figures, similar in concept but much smaller in scale, were used as crowns of staffs (called *daleu*), which were awarded as prizes for skill in Senufo farming contests. Other seated images, especially paired ones, may represent either male and female ancestors or chieftains and their wives.

The Lo society also sponsored one of the most familiar and haunting forms of all African Negro art: the thinly carved facial mask with simplified, leglike appendages issuing from the ear- or cheekline; a sharply demarcated mouth set at the juncture of the prognathous jaw and the convexities of the cheeks; and striated markings leading diagonally across part of the face from the bridge of the nose or the corners of the mouth. Horns or pointed lobes usually surmount the head. These masks were called *kpélié* and were used in initiation rites by the Lo. There can be no doubt but that this was among the first kinds of African Negro art to attract Picasso deeply.[39]

conception and technique, although modern craftsmen turn out superficial copies of masterworks on demand. Traditional Senufo sculptors belonged to a prestigious caste who also did metalwork and pottery.

The Lo society was responsible for the commissioning of objects used in agricultural and other fertility rites and at initiations or ceremonies where Lo members were raised in status. Masks and figures of more secret kinds were closely protected inside a cult sanctuary, although a Senufo family might own pieces of almost identical type and display them publicly. A consciousness of style and quality was evident in most such works, and there can be no question but that the trained professional, whatever may have been the tribal dictate, was independently imaginative in interpreting traditional forms.

202

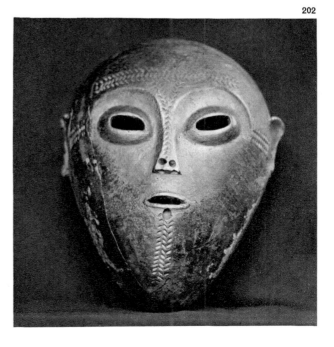

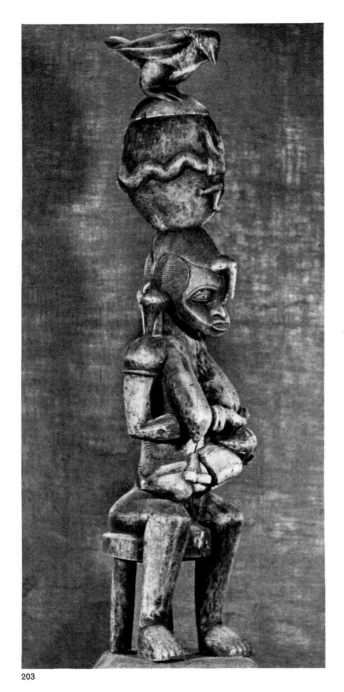

203

An equally exciting and familiar mask is the Korubla society "firespitter" (figs. 201, 204), a weird, grotesquely formed synthesis of the facial components of various mammals and amphibians—the baboon, warthog, buffalo, hyena, crocodile, and other creatures. A constant element is the open-jawed mouth, often hostile, sometimes grinning with an astonishing array of tusks. The latter might be pointed and widely separated, or peglike and bridging together the upper and lower jaws. "Firespitters" were helmet masks worn horizontally or at a slight tilt over the head. A cloak of fiber or cloth suspended from the helmet concealed much of the dancer's body. These objects were worn at night in clamorous chases which were intended to rid the community of demons who robbed tribespeople of their souls. There is a belief that these masks took their name from the wearers' practice of igniting and discharging flammable material from the gaping mouths; but "firespitters" are rarely seen which are actually scorched or charred as might be expected.

The Guro

The Guro are situated between the Dan-Ngere and the Baoule tribes. They number about one hundred thousand. The sculpture of this people is one of the most highly sophisticated arts of all Negro Africa, rivaling for sheer elegance that of the nearby Baoule. Artists were professionals or gifted amateurs. Masks (figs. 205, 211) and heddle pulleys for hand looms, both using the human head or bust as a partially functional subject, were the principal

204

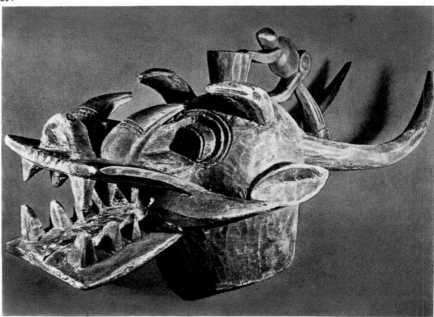

203. *Lo society maternity figure, from northern Ivory Coast or Mali. Senufo. Wood, height 46 3/8 ". Oakland University, Rochester, Michigan. Gift of The Hon. G. Mennen Williams.*

204. *Korubla society "firespitter" mask, from Ivory Coast. Senufo. Wood. Museo Pigorini, Rome.*

156

forms. Full figures were rarely carved. Figure 206 represents an especially handsome loom pulley type in head form. The prognathousness of the lower face brings to mind Senufo style, but refinement of handling is greater in the Guro example.

Horned masks of consummate finish were used by secret society "vigilantes" who, not unlike the Senufo "firespitter" stalwarts, held sorties by night against witches. A related form, strong in conception but delicate in surface detail (fig. 211), is the Zamle society dance mask. This form was used in both public entertainment and fertility rites. Its face is a masterpiece for the subtlety of transition of plane to convexity. There are delicate tensions between the lower part of the piece and the bird standing wide-legged upon the curved horns. Certain masks of the Zamle cult are surmounted by paired human figures, one of the infrequent uses of that image seen in Guro art.

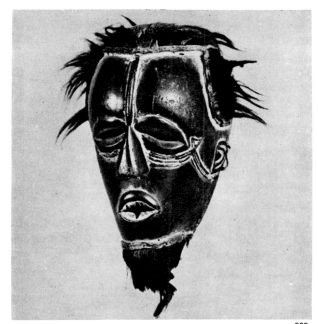

205

The Baoule

The Baoule number about five hundred thousand and are known to have settled in their present Ivory Coast habitat in the eighteenth century or earlier. They derived ethnically from the Ashanti of Ghana, an aristocratic, monarchically governed people. The Baoule, before moving westward, had already assimilated a high form of tribal culture. Their art, aside from its occasional appearance in the favored Ashanti medium of metals, has only a limited connection with Ghanaian expression.

205. Mask, from central Ivory Coast. Guro. Wood, height 9 7/8". Collection Christophe Tzara, Paris.

206, 207. Heddle pulleys, from the Ivory Coast. Guro. Wood, height c. 7–8 1/2". Private collection.

208, 209. Heddle pulleys, from the Ivory Coast. Baoule. Wood, height c. 7–8 1/2". Private collection.

210. Heddle pulley, from Ivory Coast. Guro. Wood, height 9". Collection Carl Kjersmeier, Copenhagen.

206
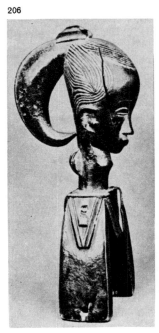

207
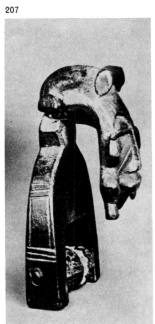

208
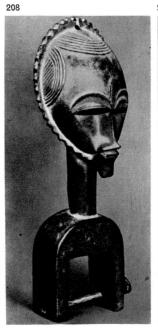

209
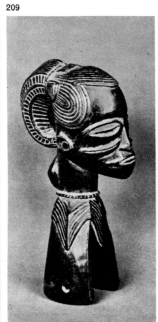

210
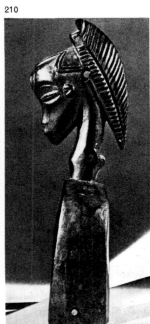

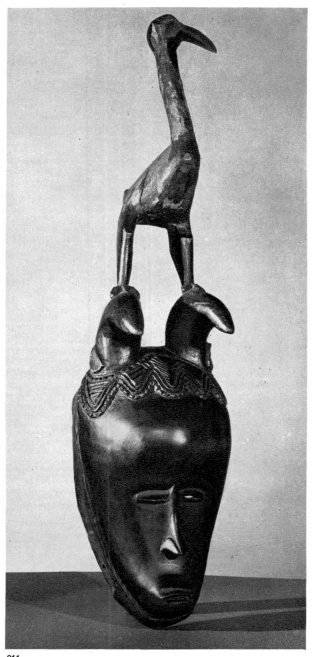

211

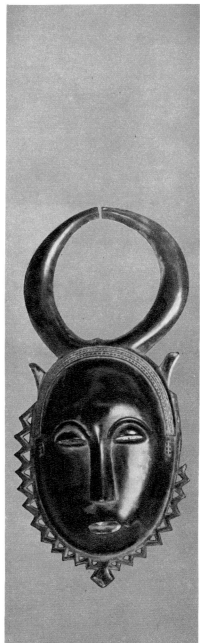

212

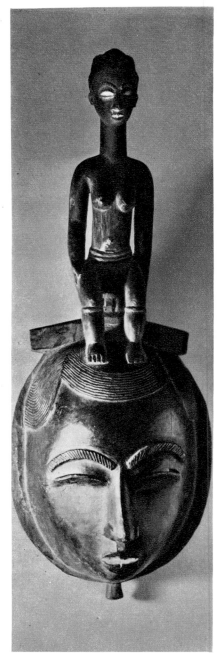

213

Rather, the Baoule have independently developed an eloquent, extraordinarily refined style of their own in wood carving. Although sometimes matched by the Guro in craftsmanship as such, the Baoule impart to their carvings an incomparable seductiveness of surface detail as well as a deceptive complexity of structure.

The human figure in the round, seated or standing (figs. 199, 219, 220, colorplates), is the characteristic theme of Baoule carvings. Pristine elegance of technique and subtlety of over-all composition are paramount in these powerful little images. Most of them are from twelve to twenty-four inches in height. A circular base, designed as part of the entire structure, is nearly always present. The delicacy of such carved detail as the tribal scarification marks is paralleled by the great dignity and

211. Zamle society dance mask, from Ivory Coast. Guro. Wood, height 20 1/2". The University Museum, Philadelphia.

212. Horned dance mask, from Ivory Coast. Baoule. Wood, height 15". Indiana University Museum of Art, Bloomington.

213. Mask with figure, from Ivory Coast. Baoule (Yaure style). Wood, height 19". Judith Small Galleries, Inc., New York.

214. Bovine helmet mask, from Ivory Coast. Baoule. Wood, painted blue, white, black, and red; length 31 5/8", height 15 7/8". Oakland University, Rochester, Michigan.

158

half-disguised asymmetry of the posture. Each part of the body, from the finely striated coiffure to the simplified delineation of the ankles and feet, appears to be emphatically articulated in itself, yet all these elements relate rhythmically to one another. The legs, firmly modeled, are comparatively heavy and short; other sections of the form are elongated. The arms are typically treated in relief and fold across the midsection. The face is remarkable for its serenity and quiet power. The observer can deeply enjoy the exquisiteness of Baoule figures either at a glance or with long scrutiny of the precisely rendered individual elements.

Unlike the neighboring Senufo and Guro, the Baoule did not develop strong secret societies which demanded quantities of ritual figures; and images were as often as not created exclusively for the sake of aesthetic appreciation. In other instances they were intended to be repositories for departed ancestral spirits or representations of deities. It is possible, though by no means certain, that some figures were actually portraits.

Masks were also abundantly produced by the Baoule (figs. 212, 213). Their resemblance to Guro types is close, although the flanged, triangularly notched beard appearing on the horned mask is an interpretation seldom seen outside Baoule provenience. The rhythmic connection of the circular arrangement of the horns with the oval of the face beneath is subtly underscored by the presence of tiny, pointed ears which lie between. The nearly closed, heavy-lidded eyes are characteristic. Adaptation of the miniature human figure to a mask form (fig. 213) comes from the Yaure subtribe of the Baoule. The single large loop of hair above the forehead of this old and splendid

work distinguishes it from otherwise very similar Guro pieces in which the hairline is typically given multiple scallops, sometimes angular rather than curved. The tiny, knoblike pendants beneath the chins of these masks are another sign of their Baoule origin. Both illustrated works have eyes which are pierced completely through the mask. Many such elegant Baoule masks have only partial perforation or linear definition of the eye, and it is reasonable to assume that they were created for the purpose of connoisseurship rather than for actual wear during dances. Totemic meaning may well be present in the figure atop the one carving, but the exact purpose of this variety of Baoule mask in not known. Some masks, like the full-length figures referred to above, may have represented deities, but they appeared in both secret and public ceremonies.

Most Baoule sculpture was shaped out of a hard, medium-dark wood. Staining and rubbing with wood powder imparted a fine blush to the surface. Painted finishes were also important in one variety of Baoule mask, the bovine helmet form (fig. 214) used in *goli* dances which were intended to avert or expunge the presence of evil spirits. These provocative pieces, worn at a slant so that the dancer might see out through the mouth-opening, were carved of a pale, lightweight wood and polychromed with red, blue, black, and white in strong contrasts. The use of paint renders more startling the spiraled design of the backswept horns, the rhythmically connected upthrust tongue, and the staring eyes. Like the Guro, the Baoule sponsored art as a professional as well as religious activity. Sculptors were individually known by reputation and some of them were summoned from one village to the next for their creative services. The collecting and displaying of personally owned sculptures was a meaningful aspect of Baoule culture. As they were perhaps the most technically gifted of all West African art-producing peoples, so were they extraordinarily sensitive to the understanding of sculpture for its artistic values.

The Ashanti

The Ashanti [40] of Ghana are a great tribe of about a million and a half who once monarchically ruled the Gold Coast area that they now occupy. They were warlike and independent but were finally brought under British colonial rule toward the end of the nineteenth century. The Ghanaians, like most other West

214

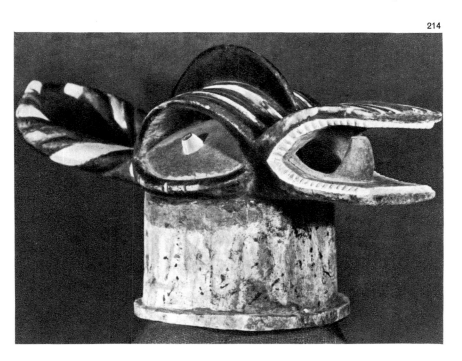

African colonial groups, regained indigenous government in the 1950s. Gold dust was once abundant at surface mines, which were controlled by Ashanti royalty, who, for obviously prestigious reasons, supported a courtly art. The most popular of sculptures by these people are the tiny gold weights (fig. 216), cast in brass or bronze by the lost-wax method. Like the precious metal against which they served as counterbalances, these weights were owned by privileged families. They represent a plethora of subjects based upon the human figure, quadrupeds, reptiles, fish, insects, and plant growths. Their sculptural quality is all too often lost, unhappily, when they are shown in crowded batches in museums or photographic reproductions. Taken singly, some of them reveal genuine aesthetic merit. Most are less than three inches in height.

The Ashanti also cast a unique type of ritual urn known as the *kuduo* (fig. 217). This vessel is circular in plan and is usually eight to twelve inches high. Its opening, smaller in diameter than the swelling lower section near the base, is covered by a hinged lid, upon which appears an ancestral figure or a pair of struggling animals. The base is indented or perforated by vertical flutings. The metallic surface is exquisitely finished with cast or chased geometrical and floral patterns. The *kuduo* is venerated in the *ntoro* and *afodie* rites (among others). The husband, who is identifiable with the *ntoro* spirit of virility, and wife celebrate the conception of a child by performing an elaborate rite in the urn's presence. Upon the death of the owner, the *kuduo* is buried near or with him. Most of these vessels have been recovered at burial sites.

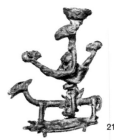

215. Proverb gold weight, from Ivory Coast. Baoule. Brass, height c. 1 1/2". Private collection, Italy.

216. Gold weight, from Ghana. Ashanti. Brass, height c. 2". Collection John J. Klejman, New York.

217. Ritual urn (kuduo), from Ghana. Ashanti. Bronze, height 10 5/8". The Museum of Primitive Art, New York.

218. Fertility dolls (akua'ba), from Ghana. Ashanti. Wood, height of two figures on right, 13 1/2 and 15 1/2". Royal Ontario Museum of Archaeology, Toronto.

219, 220. Figure of a standing woman (side and front view), from Ivory Coast. Baoule. Wood, height 14 3/4". Collection Harry Bober, New York.

The principal Ashanti art in the medium of wood was the *akua'ba* or girl's fertility doll (fig. 218). To judge from the comparative conditions of surface, the figures illustrated here belong to a more ancient style than does a second variety which has more or less naturalistic arms and legs. The discoid head, the remarkably simplified facial components, tube-like torsos, and ringed necks are common to both old and more recent kinds. These objects, most of them between ten and sixteen inches in height, were carried by young girls, and possibly by pregnant women as well, to assure the birth of sound and beautiful offspring.

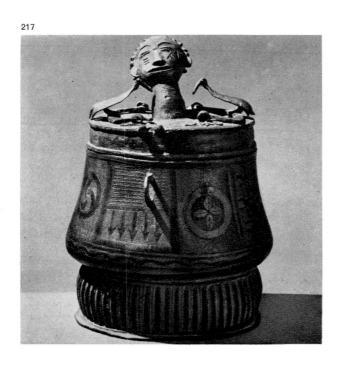

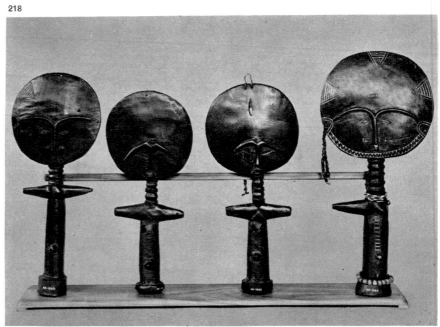

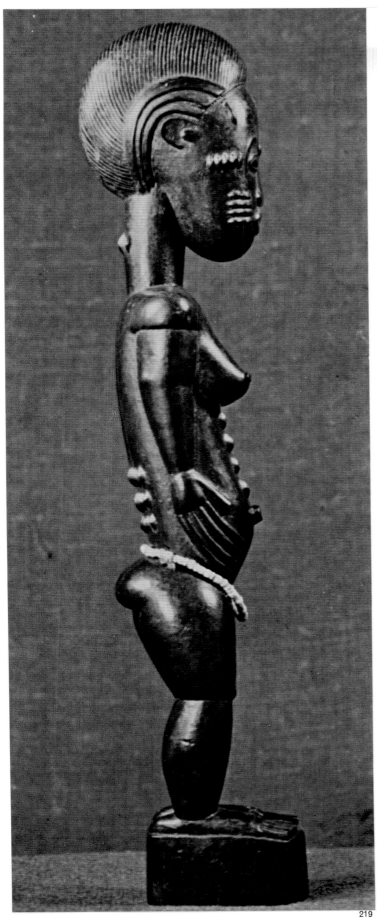

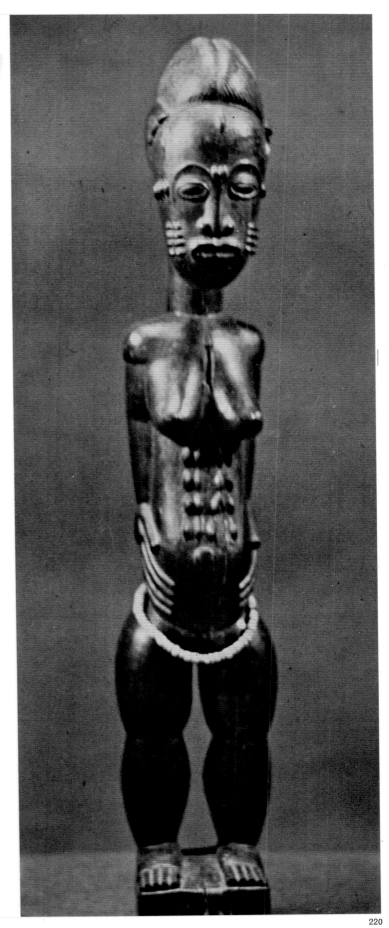

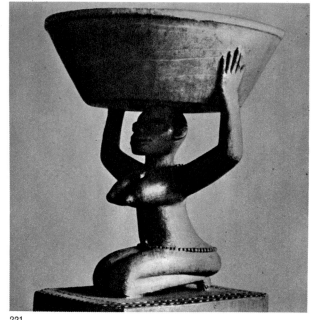

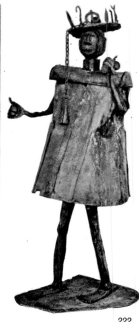

221. *Kneeling female figure supporting a bowl, used in the Fa cult, from Dahomey. Fon. British Museum, London.*

222. *The god of war and metal, Gu(?), from Dahomey. Fon. 19th century. Wrought iron, over lifesize. Musée de l'Homme, Paris.*

221

222

It is feasible, on the basis of comparing carefully selected works in small numbers, to relate Ashanti style to that of certain other areas of West Africa;[41] but a close study of Ashanti art does not confirm major affinities with outlying tribal styles.

Neighbors of the Ashanti, the Kwahu and Fanti peoples, have produced an interesting terra-cotta art of funerary heads and vessels in a style which dates probably from the late seventeenth century. It appears to relate to Ashanti figural concepts.

Dahomey

Dahomey was at one time a militant and widespread kingdom, immensely wealthy from the slave trade until that commerce was abolished in the 1860s.[42] Its art was created principally for the royalty of Abomey, a line which appears to have reached back to the sixteenth century. The French occupied Dahomey in 1872, removing many prestigious courtly sculptures to Europe.

An over-life-sized wrought-iron figure from the Fon tribe, now in the Musée de l'Homme in Paris (fig. 222), is one of the most fantastic metal sculptures of any African provenience. This weird contraption may be a cult image representing Gu, the Dahoman god of war and iron. Its astonishing technique is one of construction or assemblage rather than casting; and it anticipates the Surrealist-Expressionist works of Germaine Richier and certain aspects of New York "Action" and Pop Art. These recent Western trends enable us more cogently to approach the grotesque, haunting imagery of the Fon work.

Dahoman metal arts were largely controlled by the royalty. Small brass figures, cast in the lost-wax process and at first glance reminiscent of Ashanti brass gold weights, depicted the familiar subjects of everyday life—domesticated animals, hunters, individuals carrying parcels. They invariably convey a sense of

movement. Their purpose was not functional; they were objects of connoisseurship; and the quality of surface was typically more refined than that of Ashanti weights. Another classification of art in metal was more formal in conception and represented animals emblematic of royalty. These were made by joining small plates of silver over wooden armatures.

Bold, handsomely appliquéd textiles, as well as gourds patterned with delicately incised tracery, were mediums also reserved in the main for courtly use.

Wood carving was the only Dahoman art freely accessible to nonaristocratic groups (fig. 221). Deity figures, most of them produced by the Yoruba, whose style was centered farther east in Nigeria, and certain decorated functional objects such as stools, vessels, and implements, belong to this genre. The quality of conception and finish vary noticeably from one object to the next.

The Ife, Bini, and Yoruba

An extraordinarily great treasure of Negro African art was developed in southern Nigeria by three outstanding groups, the Ife, the Bini, and the Yoruba.[43] While each of these tribes established a unique tradition, it is possible to refer to the unifying principle among them of a full-volumed, basically naturalistic concept plus thorough and imaginative development of the sculptured surface. The Bini and Ife are renowned for their art in cast metal, the recent Yoruba for their wood carvings. There was also a fairly extensive practice of ivory carving

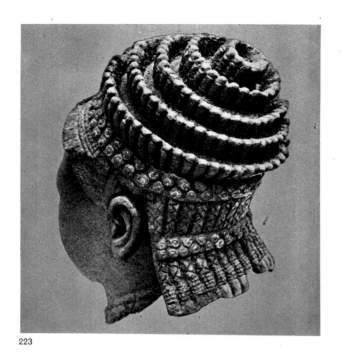

223

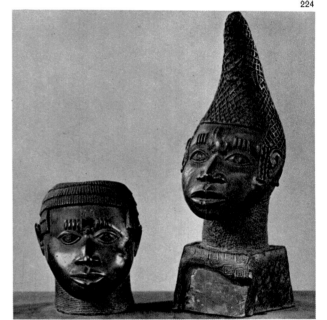

224

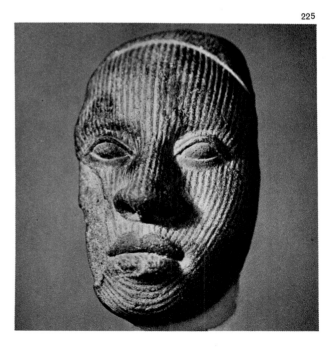

225

223. *Female head, from Ife, Nigeria. c. 11th–15th century. Terra cotta. Ife Museum. Oni of Ife Collection.*

224. *Two heads, from Benin, Nigeria. Bini. Bronze. The University Museum, Philadelphia.*

225. *Head, from Ife, Nigeria. Terra cotta, height 5 1/8". Collection Guennol, New York.*

in southwestern Nigeria which still obtains among the Yoruba, though it now lacks the conviction of the older style.

Remarkably lifelike terra-cotta and metallic heads of ancient Ife provenience were discovered by Leo Frobenius [44] and reported in 1910 (figs. 223, 225, 229). Because such sensitive naturalism appeared at the time to be altogether out of context with better-known African Negro arts, early students of Ife style not illogically attributed its origins to other peoples—for example, the ancient Etruscans, Egyptians, or other Near- or Middle- or Far-Eastern sources. The likelihood of such influences still may not be dismissed. But it is by now clearly established that, in any case, the Ife (and the neighboring Bini as well) had developed, centuries before the arrival of the first recorded European traders and navigators, a flourishing, advanced style and metal-casting technique. These people used the lost-wax method so artfully that their bronze and brass works rival in technological quality the best of Renaissance or other Western European cast sculptures. The Ife style was restricted to royal use and the principal subjects are representations—in certain cases, possibly portraits—of the divine Onis (or kings). One complete figure, in addition to the heads and a few masks, has been discovered. These are the most naturalistic sculptures yet to appear in Negro Africa. Because of that quality plus their conjectural origin, they have become, with the related Bini bronzes, one of the most widely admired arts of West Africa. But with the growth in public as well as scholarly understanding of vanguard kinds of recent Western sculpture, it is likely that the less naturalistic African traditions will become the more deeply admired.

163

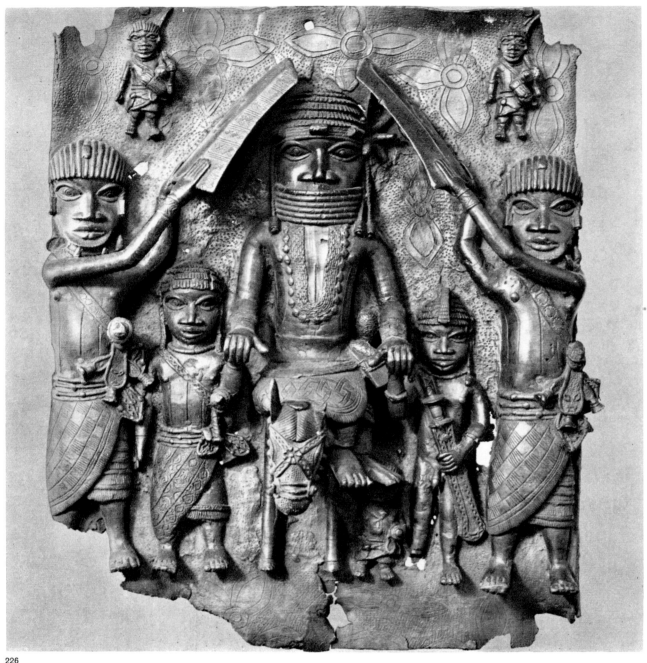

226

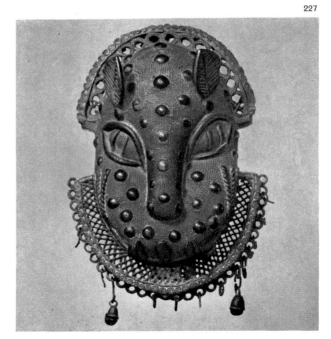

227

According to the oral history of the Bini, their Oba (king) at Benin City secured the services of an Ife master bronzeworker late in the thirteenth century. We do not know whether the Bini were already producing a wood carving expression related to the cast-metal style which resulted from this visit; but an imaginative flowering of bronze and brass sculpture followed, controlled, as was the great tradition at Ife, by the royal court. Subjects and forms included likenesses or formalized representations of Obas and queen mothers (fig. 224); royal altar stands (fig. 240, color-plate); small, full-length figures of nobility or courtly retainers (fig. 241, colorplate); relief plaques of narrative meaning, utilized as orna-mental and protective coverings for the mud-brick pillars of the palace compound (fig. 226); and other reliefs, usually figured with an animal

164

226. *Plaque showing a king and his attendants, from Benin, Nigeria. Bini. Bronze, height 19 1/2". The Museum of Primitive Art, New York.*

227. *Girdle pendant in the form of a leopard mask, from Benin, Nigeria. Bini. Bronze, height 8 1/4". Allen Art Museum, Oberlin College, Ohio.*

228. *Twin figures* (ibedji), *from Nigeria. Yoruba. Wood. Left: height 12". Collection Allen C. Davis, Washington, D.C. Right: height 9". Smithsonian Institution, Washington, D.C.*

229. *Head, from Ife, Nigeria. Brass, height 12". Ife Museum. Oni of Ife Collection.*

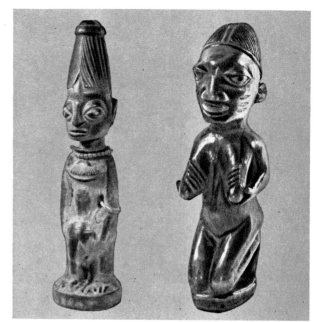

228

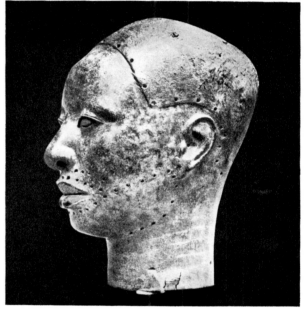

229

or fish form, and worn by the Obas as waistband or girdle pendants (fig. 227).

Benin court sculptors also made appealing bronze animals, especially leopards, which were an emblem of the Oba's authority. Metallic ritual objects such as gongs, staffs, and bells were cast for use at the altars where the Oba paid sacrificial homage to ancestors.

Benin also provided an ivory-carving tradition which included finely relieved and incised elephant tusks intended for insertion into openings in the bronze royal heads. There were also ivory masks and bracelets carved in openwork, as well as a limited number of smallish full figures. One phase of Bini art in this medium was encouraged and at least thematically influenced by Portuguese visitors after the late fifteenth century.

Benin art is generally less softly naturalistic and is more inclined toward schematization and descriptive detail than that of the Ife; but its heavier, earthier (despite its courtly function) characteristics are in themselves deeply impressive. It is one of the most memorable of older West African artistic traditions.

The Yoruba tribe is one of Africa's largest. Its five million or more members now inhabit central and southwestern Nigeria as well as parts of Dahomey. They are ethnically linked with the ancient Ife, although we think of their art as typically representing a more recent and still extant style.[45]

Most modern Yoruba who have retained tribal customs are farmers. They observe fertility rites and sustain the old beliefs in hundreds of nature-spirits. There is a special cult which honors Shango, the king who after death, according to legend, became god of lightning and bringer of fertility to women.

Shango is honored in Yoruba sculpture by half-crouching female shrine figures with double-ax forms atop the head. The god himself appears as an equestrian figure (fig. 242, colorplate).[46] The illustrated work is an exceptionally fine, traditional Yoruba carving of its type, its surface beautifully patinated from rubbing with deep-red wood powder.

Another type of figure is called the *ibedji*, or twin (fig. 228), and is sometimes seen as one of a pair. It appears under sponsorship of the Ibedji cult in most parts of Yoruba territory. If one of a pair of twins dies, a carving is created in his memory and is cared for by the surviving sibling. Because actual twins are regarded as sacred by the Yoruba, these cult figures occupy a deeply venerated place in the culture and may be preserved for several generations.

165

Various masks are still used by the Yoruba in religious and secular rites. The Gelede society holds yearly dances and dramas at which a special type of mask is worn horizontally on top of the head. A northern Yoruba variety is the complicated helmet mask, known as the *epa*, often three feet or more in height and worn vertically. It is elaborately figured with a superposed deck bearing figurines of horsemen or animals.

Yoruba forms in wood also include staff-top figures of women nursing children, double-tiered chieftains' stools with caryatid figures, and many kinds of vessels, some of which are used ceremonially. Regardless of the purpose or subject, however, the characteristics of style in Yoruba carving are consistent. Their expression is one of the most distinctive in all Negro African art. Fundamentally naturalistic, it strongly exaggerates certain aspects of actual Yoruba physiognomy, especially the wide base of the nose and the heavy lips. The eye is biggish and heavy-lidded in form yet persistent in its stare. The head is usually greatly overscale in proportion to other parts of the body. Scarification marks are in most instances deeply pierced rather than raised. Large, even bulbous volumes are typical.

Although painted accents were present in many older Yoruba sculptures, extensive and often garish polychromy has become a regrettable component of the commercial export or tourist art of this tribe. Another unfortunate recent tendency is the piling up of tiny forms upon main sculptural masses to such an extent that the essential structure becomes obscured. But the traditional Yoruba contribution to African art history has been rich and extraordinarily abundant.

The Ibo and Ibibio

The several tribes who inhabit the Niger River Delta, east and south of the Bini and Yoruba, developed styles not distinctly related to those of either West or Central Africa. Among these peoples are the Ibo, a tribe almost as huge as the Yoruba, and the Ibibio. Both are located in the Cross River district.

Secret societies were dominant forces here and, with ancestor worship, motivated the creation of ritual objects. An Ibo mask of menacing expression and terse design is shown in figure 230. This type of object, the essential form of which was derived from the human skull, was used by the Maw (Mmwo) society at Ibo funeral

230. Maw society mask, from southern Nigeria. Ibo. Wood, height 16 7/8". The American Museum of Natural History, New York.

231. Post with equestrian deity figure, from the royal palace of Savé, Dahomey. Painted wood, height c. 53". Musée de l'Homme, Paris.

232. Ekpo society mask, from Nigeria. Ibibio. Wood, height 13 3/4". Lindenmuseum, Stuttgart.

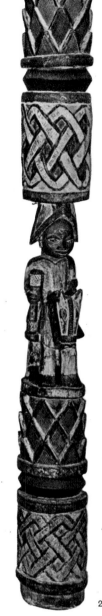

231

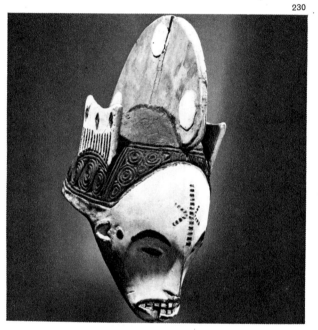

230

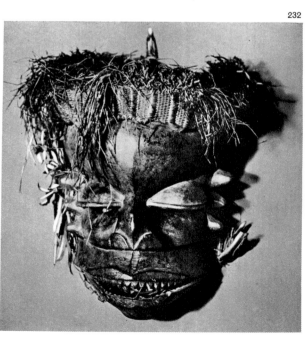

232

166

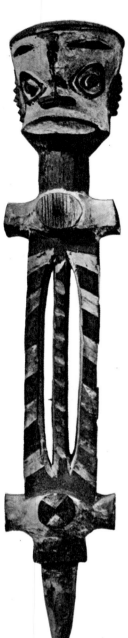

233

233. *Stylized figure, from Nigeria. Ibibio. Wood, height c. 15". British Museum, London*

234. *Mask, from Cameroon. Bamum. Wood, height 18 1/2". Collection Carl Kjersmeier, Copenhagen.*

235. *Standing figure, from central Cameroon. Wood, height 15 1/2". Chicago Natural History Museum.*

236. *Mask with movable jaw, from Nigeria. Ibibio. Wood. Collection Carl Kjersmeier, Copenhagen.*

234

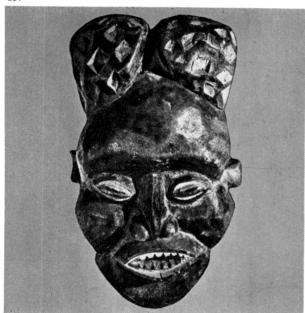

235

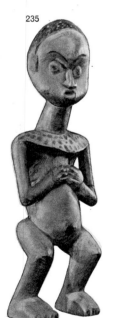

236

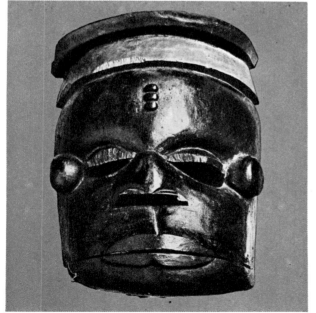

and agricultural rites. Ancestors were believed to speak through the hostile, grimacing mouths of these apparitionlike pieces.

Other characteristic Ibo art forms were *ikenga* figures, usually seated in pose and symbolical of moral virtues sought or admired by the owner, and clay figures which were modeled over thin wooden armatures. The latter were presented at the dedication of religious buildings.

The Ibibio are a Bantu linguistic group, unlike their Sudanic-speaking neighbors the Ibo; but the two tribes share many cultural traits. Their artistic styles are at least generally kindred. A humorous-looking mask is shown (fig. 232) by way of contrast to the frightening, skull-like imagery of the Ibo work referred to above. Ibibio pieces of this kind were worn at the harvest festivals and at the less fearsome rites of the Ekpo society, an organization once so exclusively secret that nonmembers discovered watching its performances might be killed outright.

Other art-producing tribes of the Niger River Delta are the Ekoi, best known for their carved wood, skin-covered sculptures of the human head, and the Ijaw, whose masks combined bold geometric patterns with animal faces. Funeral rites and ancestral worship were responsible here, as among the Ibo and Ibibio, for a variety of art forms.

Cameroon

There are two principal artistic regions in Cameroon: one the rain forest near the coast; the second an inland plateau called the Grasslands, the average altitude of which is about four thousand feet. The Grasslands was the home of most of the art-producing tribes, namely, the Bamum, Bafum, Bamileke, Bali, and Bangwa. Many Cameroon artists were professionals who traveled from one village to another.

There was a courtly as well as a secret-society sponsorship of art. Sculpture was carried out in wood, terra cotta, and brass. An abundance of ritual figures, masks (fig. 234), pipebowls, door-lintel reliefs, thrones, and elaborate vessels developed in this area. Cameroon art is in the main boldly conceived and forcefully executed, some masks and figures emanating a startled, grotesque expression. This vigor of form, combined with either implicit or actual movement (fig. 235), is the distinctive quality of Grasslands aesthetic. Paul Wingert has referred to Cameroon style as the most homogeneous of any large region of Negro Africa.[47]

167

Central and East Africa

For the purposes of our study, Central and East Africa embrace Gabon, the Congo (Congo-Brazzaville and Congo-Kinshasa or the former Belgian Congo), and parts of Angola, Zambia (formerly Northern Rhodesia), and Tanzania (Tanganyika). The political structure and means of livelihood of this immense territory do not differ sharply from their counterparts in West Africa. The village remains a significant sociological unit, and agriculture, usually reinforced by some degree of hunting or cattle raising, is the chief means of subsistence. Most art-producing peoples, especially those of the Central Congo, are located near one of the numerous large rivers of this area. The climate is considerably wetter here than in most areas whose art we have examined. This region is also more heavily forested, although there are some great inland plains and plateaus. Almost all tribal inhabitants of the Congo speak Bantu

rather than Sudanic dialects. Christianity and other European influences reached the Congo in the late fifteenth century.

The Warega (Balega), Mangbetu, Makonde, and Barotse tribes of Central and Eastern Congo, Tanzania, and Zambia dwell in the easternmost division. The coastal tribes of Gabon and the Central Congo mark the western extremity.

Overall, a series of definitive traditions existed, the majority of them related in some degree.[48] The Congo was an area no less quantitatively and stylistically rich in traditional art than was West Africa.

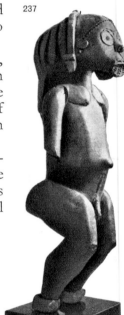

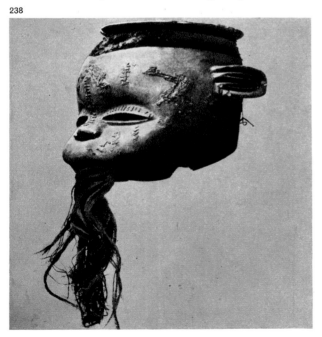

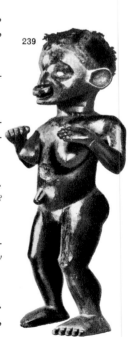

237. Standing male figure, from Gabon. Fang. Wood, height 27 5/8". Formerly collection Sir Jacob Epstein, London.

238. Mask showing labial deformation, from Tanganyika. Makonde. British Museum, London.

239. Standing female figure, from Tanzania. Makonde. Wood, height 29 1/8". Lindenmuseum, Stuttgart.

240. Royal altar stand, from Benin, Nigeria. Bini. Bronze, height 8 1/4". The Museum of Primitive Art, New York.

241. Figurine of an executioner, from Benin, Nigeria. Bini. Bronze. Collection Harry Bober, New York.

242. Divinity figure on horseback, from Nigeria. Yoruba. Wood, height 30". Judith Small Galleries, Inc., New York.

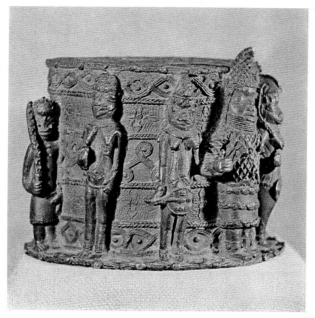

240

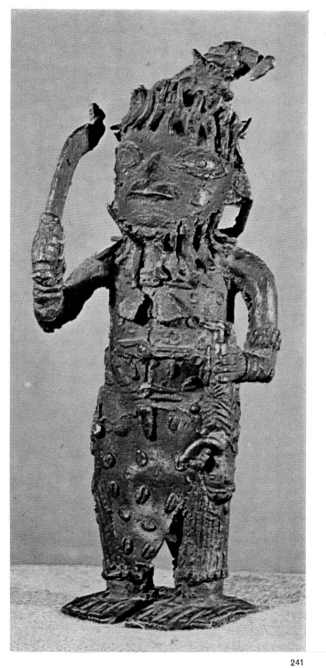

241

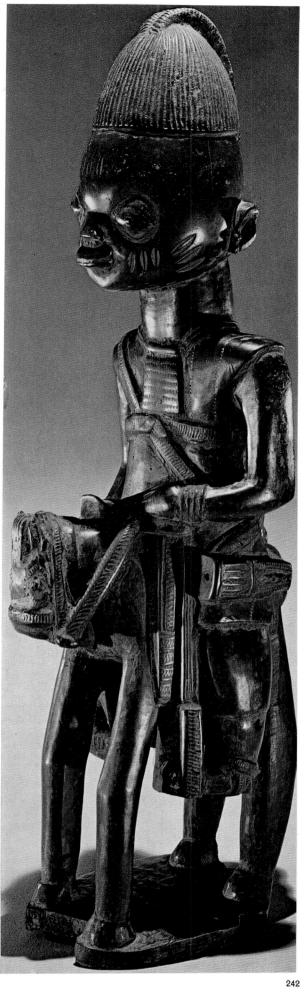

242

The Fang (Pangwe), Bakota, and Ogowe River Styles

The Fang are a populous complex of tribes who live in northern Gabon and Rio Muni. They include the Pangwe (Mpongwe, Pahouin), who are often referred to as a separate group. The Bakota are located to the south on the Ogowe River, along which live various related peoples. Throughout this region there are active ancestral cults and associated secret societies.

Some of the greatest art of Gabon is impelled by funeral rites. Mortuary figures and half figures (northern Fang), highly schematic ancestral "guardian" figures (the Bakota and Osyeba), and "ghost" masks (Ogowe River peoples) are typical forms. Few tribes, however, produce both figures and masks; each appears to specialize in the one form or the other.

Fang mortuary figures (*bieri*) such as the example shown in figure 245 were carved for attachment to barrel-like containers of ancestral skeletons. They were given an extremely dark finish and are powerfully sculpturesque. Main junctures of the body are markedly articulated; but the emphatic verticality of the posture, plus an over-all stressing of geometric masses, yields a convincing unity of parts. Equally powerful half figures and heads (fig. 243) were created for the same ritual purpose and were related to the full-length images. The heads were believed to prevent evil spirits from approaching shrines where ancestral bones were kept.

Bakota ancestral grave figures, known as *mbulu-ngulu* (fig. 265, colorplate), denote a marked contrast to those of the Fang. These works, equally commanding in presence, are among the most nearly abstract sculptures of any African provenience. An extremely stylized, almost two-dimensional head with an oval face and transverse, crescent-shaped coiffure, is

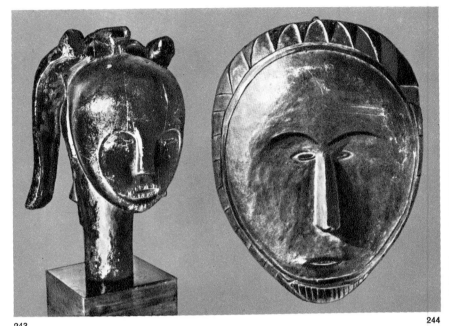

243

244

245

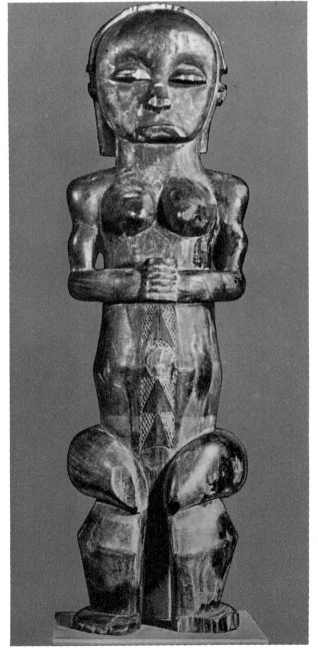

243. Mortuary carving, from Gabon. Fang. Wood, height 15 3/4". Formerly collection Princess Gourielli, Paris.

244. Bronze copy of a Fang mask given to Maurice de Vlaminck.

245. Mortuary figure, from Gabon. Fang. Wood. Musée de l'Homme, Paris.

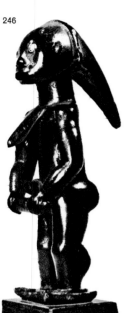

246. *Standing figure, from Gabon. Fang. Wood, height 9". Collection Charles Ratton, Paris.*

247. *Female "ghost" mask, from the Ogowe River region, Gabon. Balumbo-Pangwe. Painted wood, height 8 5/8". Musée de l'Homme, Paris.*

248. *Kneeling male figure, from Congo-Brazzaville. Bakongo. Wood, height 11 3/4". Formerly collection Princess Gourielli, Paris.*

249. *Standing female figure, from Congo-Brazzaville. Bakongo. Wood, height 12 1/2". Indiana University Museum of Art, Bloomington.*

placed atop a cylindrical neck. Immediately beneath the neck is located an open, lozenge-shaped form which may represent either the arms placed akimbo or an entire body in abstracted or conceptualized gestalt. Some of these weird, beautifully imaginative carvings have convex faces which are said to indicate the male sex, or concave ones to indicate the female. All of the figures, however, consist of copper or brass sheets or flatly beaten strips affixed to a wooden armature. The Bakota ancestral funeral figure is a memorable, distinctive class of African Negro art.

Another outstanding form from Gabon is the female "ghost" mask of the Ogowe River tribes and the Balumbo groups nearer the coast (figs. 247; 266, colorplate). A great sensitivity to relationships of plane and volume distinguishes these objects. Most of them are painted with white faces, red lips, and black hair. Lozenge-shaped groupings of scarification marks occur on the forehead and sometimes at the temples. The purpose of these objects, many of which are remarkably beautiful, may have been both protective and commemorative: they were used in ceremonies honoring the departed spirits, and their wearers at times appeared in stilt dances which are said to have been sponsored by the Mukui secret society. An elongated variation of this mask form, also white-faced but far more schematic, was used by males in the Ngi society rites.

The Bakongo

The Bakongo inhabit the southernmost reaches of the Congo River to the west of the political

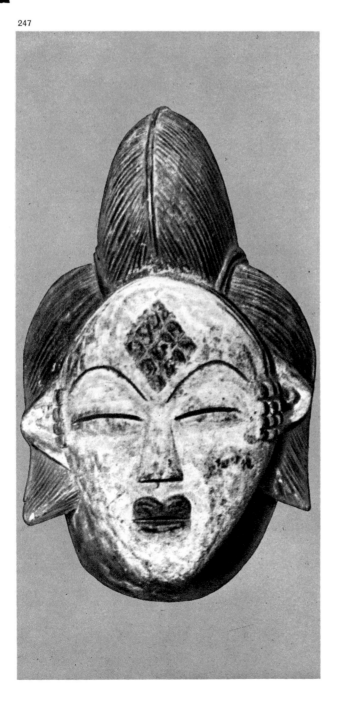

247

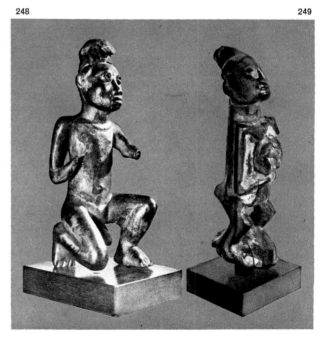

248

249

divisions of Congo-Brazzaville and Congo-Kinshasa. They are a large tribe among whom both traders and missionaries from Europe settled during the late fifteenth century. That fact is used by some scholars to explain the essentially naturalistic basis of Bakongo sculpture (despite the example of Nigeria, where a more naturalistic style existed long before the arrival of Europeans). Commemorative and fetish figures, along with representations of mothers holding children,[49] are the principal forms. Masks are relatively scarce.

The Bakongo-style female fetish figure (fig. 249) combines naturalism with schematized enframement of the umbilical zone. Such figures were designed with abdominal niches into which were pressed sticky substances. This mass would then receive bits of glass, bone fragments, or other "magical" material. Another well-known form was the *konde* or nail fetish into whose surface were pounded spikes or blades (fig. 269). These carvings were petitioned to intervene on behalf of the supplicant for protection or good fortune.

The Bakongo seated mother and child motif is beautifully interpreted in the statue shown in figure 280. The cross-legged pose and the dramatic inclination of the mother's head are typical. Such carvings are usually supported by a low, circular plinth which is organically designed as part of the group. The purpose of these figures is initially commemorative; but in this image the infant has the special abdominal cavity common to mirror fetish carvings. This combined function is not rare in examples of the Bakongo nursing mother and child theme.

Lower Congo works differ considerably in general aesthetic quality, especially in the degree of completeness of surface; but they are typically forceful in conception and vigorous in expressive details.

The Bateke

The Bateke tribes live to the north of Brazzaville and extend into the nearby region of the Congo-Kinshasa Republic. As among the Bakongo, to whom the Bateke are culturally related, fetish figures are a prolific form of art (figs. 250, 251, 253).[50] Each of these carvings combines fundamentally naturalistic elements with geometrical ones. Motifs typical of this style are a hatlike headgear or hairdress which may be conical or crested; a spadelike beard jutting forth diagonally from the chin; and smallish, narrowed eyes with pointed corners. The pose is usually rigid, movement being contained

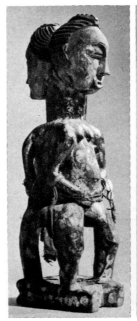
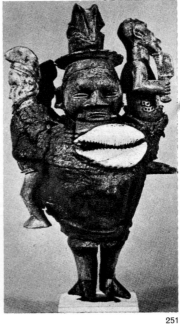

250 251 252

250. *Fetish figure, from Congo-Kinshasa. Bateke. Wood, height 18 1/2". The Museum of Primitive Art, New York.*

251. *Fetish figure, from Congo-Kinshasa. Wood, height 12 1/4". Museum für Völkerkunde, Basel.*

252. *Headdress, from Nigeria. Ekoi. Wood and hide, height 16 1/2". Collection Ernst Anspach, New York.*

253. *Three standing figures, from the Congo. Left to right: Bateke, Mayombe, Bena Lulua. Wood, height of two smaller figures c. 10". Smithsonian Institution, Washington, D.C.*

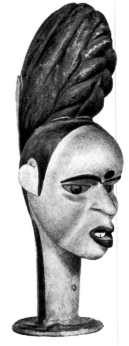

253

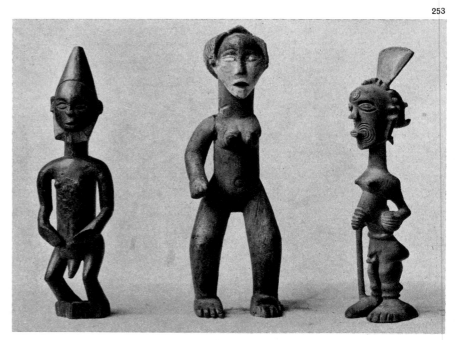

rather than asserted by the flexed legs. Some of these fetishes have geometrically shaped abdominal recesses like those of the Bakongo, while others do not; and they were usually at least partially coated with gummy matter, strips of cloth, or other magical substances. Further like their Bakongo counterparts, Bateke fetishes are by no means of uniformly excellent finish, but they are convincing for an over-all power of sculptural form. Most of them are less than twelve inches in height, although exceptions measure two feet or more.

The Bayaka

An especially distinctive Congo sculptural tradition was developed by the Bayaka,[51] whose villages lie near the Kwango River south of the Bateke area. This stylistic region is sometimes called the Western Congo. Both figures and masks (figs. 254, 255) were produced in large numbers. Most figures were commemorative in purpose; others were used as guardian images at the entrance to ceremonial houses. They vary in degree of technical refinement, but all are powerfully three-dimensional in concept. The principal zones of the body are strongly articulated and distantly suggest Fang mortuary carvings, though they are more schematic that the latter. Legs and arms are usually almost tubular in definition. The head terminates sharply, usually as an inverted, truncated cone or a crested, longitudinally placed headdress not. unlike that seen on typical Bateke fetishes. A squarish beard likewise recalls Bateke facial elements.

254. Mask used in circumcision rites, from the Western Congo. Bayaka. Painted wood with raffia fringe, height 20 1/2". Musée de l'Homme, Paris.

255. Standing figure, from the Western Congo. Bayaka. Wood, height 10 1/2". Musée Royal de l'Afrique Centrale, Tervueren, Belgium.

256. Helmet masks, from the Western Congo. Painted wood and raffia fringe. Left: Basuku, height 23 5/8". Museum Rietberg, Zurich. Von der Heydt Collection. Right: Bayaka, height 22". Sammlung für Völkerkunde, University of Zurich.

257. Woman's mask, from Congo-Kinshasa. Bapende. Wood, cloth, and paint, height c. 11". Indiana University Museum of Art, Bloomington.

254

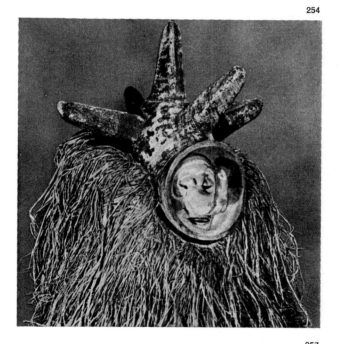

255

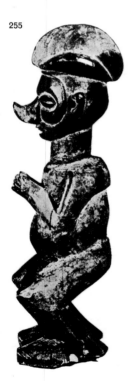

256

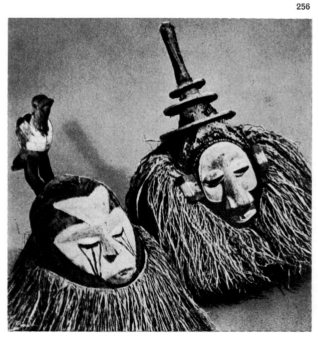

257

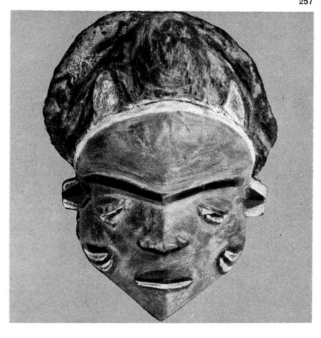

173

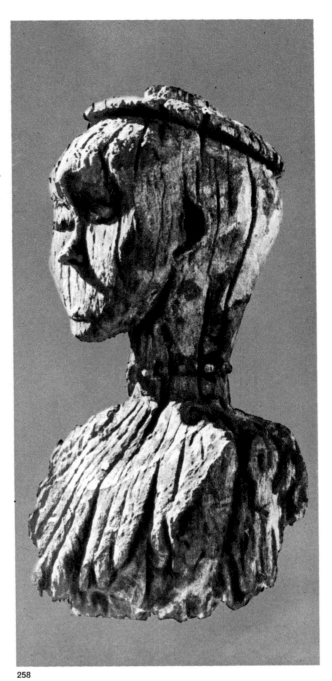

258

258. *Female bust, from Congo–Kinshasa. Bapende. Wood, height 17 1/2". Collection Harold Rome, New York.*

259. *Amulet masks, from Congo–Kinshasa. Bapende. Ivory, height 2". Musée de l'Homme, Paris.*

260. *Initiation mask, from Congo–Kinshasa. Bapende. 19th century. Wood, height 12". Allen Art Museum, Oberlin College, Ohio.*

ancestral spirit during certain dances. All types of Bayaka masks akin to the illustrated example were used at the circumcision rites of young boys. The masks might be recarved or repainted to some extent after each appearance. Some rites were extremely secret; others were publicly performed.

An altogether different treatment of the features appears in the facial masks called *kakunga,* actually the title of adult males who instructed young boys in the *nkanda* school and helped to conduct initiations. Puffy, paint-blackened or reddened cheeks and forehead

259

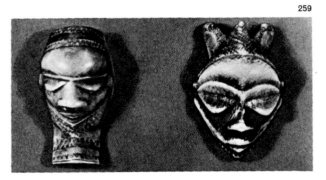

260

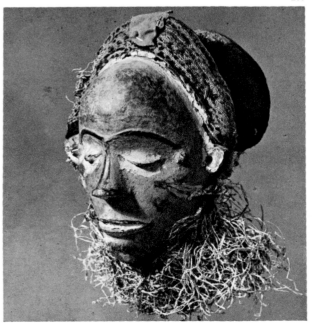

The most distinctive feature of Bayaka figures and masks, however, is the astonishing, upswept nose. Appearing only moderately raised in some carvings, it is frequently given, as in the mask in figure 254, a completely right-angled vertical turn and then curved backward toward its own bridge. This amusing emphasis is unforgettable as an aspect of Bayaka style.

Three types of masks prevailed here as in much of the vast area known formerly as the Belgian Congo—the helmet (fig. 256), facial, and handle varieties. Masks of the handle type were held vertically before the face rather than worn upon it. All varieties were typically painted and surrounded from the temples downward by a thick fringe of raffia. The latter was sometimes long enough to conceal completely the wearer, who represented an

174

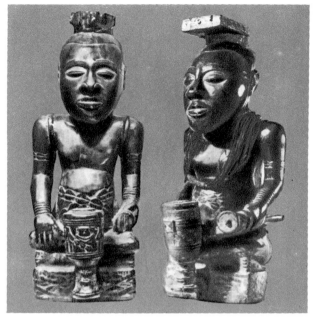

261

contrasted with whitened mouth and eyes to form a threatening visage. Although it relates in its large volumes to the concept of Bayaka commemorative figures, the *kakunga* type appears, if compared with the upturned-nose masks, almost to be the product of a different tribe.

The Bapende

Masks are the principal art form of the Bapende, a group of tribes located near the basin of the Kwilu River and along the nearby Kasai (figs. 257, 260). Their carving style is generally related to that of the Bayaka and Bateke; but certain facial elements clearly distinguish Bapende masks. The area immediately above the

eyes is typically marked by a wide, chevronlike ridge which appears to represent at once completely joined brows and the supraorbital structure. Moreover, the chin is typically more sharply pointed than it is in sculptures of nearby tribes; and the mouth receives a pronounced emphasis either as a result of the notched teeth, which appear between parted lips, or from the use of contrasting painted accents in the same zones (fig. 257). The eyes are almost fully closed and lead downward diagonally from the inner corners. Raised or raised-and-grooved scarification marks appear usually in pairs on the cheeks. The example in figure 260 is an exceptional masterpiece of this class, being more subtly naturalistic in conception and finish than are typical Bapende carvings. Such masks were worn at initiation rites and plays, some representing the spirits of ancestors.

Ivory maskettes and pendants in the form of the human face (fig. 259) and, less often, full-length figures in wood were also produced by these people. The splendid bust shown in figure 258 is evidently the remains of a whole statue once used as a roof ornament on a chief's house.

The Bushongo (Bakuba)

Bushongo art is one of the very greatest of Negro African creative traditions.[52] As stylists, these Central Congo people may be compared favorably with any West African group. Their works range in expressive quality from delicacy to earthiness, but the formal components are found to be remarkably consistent when

262

263

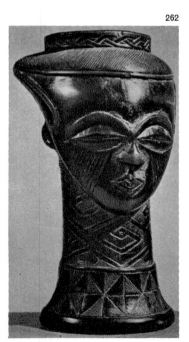
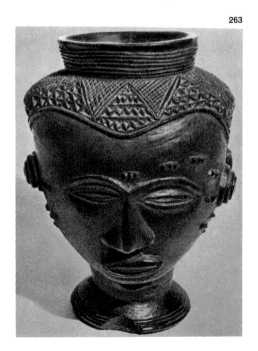

261. Portrait statues of the Bakuba kings Pelenge-Che (left) and Kata Mbula (right), Kasai region, Congo-Kinshasa. Bushongo (Bakuba). Wood, height of figure on right 20 1/8". British Museum, London, and Musée Royal de l'Afrique Centrale, Tervueren, Belgium.

262. Cup in the form of a human head, from Congo-Kinshasa. Bushongo. Wood with traces of tukula powder, height 8 1/4". The Museum of Primitive Art, New York.

263. Cup in the form of a human head, from Congo-Kinshasa. Bushongo. Wood with traces of tukula powder, height 6 1/4". Collection Carl Kjersmeier, Copenhagen.

175

studied in quantity. Much Bushongo figural carving has about it great dignity, even a solemnity. Proportions are invariably sculpturesque and masses are stable and fluidly unified. Wood, by far the most favored medium of the Bushongo carver, is treated with respect for its material qualities of resiliency or toughness as the case may be; but the artist makes no fetish, as it were, of the physical character of the medium. His quest is for sculptural values. Always handsome, often beautifully complete of surface, Bakuba carvings reflect the purpose of their makers to create not elegance of detail but fullness and power of total image. A rich darkness, a space-cleaving wholeness of presence, and superb conceptualization are the constants of Bushongo style.

The Bushongo, better known to other Africans as the Bakuba, are centered in the forested expanse east of the confluence of the Kasai and Sankuru rivers. Their cultural traditions, recorded in official oral legends of the Nyimi's court, appear to have developed since the earlier centuries of the Christian epoch.

Bushongo or Bakuba art, which boasted an advanced style of weaving and metalcraft as well as of sculpture, was chiefly fostered by the ruling caste of the powerful and ancient kingdom in which it flourished. Some master carvers were pledged to work for the court alone. Their status was such that they might be called upon by the monarch to consult in matters of state.

A unique tradition of royal portraiture (fig. 261) was engendered under this system evidently before the seventeenth century. Some of the most distinguished of the few surviving examples are now in the British Museum and the Musée Royal de l'Afrique Centrale in Tervueren, Belgium. The portrait representing Kata Mbula (right), who was, according to seriously treasured oral legend, the 109th Nyimi, dates from about 1810. Kata's image, like most portraits of this type, combines naturalism with what may be called idealized schematization, especially in the interpretation of the features. He presents before his crossed legs the emblem of his reign, an elaborately carved drum. Palenge-Che (left) is interpreted as an equally dignified, reflective monarch. All royal portraits of the Bakuba followed the basic pose seen in these examples; but in the late 1800s the style became increasingly suave and mannered.

The Bushongo fusion of naturalistic forms with schematized particulars, especially those of facial elements, is also present in another unique art form of this region, the cup carved in the image of the human head or figure (figs. 262, 263). We may assume that vessels of

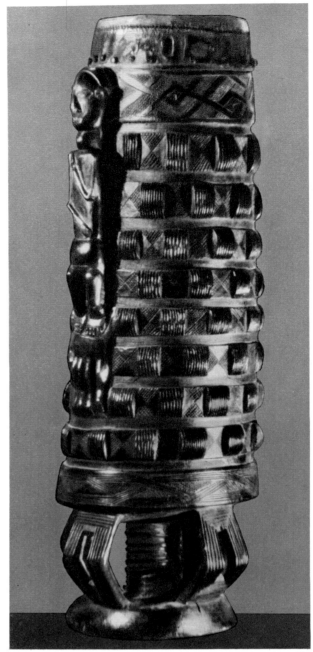

264

264. *Drum with figure, from Congo-Kinshasa. Bushongo. Wood and leather, height 39 1/2". The Museum of Primitive Art, New York.*

265. *Funerary figure, from Gabon. Bakota. Copper and brass sheets over wood, height 23 3/4". The Museum of Primitive Art, New York.*

266. *Female " ghost " mask, from the Ogowe River region, Gabon. Balumbo-Pangwe. Painted wood, height c. 11". The University of Alabama, Tuscaloosa.*

176

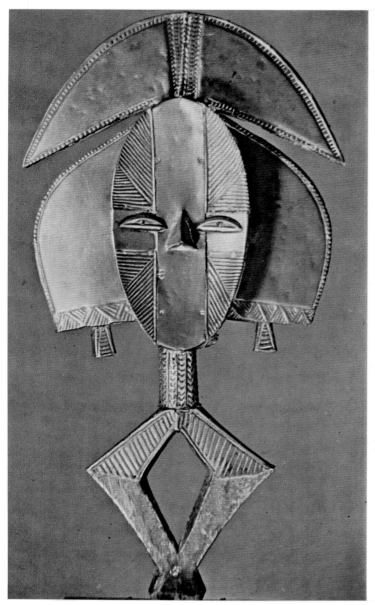

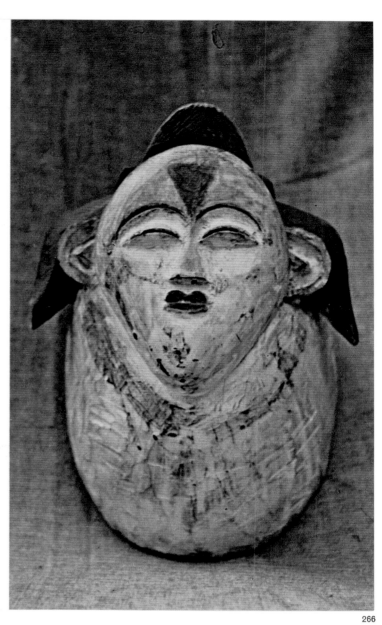

265

266

such fine quality were not utilized for everyday purposes. It is known that men's societies used them in the so-called rite of drinking palm wine, but this "ceremonial" function does not suffice as the full explanation. Torday and Joyce in 1910 reported the alleged employment of such special containers in trials by the ordeal of poison, and other sources have less convincingly suggested their origin in an ancient practice of drinking from human skulls. A more plausible reason for the making of these finely shaped objects is that they met a demand of connoisseurship. Cups of shapes much like European mugs and tallish drinking glasses were also carved by the Bakuba, Bambala, Bashilele, and related groups, and

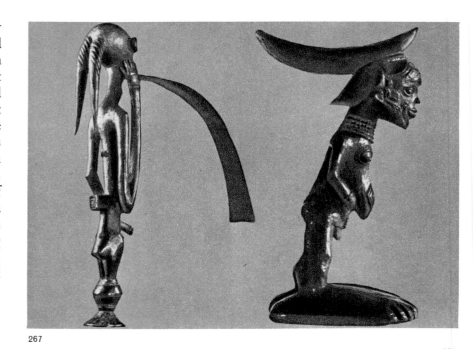

267

267. Ceremonial ax of a woodcarver, from Congo-Kinshasa. Bushongo (Bawongo).

268. Figure (neckrest?), from the Central Congo. Bena Lulua. Musée Royal de l'Afrique Centrale, Tervueren, Belgium.

269. Nail fetish, from the Lower Congo. Bakongo(?) Wood and nails, length 41 3/8". British Museum, London. Webster Plass Collection.

270. Tobacco mortar in the shape of a squatting figure, from the Central Congo. Bena Lulua. Wood, height 5 1/2". Collection Carl Kjersmeier, Copenhagen.

271. Helmet mask, from eastern Congo-Kinshasa. Baluba. Wood, height 25 5/8". Musée Royal de l'Afrique Centrale, Tervueren, Belgium.

268

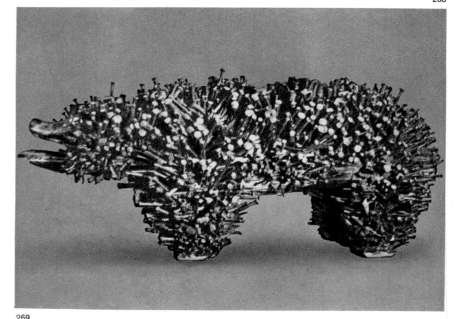

269

270

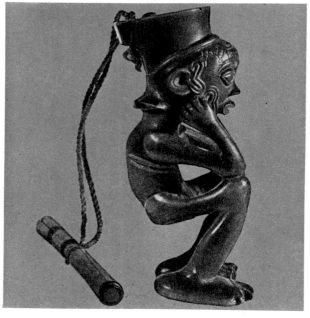

271

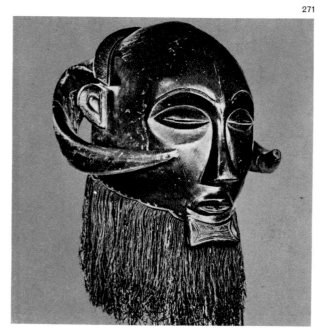

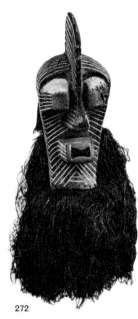

272

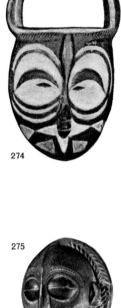

275

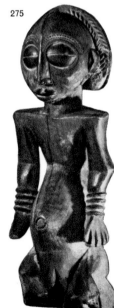

were elaborately incised and relieved with interlaced, crosshatched, and other geometrized patterns, some of them symbolic or heraldic.

The large drums of this area (fig. 264), some of them over three feet in height, are among the finest of Central Congo decorative and utilitarian forms. The entire surface of the illustrated example is activated by geometrical designs quite similar to those found on the cups described above. Some of these patterns also closely resemble the textile motifs and tribal scarifications of the Bakuba. The small, high-relief figure at the left shown standing upon a handlike form is probably symbolic of a military fraternity. This warrior group required its initiates to demonstrate proof of success in battle by displaying the hand of a slain enemy.

The Bushongo tribes also produced several classes of elaborate, sometimes terrifying masks. The type known as *shene-malula*, sponsored by the Babende secret society, was intricately adorned with cowrie shells, trade beads, and paint. Bombo masks, reportedly derived in design from the form of Pygmy skulls, were extensively used in semisecret initiation rites. Carved divination animals of simplified form, used in foretelling the future, was another class of Bushongo sculpture.

The weaving of cloth from raffia fiber was a prolifically and beatifully practiced craft among the Bakuba. Legend holds that the technique was introduced around 1600 by the renowned Nyimi Shamba Bolongongo after he had traveled westward in the Congo. The intricate patterns of Bushongo textiles coincide with those of the geometrically carved vessels mentioned above; and some authorities insist that these designs originated in the woven, rather than sculptured, medium. Evidence fails conclusively to support such a conjecture; nor can we be certain that the prominently raised cicatrices of Bakuba body scarification were not the source of such motifs.

The Bushongo peoples developed one of the most comprehensive and vigorous artistic traditions of Negro Africa.

The Bena Lulua

The Bena Lulua are a small Congolese tribe located south of the Bushongo, from whom they have received various cultural influences. They are related to the Baluba. Their sculpture consists mainly of small standing figures. The exact origin of some types of these is not precisely known, but certain of them may represent ancestors, while others are known

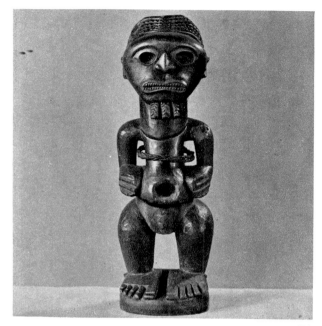

273

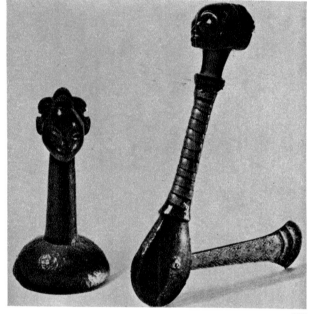

276

272. *Dance mask* (kifwebe), *from central Congo-Kinshasa. Basonge. Wood and raffia, height c. 16". Galerie Kamer, New York.*

273. *Fetish figure, from central Congo-Kinshasa. Basonge. The University Museum, Philadelphia.*

274. *Mask, from Congo-Brazzaville. Babembe. Painted wood. Musée de l'Homme, Paris.*

275. *Ancestor figure, from Congo-Kinshasa. Baluba. Wood, height 30 3/4". The Museum of Primitive Art, New York.*

276. *Cereal pestle and ceremonial ax, from eastern Central Congo. Left: Baluba, height 9 1/2". Right: Baluba-Hemba, height 14 1/4". Museum Rietberg, Zurich. Von der Heydt Collection.*

274

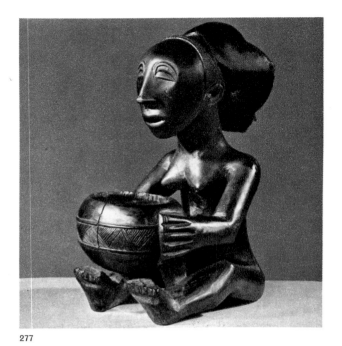

277

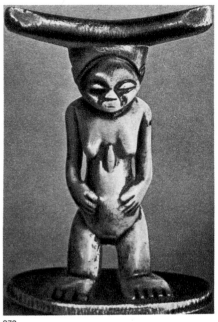

278

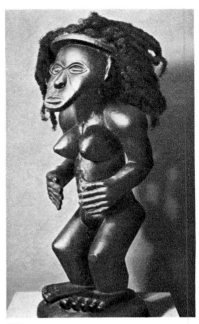

279

to be images of chieftains. Fetish figures were also produced by the Bena Lulua, warriors and the mother and child being widely favored subjects. Crouching figures, some of them functioning as containers (fig. 270), are a special form. The style is unmistakable because of its extensive and characteristic elaboration of surface. Chevroned, looped, and other emphatically raised patterns often cover most of the surface and are so adjusted to the volumes and planes of the figure that they actually reinforce the structure.

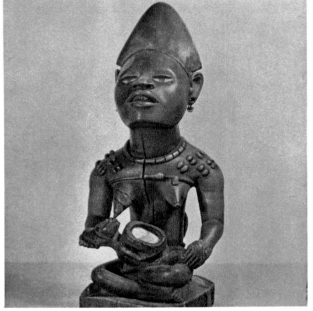

280

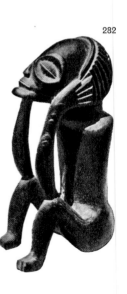

281

282

277. Seated female figure holding a bowl, from Congo-Kinshasa. Baluba. Wood, height 12 1/2". The University Museum, Philadelphia.

278. Neckrest, from eastern Central Congo. Baluba. Ivory, height 7 1/8". Collection Charles Ratton, Paris.

279. Standing female figure, probably from Angola. Bajokwe. Wood, height c. 13 1/4". Museum für Völkerkunde, West Berlin.

280. Fetish carving of a mother and child, from the Lower Congo. Bakongo. Wood, height 10 1/2". Brooklyn Museum, New York.

281. Mask, from Angola. Bajokwe. Wood, height c. 16 3/4". Formerly collection Sir Jacob Epstein, London.

282. Figurine, from southern Central Africa. Bajokwe. Wood, height c. 8". Musée Royal de l'Afrique Centrale, Tervueren, Belgium.

The Bena Lulua masks are much closer in style to the Bushongo *bombo* type than to figural works of their own provenience. Authorities on these tribes differ in their views on the priority of the mask tradition. The Bushongo and Bena Lulua appear to have used the *bombo* form in similar ways.

The Basonge

The Basonge, like the Bena Lulua, are related to the Baluba. Their best-known creative works are figure carvings, especially fetishes (fig. 273), and the renowned *kifwebe* masks (fig. 272),[53] one of Africa's most unforgettable art forms. The Basonge may or may not have taken the pattern of this startling mask from the Baluba

180

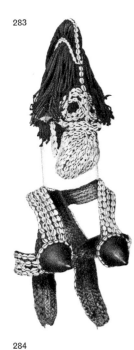

type known as *kya lubilo*. Although the style is definitive, it is given notably different interpretations from one example to the next. Typical facial components of the Basonge *kifwebe* are a very tall, rudderlike crest which emerges from the bridge of the nose and sweeps over the length of the skull; a schematized, outthrust mouth, often articulated by geometrically shaped, pinched lips; and, above all, parallel, striated passages leading in curves or diagonals from the eye, nose, and jaw. These grooved, white-filled patterns actually help to reiterate the powerful volumes and planes of the mask. There is almost always a blackish fringe or hood of raffia suspended from the jowl and back of the piece. This ominous garment accentuates an already astonishing presence. Basonge masks of this kind are reported to have been worn at the funerals of chiefs and by dancing sorcerers who, representing various spirits, tried to rid villages of sickness.

The Baluba

The Baluba are a populous and widely influential complex of many tribes.[54] They are located in the eastern Central Congo between Bakuba territory to the northwest and the southern shores of Lake Tanganyika to the east. The Baluba were at one time so unified as to constitute a strong kingdom.

The sculpture of these people at its best is not excelled by any style of the Congo. Among its typical forms is the ancestor figure (fig. 275). This example, in the Museum of Primitive Art in New York, is a distinguished work which embodies the main elements of the type: an imposing dignity; clearly articulated but associated body parts with some geometrization; a remarkably long torso; squat legs; and heavy-lidded, brooding eyes. Some ancestor carvings bear extensive scarification marks; others have few or none. Closely related in facial treatment to the illustrated work is the exquisite horned mask of figure 271. Such a combination of animal and human forms is relatively unusual in the Congo. Both the figure and the mask denote stylistic affinities with Basonge art.

Another important class of Baluba sculpture is the seated or kneeling woman holding a bowl (fig. 277). Such works are referred to, correctly or not, as "mendicant" figures. A number of these *kabila* were carved, most of them at Buli, a northeastern Baluba village; and, because the style is so distinctive, these works are sometimes attributed to an anonymous "Master of Buli." It seems possible that only a few artists developed these eloquent, essentially naturalistic images. The type is among the most sensitively interpreted of all Congo forms.

The Baluba are also renowned for their

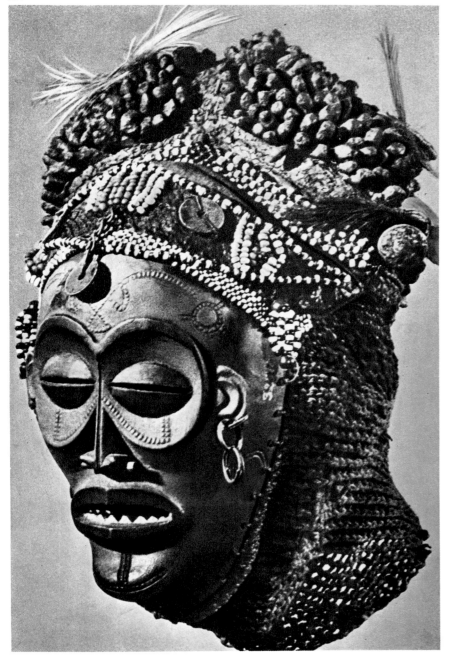

283. Secret society mask representing a young girl, from Central Congo. Height 17 3/4". Musée de l'Homme, Paris.

284. Dance mask, from southern Central Africa. Bajokwe. Musée Royal de l'Afrique Centrale, Tervueren, Belgium.

181

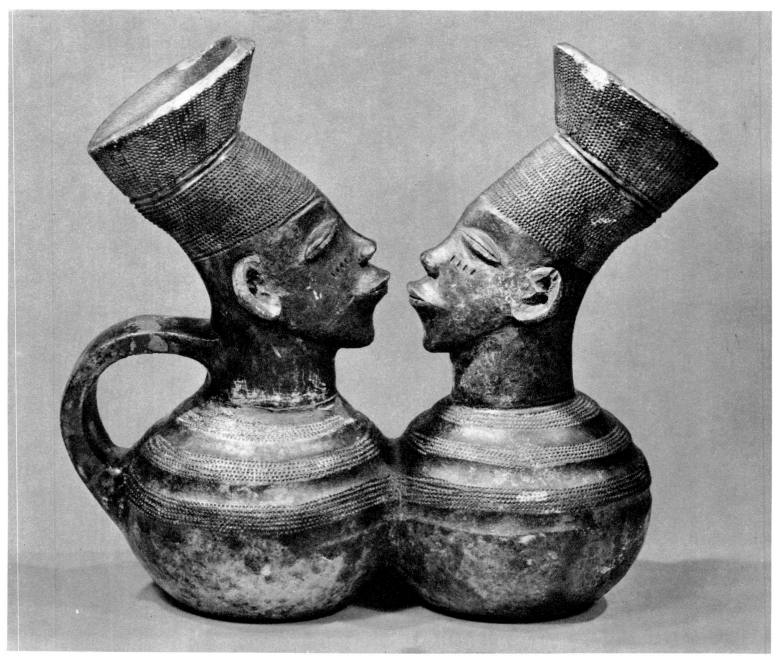

285

carved stools or seats. These were fashioned with caryatid figures, usually female, kneeling or standing and supporting a circular seat upon the head and fingertips. Seats of this distinctive form were typically used only by persons of great rank. The characteristics of the caryatid faces and figures are in the general style of the ancestor figures and women holding bowls.

The *kifwebe* ritual mask discussed above may possibly have originated among the north-western Baluba. But the latter interpreted this form with greater restraint of contour and of individual facial parts. The face was either round or almost perfectly oval and usually lacked the spectacular jutting mouth and complex eye-structure of the Basonge *kifwebe*. However, the use of fluid, form-defining, parallel lines was equally striking.

285. Double effigy jar, from Congo-Kinshasa. Mangbetu (Makere). Pottery, height 8 1/2". The American Museum of Natural History, New York.

286. Neckrest, from Zambia. Barotse. Wood, length 18". Museo di Antropologia e Etnologia, Florence.

287. Figures of a man and a woman, possibly from southern Tanganyika. Wood, height 39 3/4". Formerly collection Sir Jacob Epstein, London.

182

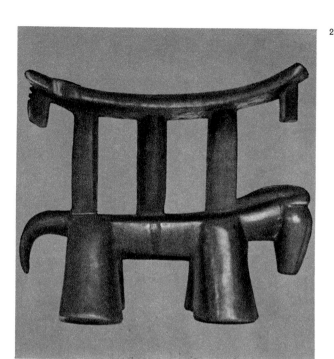

286

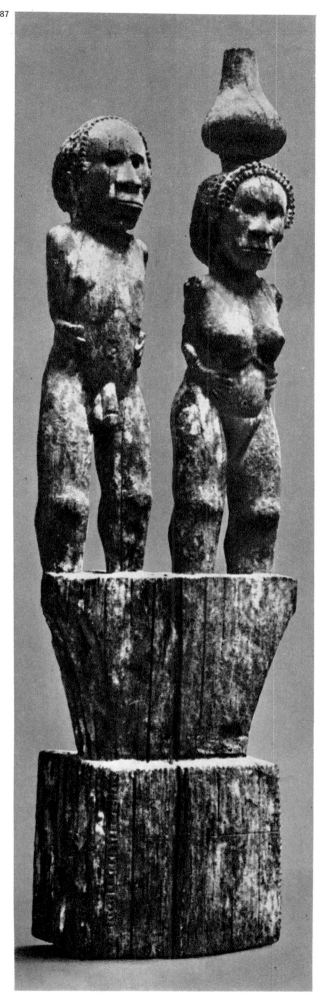

The Baluba contribution to Congo sculptural tradition is distinguished both for its keen aesthetic quality and its great number of individual masterpieces. The human figure reaches sensitive, sometimes touching levels of dignity in Baluba carving. Baluba style is among the most memorable of Central Africa.

The Bajokwe

One of the most extensively spaced tribal groups of southern Central Africa are the Bajokwe (also called Batshioko, Vatchivoko, Chokwe), a warlike people who belonged to the ancient Balunda kingdom. They inhabit parts of the Kasai-Sankuru area in the south-central Congo and range as far east as Lake Tanganyika. Some villages lie in northern Angola.[55]

Bajokwe carving is related in certain respects to that of the Central Congo groups to the north; but the style is more aggressive in pose and facial expression and more angularly marked from one salient form to the next (fig. 279). The *mwana pwo* or "maiden" mask (fig. 284) projects some of the intensity of feeling which was often imparted by Bajokwe artists to the human face. The sharply stylized mouth with its parted lips, pointed teeth, and the slotted "coffee bean" eyes encircled by spectacle-like forms, suggest an inner tension. The illustrated work is an exceptional master-piece of its class, but it is nonetheless typical of Bajokwe vigor and expressiveness of style. *Mwana pwo* masks were once worn at women's initiation rites but now appear at public dances and games.

Dynamism of pose is seen in many adaptations of the human figure to decorative and utilitarian objects (fig. 282). Female figures used as crowning elements on tobacco or snuff containers or as backrests of chiefs' benches are tensed as if preparing for sudden movement. Carved neckrests, heads at the tops of ritual staffs, and a variety of elaborately formed utensils reflect a similar energy.

The Warega (Lega, Balega), Mangbetu, Barotse, and Makonde

Much of Warega, or Balega,[56] sculpture is sponsored by the powerful Mwami secret society. One of the easternmost tribal groups of the Congo, these people carve principally in elephant ivory, although certain of their more imaginative forms are of wood. Some wooden objects such as the four-faced ritual carving (fig. 288, colorplate), reveal a Baluba influence. No specific Baluba figure or mask type can be directly associated with its total style, yet the articulation of the eyes suggests counterparts in Baluba ancestral figures and even in the Basonge *kifwebe* style. Janiform carvings of this class are reported to have been used in secret rites of the Mwami society and as hunting charms. Mwami dancers sometimes wore a mask on each shoulder as well as upon the face, and this practice may have devolved upon the form of the multifaced sculpture in our illustration. The possibility of a totemic arrangement should not be dismissed. The work is a colorful and a rhythmic statement which well represents its type. Janiform and semiabstract objects like the one in our figure are also created in ivory.

Ivory is used for small masks or maskettes which are likewise sponsored by Warega secret societies and serve as signs of rank (*kindi*). They are of unimpressive size, yet they suggest much larger scale. Because ivory is a material resistant to the carver's tool, the maskettes are often interpreted by very simply turned planes or slightly rounded, thin volumes. Some of the faces are textured by parallel rows of dots as eyebrow and cheek patterns or as complete encirclements of the face.

A distinguished ceramic sculpture was practiced by the Mangbetu (Makere) in the extreme northeastern part of the Central Congo. These people also worked imaginatively in wood, sometimes using a heated iron to round away resistant passages in the material. Traditional pieces, especially stringed musical instruments and imaginatively formed containers topped by images of human heads, possess a delicate, appealing value. In recent times, however, the Mangbetu, like the Yoruba in Nigeria, have become adept at turning out quantities of wood carvings of tourist-trade quality.

The Mangbetu best assert their sculptural values in the medium of pottery. A masterpiece of their figural ceramics is shown in figure 285. Two identical, finely shaped vessel forms are joined by the leading edges of the containers, the upper part of each bowl being topped by naturalistically interpreted human heads. The long, sloped foreheads result from direct observation by the sculptor and do not denote artistic license, for the Mangbetu practiced deliberate flattening of the skull. Such double jars as this example are said to have held wine at initiations and other rites. These people also produced geometrically incised vessels of excellent technique. Mangbetu ceramic sculpture and utilitarian ware is among the most distinguished of African Negro art in the clay medium.

The Barotse of western Zambia are best known for an almost suave style of utilitarian forms such as seats, containers, and ornaments. They have also produced a limited quantity of masks and figures. Such carvings as the neckrest in figure 286 reveal an imaginative handling of geometrized animal forms, very rhythmically adjusted to the function of the object. The superposed arrangement of forms and the surprising reversal of the animals one to the other leads to attractive, sharp-cut spatial intervals. Barotse sculptures are not abundantly represented in most collections of African art.

East Africa proper is not a major source, comparatively, of great tribal arts. The Makonde of southern Tanzania were outstanding in that region as makers of masks (fig. 238) and figures (figs. 239, 287). Masks were usually of the helmet type. They were used both publicly and at secret rites including boys' initiations. Some masks of this class were remarkably naturalistic and of skillful, carefully formed detail. Others, apparently a recent variety, are more grotesque and appear to be caricatures of specific persons. Fine examples such as the one illustrated here are rarely seen in museums or in use among the present-day Makonde.

288. *Four-faced ritual carving, from the eastern Congo. Warega. Wood, height c. 23 5/8". Smithsonian Institution, Washington, D.C.*

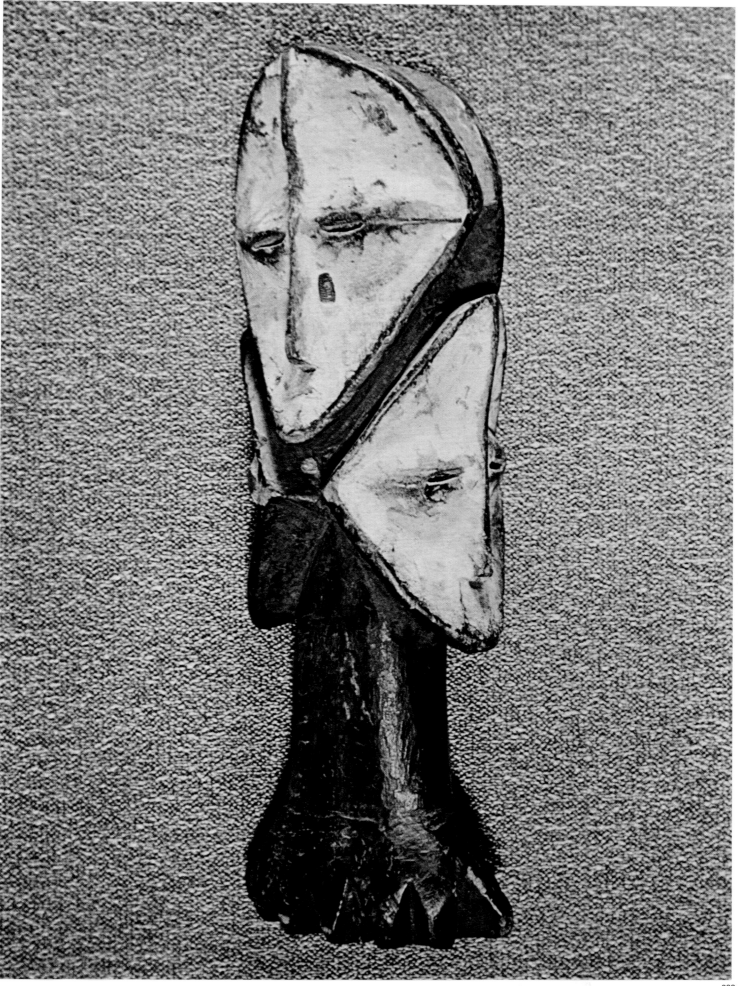

The Art of the North American Indian | JOHN GALLOWAY

Introduction

Our study of North American Indian art will benefit from our first comparing its popular and professional acceptance with that of African tribal art. We have considered earlier in this book that the latter enjoyed great recognition after it influenced Picasso and other Cubists, the Fauves, and the German Expressionists. Partly through its indirect assimilation into the aesthetic of later painters and sculptors of Europe and the United States, African sculpture has gained wide popularity. The pioneering creative artists who first recognized as such the artistic values of African works rather than admiring that art only for its technological skill or ritual significance contributed tellingly to its present acceptance. It is now honored by extensive exhibiting and is being acquired by private collectors as well as by museums and specialized galleries.

North American Indian art did not have a parallel "discovery" by outstanding painters and sculptors in the United States; nor, despite the widespread consumption by tourists of its commercialized, gaudy "souvenir" forms, have most Americans and Europeans yet recognized the aesthetic significance of the stronger traditions of Indian sculpture, painting, and architecture. Few art historians and art critics have studied intensively North American Indian art,[1] and, though museums and galleries [2] have presented a number of comprehensive exhibitions of it, these have been received with less enthusiasm than have African or Oceanic expositions of similar scope.

The scientific investigation of the North American Indian and his general culture has been as extensive, however, as the art-historical and critical interpretation has been limited. Archaeological and ethnological field work has been carried out on a remarkably wide scale by the United States government, as well as by several universities, privately sponsored museums, and other groups. These organizations have published a voluminous, specialized literature on their findings. Such reports concern all phases of Indian life, including the production of art and handcrafts. But, until quite recent times, a majority of ethnologists and archaeologists made little distinction between works which have aesthetic value and those which are interesting only as testimony to manual skill or sociological phenomena, as has indeed been the case with European students of African and Oceanic "artifactual evidence." Moreover, the displaying of this material in most public museums was correspondingly indiscriminate until well after 1900; and in some instances it remains woefully inept. The visitor most often saw, for example, a number of small sculptures of perceptible artistic merit, laid out (more or less in the mortuary sense of that word) among crowded mazes of arrowpoints or stone flakings or vegetal material. These same sculptures invariably recapture the vigor and dignity they once enjoyed if they are removed from the neighboring plethora of technological or botanical minutiae.

We should not, however, take this apparent callousness out of context. Late-nineteenth-century norms of beauty were still based upon Classical or Neoclassical sculptures of the human figure or French academic paintings on the same theme. Unique indeed would have been the scientific fieldworker who could have seen in the proportions and details of North American Indian figural carving an aesthetic that related to those ideals. As Frederick Dockstader has recently pointed out,[3] many of these earlier investigators of Indian culture

simply had neither training nor interest in art. But we are deeply indebted to them, nonetheless, for having collected the material itself. They did that in abundance.

Another detraction from adequate understanding of this art is that the American public has a curiously misadvised knowledge of the Indian. Americans and Europeans alike now realize that the Indian was neither exclusively the marauding savage of the early novels and motion pictures nor the pompously overdignified and impeccably innocent knight of contemporary television legend. Our understanding of the Indian's art, however, has been seriously impeded by these and other imbalances. For example, we are still sometimes, though fortunately less and less often, called upon to regard Indian art from an Indian's point of view, just as in the case of African art we are now and again put upon to behold it with tribal African eyes. This attitude is neither scientific, desirable, nor possible. We live in a present, as men always live in a present, in which we cannot turn our backs upon an accumulation of knowledge and sensitivities which has been hard-won. The individual who can receive the Archaic *kouros*, the Gothic cathedral, the Sistine Ceiling, Picasso, and African sculpture without playing the charade of doffing his rightful intellectual cloak in favor of other mental costumery can come with equal sensibility to understand North American Indian art. It may reasonably be expected of him that in this process he acquire as much general knowledge of Indian life as he must of eighteenth-century French society if he wishes to know the Rococo. But his eyes cannot now become those of the courtly subject of Louis XV.

Still another deterrent to a vigorous following of Indian arts of the United States and Canada is the immense shadow of ancient Middle and South American achievements. The "high civilizations" of the Andes and Mexico bequeathed such a dazzling treasure of architecture and sculpture that invidious comparisons are inescapable.

Ours is the twofold challenge, on the one hand, to select and explicate the validity of those forms which are unique to the Indian of the North, and, on the other, to treat thoughtfully his struggle for modest achievement in forms already brilliantly interpreted by the artists of other primitive societies. We cannot answer this challenge by defending dull works because they were produced by a mistreated or little understood people. Neither can we justify all objects of this art because they were motivated by one or another esoteric tribal demand which is of greater interest in itself. If North American Indian art is to achieve the popular

and professional esteem it merits, it can do so only by being definitively placed in its rightful ambiance of world primitive art. That place, we feel, is a distinguished one which does not require privileged methods of scrutiny.

The North American Indian's most distinctive arts are those which are traditional to all great Western civilizations: sculpture, painting, and architecture. His contribution to each of these branches of expression was strong, although certain arts are only sparsely represented in some of the territory occupied by him, while all were practiced vigorously in other regions. The Indian was also a superb craftsman or technologist in such decorative or utilitarian mediums as weaving, basketry, ceramics, and tool or weapon making. Tools and weapons frequently disclose so sensitive a grasp of form that they must be acknowledged as arts rather than as handcrafts.[4]

Sculpture was created in several mediums including stone, wood, terra cotta, shell, copper, bone, and ivory. Painting appeared most characteristically on ceramic vessels and figures, animal skins, and panels of wood, and it was also used to enhance the expression or form of masks and other ritual objects. Architecture was created in stone, wood, and earth-mound mediums, and its most typical forms included individual and group houses, temples, and tombs.

The North American Indian used a wide span of subjects in painting and sculpture. As we might expect, many of these depicted the wildlife he saw around him as well as certain domesticated creatures—the bear, mountain sheep, bison, deer, seal, whale, fish, reptiles, and, later, the horse. The human figure was prolifically and imaginatively represented. Geometric patterns appeared in both relief and incised sculpture and in painted ceramics, often in combination with images taken from nature. Both figural and geometric subjects often had symbolic implications, many of which remain conjectural to us (indeed, they were sometimes of exclusive meaning to small tribal groups or even to the particular individual who created them). Totemic content was often present in composite human-animal arrangements. Narratives of the hunt or of outstanding individual exploits were often recorded. Expression varied, depending in large part upon the region, from compact, naturalistic interpretation of these subjects in a single medium to spectacular, wildly imaginative renditions set forth in combinations of wood, metal, fur, shell, and bright tones of paint.

It has not been found advantageous or objective to discuss North American Indian art in the conventional, twofold divisions of pre-

190

European or archaeological styles on the one hand, and "ethnological" or historical arts on the other. A decline in almost all Indian arts occurred at some point in the various regions of America following the ascendancy of the white man, but a prehistoric-versus-historic classification is arbitrary and, in some respects, misleading to us in interpreting adequately the values of specific works. Some important traditions had apparently begun to decline well before the arrival of the white man. Others flourished long after his arrival. In any case, there is no more justification for so clear-cut a chronological separation of Indian arts than there is of African arts, except perhaps in degree. Unfortunately, certain outstanding museums in the United States, as well as much literature on the subject, still continue this nineteenth-century practice instead of evaluating individual objects and basing presentation or discussion upon the factor of aesthetic validity. This is all the more regrettable because it has contributed to a certain dichotomy of approach in the professional training and attitudes of specialists in archaeology and ethnology—a condition not infrequently deplored by members of both groups. Be all this as it may, it has been considered indispensable to the organization and objectivity of this brief study to discuss characteristic examples of the arts of each major region of the United States and Canada primarily with a view toward their aesthetic integrity, referring wherever possible to probable date but declining to permit the latter to interfere with fundamental interpretation.

The North American Indian made his outstanding contributions to world primitive art in five regions of the United States and Canada, which are best defined as the Southwest, the Plains, the California Coast, the Northwest Coast and Plateau, and Eastern Canada and United States.[5] Each of these areas has distinctive artistic as well as general cultural traditions. Painting,[6] architecture, and sculpture [7] were all prolifically represented in the Southwest and Northwest and in much of the East. Painting on animal hides was the best-known art of the Great Plains, but a number of smallish, powerfully simplified carvings in pipestone were also created there. Sculpture in stone, often intricately inlaid with shell, was the only fine art [8] produced by the peoples of the California Coast.

Evidently the prehistoric traditions of all major regions were developed over a span of many centuries, some of them certainly originating well before the beginning of the Christian epoch. The historic periods of painting, sculpture, and architecture varied from one territory to the next, depending not so much upon the date of the white man's arrival as upon how soon thereafter his cultural institutions began to affect those of the Indian. In the Southwest the Pueblo peoples long resisted Spanish influence, both artistic and religious; and it was commercialism rather than social conviction that gradually led to the stylization of their great ceramic art and carving. The Chumash of the Santa Barbara region and adjacent parts of the California Coast and offshore islands, however, were all but decimated within one hundred and fifty years after extensive European settlements—missions, specifically— had developed in the mid-seventeenth century. But, the style of sculpture which had been established in prehistoric times by these Indians did not fundamentally change as a result of European colonizing; it simply died out with the tribes who produced it.[9] Those prehistoric groups known collectively as the Mound Builders had similarly formed an early and distinctive kind of stone carving which ended shortly after the Spanish and other Europeans arrived in the middle Mississippi and southeastern parts of the United States during the late sixteenth and seventeenth centuries. Thus, as was the case among the Chumash, the effect of European settlement upon the Mound Builders was to terminate an artistic tradition rather than to alter its aesthetic. The peoples themselves were displaced and their life patterns disrupted, some subtribes literally disappearing, others relocating and making substantial changes in their social structure. Prehistory ended somewhat later on the Northwest Coast. The arrival of Captain Cook and the subsequent establishment of trading centers toward the end of the eighteenth century had a different effect upon the production of art. An already flourishing woodcarving tradition, which had been preceded by one of sculpture in stone, appears actually to have received impetus at first from white contact. As was the case with the Pueblo peoples of the Southwest, most forms of Northwest Coast art did not quickly change, and they are, in fact, practiced to some extent today; but commercial production has resulted in general vitiation of the older and more potent styles.

We cannot, therefore, justify a twofold stylistic categorization of prehistoric and historic divisions. We can speak only of early and strongly developed traditions as against expressions which in time became altogether dissipated or significantly weakened. To put it another way, we may, on the one hand, refer simply to a continuation and flourishing of established pre-European forms and, on the other, to vitiated remnants of those styles which should not be considered as fully representative of traditional

North American tribal art. This attitude applies alike to certain handcrafts—Navajo silverwork, to mention a single example—which were actually introduced by the white man and made capital of by the Indian. None of these forms, despite the ornamental attractiveness and superb technology of certain of them, may be justified as significant to the development of North American Indian style. They are not only extraneous to the distinctive core of Indian aesthetic but they are, in fact, not art.

It is pertinent to consider the antiquity of the Indian in America before proceeding to a discussion of his art as it developed from one region and time to the next. The locutions "indigenous arts" or "native aesthetic" have been avoided in the preceding discussion because the North American Indian is no more indigenous to his continent than are the Europeans who arrived so much later. Like the modern inhabitants of the United States and Canada, the Indian is an immigrant, and, like the first European settlers, he was forced to create a new mode of existence.

Specifics of the time of his arrival and the precise area of origin of the North American Indian are still conjectural; but it is agreed by most archaeologists that he came from Asia at least nine thousand years before the beginning of the Christian epoch, and recent scientific dating of Indian physical remains in various parts of the Americas indicates that he may have been present long before then, perhaps thirty thousand or more years ago.[10] There is no evidence at the present time to confirm that man actually developed and emerged as Homo sapiens within the boundaries of the New World. It appears that he entered Alaska by way of land or ice bridges from northeastern Asia, probably no later than about 11,000 B.C. However,

the Paleo-Indian, as our subject is called by many archaeologists, was less Mongoloid than is his descendant, the modern American Indian, and possessed more Caucasoid physical attributes than does the latter. Deposits of small artifacts, as well as skeletal remains, show that the Paleo-Indian proceeded slowly to the Valley of Mexico, surviving by hunting and gathering what food existed in the rigorous landscape and climate which then faced him. He may have first gone by way of the Mackenzie River region. As he entered warmer zones, he subsisted more and more on plant life. Eventually, perhaps by seven to four thousand years ago, he had begun to learn the arts of agriculture which in Mexico eventually all but replaced hunting. Localized groups of the Paleo-Indian began to form villages many centuries before the time of Christ. This development took place in New Mexico and adjacent regions of southwestern North America around the beginning of the Christian epoch. With the growth of the first North American tribal villages came the slow perfection of the paleolithic tools and the weapons which the Indian had known before arriving in the New World. It is significant that, in such very early cultures as the Folsom (named after a site in New Mexico where remains were found), ornamental objects such as beads and tabular, geometrically incised objects predated such utilitarian forms as pottery and basketry and textiles.[11]

During the first few centuries of the Christian epoch, the Paleo-Indian began to form distinctive ethnic groups in many parts of the present confines of the United States and Canada, and the first of his arts of ceramic and stone sculpture, planned architecture, and painting began to flourish.

We turn now to a short study of those arts.

The Southwestern
United States

The preceding, very brief discussion of the arrival of the North American Indian and his eventual settlement in Mexico and the southwestern United States has indicated that a fundamentally Asiatic people, whose reasons for leaving their aboriginal habitat and forcing their way to the New World remain unclear, were put upon to create a new life style. Just as the early Indian at last ceased to hunt nomadically and developed agriculture and a sedentary, village-rooted existence, so did he come to form distinctive new expressions in art and architecture. It is not difficult to point to stylistic details which relate North American Indian ornament to that of the apparent region of Paleo-Indian origin in Siberia; but the study of quantities of New World Indian art demonstrates that it is, despite particularized analogies which may come to light, a quite different collective expression. Like the kinds of tribal society which reached definition over centuries' time in North America, Indian arts achieved peculiar identity.

Among the first peoples to evolve an important aesthetic on this continent were the Anasazi[12] or combined Basket Maker and Pueblo groups of the region now composed of northern Arizona and New Mexico and southern Colorado and Utah, especially where the corners of these states converge. Other ancient and definitive cultural groups in the Southwest were the Mogollon[13] and the Hohokam.[14] Still other significant cultures have been given separate designations by some archaeologists—the Mimbres of southwestern New Mexico, for example. All of these peoples shared certain traits,[15] but it is likely that they spoke different languages. Moreover, each group inhabited, allowing for overlaps, special sections of the same general area. For example, a majority of the Pueblo and Basket Maker Indians lived in the high plateaus or semimountainous areas, especially of New Mexico, while the Hohokam were chiefly Arizona desert dwellers, usually located near the few available streams which they ingeniously diverted into primitive canal systems. The Mogollon occupied the mountainous or forested country of southeastern Arizona and southwestern New Mexico.

The Basket Maker people, ancestors of the Pueblo Indians, were named after their ancient tradition of weaving utilitarian containers, a practice which appears to date from shortly after the beginning of the Christian epoch. A more significant Basket Maker art, however, was that of small but striking sculptures of the wildlife of their region. Stone turtles and birds disclose a modern feeling for essential and compactly reduced forms. The artist sometimes took advantage of the natural graining of the stone to reinforce ovoid volumes. The Basket Makers were probably the first Southwesterners to create stone carvings.[16] These smallish objects, as well as clay figurines of very primitively interpreted female form, have usually been discovered in caves. There is no evidence that they were used ritually, and they may very well indicate either an ancient tradition of connoisseurship in this area or simply the result of aesthetic urge.

The Pueblo

The Pueblo or Anasazi peoples underwent a number of relatively distinct phases of cultural development between about A.D. 700 and 1700, after which time their region became widely settled by Europeans. Some of the greatest Pueblo or Anasazi works of sculpture and painting of ce-

ramic objects, as well as architecture, were produced during the interval known as Pueblo III or the "Great" or "Classic" period from about 1100 to about 1300.[17] A prolific creativity occurred. The fanciful creature in painted ceramic form shown in figure 289 characterizes the imaginativeness of the artist of this great culture. His boldness of form is successful because of the adjustment of two strongly contrasted forces which work with, rather than against, one another—the fluid silhouette and swelling volumes of the figure emphasized, rather than contradicted, by the sharply geometric lozenges, bands, and angular stepped motifs. The illustrated example came from Tularosa Canyon, New Mexico, one of the many Anasazi sites which produced a distinctive type of decorated pottery. Equally fine vessels came from Mesa Verde, Colorado, where black-on-white painted geometric containers of imaginative as well as purely utilitarian shape were created; Chaco Canyon and its vicinity, where black-on-white designs were also predominant; and the Kayenta area, which produced polychrome wares in combinations of black, red, and orange. By the time of the Pueblo III or "Classic" period, the continuous coil method of forming pottery was in general use. Thin, carefully rolled ropes of clay were built up in circular or spiral fashion in the desired shape and size, and the surface was then dampened and smoothed by a paddle or by the fingers. Earlier pottery had been formed in basket molds, modeled by hand-scooping and forming, or constructed with short, superposed bands or rings of clay. Colors used for the painted designs usually came only from vegetable substances and iron manganese; but many variants of the basic tones were achieved by deliberate and sudden changes of temperature during the firing process.

The architecture of the Anasazi peoples was impressive and sometimes dramatic because of both scale and choice of site. The most famous of cliff houses and mesa-top structures were erected during the Pueblo III phase. Cliff Palace at Mesa Verde in southwestern Colorado (fig. 291), probably completed by about A.D. 1150, is one of the most impressive of Anasazi "towns." It was enclosed beneath the sheltering rim of a cliff (fig. 290) and comprised stone and adobe brick, multistoried, setback apartments of adjoined rooms, terraces, and kivas. The kivas were ceremonial rooms set apart from the chief complexes of housing units and were apparently an outgrowth of subterranean "pit houses" of earlier Pueblo periods. They were typically circular in plan and wholly or partly underground, and thus were entered from above. The largest of them sometimes had superposed chambers or vaults at ground level or above.

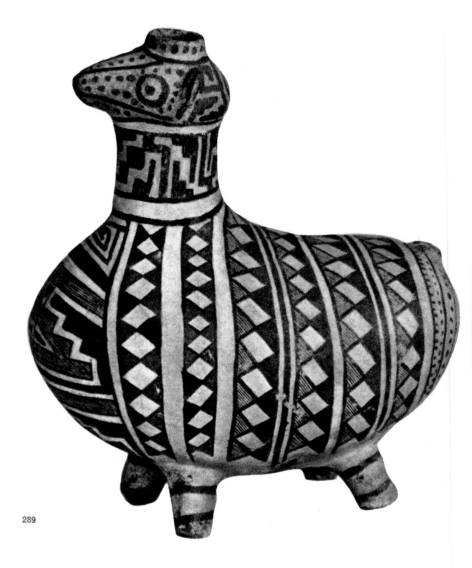

289

289. *Effigy vessel, from Tularosa Canyon, New Mexico. Anasazi culture. c. 1100–1300. Painted pottery, height c. 8". Museum of the American Indian, Heye Foundation, New York.*

290, 291. *Cliff Palace at Mesa Verde, southwestern Colorado. Anasazi culture. Completed probably c. 1150.*

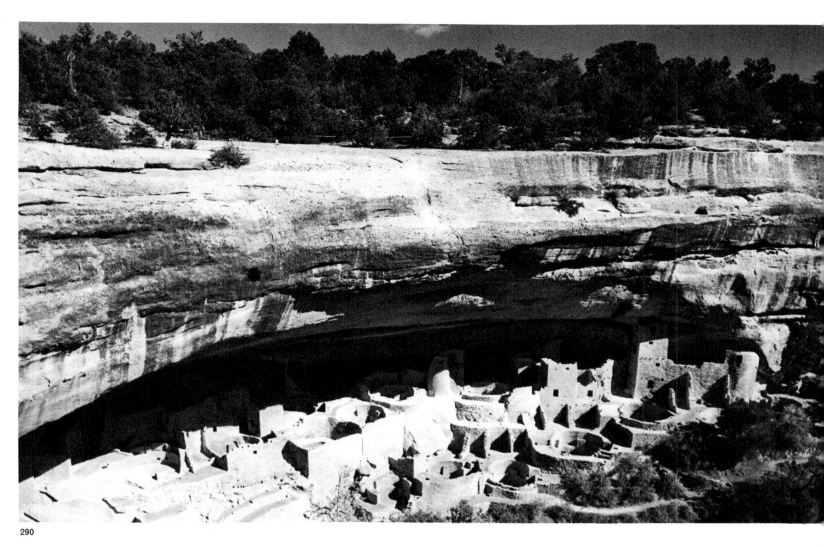

290

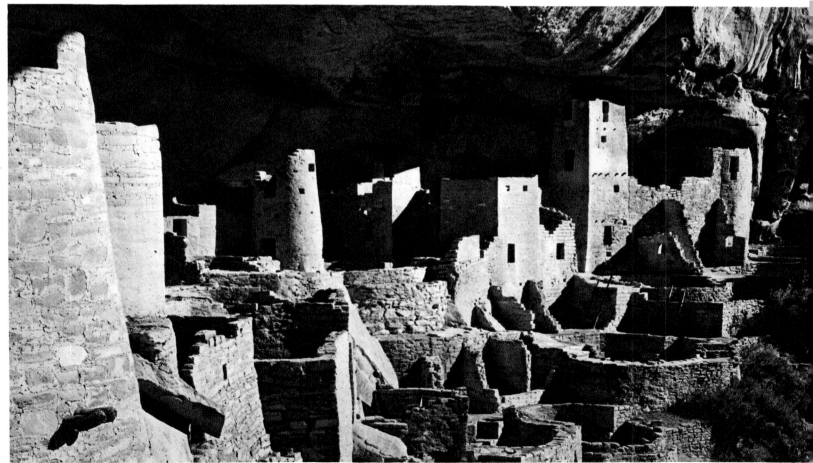

291

195

Within the kiva proper was located a fireplace or fire-pit, fresh-air conduits, stone or other seats, and a small opening in the floor called the sipapu, which is known to have represented the entrance to the Spirit World. Some contained well-organized, large-scale mural paintings.[18] Larger kivas were over forty feet in diameter. While the main purpose of these units appears to have been religious, their function as a fraternal gathering place for tribesmen also seems likely. Many other elaborate Pueblo collective dwellings were built at such sites as Chaco Canyon (northwestern New Mexico), Pecos (north-central New Mexico), Kayenta (northeastern Arizona), and Lowry (Colorado). The last named was built in the open rather than under a cliff. Plans were usually in the form of a D, an ellipse, or a rectangle. Masonry techniques varied notably from one Pueblo structure to another. At Mesa Verde the stones were attractively and strongly laid in rectangular courses with the large stones interspersed by flat, thin ones. The brush-and-clay (adobe) roofs of Pueblo apartments were supported by heavy poles or beams. These survived in large numbers in the generally dry, mountainous and desert climate of the Southwest and provided material essential to an ingenious method of dendrochronological dating developed by Dr. Andrew E. Douglass.[19]

These large architectural complexes and the ceramic painting and sculpture of the Anasazi peoples have commanded such widespread attention from archaeologists and other admirers of Southwestern Indian art that another important tradition, that of small sculptures in stone, has been largely neglected in the study of this region. In achieving recognition as a distinctive art, these carvings have suffered from the oversharp distinction made between the archaeology and ethnology of the Southwest.[20] The style of sculptures such as the owl illustrated in figure 292 is related to that of the Basket Maker works already discussed and is very likely of considerable antiquity within Anasazi chronology, even though it has been referred to by certain sources as "late" or Pueblo V, thus historical. This compact, economically rendered form is reminiscent of early-twentieth-century abstract sculpture.

The Zuñi

Scores of smallish animal images in stone were used as fetishes by the Zuñi descendants of the Anasazi. Because they were being employed in rites by the historic Zuñis when they were collected in the 1880s,[21] they are regarded as "eth-

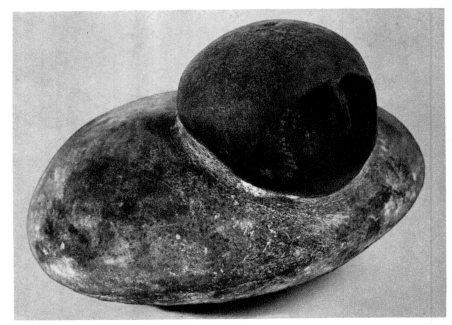

292

292. Owl. Late Pueblo or early Zuñi culture. c. 1400–1700. Sandstone, length 10 1/4". Smithsonian Institution, Washington, D.C.

293. Wood carving, collected at Sia Pueblo, New Mexico. Early Zuñi culture. c. 1700(?). Smithsonian Institution, Washington, D.C.

293

nological," or of recent origin. Their style, however, derives directly from the Basket Maker and Pueblo expression of earlier periods. There was thus a distinctive tradition of Anasazi stone art, most of it very small in scale, based upon animal subjects. In historic times each such subject—the wolf, eagle, bear, coyote, and other—represented a sacred region or one of the natural elements.[22]

Another tradition among the Zuñi and Hopi tribes of the historic villages is that of wood assemblage, or sculptures with fitted or joined parts. This art reaches its most complex stages in the Kachina figurines and dolls (figs. 297; 302, colorplate) still being made in New Mexico and Arizona.[23] As fascinating as these objects are from an ethnological point of view, however, few of them are remarkable for soundly sculptural quality; and, typically, they are con-

294

fusingly overelaborate because of the often indiscriminately placed additives of feathers, cloth, hair, and other substances. But certain related carvings and constructions in wood belonging to earlier phases of the historic Southwest retain some of the power of the ancient Basket Maker and earlier Pueblo style (fig. 293). The illustrated object, semiabstract in concept, was collected at Sia Pueblo, New Mexico. It may date from about 1700 or somewhat earlier. The stepped form of the head has its counterparts in the more recent Kachina forms, sometimes reversed in the latter with the stepped silhouette appearing as a void. The stone "idol" of figure 294 probably dates from the same late prehistoric or early historic epoch assigned to the wooden construction, and it shares this same interpretation. A stage in the historic development of this motif may be seen in the headdresses or helmets of the two late-nineteenth-century Zuñi wooden war-gods of figures 295 and 296, the trend being here one of simplification of the ancient motif rather than an elaboration of it as is seen in many recent Kachinas. The origin of this stepped design, however, well predates any of the works illustrated. It appears in a thin, slablike figure from Pueblo San Lazaro in the Galisteo Basin of New Mexico, apparently of late Pueblo III or Pueblo IV provenience. The San Lazaro stone carving, now in the American Museum of Natural History in New York, was excavated from a shrine room and very likely represented a god. It is thus possible to witness the continuation of a specific sculptural motif from ancient to quite recent times. Although the general configuration of the most recent objects shown here, the two war gods, is quite unlike that of the wood construction of figure 293, it is evident that the late style is derived from a much

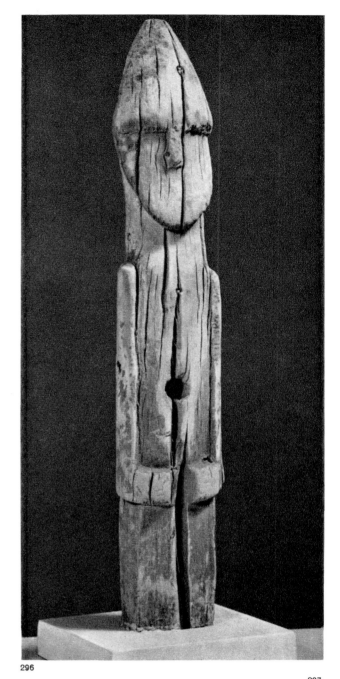

296

297

294. *Seated deity. Late Pueblo or early Zuñi culture. Probably c. 1700. Calcite, height 7 1/8". Smithsonian Institution, Washington, D.C.*

295. *War-god. Zuñi. Late 19th century. Wood, height 24". Brooklyn Museum, New York.*

296. *War-god. Zuñi. Late 19th century. Wood, height 30". Brooklyn Museum, New York.*

297. *Kachina doll. Pueblo Indian. Painted wood and feathers, height 7 1/8". Musée de l'Homme, Paris.*

295

more ancient one, the evidence of this tradition being mainly the treatment of the head. The continuation of such elements of style has been stressed in the preceding discussion in the effort to make clear that arbitrary separation of pre-European and ethnological periods can be a specious procedure insofar as an understanding of specific traditions is concerned.

The Hohokam

The Hohokam people, whose present-day descendants are the Pima and Papago Indians of Arizona, also produced a distinguished complex of architecture and art works. The Hohokam were a desert people centered on the Gila and Salt rivers. They were forced to devise canals in order to develop agriculture in this arid territory. This was evidently a unique contribution to prehistoric Indian architecture and engineering in North America. They also built ball courts not dissimilar in plan and arrangement to those of the Pre-Columbian Mexican peoples. Hohokam collective dwelling units, though less dramatic in scale and design than those of the neighboring Pueblo Indians, sometimes reached impressive size and complexity of design, as at Casa Grande in southern Arizona. They produced excellent polychrome pottery of which the best-known types are Red-on-Gray, Red-on-Buff, Smudged, and Red, most varieties being given also the name of the site or sites at which they were discovered—Vahki, Estrella, Snaketown, Santa Cruz, Gila Butte, and Sacaton, for example. The Sacaton style is represented by both Red and Red-on-Buff vessels of exceptionally high quality. Pigments used in painting the designs were derived from vegetal matter and iron oxide. Jars of as much as thirty-gallon capacity were made. Techniques were essentially the same as those of the Anasazi, certain of whose "trade wares" were found at various Hohokam ruins. The interchange of influence was present to some extent, though each people retained its own distinctive ceramic tradition. Ceramic vessels of different shapes served not only the utilitarian purposes of water or food storage and as cooking utensils but also as burial urns for cremated remains.

The chronology of Hohokam cultural development roughly parallels that of the Anasazi, allowing for variants of outstanding or regressive phases. It is sometimes divided into five periods: the Pioneer, from shortly before the beginning of the Christian epoch; the Colonial, from about A.D. 500; the Sedentary, about 900–1100; the Classic, 1100–1400; and the Historic, from about 1400 until the present.[24] Most of these periods witnessed a strong creative tradition in the arts, but the Colonial, Sedentary, and Classic periods saw the greatest flourishing of most forms.

As with the Anasazi, stone carving among the Hohokam has been overshadowed by more spectacular forms of architecture and ceramics. However, a distinctive stone sculpture was developed by these people beginning in the ancient phases of their culture. The excavations at Snaketown, Arizona, disclosed a complex of small animal images both in the round and in relief on mortars, palettes, and bowls. The Colonial period likewise produced simplified images of birds, mountain sheep, bears, the human figure, and plaques with frogs or lizards in relief (fig. 298). The strength of the Hohokam sculptural style may easily be overlooked because of the modesty of the scale of such objects (this example is fourteen inches in height, and some works are much smaller); but closer scrutiny reveals a sensitive balance of contrasting elements of design. In the lizard relief, the large, circular form is notched around its perimeter, not only in representation of the horny skin of this desert amphibian, but because it lends provocativeness to the blander shapes. This form is in contrast to the horizontals of the front and back legs, the right and left ends of which turn upward in the upper pair and downward in the lower. Notchings, echoing those of the circular belly, appear as claws at these terminals. The head of the lizard, more lightly serrated at the edge, is of a lozenge or diamond form, softly rounded at its points.

One of the masterpieces of Hohokam sculpture is the frog shown in figure 299. This sensitively modeled object of quartzite is lifelike in over-all depiction, but the artist has gone

298

further and has suggested the swelling, pulsating motion of the creature's breathing. Its provenience was Canyon de Chelly, Arizona, although it may have been carried there from another site. Its dating is conjectural, since its quality is so high as not to fit conveniently into that of typological groups of such works from any period. In any case it was created probably between 500 and 1400.

The subtlety of relating one subsidiary component of the total form to another may be seen typically in Hohokam stone carvings of various animals, many of which are in the form of mortars or jars.[25] The essential quality of the animal's form is captured in each case: carvings representing bears suggest lumbering, deliberate power and stubbornness; those of mountain sheep indicate a contained tension which might instantly, in the life fashion of that wary creature, uncoil into fleet movement.[26] The style of Hohokam stone art is related basically to that of the Anasazi, but it reflects an even keener assimilation by the artist of the interior, as well as the exterior, characteristics of the specific subject. Human subjects are generally of less interest in stone art than are those of reptiles

298. Plaque with lizard in relief. Hohokam culture. c. 700. Stone, height 14". Smithsonian Institution, Washington, D.C.

299. Frog, from Canyon de Chelly, Arizona. Probably Hohokam culture. c. 500–1400. Quartzite. Brooklyn Museum, New York.

and other animals. There was also a tradition of figural sculpture in clay, fired and unfired; but it lacks the distinction of the stone works.

It has been mentioned that the development of irrigation in the southwestern United States was a unique Hohokam contribution to prehistoric Indian engineering. The Hohokam also contributed the lost-wax method of metal casting, a technique widely practiced in Pre-Columbian Central America, but which was unknown earlier in the North. Copper bells three or four inches in height were the principal, if not the only, metallic art thus made by the Hohokam about A.D. 900. The copper is believed to have come from deposits in nearby parts of the Southwest. Another technique, little used elsewhere in prehistoric North America, was the ornamental etching of shells with vegetal acids over a scratch-patterned resisting substance. Pendants and bracelets were produced in this medium. Yet another unusual Hohokam contribution was the making of so-called mirrors or plaques in mosaic designs with thin sheets of superposed iron pyrite. These forms appeared during the Sedentary period (900–1100) or possibly earlier.

The Hohokam of the Gila Basin of Arizona thus contributed a varied and rich tradition to the arts of the Southwestern area. Their culture, one of a thousand years' duration, was transmitted to the Pima Indians, who were first seen by the Spanish in the mid-fifteenth century. The older, extensive settlements of the Hohokam had declined or been abandoned. The Pima word "Hohokam," used in reference to their ancestors, means "those who have gone."

The Mogollon

The Mogollon tradition of southeastern Arizona and southwestern New Mexico is combined by some archaeologists with the name of the culture of one of its phases, the Mimbres. The Mogollon proper were one of the oldest of Southwestern cultural groups, the date of 300 B.C. having been established through the carbon-14 method as the beginning of their production of pottery. They derived, it appears, from the even more ancient people known as the San Pedro Cochise, who were among the first North Americans to cultivate corn and other crops. The Mogollon were artistically conservative; their pottery and architecture were adequately utilitarian, but infrequently more than that. The most distinctive art was that produced by the Mimbres people, or *Mimbreños*, between about A.D. 1000 and 1300.[27] Mimbres architecture was less distinguished than that of

199

the Anasazi, but their ceramic painting is outstanding in Southwestern art. Its superb, sometimes precise, brushwork was seldom matched by either Hohokam or Anasazi artists. Although many bowls were decorated only with sharply defined, ingeniously linked geometrical patterns, the typical form contained a human, insect, or animal figure, more or less centered upon the interior bottom of the vessel (fig. 300). This example suggests a composite frog-and-human subject or a human with a pathological condition of the abdomen. There is here, as in a majority of Mimbres bowls with human or animal subjects, an implicit story. Some are truly narrative in content; there are struggles between man and animal, or paired figures in intriguing poses. A characteristically sharp, schematized animal, probably a wolf, appears inside the vessel shown in figure 301. A contained vigor is typical of Mimbres depiction of such creatures. The form of the animal is skillfully unified with the banded linear passages which circle the inside rim of the vessel.

Both polychrome and black-on-white ceramics appeared in the Mimbreño area of southwestern New Mexico, but the latter was dominant. The least-known polychrome ware, which developed in earlier Mogollon times, was San Francisco Red.

Mimbres bowls were almost invariably punctured or "killed" with a hole through the center when they were interred with a deceased person. This allegedly permitted the escape of the spirit. These people must have appreciated the fineness of their own art, because the perforations are usually smallish and controlled. Moreover, it was the practice to use only a fragment of such a vessel to accompany the body of an infant in the grave.

The foregoing discussion is intended to demonstrate the variety, the strength, and, in some instances, the subtlety of the great arts of the Anasazi, the Hohokam, and the Mimbreños of the Southwest. Their traditions obtained long after European intrusion (as among the historic Zuñis) or had suffered partial or complete decline, as in the instances of the Hohokam and the Mimbres peoples, prior to the arrival of the white man. While it is a sympathetic speculation to suppose that resurgences of creativity would have occurred had not the Spanish appeared to missionize and to exploit the Southwest commercially, it is also a warming and even inspiring assurance to know that these ancient peoples were able to sustain, as they did, their own powerful cultural identity over the period of many centuries. Their contributions to the whole culture of the North American continent from pre-Christian times to the present have been memorable.

300. *Bowl with a bloated figure, from New Mexico. Mimbres culture. c. 1000. Painted pottery, diameter c. 8 1/2". Smithsonian Institution, Washington, D.C.*

301. *Bowl with the figure of a wolf(?). Mimbres culture. c. 1000. Painted pottery, diameter 8 1/2". Smithsonian Institution, Washington, D.C.*

302. *Kachina doll. Pueblo Indian. Painted wood and feathers.*

303. *Woman's shawl. Navaho. Middle or late 19th century. Wool, 36 x 51". Museum of the American Indian, Heye Foundation, New York.*

300

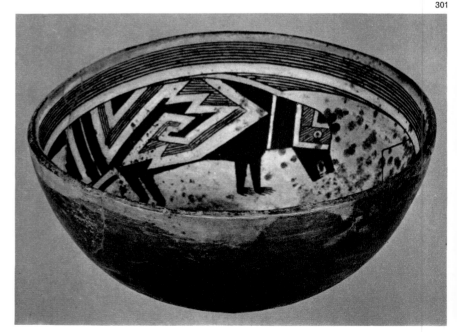
301

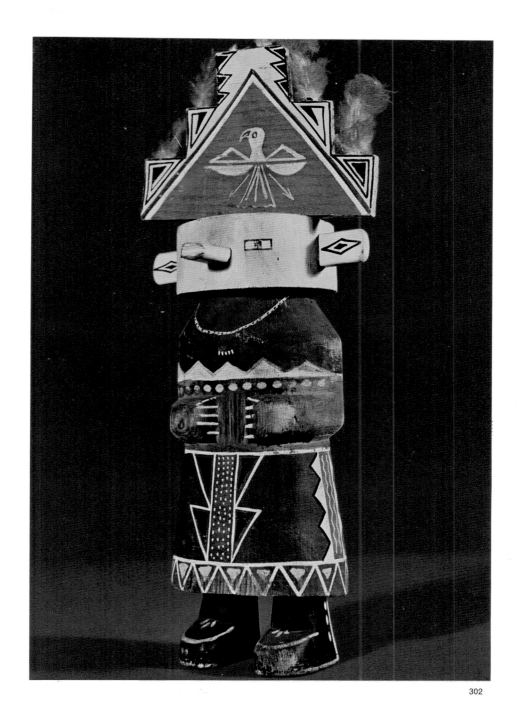

302

303

The Navajo

A geographically contiguous, but ethnically and culturally separate, Southwestern culture was that of the Navajo.[28] These Indians, who were of Athapascan linguistic stock and who had traveled to the Southwest from Alaska and northwestern Canada, lived in the Anasazi region; but, as best we know from archaeological evidence, they followed in late prehistoric times a quite different life pattern from that of their Pueblo neighbors. Apparently they arrived during the period known as Pueblo IV, or around A.D. 1500; but an earlier date is possible. It is unclear as to whether, as was once almost universally believed, they constantly raided the allegedly peaceful Anasazi nearby. They had little prehistoric tradition in the major arts. Their history from the late sixteenth century onward is better known. Historic Navajo arts are technologically eclectic: they borrowed weaving from the Pueblo Indians and silver-crafting from the Spanish, the former near the end of the seventeenth century and the latter in the mid-nineteenth. Today they practice both of these arts vigorously and to commercial advantage, but both have tended to become more and more elaborate, even when based partly upon the older patterns. It is evident that the absence of a truly viable ancient expression, comparable with that of the Pueblo peoples, for example, is responsible for less convincing varieties of late Navajo work, skillfully carried out and eye-catching as it may be in a purely technological sense.

A mid- or late-nineteenth-century woman's shawl of finely woven, handworked wool (fig. 303, colorplate) discloses the handsome appearance and fundamental good taste of the older styles. This variety of garment was popular until shortly after 1900, but is no longer made.

The Plains

The Plains Indian [29] represents *the* Indian to most Europeans and Americans alike. It is this equestrian, buckskin-clad, war-bonneted nomad whose romantic image comes immediately to mind when most of us hear the words "American Indian." He is known for his fierce resistance during the nineteenth century to the white man's invasion of his territory. The accidental adaptation of the horse from the Spanish sharply and picturesquely altered an older, prosaic life style on the Plains. This Indian became more and more nomadic during the eighteenth century after he became one of the most skillful horsemen ever known.

The roots of Plains Indian prehistory, however, seem to extend back to the ancient Folsom culture of 15,000 to 10,000 B.C. Later, the archaic period known as Old Signal Butte was developed by A.D. 500 in Nebraska, where the ancestors of the Plains Indian followed both hunting and food-gathering. Agriculture was not practiced at that stage, although in following stages it became more and more widely known to groups who lived alongside streams. Hunting, however, continued to be important to these people long before the horse was acquired. Archaeological remains, in Kansas and Nebraska particularly, disclosed only a nominal practice of ornamental art and pottery of a conservative type. Log-and-earth houses of roughly circular plan were typical of prehistoric Plains architecture.

The best-known Plains art is painting on animal hides, and this practice apparently developed during historic periods of this culture. It was not reported until about 1800, at which time it was well advanced in technique.

The skins of buffaloes, deer, and other animals, which were hunted primarily as food, also afforded a large and texturally desirable surface for decoration. Earth pigments of ferruginous clay, especially yellow, brown, and red, were primary in this art; vegetal matter provided green; black was derived from burned wood or bone. The vehicle or binder was a thin glue of boiled hide scrapings. The tool used for applying the paint was not a brush in the modern sense of the word, but a semiresilient, pointed object such as the spongy part of a quadruped's leg-bone or the chewed end of a wooden stick. The paint was rubbed and pressed into the hide rather than applied upon its surface as an extra layer. It is generally believed that men painted designs representing subjects from life, while women created geometric patterns only.

Among the hide objects which were painted with narrative or purely decorative patterns were robes, drums, shields, the linings as well as the outer surfaces of tipis (tepees), and a special type of container known as the parfleche, a flat, extensible carrying envelope for food or personal possessions.

The Crow Indian shield in figure 306, showing two buffaloes in combat, is characteristic of Plains shield paintings and dates from about 1850–75. All shields were highly prized by their warrior owners, and were believed to contain magical as well as material protective powers. Some varieties were used more or less as divining objects: rolled along the ground by the owner while he was deciding upon a venture, the shield would, if it toppled over face up, signify impending success; if it fell face down, failure was foretold. A war shield was painted personally by its owner, who, according to reports by students of the Plains Indians, received his designs during visions. The symbolism of these painted signs or narratives is usually obscure and was often known only to the warrior-artist.

Carving was done in both wood and stone by the Plains Indians, though not in abundance. Some small sculptures in the form of pipe bowls are of provocative imagery (figs. 305, 344). The majority of Plains pipes, which were carved of a material called catlinite or reddish pipestone, were nonfigural, and of a simple T or L shape.

Occasional small sculptures in the round have been found in the Great Plains. The sensitively reduced image of a bison shown in figure 304 is characteristic of these. Their purpose is not clearly known, but some of them may have served as fetishes and were carried in the "medicine bags" of warriors. This example was found in Crow Indian territory in Wyoming and is believed to date from the late nineteenth century. Its form suggests derivation from a prehistoric tradition, however, and it is not unlike Zuñi fetishes, whose origins almost certainly date back to early Pueblo times.

Among the tribes most active in hide painting were the Kiowa and Osage in the southerly reaches of the Plains, the Cheyenne and Crow of Wyoming and Montana, and the Blackfoot of the northerly region extending into southwestern Canada.

The Assiniboin, Hidatsa, Arikara, and Nez Percé, in addition to the groups just mentioned, practiced the elaborate craft of dressed-hide costume. Some of their work was adorned with painted areas, porcupine quills, and, later, glass trade beads. This aesthetic tends toward overcomplexity and, while it serves to enhance the picturesque aspect of the Plains Indian and testifies to great technological skill, it cannot properly be defined as an art.

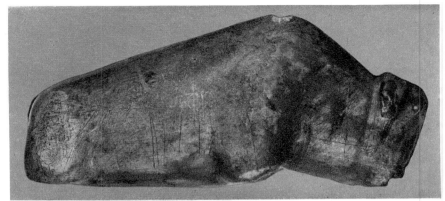

304

304. *Sculpture of a bison, found in Crow Indian territory, Wyoming. Probably late 19th century. Limestone, length 8 3/8". Smithsonian Institution, Washington, D.C.*

305. *Pipe with a head and an animal. Possibly Sioux. Catlinite, length 7 1/4". Museo Pigorini, Rome.*

306. *Shield representing two buffaloes in combat, from Montana. Crow. 1850–75. Painted hide, diameter 20 1/2". Museum of the American Indian, Heye Foundation, New York.*

305

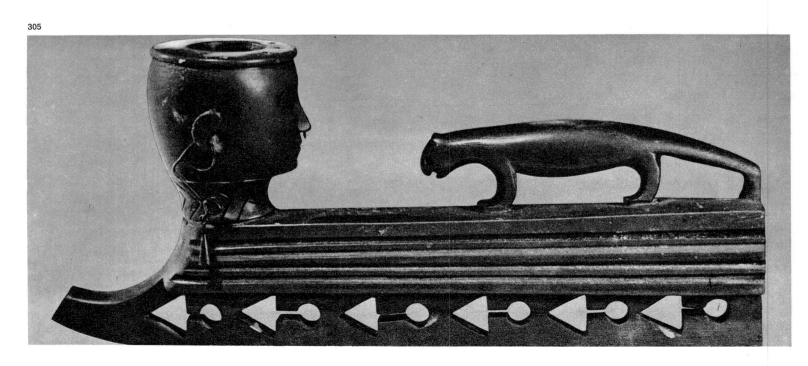

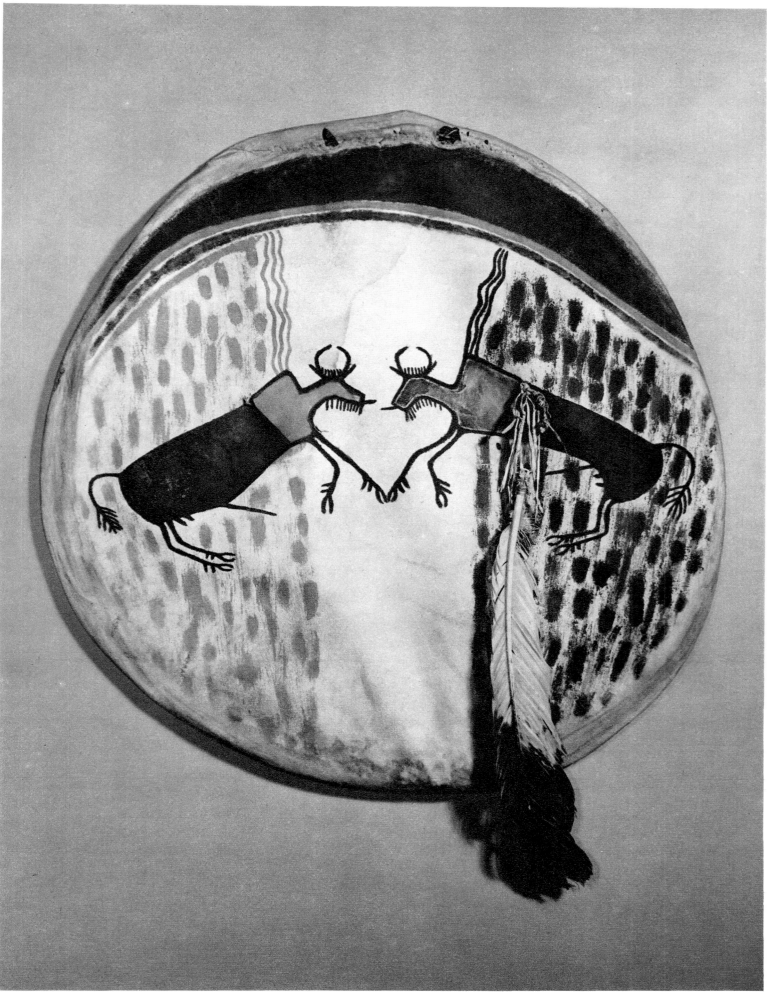

The California Coast

The outstanding art of the central and southern areas of the California Coast and nearby offshore islands was the stone carving of the Chumash Indians and their prehistoric antecedents.[30] This rich sculptural tradition, evidently formed during the early centuries of the Christian epoch, was practiced by the Chumash, and by the Fernandeno, the Gabrielino, and the Juaneno, which are named after the Spanish missions in their vicinity. These groups existed principally by fishing and food-gathering. Their seagoing canoes were splendidly formed of adzed planks sewed together and seamed with asphalt, which abounded in local deposits.

The Chumash

Chumash and related carvings were shaped with flint or other hard stone tools in local varieties of steatite, an easily worked mineral when first quarried, but which later turns very hard. Their characteristic subjects were taken from the marine life around them—whales, fish, crustaceans, amphibians. A basically naturalistic, compact style prevailed. A typical example appears in figure 307, a whale's image from Santa Cruz Island, concisely formed but enhanced with restrained inlays of haliotis shell, a widespread practice of these artists. The shells were strongly imbedded in carefully formed indentations in the surface and fixed with natural asphalt.

A more elaborate interpretation of a sea creature is shown in figure 309. This curiously shaped crustacean or amphibian, which was excavated in Los Angeles County, represents what may be referred to as a substyle of more fantastic sculptures of Chumash provenience.

A majority of them are given a nominally utilitarian form, such as a mortar or palette, as in this example. Other fanciful carvings are in the form of pipes or "cloud blowers," as they have been called.[31]

Not all Chumash sculpture, however, represented such subjects. Strikingly attractive pendants (fig. 308) were given semiabstract, shell-inlaid patterns suggestive of land-animal forms or totally imaginative designs. The present example weighs over two pounds and, if it was actually suspended from the neck or waist, must have been worn for only limited periods. It has been suggested that larger ornaments of this type were carried as staff-mounted standards during ceremonies, although our knowledge of early Chumash rites is limited. The shell elements forming the central design in this work are shaped and fitted with unusual care.

307

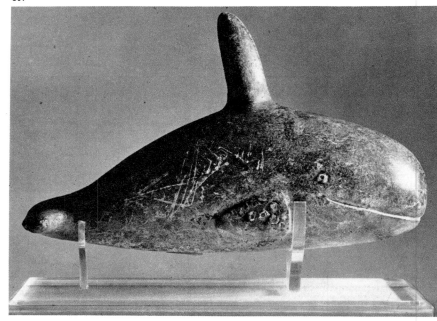

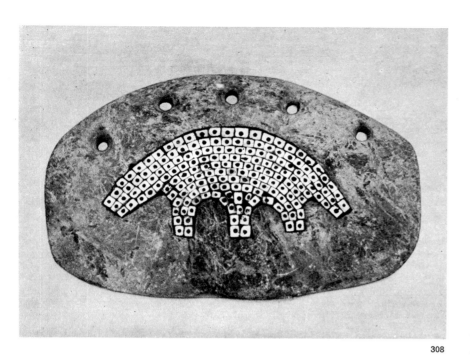

308

Additional Chumash sculptural classifications include large, handsomely formed stone bowls, many of them inlaid in the same way as the figural works and pendants. Some archaeologists have postulated a ritual use for Chumash carvings of especially refined quality, but there is little evidence to bear out this supposition. The fact is well known to ethnologists that quite crude objects, even natural stones suggesting the form of an animal, often possessed quite as great power or magic as did carefully executed sculptures. The strength of design and excellence of surface of Chumash stone art demonstrates, first of all, an aesthetic urge of great conviction. Secondly, the possession of these little sculptures undoubtedly enhanced the prestige of the collector. It is therefore likely that, while fetishistic and burial purposes may not be dismissed as motivating factors, connoisseurship was significant in their production.

Basketry was also developed during prehistoric times in southern California, both inland and along coastal sites; but most of it, being of perishable vegetal material, has disappeared. In recent centuries various California Indian groups have continued the early tradition and have produced, in both coiled and twined techniques, a distinctive and prolific craft. Fern and spruce roots, grass, and porcupine quills are at times combined by the Yurok in their weaving techniques. Some of their baskets reach the diameter of ten or more feet. The Washo and Pomo are also gifted basket weavers, the latter being especially well known for their featherwork containers.

307. Sculpture of a whale, from Santa Cruz Island, California. Chumash. Steatite with shell inlays, length 8 1/4". Judith Small Galleries, Inc., New York.

308. Pendant, from California. Chumash. Steatite with shell inlays, length 8". Museum of the American Indian, Heye Foundation, New York.

309. Bowl in the shape of an arthropod, from Los Angeles County, California. Chumash. Steatite, length 10 1/4". Museum of the American Indian, Heye Foundation, New York.

309

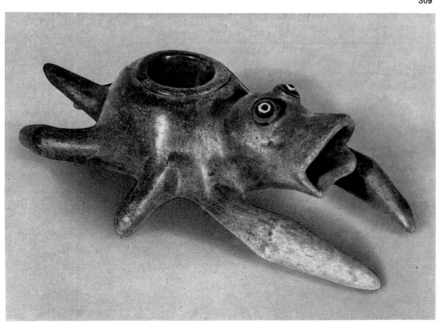

The Northwest Coast and Plateau, and the Eskimo

The Northwest Coast of North America has been one of the most productive areas of world primitive art. A rich tradition of sculpture, dating from prehistoric times, has existed until the very recent past, while architecture and weaving have also had impressive productions. This region begins with Oregon and Washington and reaches northward through coastal British Columbia and into southern Alaska. Its rich forests, the sea, and inland streams provided the means for an abundant livelihood and the sponsorship of an elaborate and sometimes spectacular art.[32]

The Northwest Coast is best known to popular and professional admirers of primitive art for its painted wood carving—masks, totemic monuments, figures, and decorated functional objects—of the period following the arrival of white settlers in the late eighteenth century; but the distinctive expression of these historic arts of this territory had its origins in an ancient style of stone carving which was developed during, or perhaps slightly before, the early centuries of the Christian epoch.[33] Many sculptures, some of them showing a seated human figure holding between its knees a bowl (figs. 310, 311), have been excavated from sites of great antiquity in southwestern British Columbia and northwestern Washington. Other stone works of this general type were discovered still in use among the Salish and other Indians of this region. The significance of such carvings to the predecessors of historic tribes is not clearly known. The historic Northwest Coast tribes sometimes used them in fishing rites, and it was reported shortly before 1900 that one seated stone figure had been carved not long before that in commemoration of a deceased tribesman. It was taken by one of his mourners to a fishing site and lowered by

rope, the belief being that it would, through magical potency, attract fish.

There are many classifications or substyles of the ancient carved figure holding a bowl, but all are characterized by a basic naturalism and the essentials of the pose shown in figures 310 and 311. Dramatic quality is present in the slight backward tilt of the head; and this gesture, plus the presence of the bowl, may denote supplication to spirits or the elements. Most of the works in this form are from three to twelve inches in height; a few are more than twenty inches high.

Figure 312 illustrates a human bust from the state of Washington, a work in scoria (a kind of rock formed by deposits of lava), which was fashioned by the combined techniques of pounding, pecking, and carving with harder stone tools. The circular treatment of the eye discloses

310 311

that stylistic differences existed between the northerly sculptures of the Fraser River and the Gulf of Georgia and those of the Plateau region of the Columbia River Valley. The delineation of both types of eye, the pointed interpretation of this feature in British Columbian works, and its rounded, encircled depiction further to the south found distinct repetition in the wood carvings of historic times in those respective areas.

The ancient Northwest Coast and Plateau tradition of works in stone included also a varied complex of standing figures, some of them reaching the height of four feet and suggesting a totemic arrangement, another feature of much carving in wood which followed centuries later. Stone utensils and clubs in the form of mountain sheep, birds, composite animal-human subjects, and amphibians (fig. 313) have been found in large numbers in the Columbia River Valley, well inland from the coast. The example here illustrated represents a turtle swimming, its back given two depressions which may have served as a mortar for the grinding of berries or other food, or as a palette. Faint traces of paint are sometimes seen on various parts of these vessels. The turtle's sides are figured with a chevronlike motif, which had very wide use in the early art of the Northwest and which also appeared later in wood carving (fig. 315). The chevron design

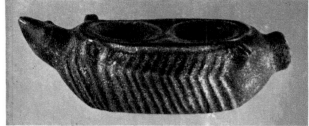

312

310. Seated figure holding a bowl. Northwest Coast. Stone, height 4 3/4". Provincial Museum, Victoria, B.C.

311. Seated figure holding a bowl. Northwest Coast. Steatite, height c. 3". Provincial Museum, Victoria, B.C.

312. Human bust, from Klickitat County, Washington. Prehistoric culture. Scoria, height 12 7/8". Museum of the American Indian, Heye Foundation, New York.

313. Vessel in turtle form, from the Columbia River Valley, Oregon. Prehistoric culture. Stone, length 8 1/2". Smithsonian Institution, Washington, D.C.

313

may very possibly represent the internal rib-structure, and its depiction on carvings of human figures, suggesting skeletal symbolism, has been linked by archaeologists and ethnologists with the existence of a death cult believed to have been widespread at one time in the Columbia Basin.[34] It is to be remembered that many paleolithic European rock engravings, as well as the bark paintings of Arnhemland in Australia, present similar externalization of inner body parts. An excellent example of this art is the grouselike bird of figure 314, which was discovered in a gravel bar on the Columbia River near The Dalles, Oregon, one of the principal sites of Northwest Coast and Plateau stone art.

While these carvings in scoria, sandstone, and granite lack the spectacular expressiveness of the later wooden masks and totem poles of well-known Northwest Coast historic tribes, they

possess a compact and powerfully sculpturesque quality. They comprise a distinguished but all-too-slightly known and admired contribution to North American Indian art, and future archaeological and art-historical study will surely bring to them the high recognition which they so clearly deserve.

The early historic European explorers and traders of the Northwest Coast found an already flourishing society. The possession of art works and the use of carved and decorated masks, spirit figures, and ceremonial noise-making devices for dramatic and narrative effect during tribal rites were outstanding phenomena. An essentially capitalistic social structure, without true parallel among other Indian groups of the United States and Canada, made prestigious the accumulation of wealth and its symbol, art. The prolific, often dazzling, sculptural and painted forms created by these tribes are unsurpassed by those of any region of the primitive world.

Northwest Coast tribes are divisible in the broadest sense into two major groups: the Salish peoples of the southernmost part, and the neighboring, and more northerly, non-Salish. This basic distinction is made largely on linguistic grounds,[35] although between Salish sculpture and that of the northern tribes there is also an important cultural difference.[36] Most groups lived under a fourfold system of tribal chiefs, clan or "house" chiefs, freemen, and slaves. The Indian population of this area may have been fifty thousand or more around the year 1800. It is less than half of that today.

The southernmost region,[37] that of northwestern Washington, Vancouver Island, and the southwestern British Columbia coast, was the home of the Nootka and Coast Salish. Somewhat farther north in British Columbia lived the Bella Coola and Kwakiutl, the latter occupying the northern part of the Queen Charlotte Islands. The Haida, Tsimshian, and Tlingit lived still farther north, the Tlingit group extending into southeastern Alaska. To the north of the Tlingit lived the Alaskan Eskimo.

The Salish

Although cedarwood sculpture is the best-known and by all means the most distinguished art of the historic Northwest tribes, their split-plank communal houses were among the most interesting of domestic structures north of the Pueblo region. The Salish specialized in a horizontally planked dwelling of longish-plan, supported by a log and pole framework. Some were over five hundred feet in length. The typical roof was the single-pitched, or "shed," type.

314

Carved house poles with emblematic animals appeared as inside panels or supports. Exterior carved house posts combining animal and human motifs were another characteristic form. Planked grave-houses with narrative or totemic animals and clan-ancestor images carved in high relief were also typical.

A special variety of Salish wood sculpture was the spirit canoe figure (fig. 315), used in a ceremony carried out in imaginary canoes in quest of lost souls. Carvings of this type were thrust into the ground in the general outline of a canoe, and travelers were led about these figures by a shaman or tribal sorcerer.[38] The harshly angular, semiabstract interpretation of the human image seen in this example is characteristic of much Salish art. It is relevant that this figure, like many of its class, bears the chevronlike motif referred to in the discussion of prehistoric stone carving of this general area and its possible connection with a death or ghost cult.

Typical Salish masks, like Salish figures, are distinctive and have no near parallels in the

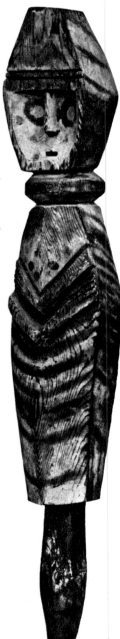

314. Bird figurine, discovered along the Columbia River near The Dalles, Oregon. Prehistoric culture. Scoria, length 5 3/4". Museum of the American Indian, Heye Foundation, New York.

315. Spirit-canoe figure. Salish. Wood, height 46". Chicago Natural History Museum.

315

210

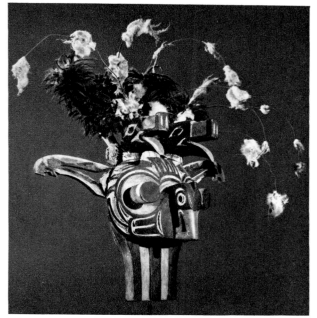

316

more northerly art of the Coast (fig. 316). The specimen shown here is known as the *swaixwe* (*xoaexoe*) type which was worn in rites invoking the spirit of a mythical creature who was believed to swoop to earth and dwell like a bird in lakes. Blackish-blue, red, and white polychrome, plus red feathers, cloth, and twigs, give these masks a weird, complicated imagery. This work represents a Salish substyle which was practiced in the Fraser River territory of this group. A number of distinctive local or village Salish styles may be determined, as they may be in the art of tribes farther north. Although it is not possible beyond a point to generalize about Salish or any other Northwest Coast expression because of the essential homogeneity of style throughout, it may be observed that Salish carving tended toward a more nearly abstract, reduced style, relatively intellectual in its containment, and less floridly decorative than the styles of most groups farther north.

The Nootka

The second of the southern peoples of the Northwest Coast were the Nootka of Vancouver Island, who appear to have been a comparatively recently formed tribe. Their art style is to some extent eclectic, drawing inspiration from both the Salish and, more often, the Bella Coola and Kwakiutl. One of the most famous of Nootka works, a panel painting, is shown in figure 317. This masterwork was carried out in what amounts to an oil medium, the vehicle being crushed salmon eggs; and the ground is a panel of hand-adzed boards fixed tightly edge to edge by root-fiber thongs. The narrative involves the abduction of the Killer Whale by the mythological Lightning Snake (a prominent being in the legends of these people) and the Thunderbird, while a wolf also enters the composition. The principal forms are recognizable as specific animals, or fanciful creatures with animal characteristics, as the case may be. A high order of imagination accompanies the details of presentation. This is an exceptionally large panel of a type which was usually stored and only brought out for display at elaborate ceremonies known as "potlatches," where a chieftain would ostentatiously destroy his valuable objects in order to shame a rival tribesman.

The Kwakiutl

One of the most dramatic of Northwest Coast styles was that of the Kwakiutl. Although this tribe adapted many stylistic elements from the art of nearby groups, their masks and related ceremonial sculptures are memorably flamboyant and projective of intensely felt emotion, at

317

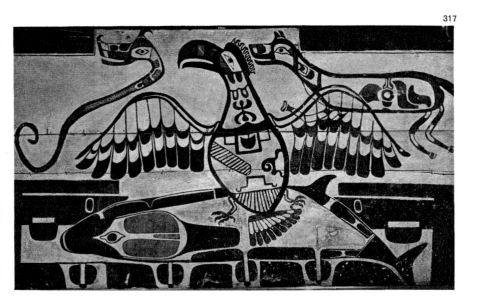

316. Mask (swaixwe), *from the Lower Fraser River territory, British Columbia. Salish. Painted wood with feathers, cloth, and twigs, height 20". The American Museum of Natural History, New York.*

317. The Killer Whale Abducted by the Lightning Snake and the Thunderbird, from the Northwest Coast. Nootka. Fish-oil color on wood, width 9'10". The American Museum of Natural History, New York.

211

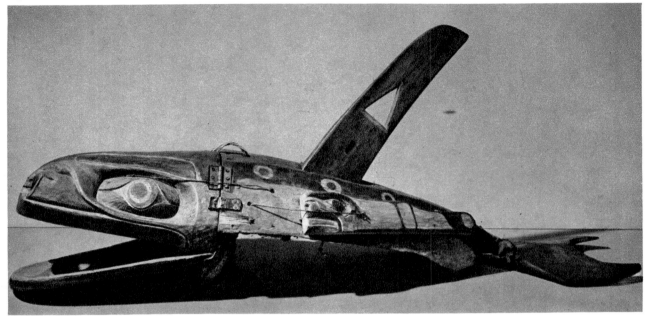

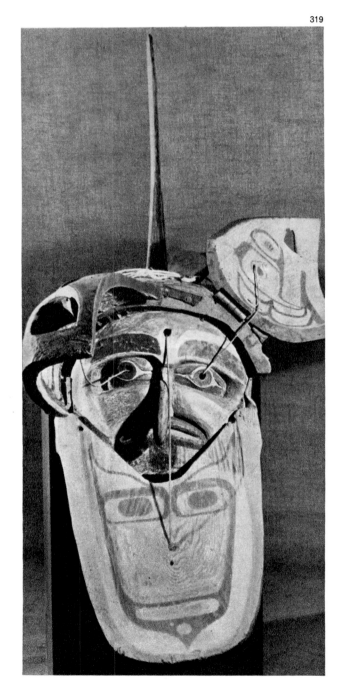

times comic, at times hostile and aggressive. The dance mask (fig. 329, colorplate) represents one of the mythic Cannibals of the Kwakiutl. With its brilliant polychromy and the reinforcing cedar-bark fringe, it evokes in the spectator an immediate and not easily forgotten response. When such objects were actually worn in the complex dance rites of the Kwakiutl, the sometimes regular, sometimes broken, rhythms of physical movement were accompanied by the flapping of the movable jaw of the mask and the concomitant jiggling of the fringe. The effect must have been overpowering on tribal witnesses at ceremonies where scores of equally dramatic carved images were brought fearsomely to life by the celebrants.

A larger and more complex object is the horizontally worn type shown in figure 318, actually a "construction" rather than a carving. This work, which represents the Killer Whale, is over five feet in length and typifies a multiple-image type of movable mask, which could be so controlled by the wearer that an outer face could be opened up, either partially (fig. 319) or fully, revealing an inner image. An ingenious system of cords not only made possible the baring of an additional face, but set in motion the dorsal fin and flippers of this weird contraption. This work is an exceptionally fine one of its category and probably dates from the mid-nineteenth century. Some of its red, blue, and green colors were derived from natural sources—vegetal substances such as berries or the bark of certain trees, corroded native copper, and fern or moss—with some parts suggesting later European commercial pigment.

The ceremonies in which these fanciful masks were worn were usually sponsored by secret societies. They were supervised by sorcerers or shamans and held in the great communal plank

houses. But, whether the festivities were religious or secular in nature, they were impelled by the omnipresent, deeply self-centered seeking of individual wealth and enhancement of status. The parallel with certain twentieth-century "civilized" social-religious attitudes is all too obvious.

Kwakiutl architecture was hardly less ostentatious than was the sculpture and its uses. In contrast to the southern, or Salish, plank houses, those of the Kwakiutl and other tribes in the central and northern areas of the Coast usually had double-pitched, or gabled, roofs; and the split-log planks were typically vertical, not horizontal, in placement. Elaborate painted crests or narratives of clan animals frequently framed the small doorways. Figural house posts flanked the entrance.

The potlatch has been mentioned in passing. This wantonly destructive, conspicuously egocentric ceremony was nowhere more dramatically carried out than among the Kwakiutl.[39] To achieve rank superior to that of his rival, a chief might hold a feast at which he would ostentatiously give away or burn his most prized possessions, even to the extent of rendering his family temporarily destitute. If his competitor declined to respond with an equally demonstrative feast, he might commission a tribal artist to carve in wood a derisive image of that chief. The carvings shown in figures 320–21 may be of such origin, or may represent the spokesmen or "seconds" of the chief himself. The simplicity of features and gesture stands in contrast to the weird complexity of the masks. This type of figure was sometimes used as a gable figure or was placed upon a post outside the house.

The Haida

To the north and west of the Kwakiutl were located the Haida, a tribe which centered in the Queen Charlotte Islands. The best-known art of the Haida was the totem pole: indeed, this object is probably the most popular of all Northwest Coast sculptures among the general public. The term is, in a sense, misleading, for, although the arrangement of the vertical elements is totemic in that superposition results, the individual faces, figures, and decorative forms are actually family crests and symbols of myths or legends pertaining to a family, or the animal associated with its clans. Some carved poles of this genre were actually house poles or commemorative or grave markers (figs. 328, 330, colorplates).[40] In some of the more elabo-

318, 319. Double mask representing the Killer Whale (side view and front view showing outer mask partially open), from British Columbia. Kwakiutl. 19th century. Painted wood, length 63 1/2". The Museum of Primitive Art, New York.

320. Standing male figure, from British Columbia. Kwakiutl. Wood, height 67". Museum of the American Indian, Heye Foundation, New York.

320

213

rate of Haida poles, the vertical figures or partial figures are linked one to the other. Some totem poles or grave poles are simpler and contain only a single clan or individual family crest superposed upon an unfigured shaft. But in all cases the underlying motive for erecting these markers was, like that of the potlatch ceremony, the assertion of prestige or rank, whether of a deceased or a living person.

The so-called totemic carvings illustrated here indicate the flourish and elaboration of the best-known style of this Indian group. But the Haida sometimes carved portraitlike masks (fig. 322), which are expressive of a quieter mode of the society of Northwest Coast Indians.[41]

It is ironic that the artistic medium used with such appealing economy of technique and directness of expression during prehistoric times in the Northwest Coast should have been conspicuously utilized in a quite late resurgence of European- and Japanese-influenced, excessively detailed carving among the Haida. Stone—specifically, slate or argillite—was found to be a carver's vehicle, which occasioned widespread popular demand when produced by the Haida in a plethora of decorative-utilitarian forms, such as plates, trays, chests and miniature totem poles. Much of this "art" from 1900 onward is so embarrassingly inartistic and is so precisely and lavishly detailed that it suggests production-line origin.[42] On the contrary, occasional works of considerable merit, more restrained in technological virtuosity and given expressive value, appear in figural groups (fig. 325). The illustrated work follows a theme favored among the Haida and which is the subject of several masterpieces in the generally abused slate or argillite medium. This is the legend of the Bear-Mother, who was abducted by bears and who cohabited with the bear chieftain, later giving birth to a child of human physiognomy but with animal, savage habits.

The Niska

One of the masterpieces of the Northwest Coast mask form is represented here in a work by the Niska tribe of the northern Nass River district (fig. 324). Usually described as realistic, this work is a startling document of surrealism. The striated wrinkles, the puckered and half-open mouth, and the goriness of the lower lip with its shell-inlaid labret all combine to project a lurid imagery unsurpassed by either medieval or twentieth-century art of the grotesque. Paradoxically, the labret, or surgically imbedded lip-plug, has long been considered by various primitive peoples to enhance the beauty of the

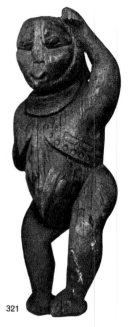

321. *Standing figure, from the Northwest Coast. Kwakiutl. Wood, height 37 1/2". The American Museum of Natural History, New York.*

322. *Mask representing a Haida woman with ear ring, nose ring, and small labret, from the Northwest Coast. Haida. Painted wood with metal. The American Museum of Natural History, New York.*

323. *Communal house with totem poles. Ketchikan, Alaska.*

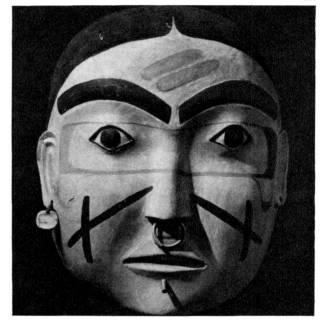

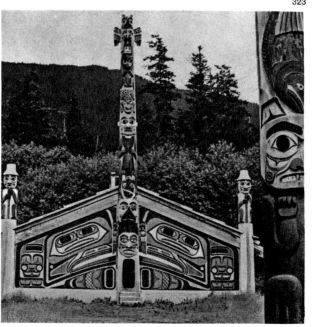

324. *Mask representing an old woman wearing labret, from the upper Nass River, British Columbia. Niska. Wood with abalone-shell inlays, height 9 1/4". Museum of the American Indian, Heye Foundation, New York.*

325. *Bear-Mother carving, from British Columbia. Haida. Slate, width 9". Collection Harry Bober, New York.*

324

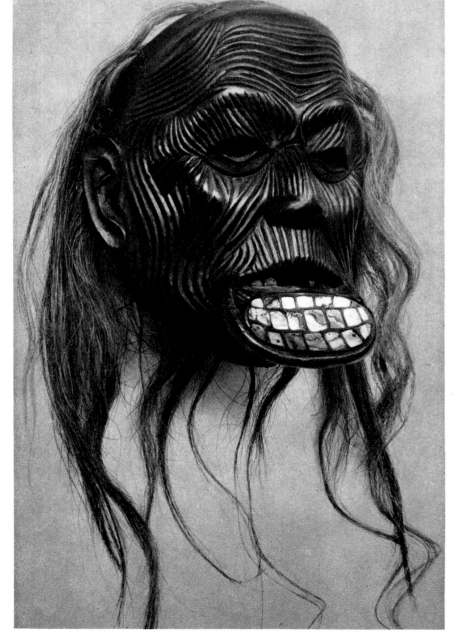

female features. (Contrast the reserved effect of the simple insert below the lip in the mask of figure 322 with this gaping, woundlike snaggle of bunched teeth and punctured skin.)

The Tsimshian

The arts of the Tsimshian are more subtly conceived and less florid in over-all interpretation than those of the more southerly peoples of the Northwest Coast. Masks are frequently more naturalistic (though with certain conventionalizations of features, to be sure) than those of their Haida and Bella Coola neighbors.[43] Facial planes and modeling are sensitively handled. Tsimshian carving is generally more three-dimensional and fully cut from the wood than is much Northwestern art, and, in such forms as totem poles, an unusual clarity and unification of parts replaces the profusion of details and decorative virtuosity of Haida and Kwakiutl works in this monumental genre. Tsimshian style is sculpturesque, and its underlying power is not obscured by the extensive detail which in some instances accompanies the total form of a given mask or figure.

The Tlingit

The northernmost of Indian tribes in this region is the Tlingit group, at one time immensely wealthy because of the European fur trade. Their habitat reaches from the northern extremity of the Tsimshian area of upper British Columbia into the southeastern tip of Alaska. The Chilkat, a subtribe of the Tlingit, have produced one of the best-liked and most characteristic forms of this area, the handsomely woven, semiabstractly patterned dance kilt or blanket. These garments are hand-loomed from mountain-sheep wool and shredded bark. A longish fringe appears at the lower edge. The

325

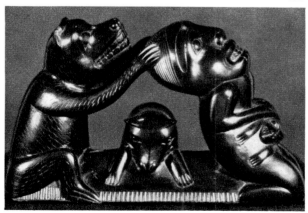

326, 327. Chiefs' ceremonial headdresses, with appended ermine-skin garments, from the Northwest Coast. Tlingit. Painted wood with shell inlays, sea-mammal bristles, and feathers, height 42". Chicago Natural History Museum.

328. Totem pole, from the Northwest Coast. Haida. Wood, height c. 30'. Lowie Museum of Anthropology, University of California, Berkeley.

329. Dance mask, from the Northwest Coast. Kwakiutl. Wood with bark fringe, length 22 3/4". Detroit Institute of Arts.

330. Totem pole (detail), from the Northwest Coast. Haida. Lowie Museum of Anthropology, University of California, Berkeley.

331, 332. Ceremonial shirt (front and back), from the northern Northwest Coast. Tlingit (Chilkat). Length 37 1/4". Detroit Institute of Arts.

326
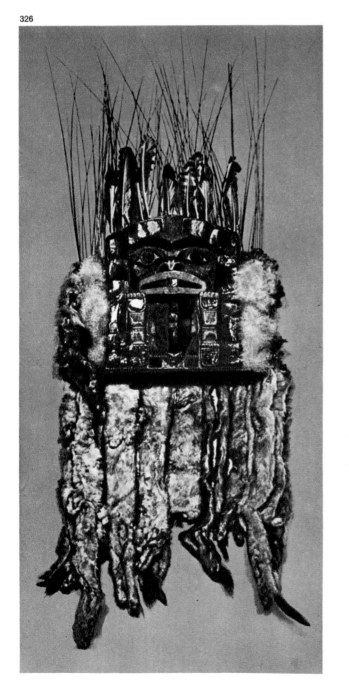

327
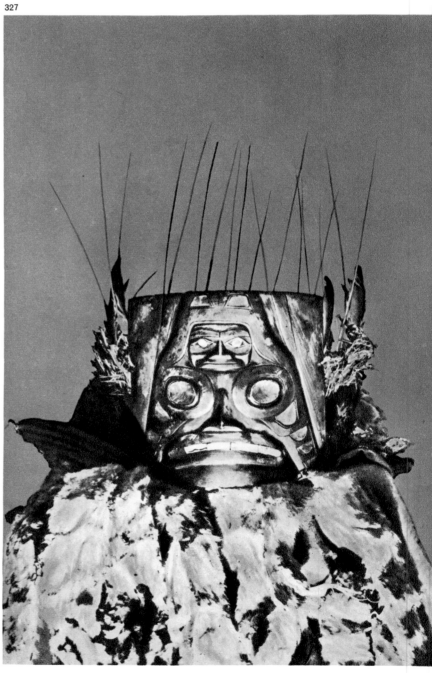

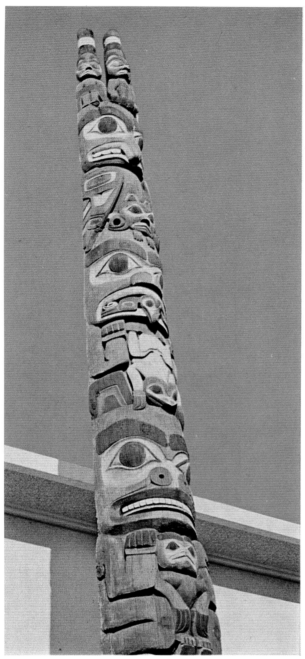

328

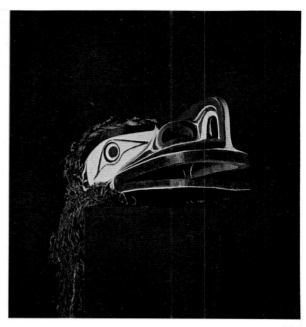

329

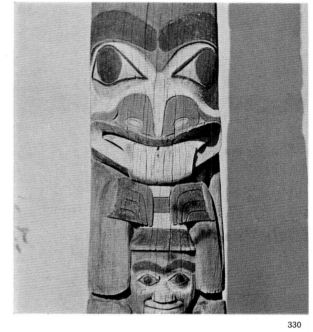

330

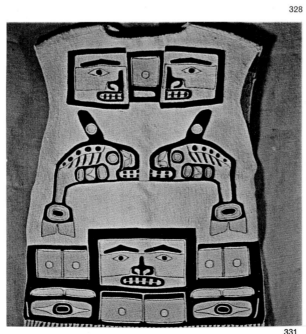

331

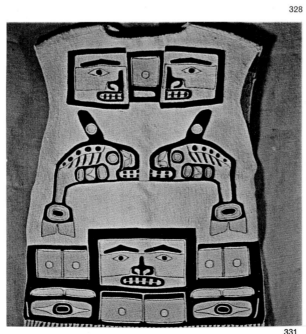

332

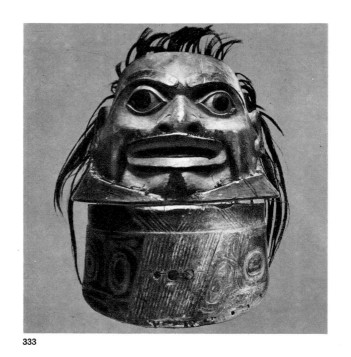

333

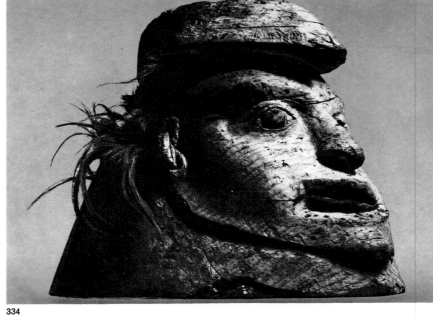

334

field of design is typically outlined by a blackish border which powerfully enframes a complexly zoned depiction of a clan animal woven in "split" fashion. Motifs such as eyes, whale-fins, bear-paws, or whole heads are sharply defined in pale blue, yellow, and soft black. Closely related in concept is the ceremonial shirt (figs. 331, 332, colorplates), the front of which is characteristically decorated with emblematic whale and facial forms, heraldically arranged. The reverse of the garment is figured with a simple but stunningly attractive, checkerboard pattern of yellow squares, typical of the dance kilt or blanket, opposed by strong black and light blue counterparts. Such garments are among the most appealing costumes of the primitive world.[44]

The wearing of masks by Tlingit sorcerers or shamans was sometimes concerned with the remedy of physical ailments of tribespeople. More than one mask might be used during the ceremony, in the hope that multiple supplication to various spirits might be the more effective. The Tlingit penchant for fantastically designed costume is extended to such masks or to the examples illustrated here (figs. 326, 327), two headdresses with ermine-skin garments appended. A raven is totemically represented by the face in figure 326. It is surrounded by a richly shell-inlaid, rectangular panel which bears blue, green, red, and black paint. Long sea-mammal bristles and bird-feathers sprout from the crown. These richly composed objects were intended to house spirits which would, implemented by special gestures and dances of the shaman, rid a sick person of disease.

The Tlingit also carved an extraordinary kind of wooden helmet which bore the image of a human face (figs. 333, 334). The features of some

of these objects lend a distinctive and unexpected expressiveness. It is not known if the labial gesture, usually a derisive one, was intended to convey an inner state of emotion or to depict some pathological condition. The helmets actually served a protective purpose and were reinforced from beneath by a heavy collar of wood or hide. Our attention is immediately drawn to the mouth, but the total aspect of the features reveals the Tlingit capacity for strong analysis of all facial zones.

Our discussion has concerned only the major forms of Northwest Coast sculpture, architecture, and weaving; but, throughout the vast coastal and insular territory from northern Washington to Alaska, an extravagant complex of ceremonial and functional decorated objects, tiny and huge, was created in wood, shell, bone, ivory, and sometimes copper. The finely shaped, steam-bent wooden boxes of the Haida and other tribes, the huge seagoing canoes of the Salish and Kwakiutl (some of which were greater in length than the earliest European sailing vessels which transported settlers to the American continent), pendants of whale ivory, war clubs with grips topped by images of the human head, carved rattles and whistles of animal or human shape, and a multiplicity of related forms abounded everywhere. Even the wooden grip of the short-bladed hand adze with which the Northwest Coast sculptor formed his images was often incised or relieved with the slow, undulating curve or the pointed eye motif so prevalent in the aesthetic of this region. The flourishing tradition of dramatically polychromed or shell-inlaid wood sculpture, the great communal houses built of hand-shaped planks, the strikingly attractive woven dance costumes, the prehistoric stone

218

images with their compactly powerful form, all resolve into one of the most distinctive and prolific contributions known to world primitive art. The bequest is one of unsurpassed strength of concept and certainty of technique.

The Eskimo

The art of the Eskimo, both old and modern, has consisted mainly of small sculptures in ivory, bone, antler, stone, and driftwood,[45] while fantastic masks of wood with additives of feathers, hide, and fibers have also been produced in some areas. The Eskimo's was one of the most formidably difficult of adjustments ever made by man to environment; his arctic and subarctic habitat is rigorous and threateningly cold. But, from very ancient times, his aesthetic urge has been applied to a variety of incised or three-dimensional forms of unique and appealing value.

Most archaeologists divide the Eskimo region into three principal zones: the Northwestern Area (northeastern Siberia and northwestern Alaska); the Southwestern Area (the Aleutian Islands, parts of the Alaskan peninsula, Kodiak Island, and Cook Inlet); and the Eastern Area (the arctic islands and Hudson Bay in Canada, Greenland, Labrador, and part of Newfoundland).

A majority of Eskimos are hunters and meat eaters; the small boat and the harpoon (fig. 336) have been strategic to their survival. Weapons and other accessories to the hunt by sea or by land were engraved, or the images of sea mammals or land animals were carved in the round, from the very early stages of their presence in North America. From the Old Bering Sea culture of northern Alaska, one of the first definitive periods of Eskimo prehistory, and dating apparently from well before the beginning of the Christian epoch, came curious winglike or butterfly-shaped, thin, walrus-ivory forms (fig. 336). These are delicately incised with curvilinear passages and the circle-and-dot motif. The latter is common to one or another phase of Eskimo art for many centuries thereafter. The exact purpose of these small sculptures, most of them six to eight or nine inches in length, is still not clear; and they may have had no utilitarian function at all. Occasional images of human or animal figures have also been found at Old Bering Sea sites and in the Okvik and Ipiutak complexes, which were roughly contemporary, as well as in the Punuk and Birnirk periods and in the so-called post-Punuk phase, which followed in the same area and lasted until historic times.

333. Helmet, from the Northwest Coast. Tlingit. Wood, height c. 9". Lowie Museum of Anthropology, University of California, Berkeley.

334. Helmet, from the Northwest Coast. Tlingit. Wood, height c. 10". Lowie Museum of Anthropology, University of California, Berkeley.

335. Needle cases, from Hudson Bay and Labrador. Eskimo. Archaeological period. Ivory, height 4 3/4". Musée de l'Homme, Paris.

336. Winged object, harpoon heads, and other small carvings, probably from Point Hope, Alaska. Eskimo. Old Bering Sea culture. Ivory, length of winged object 8 1/8". Smithsonian Institution, Washington, D.C.

335

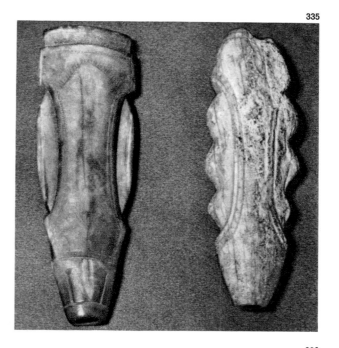

336

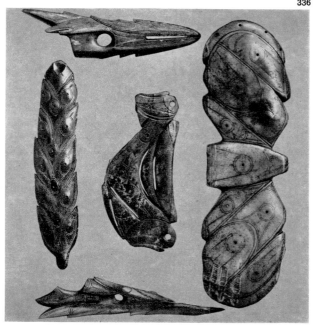

Southwestern (Aleutian Island and peninsular Alaskan) Eskimo cultural periods followed a generally similar chronology. Linear designs on weapon points, occasional incised images of the human face, and smallish ornaments seem to date back to slightly before Christian times. But the late period of Aleut prehistory, which ended about 1750, produced complex, grotesque wooden masks which have enjoyed an elaborate tradition since that time (figs. 342, 343, colorplates). Figure 342 represents a composite deer-and-human image, a type of mask characteristic of southwestern Alaska. An animal, or part of an animal, is frequently superposed on the human features of masks, as in the present case. Most Eskimo carvings of this kind were too delicate to be worn and were held before the face. Figure 337 shows a mask representing the Cold Weather Spirit Negakfok. The handlike ears are characteristic of many of these objects. These masks offer remarkably grotesque compositions and conglomerations of appended elements, which were intended to flutter and to add to the lively sense of movement and rhythm of the dancer who wore them during feast ceremonies or in magical rites preparatory to the hunt. The Kuskokwim River of Alaska is an important center of the production of these driftwood, polychromed, often humorous images. It is not possible within the scope of this study to consider at length the possible prehistoric and historic connections between Eskimo sculpture and that of the Northwest Coast Indian tribes; but it appears likely that interchanges, as yet not fully investigated by archaeologists or ethnologists, did exist, and probably at early times.

The eastern Greenland Eskimo likewise produced masks of grotesque, provocative design. Most of these are more compact in form and less complicated by the appendages which characterize Alaskan Eskimo counterparts.

In quite recent years, Eskimos of various arctic regions have produced small sculptures of animal and human subjects in stone, bone, or ivory which have enjoyed a vogue and have frequently been exhibited in the United States and elsewhere. The best of these carry over some of the compact, strongly three-dimensional concept of the traditional styles; but more of them are schematic, toylike, and unpleasantly streamlined.

The Eskimo, laboring under the rigors of creating a new life pattern in an unsympathetic climate and bleak topography, has for many centuries courageously demonstrated that the creation of art forms, even under the severest of physical conditions, is an essential institution in the life of man.

337. Mask representing Negakfok, the Cold Weather Spirit, from the Kuskokwim River area, Alaska. Eskimo. Painted wood with feathers, height 36 1/2". Museum of the American Indian, Heye Foundation, New York.

337

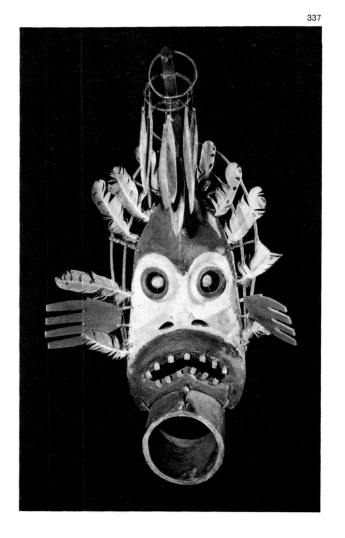

The Eastern United States

The principal arts of the Eastern North American Indian are the prehistoric sculptures in several mediums of the peoples known as the Mound Builders; the architecture, especially great earthworks used as temple and burial sites by that group; and, in more recent times, the carved masks of the Iroquois of the northeastern part of the United States, especially New York State and nearby areas of Canada. A prolific and appealing output of ornament, as well as of decorated utilitarian objects, also occurred in the area from the Great Lakes and eastward in Canada to New York. But the fine arts of Eastern North America issued chiefly from various archaeological sites, most of them related either by general cultural traits, or by artistic styles, or by both, which were located in the extensive region prehistorically occupied by the Hopewell, Adena, and Mississippi peoples.[46] Stylistically, this territory includes almost all states east of the Mississippi River and south of Virginia, plus a number of separate areas west of the Mississippi. Archaeologically speaking, the Eastern United States also includes the Great Plains, which we have already treated as a distinct area of North American Indian art.

Several chronological and spatial divisions of this territory have been made on the basis of archaeological remains. As many as twenty distinct phases may be referred to; the most clearly definitive time-and-area sequences are referred to as the Paleo-Indian period (mentioned earlier in this study in connection with the arrival of early man on the North American continent and his settlement in the Southwest), which so far has produced little evidence of effect on Eastern United States culture, although artifacts discovered in New England indicate that the ancient Folsom culture, widespread in the Plains and in the Southwest, did extend into the eastern Woodlands; the Eastern Archaic and Transitional Woodlands periods, dating back perhaps six thousand years (or to about 4000 B.C.), but with almost no art works of advanced aesthetic quality; the Early Woodlands period, some phases of which may extend from about three thousand years ago (or 1000 B.C.) until the early years of the Christian epoch; the Middle Woodlands–Hopewell period, in which small sculptures and ornaments of sound quality appear, along with certain types of the earthwork structures for which the Mound Builders are justly famous, the dates appearing to be roughly from the beginning of Christian times to about 1200 or 1300; and the Mississippi period, a stage of great development in ceramics, stone and shell sculpture and ornament, and various kinds of earth-mound architecture, dating from about 1200 or 1300 to about 1600, depending upon the locality. It is emphasized here that throughout the Eastern United States, overlappings occur in such a chronological schema, and variations exist in quality and type of particular works of art from one subregion to the next. The distribution of aesthetic achievement did not correspond precisely to a fixed sequential arrangement of dates, nor to the over-all level of other cultural achievements manifested at a given Indian settlement.

It may be said without qualification, however, that between the very early centuries of the Christian era and about 1600 a flourishing, distinctive art was developed by the Hopewell and Mississippi peoples, for whom the designation Mound Builder still applies with general accuracy, in the greater part of the midwestern and southeastern United States.[47]

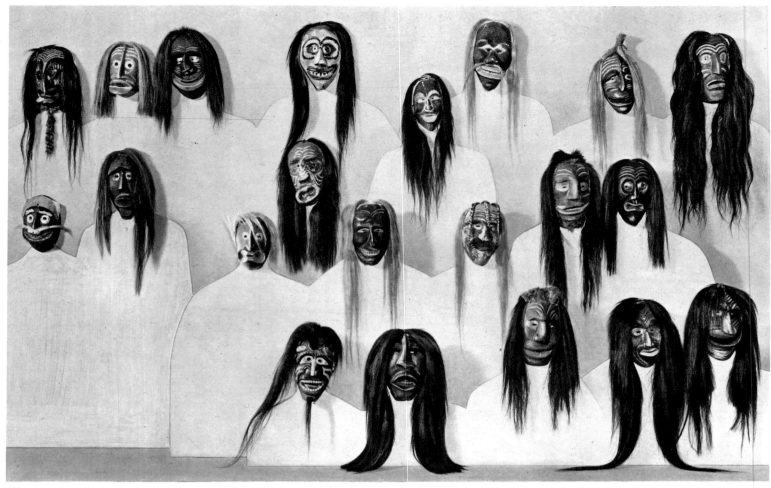

338

The Iroquois

It is believed by some archaeologists and ethnologists that the Iroquois developed their culture farther west or south before occupying their historic region in the Northeast, possibly not arriving in the New York area until around A.D. 1200. They became powerfully organized during the sixteenth century under a formal and representative government known as the Six Nations. This strong tribal unity was of great advantage to them following white intrusion in the area, and helped them remain in their chosen habitat after their ultimate defeat by the whites.

The prehistoric arts of the Iroquois area lacked the distinction which we find in the ancient ceramics, sculpture, and architecture of the Mound Builder area to the west and south. Some weapons of forceful and attractive design, especially ball-headed war clubs, are of pre-European origin in style, and a number of finely worked bone combs, some of them having superposed, heraldically paired animals, undoubtedly carry over from antiquity. But the Iroquois are best known for their masks of historic and even contemporary times.[48] Many of these rival Northwest Coast and Eskimo masks for dramatic and sculptural quality

(fig. 338).[49] Humorously grotesque in conception, with the exaggeration of the mouth and eyes usually acting as the carrier of comical or other emotional states, they convey an instant and startling impact. Deeply incised striations usually divide the face into distinct zones or otherwise contribute to strong demarcations of eyes, cheeks, mouth, and forehead. Metallic rims were sometimes placed around the eyes. Twisted and even displaced features are not uncommonly seen in the type here illustrated. Appendages of hair from the tails of horses, plus a usually simple chromatic treatment of red and black, add to the wild effect of these carvings. The carving of Iroquois masks in wood was initiated on the living tree itself, especially the basswood, so that the ultimate forms would contain part of the tree's spirit. They represented legendary beings who were impersonated by dancers of the False Face society in a number of rites and festivals, some of the latter given in celebration of good harvests. A second Iroquois mask was the cornhusk type (fig. 339) worn by the Husk Face or Bushyhead society. Like the technique of the dramatic False Face masks, that of the cornhusk type is said to be ancient. Shredded fringes and braided coils are effectively used in forming a spiraled face whose eyes and mouth, although

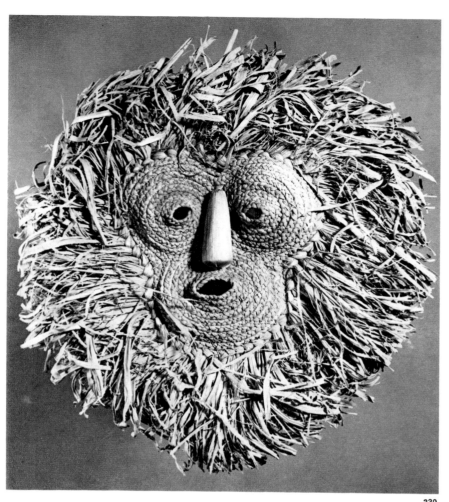

339

interpreted very differently from those of the False Face classification, are similarly the carriers of a startled or confused expression. Both types are still being made by these Northeastern Indians, whose early-founded confederation has gone far to sustain many basic aspects of pre-European tribal patterns.[50]

The characteristic dwelling of the Iroquois was the "long house," a rectangularly-planned, tunnel-roofed, wooden structure of pole framework with sheet-bark covering. Surrounded by the aggressive Algonkin tribes, the Iroquois often encircled their complexes of long houses with protective palisades.

The Algonkin tribes of New England and Canada[51] appear to have originated the tipi (tepee), the conical-pyramidal tent of bark or skin, supported by a radial frame of thin poles. Apparently this form gradually became familiar in the Great Lakes region farther west and was eventually adapted by the Plains Indians. We usually associate its greatest development with the latter culture.

The Mound Builders

The prehistoric Mound Builders [52] and kindred groups of the Ohio and Mississippi river valleys and most of the southeastern states rival the Northwest Coast Indians and the Anasazi peoples in total aesthetic expression, although the styles of this region are decidedly unlike the others. Monumental architectural complexes were constructed by the Mound Builders, but they were not of the communal dwelling type known to the Indians of the Southwest or Northwest; and mask forms, excepting such objects as mortuary facial coverings of shell, were not one of the outstanding forms of American Eastern Indian art.

Moreover, a comparative study of ritual uses of Mound Builder art and that of the Anasazi or the Northwest Coast and Plateau is not possible, since almost none of these prehistoric peoples has remained in its original location as a subject for ethnological study. We simply do not know clearly either the motivation or the actual purposes of most Eastern archaeological material. Many of the Southeastern tribes gradually died out or changed their life styles significantly following white settlement. Others, the "Five Civilized Tribes," were constrained to move to Oklahoma, and a few other groups have survived on reservations away from their original habitat. Thus, the older, romantic notion that the Mound Builders were a mysterious people who made their great contribution and then simply disappeared, is at

338. Masks of the False Face society, from the Eastern Woodlands. Iroquois. Chicago Natural History Museum.

*339. Husk Face society mask, from New York State. Iroquois (Seneca). Cornhusks, length 15".
Museum of the American Indian, Heye Foundation, New York.*

223

least generally true in one sense, despite a quantity of thoughtful, scientific literature which provides specific data about many groups, sites, and times in prehistory.

The earth structures which give the Mound Builders their popular name were of several types and of varying sizes and purposes. Flat-topped, stepped, or terraced mounds were crowned by temples and possibly palaces, only fragments of which have been discovered. On the basis of simple deduction, rather than upon the existence of any conclusive evidence, the palaces or other dwellings were occupied by tribal chieftains. Large, collective dwellings for the tribespeople of lower status are not common to the remains of this culture. More intricate in plan were the so-called effigy mounds. These were low-lying, extensive, raised lines of earth resembling the shape of some reptile or other animal. One such linear mound was nearly eleven hundred feet long and encompassed sixteen acres. Some contained burial deposits; others may have had ceremonial uses which, despite many conjectures, remain unknown. A third major classification of earth mound was the conical form, some examples being fifty to one hundred feet high, used largely for burials. These contained log-lined mortuary chambers in which deceased persons were placed along with their valuables; and it is from such cone-shaped earthworks, especially those in Ohio, that we have recovered most of the wealth of small, usually naturalistic sculptures which equal in aesthetic concept and technical finish any three-dimensional art of the North American continent.[53]

Occasional Mound Builder carvings have been found accidentally on or near the surface of the ground (as by farmers plowing, or by campers); but most of this art has come from systematic or amateur excavation. More than 150 stone pipes in the form of various animals and birds were discovered in a single cache at Mound City, Ohio, in 1846.[54] A similarly large group of these compact, handsomely formed and finished carvings was excavated at the Tremper Mound, also in Ohio, in 1915. Fortunately, almost all of these were retained in the Ohio State Museum in Columbus. One of the Tremper Mound works is the keen, hawklike form of the pipe shown in figure 340. The silhouette of this bird reveals a strong feeling for sculptural quality; and the incised depiction of details such as feathers and lines of the beak is at once economical and fully descriptive. The adjustment of the legs and claws of the creature to the upright of the pipe's bowl and the slightly curved platform beneath is sensitive and convincingly realistic in gesture. An elegant note is the copper inlay of the eyes.

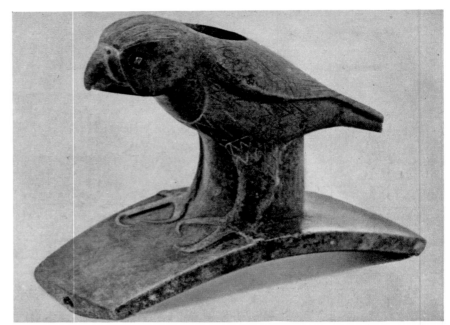

340

The culture which produced this and related animal-form pipes is called the Hopewell, named after the Hopewell family upon whose property in Scioto County, Ohio, were found a number of Mound Builder works. The pipes were carved with flint or similar hard stone tools from a warm gray pipestone technically known as aluminum silicate. They were then smoothed with abrasives until they achieved their characteristically fine surface. Indians smoked from these objects by holding the platform at one end and puffing through an opening in the other. They were stemless pipes, and not held between the teeth.

340. Pipe bowl in the form of a hawk, from Tremper Mound, Scioto County, Ohio. Hopewell culture. Stone, length c. 4". Ohio State Museum, Columbus.

341. " Death's head " vessel, from Crittenden County, Arkansas. Mississippi culture. Painted pottery, height 8". Smithsonian Institution, Washington, D.C.

342. Mask, from Alaska. Eskimo (probably Kuskwiogmut). Height 19 3/8". The Museum of Primitive Art, New York.

343. Mask, from the Kuskokwim River area, Alaska. Eskimo. Wood and fur. Smithsonian Institution, Washington, D.C.

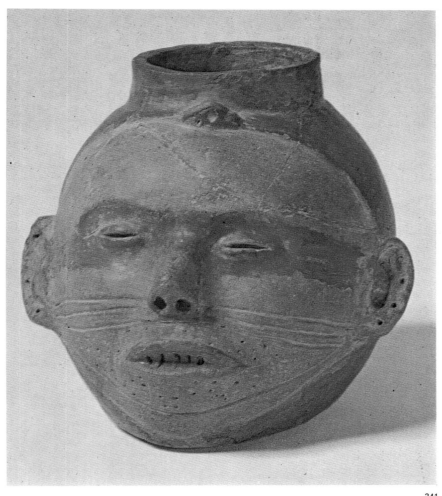

341

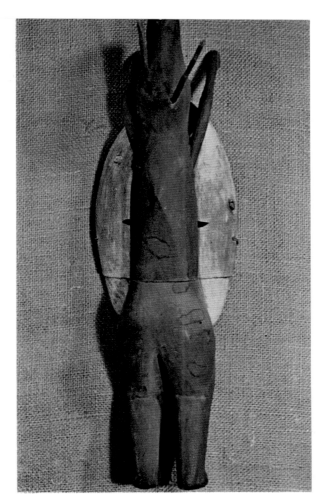

342

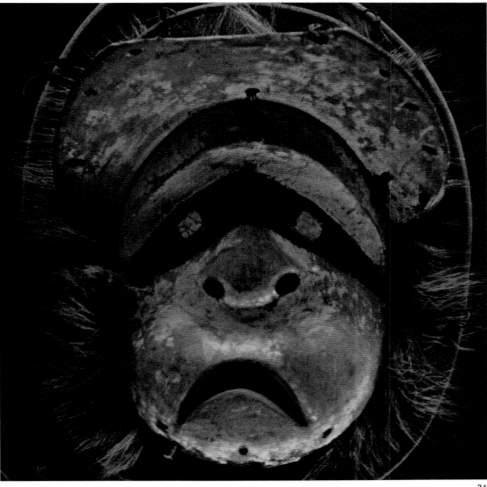

343

A second Ohio culture given separate identity by most archaeologists is called the Adena —also named after a specific site, excavated by W. C. Mills in 1901. A remarkable pipe of human form, reflecting what appears to be Mexican influence, was recovered here; and one school of archaeologists sees Mexican stimulus in the platform mounds themselves as well as in various other cultural remains of the Mound Builder. That these North American Indians were active traders in quite distant areas has been clearly established by various nonregional materials found among their remains. However, a comparison of a hundred Mound Builder sculptures with as many Middle American works makes it remarkably clear that intrusive influences were essentially localized and that there is, after all, such a thing as a coexistent Pre-Columbian Mexican style and a Pre-Columbian Hopewell and Adena style. In point of fact, the prehistoric art of the Mound Builders was one of the most distinctively North American Indian of any produced, and its remarkably high quality does not require, for popular or for scientific admiration, the exotic reinforcement of extraneous culture elements.

Equally sensitive animal images in pipe form were created at various places in Tennessee, Kentucky, and elsewhere in the Southeast. Some of these had circularly formed mouthpieces which corresponded to the cylindrically-shaped bodies of wolves, bears, and other quadrupeds as well as birds. One exceptionally attractive example (fig. 345) in composite human-animal form is from Missouri. At the Spiro Mound in Oklahoma, which represents one of the most westerly sites of the Hopewell-Adena complex, a narrative carved pipe was discovered, the theme being a warrior beheading a victim. Some of these objects are twelve or more inches in length and weigh fifteen or more pounds. It is likely that they were placed on the ground or on a raised surface, rather than held or passed about for smoking purposes. The Spiro Mound appears to have been an outstandingly important center for ceremonial meetings by visiting Mound Builder groups, and some of the greatest of the stone sculptures of these people, especially works in human form, were located there.

The Hopewell culture also created distinctive sculptures in other mediums. Copper from Lake Superior and mica from sites in the Carolinas far to the east were hammered or carved into silhouettes of the human hand, birds, or nonfigural ornaments. A combination of incising and *repoussé* was used in decorating the copper objects. A limited number of small works in gold and silver were also made. Master sculptor that he was, however, the Hopewell or Adena

344

344. Pipe bowl in the shape of a horse's head, from the Central Plains, upper Missouri River. Mid-19th century. Catlinite, length 4 1/8". Smithsonian Institution, Washington, D.C.

345. Pipe in human - animal form, from Missouri. Mound Builder culture. Limestone, heigh t7 5/8". Smithsonian Institution, Washington, D.C.

346. Carved birdlike forms, from Ohio. Mound Builder culture. Stone, greatest length 5 1/4". Smithsonian Institution, Washington, D.C.

347, 348. Funerary figure (front and side views), from Illinois. Mound Builder culture. Stone, height 12 1/2". Chicago Natural History Museum.

345

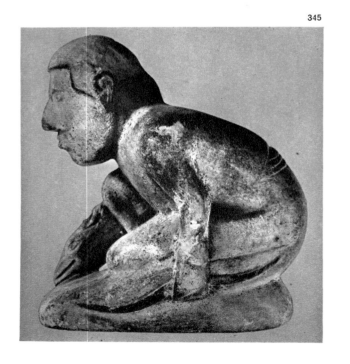

346

adjoining "wings," and there is a hole bored through this middle axis which might have held at one time a staff—hence, bannerstones may have been carried as ceremonial emblems. It seems quite as likely that they were used as weights for spear-throwing devices, or as straighteners for arrowshafts, or simply as personal adornments; but we have not yet reached the stage of understanding of Indian and other primitive arts at which we dare permit the aesthetic factor to take precedence over rite, even in the case of such obscurely motivated archaeological material as we have been discussing.

A number of stone figures in the round, some of them in the form of large mortars and others of quite unfunctional design, have been located at numerous burial sites in Illinois (figs. 347, 348), Tennessee, Alabama, Georgia, Arkansas, and elsewhere in the middle south and the southeast. Most of them are twelve to twenty inches high and are usually carved from one or another type of sandstone or limestone. Their function, like that of much Mound Builder sculpture, is actually not known; but the supposition that they are memorials to ancestors is not unreasonable, since a majority of them have been found in graves with skeletal remains and personal valuables. It has also been reported that in some instances they were placed in the temples of the platform mounds, in which case they may have been the object of worship or ceremony. These images have a boldness of concept, a grandness of scale, and, although their style is distinctly separate from that of Northwest Coast figural sculpture, there exists, nonetheless, a kindred feeling for large volumes and dramatically simple handling of detail. Mound Builder stone sculpture is one of the most memorable Pre-Columbian North American Indian arts, and one of the most direct statements of form to be found in the Americas generally.

artist never permitted his material to take precedence over his own skill; his was the art of a sensitive professional who was invariably in full control of the substance at hand.

Hundreds of semiabstract stone carvings resembling birds have been found from the Middle Mississippi Valley northeastward as far as southern Canada (fig. 346). Like the sculptured pipes, they had especially wide distribution in Ohio. As may be expected, several ritual uses have been proposed as the motivation for these beautifully finished, crisply designed forms of banded slate or sandstone; but their purpose is, in fact, not known. A not dissimilarly shaped object, though even more nearly nonfigural in concept, is the "bannerstone," so called because its remotely butterfly-like, heraldic shape has a center thicker than the terminals of the

347 348

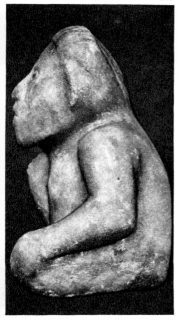

While stone, to some extent supplemented by copper and mica, was the favored sculptural material of the northern Hopewell peoples, the Mississippi culture Mound Builders of Arkansas and Alabama frequently used the ceramic medium with equally powerful and often more dramatic effect. A number of pottery vessels known as "death's heads" (fig. 341, colorplate) have been recovered from mounds in many parts of the Mississippi drainage region, especially Arkansas, where both heads and figures of intense expressiveness appear. The heads usually have half-closed eyes and slightly parted lips, a facial state denoting death or dying in the art of some primitive cultures. The features are sometimes distorted in other ways, for example, by a twisted or slightly misplaced

227

mouth. Ceramic figures of Arkansas provenience are usually seated and are either gesturing (figure 349) or expressing a quizzical facial attitude. They are notable for huge, sometimes almost bloated-looking torsos, thinnish arms and legs, and heads growing out of necks of equal diameter. Like one distinctive type of pottery ware from this area, the human figures in clay are often painted with a soft red spiral design over the natural cream-white of the clay ground. The example illustrated here is one of the outstanding figures in its medium to issue from the southern Mound Builder area; it is a masterpiece of its class. Like the stone images from the Middle Mississippi and the Hopewell area proper farther north, these forms may have represented ancestors or may have received tribal worship.

An elaborate art in shell was also practiced in the southeast (fig. 350). Mounds in Tennessee have yielded such dramatic pendant or mask forms as the illustrated example, which was recovered from a burial site in 1869. They were used to cover the face of the deceased or were placed upon his chest. Some of these strangely featured objects, which are formed with economical but striking effect from asymmetrical ocean shells brought inland from the Atlantic coast, testify to the extensive trade which existed in all parts of the Mound Builder area.

In Tennessee, Georgia, Mississippi, Louisiana, and elsewhere in the lower Mound Builder area, circular gorgets or pendants of shell were a widespread decorative form. Many were fashioned from conch shells from the Gulf of Mexico. A lively movement is present in many of them, radially arranged in conformity to the silhouette of the object. Some are perforated; others bear elaborate incised motifs, typically of the human figure or of grotesque composite animal-humans. A number of these reveal a distinctive Mexican influence of actual style as well as motif, the visual evidence of intrusive effect being far more convincing in these instances than in the Hopewell complexes of stone art farther north. Some disks of this general type are of sandstone rather than shell; but all of them are so perforated as to accommodate cords for the purpose of wearing as pendants or perhaps as girdle masks. Because certain birds, spiders, and snakes have been conjectured by several archaeologists to be symbols of death among prehistoric Indians of this region, some of the gorgets or disks have been postulated as one of many other signs of a "death cult" in late prehistoric times. Shell carvings have been found as far west as the Spiro Mound in Oklahoma (already mentioned for the richness of its stone sculpture).

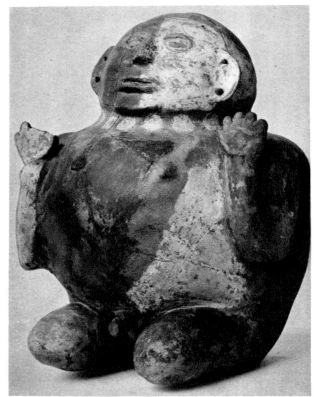

349

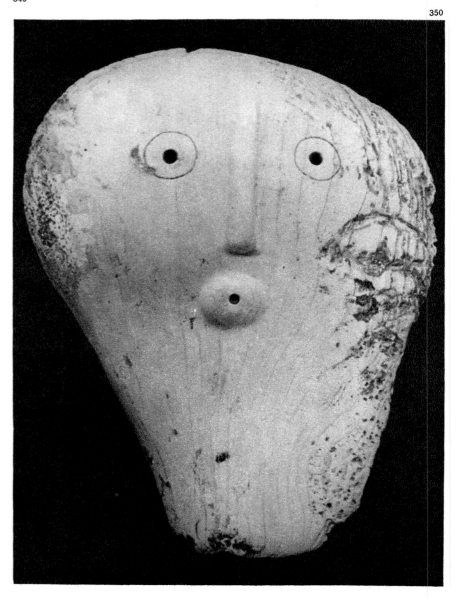

350

228

349. *Vessel in human form, from Arkansas. Mississippi culture. Pottery, height 10 1/4". Smithsonian Institution, Washington, D.C.*

350. *Incised shell mask, from Brakebill Mound, eastern Tennessee. Mound Builder culture. Height 8 5/8". Peabody Museum of Archaeology and Ethnology, Harvard University, Cambridge.*

351. *Deer masquette, from Key Marco, Florida. Wood, height 7 1/2". The University Museum, Philadelphia.*

The Key Marco Indians

Florida has yielded somewhat less rich a store of pre-European art than have nearby southeastern states; and the garish, appliquéd tribal garments sold by present-day Seminoles to tourists are hardly a credit to the once vital craft which was typified by Seminole costume. But the contribution of a single prehistoric people, the Key Marco Indians who were probably the predecessors of the now extinct Calusa tribe, offsets any other deficiency of this area. A group of wood carvings representing both land animals and amphibians was unearthed from large deposits at southerly Key Marco in the 1890s (fig. 351).[55] These are unsurpassed in sculptural quality by any kindred art in North America; and many modern sculptors and archaeologists alike agree that these heads and maskettes are the crowning achievement of the American Indian in the naturalistic interpretation of indigenous wildlife. Because

351

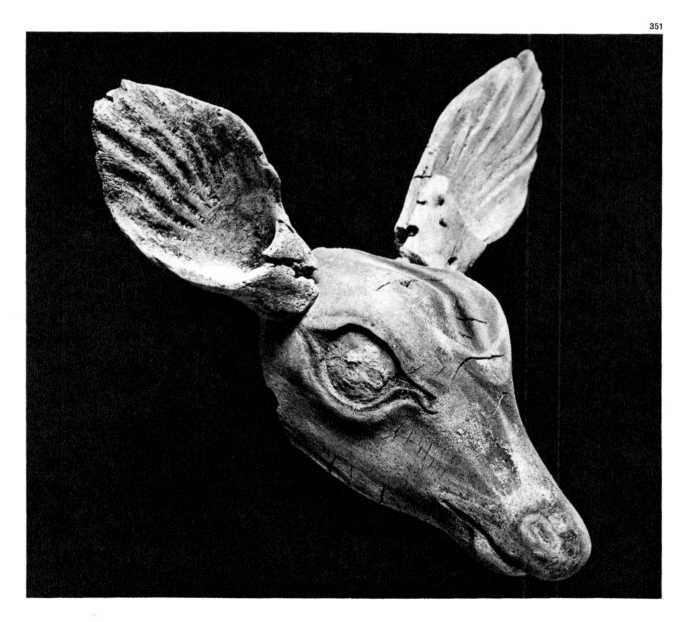

these delicately carved masterpieces had been beneath the mud for centuries at the time of their excavation, many split or disintegrated upon initial exposure to the air; others warped badly afterward. But several of them, notably heads and masks of birds, a wolf, an alligator, and the deer illustrated here, afford a rich contribution to North American Indian art.

A future generation of American and European painters, art historians, and critics will, beyond any doubt, arrive at a more incisive understanding and evaluation of North American Indian art than it has been our good fortune thus far to develop. An increasing willingness of the ethnologist to understand the difference between a work of art as an aesthetic entity and a tribal artifact as evidence supportive of a scientific hypothesis is an encouraging sign, and the perpetuation and sharpening of this attitude is indispensable to the ultimate popular, as well as scholarly, acclaim, which should have long ago accrued to this memorable expression. Indian art remains too closely connected with, and obscured by, Indian curios, past and present, to attain clarity of recognition; but the example of the acceptance of African and Oceanic arts as valid creative forms should serve as a touchstone to those of us who desire similar acknowledgment of the genius of North America's first immigrants. We repeat that this understanding will come from a future generation whose intellectual grasp of Western civilization and its most recent aesthetic, no less than its familiarity with Indian life style, can enable interpretation in a depth not presently accessible to us. It is exciting to anticipate the great stimulus which is certain to result.

The Art of Oceania | ANDREAS LOMMEL

Introduction

Polynesia, the wide-ranging region of the central Pacific, comprises such well-known islands and archipelagoes as Hawaii, the Marquesas, the Cook Islands, Samoa, the Tonga Islands, Easter Island, and New Zealand. Its inhabitants are fairly homogeneous in race and culture, and were the last of the various groups of immigrants that came from Asia to settle the islands of the Pacific.

Melanesia, the island region north and northeast of Australia, extends from New Guinea, New Britain, and New Ireland to the Solomons, the New Hebrides and as far as New Caledonia, and is inhabited by a dark-skinned people. The settling of this region began very early. Considerable differences exist in the language and culture of the various island groups.

Micronesia, the island region between Melanesia and Japan, is, to a great extent, related culturally to Polynesia, especially in its eastern portion.

The continent of Australia has a unique historicultural position, in that it possesses a survival of the early hunter cultures that have all but disappeared from the rest of the world.

The Oceanic cultures are island cultures; the culture of the Polynesians, in particular, but that of the Melanesians as well, was made possible only by their success in overcoming the broad reaches of the Pacific. The distances between many of the island groups in Polynesia are incredibly great. The Hawaiian Islands in the north are almost two thousand miles from the nearest inhabited island; Easter Island is almost one thousand miles from any neighbor. Obviously, seaworthy boats were necessary for the settling of these islands. We must assume that consciously planned voyages of exploration and settlement, often ranging over five hundred miles, were undertaken. In Melanesia, where the distances are shorter, some room for chance may be conceded, and occasionally settlements derived from groups of vanquished peoples. There is no doubt, however, that the present population of Melanesia is made up of descendants of various waves of settlement and immigration; this explains the cultural diversity in that island region.

The original inhabitants of Australia were, during the period of migrations, and are, even today, still in the stage of hunting and food-gathering. At this level of culture seagoing boats are unknown, and the immigration into Australia must have been essentially over land bridges. It would seem that the early hunter culture reached Melanesia only sporadically and Polynesia not at all.

The widely separated island groups of Polynesia could only have been found by men whose innermost nature it was to conquer huge distances and who possessed the technical prerequisites for seafaring. The attitude of the Polynesians toward space must have been different from that of any other primitive group. Even their attitude toward time was different from that of other primitive peoples. In contrast

233

to most others, they did not know any golden age in the past, but rather recognized a constant progressive development from the present into the future. Each generation inherited the spiritual powers of its ancestors and therefore rose above the previous generation.

It is generally held that the successive groups of immigrants coming originally from Indochina, reached some of the Polynesian archipelagoes about 200 B.C. The latest research has yielded the following approximate dates, based on radiocarbon dating: Marianas, middle of the second millennium B.C.; Marquesas, about 200 B.C.; Easter Island, about A.D. 300; Hawaii group, about A.D. 800. The first waves of migration must have been followed by others, but only the era of the great voyages from the seventh to the twelfth centuries A.D. has left a trace in the myths of the Polynesians.

In their catamarans the Polynesian seafarers reached the area of perpetual ice to the south, Easter Island to the east, and the Hawaiian group to the north. The great migration from central Polynesia to New Zealand took place in the fourteenth century. According to legends, it was the handsome hard jade (nephrite) that chiefly attracted the wanderers to this region. At the high point of Polynesian culture all the island groups knew of one another's existence and exchanged regular visits.

The decline of the Oceanic cultures began with their discovery by the Europeans. In the second half of the sixteenth century Spanish seafarers from America plowed the South Seas. They never saw any of the Polynesian islands, but first landed in the Solomons, in the western Pacific. Later the Dutch also crisscrossed the Pacific, but it was only two centuries later, in the second half of the eighteenth century, that the South Seas and its inhabitants started to play a role in the consciousness of Europeans. This was the time during which the thirteen American colonies freed themselves from England, with the result that England's colonial efforts were diverted from the American continent to other regions, and in particular to Oceania.

Moreover, the intellectual movement of the Enlightenment at this time made Europeans interested in primitive cultures. Previously, the world outside of Europe had been regarded primarily as a source of plunder. Now, Jean-Jacques Rousseau's doctrine of the happy state of natural man led to intense interest in the "uncivilized" peoples, especially those of the South Seas, where, it was believed, Rousseau's views would find confirmation. None of these philosophical ideas was confirmed, however, in Australia. The aborigines seemed too ugly and too poverty-stricken in their culture for the European settlers to feel any interest in or sympathy with them. Since, in addition, they could not be used for labor and came to be regarded as nothing more than cattle thieves, their numbers shrank at a terrifying rate. For the inhabitants of Oceania, too, discovery by Europe brought an end to their culture and a catastrophic depopulation. The devastating effects of European civilization were felt in Polynesia as early as the 1700s, and in Melanesia and New Caledonia in the course of the nineteenth century.

At the present, the population decline seems to have been overcome in the South Sea islands, and the number of natives remains generally constant. It totals about 200,000 for Polynesia. In many areas the population is even increasing, but, nonetheless, the percentage of the native population is small on many islands. When the Hawaiian group was discovered, it was estimated to have about 300,000 inhabitants. Today the natives number only about 11,000, roughly 2 per cent of the total population of about 500,000, which is largely made up of the descendants of European and Asiatic immigrants. The inhabitants of the Fiji Islands number about 250,000; more than half, however, are immigrants from India. The natives constitute a little more than half of the approximately 60,000 inhabitants of New Caledonia. Maoris, the native inhabitants of New Zealand, come to about 52,000, in a total population of 1,600,000. Most of the other islands of Polynesia have shown a tendency for the population to grow; the individual island groups have 30,000 to 70,000 inhabitants. Melanesians are much more numerous: all in all, they number about 1,500,000. The aboriginal population of Australia is not more than 50,000 today, and those still living at the Stone Age level of culture are only a few hundred.

Today most of the islands of Oceania are

colonial regions, and their political development by and large follows the same patterns as in other colonies. Polynesia, which has entered into civilization to a greater degree than Melanesia, is going through a slow evolution into political independence. In Melanesia a cultural synthesis is in process between the old social system and modern civilization, but developments there are more uneven. Integration of the Australian natives into modern civilization is taking place mainly at the remote farms of the mission stations. There they work as cowherds; in the cities they are more or less dependent upon social welfare.

Material Culture

At first glance the material culture of Oceania seems meager. Important materials such as metals and cotton are lacking. Tools, therefore, are made of stone or shell. Almost everywhere the universal tool is a stone-bladed adze (fig. 352). In Melanesia the blade is round in cross section (the so-called cylindrical adze) while in Polynesia the common type is rectangular in cross section and closely resembles prehistoric adze forms in southern China and Indochina. In Micronesia the lack of stone accounts for the prevalence of shell for the blades.

Boatbuilding was on a high technical level everywhere in Polynesia. In Melanesia, too, large seaworthy boats were built, but shipbuilding and seafaring were never as important there as in Polynesia. Settlement of the Polynesian islands and the close cultural intercommunication of the various island groups over the centuries were made possible only through the use of seaworthy boats. The large boats of the voyages of settlement seem to have been double hulls in every case. A reversion to single hulls appears to have taken place in New Zealand after the settlement, while on Easter Island boatbuilding degenerated completely in time. Significant knowledge of the sea was transmitted within special groups on many islands. In the Marshalls there were even marine charts made of bamboo sticks.

Pottery is absent in Polynesia, but spread throughout Melanesia, where there were centers of production on various islands; their ware was dispersed over a wide area. The pottery of the Sepik Valley in New Guinea is notable. Very large jars were made there, which were either painted (fig. 356) or ornamented with modeling or engraving (fig. 480). This pottery stands apart from the simple products of the

352

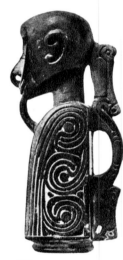

353

354

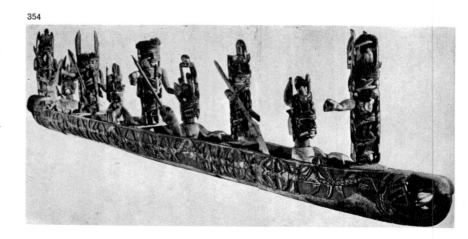

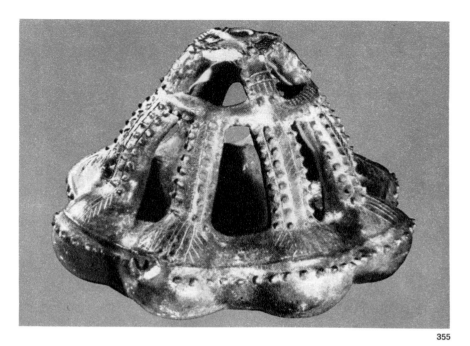

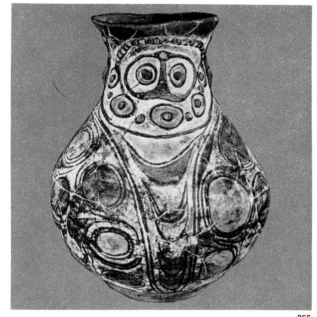

355

356

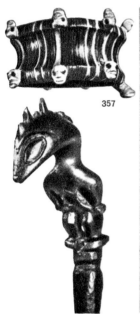

357

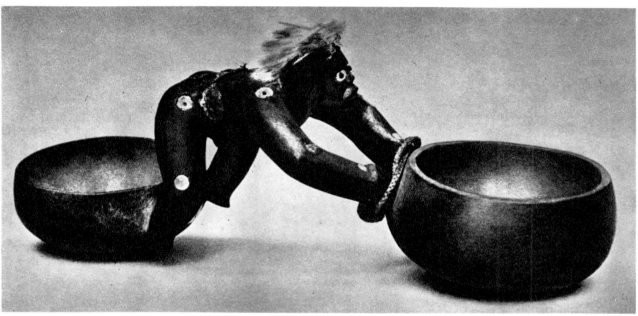

358

359

355. *Water container, from the Fiji Islands, Melanesia. Glazed pottery, height 7 7|8". Musée de l'Homme, Paris.*

356. *Jar for storing sago, from the Sepik River district, New Guinea, Melanesia. Painted clay, height 27 1|2". Museum für Völkerkunde, Basel.*

357. *Bracelet, from the Hawaiian Islands, Polynesia. Tortoise shell and bone, external circumference 6 3|4". Bernice P. Bishop Museum, Honolulu.*

358. *Temple figure, from the Hawaiian Islands, Polynesia. Wood, height of image 5 1|2". Bernice P. Bishop Museum, Honolulu.*

359. *Double dish with central figure, from the Hawaiian Islands, Polynesia. Wood with mother-of-pearl inlays, length 11". British Museum, London.*

352. *Adze with stone blade, from the Trobriand Islands, Melanesia. The Museum of Primitive Art, New York.*

353. *Mortar for betel, from the Massim area, New Guinea, Melanesia. Wood. Museum of Anthropology and Ethnology, Leningrad.*

354. *Soul boat, from New Ireland, Melanesia. Wood, length 19' 5". Lindenmuseum, Stuttgart.*

237

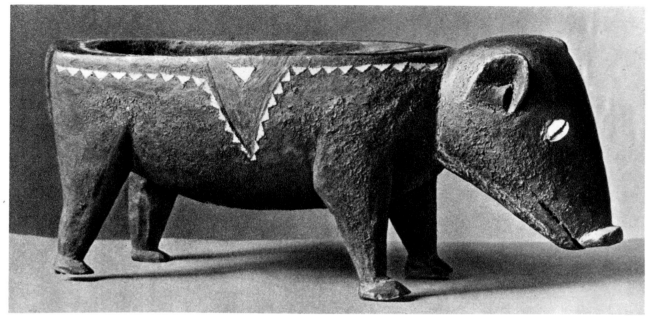

360

other Melanesian islands, as a unique high point of primitive pottery. Also notable is the glazed ware of the Fiji Islands, (fig. 355), isolated examples of which were sold as far away as the Tonga Islands in Polynesia. In both Polynesia and Melanesia dishes were made from gourds, coconut shells, or bamboo. Particularly handsome bowls carved out of wood are found in the Solomon Islands (figs. 360, 361), Hawaii (fig. 359), Samoa, and the Fiji Islands. The striking elegance that marks all Hawaiian work is also shown in the delicately patterned, painted gourd vessels; their wooden bowls, which are undecorated, produce their effect only through form, polish, and grain. In the Marquesas (fig. 484) and New Zealand the bowls are carved; in the Carolines they are painted in red and sometimes inlaid with mother-of-pearl. Unusual bowl forms are found on Matty (Wuwulu) and Duror (Aua) islands north of New Guinea, which give a remarkable and arbitrary elegance of form to everything produced there.

Polynesia and Melanesia have no weaving; it is a technique that, coming from Indonesia, extends no farther than Micronesia. The substitute for cloth in the Pacific islands is the non-woven bark cloth, called tapa (fig. 362). The paper mulberry, from which it is made, is grown for this purpose on most Polynesian islands. New Zealand is the only exception; the paper mulberry did not thrive there and the inhabitants were forced to resort to a kind of flax. Knotted flax garments take the place of tapa clothing on that island. In the making of tapa, paper mulberry saplings are felled, the bark taken off, and the soft inner bark softened in water and beaten with special mallets. In the process many small pieces are superposed and beaten together until the piece of goods has the desired size. The end product is a soft,

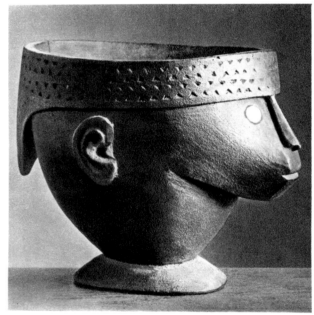

361

360. *Dish in the form of a pig, from San Cristobal, Solomon Islands, Melanesia. Wood with mother-of-pearl and cowrie-shell inlays, length 34 1/4". Museum für Völkerkunde, Basel.*

361. *Bowl, from the Solomon Islands, Melanesia. Wood with mother-of-pearl inlays, height 6 3/4". Collection Joseph Müller, Solothurn, Switzerland.*

238

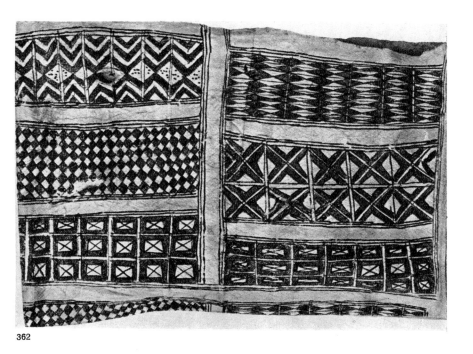

362

363

tough, paperlike fabric, which is used for clothing, for mats, and as wall hangings and space dividers inside huts.

Decorated tapa cloth is found in all the islands except the Marquesas. In Hawaii it was dyed, painted, and printed with patterns cut from bamboo; in the Society Islands, with leaves dipped in dye. In Samoa the tapa was printed by means of cutout stencils. Another technique was to spread the tapa out on pandanus leaves which were sewed together with little wooden splints. Red dye was then rubbed into the cloth, showing only on the raised spots and resulting in an attractive irregular pattern. Bark cloth was often oiled and varnished to make it weatherproof.

Ceremonial clothing was made of feathers sewed to a net base; this was done especially in Hawaii, but also in the Tonga Islands and New Zealand. The feather cloaks of the Hawaiian Islands are famous (fig. 365, colorplate).

362. Tapa with geometric motifs, from the Fiji Islands, Melanesia. Museo Nazionale di Antropologia e Etnologia, Florence.

363. Boomerang incised with geometric-symbolic motifs, from northeastern Australia. Museo Pigorini, Rome.

In the cultures of Oceania the forms of the few useful objects are understandably reduced to the simplest; the desire for ornamentation was directed to the human form, which was decorated in every conceivable way. Tattooing was done luxuriantly on almost all the islands, most notably in the Marquesas and New Zealand (fig. 421). On even the poorest islands, ornaments were made using everything imaginable as materials: stones, shells, feathers, fruit pits, nuts. In the assembling of materials and colors great elegance was achieved.

The Stone Age culture of Australia belongs to the terminal phase of the Paleolithic. It is ignorant of pottery, and all but ignorant of polished stone, and is most comparable to the hunter culture of the Magdalenian period in southern France (15,000–10,000 B.C.). The only other parts of the world in which similar cultural stages have survived are South Africa (Bushmen), the Arctic (Eskimos), and isolated parts of South America. Materially, these cultures are extremely poor, but although tools and equipment are lacking, great skill in application and an amazing capacity for adaptation to external conditions are evident. The Australian aborigines have neither houses nor clothing. They roam their tribal district in small groups, gathering edible fruits and hunting game. They employ spears, propelled by throwing sticks, and boomerangs (figs. 363, 375), especially for hunting birds. Both throwing sticks and boomerangs were used during the European Magdalenian period; these refined weapons are among the early inventions of mankind, in its most primitive stage of material culture. In contrast to the material phase, spiritual, and above all artistic, culture is highly developed.

Philosophy of Life

It is not easy to say something in a few words that will be generally applicable to the religious concepts expressed in the art of Oceania. An all-powerful ancestor cult is found everywhere in Melanesia, and as a strong undercurrent in Polynesia. Almost all religious ceremonies are devoted to ancestor worship. The spiritual powers of the forefathers are conceived of as being specially concentrated in their skulls; accordingly, ancestral skulls must be regarded as the models and source of plastic art. Often this origin is still quite clear: in New Guinea, plastic depiction starts from the actual ancestral skulls, modeled over in clay and painted red and white (figs. 364, 418). In the Solomons, representations of the head are among the most noteworthy plastic works; in the New Hebrides modeled and painted skulls constitute the outstanding art works (fig. 420). In Polynesia, too—New Zealand, the Marquesas, and Easter Island—depictions of ancestors and the dead are almost the only subjects of plastic art. The modeled skulls, or images of them, are not memorials in our sense, but are considered the dwelling place of the spiritual powers of the ancestors and derive their importance from this belief alone. Works of plastic art are often (for example, in the Marquesas) treated with no respect until, by virtue of certain definite ceremonies, they come to be regarded as the abode of the ancestors; then they enjoy religious veneration.

The use of masks, common throughout Melanesia (figs. 366–68) although lacking in Polynesia, is to be linked with the ancestor cult. The wearer of a mask believes that he is sharing in the spiritual power of the departed, who is represented and made present by the mask. All sorts of facial images are made, usually in order to avert evil. They are widespread, partic-

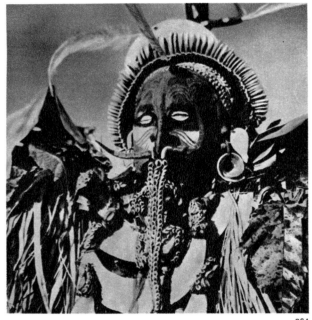

364

364. *Overmodeled skull of an ancestor. Timbunke, Sepik River district, New Guinea, Melanesia. 1955.*

365. *Feather cape, from the Hawaiian Islands, Polynesia. Height 68 7/8". British Museum, London.*

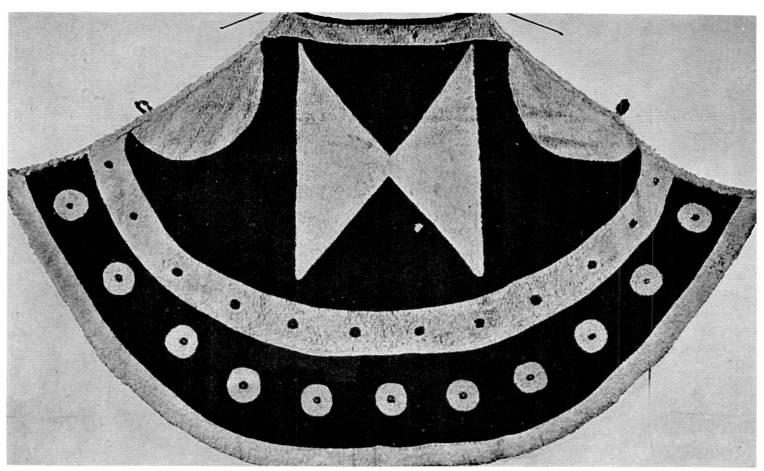

ularly in New Guinea, but in the rest of Melanesia as well (for example, in New Caledonia). Masks are often used by secret societies in New Guinea. These societies, too, are oriented toward the afterlife; and they, too, serve ancestor worship. In them the representation of mythical events constantly imparts to the new generation the traditions of the culture. Very often we find artistic activity closely bound up with the ceremonies of the secret societies, as in Melanesia.

The conception of the world of the Australian aborigines is probably the only example of the conceptual basis of a hunter culture that has come down to us, but in it traces of an agricultural conception can also be discerned. The essential feature of the conceptual world of the Australian aborigine is the idea that man cannot and must not enter into the life of nature without the aid of magic or sorcery or some religious bypath, nor without engaging in practical activity. In these people we find a completely primeval and uninterrupted feeling of the unity of man with the world around him. Living in this world means being active. Every man, from birth, is linked to definite phenomena of nature, including animals or plants, and united with them into a group. All ceremonial life in Australia—and that means all artistic life—is bound up with multiplication rites conducted by men for the plants or animals linked to them. The rock pictures, especially in the northwest, today still have their place in these ceremonies, as do the ornamented wooden and stone implements and the bark pictures. It is only on the basis of these ceremonies that this art can be understood and explained.

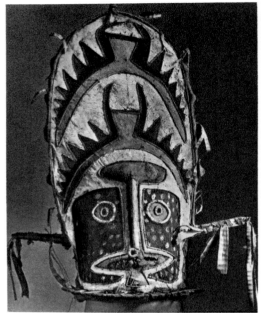

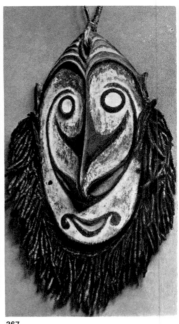

366

367

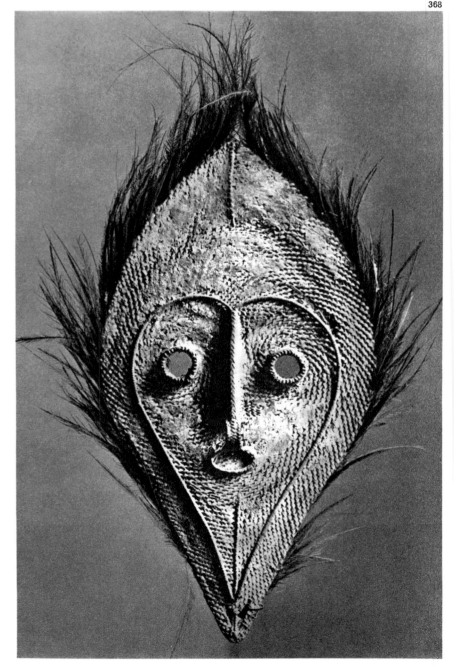

368

366. Dance mask, from the Gulf of Papua, New Guinea, Melanesia. Painted tapa, height 31 1/8". Museum für Völkerkunde, Hamburg.

367. Mask, from the Sepik River district, New Guinea, Melanesia. Painted wood, height 13 3/4". Übersee-Museum, Bremen.

368. Mask, from the Sepik River district, New Guinea, Melanesia. Basketwork and feathers. Bernisches Historisches Museum, Bern, Switzerland.

369. Bark painting showing a tuber in the ground, with its root system, from Goulbourn Island, northern Arnhemland, Australia.

242

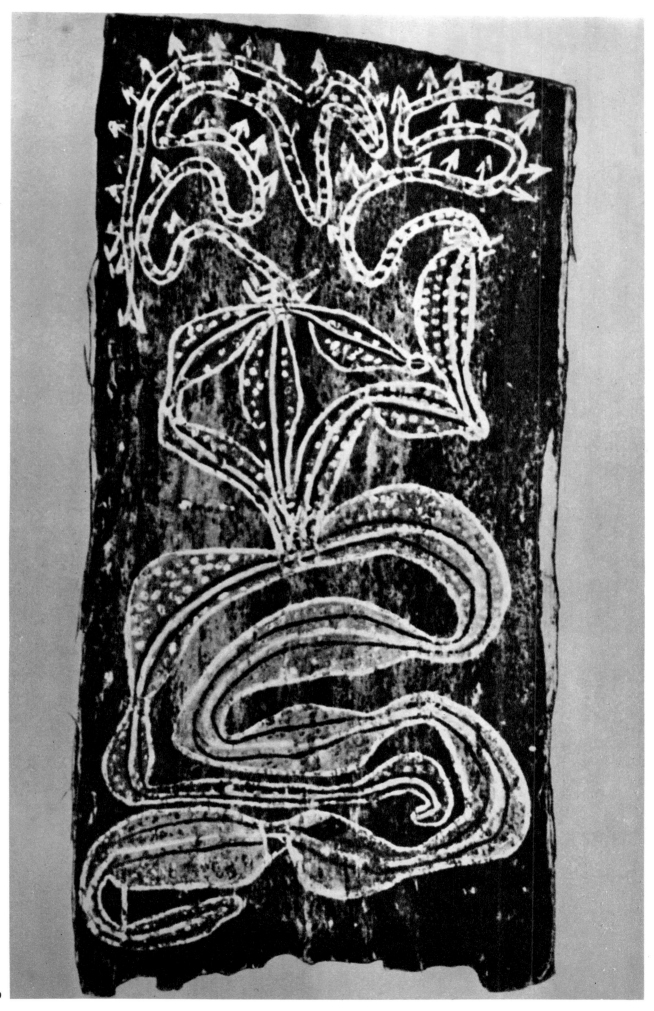

369

Art

Much has been written on the art of Oceania, and our age is becoming more and more interested in it. Nonetheless, many mistaken ideas about this art are current, not least among artists and art historians. Our way of looking at art and producing it and especially our notions of the place of art in modern life seem to be entirely different from the position of art in the cultures of the South Seas; and the place of the artist in our society, too, is totally at variance with his position in Oceania.

In any society in which writing plays an important part, the art of representation loses significance; but in a society without writing the picture, along with the spoken or chanted word, communicates basic ideas—the picture itself is the idea. The more the idea is crystallized in written form, the more the picture retreats into the background. The image is suppressed by general education: the more educated a society is, the poorer it is in images. The aversion to the written word that is characteristic of our time, our turning to images, for example, as films and television communicate them—this reversion to illiteracy is a logical development. People compelled to live without images and without models cannot long endure this state of things; they seek out the picture, and that includes also the model. More and more they lose the ability to criticize the printed or spoken word; but, at the same time, they have a decided relationship, rejecting or accepting, to pictures, which may well develop into myths. (Here too we find a root of modern man's passionate attachment to music; it asserts itself, in a world that has lost its images, as an art that cannot be attacked, suppressed, or destroyed by words.)

In a primitive society, in which the image still has the same predominant role that it had in the early days of mankind, the artist, too, occupies a special place. The special position that he occupies, or tries to occupy, in our society and that is often attributed to him in a distorted form, is taken for granted in primitive society. There the artist is not "surplus" and is not in opposition to a tradition that he might feel to be outworn and inhibiting. In almost every case the relation of the person working in the arts to the public is not an arbitrary one, but is regulated by tradition. The strong collective consciousness of primitive communities often leads Western critics to the false conclusion that fully developed personalities have not appeared or "have not yet" appeared or have had no chance to develop there. When we look into the matter more closely, however, we see that primitive societies are very stable and organized. The social practices that may seem bizarre are very often not merely the result of automatic adherence to tradition, but are rather the result of generations of experience; they are forms retained over a long period, valid solutions of social problems. The relationship of the individual to the community is regulated, often very skillfully, and in such a way that the individual has full possibility for development without harming the society as a whole. The artistic personality is not hemmed in, but can develop completely within the framework of the tradition and is valued precisely as the preserver and shaper of that tradition.

The South Sea islanders are richly gifted in the arts and have a strong sense of beauty. Not every person, of course, has the same capacities, but in this culture, there are artists everywhere who enjoy general recognition. In many regions their position must have been a privileged one in times past. We know, for example, that in the Cook Islands there were special burial customs

for image carvers, who were honored even after their death.

In Melanesia (for instance, in New Ireland) the image carvers today still are particularly honored. Their work is done within strict traditional limits, the details of each picture are precisely laid down, and only certain persons have the right to use specific motifs or to let them be used. This rigid linkage of artistic representation to definite motifs is found not only where the religious background is still alive: there are areas in which, for generations, the same ornamental forms have been painted or carved over and over again with the greatest care and accuracy without the natives being able to explain their significance.

One misconception that keeps cropping up in considering the art of primitive peoples may be mentioned here. Observers often marvel that people with simple stone tools (and these were the ones generally used in Oceania) have been able to produce works of the highest artistic quality. But the perfection of the tool is not a measure of the significance of the work of art produced by that tool. The enormously long time required to do a piece of sculpture using simple stone implements gives that sculpture an intensity that is surprising at first, but then becomes quite understandable. When we realize that wood carvings often take years of work and that large stone sculptures may perhaps represent the labor of generations, we can understand that the relationship of the artists to their works must have been intense to a degree we can no longer conceive. In the South Seas the value of a work of art often was in direct proportion to the time required to do it.

Respect for Tradition

The adherence, often a rigid one, to artistic formulations that are consecrated by tradition is found everywhere in Oceania. But the ossification of artistic expression that we see today in many parts of the South Seas does not mean that in earlier times changes and developments did not occur in art. The surface divisions of Polynesian wood carvings and bark cloth that produce so "modern" an effect seem to occur only in a final stage of this art. Excavations and accidental finds in the South Seas often show that the initial stages of art on the islands had a different style, frequently primeval and broad. What the European discoverers found comprises much of the Oceanic art in the museums today; it is not representative of the art of Oceania of all times, however, but of only one

phase, and the last one in its development, at that. It is possible that in sculpture, which was still alive in the South Sea islands, particularly in New Zealand, the Marquesas, and Hawaii, at the time of the discoveries, a feeling for art may still have existed that had been lost much earlier in other island groups. In central Polynesia, as in Samoa or the Tonga Islands, and in many parts of Melanesia, most clearly so in New Ireland, we frequently find the form as a whole overgrown and choked by a crowded mass of detail (figs. 354, 370, 376). Even in New Zealand and the Marquesas intensification of a curving style threatens more and more to obscure the plastic form (fig. 481). In the Cook Islands a uniform geometric style, in chip-carving patterns executed with great precision, gradually submerged sculpture and, it appears, eventually completely overshadowed the sculptural representation of the human form.

Polynesian wood carvings present an economical, reduced mode of imparting form that is very attractive to the modern aesthetic sense, and the same is true of the Polynesian way of letting the material—beautifully grained wood (fig. 371), bark cloth, or shell—speak for itself, or at most with a restrained use of color. Melanesian art, on the contrary, is demoniacally wild. In it, exaggerated forms and strong colors seem to express an unconfined surge of inner movement; and yet, not only the motifs but often even the details of artistic representation and execution are laid down minutely by tradition.

The aboriginal art of Australia is strict and spare. Color is used only in the far north, and this in many cases may be the result of the influence of the colorful art of New Guinea. In the rest of the continent native art is without color, rhythmic, and rigid. The rock carvings often present a primitive naturalism; the ornamentation of cult objects can often be traced back to a few motifs, such as the spiral, zigzag, and lozenge, which are used with great finesse. A feeling for the material—wood, stone, or shell—often comes through, a feeling that was rediscovered and sought again only in modern art.

It would seem that the suppression of sculpture by geometric ornament that is seen in many parts of Oceania is the outcome of a long evolution. Its history first became apparent through the researches and excavations of the last century. With this knowledge a new aspect of "primitive art," the art of primitive people in general was revealed. At first this art was regarded as eternally static and without a history, but that is not, however, one of its essential traits. Since only the frozen formulations of the final stage were known, it was

believed that constant repetition of unchanging formulations was the essence of primitive art. Actually, primitive art changes with history in the same way as the art of a highly developed culture, but once rigid formulations are established, they can no longer be thrown off. They are then perpetuated through generation after generation, long after their content and meaning have been forgotten. Only highly developed cultures seem to have the ability to free themselves from rigidity of this kind, to accept new, vitalizing influences and to incorporate them into their art.

The cultural and artistic wealth of forms of the Asian mainland reached the distant islands of the South Seas only sporadically. Presumably each separate wave of wanderers brought different aspects of the manifold mainland cultures. To take one example, we see that in eastern

370. Malanggan sculpture *(totok* figure*), from northern New Ireland, Melanesia. Painted wood, height 52 3/8". Ethnographical Museum, Budapest.*

371. The divinity figure Rongo, from the Cook Islands, Polynesia. Wood.

370

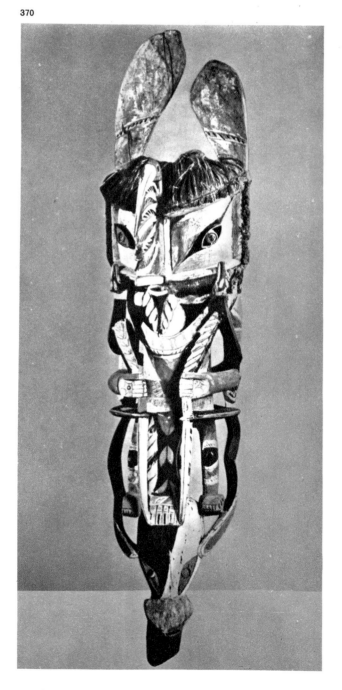

371

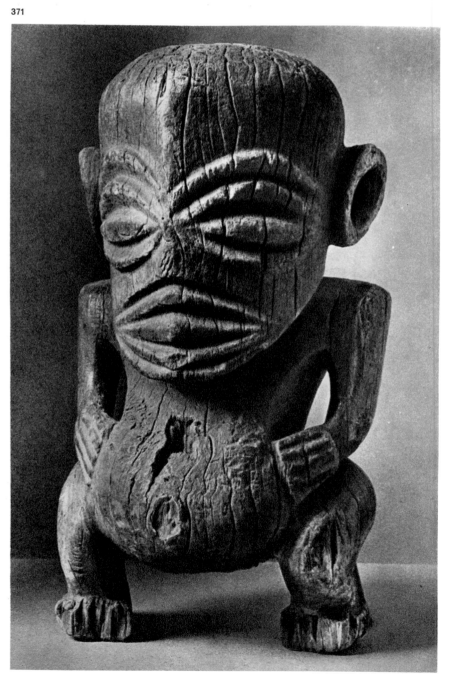

372. *Rock painting of Naibidii men and women hunting kangaroos. Unbalanya Hill, Arnhemland, Australia.*

New Guinea and northern New Zealand the spiral motif was dominant. No other motif to have reached these areas was able to hold its own against the spiral.

The Early Hunter Culture

In Australia the art of the early hunters has come down to the present, and can be found in fairly pure form, despite some traces of influence from agricultural cultures. This is not to say that Australian aboriginal art as a whole, as seen since the discovery by Europeans, is purely a hunter art or that an early form of hunter art has held its own until the present. Certainly the hunter tradition is present in the rock pictures (fig. 372); in them some very early motifs, such as the depiction of animals

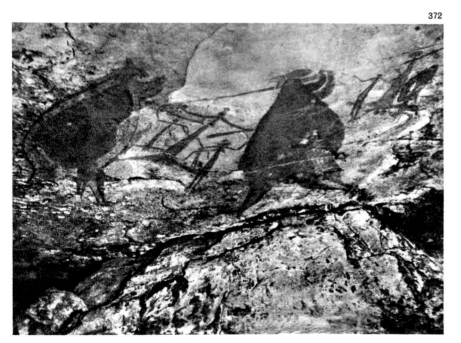

372. *Rock painting of Naibidii men and women hunting kangaroos. Unbalanya Hill, Arnhemland, Australia.*

in X-ray style (fig. 373, colorplate), and the running man in profile, have been preserved.

The rest of the aboriginal art of Australia, mainly ornament used in the decoration of useful objects and weapons, gives an impression of great antiquity but also of formulization and lifelessness, with a few noteworthy exceptions. All the motifs, even those taken over from planter cultures, seem here to have undergone rigid geometrization. The most complicated motifs, even those of a nongeometric nature, are drastically simplified and geometrically reduced. The vivid naturalism of the rock pictures seems to have been preserved only at the edges of the continent, that is, in places that are to be taken as points of entry for foreign stimuli; but even these stimuli turned into frozen formulas on the rest of the continent. In the peripheral regions the primeval vividness is operative down to the present, although in a simplified form.

The art of a hunter culture differs in nature from the art of any other cultural level or group. Hunters have a different feeling of time and space than do planters, farmers, or city dwellers, and hence must have a different art. The life of the hunter is lived according to a rhythm different from that of settled men; his feeling of space and time is less defined by fixed points than is the peasant's. The rhythms of the seasons make less of an impression on him; the points of reference that determine the spatial sense of sedentary men mean nothing to him. Possibly the great art of the hunters stems from a time in which they did not sweep fixed and known regions, but wandered in groups from place to place, following game.

Hunter art, in the oldest form known, is concerned only with animals; in its second phase, representations of the hunter in motion are added. Both themes have been preserved in Australia and must have been brought there by different groups or waves of immigrants. The variations of these two fundamental motifs of hunter art—one of them, the animal motif, being the hunter theme par excellence—afford important points of reference for the development of this art, especially in Australia. The art of the rest of Oceania, an art of planters and seafarers, can also be classified by motifs and grouped and judged by their thematic variations.

Judging an art according to its motifs is not iconography. In European art, and particularly in Christian art as late as the Baroque period, it is essential to know what is being depicted. Not until the beginning of modern art can stylistic criticism of European art disregard the details of iconography. Different criteria pertain, however, when we consider primitive

cultures; iconography becomes less important when the art as a whole, as in Oceania, can be reduced to a few motifs. We find that the number of motifs is infinitesimal in contrast with, say, the medieval art of Europe; the motifs vary widely, however, and this amplitude of variation, which also includes derivations and abstractions from motifs, is the essential feature in the art history of such a region. The fact that the history of art of a primitive people can be observed at all is due less to the decline of old themes and the rise of new ones than to the variations and abstractions derived from specific motifs, because motifs, once adopted, are adhered to unmistakably thenceforth; there are few exceptions to this rule.

In this essay the art of Oceania, including Australian aboriginal art (with occasional glances at Asia and America), will be considered as a history of the variations of a few motifs. It seems a waste of effort to arrange the art of the South Seas in geographical sequence, as has been customary. The essence of this art is more easily reached if it is reduced to a few fundamental motifs, which are then subdivided into motifs of hunter cultures and planter cultures, and the variations of individual motifs investigated in the separate regions. This procedure will also make it possible to arrange the art in sequence of time, for clearly the abstraction of a motif becomes possible only after it has been adopted, has become common in its fundamental form, and has been made uninteresting by long usage; abstraction then can make it fresh and attractive once again. We shall therefore arrange the art of Oceania according to motifs and groups of motifs without laying too much stress on their geographical origin but with a fresh view to their geographical distribution as a whole.

373. Rock painting of a fish in X-ray style. Obiri, Arnhemland, Australia.

248

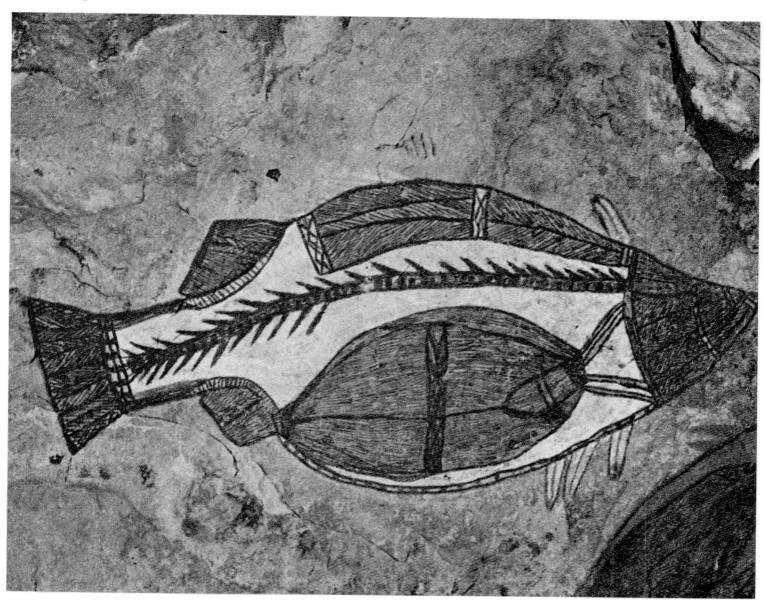

Motifs

There are centers in Oceania in which the predominance of a motif or the freezing of a formula makes artistic expression one-sided —often magnificently so. There are other regions that always seem to have shown a flourishing, vital productivity. One of the most prominent of such districts is the area around the Sepik River in New Guinea. There every village presents ever new and living forms of artistic expression, ever new and surprising modifications of a few motifs.

The motifs on which the art of the South Seas is based fall into three groups. The first, which goes back to the hunter influence, is not very widespread, since the earlier hunter cultures had few boats and the islands of Micronesia and Polynesia were unreachable. The second group includes motifs of the early agricultural cultures that spread out from southern China to all of Melanesia and Polynesia. The first traces of these cultures appeared on Saipan in 1527 B.C. and in New Caledonia in 847 B.C.; they may have begun to disseminate as early as the middle of the third millennium B.C. The artistic formulation of these cultures appears to be based on skull modeling and the squatting-figure motif—that is, on the ideas of the skull cult, head-hunting, ancestor wor-

ship, and fertility. The third group, in which the spiral motif is dominant, possibly should be referred to later influences from Bronze Age cultures. On the basis of purely formal comparisons, Bronze Age influences in Oceania go back to the China of the later part of the Chou period (1027–256 B.C.) and also brought the formulations of the nomadic art of Central Asia far out into Indonesia (for example, the superposed animals, animals put together mechanically from parts of several animals, and animals with spiral decoration). Instances of motifs of this kind are found in Indonesia on the islands of Alor, Timor, Sumba, and Borneo.

The best way to begin a study of the motifs of Oceanic art is to trace the distribution of the X-ray style, and then that of the spiral and the squatting-figure styles. The latter is the most important motif in the art of the South Seas, occurring everywhere either as a primary form or as a derivative. There are limits, easily understandable, to the expansion of motifs in the South Seas. A motif belonging only to hunter cultures, such as the X-ray style, is not widespread, since the hunter cultures did not have seaworthy boats. The occurrence of this motif in North America must therefore be due

374

374. Two crocodile-spirits, from the Middle Sepik district, Karawari River, New Guinea, Melanesia. Wood painted with red earth, full length 23' 6". and 21' 2". Museum für Völkerkunde, Basel.

to overland transmission. Motifs belonging to agricultural peoples prove by their expansion that the cultures in question must have had highly seaworthy vessels, even if navigation later degenerated.

In addition to the X-ray style, the depiction of running men is characteristic of the hunter style. The distribution of both motifs is closely linked to the spread of early hunting weapons, such as the boomerang and the throwing stick. So far as we can judge today, both weapons originated in Magdalenian southern France and spread with the hunter culture to Australia; the throwing stick also found its way to America. Australia is unique in that both weapons appear together there and have been used down to modern times.

The depiction of movement and the X-ray style are, of course, typical for a hunter culture and, as can be proved, for the earliest hunter cultures of mankind in general. Hunters cannot but be familiar with the movement and running of animals and humans, while their experience also includes knowledge of the internal organs of animals. Their conceptions of the vital functions of these organs, and the resulting religious and magical ideas, lead to hunting magic and the representation of animals for magical purposes.

What is involved in a study such as this is neither the consideration of Oceanic art in isolation, nor its division into constituent regions—Polynesia, Melanesia, and Australia—as is usually done. Asia, especially Southeast Asia, must be brought into the picture, and America as well, for its western coast received the last spurs of this art. We are concerned not with the art of the South Seas alone, but with the art of the South Seas and the sur-

rounding regions, in other words, the art of the Pacific. The examples, the central themes, that are used here include the motifs of the early hunter cultures, essentially confined to Australia but found in prehistoric western Europe as well—the running man shown in profile and the X-ray style; the motifs of an early agricultural culture, possibly originating in southern China and disseminated from there over the South Seas—skull modeling and the squatting figure and its variants; and, finally, the motif that should be referred in essence to Bronze Age cultures, although an early form may have reached Australia with the hunter culture—the spiral.

The culture of Oceania, Melanesia, and Polynesia taken together, seems to consist of variations of an agricultural culture that originated in Southeast Asia (in Melanesia the extent of this culture coincides fairly well with the area of the cylindrical adze). Polynesian culture seems to be a derivative of this, at least so far as the application of artistic motifs is concerned; its art is based on the fertility cult and ancestor worship. Skull worship and head-hunting form a part of this; the modeled-over ancestral skull seems to be a starting point for plastic representation. In addition to this, as a sign of life, comes the squatting ancestor figure. The innumerable variations of this squatting-figure motif, which is spread over the entire Pacific, are the foundation of the art of Melanesia and Polynesia.

All these motifs came from various regions of Asia, reached America, and found varying formulations in the island groups and in Australia. They have been preserved in quite different stages on the various islands; in one place they are clearly recognizable, in another varied to

375. Boomerang incised with geometric-symbolic motifs, from central Australia. Museo Pigorini, Rome.

376. Malanggan figure, from northern New Ireland, Melanesia. Painted wood, height 67 3/4". Ethnographical Museum, Budapest.

377. Ancestor figure, from the Eilanden River area, New Guinea, Melanesia. Asmat. Wood, height 29 1/2". Museum für Völkerkunde, Basel.

378. Full-length male figure, from the Kaniet Islands, Melanesia. Wood, height 31 7/8". Übersee-Museum, Bremen.

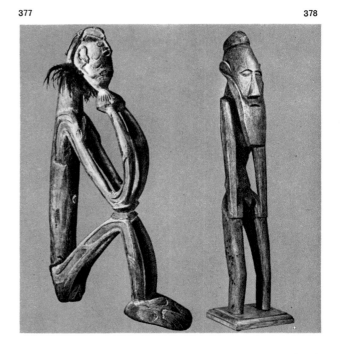

the point of unrecognizability or combined with other motifs, and in still another virtually suppressed or so abstracted that only comparative study can bring out the underlying motif.

In an undertaking of this kind it is not always possible to recognize the significance of each motif directly. One motif will have a definite significance and retain it everywhere; another will appear as pure ornament; a third may have a comprehensive, manifold significance, which never appears in its entirety, however, but only in varied aspects. Motifs persist through space and time and through quite different stages of culture. The use of diverse materials—stone, wood, bronze, or leather—may often make a motif unrecognizable, and only a second glance will convince us that a Chinese bronze and a wooden dish from the Marquesas present the same theme. It should not be forgotten that in many cases it is only through photographs that motifs can be seen independently of the diversities of the materials in which they are executed.

Geography plays a dominant role in any broad view of non-Western art. Arrangement by geographical divisions is the most obvious one, the most natural and the most practical, but it is by no means the only possible one. Instead of grouping objects by geographical origins, as is the usual practice in exhibitions and books, another method can be used—that of classifying them according to artistic motifs. This procedure can reveal entirely new

aspects of primitive art in general. A survey using this method and covering several motifs of Oceanic art will show that this art is based only on motifs that have been preserved in an enduring tradition and that here, as anywhere else, there is no art without fixed motifs. This is not in any way to deny the possibility of abstraction; even after sweeping abstraction the motif is still maintained and is recognizable. Abstraction is conditioned by an altered artistic vision or attitude; increased alienation from tradition does not help in and of itself. Abstraction often seems to signify freedom with respect to the form that was already present in the beginning—in this case, in the art of the early hunters.

379

380

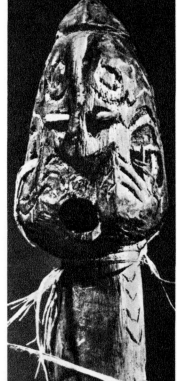
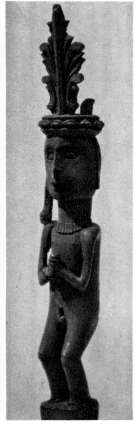

Planar Art of the
Hunter Cultures

The most diverse motifs and culture variants of the hunting stage of human civilization have persisted in Australia, where, by reason of long isolation, they have fused into a unity. It is not surprising, therefore, to find elements of different epochs, the late Paleolithic, the Mesolithic, and perhaps the Neolithic, side by side and mingled in Australia. Among the most remarkable implements of earlier times that have been preserved in Australia are the boomerang and the throwing stick. Both have been found in the paleolithic caves of southern France. Outside of Australia, the boomerang is known to have existed in prehistoric Spain, North Africa, Indonesia, Melanesia, and in various regions of America. Throwing sticks are found in eastern Asia and in North, Central, and South America. They would seem to have taken a northerly route to the shores of the Pacific, while the boomerang came by a southerly route, the two meeting in Australia. It may be that the apparently thoroughgoing unity of Australian civilization is to be regarded as nothing more than a successful fusion of various early cultural streams. This sort of diffusion may also explain the sporadic and

381

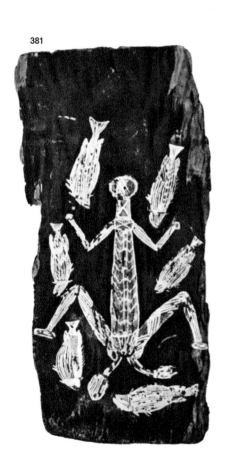

382

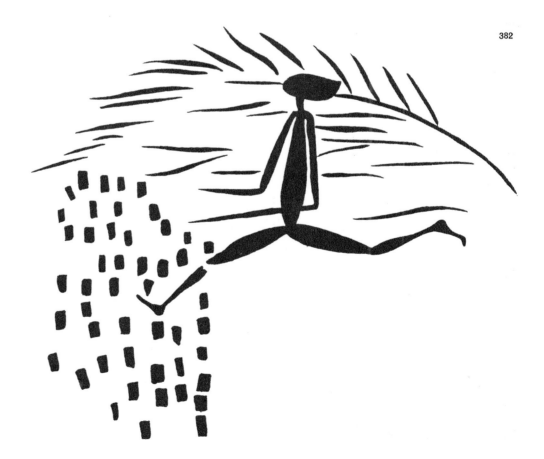

narrowly confined manifestations of various art styles in Australia that are comparable to phenomena in altogether different parts of the world.

To a certain extent some themes of Australian aboriginal art can be brought into relation with motifs of the early art of Europe, if we follow the path indicated with reference to the boomerang and the throwing stick. For example, the Australian motif depicting men in profile in rapid motion is found in a strictly delimited geographical region. Pictures of this kind occur at the mouth of the Drysdale River, in the Kimberleys, in the northwest, and again in the rock picture sites around Oenpelli in Arnhemland, in the north. In the rest of Australia profile pictures of men in motion are very rare, and incomplete or mistaken in form, at that. What is known as the "elegant" style goes back to these few profile figures in motion in the northwest and the north (figs. 168, 382).

The second motif, which occurs in Australia only in a limited area, is the representation of animals in the so-called X-ray style. In Australia, this kind of painting occurs only in rock pictures in Arnhemland, near Oenpelli and south from there to the Katherine River, and in bark pictures in the neighborhood of Oenpelli and from there south to the area of the Liverpool River (figs. 373, colorplate; 387, 394, 401). Nowhere else in all of Australia is the fully developed X-ray style found.

Both motifs clearly originated in European mesolithic art, the running man in the Spanish Levant, and the animal in X-ray style in Northern Europe (unless a preliminary form in the Ice Age art of Spain is to be regarded as the source of this mode of representation). Both motifs can be traced to Australia through migrations, whose details cannot be stated but whose general direction is indicated by the distribution of artifacts. The northern path that the X-ray style took through Asia is identified by the course of the throwing stick, which may be assumed to be concurrent with it. The southern path, taken by the motif of the running man shown in profile, is clearly outlined by the diffusion of the boomerang.

The diminutive human figures can be traced to Australia from Spain (figs. 121; 128, colorplate) via North Africa and India. This area of expansion and the directions taken are further confirmed by the fact that pictures of men, corresponding in style to the Australian profile pictures of men in motion, are frequently found with boomerangs. Among the paintings listed by Lenoch are works of this kind from eastern Spain, North Africa (in the Tassili Mountains and the Djebel Auenat in the Libyan Desert), east-central India, and Australia.

The boomerang is no longer produced by the natives in northwest Australia. The justification for believing that it comes from outside Australia, when there are so few existing examples, lies in the fact that representations of the boomerang in Spain and in northwest Australia are extraordinarily similar in their connection with human figures, and, in addition, that the Indian example is a picture of a kangaroo; the kangaroo is extinct in India but may well once have been favorite game there as it still is in Australia.

As has been noted, primitive hunter civilizations have survived until the present time in Australia. The culture and art of these peoples are not uniform, but are residues of various waves of immigration, which were fused into a conglomerate. One of these waves seems to have come from India via Indonesia and New Guinea; for geographical reasons, this must have been the case. There are, in addition, traces of an influence that bespeaks Siberia. Certain motifs of hunter art that have come down to modern times in Eurasian civilization seem also to have reached Australia, although the path they took can no longer be identified.

All the motifs that can be traced back to hunter motifs could understandably expand only slightly in the South Seas. They are limited to Australia and to a few rudimentary examples in Melanesia, especially in New Guinea. Some traces of north Eurasian fishing cultures are found in New Zealand and the Marquesas.

Although it cannot be clearly defined, a slight Siberian influence on Oceania and its cultural elements must be presumed. Bengt Anell has pointed out this influence, and on the basis of his researches believes that northern Eurasian fishing cultures influenced Oceania. The principal evidence of this influence appears to be a northern form of harpoon, used today, or until very recently, by the Eskimos. Traces of this harpoon have been found in excavations in the Marquesas, in New Zealand, and in the Chatham Islands to the east of New Zealand.

The Harpoon

The harpoon is first seen in the last phase of the Paleolithic, the Magdalenian period, in southern France (15,000–10,000 B.C.). The next find is at Stellmoor (near Ahrensburg, Germany), dating from about 6500 B.C. We may presume that the harpoon continued to be in common use in northern and eastern Europe through the Mesolithic and Neolithic down to modern times. From Europe it was dispersed through

Russia to Siberia, where it was used at Serovo on the Angara River (c. 3000 B.C.); from Siberia it traveled to China (2500–1500 B.C.), the region where it is most frequently found. The only exception to this progression is a find in Manchuria, which has been dated 5000 B.C.; comparison with the occurrence of the harpoon in the rest of eastern Asia suggests that this date is too early. Harpoons were common in Neolithic Japan, about 1000 B.C.; they reached Formosa about the same time. They have been retained on the coasts of the Pacific among the Ainus in Japan and the Haida in British Columbia, and in Oregon. Among these peoples and in other groups in the Mergui Archipelago off Burma, the common form is the double harpoon.

In the Marquesas the harpoon was in use at the time of the coming of the Europeans. On the two islands of New Zealand and in the Chatham Islands it is an object of archaeological finds. There are occasional occurrences in southeastern New Guinea and northern Australia. In the former region it is found near the Torres Strait, and from the testimony of the rock pictures it must have occurred in northeastern Arnhemland, on the Cape York Peninsula, in Queensland, and on Groote Eylandt. The harpoons of the Marquesas, New Zealand, and the Chatham Islands are clearly related to the harpoons of the arctic fisher folk. The Torres Strait harpoon is more like the harpoons and harpoon arrows of Indonesia and India, while in Arnhemland it was single, often jagged, as the rock pictures show, but neither the material from which it was made nor its place of origin can be clearly determined. This northern influence need not, of course, have come from more or less primitive groups in Siberia; its origin may have been Chou China, the influence of which is clear from the artistic motifs of the Marquesas and New Zealand.

Another indication of a northern influence may be a form of comb motif. In the so-called primary style of western Polynesia there occurs a motif—the diagonal comb on the heads of figures—that also appears in the woodcarvings of the Golds and Gilyaks of eastern Siberia. Its teeth represent beneficent spirits in the shamanistic interpretation of the world. Comparable comb figures occur on the Mortlock island of Nukumanu and in the Kaniet Islands. The helmets of New Ireland and Hawaii may perhaps be related to this, as well (fig. 384). Rudimentary abstractions found in bogs in New Zealand might be traced back to the same motif.

Traces of a similar influence can be shown in Melanesia, particularly in New Guinea, where many motifs appear that can be explained only on the basis of a hunter culture, and in particular, of shamanism. Another trace of shamanism is evident in the assertion by Australian natives that medicine men in a state of trance can visit distant lands riding on serpents.

The crocodile statues from the Karawari River, in the Sepik area (fig. 374), have faces carved on their backs. These faces are worked in the form of half-moons, with hooks like birds' heads between them. The crocodile's sides are decorated with spiral ornamentation. Similar forms are found in the rock pictures of northwest Australia. At Wonalirri, for example, a snake is represented with human faces painted on its body; the faces, which have no mouths, are known as *wondjina* faces (fig. 386, colorplate). The snake represents Ungud, the creative being, and the *wondjina*

383

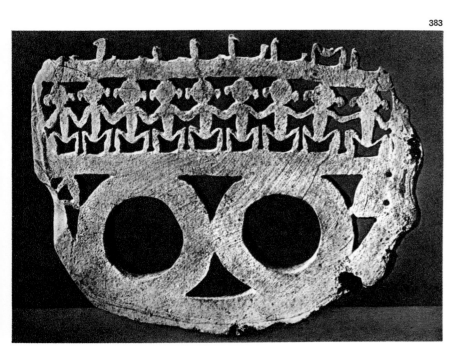

383. Openwork ornamental plaque from a mortuary shrine, from Choiseul, Solomon Islands, Melanesia. Tridacna shell, height 9". Museum für Völkerkunde, Basel.

255

faces, the first anthropomorphic beings, the ancestors of living men.

It is not impossible that an influence coming from the north could be traced to the Sepik Valley and to northwestern Australia. The ideas of medicine men; the residues of the X-ray style in the Sepik Valley, among the Marind-anim on the southern coast of New Guinea, and in western Arnhemland; the figures with combs on their heads—all these might be traces of a hunter culture influence from Siberia.

But more than anywhere else, the hunter culture can be traced in the rock pictures of Australia. Naturally, these rock pictures seldom present a definite style. For the most part they combine several styles and often do not present even these styles in pure and original form, being late and often feeble derivations. Austra-

384. The goddess Pele with a crest, from the Hawaiian Islands, Polynesia. Wood, height 33 7/8". Musée de l'Homme, Paris.

385. Openwork plaque, from the Solomon Islands, Melanesia. Tridacna shell. Museum für Völkerkunde, Basel.

386. Rock painting of wondjina *faces and a serpent. Wonalirri, northwestern Australia. Copy by K. Lommel, Museum für Völkerkunde, Munich.*

384
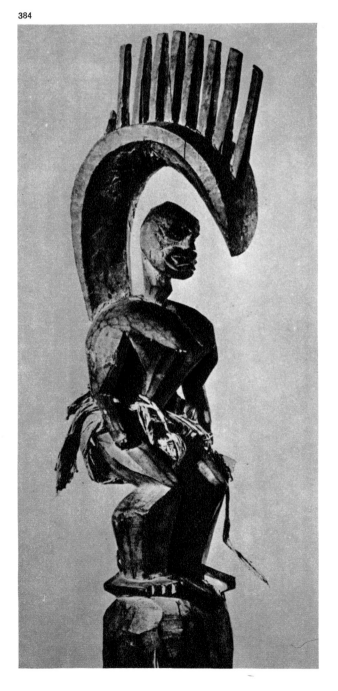

385
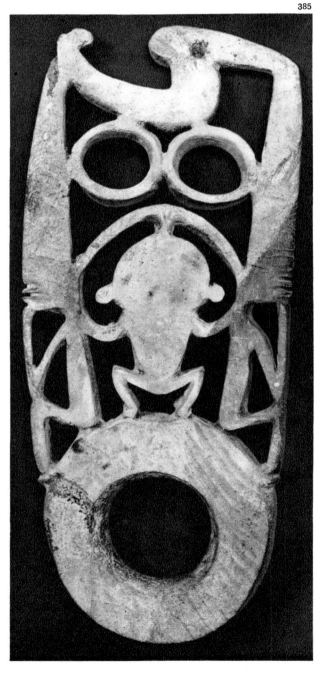

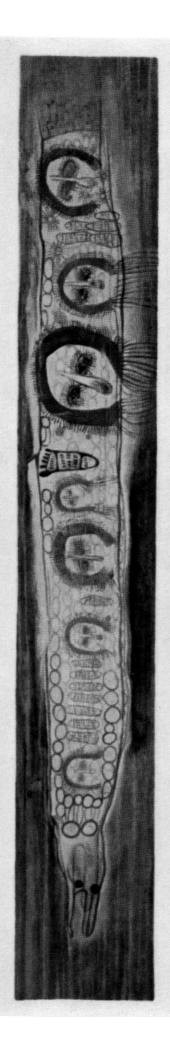

lia's long isolation led to meager local styles; on the northern coast, however, under the influence of New Guinea, richly colored "Melanesian" styles arose. The best way to give a general view of these styles is to treat them separately: first the pure hunter styles, such as the X-ray and the running-figure styles, and second, the developments of, and derivations from, these styles, namely, an animal style that goes back to the X-ray style and a style in which small human figures are represented in motion. Both are found only on the northern edge of the continent. It was there that strong influences reached Australia, and the pure styles could be preserved for a while whereas the derivatives soon became very primitive. The figures of men in motion are found only in the vicinity of Oenpelli; an animal style that can be traced back to the X-ray style occurs only at Oenpelli and the Kimberley region in northwestern Australia. An anthropomorphic, naturalistic style, with some representations of motion, extends farther east and can even be found in the southeast. This style must be connected with the squatting-figure motif that came to Australia from Southeast Asia and Melanesia. Pure squatting-figure images in rock pictures and bark painting are seen only in the extreme north and northwest of the continent, while the southeast presents a derivative of the squatting-figure style, in which motion is depicted.

The rock pictures of the *wondjina* style, with large colored surfaces, are confined to the northwest. They always show an oversized and very primitive human figure, somewhat influenced by the movement style but basically of Melanesian inspiration, going back to skull-worship conceptions. They are therefore treated below in the section about the skull motif. The meager desert style of Australia, whose few motifs also dominate the bark pictures of the northeastern part of the country, must go back to an early linear, abstracting art of the hunter culture.

Rock Picture Styles

The X-ray style refers to the art of hunter peoples in which the internal organs and sometimes the skeleton of animals known to the hunter are depicted, although they are not, of course, seen in the living animal (fig. 373, colorplate). This is often reduced to what is known as the life-line, a line going from the mouth of the pictured animal to the region of the heart or stomach (fig. 389). Such images have been made in various parts of the world,

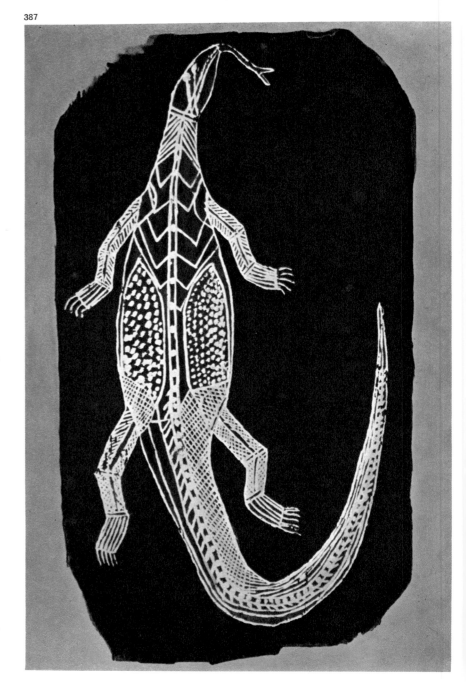

388

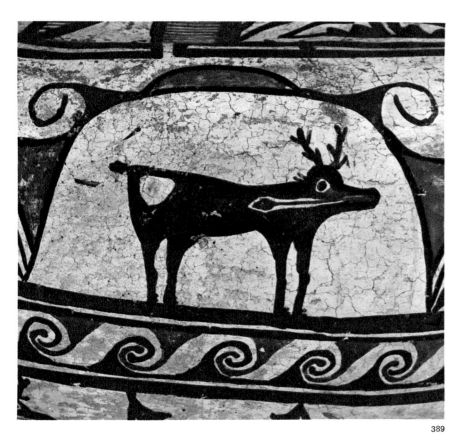

389

387. *Painting on bark of a monitor lizard in X-ray style, from Arnhemland, Australia. Städtisches Völkermuseum, Frankfort.*

388. *Rock painting of* wondjina *and a plum tree. Wonalirri, northwestern Australia. 4' 11" × 19' 8". Copy by K. Lommel, Museum für Völkerkunde, Munich.*

389. *Representation of a deer with a life-line, from the southwestern United States. Zuñi. Painting on pottery. Museum für Völkerkunde, Munich.*

for purposes of hunting magic, almost down to our time (fig. 395).

The earliest traces of the X-ray style are found not in rock pictures but on fragments of bone from the late Magdalenian period in southern France (15,000–10,000 B.C.). An Ice Age drawing in the cave of El Pindal in northern Spain may also be described as in the X-ray style: a red spot within the outline of a mammoth has been interpreted as a "heart" (fig. 106). It is remarkable that the X-ray style does not seem to have spread from southern France or northern Spain to eastern Spain or North Africa. The next comparable works clearly in the X-ray style are among the rock carvings of the so-called Arctic art of Norway (6000–2000 B.C.). It is certain that these Arctic pictures are linked to the Ice Age art of southern France. It is also a fact that rock pictures in northern Russia and Siberia have a great resemblance to those in Norway, especially those of what is called the "eastern group." Almost identical images are found at both extremities of the region of Arctic art—Norway (fig. 393) and the Amur-Ussuri region (fig. 392).

In addition to appearing in rock pictures, the X-ray style is seen, even today, in the ornamental art of Siberian hunting peoples such as the Ostyaks, or of Eskimos (fig. 391) or the American Northwest Coast Indians; traces of it can be found in the decorative art of the Pueblo Indians (fig. 389). Pictures in the X-ray style are known also in India, Malaysia, western New Guinea, New Ireland, and in a small district in northern Australia (figs. 387, 394), where in modern bark pictures, the X-ray style shows a definite tendency toward abstraction.

259

The Human Figure in Motion

Depictions of the human figure in motion, i.e., a running man shown in profile, are found sporadically in northwestern Australia (figs. 168; 413, colorplate), but they are extremely rare and did not penetrate very far inland. They occur principally in the rock pictures near Oenpelli in western Arnhemland. In the vicinity of this mission station, C. P. Mountford, the leader of an Australian-American expedition in 1947–48, found a number of large rock-picture sites with depictions of animals (mainly fish, turtles, and snakes), for the most part in a marked X-ray style. The natives still have a living relation with these pictures (less so with the numerous depictions of men in motion that cover the rock walls) and believe that spirits created them. The pictures themselves are remarkably diverse in style, at once vivid and degenerate. Men are shown in profile, running, with darts and throwing sticks; there are groups of often thin-limbed figures standing or dancing. As a rule, several strata are superposed. It is difficult to establish a time sequence at Oenpelli, however; certain types may be seen to be later at one site, while at another the sequence will be entirely reversed. This style, limited to Oenpelli, did not spread, but may have given a stimulus to the characteristic mode of depicting men in northern Australia. In the southeast the pictures of human beings, including those in motion, seem to derive from another model, the squatting figure.

Starting from the art centers of the northwest, which have retained the early hunter style, and from which, essentially, Australian art derived its origins, we can obtain an overall view of Australian rock pictures. The entire subsequent animal style, as it appears from the northwest down into the center, can be seen to have derived from the X-ray style; the anthropomorphic style to a great extent derived from the representation of the running man.

Animal Style

It is quite in order to speak of an "animal style" in Australia. Pictures of animals in naturalistic style are very common and are found over the entire region of rock paintings and rock engravings. In isolated cases animal images in decorative form appear in the center of the continent, which is usually characterized by abstract geometrical motifs. The animal

395

390. *Representation of a small kangaroo in X-ray style. Southern New Guinea. Marind-anim. Painting (after Wirz).*

391. *Representation of a seal in X-ray style. Alaska. Eskimo. Drawing.*

392. *Representation of a deer in X-ray style. Amur-Ussuri River region, Siberia. Sakachi. Rock art.*

393. *Representation of a deer in X-ray style showing the life-line. Evenhus, Nord-Tröndelag, Norway. Rock engraving.*

394. *Representation of a kangaroo in X-ray style. Australia. Bark painting.*

395. *Map of the Pacific area showing the diffusion of the X-ray style. Solid dots: rock-art sites where the X-ray style is found. Hatching: areas where the X-ray style has continued in use in modern ornamental art.*

images almost never occur alone, but always in conjunction with human representations. The only exception is the decorative style of the Kimberleys, where the same sort of animal representation is used as in the rock pictures (fig. 426, colorplate).

Pictures of animals, therefore, are found either on the periphery of the region of anthropomorphic painting or in conjunction with human figures—in other words, where the power to practice this kind of art has been weakened by distance, in space or in time, from its point of origin. It must be presumed that the capacity for naturalistic art in Australia goes back to an external influence, perhaps adopted with a stimulus to anthropomorphic painting. When this stimulus weakened, the Australian turned to pictures of animals, which are basic to the hunter culture. A special case in this connection is the X-ray style animal pictures of Arnhemland. This style today is increasingly detached from the northern geometrical style native to Arnhemland, especially in the east. This process suggests an effect limited, like the X-ray style, to a very small district between Oenpelli and the Liverpool River.

Stylistic Areas

Stylistically, the rock pictures fall into two groups. In an arc along the western and northern coasts, and again in a sector at the southeastern corner of the continent, there is a more or less primitive-naturalistic anthropomorphic and zoomorphic style. From the southwest to the center and then to the south, there extends an abstract-geometric style. Today we can state that this second style is abstracted from the naturalistic style. For the time being we cannot

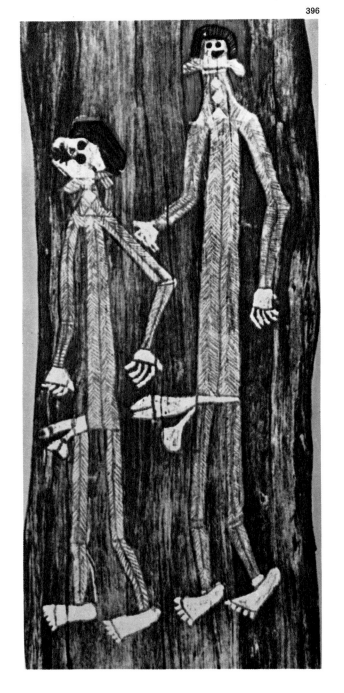

396

396. Bark painting of the spirits called Namarakain, from Oenpelli, Arnhemland, Australia.

397. Bark painting of a totemic ancestor of the wondjina *type, from the Prince Regent River area, northwestern Australia. Unambal tribe. Städtisches Völkermuseum, Frankfort.*

398. Bark painting of a mythical being associated with rain making, from the Drysdale River area, northwestern Australia. Städtisches Völkermuseum, Frankfort.

explain why the geometric-abstract style of rock pictures is found mainly in the southern and southwestern parts of Australia, but also seen on wooden ritual objects and personal ornaments in the north and east; this decoration is painted, not carved, in the extreme north and northeast. The southwestern engravings in the abstract style are usually very clumsily applied to the rocks and stand in noteworthy contrast to the elegant lines on the churinga objects of wood; they are also rare. Abstract lines are uncommon in painting as well.

Rock pictures in naturalistic style extend in a kind of arc through the continent from northwest to southeast; the southwestern and northeastern corners are excluded. Both quantity and quality fall off sharply in the progression from the northwest to the southeast. In the paintings of the southeast there are, once again, reminis-

cences of the elegant style of the small figures of the northwest, but in other respects the rock pictures of the east, mainly engravings, are to be regarded as a primitivized continuation of this style.

The naturalistic style, as applied to wooden ritual objects and to personal ornaments, is found in a much narrower area, in the northwest and north, and sporadically in the southeast. Undoubtedly, contact with Europeans has promoted use of the naturalistic style for ornament in the west, and even more so in the southeast. The naturalistic style of rock pictures in the north and northwest goes back to non-European influences, as is shown merely by its geographical position on the edge of the continent.

The fact that the northwest was the area of introduction of the anthropomorphic style can be seen not only from geographical but also

397

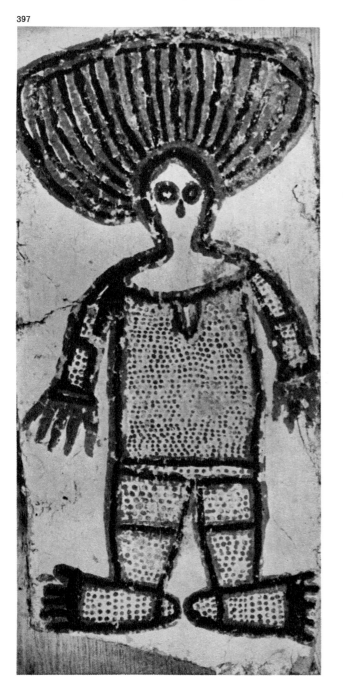

398

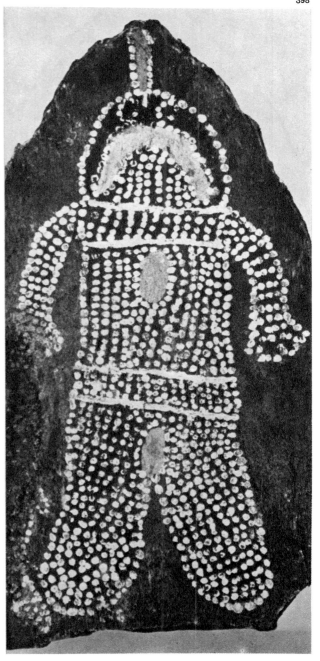

263

from stylistic considerations, and from the evolution of motifs. Study of the various forms of human representation in Australian rock pictures shows that the depiction of profile figures in motion is confined to a few centers in the far north, and appears only in a confused, misunderstood form in the southwest and southeast.

Australian rock art may be divided into two major style groups, abstract-linear and naturalistic. The rock pictures of the abstract-linear style are found in the southwestern corner of the continent, with isolated instances in the northeast, in Queensland, and in New South Wales.

The path of the naturalistic rock-picture style goes in an arc from the extreme northwest (fig. 413, colorplate) to the east and southeast of the continent. On either side of this "style bridge," which is much weaker in the middle than at either end, there are paintings and engravings in which the two styles mix. This is true of the few rock paintings of Queensland and eastern New South Wales, as well as of the engravings of southeastern Australia.

In this classification the squatting-figure images of the northwest and north and the few in the southeast have a place apart. They must certainly be linked to similar pictures in Melanesia, and even in Polynesia. The nearest comparable examples are the rock pictures of western New Guinea.

Bark Pictures

The technique of painting on pieces of bark is widespread along the coast of northern Australia. There has been a tendency to regard these works as an extension of the rock paintings. It may be true that painting is done on pieces of bark today where it was formerly done on rocks, a practice that, if it survives at all, does so very rarely. Probably the two techniques were formerly practiced concurrently. Bark painting is actually the only primitive art form of the Pacific that easily adapted itself to modern times. Naturally, the traditional motifs, which are often ritual in origin, tend to give way to decorative forms of expression in the process. Bark painting is alive today as a decorative art; it is promoted by government agencies and missions, but the artists, too, realize that they can sell their pictures and easily produce new works.

There is some doubt as to the function of the early bark pictures of northern Australia. It is not known whether they were created for the sheer joy of painting or served some magical

399. Stylization and dissociation of the human face into ornamental elements on bark belts, from the Gulf of Papua, New Guinea, Melanesia (after Haddon).

400. Painting on bark of the male spirits Eradbati and Kumail-Kumail from Oenpelli, Arnhemland, Australia.

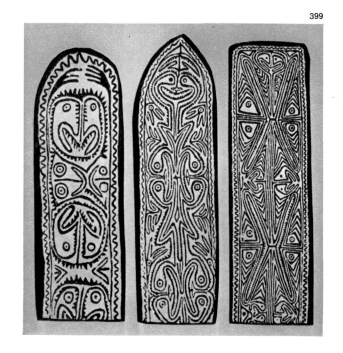

399

264

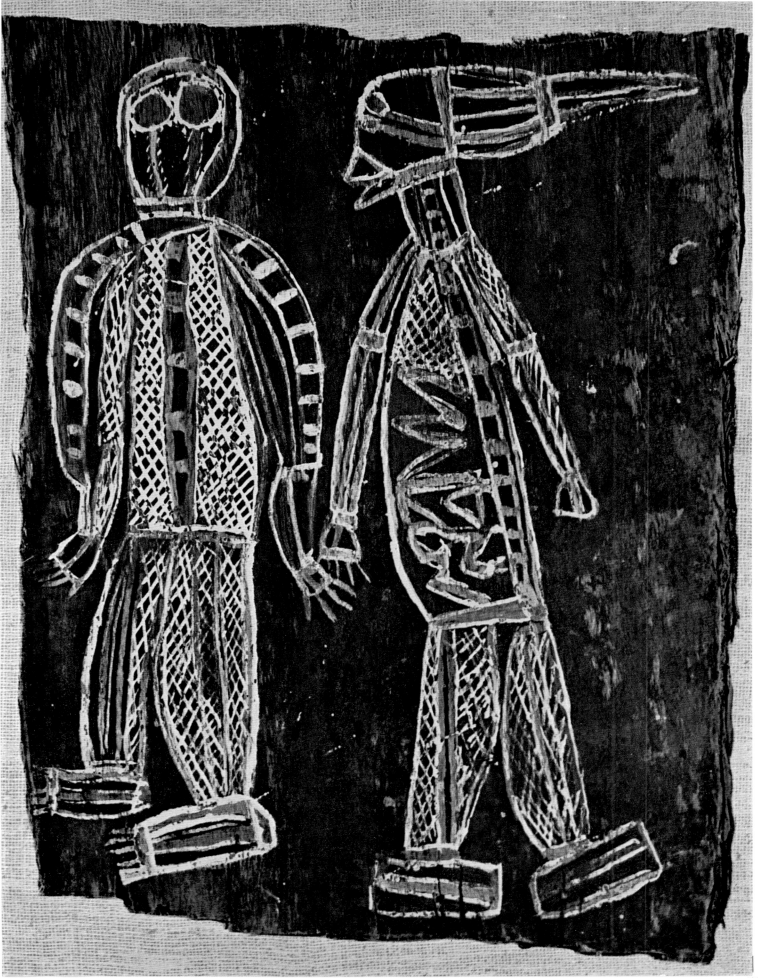

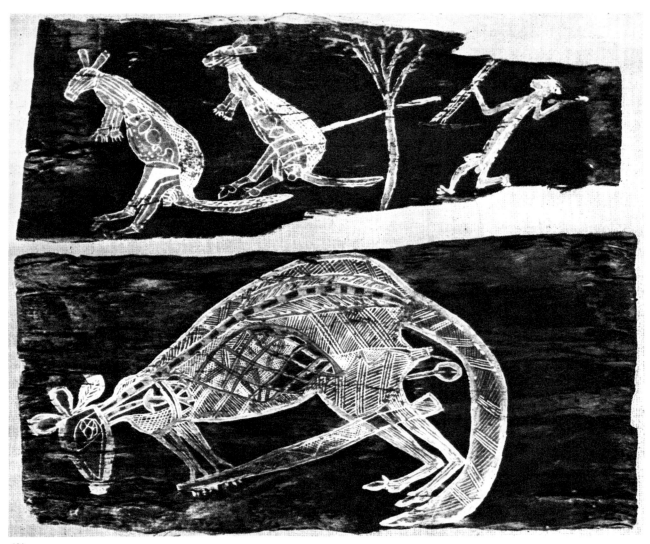

401

purpose. The bark pictures from the Katherine River published by H. Basedow in the form of drawn copies sometimes show a strict stylization, an almost heraldic arrangement, and sometimes the so-called playing-card arrangement. Basedow does not report anything concerning rock pictures or the other pictures in a primitive naturalistic style that he also collected near Katherine. The oldest bark pictures known are those from Field Island, dating from 1884 (fig. 468, colorplate). They present a strange and strongly marked style in which human and animal figures are shown. The animals (birds, fish, and mammals) are ornamentally divided: a kind of X-ray style often remains, but usually the internal organs of the animals are decoratively simplified. The human figures are drawn in hard outlines and filled in with diagonal hatching. We see a strange degeneration of the capacity to portray the human form; the members are added to the body by connecting lines but are no longer understood "anatomically." The weird ghostlike representation is heightened by this abstraction from the naturalistic. The figures seem to be painfully added up out of their parts.

401. Bark painting of Wili-Wilia, the male spirit who hunts kangaroos (above), and Kandarik, the kangaroo spirit (below), from Oenpelli, Arnhemland, Australia.

266

These figures are directly comparable with a certain phase of the rock-picture style at Oenpelli. There too we find the fluid, ghostly quality, as well as the human body divided into its component parts and the filling-in with lines.

The makers of the pictures that B. Spencer collected in the vicinity of Oenpelli in 1912 belonged to the Kakadu tribe. As compared with the Field Island pictures, they show a definite coarsening. Here too spirits and animals are depicted, and in many cases a relation can be seen to the bark pictures of Field Island and to the rock pictures at Oenpelli. Sometimes they are primitively naturalistic, at other times rigidly stylized, and often the two are fused; for example, the viscera of a naturalistically drawn animal may become purely ornamental abstractions. Those internal organs of the animals that the natives know are not shown naturalistically in the X-ray style, but as abstract ornament, in one case as a stippled band. Anthropomorphic pictures are found either in a crude stiff style (fig. 396) or as forms covered all over with varied colored lozenges and triangles, but there are also primitive naturalistic drawings of running hunters (fig. 401). All the modes of representation have parallels in the rock pictures, with the exception of the polychrome lozenge pattern; the pictures are called "spirit pictures" by the natives (fig. 400, colorplate).

The art practiced today in western Arnhemland, that is, on Goulbourn (fig. 369) and Maung islands and in the vicinity of Oenpelli (figs. 396; 400, colorplate; 401), seems to have little connection with the Field Island pictures and those of the Kakadu tribe. Human representation becomes less and less important and increasingly schematic and motionless. In animal representation, the internal ornamental elements crowd out movement; the decorative trend smothers all other stylistic traditions. Frequently there are depictions of something like the firmament, with colored stars giving the effect of the pattern of an Oriental rug. Eastward from Goulbourn Island, on the Liverpool River, at Milingimbi, Yirkalla, and Groote Eylandt, an old tradition of the ornamental style seems to have prevented even the beginning of naturalistic representation. In the bark pictures these ornaments show great finesse; the image consists almost exclusively of multicolored diagonal hatching, filling in and wiping out all the contours. Certain patterns are hallowed by tradition and are also used by preference in everyday representation. The piece of bark that the educated Milingimbi artist paints shows clear traces of an earlier, primitive, anthropomorphic representation that

here becomes the depiction of a mythological event.

Melville Island presents an entirely different kind of bark painting from that of the coastal area. Here bark baskets are painted in colors for ceremonial purposes (fig. 435, colorplate). Apparently they are used exclusively at burials, to carry the totemic signs of the deceased and his relatives. Perhaps we should not speak here of "bark pictures" proper, but only of a decorative genre of painting. The Melville Island motifs are purely ornamental. A number of motifs appear that are known on the Australian mainland, but are seen very seldom in the painting along the coast, e.g., the concentric circle, the concentric square, the vertical line with cross-lines, and the lozenge hatching known on the coast. Human or animal representation is found only in the most recent bark paintings and does not seem to have occurred previously. Melville Island paintings are marked by bright colors, a free use of red and yellow, and refined, studied composition. Spencer has collected the oldest painted bark baskets; they are in the Melbourne museum. Like the rest of the local culture, the art of Melville Island gives the impression of long isolation. The influences to which the anthropomorphic style of the coastal rock and bark pictures must be traced do not seem to have reached there. The color composition and motifs seem to have remained as something apart in the development of Australian art.

The bark pictures of the mainland of Australia, seen as a whole and disregarding their dates of production, may be divided into two main groups, showing great variations and often overlapping. In the west, from the Kimberleys to Oenpelli, there is an essentially naturalistic style, representing animals and often men as well; in the east, there is a purely schematic style, whose essential characteristic is lozenge hatching, with the lozenges filled with various colors. From Oenpelli to Groote Eylandt the two styles intermingle; men and animals are represented everywhere in this region, but the lozenge-hatched style is almost always the more basic element in eastern Arnhemland. It seems as if the naturalistic mode of representation had once been adopted there and is now being gradually supplanted or transformed by the hatching style. This impression is strengthened when we see how in animal pictures on bark the characteristic X-ray style is slowly schematized and turned into a geometrical formula. The transformation suggests that the X-ray style was the older one in eastern Arnhemland, where it is the traditional, hallowed style and is therefore taken by the natives to be more important.

We can see the process of decline in bark painting in the naturalistic style in the north. These paintings often express great personal skill, but the more the bark pictures lose their traditional meaning and become representations of events of daily life, the less possible it is for traditional content to find expression in them. The lozenge style, more and more victorious, promotes schematization and makes it easier for the anthropomorphic style to become immobile and gradually to disappear.

The Spiral

Although it may seem strange at first, the spiral motif and its derivatives in Australia must be attributed essentially to the early hunter culture. In the South Seas, in general, the spiral is to be related to the influence of a Bronze Age culture, the Dong-Son culture, which came to the South Seas (New Guinea, New Zealand, and the Marquesas) about the beginning of our era, bringing with it the spiral forms developed in China. Australia, too, may have been touched by this wave, but there, the spiral ornament was confined to the center, and might be attribut-

402. Map of the Pacific area showing the diffusion of the figure with bent-legs motif.

403. Shield decorated with spiral motifs, from the Ramu River area, northeastern New Guinea, Melanesia. Museum für Völkerkunde, Munich.

404. Sea shell decorated with meander ornament (rubbing), from King Sound, northwestern Australia. 16 1/2 x 4 3/4". Western Australian Museum, Perth.

405. Stone churinga, from central Australia (rubbing).

406. Rock painting of a male and a female figure. Wellington Mountains, Arnhemland, Australia.

402

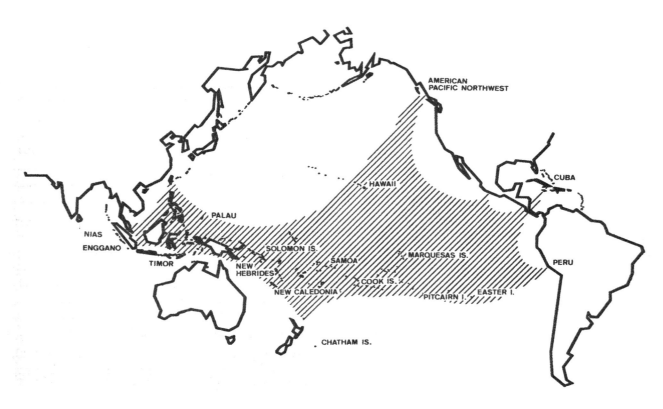

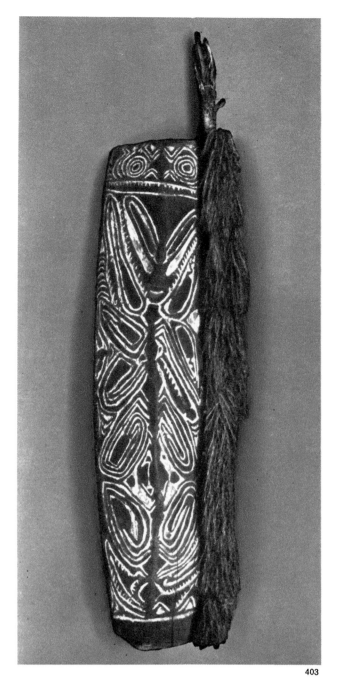

403

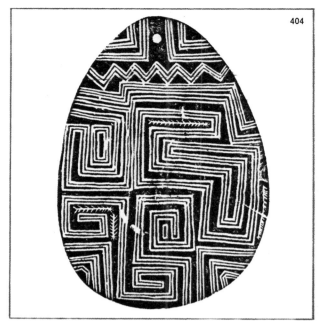

404

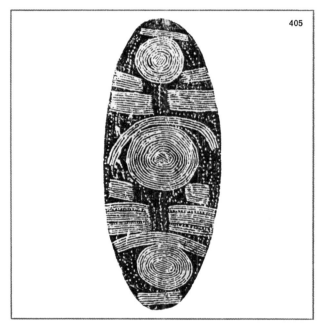

405

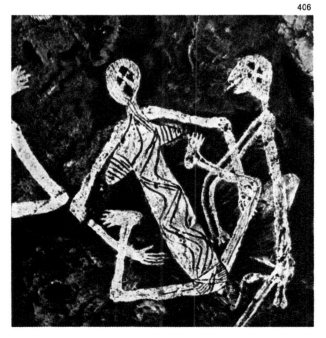

406

able to an influence from the north. It is likely, though, that spiral forms came to Australia with an earlier immigration. Some spiral forms with a free line, such as those used by the Warramunga, the northern neighbors of the Aranda, are directly comparable to Magdalenian bone carvings of southern France. It is quite conceivable that these early spiral forms were developed in Magdalenian southern France, as were the boomerang and throwing stick, and came to Australia before the Bronze Age spiral forms. Rudimentary spirals are found in rock pictures, and it has been possible to date one such engraving (Devon Downs, about 2400 B.C.).

407

The ornamentation on wooden ritual objects in southwestern and southeastern Australia shows derivatives from the spiral, namely, concentric lozenges and squares; these are forms that developed from the spiral in other regions as well, for example, on the banks of Lake Sentani in northern New Guinea. Although the term "development" is hardly appropriate in describing these forms since a process of immobilization and impoverishment is taking place, extreme southwestern Australia does show a genuine development out of the spiral— an advance to a free, elegant line, something isolated and unique. Some examples of wooden ritual objects ornamented in this style are in the museum in Perth. The only comparable developments in free, linear ornamentation, apart from certain modern European and seventeenth-century Japanese art, are found in the "finger spirals" of Ice Age art (in Altamira; La Pileta, fig. 43; and La Baume Latrône) and in late Magdalenian bone carvings of southern France. The meaning of this free, linear art that developed out of the spiral motif may perhaps be explained by the conception of the Australian hunter that the representation of the path of a man or animal represents the actual man or animal.

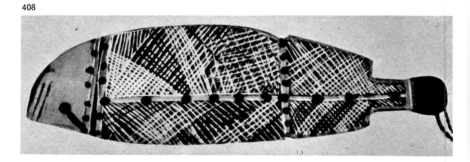
408

J. E. Hammond said once that engravings on an object represent a "road map" of the tribal district. It may be possible that the free lines are a kind of mythological road map, intended to make visible, if not to depict, the wanderings of culture heroes and ancestors. A similar conception, in somewhat stricter form, is found in the churingas of central Australia (fig. 405), in which the spirals and related lines represent ritual sites and the wanderings of culture heroes.

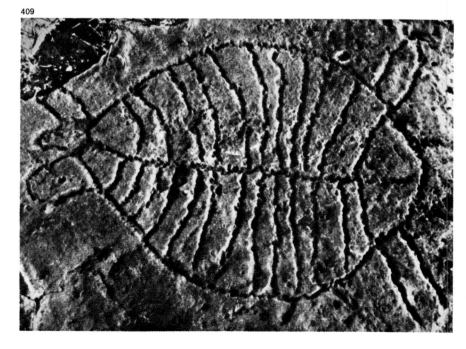
409

At first sight, central Australian art seems to be dominated by representations of concentric circles and spirals. Along with these dominant motifs, however, there are many others, less important today but which probably played a more prominent role in the past.

270

It appears as if the concentric circles and spirals of central Australia were the last survivals, fixed into a stereotype, of a definite abstract style whose older forms can still be seen in some rock pictures in the Man and Ayers ranges. What this style was like is shown on the northern edge of central Australia among the Warramunga, where the concentric circle appears with serpentine lines in ground drawings.

A continuation of this composition occurs in central Western Australia, where the principal ornament on the secret ritual objects of wood of the Niol Niol consists of concentric circles, in conjunction with parallel serpentine lines. Among the desert tribes of west-central Australia we find concentric circles entering into variegated, complicated, and elegant line patterns. This art is a transition to the style of the southwestern desert, in which motifs as such can no longer be traced but the capacity of playing with the independent line reaches its high point. Triangles and lozenges appear there, to be sure; in the west-central region all these motifs are combined with the concentric circle form that came from the center of the continent. Another element linked with these is the meander-like motifs of the Karadjeri tribe; these motifs are broadly distributed, either by themselves or in conjunction with other forms. In the southwestern portion of the continent as far as central Australia we find on the churingas free, independent line patterns, which can often no longer be classified as definite forms. They appear to be a survival of an early, we may well say essential, Australian form of expression; but their creators are dead and we cannot learn anything directly about the meaning of these patterns. At most we can draw inferences from what central Australian natives say as to the meaning of their patterns. The artistic significance of the line patterns of the southwest has been little recognized or appreciated hitherto; perhaps it is only in our time, under the influence of modern nonobjective art,

that we can come a little closer to understanding this art.

Although the wooden objects used for ritual purposes have an importance that can hardly be exaggerated, they are difficult to classify. They are supposed to have originated out of the limbs of ancestors. Today they constitute a link to those ancestors; they are bearers of life force and fertility, and as such are treated with the greatest reverence. Wooden ritual objects are kept in crevices in the rocks and in hollow trees; even today entire storehouses of them are found in lonely spots. All are ornamented. The old men explain them to the newly initiated; they express the mysteries of the mythological ideas. When similar ornamentation is found on objects of daily use, on shields, or bark, or wooden vessels, it has been taken out of its hallowed, secret atmosphere and we can well speak of it as "decorative art."

Ornamental motifs vary little within the several districts of Australia. It is not difficult to delimit several large regions of distribution. Many motifs appear combined in various compositions, but can readily be traced back to a few basic themes. Nothing could better express Australia's long isolation from the cultural movements of the rest of the world than the intensity of the effort made here to express the innermost content of a conception of the world by means of a few motifs.

For decorative art, too, we can begin with the northwest, the Kimberley region. There the animal style, already familiar from the rock pictures, appears on utensils—weapons, and bark water containers. They are often decorated with pictures of snakes, turtles, or other animals. Frequently the meaning of a given motif can still be traced. This free and primitive animal style is not confined to the Kimberley region; it extends to the upper Victoria River, to Pine Creek, and from there south to Daly Waters and as far as the Aranda region in central Australia. In the north this style extends to the coast of Arnhemland, and in the east to the Gulf of Carpentaria. In the center of the continent it is found alongside arc and concentric circle motifs.

Colored decorations are customary not only in the northwest but also in the northeast, but the motifs are completely different. With the exception of a few transitions, there is a sharp boundary between the free style of the northwest and the geometrical motifs of the northeast. Utensils in the northeast show strongly colored lozenges and lines of lozenges, inward-curving arcs, and the like. The explanations the aborigines give for the significance of the motifs is meager and does not give the impression of being very reliable, as becomes apparent

407. *Incised and painted funerary posts. Melville Island, Arnhemland, Australia.*

408. *Cult object of churinga type, from Arnhemland, Australia. Polychrome painting on wood. Städtisches Völkermuseum, Frankfort.*

409. *Rock engraving of a turtle. Port Hedland, northwestern Australia.*

271

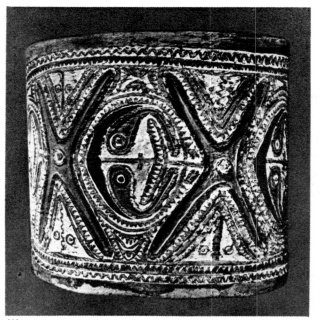

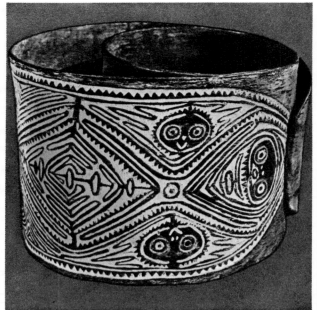

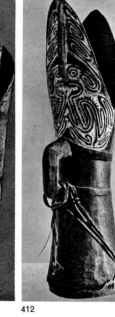

410

411

412

when we study the origin of the same motifs in other parts of Australia.

It is noteworthy that motifs painted in color appear on the north coast of the continent, penetrate into the center, and in a few cases are found as far as the south coast around Adelaide. In the west and east the motifs of decorative art are always carved; color is added only in exceptional cases. However, a large number of motifs are common to both techniques. One instance is the vertical line crossed by one or more lines. As is frequently the case in Australia, this is often used not only in a positive but also in a negative form; that is, instead of the vertical line and cross line or lines, we find two vertical series of rectangles parallel to one another. This is found in the western part of the continent, across the north to eastern Queensland, and in southeastern Australia.

It is questionable whether simple parallel bands, either vertical or horizontal, should be classified under this motif or treated separately. The distribution of the two motifs is very similar. Simple vertical or horizontal bands are painted on churingas (fig. 408) in the western part of the country, on rock pictures at Port Hedland (fig. 409), in dance paintings in the Kimberleys, as filling in *wondjina* pictures, in dance painting in central Australia, and on wooden ritual objects near Glenormiston in Queensland. In listing very simple motifs, there is often a tendency to regard them as a universal human conception that should be found everywhere in the world. But the pattern of distribution in Australia consistently demonstrates that these are specific art forms linked with other cultural phenomena. For example, the use of dots as a means of decoration is confined to wooden ritual objects in the southwest and center and to rock pictures in the

northwest and in Arnhemland. D. S. Davidson has studied the distribution patterns of several motifs and plotted them on a map. His maps might be made even more convincing by bringing together related motifs. For example, Davidson distinguishes between the lozenge and the diagonally hatched motif; but the latter undoubtedly gives the effect of lozenges and hence may be combined with the former. If we include the thread cross in the group of this motif, as seems reasonable, since the thread cross evokes at least the optical effect of a lozenge or double lozenge, the field is still further expanded. It is clear that lozenge motifs are common in the west and northwest and are predominant in Arnhemland, especially in

410. Belt with low relief decoration, from the Gulf of Papua, New Guinea, Melanesia. Bark with red and white decoration, width 9". Ethnographical Museum, Budapest.

411. Belt with incised decoration, from the Gulf of Papua, New Guinea, Melanesia. Bark enhanced with lime, width 6 1/8". Ethnographical Museum, Budapest.

412. Carved drum, from the Gulf of Papua, New Guinea, Melanesia. Painted wood and lizard skin, height 27 1/2". Ethnographical Museum, Budapest.

413. Rock painting of dancers. Rock picture site 17, Aulen, northwestern Australia. Height 22". Copy by K. Lommel, Museum für Völkerkunde, Munich.

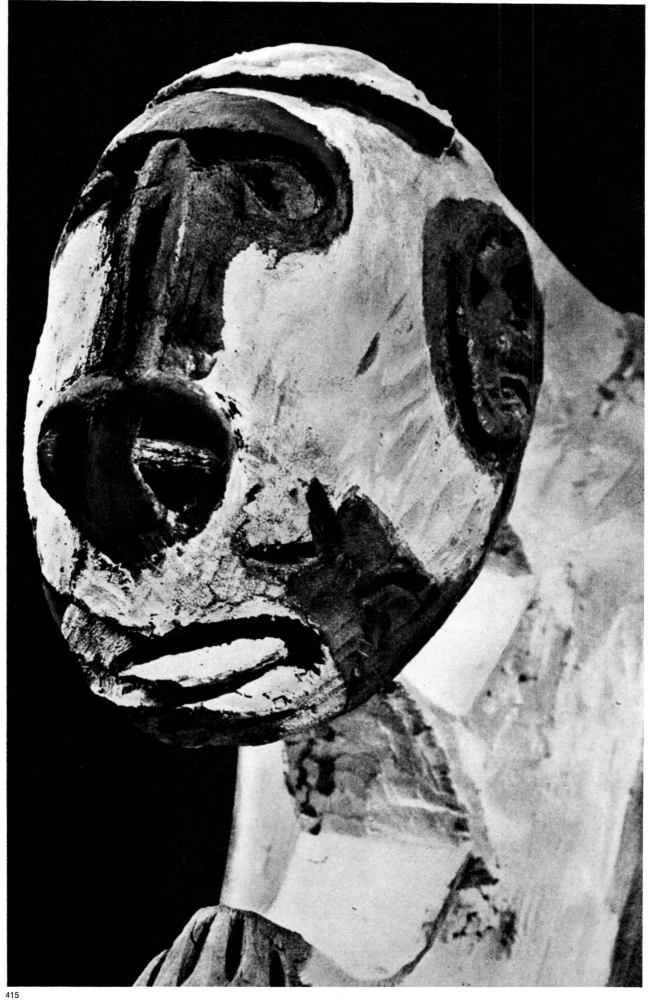

415

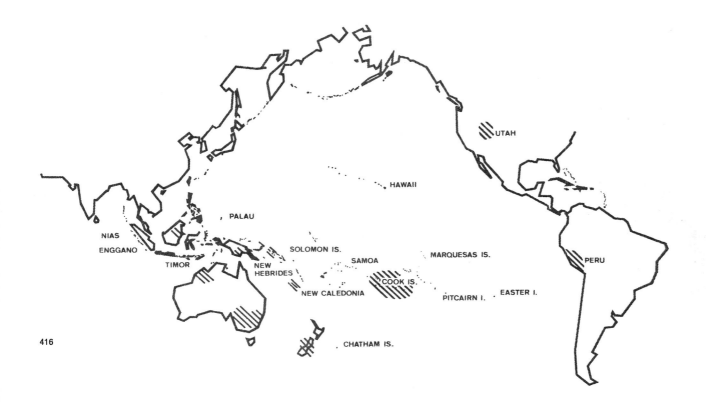

often among the Yaro. Farther to the south, at Nannine, human figures were carved on wood. In eastern Australia representation of the human figure is not very common, but Davidson notes them in northern New South Wales, in southeastern Queensland, in Victoria, and in northern Australia.

It has been suggested that the naturalistic anthropomorphic depictions in Australian decorative art are the result of a late European influence. It is certain that since European influence has appeared, the human figure has been used more frequently in decorative art; an illustration of this is found in the carved baobab nuts from the vicinity of Derby in western Australia, which present the anthropomorphic motif while earlier examples show abstract patterns. Human figures appear also on wooden ritual objects at Nannine in western Australia, beginning in the first years of the twentieth century.

In general it can be said that all of Australian aboriginal art today seems to be in the grip of a schematizing trend that suppresses any artistic power; works of art demonstrating great vitality are very scarce. Their occurrence can be plotted on a map: it can be seen that geometric and abstract motifs occur only in the extreme west and southwest on ceremonial objects of wood, or were made about one hundred years ago, when examples of this work could still be collected by Europeans. They are extremely rare in the center, the northeast, and the north. In the center, however, a few rock paintings have been preserved that show the geometric-

abstract style at its height. The only datable rock engraving of Devon Downs, which was done about the beginning of the second millennium B.C., is on a much lower level.

In the realm of anthropomorphic art, vigor was able to sustain itself only in the oldest examples and only in the northwest, the presumable contact region. On the whole, the anthropomorphic art on bark and rocks that has come down to us seems like dull late work, when studied from the point of view of artistic vitality and power.

416. Map of the Pacific area showing the diffusion of the representation of movement traceable to or deriving from the squatting-figure motif.

417. Winged object with incised geometric decoration, probably from Point Hope, Alaska. Eskimo. Old Bering Sea culture. Ivory, length 8 1/8". Smithsonian Institution, Washington, D.C.

418. Painted overmodeled skull, from the Sepik River district, northeastern New Guinea, Melanesia. Formerly Korrigane Collection.

419. Model of an umiak, made in Greenland. Eskimo. Length 25 1/4". Musée de l'Homme, Paris.

Sculpture
of the Sedentary
Peoples

The motifs of the hunter culture that have been discussed above are without exception motifs executed on a flat surface, as painting or engravings on stone or wood. Hunters seldom produce sculpture, and then always as the result of some outside influence. Small carvings of animals in wood appear on the north coast of Australia, and in bone, among the Eskimos. The few figures in the round of the Australian north coast are attributable without exception to contact with New Guinea.

Sculpture in Oceanic art is limited to the planter folk of Melanesia and Polynesia. We cannot say that the stimulus for this came from the advanced cultures of the mainland; rather, the artistic representation of mythological ideas furthered or even demanded the plastic form. Sculpture in the Pacific begins with the representation of ancestors and skulls. The idea that the spiritual powers of a man are concentrated in his head and can be transmitted by the veneration and collection of heads, whether of ancestors or enemies, leads to skull sculpture. Skulls were decorated and later modeled over. It would appear that, at the outset, these techniques were at the base of sculpture everywhere in the South Seas. A rudimentary sort of body was constructed to support the skull and thus an entire image of the man was developed, almost always with the head overemphasized. Closely connected with this development is the squatting figure of the ancestor.

417

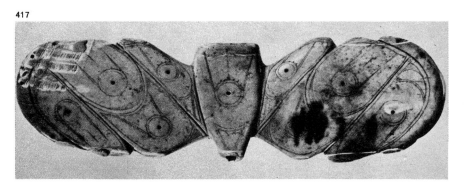

419

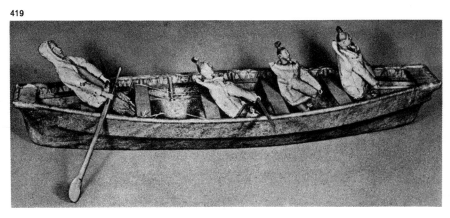

418

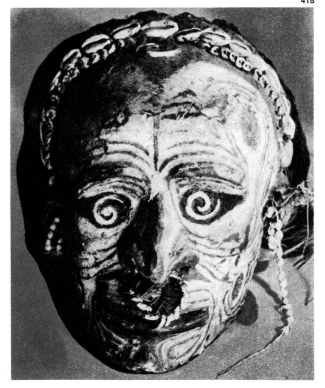

How this conception arises will be discussed below; but it is clear that the squatting figures, too, often serve merely as the substructure for an ancestral skull.

Thus, the skull cult and the representation of ancestors as squatting figures, are decisive for the development of sculpture in the South Seas. Where both of these are not adopted there is no sculpture. When we come to deal with the *wondjina* figures, large rock pictures, we shall see an interesting intersection of the two-dimensional representation of hunters with the skull worship of planters in northwest Australia.

The Skull Motif

The skull motif in art, which may be defined as an overemphasis on the head, is widely distributed in the Pacific, and very frequently conjoined with the squatting-figure motif. The skull motif is expressed either by decorating skulls (Borneo; New Guinea, figs. 364, 418; New Zealand, fig. 421) or by copying them (Peru, fig. 483, colorplate), by overemphasizing the head in depicting the figures, by pictures of faces on house-posts, to ward off hostile influences (Borneo, New Guinea), or on skulls (Borneo, New Guinea), or—very common in Melanesia and New Guinea—by reducing portraits to the face or eyes alone; for this reason the motif is often denoted simply as the "eye motif."

The belief is widespread in Southeast Asia and Oceania that the mental and spiritual powers of a man are concentrated in his head; for this reason the skulls of the dead are preserved and the heads of enemies are taken, in order to procure additional spiritual power for the individual or the community. Skull worship, head-hunting, and head trophies are the visible result of this belief, and it is not surprising that the representation of skulls has a dominant role in the art of these areas.

The skull motif appeared in southern China in the second millennium B.C. and then, transformed and varied, spread over the Pacific with the various waves of migration. It found expression particularly in the Melanesian masks. The masks that are still to be seen on the modeled skulls of New Guinea and New Britain go back directly to skull sculpture. Masks are important objects in Melanesia; they represent spirits of ancestors and therefore are for the most part anthropomorphic or reductions of an anthropomorphic conception. There are, of course, masks of animals as well, representing the ancestor's spirit in animal form. Abstrac-

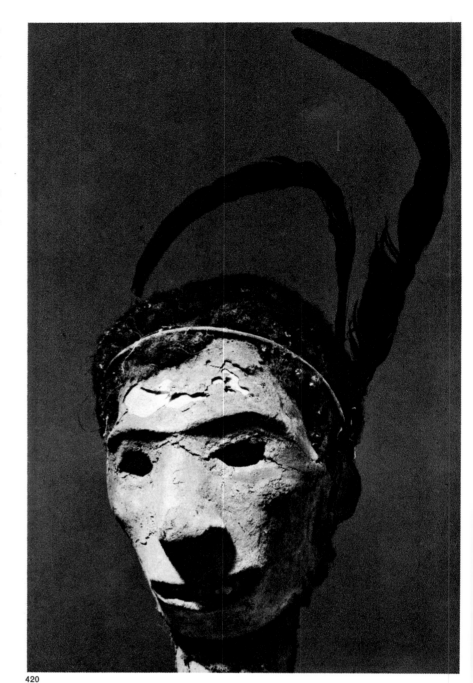

420

421

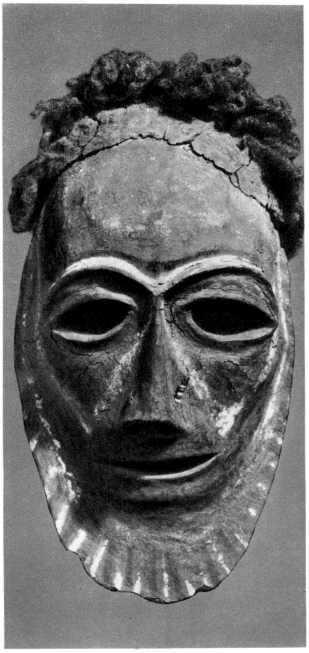

422

tions of masks are carried particularly far in Australia, where there are no actual masks. Instead, the masking process consists of painting the body, often with the addition of feathers, patterns, and the like. Complete abstraction of the human figure to a symbolic form can occur here.

The motif unmistakably used for purposes of warding off evil — from China through Borneo to New Guinea and New Zealand—is the face with protruding tongue. Representations relating to skull trophies and head-hunting are found in southern New Guinea, the Solomons, New Zealand, the Marquesas, and Peru. A simple, derivative form of ancestor and skull worship without head-hunting occurs in northwestern Australia, where the large *wondjina* pictures are to be explained as derivatives of the skull motif (figs. 386, colorplate; 388, 397, 398).

As Leonhard Adam has justly pointed out, the *wondjina* pictures are essentially representations of skulls without the lower jaw. At many rock-picture sites having *wondjina* pictures skulls are also found, painted in red ocher; they are skulls of deceased members of the group in question. Ancient and primeval as this rock picture style seems, it is recent and is obviously derived from Melanesian influence.

In northwestern Australia the natives, almost until the present day, were able to offer substantial explanations of the meaning and significance of the rock pictures; in other regions the tradition is lost and the natives have died out. Accordingly, in considering Australian art, and especially the rock pictures, the *wondjina* rock pictures of the northwest may very well occupy the central place. But the assumption that they are the oldest and most primeval examples of this art must be avoided. They give that impression at first, it is true, and for a long time the learned world believed that here the earliest record of rock-picture art as a whole had been discovered. This was incorrect, but since these pictures were alive in the ideas of the natives down to very recent times, there existed the possibility of having the meaning and content of rock pictures explained by still living Stone Age men.

The *wondjina* pictures are made under overhanging cliffs, where they are protected from the tropical rains. The overhangs are often under large mushroom-shaped rocks standing alone on the plateau; the tops of the rocks spread out protectively in all directions from a relatively small base, making it possible to paint pictures over large areas of the stone and to have them protected from the rain. Often the cliffs are in the mountains and difficult to reach; sometimes they are in deep gorges.

420. Painted overmodeled skull, from Santa Maria (Gaua), Banks Islands, New Hebrides, Melanesia. Height 9 1/2". Museum für Völkerkunde, Munich.

421. " Cured " head, showing tattooing, from New Zealand, Polynesia. Maori. Museum für Völkerkunde, Munich.

422. Painted overmodeled facial bones, from Gazelle Peninsula, New Britain, Melanesia. Baining. Museum für Völkerkunde, Munich.

279

The figures in the *wondjina* pictures are crude, often inept, anthropomorphic representations. Diverse artistic qualities can be observed: often the pictures are simply crude, but sometimes they are executed with a certain finesse and frequently the natural undulations and indentations of the stone are used to produce sculptural effects in the pictures. The *wondjina* is usually shown in a recumbent position (fig. 388); a broad horseshoe-shaped band in red or yellow ocher surrounds the face, in which only the eyes and nose are depicted and the mouth is missing. Various mythical accounts are given for the absence of the mouth, but since there are such diverse versions, one is inclined to doubt that any of them is trustworthy. The body of the *wondjina* is usually whitish and filled in with longitudinal stripes. The arms and legs are depicted, the hands and feet in a very primitive way; for the most part the feet are drawn with the soles showing, that is, a footprint is shown instead of a foot. This is understandable when we reflect on how important tracks are to hunters and realize that all over Australia the footprint very often represents the being that made it. On the breast of the *wondjina* there is a long object, explained, but not clearly established, as being the heart or the breastbone. The sex of the figure is rarely suggested, but nonetheless, the natives are usually certain as to whether a specific *wondjina* is male or female. Alongside the *wondjina*, above it and on it, smaller *wondjina* figures are often painted, or merely indicated by their heads. They represent the "children" of the *wondjina* or the souls of the human beings descended from it. Numerous representations of animals—kangaroos, fish, birds, dingoes, opossums—and of edible plants and tubers, show that these things were born with the *wondjina* at the beginning of time and have a spiritual home

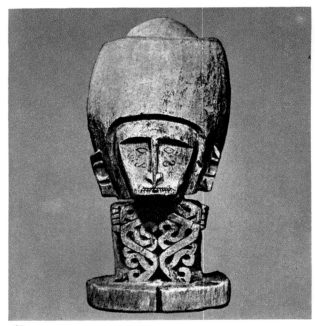

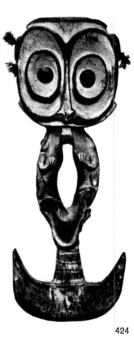

423

424

423. Korwar figure, from Biak, Geelvink Bay, western New Guinea, Melanesia. Wood, height c. 16". Rijksmuseum voor Volkenkunde, Leiden.

424. Double suspension hook, from the Sepik River district, northeastern New Guinea, Melanesia. Wood, height 39 3/8". Museum für Völkerkunde, Basel.

425. Skull rack, from the Sepik River district, New Guinea, Melanesia. Bark, length 71 1/4". Museum für Völkerkunde, Basel.

426. Rock painting of serpent figures. Malcott, northwestern Australia. Copy by K. Lommel, Museum für Völkerkunde, Munich.

425

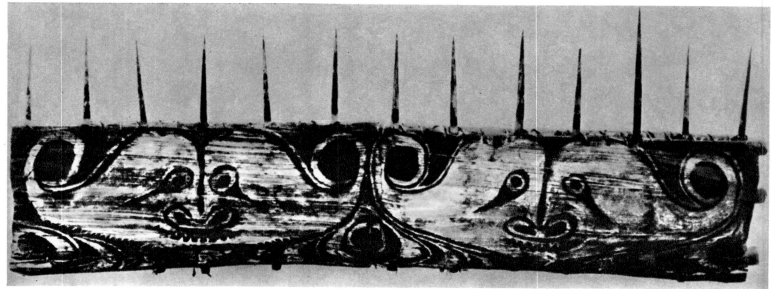

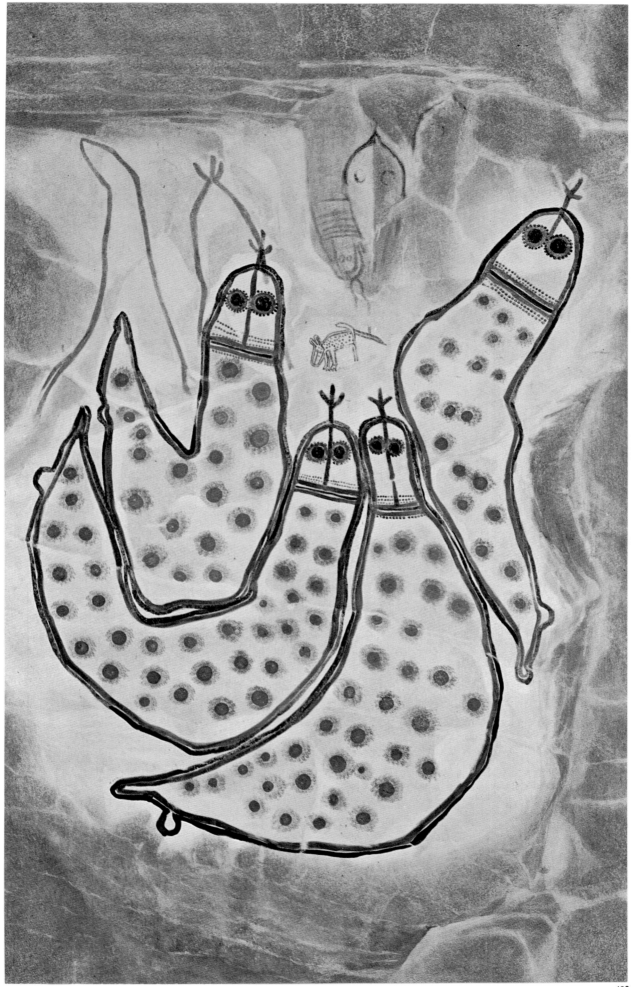

at the site of its picture. Traditionally, a *wondjina* picture should be newly painted every year by the oldest member of the human group presumably descended from it. Although they are rare, even today freshly painted pictures are found. It can be seen from earlier pictures that they fade and flake off relatively soon, since the colors—red and yellow from ocher earths, white from white clay, and black from crushed charcoal—are simply mixed with water and applied. We often find, at rock-picture sites, remains of the twigs chewed to form brushes, of the pieces of bark used as palettes, and pieces of charcoal. In the repainting the artists always retain the same theme, but by no means follow the lines drawn by their predecessors. It is not hard to discern the contours of an older picture under a fresh or relatively young one. It is also easily seen that the ability of the individual painters differs greatly. Some compose sweepingly with free lines while others construct the picture painfully, from details.

Rock pictures are the externally visible expression of the civilization of the aborigines of northwestern Australia. Myths, the story of creation, the conception of the world—everything is represented and expressed in these widely dispersed pictures. The primeval creative power on which all life depends is symbolized by a snake. From the snake comes an anthropomorphic being, the ancestor of man and also the fructifying rain, the *wondjina*, which is always present in the pictures, along with plants and animals. All the pictures embody spiritual substances and power; souls of animals and plants emanate from these pictures and after dying return to them. The souls of human beings, their *jajarus*, appear linked to the pictures and the springs of water attached to them. They, too, return to the picture after death to await a new incarnation. The creative dream-state of the primeval epoch, *Lalai*, is contained and depicted in these pictures.

The pictures, as they are painted on the rocks, are the expression and representation of the conceptual world of these men. The natives are always explicit in saying of the rock pictures, and we can realize this from what has been said above, that they only "touch" the pictures and did not originally paint them. In point of fact, "touching" the *wondjina* and *ungud* pictures seems to consist only in refreshing already existing paintings. Primitive as these views seem, it is remarkable that the natives do not relate at all to rock pictures in other styles. The rock pictures mentioned above—the small, profile human figures in motion and their cruder derivations—are inexplicable to the natives, and they do not know the sites where they are found. The

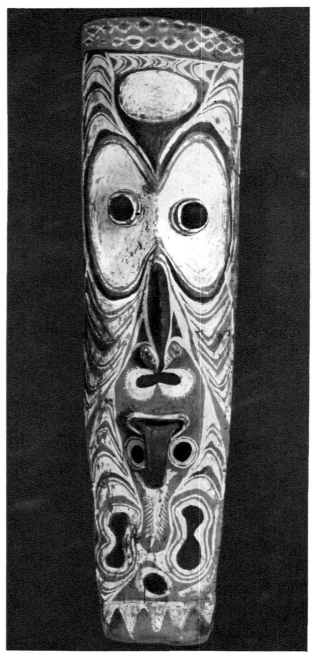

427

427. *Carved and painted shield, Sepik River district, northeastern New Guinea, Melanesia. Wood, height 59 1/2". Museum für Völkerkunde, Munich.*

researcher must rely on chance discoveries.

There is no doubt, however, that the pictures in the other style go back to the early depictions of the running man in profile. Drawing in profile has been preserved only in rare cases, but the representation of movement, or the attempt to represent it, is common to all these small pictures. They are found in the Kimberley region in northwestern Australia and in Arnhemland. In the former area they are clearly distinguishable from the pictures in the *wondjina* style, and are probably earlier; here and there transitional forms between the two occurred.

Comparison between the *wondjina* and the "elegant" style is possible only in northwestern Australia, since the *wondjina* style is limited to the region of the Kimberleys. Farther east, on the Forest River, traces of the Kimberley style are still to be found. Basedow, who worked on these rock pictures, has published a *wondjina* head, animal pictures that are comparable to those of the Kimberleys, and anthropomorphic pictures that can only be ranged alongside the latest and most degenerate art of the northwest. To the east, the art of the Kimberleys vanished completely. Rock-picture sites that can be linked to those in the Kimberleys are found only sporadically in the Northern Territory.

Basedow has also published drawings of rock pictures from the region of the Victoria River and its tributary, the Humber River, and from Pidgeon Hole. They show a remarkably vigorous style and can no longer be connected with the work of the Kimberleys. The figure of a squatting or running woman, from Blunder Bay, can at best be taken as parallel to the devil figures of the Kimberleys.

Clear relationships to the Kimberleys are found, however, in the rock pictures of Delamere, which Davidson discovered and studied. Even externally, in its arrangement and execution, the site shows relationships to the west; the same applies to the mythology, as Davidson was able to establish. The anthropomorphic figures depicted are known as "lightning brothers." They have certain relationships to the *wondjina* style of the west, such as the striped bodies, the absence of mouths on the faces, and raylike head coverings. The rock-picture site has many primitive pictures of animals, and seems to be intermediate between the two artistic provinces of the north, Kimberley and Arnhemland, not only geographically but in style as well.

A reference datum for the time at which the other, "elegant" style was imported is the fact that the pictures in India that are comparable with this style cannot be dated earlier than the fifth century B.C. The date of importation may be set somewhere between that time and the end of the first millennium A.D. That would indicate an age of at most two thousand years for the pictures in the "elegant" style, but in all probability the earliest examples have not survived, and the known ones are considerably younger.

The introduction of the "elegant" anthropomorphic style is probably the source of all the pictures of human beings in motion, both the primitive ones of the northwest and southeast and the isolated instances in the center. A subsequent influence from Melanesia, or an influence that reached Melanesia and Australia at the same time, may well be the source of the abundant use of color in these pictures and the development of the *wondjina* style. The primitive animal style of the northwest, north and east may be regarded as a development of the Arnhemland X-ray style.

The Squatting-Figure Motif

The most important motif of Oceanic art is the squatting human figure, which is encountered, in many variations, as a motif of pictorial art from Indochina to America: sculptured squatting figures, reliefs, abstract forms in the minor arts, engravings on rocks. There are squatting figures with antlers or with protruding tongues (fig. 428), standing figures with legs slightly bent, figures that are no longer squatting but seem to have their legs arched upward, and many other types. A survey of the motifs and forms of Pacific art readily shows that the squatting figure is the dominant motif. A squatting human figure appears as the basic form of almost all sculptural representation, whether of ancestors or gods or derived from skull worship and cannibalism.

The squatting-figure motif has a definite, but not yet adequately defined, area of distribution that comprises Southeast Asia, Indonesia, and Melanesia (fig. 416). Traces of the motif also are found in the art of Polynesia, northwestern America, and Central and South America. The motif is undoubtedly the dominant one in Pacific art, and expresses an entire cultural outlook. A survey and history of the art of the regions of the Pacific could be made on the basis of this motif alone. The concepts linked with the squatting figure vary from one region to another, and perhaps from one epoch to another, but one fundamental aspect is never abandoned; the motif cannot be defined by a single word, but involves various connected and related concepts.

In early times the squatting position must

have symbolized the birth position, and perhaps also the fetal position. The widespread custom of burial in the flexed-knee position is undoubtedly not intended to bind the dead and prevent them from returning, but rather to return them to the fetal position in order to assure their rebirth; it represents the belief in resurrection or reincarnation. This train of thought leads to representing ancestors as squatting figures, a custom which may have started in China, and is typical in extensive regions in Indonesia and Melanesia (fig. 377). A derivative from this is the representation of an ancestral figure with bent legs, the type of figure most common throughout Polynesia. It may be only technical considerations, however, that led to this reduction.

The squatting-figure representation of the ancestor is often connected with skull worship and head hunting. Examples of this linkage are the *korwar* figures of eastern Indonesia and western New Guinea (figs. 423, 430, 463–65).

Naturally enough, from the squatting-figure representation of the ancestor there derived images aimed at protecting and at warding off evil, and ultimately images representing fertility in general. In the course of history, all these representations are reduced and abstracted. The history of Oceanic art consists to a great extent of the transformation of the squatting-figure motif; from the degree of change we can detect the remoteness and the advancing degeneration of the art of entire regions in Polynesia and Melanesia, and particularly in New Guinea.

It is understandable, too, that this motif should be the foundation of all plastic art in the South Seas. A plastic art can be developed more readily from the squatting human figure than from the motifs previously discussed, which are essentially drawings that go back to early rock-picture art; decorative motifs like the spiral, are intrinsically adapted only to the ornamentation of a more or less sculptured body. Nor could the skull motif, by reason of its concentration on the head and its neglect of the body, contribute much to the development of a plastic art. For all that sculpture in Oceania may be referred back to the squatting-figure motif, it is equally true that this motif is often, and perhaps very quickly, subsumed and transformed in relief representation. At first the squatting figure is represented only in profile view; frontal representation is obtained only when it is " bilaterally split. " This sort of bilateral splitting is the most frequent and the one with the widest distribution. It is a clear, and almost universal, consequence of the technique; in some cases it seems to have arisen out of profile depictions of squatting

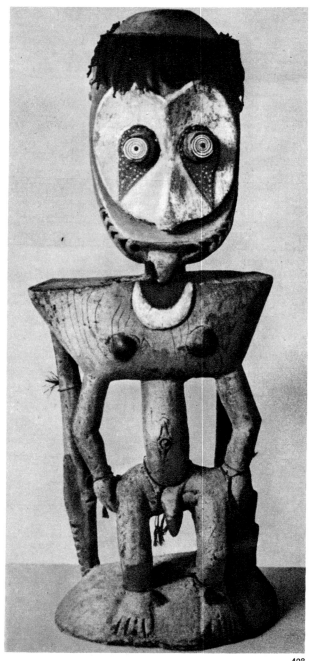

428

428. Ritual stool with ancestor figure, from the Sepik River district, northeastern New Guinea, Melanesia. Wood, height 55 1/8". Museum für Völkerkunde, Basel.

429. Neckrest, from the Sepik River district, northeastern New Guinea, Melanesia. Wood painted in earth colors with cowrie-shell decoration, height 5 1/2". Rautenstrauch-Joest-Museum für Völkerkunde, Cologne.

430. Korwar figure, from Geelvink Bay, western New Guinea, Melanesia. Wood, height 12". Museum für Völkerkunde, Frankfort.

284

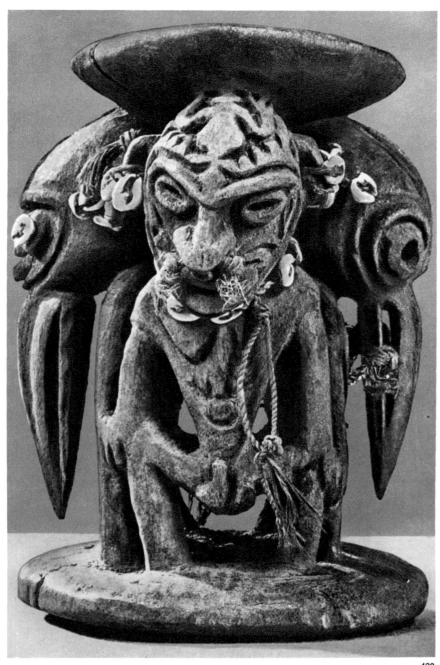

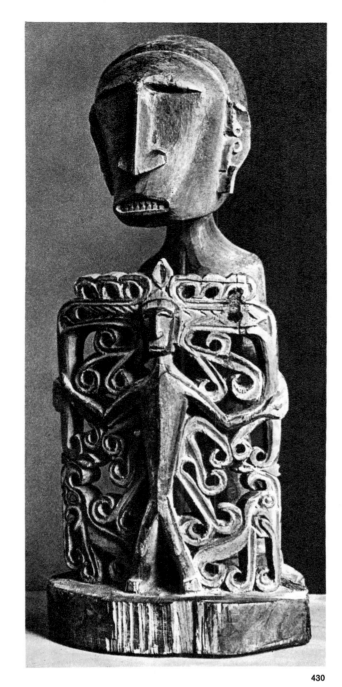

figures back to back, facing in opposite directions. Here there is an approximation to the pictures of living creatures, mostly animals, of Chou China, consisting of a head and two bodies. The head is in the middle, the bodies always located symmetrically on either side. This "bilateral splitting," as it has been called, is still encountered in the art of northwestern America.

The system of ideas connected with the squatting image as a fertility symbol and also with skull and ancestor worship must have touched northwestern Australia in its passage. Proof of this is not only the squatting images but the *wondjina* representations themselves. The comparable *wondjina* faces are depictions of skulls; they could be regarded as derivations of the *korwar* images, a planar representation of ancestors unrelated to the squatting-figure motif.

A preliminary form of the motif can be found in Europe in the art of the Danish Maglemose epoch, in which rudimentary squatting figures seem to be representations of the earth mother. Later, in early China, deceased forebears are represented in a squatting position. The drawn-up position in burials and in the depiction of the deceased is to be regarded as a representation of the fetal position and is connected with the idea of rebirth. Throughout the Pacific the squatting ancestor is to be regarded as a motif of fertility, for warding off evil, and as representing life, continuing life, and being alive.

In western Melanesia clearly defined squatting-figure images are not found; they reappear only in Central America. Oceanic intermediate forms are the figures with bent legs and the rudimentary squatting figure-images depicting motion.

285

Certain squatting figures indicate a relationship to early hunter cultures: the depiction of the squatting bear as a totemic motif in China and the American Northwest Coast; and an early hunter motif, like that of the " Lady of the Beasts," which is often mixed with the squatting-figure motif in the Pacific. In view of the significance of the squatting-figure motif, it is not surprising that it predominates in the rock pictures of the region under consideration. In the course of time the motif came to be abstracted for special use on shields, where it has its particular place as a defensive image (fig. 431). If this development is traced, it can lead to far-reaching conclusions as to the history of art in the South Seas and the directions of transmission. For one thing, the importance of New Guinea for the art of Australia becomes particularly evident.

Oceanic art, as such, and its development into abstraction, can be accurately judged only if its iconographic foundation is known. Reference of the no longer recognizable variants of New Guinea, especially its southwestern portion, to the squatting-figure motif first makes it possible to understand the development of this art and its possibilities of solid and transmissible formulations.

Genealogical Trees

The attempt (made primarily in the sculpture of Oceania) to represent generations by squatting figures set one above the other led to the development of ancestor poles; they are found in New Guinea (figs. 432, 434), the New Hebrides, New Zealand, and North America (fig. 433). In a smaller, more sketchy form, often reduced to merely ornamental art, they exist among the Bataks on Sumatra, in the Philippines, in New Ireland, in the Marquesas, and in the Cook Islands.

Schuster points out the occurrence of ancestral representations of this kind, in a highly abstracted form, in the Admiralty Islands and in many parts of South America. Australian ritual objects also seem to be derived from these genealogical trees. Polynesia has abstract images of the genealogical tree motif, especially in the Cook Islands and in the Tubuaï (Austral) Islands. In the British Museum there is a statue of a squatting figure from Rurutu that represents the god Tangaroa in the act of creation (fig. 439). The god brings forth other gods from his body, almost all represented as squatting. Another formulation of the same theme is found on Rarotonga: Te Rongo with his three sons, growing out of his body and

shown as squatting figures (fig. 440). Still another modification of this image are the Tangaroa representations from Rarotonga, which are not statues in the round but show only a profile view; the reduced, rodlike body is a row of bosses that upon closer examination can be recognized as stylized squatting figures (figs. 437, 438).

Further abstractions from this motif are found in the sculptures presented to the British Museum by the Missionary Society. These works, reduced to rods with hooked forms, show, at their tops, the remnants of three little figures, obviously once again the three sons of Tangaroa. These images are undoubtedly to be regarded as genealogical trees—mythological ones, of course—and as representations of the creation.

Early Squatting-Figure Images

The earliest squatting-figure images we know of in the Pacific region come from China. We mention a small squatting-figure image with spiral decorations from Hsiao-t'un (2000–1050 B.C.). Li Chi discusses Southeast Asian squatting figures with reference to their relationship to, or presumptive derivation from, the Chinese. He believes that squatting images might go back to a group, called Eastern I or "squatting barbarians," that lived on the eastern coast of China in the second millennium B.C., and can be identified archaeologically by a type of black pottery.

The contemporaneous or somewhat older squatting figures on Yang Shao pots (2200–1700 B.C) are not yet clearly defined, but are undoubtedly anthropomorphic figures with elbows lowered and hands raised. The depiction of the legs varies; often the knees seem to point down rather than up. Squatting figures with legs bent upwards are still found in Botel-Tobago; on Formosa; in western New Guinea,

431. Painted board, from Santa Maria (Gaua), Banks Islands, New Hebrides, Melanesia. Of relatively recent manufacture. Height 27 5/8". Copy by K. Lommel, Museum für Völkerkunde, Basel.

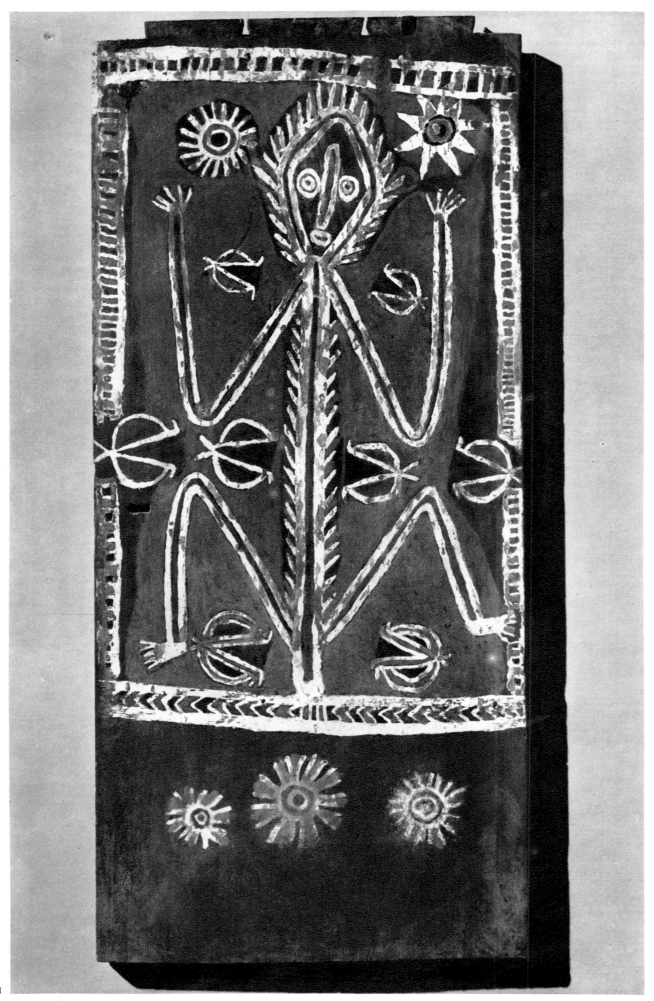

431

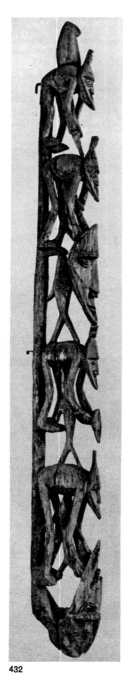

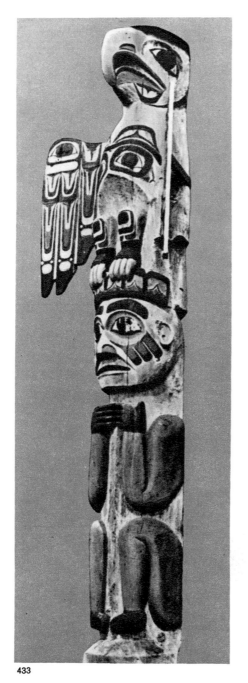

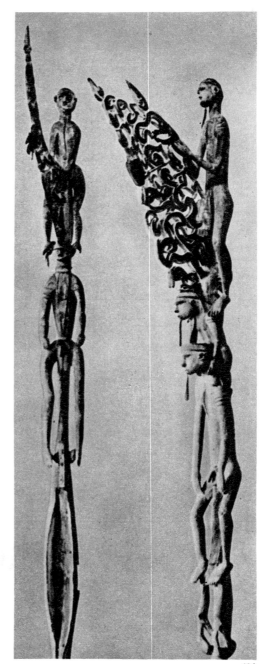

432 433 434

especially in the Asmat region; and in bark paintings in Australia (fig. 387).

In the Yang-Shao period ribs are clearly shown on a squatting figure (fig. 441). This is a dead person, then, and here, obviously, is the beginning of the conception of the squatting-figure image as a deceased forebear. The wide-spread custom of burying the dead in the drawn-up position is undoubtedly linked to ideas of continued life or resurrection, and this must be regarded as a fetal position. Squatting-figure images in the cult of the dead are to be referred back to ideas of this sort. Similar images are also known from the Marquesas (fig. 443), Hawaii, and the Chatham Islands, east of New Zealand (fig. 442), where squatting-figure images with ribs are incised on bark in memory of the deceased. The Marquesas and New Zealand are the two island groups of Oceania that present

432. Vertical openwork frieze, from Seleo Island, Sepik River district, northeastern New Guinea, Melanesia. Wood. Übersee-Museum, Bremen.

433. Totem pole. Ketchikan, Alaska. Northwest Coast culture.

434. Bisj poles, from southwestern New Guinea, Melanesia. Asmat. Koninklijk Instituut voor de Tropen, Amsterdam.

435. Painting on a bark basket, from Melville Island, Arnhemland, Australia. South Australian Museum, Adelaide.

288

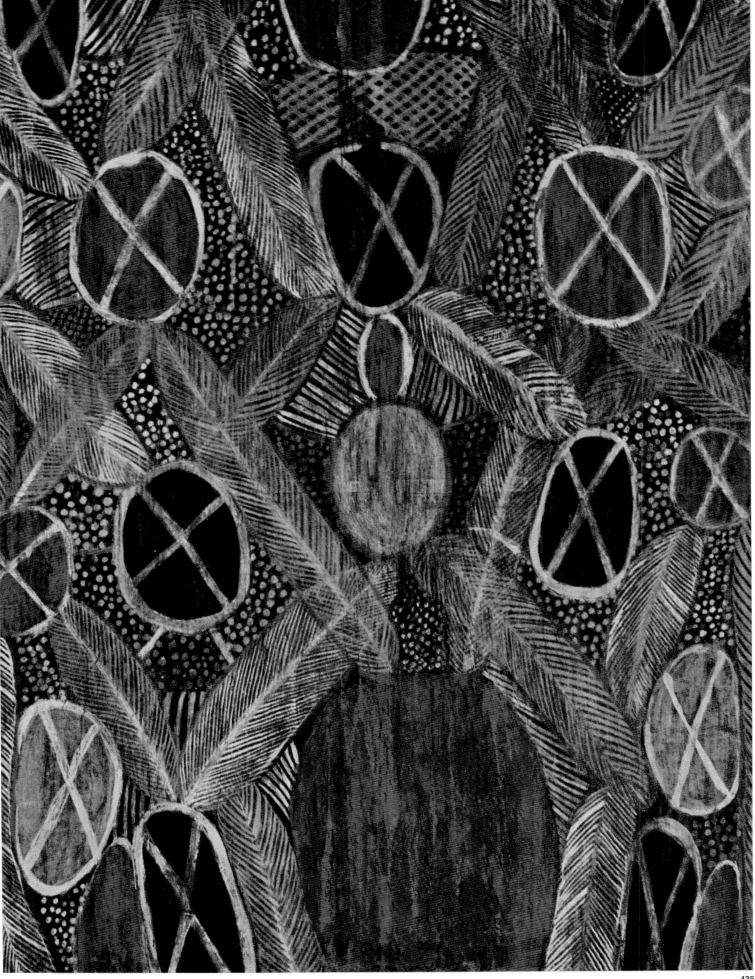

northern influences not always attributable to contact with China. One instance of this is the harpoon, which is found in a very northern form in both groups.

Archetypal Squatting-Figure Images

Sculptural representation of the squatting-figure motif covers a region extending from ancient China to Burma, southern Indochina, large portions of Indonesia and Melanesia, and the central Solomons. In the South Seas true squatting-figure images appear in a weaker form; the purer forms recur only in north-western America, sporadically in Central America, Colombia, and Venezuela.

Many wooden figures in Borneo go back to squatting-figure models. In reliefs or textiles, however, the model is often only hinted at. The pictures are almost always of the male. In Sumatra the motif occurs only among the Batak. There it appears on large stone burial urns and on wooden objects used to ward off evil spirits; in minor arts we find it on powder horns and on the so-called magic staff (fig. 462).

Squatting-figure images predominate on the island of Nias, where they are ancestral figures carved out of wood. The figures occur in every form—squatting, sitting, and standing—and they are almost always male, usually with an intricate headdress often reminiscent of antlers (fig. 448).

In eastern Indonesia, squatting-figure images are known on Timor. On the island of Roti the motif occurs on a prehistoric bronze adze. On Sumba the motif is very common on textiles.

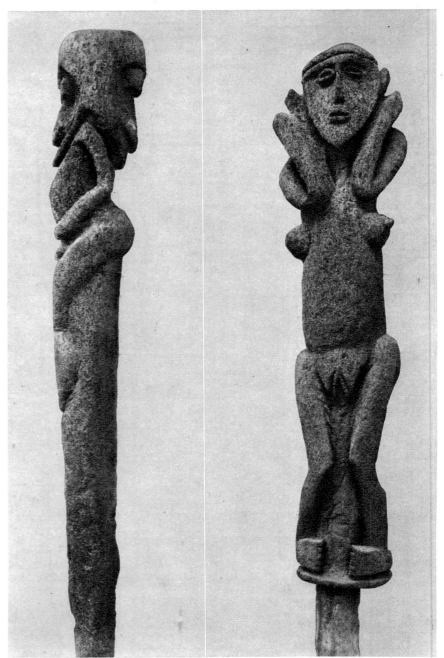

436

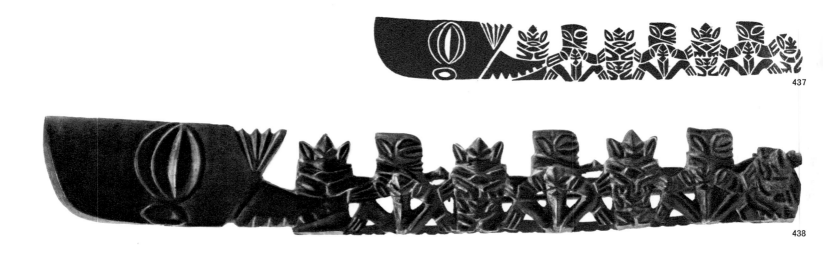

437

438

290

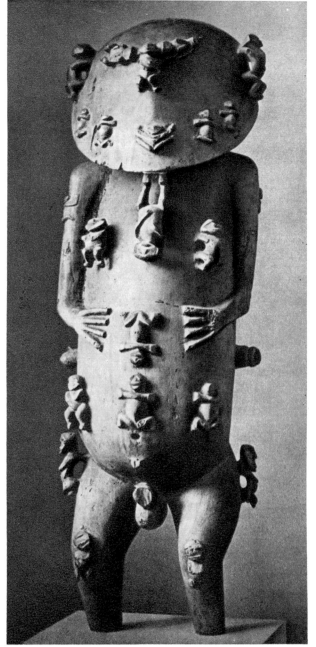

439

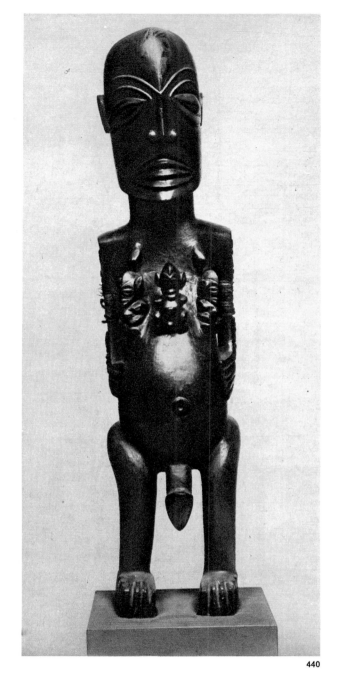

440

436. *Two-faced male figure and a female figure, from Ambrym, New Hebrides, and Santa Maria (Gaua), Banks Islands, New Hebrides, Melanesia. Tree fern, height of female figure 74". Both, Museum für Völkerkunde, Basel.*

437, 438. *Staff god Tangaroa (and schematic drawing), from Rarotonga, Cook Islands, Polynesia. Height 28 3/8". Museum für Völkerkunde, Munich.*

439. *The god Tangaroa creating gods and men, from Rurutu, Tubuaï (Austral) Islands, Polynesia. Collected end of the 18th century. Wood, height 44 1/2". British Museum, London.*

440. *The god Te Rongo and his three sons, from Rarotonga, Cook Islands, Polynesia. Collected end of the 18th century. Wood, height 27 3/8". British Museum, London.*

291

In the Babar (fig. 447), Tanimbar, and Leti islands it occurs in a clear, explicit, and predominant form. The Leti figures are quite similar to those of upper Burma on the one hand and of western New Guinea on the other. In the Philippines the motif is found in northern Luzon both explicitly and in derivations; these figures, too, can be stylistically compared with those of eastern Indonesia and upper Burma. In western New Guinea squatting-figure images are widespread, as ancestor images or as skull holders. Derivatives of the squatting figures occurred here very early, including statues in the round having only a profile view (in the Mimika and Asmat region). A special squatting form representing a mother and child is found in the Lake Sentani region (fig. 445). Coarsened squatting figures occur in the region of the Sepik and Ramu, and in the decorative art of the Massim region in eastern New Guinea. A variant in which the drawn-up legs are turned backward is known from the island of Tami. On Choiseul, in the Solomon Islands, squatting figures in stone and wood are found, although not very frequently.

Clear and definite squatting figures in the round do not occur in the rest of Polynesia, and reappear only in America, where, however, the motif is seldom so clearly depicted or worked out as in Southeast Asia and Indonesia. The motif is clearly developed in the decorative art of the American Pacific Northwest. This brings us to the outer edge of the squatting-figure area. As might be expected, in this area, where the ideas as to the formulation of the motif weaken, original derivatives occur and abstraction dominates. Instances of this can be cited from various regions, such as Siberia, southern New Zealand, South America; one especially impressive example is from Central Australia.

Figures with Bent Legs

Polynesia has no explicit squatting figures in the round, only approximations. These are figures with bent legs. On the basis of intermediate forms occurring in Borneo, the Philippines, New Guinea, New Britain (fig. 489, colorplate), and the Solomons, it may be presumed that these figures are derived from the squatting-figure image. This might also have been an independently conceived motif with no close connection with the squatting motif (figs. 378, 380); there are, however, clearly marked transitional forms, indicating that one motif was derived from the other. Such devel-

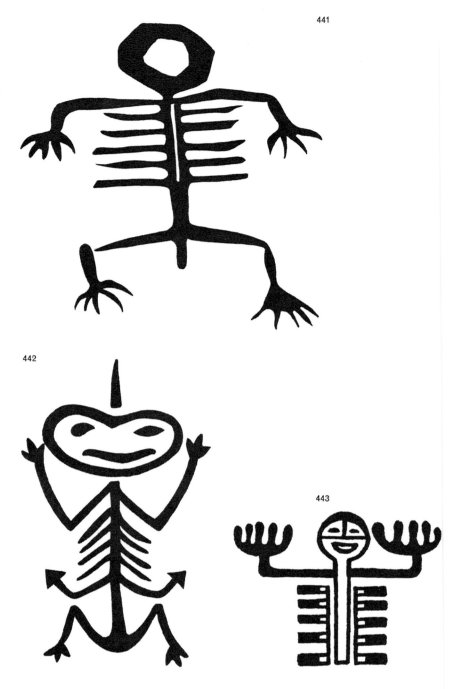

441

442

443

441. *Representation of a squatting human figure showing the rib cage. China. Yang-Shao period (2200–1700 B.C.). Vase painting.*

442. *Representation of a squatting human figure showing the rib cage. Chatham Islands, Polynesia. Tree carving.*

443. *Representation of a squatting human figure showing the rib cage. Marquesas Islands, Polynesia. Tattoo design.*

444. *Tapa loincloth, from the Lake Sentani region, western New Guinea, Melanesia. Koninklijk Instituut voor de Tropen, Amsterdam.*

292

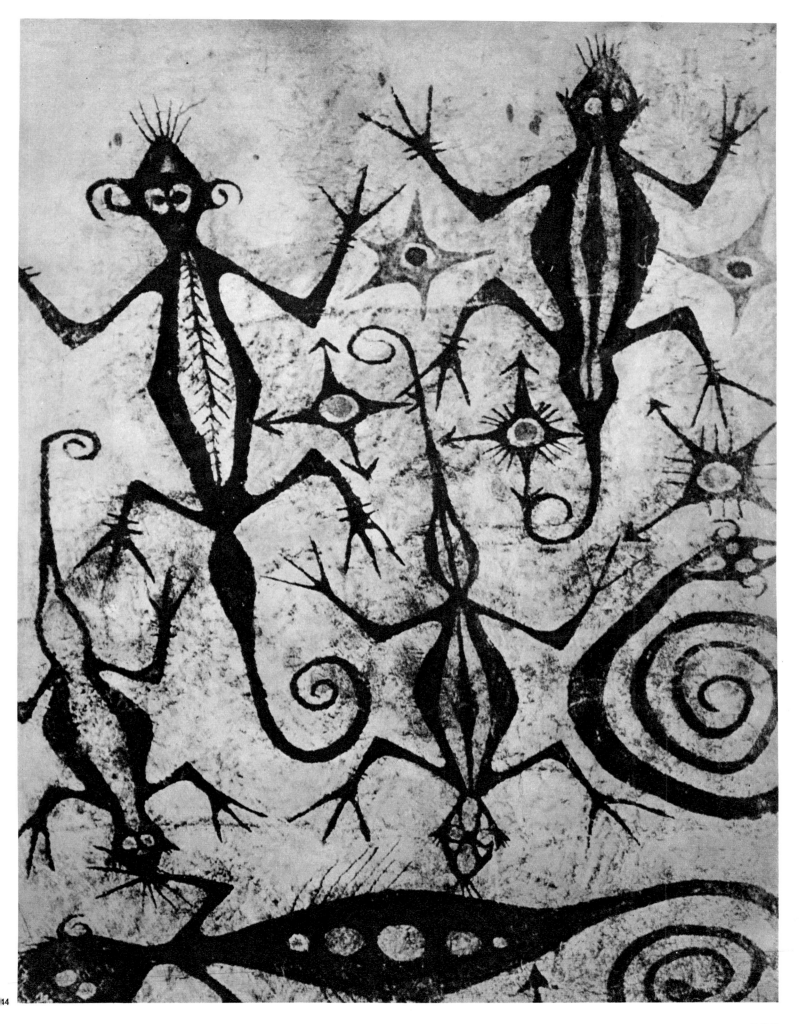

opmental series are particularly well marked on the island of Nias, where ancestral figures are represented as squatting, as seated, as standing with legs bent, and as standing with legs straight (fig. 448). This development has technical bases there; the simplification of the carved figures arises out of the need for simplifying the working process. The standing figures are often simple sticks with suggestions of faces, true abstractions of a figure in the round.

Approaches to, or a kind of reminiscence of, the squatting figure, in the form of figures with bent legs, occur in districts where no true squatting figures appear today, namely Formosa, Enggano, the Admiralty Islands, New Guinea (fig. 456), the New Hebrides, the southern Solomons, and New Caledonia, as well as northwestern America, Central America, and Peru (fig. 402).

P. H. Buck has shown the presence of this type of figure in Polynesia: New Zealand, the Marquesas (figs. 450, 451), Tahiti, Hawaii, Rarotonga, Aitutaki, Raivavé, Mangareva, Tonga, and Easter Island (fig. 452). It is the only true sculpture in the round of Polynesia. Occasionally there are stick sculptures, which are either degenerate forms, that is, excessively simplified, or, as has been suggested, are related to simple Siberian squatting-figure statues. In general, though, the plastic sense is still lively in the figures with bent legs. Fine examples can be found in eastern and central Polynesia, Rarotonga, Tahiti, New Zealand, and Hawaii. The rare small sculptures of Tonga and the Fijis are round and sculptural in feeling, whereas in places such as Aitutaki, Raivavé, Mangareva, and Easter Island an enfeeblement of the capacity for sculptural vision and form takes place.

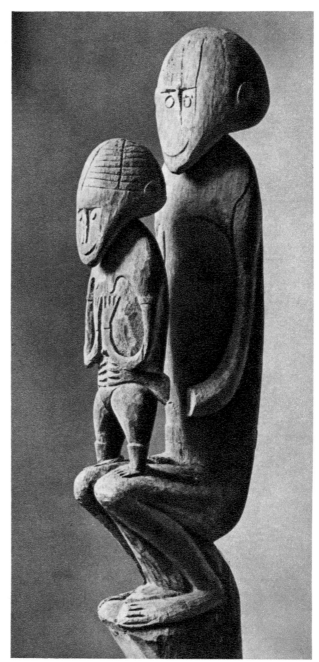

445

446

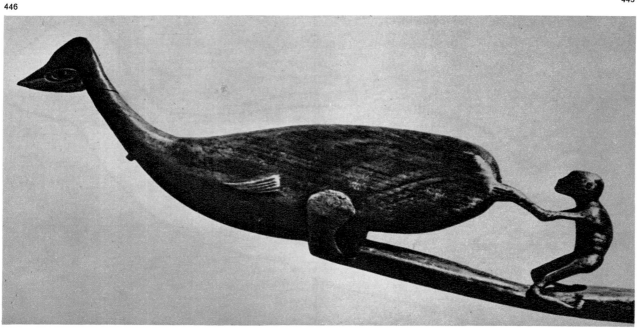

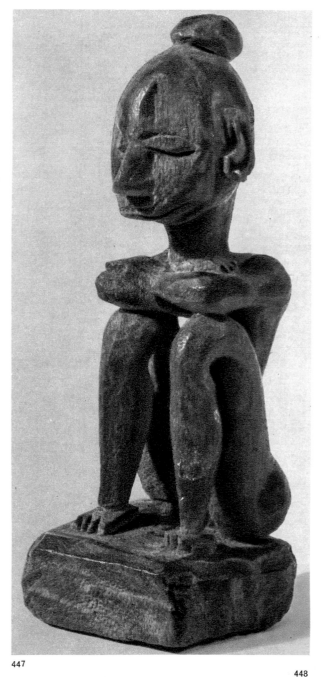

447

448

Seeing sculpturally has nothing to do with size; the gigantic stone statues of Easter Island are no exception. The trend to abstraction, however, goes hand in hand with the enfeeblement of sculptural representation, especially in eastern Polynesia and western New Guinea, as we have seen. Naturally, developments in the two regions cannot be linked logically, but only established geographically. It is not immediately evident why there are no true squatting figures in Polynesia but only derivative forms, i.e., figures with bent legs. This type of figure cannot be described as a degenerated form, nor can merely technical considerations explain it, illuminating as such an explanation would be. It is hard to carve a squatting figure from hardwood, whereas a figure with legs bent can be designed on any stick. Practical considerations of this kind are not generally applicable in Oceanic culture, where, as a rule, time and toil are no obstacles to hewing the desired form out of even the most obdurate material.

Other than technical reasons can also be given as possibly having led to this variation of the squatting-figure motif. In a report, V. J. Jansen gave a number of interpretations for the variants of squatting figures. Among the Asmat in southwestern New Guinea ancestors are depicted in wooden figures in various stages of squatting: the figures fashioned with straight limbs represent forefathers who have not yet been resurrected; those with bent legs are almost alive; true squatting figures represent men who are fully alive (fig. 449). These variations relate back to a myth that presents the story of the creator-being who came from heaven in a boat and went downstream; on the banks of the river he erected a

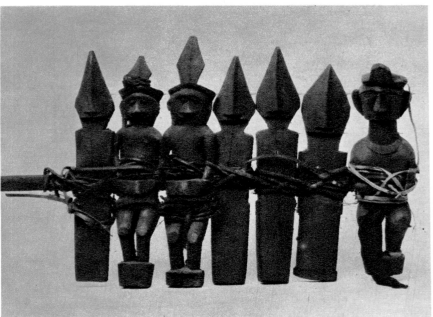

445. *Mother and child figure, from Kabiterau, Lake Sentani, western New Guinea, Melanesia. Wood, height 36 1/4". Museum für Völkerkunde, Basel.*

446. *Carved ridge pole with bird and squatting figure of a man, from Asei, Lake Sentani, western New Guinea, Melanesia. Collected 1927. Wood, length 8' 8". Museum für Völkerkunde, Basel.*

447. *Ancestor figure, from Waserili, Babar Islands, Indonesia. Museum für Völkerkunde, Munich.*

448. *A group of seven ancestor figures, from Nias, Indonesia. Wood, height 9 7/8". Museum für Völkerkunde, Munich.*

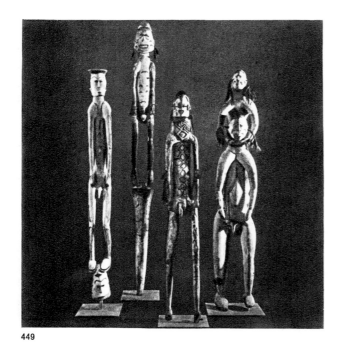

449

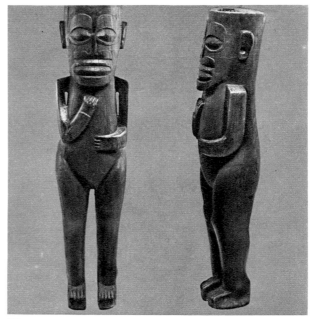

450

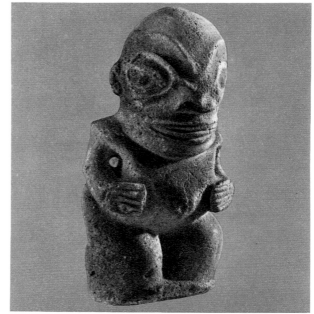

451

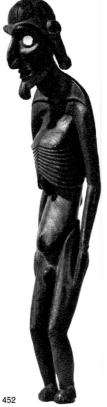

452

house and filled it with carved figures of men and women, which he waked to life by means of drum music. The various phases of this coming to life are expressed in the different stages of the squatting position.

According to this myth, the true squatting position is the sign of life. In fact, this may be the fundamental significance of the squatting-figure motif, the first and widely valid formulations of which probably came into being in China in the second millennium B.C. and spread

449. Standing male figures, from southwestern New Guinea, Melanesia. Asmat. The Museum of Primitive Art, New York. Michael C. Rockefeller Collection.

450. Ancestor figure (front and side views), from the Marquesas Islands, Polynesia. Wood, height 55 7/8". Museum für Völkerkunde, Munich.

451. Figure, from Fatu Hiva, Marquesas Islands, Polynesia. Stone, height 7 7/8". Museum für Völkerkunde, Munich.

452. Male figure, from Easter Island, Polynesia. Wood, height 18 1/8". Museum für Völkerkunde, Munich.

453. Shield showing the skull motif, from the Sepik River district, northeastern New Guinea, Melanesia. Museum für Völkerkunde, Munich.

454. Carved and painted shield, from the Era River area. Uramu territory, Gulf of Papua, New Guinea, Melanesia. Copy by K. Lommel, Koninklijk Instituut voor de Tropen, Amsterdam.

296

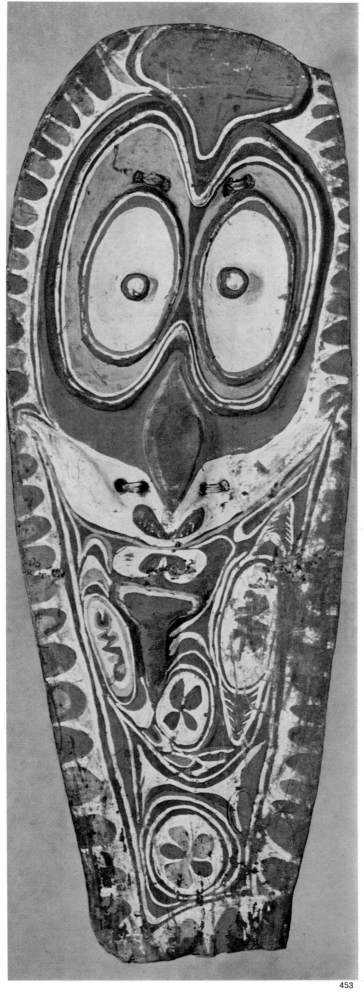

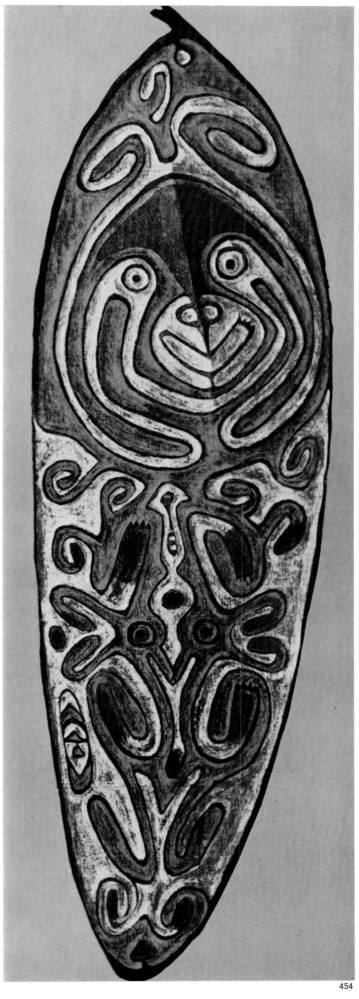

453

454

from there to the South Seas. Likewise, according to the myth, the motif with legs bent would also be a representation of being alive; probably figures shown in this position express simply the life or continued existence of ancestors. This conception seems to be connected to prehistoric, perhaps European, motifs; but it is also typical of African sculpture. Oceania also shows a deviation or further development of the motif to pure representation of motion.

It is difficult to assert that this deviation is based on a total misunderstanding of the squatting-figure motif. It is quite possible, of course, that in Oceania, and especially in Australia, a stimulus from hunter art is operative. We have seen that the only representation of motion, in a geographically limited region in northwestern Australia, can be traced back to the early hunter art of India, North Africa, and eastern Spain. In primitive art everywhere, there is an attempt to depict motion, but rarely does it go beyond a hint. Representation of motion in animals is found as early as in Ice Age art. We need only recall the horse at a full gallop in the Niaux cave; running men are frequently depicted in the prehistoric art of eastern Spain, and the style seems to have reached as far as northwestern Australia, but not to have penetrated to the interior of the continent. Profile representation of running men is encountered only in the northwestern corner of the continent; motion, including dance, almost always frontally depicted, is found on rock pictures of the southeast. Here it is clearly a derivative of the squatting-figure motif. In general, stimuli to depiction of motion arising out of the conceptual world of the hunter may still be at work here and may have been maintained as well in other regions such as Polynesia and Melanesia.

Squatting figures as representations of motion appear chiefly in the ornamentation of the Cook Islands. Stolpe refers to squatting figures and the line of dancers in the ornaments on oars in the Cook Islands (fig. 460). These lines of dancers are clearly female figures. Stolpe reported that the idea of the first man, Tiki, a widespread concept in Polynesia, is changed to a female on Mangaia. There she ranks as the sister of the first man, who now has died and receives the deceased at the threshold of the lower world. The Mangaian notion that Tiki is female probably explains the female squatting figures on the ceremonial paddles.

In a later development the dancer motif is still further reduced and abstracted, until it becomes in the end nothing more than a sort of lozenge pattern. These lozenge patterns, which appear in connection with squatting figures among the Wa in Burma as well, are the most common—almost the exclusive—motif in the Cook Islands, on both ceremonial paddles and ceremonial adzes. The line of dancers, still recognizable, is present only on the handles of these paddles; the vertical position of the squatting-figure motif in the form of the dancers on ceremonial adzes shows that they are a variant of the above-mentioned genealogical-tree motif.

In southeastern Australia, in contrast to the northwest, the squatting figures are clearly delineations of motion (paintings and engravings in western New South Wales; fig. 458). There is only a single clear-cut squatting figure in Victoria (southeastern Australia), and it is not a representation of movement. In New

Representation of Motion

Squatting figures as portrayals of motion occur mainly in the form of the so-called line of dancers. A notable example is a bark picture from the Aird River delta on the Gulf of Papua in New Guinea (figs. 455, 456). Similar dancer figures have been found on Groote Eylandt, also as decorative motifs on Choiseul Island in the Solomons (figs. 383, 385, 461). A link to the original significance of the squatting figure as ancestor is seen in the fact that the figures sawed out of tridacna shells decorate mortuary shrines serving to keep the skulls of forebears (figs. 383, 461). Profile views also appear in these carvings, and in style and workmanship show a surprising similarity to divine figures from the Cook Islands.

455, 456. Row of dancers. Aird River delta, Gulf of Papua, New Guinea, Melanesia. Painting on bark (after K. Lommel).

457. Representation of a running man. Lanai, Hawaii. Rock drawing.

458. Row of dancers. Australia. Rock painting.

459. Three figures. New Zealand. Maori. Rock picture.

460. Row of dancers. Cook Islands, Polynesia. Museum für Völkerkunde, Munich. Wood carving on an oar.

461. Row of dancers. Choiseul, Solomon Islands, Melanesia. Museum für Völkerkunde, Basel. Tridacna-shell carving.

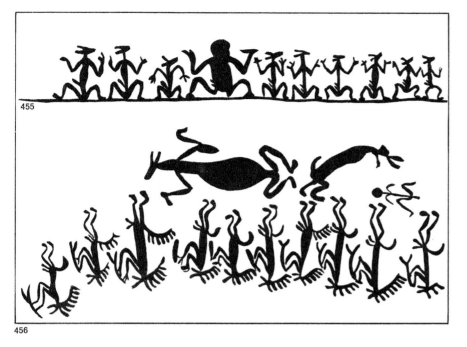

455

457

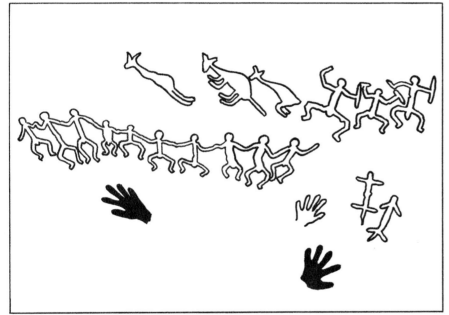

456

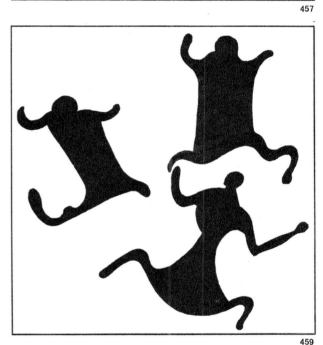

459

458

460

461

Caledonia, too, there are squatting figures representing motion, but they occur singly and in a style lacking precision. The rock paintings in southern New Zealand, insofar as they can be regarded as derivatives of the squatting-figure motif, likewise seem to be depictions of motion (fig. 459). In the art of northern New Zealand true squatting figures are very common in relief carvings, but have not been found as rock pictures. Farther into the South Seas the motif is found in Tahiti, in bamboo carvings; in the Hawaiian Islands (Lanai, fig. 457) in rock drawings; and again in America, especially in Arizona.

Profile Representations

Representations of squatting figures in profile are extremely rare, and apparently are found only in regions in which sculpture in the round is customary; they may simply be derived from sculpture. Other profile depictions of squatting figures in two-dimensional art come from New Guinea, in the Asmat region. Profile images of squatting figures occasionally occur in New Guinea (Papua), in Polynesia, in Hawaii, and on Easter Island, as well as in northern South America.

There are figures, including squatting ones, in Polynesian sculpture that permit only a profile and no frontal view. In the minor arts these profile figures are double figures, as on a fan handle from Tahiti or the Marquesas in the Museum für Völkerkunde in Munich. Small figures of this kind frequently occur in the Marquesas, and are to be found in New Guinea as well. Since the two figures are attached to each other, we are led to regard them as representations of the mythological twins.

The *Korwar*

In the western Pacific there are three further variants of the squatting figure, which are derived from a mixture with other motifs. These are the squatting figure with antlers and protruding tongue, the *korwar*, and the squatting bear. The first variation, common in Borneo, Nias, and Enggano, undoubtedly came from China; it has been treated in the studies of A. Salmony.

The second variant, essentially limited to eastern Indonesia, is the *korwar*. This is a squatting figure whose head consists of a human

skull, or into whose head a human skull has been set. In upper Burma, among the Wa, there are derivatives of squatting figures that are remarkably like the *korwar*. They represent ancestors, who have received into themselves a soul of the deceased and who continue to help their descendants. The *korwars* are the typical example of the connection between the squatting-figure and the skull motif.

In addition to simple representation, most *korwar* figures have special attributes; they hold in their hands a shield, a "balustrade" (figs. 423, 463–66), a rod, or snakes.

One variant of the *korwar* figures has the "balustrade" transformed into snake figures. Since there are also figures in which the snakes are symmetrically, or a single snake asymmetrically (fig. 466), connected with the figure, usually standing, we are led to believe, with O. Nuoffer, that the two motifs were originally linked. In and of itself the linkage of an ancestor figure with a snake motif is not surprising; it is noteworthy that even the earliest squatting figures, as on Chinese bronzes, show this connection.

Another variant of the squatting figure, appearing sporadically in almost every region in which the dominant motif occurs, is the squatting bear. This may be the earliest squatting figure, and very likely ideas as to the form and conception of squatting figures have been taken over from early hunter notions linked with the bear cult. This holds true especially for the skull and head-hunting cults, which are related to the squatting-figure conception. We may recall that in the skull worship of the Nagas the skulls of slain enemies are asked to bring their relatives, so that their skulls too can be taken. Very similar ideas are expressed in the Siberian bear cult. The oldest squatting bear depiction is found in the pre-Anyang epoch in China. Small heads suggesting bear heads are seen on a Polynesian fan handle from Tahiti. Bears superposed in the genealogical-tree form and perhaps thought of as dead forefathers, are relatively frequent on the "magic staffs" of the Batak in Sumatra (fig. 462). Squatting figures in bear form are explicit in the American Pacific Northwest, where they occur in both plastic and two-dimensional art, frontally as well as in profile.

The "rod" *korwars*, a variant of this figure, are a special form of *korwar* essentially confined to eastern Indonesia and western New Guinea. It has not yet been possible to give a satisfactory explanation of the rods that these figures hold upright in their hands. It is a striking fact that squatting figures with rods in their hands occur as reliefs in New Zealand as well; these representations are possibly reminiscences of animal

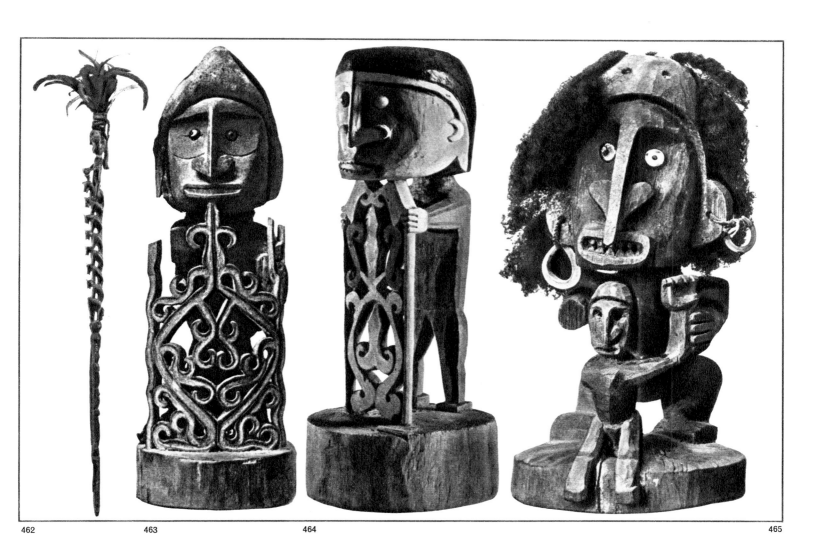

462 463 464 465

462. " Magic staff," from Sumatra, Indonesia. Toba Batak. Wood, height 60 5/8". Museum für Völkerkunde, Munich.

463. Korwar figure with arabesque shield, from Mansiman, northwestern New Guinea, Melanesia. Wood, height 12 1/4". Museum of Anthropology and Ethnology, Leningrad.

464. Korwar figure with arabesque shield, from Geelvink Bay, western New Guinea. Painted wood, height 9 1/2". Ethnographical Museum, Budapest.

465. Korwar figure with a child, from northwestern New Guinea. National Museum, Copenhagen.

301

masks. Representations of animals and imitation of four-footed animals by dancers with rods in their hands are also known among the Bushmen; rock pictures in northwest Australia can be similarly interpreted. A possible explanation for the figures with rods in their hands comes from central Australia. In initiation ceremonies the dancers with rods in their hands represent the spirits of men who have been killed and eaten; the spirits of those who have been killed look for their killers. The dancers are painted with round white spots, which represent the skulls of the slaughtered. The conclusion would be that the rod *korwar* is a combination of several ideas: the squatting ancestor figure bound up with the skull cult and head-hunting and (to judge by the central Australian example) a very old and vague notion linked to cannibalism and a residue of the skull cult.

The funeral garments of Tahiti might conceivably be a comparable artistic expression.

These garments consist essentially of large shiny flakes of mother-of-pearl, which are similar in effect to the white spots painted on the Australian dancers and may be intended to represent the same idea.

An idea as complex as the *korwar* concept is never free from ambiguity. Many examples could be cited which permit still another interpretation for the rod *korwar*: in many of them the "balustrade" or the rods have the form of an abstract man or squatting figure (fig. 430, 465). It is as though the *korwar*, which in itself is a human figure, holds out a second diminutive image of itself. The second figure may be a kind of "alter ego," or represent the future generations to be protected. With the latter idea we come back to the concept of the genealogical tree, and, in fact, there are examples in which squatting figures of this kind, with a small figure in front of them, are arranged in superposition, very clearly representing genealogical trees.

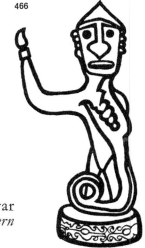

466. Drawing of an ancestor figure in korwar *style with a serpent, from Geelvink Bay, western New Guinea, Melanesia (after O. Nuoffer).*

Planar Art of the Sedentary Peoples

The squatting figure, the fundamental form of plastic representation in Oceania, is naturally not confined to sculpture; it also predominates in planar art. Interesting intermediate forms exist, in which plastic power evidently is breaking down. Profile representations are a departure from sculpture in the round; carved figures that actually can only be taken as two profiles are a sign of this development. To be sure, the change cannot be regarded as merely a phenomenon of fatigue. Ornament, for example, calls for surface representation, and the transfer to a single plane of a motif worked out for plastic depiction may be an artistic achievement. Many formulations of decorative squatting figures, particularly on the southern coast of New Guinea, indicate a long process of testing and struggle with the problem of adapting the squatting figure to planar representation. Along with successful solutions there are any number of experiments in which we can see that the artistic problem continued to involve new ventures.

The skull motif, too, was taken over into planar art, of course, where it was principally aimed at warding off evil. It is found on rock pictures, bark pictures, and shields; it is interesting to trace the evolution of the various formulations. Scenes of copulation, known as fertility representations, in which a strong Indian component is unmistakable, cannot be taken as sculptures in the round. In the Solomons and New Zealand formulations were found that must be regarded as more or less surface compositions since they permit only a side view. The planar solution on shields in southern New Guinea (figs. 471–76) must have taken place chiefly under the influence of Borneo; these images then became a permanent part of the stock of motifs and were endlessly varied and abstracted. Analyses of the ornamentation of the shields of southern New Guinea reveal the importance of this region for the final formulations of the motif, which then seem to have spread out far and wide, to Australia (figs. 477, 478) and to some extent to Polynesia.

The Squatting-Figure Image in Rock Pictures

By and large, squatting figures are the main motif in the rock pictures of the Pacific. No other predominant motif seems to have existed before the spread of the squatting figure, nor does any motif seem to have arisen later to take its place. Both painted and incised squatting figures occur. Their region of distribution begins in Ceram; extends to western New Guinea (fig. 470), northwestern and western Australia (fig. 469); and then reappears in eastern New Guinea among the Buang, in engravings in the New Hebrides, Amleitum, and New Caledonia, in paintings in southeastern Australia and New Zealand, and in engravings in the Marquesas, Hawaii, and Pitcairn and Easter Islands. In the American Pacific Northwest, in the areas of the advanced civilizations of Central America, and in South America, engravings of squatting figures are commonly found.

It is difficult to avoid comparing the rock pictures of western New Guinea with those of Australia, but the sequence of styles in Australian rock art is still too vague to permit precise comparisons. On the whole, the red-figured paintings of western New Guinea that show squatting figures, that is, the paintings of the earlier layer, are comparable to certain squatting

representations of northwestern Australia. Squatting-figure images in Australia lie between the older layer of small figures, known as the "elegant" style, and the *wondjina* style, which comes down to the present time.

The red-figured pictures of western New Guinea may be dated to about A.D. 1000; the same dating is also possible for the squatting-figure representations of northwestern Australia. The great similarity in the representations seems to indicate a relationship; the Australian squatting figures, which can best be compared with those of western New Guinea, are chiefly in the central Kimberley region, at Wonalirri, Ngungunda, and Koralyi (fig. 469). Squatting-figure images in an earlier version are found in Western Australia at Wolangkolon, Bindjibi, and Kamujoandangi and are comparable with such western New Guinea examples as rock-picture sites Fuum 2, 123; Anduir 1–4; Sora (fig. 470); and Captain Rocks. Also comparable are rock-picture sites 36; Siawacha 8–10, and 13, which offers a very good comparison with Oenpelli.

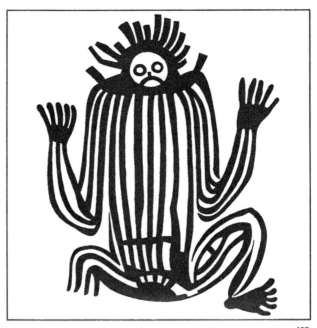

467

The "Lady of the Beasts"

In isolated instances, the motif of the "Lady of the Beasts" occurs on rock pictures and bark pictures in the Pacific region. This hunter-goddess motif, a female figure with animals, comes from western Asia and is known from classical antiquity ("Lady of the Beasts" on a Boeotian amphora, seventh century B.C., National Museum, Athens), and occurs in the Pacific in conjunction with the squatting-figure motif and the hunter X-ray style where a form of the hunter culture has been preserved, as, for example, in Northern Australia (fig. 468, color-plate) and among the Eskimos in North America.

Fertility Representations

Squatting figures are in essence ancestor images. Understandably, they are regarded as having power to ward off evil, and the idea of promoting fertility is not far removed from this, and seems to have been influenced by India. H. D. Sankalia has pointed out a variant of the squatting figure—a nude female image—that arose in western Asia and, through India, reached as far as Indonesia.

467. *Representation of a squatting figure. Rock picture at Ngungunda, central Kimberley region, Australia (after A. Lommel).*

468. *Painting on bark of the "Lady of the Beasts," from Field Island, northern Australia. Copy by K. Lommel, South Australian Museum, Adelaide.*

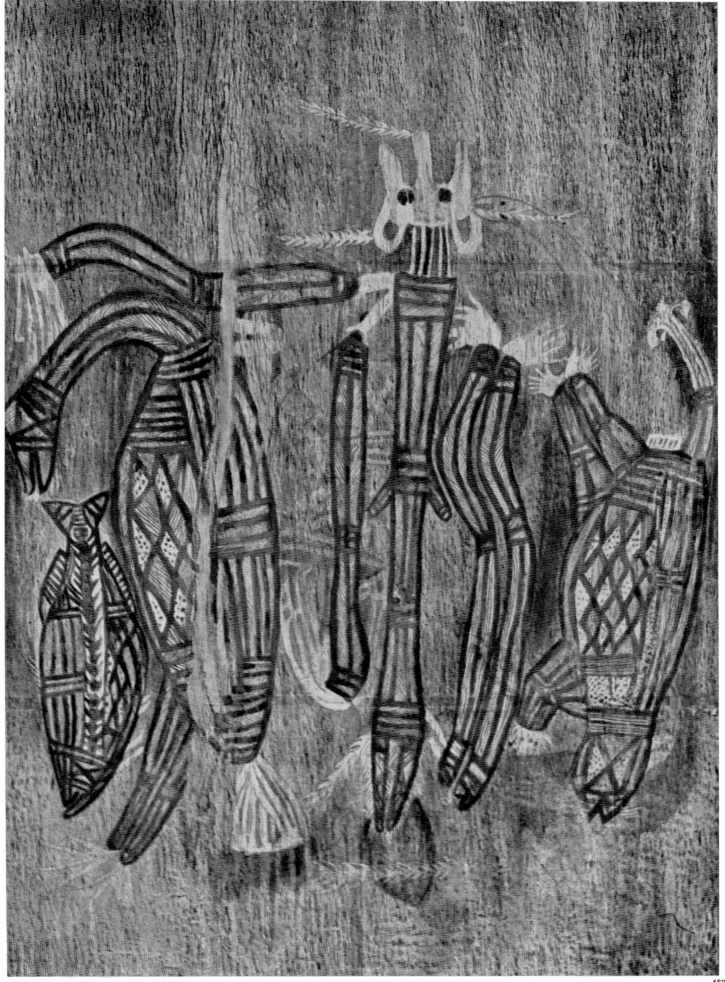

The two aspects of the squatting-figure image—ancestral figure and fertility figure—seem to meet in Borneo, where the attempt is made to combine both conceptions formally in representations of scenes of copulation. The result is groups in which the two figures are brought together in a composition in which a form with one head up and one down is produced. This formulation has its abstraction in the Chinese yang and yin symbol, and the Oceanic compositions of still recognizable animal or human figures have the same significance. The origin of the Chinese symbol is not quite clear, but probably is derived from a fish motif.

Other remarkable two-headed images of this kind are known from Borneo, from Lake Sentani in New Guinea, and from Tahiti, where the two heads are on one side. Similar two-headed images are also found in the American Pacific Northwest, in Bolivia, and, as a textile pattern, in Peru.

Clearly depicted copulation scenes are most common in southwestern New Guinean wood carvings, but are also found in Borneo and occasionally in eastern New Guinea, in northern New Zealand, and as engravings on bark in the Chatham Islands. In America they appear sporadically on rock pictures, as in Santo Domingo and Venezuela. It is relatively simple to represent such scenes in sculpture; for the most part there are two squatting figures facing each other (examples from Borneo, New Zealand, and the Solomons).

Two-dimensional representation of scenes of copulation is widespread in southwestern New Guinea, and it may be presumed that it was invented and given its definitive formulation there. The two squatting figures are stylized and placed one above the other in a design that looks at first like two doubly inward curving arcs. These were called by Davidson and other English studies, "arches"; that they in fact, represent copulation scenes is clear if we look at the rock engravings of northwestern Australia. The formulation goes back to the toad or frog images in China. There a squatting figure in conjunction with a frog is interpreted as a "son frog." Comparison with the above-mentioned creation myth of the Wa in upper Burma shows that the frog or toad counted as a primeval ancestor in the southern China–northern Annam region. In New Guinea the primeval ancestor was often represented in the form of a lizard or crocodile; this understandably led to depictions of copulation between human being and crocodile, lizard, or frog, and with advancing abstraction, to the motif of the double incurving arches, a motif to be interpreted as two squatting figures, one of them a

469

470

469. Representation of a squatting figure. Rock picture site Koralyi, northwestern Australia.

470. Representation of a squatting figure. Rock picture site 1, Sora, western New Guinea, Melanesia.

306

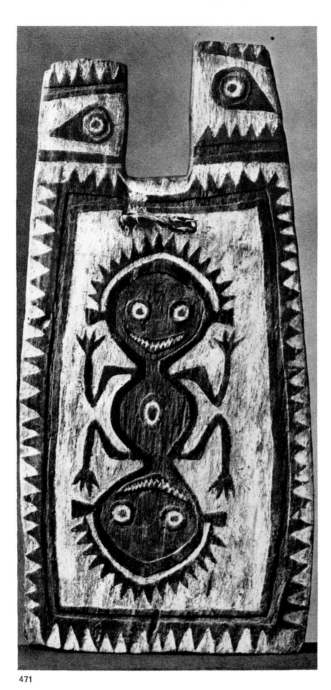

471

frog or lizard and one a human, as was common in China as early as the Yang-Shao era (2200–1700 B.C.).

The Squatting-Figure Image on Shields

In southwestern New Guinea, in the vicinity of the Lorentz River and in the Asmat region, the sculptural squatting-figure image is abstracted in many variations in two-dimensional art. Attempts were made to put the profile view of the squatting figure on a surface, but these were soon abandoned or remained isolated. The formulations that were evolved instead include the frontal "compressed" representation of the squatting figure; the frontally presented, superposed squatting figure, perhaps a resumption of the genealogical-tree motif; and the representation of fertility scenes on shields (fig. 471). Here we have the Oba River formulation in several variants. On the Northwest River the squatting-figure motif is simple and clear, sometimes appearing with profile depictions.

On the Utumba River we find, instead, rather heavy abstractions of the squatting-figure motif. In the Asmat region, on the Lorentz and Eiland rivers, there are forms in every stage of fragmentation, dissolution of the abstract new order along with simplified superpositions, which may be reminiscences of genealogical trees. Two shields from the Asmat region show progressive variations of the squatting figure: the first (fig. 473) is in an advanced state of dissolution, with the motifs all but unrecognizable; the other shield (fig. 472) can be reversed,

471. Carved and painted shield, from the Gulf of Papua, New Guinea, Melanesia. Wood, height 37 3/8". Sammlung für Völkerkunde, Burgdorf, Switzerland.

472. Drawing of a shield, from southwestern New Guinea. Asmat. Museum für Völkerkunde, Munich. Goossen Collection.

473. Drawing of a shield, from the Mapi region, southwestern New Guinea. Asmat.

472 473

474. *Drawing of a painted shield, from the Gulf of Papua, New Guinea, Melanesia. Copy by K. Lommel, Museum für Völkerkunde, Basel.*

475. *Drawing of a shield, from the Wildeman River, western New Guinea, Melanesia. Copy by K. Lommel, Museum für Völkerkunde, Basel.*

476. *Drawing of a shield, from the Gulf of Papua, New Guinea, Melanesia. British Museum, London.*

477. *Drawing of a shield, probably from Queensland, Australia.*

478. *Drawing of a shield, from the Paroo River area, Queensland, Australia.*

479. *Box for feathers (underside) with squatting figure, from New Zealand. Maori. Wood, length 22″. The Museum of Primitive Art, New York.*

that is, stood on its head and the squatting ornament remains essentially the same, except that in the correct position the arms of the figure point downward. When it is stood on its head, the arms go up. The two ornamental hooks at the top and the bottom of the shield can represent the legs in either case, and in both cases bend upward. The artists along the Wildeman River in the Mapi region have a special way of making the squatting motif (fig. 475) a dynamic one, with the figures broken up into hooks and simple squatting figures, which may well be compared with those of the Oba River. An example from the Digul River shows a geometric reduction of the motif into the empty spaces and spiral forms, which are close in feeling to the geometric ornament of Australian wooden ritual objects.

On the north coast, too, abstractions similar to those of the southwestern coast were developed. The fragmented forms on a shield from the Aitape region of northern New Guinea may readily be clarified in the drawings of two shields from the same region (figs. 486, 487). Rudimentary squatting figures can be identified as the basic forms on these shields.

Along the Sepik River and the Gulf of Papua the predominant motif is the skull; the body of the squatting figure is reduced (fig. 454, colorplate), diminished in proportions, or broken up into spiral ornaments (fig. 474). This spiral ornamentation is often abstracted into hook forms (fig. 476). On the Gulf of Papua (as at Turawa) the forms appear that become decisive for all of northern Australia: the two squatting figures are simplified into the two inward curving arcs that dominate Queensland (figs. 477, 478).

In the northeast and the center shields are decorated almost exclusively with inward curving arcs or a development of this motif; in the center it is linked with a rudimentary animal style, which was taken over from the northwest. In the southeast and the south, the inward curving arcs enter into the composition of an object with the relatively free, linear style that is customary there. In the neighborhood of the Murray River this ornament occurs again, in a less abstract form. It also seems to occur in some enclaves in the center of Western Australia.

The entire ornamental complex designated in Australia as "arches" must have originated in a formulation brought over from New Guinea. This motif is probably the source of the frequent use of arc patterns in the ornament of central Polynesia, especially Samoa. The motif recurs in South America, in forms very reminiscent of those found in southwestern Australia.

The Spiral

A widely distributed motif in Pacific art, one whose variations still occur in distant regions, is the spiral. Almost nothing definite can be stated as to its meaning. The motif is predominant as an ornament in the South Seas, but is less commonly found as the vehicle of a definite content.

In Europe the spiral appears as early as the Magdalenian period (15,000–10,000 B.C.) in southern France; a meander-like angular variant appeared in the Ukraine. In China the spiral first appears in Kansu ceramics (2000–1800 B.C.). From the Hsiao-t'un site in Anyang

479

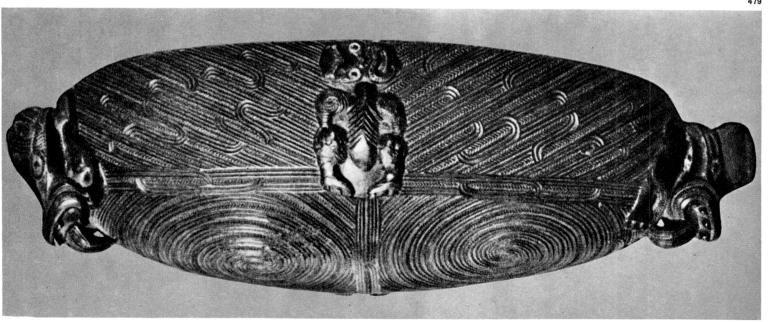

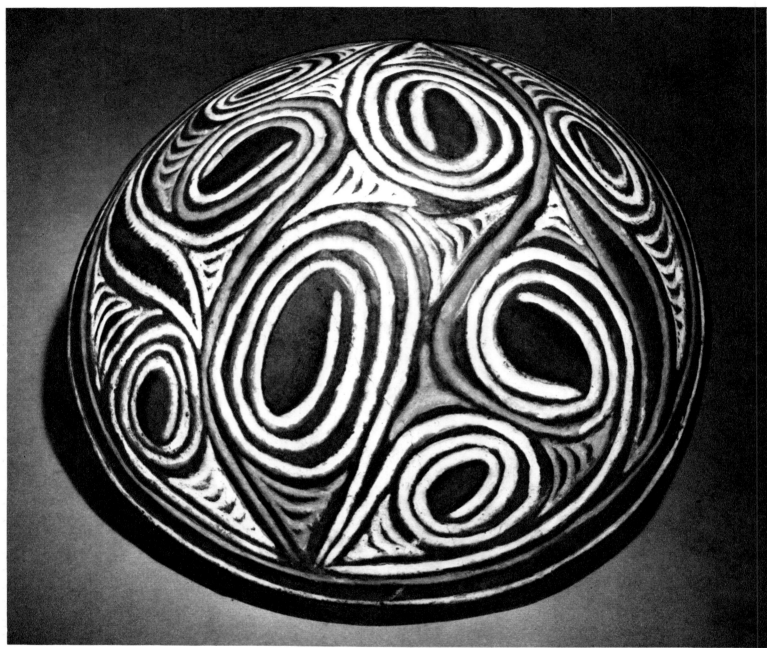

480

(2000–1050 B.C.), comes a rudimentary small squatting figure in stone ornamented with loose spirals, perhaps indicating body painting. Here two important motifs of Pacific art, the spiral and the squatting figure, are conjoined. Similar compositions are to be found in the art of New Guinea, New Zealand (fig. 479), and the Marquesas.

Thereafter the spiral is frequently encountered in Shang China (1500–1028 B.C.) and in the Chou period (1027–256 B.C.), where especially after 600 B.C., it becomes the dominant ornament in many variants under the influence of the art of the nomads of Central Asia. Many of these variations worked out in the late Chou period in China are believed to recur in the ornament of Borneo, eastern Indonesia, New Guinea, northern New Zealand, the Marquesas, and Central America. Recent research into the

480. Incised clay bowl, from the Sepik River district, northeastern New Guinea, Melanesia. Diameter 10 1/4". Museum für Völkerkunde, Munich.

481. Bas-relief with a double figure, from New Zealand. Maori. New Zealand Embassy, Washington, D.C.

310

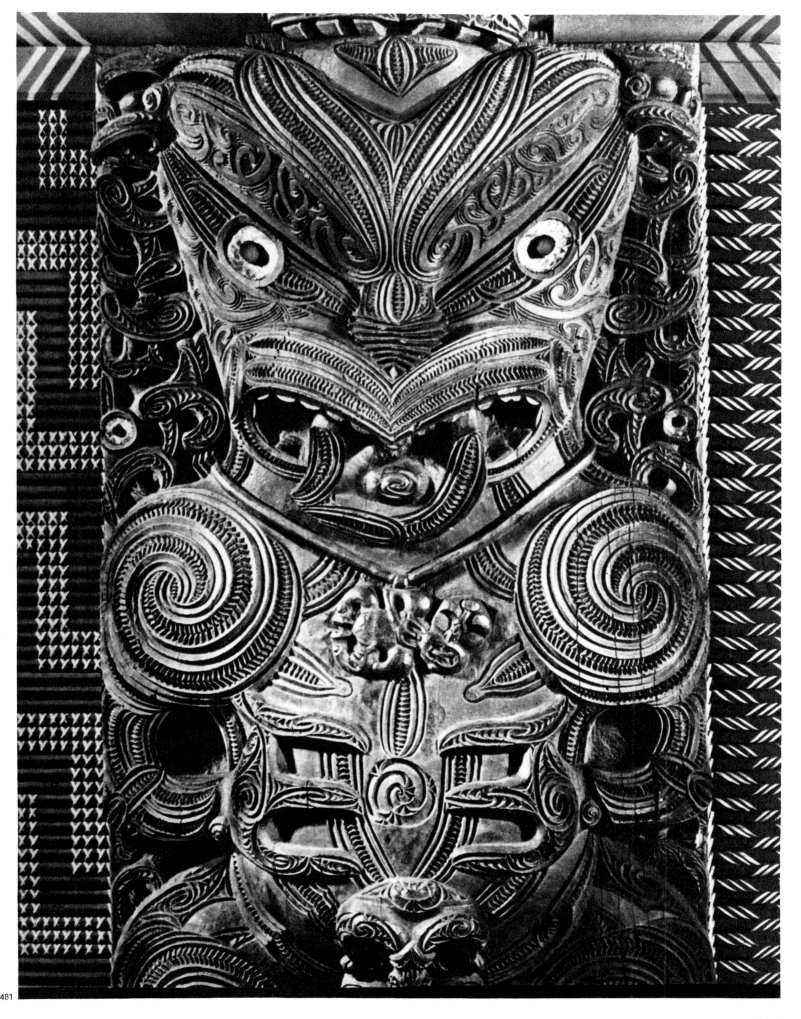

history of the settlement of Polynesia has established the date of 200 B.C. for the Marquesas, making a Chou influence possible, at least so far as the time is concerned.

Simple spiral forms came from China through Indochina and Indonesia to New Guinea (fig. 480). This dispersion is generally connected with the Dong-Son culture (300 B.C.); a bronze adze found on the Indonesian island of Roti is taken to be a key find for tracing this motif.

In the distribution of the spiral from China outward into Oceania, two forms are to be distinguished: a widespread simple spiral form that can be referred back to the Dong-Son culture of Southeast Asia and a complicated spiral, found especially in the Marquesas (fig. 484), that should be traced to comparable forms of the late Chou period in China. The decoration of many wooden bowls and paddles is directly comparable with Chinese forms of the late Chou, formerly known as the Huai style. The dating of the first settlement of the Marquesas to the second century B.C. makes this relationship more probable than was formerly hypothesized. To a certain extent the spiral in Australian art as well could be linked with the diffusion of the Dong-Son culture, but we have seen that Australian ornament derived from the spiral is older in origin.

In the rest of Oceania pure spiral ornament is relatively rare. We have already mentioned its occurrence in northern and eastern New Guinea; it predominates in the ornament of northern New Zealand (figs. 481, 482). Spirals are present in New Caledonia as rock engravings; in the Marquesas a characteristic ornament was developed out of spiral forms.

Possibly, lozenge patterns in the braided ornament of central Polynesia are also derived from concentric lozenges, that is, concentric circles converted into angular form, and hence are derivatives of the spiral. The nature of the material—braids—would then explain the variant.

In the same way, the meander forms are to be regarded as spirals carried over into another material, either braided work or textiles. This

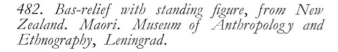

482. Bas-relief with standing figure, from New Zealand. Maori. Museum of Anthropology and Ethnography, Leningrad.

483. Vase in the form of a human head, from Paracas, Peru. Terra cotta painted after firing, height 8 5/8". Museum für Völkerkunde, Munich. 482

312

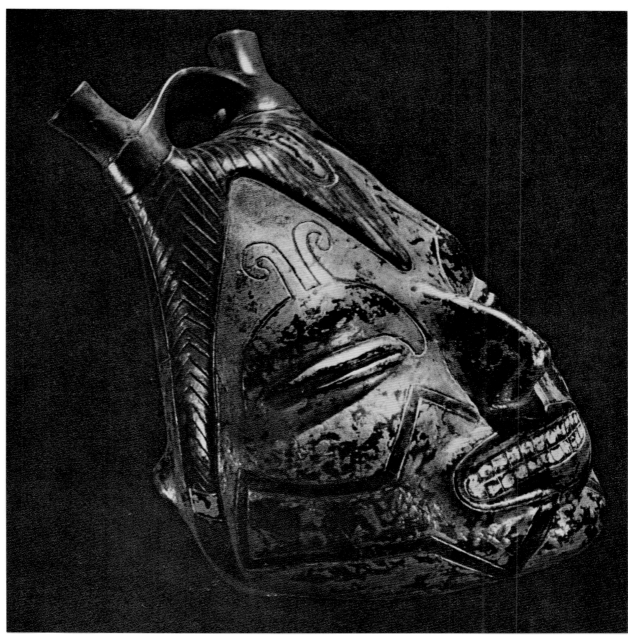

483

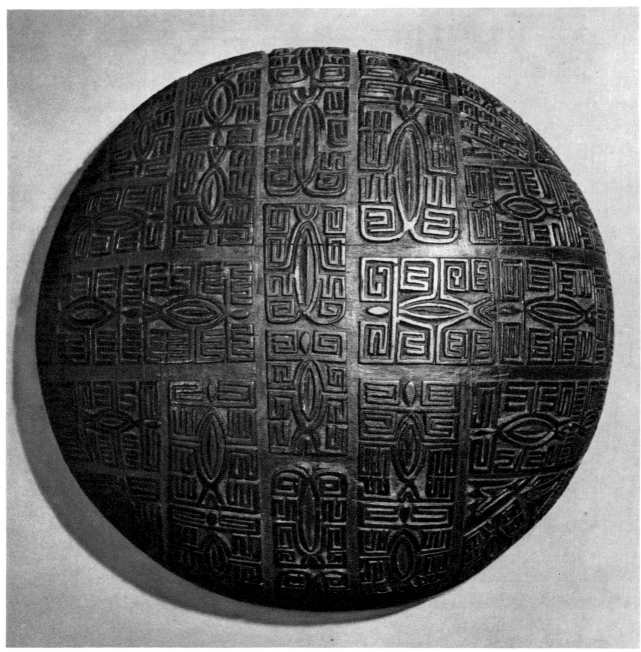

484

485

484. *Bowl with low relief carving, from the Marquesas Islands, Polynesia. Wood, diameter 9 1/2". Museum für Völkerkunde, Munich.*

485. *Shield from the hinterland of Berlinhafen, northeastern New Guinea, Melanesia. Copy by K. Lommel, Museum für Völkerkunde, Vienna.*

486, 487. *Drawings of shields from the hinterland of Berlinhafen, northeastern New Guinea, Melanesia.*

488. *Spirals in Old Bering Sea style, Alaska (after M. Covarrubias).*

487 486

488

may explain why, by and large, meander forms are found only where weaving is practiced (e.g., in China and Central America); clear-cut meander forms are extremely rare in Oceania and seem to occur only in braiding, whereas the spiral has held its ground. When the spiral degenerates, it does not become angular but turns into concentric circles. Many examples of this are to be found in the art of Australia and of the Eskimos.

In North America spiral forms occur in Alaska in the Old Bering Sea Style at about the beginning of our era (fig. 488). This style led to the derivatives of the Punuk period (about A.D. 1000) and finally to the simple circle and point forms of present-day Eskimo art. Clear-cut spiral forms are found in North America, first of all in the Hopewell culture in Ohio (A.D. 500), in the Swift Creek period in Florida (A.D. 500) and the Anasazi culture in the Southwest (A.D. 500-1200), as well as in the Mississippi period in Louisiana (A.D. 1000-1300) and the Caddoan style (A.D. 1400-1700) in Arkansas. Spiral ornamentation among the Naskap retained derivatives of spirals until the eighteenth century. In Central America spiral forms occur in Guerrero, Cholula, and Oaxaca; very strongly marked spiral forms are found on Santo Domingo. In South America spiral motifs very reminiscent of forms of the late Chou in China appear in the Chavin period in Peru (700 B.C.) and are also common in the Mochica period of Peru (A.D. 400-900). In the rest of South America, the Marajo region of the Amazon Delta is known for the manifold use of spiral forms, which apparently spread from there to Guiana and southward along the eastern coast. Very clear-cut spiral forms are still found among the Cadduveo in the Chaco region.

Conclusion

The Present

In the foregoing survey of the art of the Pacific region, the development of that art has been treated from its origins down to a point at which the development comes to an end. This point is not the age of the discoveries, but much closer to the present. But there is no mistaking the fact that the art of the South Seas is dead and has lingered in survivals in only a few places. To complete our survey, it is necessary to give an account of these survivals into the present.

They are found chiefly in Australia and New Guinea. Traditional art has also survived in marginal regions of the South Seas, in Bali, on Sumatra, Nias, the Moluccas, to some extent in the Philippines; there are some residues among the Eskimos; but the northwestern American tribes are no longer active artistically, nor are the advanced cultures of Central and South America, where a colonial culture not related to the Pacific culture existed for several hundred years.

In Australia, the art of the rock pictures has long since died out, unless, of course, the method of freshening old pictures for ritual purposes is to be called a living art. There are examples of such repainting from as late as 1953–54. On the other hand, the art of bark painting is still alive in northern Australia, is slowly working its way out of its traditional limitations, and emerging as a modern decorative art financed by tourists, collectors, and missionaries. Undoubtedly, this kind of bark picture reaches a high quality. The native art of Australia could have made its connection with the art of the modern world in the person of Albert Namatjira, who died in 1959. This central Australian native painted landscapes that were exhibited in Sydney and brought a good price in the art markets of the world. He had his whole family engaged in painting, but he was not regarded as an "Australian";

he remained a "native." In any event, he showed a way for the artistic gifts of the natives to enter into the present and present-day art.

In New Guinea the traditional art of the natives is still alive in many places, as is proved by the photographs that Saulnier published in 1950 of carved and painted shields and tall, carved sacrificial poles. The artistically productive region of the Sepik Valley has also kept its power down to very recent times. It is only today that collapse and artistic decline have set in, but there may still be many smaller centers in which the art of former days still flourishes.

The New Hebrides are also noteworthy in this respect. The famous tree-fern figures seem to have suddenly awakened to new life. Obviously under European stimulation and probably using European tools, figures in the old style, with, it must be admitted, a small admixture of Picasso, are produced and sold. Although these figures no longer have any connection with the ritual life of the islands, from the formal point of view they are art works and prove the will of this art region to remain alive.

The same can hardly be said of the rest of Melanesia, and still less so of Polynesia. Wood carvings in traditional style are still made on Easter Island. The sinister aspect of the early work has disappeared and a certain delight in the macabre has remained as the characteristic feature. This resumption of the traditional was done quite consciously; the art of Easter Island was dead and there was a period in which copies of art objects were brought to Easter Island to be reworked there and then sold as authentic.

489. Ancestor figures, from New Britain. Painted wood, height 31 1/2". Museum für Völkerkunde, Munich.

318

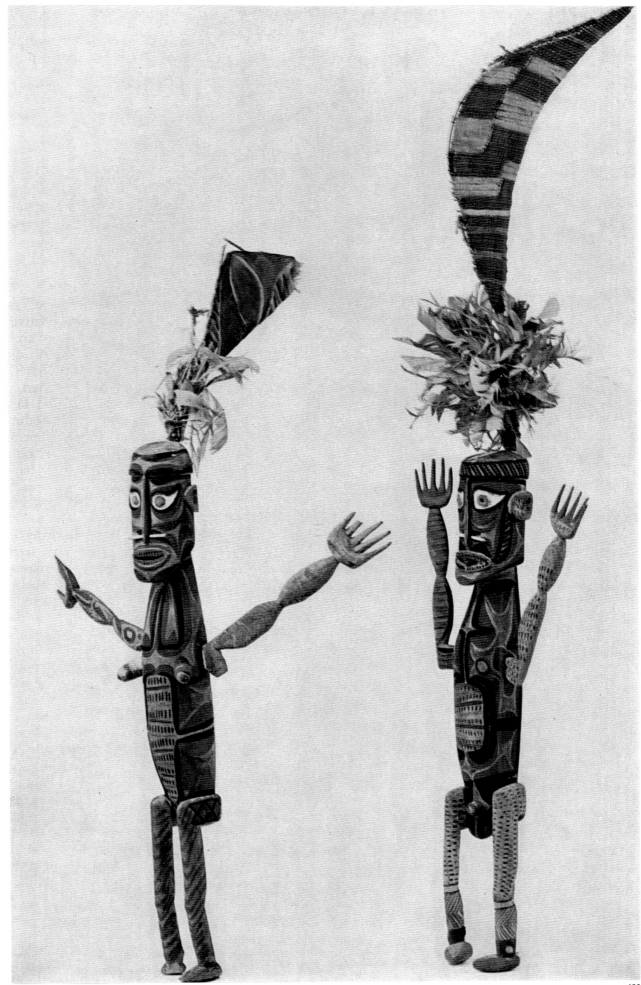

Notes

AFRICAN ART

1 Both Gauguin and Ensor had earlier become familiar with primitive masks; but their references to this form were of a different order from that which we see in Fauvist, Expressionist, and Cubist art. It is likely, however, that Ensor first brought primitive art to the attention of one or more of the German artists.

2 See Peter Selz, *German Expressionist Painting* (Berkeley, 1957), p. 83 and note 66. It appears that Kirchner may have discovered both African and Oceanic arts before these were noticed in Paris by Vlaminck, Derain, and other Fauves.

3 Compare Robert J. Goldwater's introduction to *Traditional Art of the African Nations* (New York, 1961). Goldwater's *Primitivism in Modern Painting* (New York and London, 1938), is indispensable reading for its résumé of the literature of artistic and ethnological thought about this problem.

4 See William Fagg, Introduction, "The Study of African Art," *Allen Memorial Art Museum Bulletin*, XIII (1955-56), 44-61 (especially p. 44).

5 Meyer Schapiro in his extraordinary article, "Style," in *Anthropology Today*, A. L. Kroeber, ed.; (rev. ed.; Chicago, 1962), discusses with great sensitivity many problems affecting the analysis of primitive and other once little-known arts which bear on this point.

6 Roger Fry in the section on Negro art of his work *Vision and Design* (London, 1920), says more about African sculpture in a very few pages than do many writers, scientific or not, who devote multiple volumes to the subject.

7 Paul Guillaume and Thomas Munro, in *Primitive Negro Sculpture* (London and New York, 1926), discuss the possible confusing of aesthetic with ethnological values if the art itself is lost sight of in favor of the latter. Theirs is one of the important earlier aesthetic writings on its subject.

8 Goldwater (1938), Bibliography (section on "The Evaluation of the Art of Primitive Peoples") is useful as a basic reference to much of this literature.

9 *Masques dogons* (Paris, 1938); *Arts de l'Afrique noire* (Paris, 1947), trans. as *Folk Art of Black Africa* (New York, 1950).

10 See various notes following, and individual entries in Bibliography.

11 Von Sydow's last and most comprehensive work, published posthumously with notes by Gerd Kutscher, was *Afrikanische Plastik* (New York, 1954).

12 Kjersmeier's *Centres de style de la sculpture nègre africaine* (4 vols.; Paris, 1935-38), is among the greatest works in its field.

13 See works cited in Bibliography. Goldwater's very important study of 1938 has already been mentioned.

14 His *Primitive Art: Its Traditions and Styles* (New York, 1962), accords even greater attention to the importance of tribal sociological origins of art than does the earlier study.

15 *African Negro Art* (New York, 1935), written in connection with an important exhibition supervised by Sweeney at the Museum of Modern Art in New York; and, with Paul Radin, *African Folktales and Sculpture* (New York, 1952).

16 Among the worthwhile contributions of this group is Chapter I (on Africa) in Douglas Fraser's *Primitive Art* (Garden City, N. Y., 1962).

17 See William Fagg in Eliot Elisofon and William Fagg, *The Sculpture of Africa* (New York, 1958), pp. 58-59 and in the *Allen Memorial Art Museum Bulletin* (XIII), especially pp. 50-51.

18 A detailed listing of African woods (specifically those of the Congo but many of which occur elsewhere in Africa) appears in G. Delevoy, "Le Congo forestier," and E. de Wildeman, "Les Forêts congolaises," *Ency-*

clopédie du Congo Belge, fasc. XIII. Indigenous names of trees are also given.

[19] This was reported by Émile Torday and T. A. Joyce, *Les Bushongo* (Tervueren, 1910).

[20] Widely experienced curators of this art are sometimes puzzled by such comparisons. Strong interchanges of influence, probably the result of individual contacts between sculptors from the respective tribes rather than from some diffuse set of intertribal cultural phenomena, are evident.

[21] Compare Wingert (1950), pp. 10-11; Fagg, in Elisofon and Fagg (1958), pp. 27-29 and notes to the accompanying plates; and Fraser (1962), pp. 46-48 and 84 ff.

[22] As by Wingert (1950), map and pp. 26-28; and (1962), pp. 106-7.

[23] There are still a number of Yoruba artists who, as descendants of generations of distinguished sculptors, produce a reasonably strong art; but commercialism has made serious inroads, as have certain efforts to train indigenous artists in a European aesthetic. See H. Ulli Beier, *Art in Nigeria 1960* (London, 1960), for comment on trends.

[24] Roy Sieber has reported on one such area in his *Sculpture of Northern Nigeria* (New York, 1961).

[25] William Fagg, in Elisofon and Fagg (1958), pp. 24-25, thoughtfully relates the exponential curve of such elements as antelopes' horns and boars' tusks to African ideas of increase, noting that tribal sculptors do not possess a scientific knowledge of exponential coordinates. It is well to observe here, however, that other types of curves as well appear in African sculpture. Moreover, one of the most amazing adaptations of the exponential curve may be seen in seventh- and eighth-century Hiberno-Saxon manuscript illuminations. These works having been produced by monastic artists, one trusts that the institution of increase was only hypothetically attendant.

[26] There is, for example, one such specimen six feet in height in the Museum of Primitive Art, New York (Number 58.328). Illustrated in Goldwater (ed.), *Sculpture from Three African Tribes* (New York, 1961).

[27] A concise but informative account of various purposes of masks is found in the introduction by A. D. Tushingham to the Royal Ontario Museum catalogue, *Masks: The Many Faces of Man* (Toronto, 1960).

[28] Marcel Griaule's *Masques dogons* is the basic work on this subject.

[29] See note 25.

[30] *African Tribal Sculpture* (Philadelphia, 1956), p. 18. The bird's tail corresponds to the long snout of a crocodile, and between the terminals of the wings is a form suggesting either a human forehead and nose or a crocodile's orbital structure.

[31] *Centres de style*, p. 22.

[32] As by Wingert (1950), map and p. 18.

[33] Dr. George W. Harley's field studies should be consulted for information about this provenience: *Notes on the Poro in Liberia* (Cambridge, Mass., 1941), and *Masks as Agents of Social Control in Northeast Liberia*, (Cambridge, Mass., 1950). See also P. J. L. Vandenhoute, *Classification stylistique du masque Dan et Guéré de la côte d'Ivoire occidentale* (Leiden, 1948).

[34] Some Dan-Ngere masks with twisted features may have been worn for apotropaic purposes. Gangosa, an advanced stage of yaws which destroys the membranes of the upper lip and nose, was known on the Guinea Coast though it was more widespread farther south and east. See Donald C. Simmons, " The Depiction of Gangosa on Efik-Ibibio Masks," *Man*, LVII (1957), 18, and Harley (1950), p. 34. Gangosa means " muffled voice " in Spanish.

[35] A generally similar specimen, though perhaps of Mendi origin, is fitted with a voluminous skirt of raffia (gift of The Honorable and Mrs. G. Mennen Williams to Oakland University, Rochester, Mich.).

[36] Interesting commentaries are given by T. A. Joyce, " Steatite Figures from West Africa in the British Museum," *Man*, V (1905); and W. Addison, " The Nomori of Sierra Leone," *Antiquity*, VIII (1934), 335-38.

[37] This connection has also been observed by Fraser (1962), p. 94.

[38] See B. Holas, " Note sur le fonction de deux catégories des statues sénoufo," *Artibus Asiae*, XX (1957), and the brief but instructive notes in the Museum of Primitive Art (New York) catalogue, *Senufo Sculpture from West Africa* (New York, 1963).

[39] Close examination of smaller elements of the *kpélié* mask discloses unmistakable similarities to lesser accents in the faces of Picasso's 1906-7 works, although the total form of that mask does not remind us of whole paintings by Picasso.

[40] There is an extensive literature on these people. Among many other rewarding studies are those by C. T. Shaw, " Archaeology in the Gold Coast," *African Studies*, II (1943), 139-47; Eva L. R. Meyerowitz, " Some Gold, Bronze and Brass Objects from Ashanti, " *Burlington Magazine*, LXXXVI (1947), 18-21; R. Zeller, *Die Goldgewichte von Asante*, (Baessler Archiv III, 1912); and, among works by R. S. Rattray, *Religion and Art in Ashanti* (Oxford, 1927). Carl Kjersmeier has also written on the gold weights (1948).

[41] For example, Baoule metalwork and Yoruba " twin " figures, or the smallest and least sophisticated of Nigerian bronzes.

[42] An outstanding work on this area is that of Melville J. Herskovits, *Dahomey* (2 vols.; New York, 1938).

[43] Carbon-14 dates for the organic matter found near terra-cotta heads in tin-mine deposits, though not yet conclusive, suggest an antiquity of over 2,500 years (or around 500 B.C. or earlier) for the first art of this region. These heads, some of them parts of figures, were produced by an ancient people known as the Nok who lived in the Benue River Valley north of the central location of the Ife, Bini, and most Yoruba tribes. For a discussion of the age of the Nok sculptures and their possible relevance to the later art of

other Nigerian tribes, see Fagg in Elisofon and Fagg (1958), pp. 56-66. The older schema for the chronology of the metal art of this area, particularly that of the Bini, was developed by Felix von Luschan, *Die Altertümer von Benin* (3 vols.; Berlin, 1919), as interpreted by Struck, "Chronologie der Benin-Altertümer," *Zeitschrift für Ethnologie*, LV (1923), 113-66.

44 The Ife are discussed by Frobenius in *The Voice of Africa* (2 vols.; 1913). See also Leon Underwood, *Bronzes of West Africa* (London, 1949).

45 See Ulli Beier (1960), and *The Story of Sacred Woodcarvings from a Small Yoruba Town* (*Nigeria Magazine*, special issue, 1957).

46 The reproduced work is said to have been taken in 1898 from the Yoruba royal palace where it had served as a guardian figure.

47 *Primitive Art: Its Traditions and Styles* (1962), p. 127.

48 There is a rich literature on the general culture and the art of the Congo. Here are mentioned only a few outstanding writings: Frans Olbrechts, *Les Arts plastiques du Congo Belge* (Antwerp, 1959; Trans. from his *Plastiek van Kongo*); Paul S. Wingert (1950), chs. 4 and 5; Guenter Tessman, *Die Pangwe* (2 vols.; Berlin, 1913); Émile Torday and T. A. Joyce (1910); Joseph Maes, *Aniota-Kifwebe* (Antwerp, 1924), and, with Olga Boone, *Peuplades du Congo Belge* (Tervueren, 1935).

49 Otto Nuoffer illustrates a variety of Congo works on this theme and adds photographs of actual mothers and children in their habitat in *Afrikanische Plastik in der Gestaltung von Mutter und Kind* (Dresden, 1925). See especially Plates 1-12.

50 These have been studied by R. Hottot, "Teke Fetishes," *Journal of the Royal Anthropological Institute*, LXXXVI (1956).

51 See Hans Himmelheber, "Les masques bayaka et leurs sculpteurs," *Brousse*, I (1939), 19 ff. An early report on the culture of this group was made by Torday and Joyce, "Notes on the Ethnography of the Bayaka," *Journal of the Royal Anthropological Institute*, XXXVI (1906), 39-59.

52 See Maes and Boone (1935); Olbrechts (1959); Torday and Joyce (1910); Wingert (1950), pp. 60-66, and (1962), pp. 152-66; Fagg, in Elisofon and Fagg (1958), pp. 155-60; and Leon Kochnitzky, *Negro Art in Belgian Congo* (New York, 1958).

53 See Joseph Maes, *Aniota-Kifwebe* (Antwerp, 1924).

54 An older study, still widely referred to, is R. P. Collé, *Les Baluba* (2 vols.; Brussels, 1913). See also W. F. P. Burton, "The Secret Societies of Lubaland," *Bantu Studies*, IV (1930), 217-50.

55 A popular article, valuable for its handsome color photographs of Angola tribespeople and landscape, is by Volkmar Wentzel, "Angola, Unknown Africa," *National Geographic*, CXX (1961), 347-83.

56 Balega (or, without the optional prefix Ba, meaning "people," simply Lega) is the designation now preferred by many ethnologists for the Warega.

THE ART OF THE NORTH AMERICAN INDIAN

1 It goes without saying that there are exceptions to this rule, but they are not numerous. Such penetrating art-historical works as Paul Wingert's on specific areas of Northwest Pacific American art are rare indeed. See Wingert, *American Indian Sculpture: A Study of the Northwest Coast* (New York, 1949); and *Prehistoric Stone Sculpture of the Pacific Northwest* (Portland, Ore., 1952).

2 The Museum of Modern Art in New York, held an especially important Indian exhibition in 1941 which resulted in the publication of *Indian Art of the United States* by Frederic H. Douglas and René d'Harnoncourt, one of the finest of general works in this field. An exceptionally fine collection of Northwest Coast art was organized by Professor Erna Gunther of the University of Washington for exposition at the Seattle World's Fair of 1962, and a number of similar showings have been held by university galleries. Few of these, however, have shown a full scope of tribal arts.

3 *Indian Art in America* (Greenwich, Conn., 1961), p. 30.

4 This is by no means unique with American Indian art. We refer to Greek "painting" or "drawing" largely on the basis of painted vases; and ceramic sculpture, one of the greatest of American Indian contributions to primitive art, was also a distinctive art form among Classical and Renaissance artists.

5 Ethnological and/or archaeological cultural divisions and subdivisions usually specify additional regions called, for example, the Oasis, the Great Basin, the Prairies, and various arctic and subarctic zones. However, artistic styles do not always accomodate such topographical designations.

6 See note 4. We distinguish between ceramic objects which are either primarily decorative or functional and those which clearly possess painterly or sculptural form as such. It should be noted, of course, that routine vessels, as much as aesthetically valid ones, have been valuable to the archaeologist in establishing typological series leading to the dating of certain cultures.

7 *Ibid.*

8 Some handcrafts, however, have a notable distinction and lengthy tradition in California. This is especially true of weaving.

9 The Canaliños—a term used by many contemporary archaeologists to define the Fernandino and Gabrielino Indians, as well as the Chumash—were reported by Rodriguez Cabrillo in the 1540s; but widespread Spanish settlement did not take place in the Chumash region until much later. The Canaliños are known to have continued their art of carving during the early years of colonization; but European diseases, among other effects occasioned by white trading and missionizing, quickly reduced the effectiveness of these Indians.

10 The problem of Indian origin and antiquity is engagingly and concisely discussed by Harold E. Driver, *Indians of North America* (Chicago, 1961), pp. 1-11. For specialized studies, see also W. W. Crook and R. K. Harris, "A Pleistocene Campsite near Lewisville, Texas,"

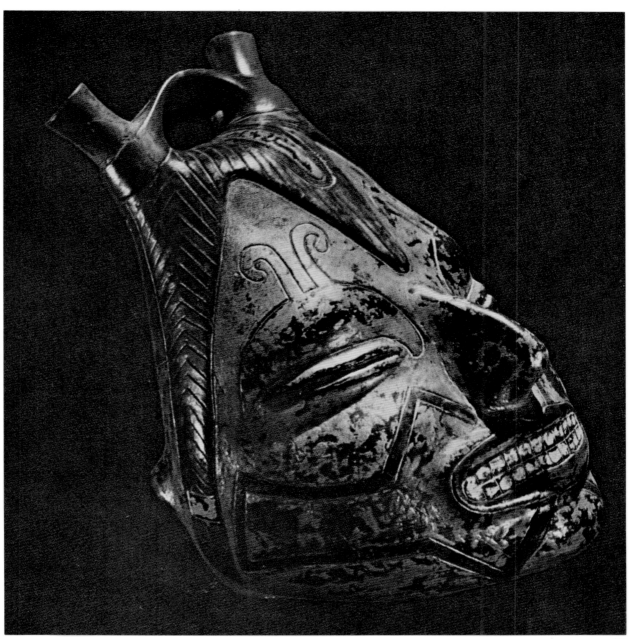

483

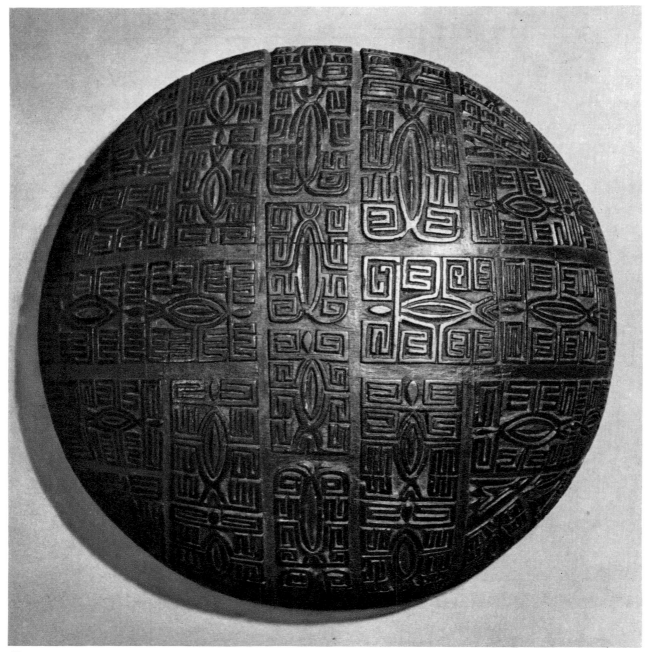

484

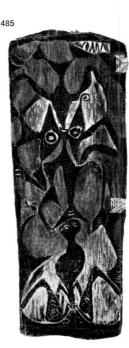

485

484. Bowl with low relief carving, from the Marquesas Islands, Polynesia. Wood, diameter 9 1/2". Museum für Völkerkunde, Munich.

485. Shield from the hinterland of Berlinhafen, northeastern New Guinea, Melanesia. Copy by K. Lommel, Museum für Völkerkunde, Vienna.

486, 487. Drawings of shields from the hinterland of Berlinhafen, northeastern New Guinea, Melanesia.

488. Spirals in Old Bering Sea style, Alaska (after M. Covarrubias).

314

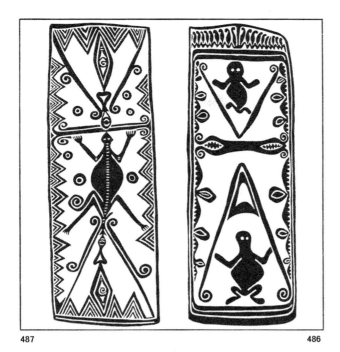

487 486

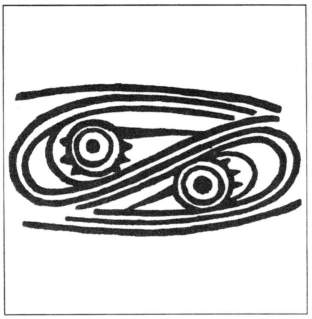

488

may explain why, by and large, meander forms are found only where weaving is practiced (e.g., in China and Central America); clear-cut meander forms are extremely rare in Oceania and seem to occur only in braiding, whereas the spiral has held its ground. When the spiral degenerates, it does not become angular but turns into concentric circles. Many examples of this are to be found in the art of Australia and of the Eskimos.

In North America spiral forms occur in Alaska in the Old Bering Sea Style at about the beginning of our era (fig. 488). This style led to the derivatives of the Punuk period (about A.D. 1000) and finally to the simple circle and point forms of present-day Eskimo art. Clear-cut spiral forms are found in North America, first of all in the Hopewell culture in Ohio (A.D. 500), in the Swift Creek period in Florida (A.D. 500) and the Anasazi culture in the Southwest (A.D. 500-1200), as well as in the Mississippi period in Louisiana (A.D. 1000-1300) and the Caddoan style (A.D. 1400-1700) in Arkansas. Spiral ornamentation among the Naskap retained derivatives of spirals until the eighteenth century. In Central America spiral forms occur in Guerrero, Cholula, and Oaxaca; very strongly marked spiral forms are found on Santo Domingo. In South America spiral motifs very reminiscent of forms of the late Chou in China appear in the Chavin period in Peru (700 B.C.) and are also common in the Mochica period of Peru (A.D. 400-900). In the rest of South America, the Marajo region of the Amazon Delta is known for the manifold use of spiral forms, which apparently spread from there to Guiana and southward along the eastern coast. Very clear-cut spiral forms are still found among the Cadduveo in the Chaco region.

315

Conclusion

It is not customary to make a survey of the art of the regions of the Pacific in terms of the distribution of definite motifs and their derivatives, but, as we have seen, doing so can lead to certain conclusions that are readily understood and are therefore convincing. Besides the motifs we have discussed there are of course others, for example, the "joint marks" exhaustively treated by C. Schuster. Such a motif, however, is more ethnographic than artistic in character, and in fact need not even be explored here, since Schuster has already dealt with it in full; its distribution simply confirms what the distribution of the other motifs has already shown. Consideration of the art of a given region with respect to its motifs gives us a clear picture of the area's art history more easily than does any other form of investigation. As we have seen, all the art forms and artistic phenomena of Oceania can be arranged under the motifs discussed, without omitting any special forms. By means of this study a meaningful picture of the interrelationship among the various island groups emerges. Instead of enumerating the art of region A and then that of regions B and C, we see a uniform diffusion of art from A to B and C. The evolution of the characteristic styles of each region becomes not only clearer but also more understandable. A survey of the various motifs and their distribution throughout the Pacific region therefore leads to some significant and easily stated conclusions.

A first conclusion is that we can distinguish between the art of hunter cultures, continuations of which can be found only in the Pacific, most clearly in Australia, and the art of the agricultural cultures of Melanesia, Polynesia, and America. In addition to a clear grouping of the motifs belonging to one or the other cultural domain, there are transitional stages. Some motifs are employed in both groups. One fact is most evident, namely, that the art of the hunter cultures remains almost exclusively two-dimensional, while the art of the agricultural peoples is mainly sculptural. The two-dimensional art of the agricultural cultures —such art of course exists—is a derivative and variation of plastic art.

Motifs are very largely independent of time and space; they spread out over wide areas and maintain themselves through several, perhaps very different, cultures.

The X-ray style originated in the early hunter cultures of the Magdalenian period and diffused over northern Asia and to southern North America. At some point, somewhere in Central Asia a southern branch must have split off from this direction of expansion; in a fragmentary way the southern branch can be traced from India to Indonesia, New Guinea, and Australia. That was as far as the early hunters traveled in the Pacific, no doubt because they had no boats able to cover the distances. For the time being, we are unable to say why the X-ray style of the hunters is not distributed in Australia farther than it actually is.

Representation of movement in profile is likewise a recognizable element of early hunter cultures. This mode of representation, too, has a narrowly confined area of distribution, namely, the northwestern corner of Australia, although stimuli to the depiction of motion must have radiated further.

The spiral, too, appears in the Magdalenian period of southern France, is taken over by advanced cultures in the course of its migration eastward, and has a number of formulations in China, as a much-varied motif of the advanced civilization of the first millennium B.C. From

China it spread, in waves that can no longer be traced, deep into the South Seas and into America. Two forms of the spiral must be distinguished. One is the old form, going back to the Magdalenian period, which was brought with the hunter culture to central and northwestern Australia; the other form is later, dating from the Bronze Age, which came to Oceania before and together with the advanced civilizations, and for the most part it was employed as a decorative element without any visible significance. In the South Seas the second spiral motif is a sign of a northern, usually Chinese, influence. Its distribution extends from Indonesia through New Guinea to northern New Zealand. A special form of the motif occurs in the Marquesas Islands. New Zealand and the Marquesas are centers of a northern influence, as is confirmed by the presence of the harpoon on both islands, and in a northern form at that. There is an unmistakable, although not very strong, northern influence—Eurasian or Siberian—in the South Seas. It is not immediately possible to correlate artistic forms with this influence.

The skull motif, along with the squatting-figure motif, is the motif of the early planters, the motif that expresses an entire complex of conceptual viewpoints and has spread out widely in Oceania in conjunction with the squatting-figure motif.

In the squatting figure, finally, we have the motif that, through all sorts of variations and abstractions, must be regarded as fundamental in Oceanic art. An early form of the motif can be observed in Europe as early as the Magdalenian period in Denmark, where it is apparently the figure of the earth mother. Later, in early China, deceased forebears are represented as squatting; the position, as we have seen in burials and in the depiction of the dead, is related to ideas of rebirth. The ancestor portrayed as squatting should be considered, throughout the Pacific, as a motif of fertility and the warding off of evil, and as a representation of life, continued life, and being alive.

Clear-cut squatting figures disappear in western Melanesia and reappear only in Central America. An Oceanic intermediate form is the figure with bent legs, and the rudimentary squatting depictions, derived from it, may be seen as representations of motion.

Special forms of the squatting figure indicate a relationship to the early hunter culture: the representation of the squatting bear as a totemic motif in China and the American Pacific Northwest. Motifs of the early hunting culture, like that of the "Lady of the Beasts," are often mingled with the squatting-figure image in the Pacific. Given the importance and significance of the squatting-figure motif, it is not surprising that it predominates in rock pictures. In the course of time the motif comes to be abstracted, especially on shields, where it is particularly appropriate as a defensive image. Tracing this development leads to far-reaching conclusions as to the course of the history of art and the artistic diffusions in the South Seas, as for example, the importance of New Guinea for Australian art.

The art of the South Seas, and its development to abstraction, can only be judged correctly when the iconographic foundation is known. It is only when the no longer recognizable variants of New Guinea, especially those of the southwest, are related back to the squatting-figure motif that we can establish the development of this art and its possibilities, as well as recognize formulations capable of being transmitted.

The Present

In the foregoing survey of the art of the Pacific region, the development of that art has been treated from its origins down to a point at which the development comes to an end. This point is not the age of the discoveries, but much closer to the present. But there is no mistaking the fact that the art of the South Seas is dead and has lingered in survivals in only a few places. To complete our survey, it is necessary to give an account of these survivals into the present.

They are found chiefly in Australia and New Guinea. Traditional art has also survived in marginal regions of the South Seas, in Bali, on Sumatra, Nias, the Moluccas, to some extent in the Philippines; there are some residues among the Eskimos; but the northwestern American tribes are no longer active artistically, nor are the advanced cultures of Central and South America, where a colonial culture not related to the Pacific culture existed for several hundred years.

In Australia, the art of the rock pictures has long since died out, unless, of course, the method of freshening old pictures for ritual purposes is to be called a living art. There are examples of such repainting from as late as 1953–54. On the other hand, the art of bark painting is still alive in northern Australia, is slowly working its way out of its traditional limitations, and emerging as a modern decorative art financed by tourists, collectors, and missionaries. Undoubtedly, this kind of bark picture reaches a high quality. The native art of Australia could have made its connection with the art of the modern world in the person of Albert Namatjira, who died in 1959. This central Australian native painted landscapes that were exhibited in Sydney and brought a good price in the art markets of the world. He had his whole family engaged in painting, but he was not regarded as an "Australian";

he remained a "native." In any event, he showed a way for the artistic gifts of the natives to enter into the present and present-day art.

In New Guinea the traditional art of the natives is still alive in many places, as is proved by the photographs that Saulnier published in 1950 of carved and painted shields and tall, carved sacrificial poles. The artistically productive region of the Sepik Valley has also kept its power down to very recent times. It is only today that collapse and artistic decline have set in, but there may still be many smaller centers in which the art of former days still flourishes.

The New Hebrides are also noteworthy in this respect. The famous tree-fern figures seem to have suddenly awakened to new life. Obviously under European stimulation and probably using European tools, figures in the old style, with, it must be admitted, a small admixture of Picasso, are produced and sold. Although these figures no longer have any connection with the ritual life of the islands, from the formal point of view they are art works and prove the will of this art region to remain alive.

The same can hardly be said of the rest of Melanesia, and still less so of Polynesia. Wood carvings in traditional style are still made on Easter Island. The sinister aspect of the early work has disappeared and a certain delight in the macabre has remained as the characteristic feature. This resumption of the traditional was done quite consciously; the art of Easter Island was dead and there was a period in which copies of art objects were brought to Easter Island to be reworked there and then sold as authentic.

489. Ancestor figures, from New Britain. Painted wood, height 31 1/2". Museum für Völkerkunde, Munich.

American Antiquity, XXIII (1958), 233-46; and Helen M. Wormington, *Ancient Man in North America*, (Denver, 1957). The former indicates the presence of Homo sapiens in southwestern North America in c. 38,000 B.C. The latter proposes a much later date for his appearance on this continent.

11 See Paul S. Martin, George I. Quimby, and Donald Collier, *Indians before Columbus* (Chicago, 1947), pp. 79-94 for a discussion of the early development of the Southwestern culture and others. An admirable, recent essay by Irving Rouse on the present status of Southwestern archaeology appears in the revised edition of Alfred V. Kidder's *An Introduction to the Study of Southwestern Archaeology* (New Haven and London, 1962); both carbon-14 and dendrochronological dates are considered for many important Anasazi sites. See also Richard Woodbury, "N. C. Nelson and Chronological Archaeology," *American Antiquity*, XXV (1960), 400-401.

12 "Anasazi" is the English form of a modern Navajo word which means "the ancient people." It is generally accepted now as a designation for the combined Basket Maker and Puebloid traditions of the ancient Southwest. See Rouse, in Kidder, *Southwestern Archaeology*, pp. 4-48; S. J. Guernsey and Alfred V. Kidder, *Basket-Maker Caves of Northeastern Arizona* (Cambridge, Mass., 1921); and J. Charles Kelley, "Factors Involved in the Abandonment of Certain Peripheral Southwestern Settlements," *American Anthropologist*, LIV (1952), 356-87.

13 An early study of this culture was Emil W. Haury's, *The Mogollon Culture of Southwestern New Mexico* (Globe, Ariz., 1936).

14 Hohokam art and architecture are discussed and illustrated in *Excavations at Snaketown: Material Culture* (Globe, Ariz., 1937) by Harold S. Gladwin, Emil W. Haury, Edwin B. Sayles, and Nora Gladwin, and in other numbers of the *Medallion Papers* published by that group in the 1930s.

15 Martin, Quimby, and Collier, Fig. 60, present an informative visual comparison of the pottery, ornament and other manifestations of Southwestern traditions.

16 Works of quite similar style and subject, however, were produced by the Hohokam in significant numbers at roughly the same time. See also Jesse L. Nusbaum, *A Basket-Maker Cave in Kane County, Utah* (New York, 1922); and Guernsey and Kidder, *Basket-Maker Caves*. Earl H. Morris has written on human figurines of Basket Maker provenience in *American Antiquities*, XVII (1951).

17 See, among other worthwhile studies, Charles A. Amsden, *Prehistoric Southwesterners from Basketmaker to Pueblo* (Los Angeles, 1949); Ruth L. Bunzel, *The Pueblo Potter* (New York, 1929); Kenneth M. Chapman, *Pueblo Indian Pottery* (2 vols.; Nice, 1933-36); Harry P. Mera, *Style Trends of Pueblo Pottery in the Rio Grande and Little Colorado Cultural Areas* (Santa Fe, 1939); Victor Mindeleff, *A Study of Pueblo Architecture: Tusayan and Cibola* (Washington, D. C., 1891); Elsie C. Parsons, "Relations between Ethnology and Archaeology in the Southwest," *American Antiquity*, V (1940), 214-20 (this is an especially thoughtful study); Terrah L. Smiley, *A Summary of Tree-Ring Dates from some Southwestern Archaeological Sites* (Tucson, 1951); James Stevenson, *Illustrated Catalog of the Collections Obtained from the*

Indians of New Mexico in 1880 (Washington, D.C., 1883); and Helen M. Wormington, *Prehistoric Indians of the Southwest* (Denver, 1947).

18 A thorough study of one important decorative complex of this type is by Watson Smith, *Kiva Mural Decorations at Awatovi and Kawaika-a* (Cambridge, Mass., 1952).

19 This system involves the comparison of rings inside living trees of varying ages with those of timbers recovered from ancient ruins also of varying antiquity, plus a correlation of the rings with obvious, alternating drought and wet-season years. An unbroken series of patterns of this kind enabled Dr. Douglass to establish very accurate dating back to the beginning of the Christian epoch and slightly earlier. See Douglass, *Dating Pueblo Bonito and Other Ruins of the Southwest* (Washington, D.C., 1935), and Terrah L. Smiley (1951). Materials of greater antiquity than about 2,000 or 2,500 years are now usually tested according to the carbon-14 method of dating. See Willard F. Libby, *Radiocarbon Dating* (2nd ed.; Chicago, 1955).

20 See above, pp. 211-12; and Elsie C. Parsons, *American Antiquity* (1940), who deplores the absence of sensitive blendings between prehistoric and ethnological study in the Southwest.

21 Most of the collected carvings and related fetish material are housed in the Smithsonian Institution, in Washington, D.C. These were reported in James Stevenson (1883), and by Frank H. Cushing, *Zuñi Fetishes* (1883). These objects are from two inches to eight or more inches in length, and, though they vary notably in aesthetic quality from one example to the next, they deserve a thorough examination on the basis of artistic value alone.

22 Cushing, *ibid.* See also Matilda V. Stevenson, *The Zuñi Indians* (Washington, D.C., 1903); and Elsie C. Parsons, *Pueblo Religion* (2 vols.; Chicago, 1939).

23 See Frederick J. Dockstader, *The Kachina and the White Man* (Bloomfield Hills, Mich., 1954); and Edwin Earle and Edward Kennard, *Hopi Kachinas* (New York, 1938).

24 A useful investigation, although it appeared before the advent of radiocarbon dating, is that by Emil W. Haury, *The Stratigraphy and Archaeology of Ventana Cave* (Tucson and Albuquerque, 1950), *passim*.

25 Few of these actually show signs of use. Archaeologists not infrequently postulate "ceremonial" or "fetish" functions of such forms rather than attributing their origins to aesthetic instinct or motivation. Carving for the purpose of connoisseurship and resultant prestige is another likely factor.

26 A variety of Hohokam stone works are illustrated, though for the greater part in smallish reproductions, in Gladwin Haury and others, *Excavations at Snaketown*. A majority of these carvings, formerly at the Gila Pueblo archaeological center, are now in the Arizona State Museum, Tucson.

27 A basic study is that by H. S. and C. B. Cosgrove, *The Swarts Ruin; A Typical Mimbres Site in Southwestern New Mexico* (Cambridge, Mass., 1932). See also Jesse W. Fewkes, *Mimbres Pottery, Design on Prehistoric Pottery*

from the *Mimbres Valley, New Mexico* (Washington, D.C., 1923); and Paul H. Nesbitt, *The Ancient Mimbreños, New Mexico* (Beloit, Wisc., 1931).

[28] The technology of Navajo crafts or illustrations of characteristic later works are given in Charles A. Amsden, *Navajo Weaving* (Santa Ana, Calif., 1934); Ruth M. Underhill, *Indian Crafts*, (Washington, D.C., 1944); Dockstader (1961), pp. 43-44 and Pls. 160, 161, 166-68; and Douglas and D'Harnoncourt, pp. 131-34 and Pls. 40-45.

[29] See Harold E. Driver, pp. 157 ff. and 192-94; Clark Wissler, *North American Indians of the Plains* (New York, 1929); Robert H. Lowie, *Crow Indian Art* (New York, 1922); and John C. Ewers, *Plains Indian Painting* (Stanford, 1939).

[30] See p. 191. The chronology and the culture of this area have been considered in a number of publications including George G. Heye, *Certain Artifacts from San Miguel Island, California* (New York, 1921); C. W. Meighan and H. Eberhart, " Archaeological Resources of San Nicholas Island, " *American Antiquity*, XIX (1953), 109-25; Phil C. Orr, " Review of Santa Barbara Channel Archaeology, " *Southwest Journal of Anthropology*, VIII (1952), 211-26; Ronald L. Olson, *Chumash Prehistory* (Berkeley, 1930); David B. Rogers, *Prehistoric Man of the Santa Barbara Coast* (Santa Barbara, 1929); W. D. Strong, *Archaeological Explorations in the Country of the Eastern Chumash* (Washington, D.C., 1936); and Robert F. Heizer and M. A. Whipple (eds.), *The California Indians* (1951). Recent carbon-14 datings indicate that man may have occupied the Santa Barbara region some 30,000 years ago.

[31] These imaginative objects are prolifically illustrated in E. K. Burnett, *Inlaid Stone and Bone Artifacts from Southern California* (New York, 1944). See also George West, *Tobacco Pipes and Smoking Customs of the American Indians* (2 vols.; Milwaukee, 1934), Pls. 13, 16, *et passim*.

[32] Carbon-14 datings for prehistoric sculptures and related material from southwestern British Columbian sites, as well as a close study of certain of the attendant problems of the stone art of that region, are given in Wilson Duff, *Prehistoric Stone Sculpture of the Fraser River and Gulf of Georgia* (Victoria, B.C., 1956). See also Wingert (1952).

[33] *Ibid.* The general development of the Northwest Coast area and the many conjectures surrounding the origin of its peoples and their art styles have been the object of a wealth of scientific study. A few of the many excellent writings available are Homer G. Barnett, *The Coast Salish of British Columbia* (Eugene, Ore., 1955); Philip Drucker, *Indians of the Northwest Coast* (New York, 1955); Pliny E. Goddard, *Indians of the Northwest Coast* (New York, 1945); Diamond Jenness, *The Indians of Canada* (5th ed.; Ottowa, 1960); Alfred L. Kroeber, " American Culture and the Northwest Coast, " *American Anthropologist*, XXV (1923), 1-20; and Marian W. Smith, " The Cultural Development of the Northwest Coast, " *Southwestern Journal of Anthropology*, XII (1956).

[34] See, for example, William D. Strong, " The Occurrence and Wider Implications of a 'Ghost Cult' on the Columbia River Suggested by Carvings in Wood, Bone, and Stone, " *American Anthropologist*, XLVII (1945), 314-17.

[35] A threefold classification of linguistic groups is used by some ethnologists: (a) the Algonkin-Wakaston, which includes the Salish, Kwakiutl, and Nootka; (b) the Nadene, to which belong the Haida and the Tlingit; and (c) the Penutian, with which are grouped the Tsimshian.

[36] One of the outstanding art-historical studies of Northwest Coast art is Wingert's *American Indian Sculpture*. This work concentrates upon Salish works.

[37] The northernmost area of the California coast, especially the Humboldt Bay region, as well as Oregon are related to the Northwest Coast art complex in general on the basis of an extensively used, animal-shaped type of flat club in stone, bone, and wood. The Columbia River Valley is an important region for early figural sculpture in stone.

[38] See Wingert (1949), pp. 8-9.

[39] Kwakiutl attitudes toward wealth are interpreted by Helen Codere, *Fighting with Property; A Study of Kwakiutl Potlatching and Warfare, 1792-1930* (New York, 1950); and, by the same author, is " The Amiable Side of Kwakiutl Life: The Potlatch and the Play-Potlatch, " *American Anthropologist*, LVIII (1956), 334-51. One of the classic studies of tribal motivations of Kwakiutl masks and other ceremonial objects is that by Franz Boas, *The Social Organization and Secret Societies of the Kwakiutl Indians* (Washington, D.C., 1897).

[40] A well-known source is Marius Barbeau, *Totem Poles; A Recent Native Art of the Northwest Coast of America* (Washington, D.C., 1932). Barbeau, unlike certain other students of this region, regards the totem pole as having enjoyed its greatest development following white contact.

[41] Douglas and D'Harnoncourt point out that masks of this general class were often made expressly for sale to European visitors as early as the 1860s; but the great quality of older Haida style had not then begun decline which marks its recent practice.

[42] Many works of this genre are illustrated in Robert B. Inverarity, *Art of the Northwest Coast Indians* (Berkeley, 1950), Pls. 180, 182, 187-93. Contrast the power of the Bear-Mother carving in Inverarity's Plate 194 with the vitiated, slick technique of the preceding examples.

[43] See Wingert in Viola Garfield, Paul Wingert and Marius Barbeau, *The Tsimshian: Their Arts and Music* (New York, 1951) pt. II.

[44] It has been long and often noted in the literature on Tlingit weaving that the males executed the pattern boards and that the women derived the actual weaving designs from these. One wonders if an occasional Tlingit female did not slyly violate this rule, so inflexibly described by ethnologists, perhaps incising, by dark of night, one or two tiny deviations upon a husband's master design.

[45] See Hans Himmelheber, *Eskimokünstler* (Eisenach, 1953); Henry B. Collins, *Prehistoric Art of the Alaskan Eskimo* (Washington, D.C., 1929); Walter J. Hoffman, *The Graphic Art of the Eskimo* (Washington, D.C., 1897); Froelich Rainey, " Old Eskimo Art, " *Natural History*, XI (1937); and Henry Schaefer-Simmern, *Eskimo Plastik aus Kanada* (Cassel, 1958).

[46] A valuable source for study of the cultural development of this region is that edited by James B. Griffin, *Archaeology of Eastern United States* (Chicago, 1952). George I. Quimby, *Indian Life in the Upper Great Lakes* (Chicago, 1961) is valuable for its consideration of cultures in the northerly region of the East. Indispensable to the study of Mound Builder art is *The Mound Builders* by Henry C. Shetrone (New York, 1930).

[47] Compare Dockstader (1961), pp. 26-27, 32, 35-37, and various pls. from 18 through 67; Douglas and D'Harnoncourt, pp. 18, 59-96; and George C. Vaillant, *Indian Arts in North America* (New York and London, 1939), pp. 21-27 and notes to Pls. 8-29.

[48] A prehistoric origin may be assumed for these objects, since they were in use already at the time of early white settlement in New York and nearby Canada.

[49] See William Fenton, *Masked Medicine Societies of the Iroquois* (Washington, D.C., 1941).

[50] See Frank G. Speck, *The Iroquois* (Bloomfield Hills, Mich., 1955).

[51] See David I. Bushnell, Jr., *Villages of the Algonquian, Siouan, and Caddoan Tribes West of the Mississippi* (Washington, D.C., 1922).

[52] See Henry C. Shetrone, *Mound Builders*; E. K. Burnett, *The Spiro Mound Collection in the Museum* (New York, 1945); Warren K. Moorehead, *The Stone Age in North America* (2 vols.; Boston and New York, 1910); W. C. Mills, "Explorations of the Adena Mound," *Ohio Archaeological and Historical Quarterly*, X (1902), 452-79; and Clarence B. Moore, *Certain Mounds of Arkansas and Mississippi* (Philadelphia, 1908).

[53] These are in certain respects reminiscent, if we make highly selective comparisons, of the older and finer Chumash or Gabrielino steatite carvings of California (see above).

[54] Lack of interest on the part of American collectors at the time resulted in the sale of this treasure of fine works in England.

[55] See Frank H. Cushing, *Exploration of Ancient Key Dweller Remains on the Gulf of Florida* (Philadelphia, 1897).

Bibliography

PREHISTORIC ART

General Works

Bandi, H. G., and Maringer, J., *L'Art préhistorique*, Basel, 1952 (Eng. trans., *Art in the Ice Age: Spanish Levant Art: Arctic Art*, London and New York, 1953).
————, *et al.*, *The Art of the Stone Age*, London and New York, 1961.
Blanc, A. C., *Dall'astrazione all'organicità*, Rome, 1958.
Boas, F., *Primitive Art*, 2nd ed., New York, 1955.
Breuil, H., and Lantier, R., *Les Hommes de la pierre ancienne*, 2nd ed., Paris, 1959.
Brodrick, A. H., *Prehistoric Painting*, London, 1948.
Graziosi, P., *L'arte della antica età della pietra*, Florence, 1956 (Eng. trans., *Palaeolithic Art*, New York and London, 1960).
Hoernes, M., and Menghin, O., *Urgeschichte der bildenden Kunst in Europa*, 3rd ed., Vienna, 1925.
Kühn, H., *Die Felsbilder Europas*, Stuttgart, 1952 (Eng. trans., *The Rock Pictures of Europe*, Fair Lawn, N. J., 1957).
Leroi-Gourhan, A., *Préhistoire de l'art occidental*, Paris, 1965 (Eng. trans., *Treasures of Prehistoric Art*, New York, 1967).
Luquet, G. H., *L'Art primitif*, Paris, 1930.

Portable Objects

Breuil, H., and Lantier, R., *Les Hommes de la pierre ancienne*, 2nd ed., Paris, 1959.
Capitan, L., and Bouyssonie, J., *Limeuil, son gisement sur pierres de l'age du renne (Publications de l'Institut International d'Anthropologie, 1)*, Paris, 1924.
Ephimenko, P. P., *Kostienki*, Leningrad, 1931.
Passemard, L., *Les Statuettes féminines paléolithiques dites "Venus stéatopyges,"* Nîmes, 1938.
Pericot-Garcia, L., *La cueva del Parpalló*, Madrid, 1942.
Saccasyn-della Santa, E., *Les Figures humaines du paléolithique supérieur eurasiatique*, Antwerp, 1947.

Cave Art

Alcalde del Rio, H., Breuil, H., and Sierra, L., *Les Cavernes de la région cantabrique*, 2 vols., Monaco, 1911.

Breuil, H., "La Caverne ornée de Rouffignac," *Académie des Inscriptions et Belles Lettres, Mémoires*, XLIV, Paris, 1960, pp. 147–67.
————, *Quatre Cents Siècles d'art pariétal*, Montignac, 1952.
————, and Berger-Kirchner, L., "Franco-Cantabrian Rock Art," in *The Art of the Stone Age*, London and New York, 1961.
————, and Obermaier, H., *La cueva de Altamira en Santillana del Mar*, Madrid, 1935 (Eng. trans., *The Cave of Altamira at Santillana del Mar (Spain)*, Madrid, 1935).
————, ————, and Verner, W., *La Pileta a Benaoján, Málaga*, Monaco, 1915.
Capitan, L., Breuil, H., and Peyrony, D., *La Caverne de Font-de-Gaume*, Monaco, 1910.
————, ————, and ————, *Les Combarelles aux Eyzsie*, Paris, 1924.
Cartailhac, E., and Breuil, H., *La Caverne d'Altamire à Santillane, près Santander (Espagne)*, Monaco, 1906.
Graziosi, P., *L'arte della antica età della pietra*, Florence, 1956 (Eng. trans., *Paleolithic Art*, New York and London, 1960).
————, "Les Gravures de la grotte Romanelli (Puglia, Italie)," *Ipek*, VIII, 1932–33, pp. 26–36.
————, "Nuovi graffiti parietali della grotta di Levanzo (Egadi)," *Rivista di Scienze Preistoriche*, VIII, 1953, pp. 123–37.
————, "La scoperta di incisioni rupestri di tipo paleolitico nella grotta del Romito presso Papasidero in Calabria," *Klearchos*, IV, 13–14, 1962, pp. 12–20.

Laming-Emperaire, A., *La Signification de l'art rupestre paléolithique*, Paris, 1962.
Leroi-Gourhan, A., "Répartition et groupement des animaux dans l'art pariétal paléolithique," *Bulletin de la Société Préhistorique Française*, LV, 5–6, 1958, pp. 315–22.
Marconi Bovio, J., "Incisioni rupestri dell'Addaura (Palermo)," *Bullettino di Paletnologia Italiana*, VIII, 5, 1952–53, pp. 5–22.
Martin, H., "La Frise sculptée de l'atelier solutréen du Roc (Charente)," *Archives de l'Institut de Paléontologie Humaine, Mémoire*, V, 1928.
Mauduit, J. A., *Quarante Mille Ans d'art moderne*, Paris, 1954.
Nougier, L. R., and Robert, R., *Rouffignac*, Paris, 1959.

Obermaier, H., *El hombre fósil*, Madrid, 1916 (Eng. trans., *Fossil Man in Spain*, New Haven, 1924).

Pericot-Garcia, L., *El arte rupestre español*, Barcelona and Buenos Aires, 1950.

Radmilli, A. M., "La produzione d'arte mobiliare nella Grotta Polesini presso Roma," *Quartär*, IX, 1957, pp. 41–59.

Windels, F., *Lascaux, Chapelle Sixtine de la préhistoire*, Montignac, 1948.

Mesolithic Art of the Spanish Levant

Almagro Basch, M., *Las pinturas rupestres levantinas*, Madrid, 1954.

Bandi, H. G., "The Rock Art of the Spanish Levant," in *The Art of the Stone Age*, London and New York, 1961.

Breuil, H., "Les Peintures rupestres de la péninsule Ibérique. XI. Les roches peintes de Minateda (Albacete)," *L'Anthropologie*, XXX, 1920, pp. 1–50.

Cabré Aguiló, J., *El arte rupestre en España*, Madrid, 1915.

Hernández Pacheco, E., *Las pinturas prehistóricas de la cueva de la Araña (Valencia)*, Madrid, 1924.

Obermaier, H., "Probleme der paläolitischen Malerei Ostspaniens," *Quartär*, I, 1938, pp. 111–19.

————, and Wernert, P., *Las pinturas rupestres del barranco de Valltorta (Castellón) (Comisión de investigaciones paleontológicas y prehistóricas, 23)*, Madrid, 1919.

Pericot-Garcia, L., *El arte rupestre español*, Barcelona and Buenos Aires, 1950.

Porcar, J., Obermaier, H., and Breuil, H., *Excavaciones en la cueva Remigia (Castellón) (Memoria de la Junta Superior de Excavaciones y Antigüedades)*, Madrid, 1935.

Post-paleolithic Art of Spain

Breuil, H., *Les Peintures rupestres schématiques de la péninsule Ibérique*, 4 vols., Lagny, 1933–35.

————, and Burkitt, M. C., *Rock Paintings of Southern Andalusia*, Oxford, 1929.

Sobrino Buigas, R., *Corpus Petroglyphorum Gallaeciae*, Santiago de Compostela, 1935.

Post-paleolithic Art of Italy

Acanfora, M. O., *Le statue antropomorfe dell'Alto Adige*, Bolzano, 1953.

Anati, E., "Nuove incisioni preistoriche nella zona di Paspardo in Valcamonica," *Bullettino di Paletnologia Italiana*, n. s. IX, 1957, pp. 189–212.

Bicknell, C., *A Guide to the Prehistoric Rock Engravings in the Italian Maritime Alps*, Bordighera, 1913.

Graziosi, P., *Le incisioni preistoriche di Valcamonica (Archivio per l'Antropologia e l'Etnologia, LIX, 1-4)*, Florence, 1929.

————, "Le incisioni rupestri di Orco Feglino nel Finalese," *Bullettino di Paletnologia Italiana*, LV, 1935, pp. 227–33.

Issel, A., *Le rupi scolpite nelle alte valli delle Alpi Marittime (Bullettino di Paletnologia Italiana, XXVII, 10-12)*, Parma, 1901.

Louis, M., and Isetti, G., *Les Gravures préhistoriques du Mont Bego*, 2 vols., Bordighera, 1964.

Reggiani Rajna, M., "Arte preistorica in Valtellina," *Archivio Storico Valtellina*, 1941.

Post-paleolithic Art of France

Baudet, J. L., "Note préliminaire sur les peintures, gravures et enceintes du sud de l'Île de France,"

Bulletin de la Société Préhistorique Française, XLVII, 1950, pp. 326–36.

Glory, A., "Peintures rupestres schématiques dans l'Ariège," *Gallia*, V, 1947, pp. 1–45.

————, *et al.*, "Les Peintures de l'âge du métal en France méridionale," *Préhistorie*, X, 1948, pp. 7–135.

Pequart, M., Pequart, S. J., and Le Rouzic, Z., *Corpus des signes gravés des monuments mégalithiques du Morbihan*, Paris, 1927.

Post-paleolithic Art in the Rest of Europe

Almgren, O., *Nordische Felszeichnungen als religiöse Urkunden*, Frankfort, 1934.

Althin, C. A., *Studien zu den bronzezeitlichen Felszeichnungen von Skåne*, 2 vols., Copenhagen, 1945.

Brögger, A. W., "Die arktischen Felszeichnungen und Malereien in Norwegen," *Ipek*, 1931.

Gjessing, G., "Die Chronologie der Schiffsdarstellungen auf den Felsenzeichnungen zu Bardal, Trødelag," *Acta Archaeologica*, VI, 1935, pp. 125–39.

Hallström, G., *Monumental Art of Northern Europe from the Stone Age, I. The Norwegian Localities*, Stockholm, 1938.

Kühn, H., *Die Felsbilder Europas*, Stuttgart, 1952 (Eng. trans., *The Rock Pictures of Europe*, Fair Lawn, N.J., 1957).

————, *Vorgeschichtliche Kunst Deutschlands*, Berlin, 1935.

Macalister, R. A. S., *The Archaeology of Ireland*, London, 1928.

Raudonikas, W. J., *Naskal'nye izobrazheniia Onezkogo ozera i Belogo Moria (Les Gravures rupestres des bords du lac Onega et de la Mer Blanche)*, 2 vols., Leningrad and Paris, 1936–38.

Rock Art of Africa

Battiss, W. W., *The Artists of the Rocks*, Pretoria, 1948.

Breuil, H., "Les Roches peintes d'Afrique australe: Leurs auteurs et leur âge," *L'Anthropologie*, LIII, 1949, pp. 377–406.

————, *The White Lady of the Brandberg*, London, 1955.

————, and Lhote, H., "Les Roches peintes du Tassili-n-Ajjer," *Actes IIº Congrès Panafricain*, 1952, pp. 1–159.

Chasseloup-Laubat, F. de, *Art rupestre au Hoggar (Haut Mertoutek)*, Paris, 1938.

Clark, J. D., *The Prehistory of Southern Africa*, Harmondsworth, 1959.

Cole, S., *The Prehistory of East Africa*, London, 1954.

Cuscoy, L. D., *Paletnologia de las Islas Canarias*, Madrid, 1954.

Flamand, G. B. M., *Les Pierres écrites*, Paris, 1922.

Frobenius, L., *Das unbekannte Afrika*, Munich, 1923.

————, and Obermaier, H., *Madschra Maktuba*, Munich, 1925.

Graziosi, P., *L'arte rupestre della Libia*, 2 vols., Naples, 1942.

————, *Arte rupestre del Sahara Libico*, Florence, 1962.

————, "New Discoveries of Rock Paintings in Ethiopia," *Antiquity*, XXXVIII, 151, 1964, pp. 187–90.

Holm, E., "The Rock Art of South Africa," in *The Art of the Stone Age*, London and New York, 1961.

————, *Südafrikas Urkunst*, Pretoria, 1957.

Jungraithmayer, H., "Rock-paintings in the Sudan," *Current Anthropology*, October, 1961.

Kemal el Din and Breuil, H., "Les Gravures rupestres du Djebel Ouenat," *Revue Scientifique Illustrée*, LXVI, 1928, pp. 105–17.

Lajoux, J. D., *Les Merveilles de Tassili n'Ajjer*, Paris, 1962.

Lhote, H., " The Rock Art of the Maghreb and Sahara," in *The Art of the Stone Age*, London and New York, 1961.

Lowe, C. van Riet, " Prehistoric Art in South Africa, " *Official Year Book of the Union of South Africa*, XVII, 1936, pp. 35–38.

Malhomme, J., *Corpus des gravures rupestres du Grand Atlas (Service des Antiquités, 1-2)*, Rabat, 1959–61.

Mauny, R., " Gravures, peintures et inscriptions rupestres de l'Ouest africain, " *Initiations Africaines*, XI, 1954, pp. 1–93.

Monod, T., " Gravures et inscriptions rupestres du Sahara occidental, " *Renseignements Colonials*, IX, 1936, pp. 155–60.

Obermaier, H., and Kühn, H., *Bushman Art. Rock Paintings of South-West Africa*, Oxford, 1930.

Vaufrey, R., *L'Art rupestre nord-africain (Archives de l'Institut de Paléontologie Humaine XX)*, Paris, 1939.

Willcox, A., *The Rock Art of South Africa*, Johannesburg, 1963.

————, *Rock Paintings of the Drakensberg*, London, 1956.

Winkler, H. A., *Rock Drawings of Southern Upper Egypt*, 2 vols., London, 1938–39.

Rock Art of Asia and Oceania

Davidson, D. S., *Aboriginal Australian and Tasmanian Rock Carvings and Paintings (American Philosophical Society, Memoirs V)*, Philadelphia, 1936.

Lommel, A., " The Rock Art of Australia," in *The Art of the Stone Age*, London and New York, 1961.

————, and Lommel, K., *Die Kunst des fünften Erdteils—Australia*, Munich, 1959.

Piggott, S., *Prehistoric India*, New York, 1962.

Tallgren, A. M., " Inner Asiatic and Siberian Rock Pictures," *Eurasia Septentrionalis Antiqua*, VIII, 1933, pp. 175–210.

Rock Art of America

Braunholtz, H. J., " Rock Paintings in British Guiana," *Anais XXXI Cong. Int. Americanistás*, São Paulo, 1955, pp. 635–47.

Casamiquela, R. M., *Sobre la significación mágica del arte rupestre nordpatagonico (Cuadernos del Sur)*, Bahia Blanca, 1960.

Dahlgren, B., and Romero, J., " La prehistoria bajacaliforniana. Redescubrimiento de pinturas rupestres," *Cuadernos Americanos*, IV, 1951.

Gardner, G. A., *Rock-painting of North-west Córdoba*, Oxford, 1931.

Heizer, R. F., and Baumhoff, M. A., " Great Basin Petroglyphs and Prehistoric Game Trails," *Science*, MXXIX, 3353, 1959, pp. 904–5.

Koch-Grünberg, T., *Südamerikanische Felszeichnungen*, Berlin, 1907.

Laming, A., and Emperaire, J., " Découvertes de peintures rupestres sur les hauts plateaux du Paraná," *Journal de la Société des Américanistes*, XLV, 1956, pp. 165–78.

Menghin, O., " Estilos del arte rupestre de Patagonia," *Acta Prehistorica*, I, 1957.

————, " Las pinturas rupestres de la Patagonia," *Runa*, V, 1952.

Steward, J. H., " Petroglyphs of California and Adjoining States," *University of California, Publications in American Archaeology and Ethnology*, XXIV, 1929–30, pp. 47–238, 343–60.

————, " Petroglyphs of the United States," *Annual Report of the Smithsonian Institution, 1936*, Washington, D.C., 1937, pp. 405–25.

Vignati, M. A., " Resultados de una excursión por la margen sur del Río Santa Cruz," *Notas preliminares del Museo de la Plata*, II, 1934, pp. 77–151.

AFRICAN ART

Andersson, E., *Contribution à l'ethnographie des Kuta*, Upsala, 1953.

Bascom, W. R., " Comment: African Arts and Social Control," *African Studies Bulletin*, V, 1962, pp. 22–25.

————, and Gebaur, P., *West African Art*, Milwaukee, 1953.

Baumann, H., " Die materielle Kultur der Azande und Mangbetu," *Baessler Archiv*, XI, 1927, pp. 1–129.

————, Thurwald, R., and Westermann, D., *Völkerkunde von Afrika*, Essen, 1940.

Beier, H. U., *Art in Nigeria 1960*, London, 1960.

————, *The Story of Sacred Wood Carvings from a Small Yoruba Town (Nigeria Magazine, special issue)*, 1957.

Bell, C., " Negro Sculpture," *Arts and Decoration*, XIII, 1920, pp. 178–202.

Biebuyck, D., " Function of a Lega Mask," *Internationales Archiv für Ethnographie*, XLVII, 1, 1954, pp. 108–20.

Brooklyn Museum, *Masterpieces of African Art*, New York, 1954.

Burton, W. F. P., " The Secret Societies of Lubaland," *Bantu Studies*, IV, 1930, pp. 217–50.

Carline, R., " The Dating and Provenance of Negro Art," *Burlington Magazine*, LXXVII, 1940, pp. 115–23.

Chauvet, S., *L'Art funéraire au Gabon*, Paris, 1933.

Collé, R. P., *Les Baluba*, 2 vols., Brussels, 1913.

Collings, H. D., " Notes on the Makonde Tribe of Portuguese East Africa," *Man*, XXIX, 1929, pp. 25–28.

Daniel, F., " The Stone Figures of Esie, Ilorin Province, Nigeria," *Journal of the Royal Anthropological Institute*, LXVII, 1937, pp. 43–49.

Dark, P. J. C., *Benin Art*, London, 1960.

Delevoy, G., " Le Congo forestier," *Encyclopédie du Congo Belge*, fasc. XIII.

Einstein, C., *Negerplastik*, Munich, 1915.

Elisofon, E., and Fagg, W., *The Sculpture of Africa*, New York, 1958.

Fagg, W., *Nigerian Images: The Splendor of African Sculpture*, New York, 1963.

————, " The Study of African Art," *Allen Memorial Art Museum Bulletin*, XIII, 1955–56, pp. 44–61.

————, *Tribes and Forms in African Art*, New York, 1965.

Forde, D. (ed.), *African Worlds*, London, 1954.

Fraser, D., *Primitive Art*, Garden City, N. Y., 1962, chap. I.

Frobenius, L., *Kulturgeschichte Afrikas*, Frankfort, 1933.

————, *Das unbekannte Afrika*, Munich, 1923.

Fry, R., *Vision and Design*, London, 1920, pp. 65–68.

Fuhrmann, F., *Afrika*, Halle, 1922.

Gaffé, R., *La Sculpture au Congo Belge*, Brussels and Paris, 1945.

Gerbrands, A. A., *Art as an Element of Culture, Especially in Negro Africa*, Leiden, 1957.

Glück, J. F., " Afrikanische Architektur," *Tribus*, VI, 1956, pp. 65ff.

————, " Die Kunst Neger-Afrikas, " in *Kleine Kunstgeschichte der Vorzeit und der Naturvölker*, Stuttgart, 1956.

Golding, J., *Cubism: A History and an Analysis, 1907–1914*, New York, 1959.

Goldwater, R. J., *Primitivism in Modern Painting*, New York and London, 1938 (rev. ed., *Primitivism in Modern Art*, New York, 1967).

_____ (ed.), *Bambara Sculpture from the Western Sudan*, New York, 1960.

_____ (ed.), *Sculpture from Three African Tribes*, New York, 1961.

_____ (ed.), *Selected Works from the Collection*, New York, 1957.

_____ (ed.), *Senufo Sculpture from West Africa*, New York, 1963.

_____ (ed.), *Traditional Art of the African Nations*, New York, 1961.

Griaule, M., *Arts de l'Afrique noire*, Paris, 1947 (Eng. trans., *Folk Art of Black Africa*, New York, 1950).

_____, *Masques dogons*, Paris, 1938.

Guillaume, P., and Apollinaire, G., *Sculptures nègres*, Paris, 1917.

_____, and Munro, T., *Primitive Negro Sculpture*, London and New York, 1926.

Hall, H. U., "Fetish Figures of Equatorial Africa," *The University Museum Journal*, XI, 1920, pp. 27–55.

_____, *The Sherbro of Sierra Leone*, Philadelphia, 1938.

Hardy, G., *L'Art nègre: l'art animiste des noirs d'Afrique*, Paris, 1927.

Harley, G. W., *Masks as Agents of Social Control in Northeast Liberia*, Cambridge, Mass., 1950.

_____, *Notes on the Poro in Liberia*, Cambridge, Mass., 1941.

Herskovits, M. J., *The Backgrounds of African Art*, Denver, 1945.

_____, *Dahomey: An Ancient West African Kingdom*, 2 vols., New York, 1938.

Himmelheber, H., *Negerkunst und Negerkünstler*, Brunswick, 1960.

Holas, R., *Les Sénoufo y compris les Minianka*, Paris, 1957.

Hottot, R., "Teke Fetishes," *Journal of the Royal Anthropological Institute*, LXXXVI, 1956.

Joyce, T. A., "Steatite Figures from West Africa in the British Museum," *Man*, V, 1905.

Kjersmeier, C., *Ashanti Goldweights*, Copenhagen, 1948.

_____, *Centres de style de la sculpture nègre africaine*, 4 vols., Paris, 1935–38.

Kline, M., *Mathematics: A Cultural Approach*, Reading, Mass., 1962.

Kochnitzky, L., *Negro Art in Belgian Congo*, New York, 1948.

Krieger, K., and Kutscher, G., *Westafrikanische Masken*, Berlin, 1960.

Kühn, H., *Die Kunst der Primitiven*, Munich, 1923.

Lavachery, H., *Statuaire de l'Afrique noire*, Brussels, 1954.

Leiris, M., *Les Nègres d'Afrique et les arts sculpturaux*, Paris, 1954.

Lem, F. H., *Sudanese Sculpture*, Paris, 1949.

Leuzinger, E., *Afrikanische Skulpturen*, Zurich, 1963.

_____, *The Art of Africa*, New York, 1960.

Linton, R., "Primitive Art," *Kenyon Review*, III, 1941, pp. 34–51.

Locke, A. L., "Negro Art, Classic Style," *American Magazine of Art*, XXVIII, 1935, pp. 270–78.

Lommel, A., *Afrikanische Kunst*, Munich, 1953.

Luschan, F. von, *Die Altertümer von Benin*, 3 vols., Berlin, 1919; reprinted, 1967.

Maes, J., *Aniota-Kifwebe*, Antwerp, 1924.

_____, and Boone, O., *Peuplades du Congo Belge*, Tervueren, 1935.

Merriam, A. P., *A Prologue to the Study of the African Arts*, Yellow Springs, Ohio, 1962.

Meyerowitz, E. L. R., "Some Gold, Bronze and Brass Objects from Ashanti," *Burlington Magazine*, LXXXVI, 1947, pp. 18–21.

Murdock, G. P., *Africa: Its Peoples and Their Cultural History*, New York and London, 1959.

Murray K. C., "Ife and Its Archaeology," *Journal of African History*, I, 1960.

_____, *Masks and Headdresses of Nigeria*, London, 1949.

Nuoffer, O., *Afrikanische Plastik in der Gestaltung von Mutter und Kind*, Dresden, 1925.

Obermaier, H., and Kühn, H., *Bushman Art: Rock Paintings of Southwest Africa*, New York, 1930.

Olbrechts, F., *Plastiek van Kongo*, Antwerp, 1946 (Fr. trans., *Les Arts plastiques du Congo Belge*, Antwerp, 1959).

Paulme, D., *Les Sculptures de l'Afrique noire*, Paris, 1956.

Pitt-Rivers, G. H., *Antique Works of Art from Benin*, London, 1900.

Plancquaert, R. P., *Les Sociétés secrètes chez les Bayaka*, Brussels, 1930.

Plass, M., *African Tribal Sculpture*, Philadelphia, 1956.

Portier, A., and Poncetton, F., *Les Arts sauvages*, vol. I: *Afrique*, Paris, 1956.

Radin, P., and Sweeney, J. J., *African Folktales and Sculpture*, New York, 1952.

Rattray, R. S., *Religion and Art in Ashanti*, Oxford, 1927.

Réalités, No. 118, September, 1960 (special issue on Africa).

Royal Ontario Museum, *Masks: The Many Faces of Man*, intro. by A. D. Tushingham, Toronto, 1960.

Sadler, M. E. (ed.), *Arts of West Africa*, Oxford, 1935.

Schapiro, M., "Style," in *Anthropology Today*, ed. by A. L. Kroeber, Chicago, 1953, pp. 287–312.

Schmalenbach, W., *African Art*, New York, 1954.

Schwab, G., *Tribes of the Liberian Hinterland*, Cambridge, Mass., 1947.

Selz, P., *German Expressionist Painting*, Berkeley, 1957.

Shaw, C. T., "Archaeology in the Gold Coast," *African Studies*, II, 1943, pp. 139–47.

Sieber, R., "The Art of Primitive Arts," *Art News*, LXVI, 1968, pp. 28ff.

_____, *Sculpture of Northern Nigeria*, New York, 1961.

Simmons, D. C., "The Depiction of Gangosa on Efik-Ibibio Masks," *Man*, LVII, 18, 1957.

Struck, B., "Chronologie der Benin-Altertümer," *Zeitschrift für Ethnologie*, LV, 1923, pp. 113–66.

Stubbe, W., *Graphic Arts in the Twentieth Century*, New York, 1963.

Sweeney, J. J., *African Negro Art*, New York, 1935.

Sydow, E. von, *Afrikanische Plastik*, New York, 1954.

_____, "Kunst und Kulte von Benin," *Atlantis*, X, 1938, pp. 46-56.

Tessman, G., *Die Pangwe*, 2 vols., Berlin, 1913.

Thomas, N. W., "Ashanti and Baoulé Goldweights," *Journal of the Royal Anthropological Institute*, L, 1920, pp. 52–68.

Thompson, R. F., "Esthetics in Traditional Africa," *Art News*, LXVI, 1968, pp. 44ff.

Torday, E., and Joyce, T. A., *Les Bushongo*, Tervueren, 1910.

_____, and _____, "Notes on the Ethnography of the Bayaka," *Journal of the Royal Anthropological Institute*, XXXVI, 1906, pp. 39–59.

Trowell, M., *Classical African Sculpture*, London and New York, 1954.

Underwood, L., *Bronzes of West Africa*, London, 1949.

_____, *Figures in Wood of West Africa*, London, 1951.

_____, *Masks of West Africa*, London, 1952.

United States Library of Congress Documents Room, *Introduction to Africa: A Selective Guide to Background Reading*, Washington, D.C., 1952.

Vandenhoute, P. J. L., *Classification stylistique du masque Dan et Guéré de la côte d'Ivoire occidentale*, Leiden, 1948.

329

Vatter, E., *Religiöse Plastik der Naturvölker*, Frankfort, 1926.

Wentzel, V., "Angola, Unknown Africa," *National Geographic*, CXX, 1961, pp. 347–83.

Wingert, P. S., *Primitive Art: Its Traditions and Styles*, New York, 1962.

————, *The Sculpture of Negro Africa*, New York, 1950.

Zeller, R., *Die Goldgewichte von Asante, (Baessler Archiv, III)*, 1912.

Zervos, C., "L'Art nègre," *Cahiers d'Art*, 1927, pp. 229–46.

THE ART OF THE NORTH AMERICAN INDIAN

Adam, L., *Nordwest-Amerikanische Indianer-Kunst*, Berlin, 1923.

Alexander, H. B., *Pueblo Indian Painting*, Nice, 1932.

Amsden, C. A., *Navajo Weaving, Its Technic and History*, Santa Ana, Calif., 1934.

————, *Prehistoric Southwesterners from Basketmaker to Pueblo*, Los Angeles, 1949.

Barbeau, M., *Haida Carvers in Argillite*, Ottawa, 1957.

————, *Totem Poles: A Recent Native Art of the Northwest Coast of America (Smithsonian Institution Annual Report for 1931)*, Washington, D.C., 1932.

Barnett, H. G., *The Coast Salish of British Columbia*, Eugene, Ore., 1955.

Birket-Smith, K., "Present Status of the Eskimo Problem," *Selected Papers of the 29th International Congress of Americanists: Indian Tribes of Aboriginal America*, Chicago, 1952.

Boas, F., "The Houses of the Kwakiutl Indians," *United States National Museum Proceedings*, XI, 1888, pp. 197–213.

————, *The Social Organization and Secret Societies of the Kwakiutl Indians*, Washington, D.C., 1897.

Borden, C. E., "Results of Archaeological Investigations in Central British Columbia," *Anthropology in British Columbia*, III, 1952, pp. 31–44.

Bunzel, R. L., *The Pueblo Potter*, New York, 1929.

Burnett, E. K., *Inlaid Stone and Bone Artifacts from Southern California (Museum of the American Indian, Contributions XIII)*, New York, 1944.

————, *The Spiro Mound Collection in the Museum (Museum of the American Indian, Contributions XIV)*, New York, 1945.

Bushnell, D. I., Jr., *Villages of the Algonquian, Siouan, and Caddoan Tribes West of the Mississippi (Bureau of American Ethnology, Bulletin 67)*, Washington, D.C., 1922.

Chapman, K. M., *Pueblo Indian Pottery*, 2 vols., Nice, 1933–36.

Christensen, E. O., *Primitive Art*, New York, 1955.

Codere, H., "The Amiable Side of Kwakiutl Life: The Potlatch and the Play-Potlatch," *American Anthropologist*, LVIII, 1956, pp. 334–51.

————, *Fighting with Property: A Study of Kwakiutl Potlatching and Warfare, 1792–1930*, New York, 1950.

Collier, J. W., *Indians of the Americas*, New York, 1953.

Collins, H. B., "Outline of Eskimo Prehistory," in *Essays in Historical Anthropology of North America Published in Honor of John R. Swanton (Smithsonian Institution Miscellaneous Collections, C)*, Washington, D.C., 1940.

————, *Prehistoric Art of the Alaskan Eskimo (Smithsonian Institution Miscellaneous Collections, LXXXI)*, Washington, D.C., 1929.

Cosgrove, H. S., and Cosgrove, C. B., *The Swarts Ruin: A Typical Mimbres Site in Southwestern New Mexico (Peabody Museum Papers, XV)*, Cambridge, Mass., 1932.

Cressman, L. S., "Western Prehistory in the Light of Carbon 14 Dating," *Southwestern Journal of Anthropology*, VII, 3, 1951, pp. 289–313.

Crook, W. W., and Harris, R. K., "A Pleistocene Campsite near Lewisville, Texas," *American Antiquity*, XXIII, 1958, pp. 233–46.

Curtis, E. S., *The North American Indian*, 30 vols., Cambridge, Mass., 1903–30.

Cushing, F. H., *Exploration of Ancient Key Dweller Remains on the Gulf of Florida (American Philosophical Society, Proceedings XXXV)*, Philadelphia, 1897.

Davis, R. T., *Native Arts of the Pacific Northwest*, Stanford, Calif., 1949.

Dockstader, F. J., *Indian Art in America*, Greenwich, Conn., 1961.

————, *The Kachina and the White Man*, Bloomfield Hills, Mich., 1954.

Douglas, F. H. (ed.), *Denver Art Museum Indian Leaflet Series*, 1930ff.

————, and d'Harnoncourt, R., *Indian Art of the United States*, 2nd ed., New York, 1949.

Douglass, A. E., *Dating Pueblo Bonito and Other Ruins of the Southwest*, Washington, D.C., 1935.

Driver, H. E., *Indians of North America*, Chicago, 1961.

Drucker, P., *Indians of the Northwest Coast*, New York, 1955.

Duff, W., *Prehistoric Stone Sculpture of the Fraser River and Gulf of Georgia*, Victoria, B.C., 1956.

Earle, E., and Kennard, E., *Hopi Kachinas*, New York, 1938.

Emmons, G. T., *The Chilkat Blanket (American Museum of Natural History, Memoir III, 4)*, New York, 1907.

Ewers, J. C., *Plains Indian Painting*, Stanford, Calif., 1939.

Feder, N., *North American Indian Painting*, New York, 1967.

Fenton, W., *Masked Medicine Societies of the Iroquois (Smithsonian Institution Annual Report for 1940)*, Washington, D.C. 1941.

Fewkes, J. W., *Mimbres Pottery, Design on Prehistoric Pottery from the Mimbres Valley, New Mexico (Smithsonian Institution Miscellaneous Collections, LXXIV, 6)*, Washington, D.C., 1923.

Garfield, V., Wingert, P. S., and Barbeau M., *The Tsimshian: Their Arts and Music*, New York, 1951.

Gladwin, H. S., *et al.*, *Excavations at Snaketown*, 4 vols., Globe, Ariz., 1937–48.

Goddard, P. E., *Indians of the Northwest Coast*, New York, 1945.

Grant, C., *The Rock Paintings of the Chumash*, Berkeley, 1966.

Griffin, J. B. (ed.), *Archaeology of Eastern United States*, Chicago, 1952.

Guernsey, S. J., and Kidder, A. V., *Basket-Maker Caves of Northeastern Arizona*, Cambridge, Mass., 1921.

Gunther, E., *Northwest Coast Indian Arts*, Seattle, 1962.

Harrington, M. R., "A Primitive Pueblo City in Nevada," *American Anthropologist*, XXIX, 1927, pp. 262–77.

Haury, E. W., *The Mogollon Culture of Southwestern New Mexico*, Globe, Ariz., 1936.

————, *The Stratigraphy and Archaeology of Ventana Cave, Arizona*, Tucson and Albuquerque, 1950.

Heizer, R. F., and Baumhoff, M. A., *Prehistoric Rock Art of Nevada and Eastern California*, Berkeley, 1962.

Henshaw, H. W., *Animal Carvings from the Mounds of the Mississippi Valley (Bureau of American Ethnology, 2nd Annual Report)*, Washington, D.C., 1883.

Heye, G. G., *Certain Aboriginal Artifacts from San Miguel Island, California*, New York, 1921.

Himmelheber, H., *Eskimokünstler*, Eisenach, 1953.

Hodge, F. W. (ed.), *Handbook of American Indians North of Mexico (Bureau of American Ethnology, Bulletin XXX)*, 2 vols., Washington, D.C., 1907–10.

Hoffman, W. J., *The Graphic Art of the Eskimo (Smithsonian Institution Annual Report for 1895)*, Washington, D.C., 1897.

Holmes, W. H., *Aboriginal Pottery of the Eastern United States (Bureau of American Ethnology, 20th Annual Report)*, Washington, D.C., 1899.

Hough, W., *Antiquities of the Upper Gila and Salt River Valleys in Arizona and New Mexico (Bureau of American Ethnology, Bulletin XXXV)*, Washington, D.C., 1907.

Inverarity, R. B., *Art of the Northwest Coast Indians*, Berkeley, 1950.

Jacobson, O. B., *Kiowa Indian Art*, Nice, 1929.

Jenness, D., *The Indians of Canada*, 5th ed., Ottawa, 1960.

Jennings, J. D., and Norbeck, E. (eds.), *Prehistoric Man in the New World*, Chicago, 1964.

Judd, N. M., *The Material Culture of Pueblo Bonito (Smithsonian Institution Miscellaneous Collections, CXXIV)*, Washington, D.C., 1954.

Keithahn, E. L., *Monuments in Cedar*, Ketchikan, 1945.

Kelley, J. C., "Factors involved in the Abandonment of Certain Peripheral Southwestern Settlements," *American Anthropologist*, LIV, 1952, pp. 356–87.

Kelly, I. T., "The Carver's Art of the Indians of Northwestern California," *University of California Publications in American Archaeology and Ethnology*, XXIV, 1930, pp. 343–60.

Kidder, A. V., *An Introduction to the Study of Southwestern Archaeology*, rev. ed., New Haven and London, 1962.

Knoblock, B. W., *Bannerstones of the American Indian*, Lagrange, Ind., 1939.

Krickeberg, W., "Die Völker Amerikas ausserhalb der Hochkulturen," in *Kleine Kunstgeschichte der Vorzeit und der Naturvölker*, Stuttgart, 1956.

Kroeber, A. L., "American Culture and the Northwest Coast," *American Anthropologist*, XXV, 1923, pp. 1–20.

———, *Handbook of the Indians of California (Bureau of American Ethnology, Bulletin LXXVIII)*, Washington, D.C., 1925.

——— (ed.), *Anthropology Today*, Chicago, 1953 (rev. ed., ed. by S. Tax, Chicago, 1962).

Levi Strauss, C., "The Art of the Northwest Coast Indians," *Gazette des Beaux-Arts*, XXIV, 1943, pp. 145ff.

Libby, W. F., *Radiocarbon Dating*, 2nd ed., Chicago, 1955.

Lowie, R. H., *Crow Indian Art (American Museum of Natural History, Anthropological Papers XXI)*, New York, 1922.

McGregor, J. C., *Southwestern Archaeology*, New York and London, 1941.

Mallery, G., *Picture Writing of the American Indian (Bureau of American Ethnology, 10th Annual Report)*, Washington, D.C., 1893.

Martin, P. S., Quimby, G. I., and Collier, D., *Indians before Columbus*, Chicago, 1947.

Mason, J. A., "Eskimo Pictorial Art," *The University Museum Journal*, XVIII, 1927, pp. 248–83.

Medallion Papers, Globe, Ariz., 1928ff.

Meighan, C. W., and Eberhart, H., "Archaeological Resources of San Nicholas Island," *American Antiquity*, XIX, 1953, pp. 109–25.

Menzies, T. P. O., "Northwest Coast Middens," *American Antiquities*, III, 1938, pp. 359–61.

Mera, H. P., *Style Trends of Pueblo Pottery in the Rio Grande and Little Colorado Cultural Areas (Laboratory of Anthropology, Memoir III)*, Santa Fe, 1939.

Mills, W. C., "Explorations of the Adena Mound," *Ohio Archaeological and Historical Quarterly*, X, 1902, pp. 452–79.

Mindeleff, V., *A Study of Pueblo Architecture: Tusayan and Cibola (Bureau of American Ethnology, 8th Annual Report)*, Washington, D.C., 1891.

Moore, C. B., *Certain Mounds of Arkansas and Mississippi (Journal of the Academy of Natural Sciences of Philadelphia, XIII)*, Philadelphia, 1908.

Moorehead, W. K., *Prehistoric Implements*, Cincinnati, 1900.

———, *The Stone Age in North America*, 2 vols., Boston and New York, 1910.

———, *Stone Ornaments Used by Indians in the United States and Canada*, Andover, 1917.

Morris, E. H., "Basketmaker III Human Figurines from Northeastern Arizona," *American Antiquities*, XVII, 1951, pp. 33–40.

Murdock, J., *The Ethnological Results of the Point Barrow Expedition (Bureau of American Ethnology, 9th Annual Report)*, Washington, D.C., 1892.

Nelson, E. W., *The Eskimo about Bering Strait (Bureau of American Ethnology, 18th Annual Report)*, Washington, D.C., 1899.

Nesbitt, P. H., *The Ancient Mimbreños, New Mexico*, Beloit, Wisc., 1931.

Niblack, A. P., *The Coast Indians of Southern Alaska and Northern British Columbia (United States National Museum Annual Report for 1888)*, Washington, D.C., 1890.

Nusbaum, J. L., *A Basket-Maker Cave in Kane County, Utah*, New York, 1922.

Olson, R. L., *Chumash Prehistory*, Berkeley, 1930.

Orr, P. C., "Review of Santa Barbara Channel Archaeology," *Southwestern Journal of Anthropology*, VIII, 1952, pp. 211–26.

Parsons, E. C., *Pueblo Religion*, 2 vols., Chicago, 1939.

Pepper, G. H., *Pueblo Bonito (American Museum of Natural History, Anthropological Papers XXVII)*, New York, 1920.

Phillips, P., and Willey, G. R., "Method and Theory in American Archaeology: An Operational Base for Culture-Historical Investigation," *American Anthropologist*, LV, 1953, pp. 615–33.

Putnam, F. W., *et al.*, *Reports upon Archaeological and Ethnological Collections from the Vicinity of Santa Barbara, California and from Ruined Pueblos of Arizona and New Mexico, and Certain Interior Tribes (United States Geological Surveys West of the 100th Meridian, VII)*, Washington, D.C., 1879.

Quimby, G. I., *Indian Life in the Upper Great Lakes*, Chicago, 1961.

———, "Periods of Prehistoric Art in the Aleutian Islands," *American Antiquities*, XI, 1945, pp. 76–79.

Rainey, F., "Old Eskimo Art," *Natural History*, XI, 1937.

Ritzenthaler, R., *Masks of the North American Indian*, Milwaukee, 1959.

Roberts, F. H. H., Jr., "A Survey of Southwestern Archaeology," *American Anthropologist*, XXXVII, 1935, pp. 1–35.

Rogers, D. B., *Prehistoric Man of the Santa Barbara Coast*, Santa Barbara, Calif., 1929.

Rouse, I., "Southwestern Archaeology Today," in *An Introduction to the Study of Southwestern Archaeology*, rev. ed., New Haven and London, 1962.

Sayles, E. B., *An Archaeological Survey of Chihuahua, Mexico*, Globe, Ariz., 1936.

Schaefer-Simmern, H., *Eskimo Plastik aus Kanada*, Cassel, 1958.

Seaman, N. G., *Indian Relics of the Pacific Northwest*, Portland, Ore., 1946.

Shetrone, H. C., *The Mound Builders*, New York, 1930.

Shotridge, L., " War Helmets and Clan Hats of the Tlingit Indians," *The University Museum Journal*, X, 1919, pp. 43–48.

Smiley, T. L., *A Summary of Tree-Ring Dates from some Southwestern Archaeological Sites*, Tucson, 1951.

Smith, H. I., *An Album of Prehistoric Canadian Art*, Ottawa, 1923.

Smith, M. W., " Columbia Valley Art Style," *American Anthropologist*, XLV, 1943, pp. 158–60.

———, " The Cultural Development of the Northwest Coast," *Southwestern Journal of Anthropology*, XII, 1956.

Smith, W., *Kiva Mural Decorations at Awatovi and Kawaika-a (Peabody Museum Papers, XXXVII)*, Cambridge, Mass., 1952.

Speck, F. G., *The Iroquois (Cranbrook Academy of Science, Bulletin 23)*, Bloomfield Hills, Mich., 1955.

Stevenson, J., *Illustrated Catalog of the Collections Obtained from the Indians of New Mexico in 1880 (Bureau of American Ethnology, 2nd Annual Report)*, Washington, D.C., 1883.

Stevenson, M. V., *The Zuñi Indians (Bureau of American Ethnology, 23rd Annual Report)*, Washington, D.C., 1903.

Steward, J. H., " Petroglyphs of the United States," *Smithsonian Institution Annual Report for 1936*, Washington, D.C., 1937, pp. 405–26.,

Strong, W. D., *Archaeological Explorations in the Country of the Eastern Chumash*, Washington, D.C., 1936.

———, " The Occurrence and Wider Implications of a 'Ghost Cult' on the Columbia River Suggested by Carvings in Wood, Bone, and Stone," *American Anthropologist*, XLVII, 1945, pp. 314–17.

Swanton, J. R., *Contributions to the Ethnology of the Haida (American Museum of Natural History, Memoir VIII)*, New York, 1905.

———, *The Indians of the Southwestern United States (Bureau of American Ethnology, Bulletin CXXXVII)*, Washington, D.C., 1946.

Teit, J. A., *The Salishan Tribes of the Western Plateaus (Bureau of American Ethnology, 45th Annual Report)*, Washington, D.C., 1928.

Underhill, R. M., *Indian Crafts*, Washington, D.C., 1944.

Vaillant, G. C., *Indian Arts in North America*, New York and London, 1939.

Wardwell, A., *Yakutat South: Indian Art of the Northwest Coast*, Chicago, 1964.

Waterman, T. T., et al., *Native Houses of Western North America*, New York, 1921.

West, G., *Tobacco Pipes and Smoking Customs of the American Indians*, 2 vols., Milwaukee, 1934.

Wickersham, J., " Some Relics of the Stone Age from Puget Sound," *American Antiquarian*, XXII, 1900, pp. 141–49.

Willey, G. R., *An Introduction to American Archaeology*, vol. I: *North and Middle America*, Englewood Cliffs, N.J., 1966.

———, " New World Prehistory," *Science*, CXXXI, 1960, pp. 76–86.

Willoughby, C. C., " The Art of the Great Earthwork Builders of Ohio," in *Holmes Anniversary Volume*, Washington, D.C., 1916, pp. 469–80.

Wilson, T. J., *Prehistoric Art (United States National Museum Annual Report for 1897)*, Washington, D.C., 1898.

Wingert, P. S., *American Indian Sculpture: A Study of the Northwest Coast*, New York, 1949.

———, *Prehistoric Stone Sculpture of the Pacific Northwest*, Portland, Ore., 1952.

Wissler, C., *Indians of the United States*, Garden City, N.Y., 1940.

———, *North American Indians of the Plains*, New York, 1929.

Woodbury, R. B., " N. C. Nelson and Chronological Archaeology," *American Antiquity*, XXV, 1960, pp. 400–401.

———, *Stone Implements of Northeast Arizona (Peabody Museum Papers, XXXIX)*, Cambridge, Mass., 1954.

Woodcock, G., " Masks of the Pacific Northwest Indians," *Burlington Magazine*, April, 1954, pp. 109–13.

Wormington, H. M., *Prehistoric Indians of the Southwest*, Denver, 1947.

THE ART OF OCEANIA

Adam, L., " Anthropomorphe Darstellungen auf australischen Ritualgeräten," *Anthropos*, LIII, 1–2, Freiburg, 1958, pp. 1–50.

Andersson, J. G., " Researches into the Prehistory of China," *Bulletin of the Museum of Far Eastern Antiquities*, XV, 1943, pp. 1–304.

Anell, B., *Contribution to the Fishing in the South Seas*, Upsala, 1955.

Bandi, H. G., and Maringer, J., *L'Art préhistorique*, Basel, 1952 (Eng. trans., *Art in the Ice Age: Spanish Levant Art: Arctic Art*, London and New York, 1953).

Bay, R., *Die prähistorische Sammlung des Museums für Völkerkunde Basel*, Basel, 1960.

Bernatzik, H. A., *Owa Raha*, Vienna, 1936.

Black, L., *Aboriginal Art Galleries of Western New South Wales*, Melbourne, 1943.

Buck, P. H. (Te Rangi Hiroa), *The Coming of the Maori*, Wellington, 1949.

Bühler, A., Barrow, T., and Mountford, C. P., *Ozeanien und Australien*, Baden-Baden, 1961 (Eng. trans., *The Art of the South Sea Islands*, New York, 1962).

Cheng Te-k'un, *Archaeology in China*, vol. II: *Shang China*, New York, 1961.

Consten, E., *Das alte China*, Stuttgart, 1958.

Covarrubias, M., *The Eagle, the Jaguar, and the Serpent*, New York, 1954.

Davidson, D. S., *Aboriginal Australian and Tasmanian Rock Carvings and Paintings (American Philosophical Society, Memoirs V)*, Philadelphia, 1936.

Douglas, F. H., and d'Harnoncourt, R., *Indian Art of the United States*, New York, 1941.

Emory, K. P., " The Island of Lanai," *Bernice P. Bishop Museum Bulletin*, XII, 1924.

———, *Stone Remains in the Society Islands (Bernice P. Bishop Museum Bulletin)*, Honolulu, 1933.

Fell, H. B., " The Pictographic Art of the Ancient Maori of New Zealand," in *Man*, XLI, 1941.

Fewkes, J. W., " A Prehistoric Island Culture Area of America," *Bureau of American Ethnology, 34th Annual Report*, 1912–13, pp. 35–268.

Giglioli, E. H., *La collezione etnografica del prof. E. H. Giglioli*, 2 vols., Città di Castello, 1911–12.

Hammond, J. E., *Winjan's People*, Perth, Australia, 1933.

Hatt, G., " Had West Indian Rock Carvings a Religious Significance? " *Ethnographical Studies*, Copenhagen, 1941.

Hébert, M. J., " Survivances décoratives au Brésil," *Journal de la Société des Américanistes de Paris*, n.s. IV, 1907, pp. 185–91.

Heine-Geldern, R., " L'Art prébouddhique de la Chine et de l'Asie du Sud-Est et son influence en Océanie, " *Révue des Arts Asiatiques*, XI, 1937, pp. 177–206.

Jansen, J. V., "Das Boot in der Asmat-Kultur (Südwest-Neuguinea)," *Tribus*, IX, 1960, pp. 164–71.

Karlgren, B., " Bronzes in the Wessén Collection, " *Bulletin of the Museum of Far Eastern Antiquities*, XXX, 1958.

Kooijman, S., *The Art of Lake Sentani*, New York, 1959.

Kupka, K., *Un Art à l'état brut*, Lausanne, 1962.

Linton, R., Wingert, P. S., and d'Harnoncourt, R., *Arts of the South Seas*, New York, 1946.

Lommel, A., " Der Röntgenstil auf Felsbildern, " in *Die " Umschau " in Wissenschaft und Technik*, VIII, 1961.

———, and Lommel, K., *Die Kunst des fünften Erdteils — Australien*, Munich, 1959.

Luquet, G. H., *L'Art néo-calédonien*, Paris, 1926.

McCarthy, F. D., *The Cave Paintings of Groote and Chasm Island (Records of the American-Australian Scientific Expedition to Arnhem-Land, 1948, II)*, Melbourne, 1959.

Menghin, O. F. A., " Die Sambaquís der Atlantikküste Südbrasiliens, " *Paideuma*, VII, 7, 1961, pp. 377–94.

Neumann, E., *Die grosse Mutter*, Zurich, 1956.

Noone, H. V. V., " Some Implements of the Australian Aborigines with European Parallels, " *Man*, XLIX, 1949, pp. 111–14.

Nordenskiöld, E., " Recettes magiques et médicales du Pérou et de la Bolivie, " *Journal de la Société des Américanistes de Paris*, n.s. IV, 1907, pp. 153–74.

Prestre, W. A., *La Piste inconnue. Au pays des chasseurs de têtes*, Neuchâtel, 1946.

Rasmussen, K., *Reports of the Fifth Thule Expedition under the Direction of Knud Rasmussen*, 1921–24, 10 vols., Copenhagen, 1927.

Read, H., and Mountford, C., *Australia, Aboriginal Paintings: Arnhem Land*, New York, 1954.

Renselaar, H. C. van, *Asmat, Zuidwest-Nieuw-Guinea*, Amsterdam, 1956.

Röder, J., *Felsbilder und Vorgeschichte des MacCluer-Golfes, West Neuguinea*, Darmstadt, 1959.

Rosenthal, E., and Goodwin, A. J. H., *Cave Artists of South Africa*, Cape Town, 1953.

Salmony, A., " With Antler and Tongue, " *Artibus Asiae*, XXI, 1, 1958, pp. 29–36.

Sankalia, H. D., " The Nude Goddess or ' Shameless Woman ' in Western Asia, India, and South-eastern Asia, " *Artibus Asiae*, XXIII, 2, 1960 pp. 111–23.

Saxe-Altenburg, F. E., " New Excavations in the Cordillera de la Costa de Venezuela, " *Proceedings of the 32nd International Congress of Americanists*, Copenhagen, 1958, pp. 315–25.

Schulz, A. S., " North-West Australian Rock Paintings, " *National Museum of Victoria, Memoirs*, XX, 1956, pp. 7–57.

Seligmann, C. G., " Note on a Painting on Bark from the Aird River Delta, British New Guinea, " *Man*, V, 1905, p. 161.

Shapiro, H. L., and Suggs, R. C., " New Dates for Polynesian Prehistory, " *Man*, LIX, 1959, pp. 12–13.

Spencer, B., and Gillen, F, J., *The Native Tribes of Central Australia*, London, 1938.

Steward, J. H., " Petroglyphs of the United States," *Smithsonian Institution Annual Report for 1936*, Washington, D.C., 1937, pp. 405–26.

Stolpe, K. H., *Entwicklungserscheinungen in der Ornamentik der Naturvölker*, Vienna, 1892.

Tischner, H., *Kulturen der Südsee*, Hamburg, 1959.

———, and Hewicker, F., *Kunst der Südsee*, Hamburg, 1954.

Tugby, D. J., " Coning Range Rock Shelter, " *Mankind*, IV, 1953, pp. 446–50.

Worms, E. A., " Prehistoric Petroglyphs of the Upper Yule River, North-Western Australia, " *Anthropos*, L, 1955.

PHOTOGRAPHIC CREDITS

Carlo Bevilacqua, Milan (199, 215); Lee Boltin, New York (242); Karl Cohen (198, 328, 330); Armand Colin (91); John Galloway, Rochester, Michigan (266); Helmut Jäger (378, 432); Mercurio, Milan (62, 302, 400); Moeschlin & Baur, Basel, copyright (431); O. E. Nelson, New York (272); Ohio Historical Society, Columbus (340); Publifoto, Milan (112, 117); Ronald Shirk (174, 179, 187, 193, 194, 203, 214, 219, 220, 240, 241, 264, 265, 275, 319, 325, 329, 331, 332, 342); The Smithsonian Institution, Washington, D. C. (201, 228 right, 253, 288, 292–94, 298, 300, 301, 304, 313, 336, 343–46, 349, 417); Barton Stewart (173, 178, 183, 188, 200, 228 left); Taylor & Dull, New York (185, 186); Charles Uht, New York (217, 226, 250, 318); United States Department of the Interior, National Park Service Photo (290, 291); Foto Vertut (76); Robert Watts, New York (312, 314).

Index

Numbers in roman type refer to text references; those in *italic* type refer to pages on which illustrations may be found.